CW00952848

1 MONTH OF
FREE
READING

at
www.ForgottenBooks.com

By purchasing this book you are eligible for one month membership to ForgottenBooks.com, giving you unlimited access to our entire collection of over 1,000,000 titles via our web site and mobile apps.

To claim your free month visit:
www.forgottenbooks.com/free84774

ISBN 978-0-484-21301-1
PIBN 10084774

THE COMPLETE
WORKS OF
JOHN RUSKIN

Two thousand and sixty-two copies of this edition—of which two thousand are for sale in England and America—have been printed at the Ballantyne Press, Edinburgh, and the type has been distributed.

THE WORKS OF

EDITED BY

E. T. COOK

AND

ALEXANDER WEDDERBURN

LONDON

GEORGE ALLEN, 156, CHARING CROSS ROAD

NEW YORK: LONGMANS, GREEN, AND CO.

1904

LIBRARY EDITION

VOLUME XIII

TURNER

THE HARBOURS OF ENGLAND

CATALOGUES AND NOTES

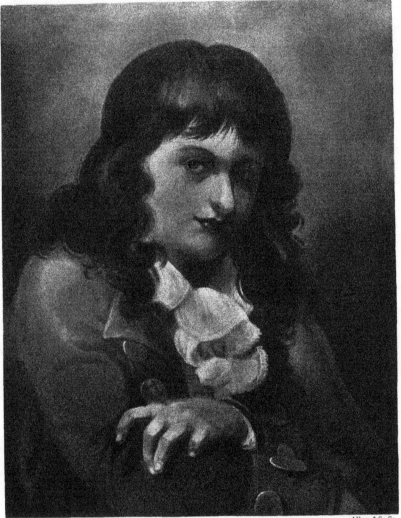

J.M.W.Turner

Allen &Co.Sc

Portrait of J.M.W.Turner,
Aged 17.
From the picture by the artist at Brantwood

THE HARBOURS OF ENGLAND

CATALOGUES AND NOTES

BY

JOHN RUSKIN

LONDON
GEORGE ALLEN, 156, CHARING CROSS ROAD
NEW YORK: LONGMANS, GREEN, AND CO.
1904

[4·

CONTENTS OF VOLUME XIII

PAGE

3. "CATALOGUE OF THE TURNER SKETCHES IN THE NATIONAL
 GALLERY," PART I. (1857) :—

 BIBLIOGRAPHICAL NOTE 186

 TEXT OF ALL THE EDITIONS :—

 PREFATORY 187

 CATALOGUE 191

4. "CATALOGUE OF THE SKETCHES AND DRAWINGS BY J. M. W.
 TURNER, R.A., EXHIBITED IN MARLBOROUGH HOUSE,
 1857–1858" :—

 BIBLIOGRAPHICAL NOTE 231

 TEXT OF ALL THE EDITIONS :—

 INTRODUCTORY REMARKS 235

 CATALOGUE :—

 PERIOD OF DEVELOPMENT (1790–1800) . . 250

 FIRST STYLE (1800–1820) 261

 SECOND STYLE (1820–1835) 279

 THIRD STYLE (1835–1845) . . . , . 289

 SUPPLEMENTAL SERIES , 297

5. "MR. RUSKIN'S REPORT ON THE TURNER DRAWINGS IN THE
 NATIONAL GALLERY " (1858) :—

 BIBLIOGRAPHICAL NOTE 318

 TEXT 319

6. LETTERS TO THE PRESS ON THE EXHIBITION OF THE TURNER
 DRAWINGS IN POSSESSION OF THE NATION (1858,
 1859, 1876) :—

 BIBLIOGRAPHICAL NOTE 328

 TEXT :—

 THE TURNER SKETCHES AND DRAWINGS (" LITERARY
 GAZETTE," NOVEMBER 13, 1858) . . . 329

 THE TURNER GALLERY AT KENSINGTON (" TIMES,"
 OCTOBER 21; 1859) 339

 TURNER'S DRAWINGS (" DAILY TELEGRAPH," JULY 5,
 19, 1876) 341, 345

CONTENTS

CONTENTS

INDEX

THE FOLLOWING MINOR RUSKINIANA ARE ALSO INCLUDED IN THIS
VOLUME :—

LIST OF ILLUSTRATIONS

PLATES

"THE HARBOURS OF ENGLAND"

(*Photogravures from the engravings after Turner by Thomas Lupton*)

TURNER'S DRAWINGS AND SKETCHES IN THE NATIONAL GALLERY

(*Photogravures from the originals, except XVI.*)

INTRODUCTION TO VOL. XIII

(In the chronological order, this Volume follows Volumes V. and VI.)

In this volume are collected all Ruskin's pieces which deal exclusively with Turner. In one sense the whole body of · Ruskin's art work was written around Turner, and there are thus many other pieces which belong in subject to this volume; as, for instance, the greater part of the pamphlet entitled *Pre-Raphaelitism*, and the third of the Edinburgh Lectures (both in Vol. XII.). But it has been felt impossible to separate those writings from their context, chronological or otherwise. With two exceptions the main writings here collected have both a chronological and a topical unity. They all deal with Turner, and they all were written during the years 1856, 1857, 1858. The exceptions are the last of Ruskin's three catalogues of Turner drawings in the National Gallery, and the Notes on his Drawings by Turner. Of these the former, though published in 1881 as a new pamphlet, was in some sort a revision of the earlier catalogue published in 1857–1858; and the latter, though not written till 1878, describes the collection which Ruskin for the most part had formed and studied in much earlier years.

Resuming the biographical thread from the Introduction to Vol. V. (p. li.), we there left Ruskin at the completion of the third and fourth volumes of *Modern Painters*, in April 1856. There was now once more to be a long interval in the production of that work, of which the last volume was not published till June 1860. Ruskin's multifarious literary activity during these four years occupies Volumes XIII. to XVI. of this edition.[1]

As it has been impossible to make the contents of these volumes strictly chronological (for in that case the several Turner catalogues, for instance, would have had to be dispersed through various volumes), it will be convenient here to map out in general form the occupations of the four years now under review.

[1] Together with some pieces of later date, comprised in the same volumes, for convenience of grouping in subject-matter.

1855.—Ruskin wrote *The Harbours of England* (Part I. in this volume) and the first of the *Academy Notes* (Vol. XIV.).

1856.—Ruskin was now much interested in the building of the Museum at Oxford; he lectured to the workmen there in April (Vol. XVI.). Returning to London, he wrote the second of the *Academy Notes* (Vol. XIV.). He then went abroad with his parents (May 14 to October 1) on a tour, of which some account is given in the Introduction to Vol. VII. (the fifth volume of *Modern Painters*). During the winter, 1856–1857, he was engaged, in connexion with his teaching at the Working Men's College, in writing *The Elements of Drawing* (Vol. XV.).

1857.—The arrangement and exhibition of the pictures and drawings bequeathed by Turner to the nation was now beginning. In January Ruskin was engaged in assisting Mr. Wornum, the Keeper of the National Gallery, in arranging the exhibition, mainly of oil-pictures, at Marlborough House; and he wrote the catalogue (Part II., No. 2 in this volume). During March he was constantly engaged at the National Gallery, examining the Turner sketches and drawings. He wrote a preliminary catalogue of one hundred of them (Part II., No. 3). A little later he wrote another catalogue of 153 drawings, which were exhibited at Marlborough House (Part II., No. 4). In the early months of the same year (January, April, and May), he delivered various lectures (Vol. XVI.), and gave evidence before the National Gallery Site Commission (Appendix I. in this volume). The third series of *Academy Notes* was issued in May. Next, he prepared lectures (delivered at Manchester in July) on *The Political Economy of Art* (Vol. XVI.). His holiday in August and September was to Scotland (see Introduction to Vol. VII.). On returning to Denmark Hill he resumed his teaching at the Working Men's College, and the arduous work of sorting the Turner drawings. This occupied him the whole of the winter, 1857–1858, as well as the spring of the latter year.

1858.—In January he delivered at South Kensington the lecture on "Conventional Art," and in February at Tunbridge Wells that on "Iron," afterwards published as Lectures i. and v. of *The Two Paths* (Vol. XVI.). By the end of March he was able to draw up his Official Report on the Turner Bequest (Part II., No. 5 in this volume), but the work of arrangement was not finished till May. After writing the fourth series of *Academy Notes* (Vol. XIV.), he went abroad from May to September (see Introduction to Vol. VII.). On returning to Denmark Hill he prepared his *Inaugural Address*, delivered to the Cambridge School of Art in October (Vol. XVI.).

1859.—In this year he gave two other lectures—at Manchester on "The Unity of Art" (February), and on "Modern Manufacture and Design" at Bradford (March)—which were afterwards included in *The Two Paths* (Vol. XVI.). He also wrote *The Elements of Perspective* (Vol. XV.). Then came the fifth series of *Academy Notes* (Vol. XIV.), after which he again went abroad (May to October)—see Introduction to Vol. VII. On his return he settled down to resume and finish *Modern Painters.*

This biographical abstract will serve to show how busy Ruskin was during the four years which intervened between the fourth and fifth volumes of his great work. The scattered labours group themselves, it will be seen, according to subject-matter, under four heads, corresponding to the present and the three following volumes of this edition: (1) Turner (Vol. XIII.); (2) criticism of contemporary art—*Academy Notes* (Vol. XIV.); (3) teaching of art—*Elements of Drawing* and *Perspective* (Vol. XV.); and (4) lectures on art—*Political Economy of Art, The Two Paths*, etc. (Vol. XVI.).

With regard to the present volume, its contents are arranged in three Parts: I. *The Harbours of England.* II. Turner's Pictures and Drawings at the National Gallery. III. Ruskin's own Collection of Turner Drawings, together with his notes on his own handiwork. The Appendix contains various minor writings connected with cognate subjects.

I

We thus pass to *The Harbours of England*, the first of the pieces here collected in order both of composition and of publication. This book was the fulfilment by Ruskin, so far as existing materials rendered it possible, of a work designed by Turner. It was written by Ruskin in the spring of 1855, after a visit to Deal, already noticed (Vol. V. p. l.), where he had made studies of ships and shipping. The circumstances in which he came to undertake the task are described by himself in his Preface (below, p. 10), and some additional particulars will be found in the Bibliographical Note (p. 5). A letter from his father to Mr. W. Smith Williams, for many years literary adviser to Messrs. Smith, Elder & Co., explains the matter further :—

"CHAMOUNI, *August 4th*, 1856.

"MY DEAR SIR,—I hear that in the *Athenæum* of 26th July there is a good article on my son's *Harbours of England*, and I should be greatly obliged by Mr. Gordon Smith sending me that number. . . .

"The history of this book, I believe, I told you. Gambart, the French publisher and picture dealer, said some eighteen months ago that he was going to put out twelve Turner plates, never published, of English Harbours, and he would give my son two good Turner drawings for a few pages of text to illustrate them.* John agreed, and wrote the text, when poorly in the spring of 1855, at Tunbridge Wells; and it seems the work has just come out. It was in my opinion an extremely well done thing, and more likely, as far as it went, if not to be extremely popular, at least to be received without cavil than anything he had written. If there is a very favourable review in the *Athenæum* . . . it may tend to disarm the critics, and partly influence opinion of his larger works. . . .—With our united kind regards,

"Yours very truly,

"JOHN JAMES RUSKIN."[1]

The Introductory Essay to *The Harbours of England*, and the descriptions of Turner's drawings, form a supplementary chapter to *Modern Painters*. The scientific portions of that book were, as Ruskin says,[2] "divided prospectively, in the first volume, into four sections, . . . meant to define the essential forms of sky, earth, water, and vegetation; but finding," he adds, "that I had not the mathematical knowledge required for the analysis of wave-action, the chapters on sea-painting were never finished, the materials for them being partly used in *The Harbours of England*." From this point of view, then, the book was a continuation of the chapters on sea-painting in the first volume of *Modern Painters*. From another point of view, it was a chapter supplementary to the fourth and fifth volumes, for the analysis of the several drawings by Turner illustrates the artist's principles of composition as expounded in *Modern Painters*. "Turnerian Topography," for instance, treated in Vol. IV. ch. ii., is illustrated in the "Dover" (see below, p. 51); and Turnerian methods of composition, again, in the "Dover," and in the "Scarborough" (p. 74).

Ruskin's father considered that his son's essay was "an extremely well done thing," and "more likely to be received without cavil than anything he had written." The judgment of competent criticism has endorsed the former opinion, and the reviewers of the day justified the latter. The Introductory Essay, written in the middle of Ruskin's active life, and in the plenitude of his power, has generally been recognised

* Mr. E. Gambart (who is still living) states that, to the best of his recollection, he paid Mr. Ruskin 150 guineas for his work. Probably this was the price originally agreed upon, the two Turner drawings being ultimately accepted as a more welcome and appropriate form of remuneration. [Note to the edition of 1895.]

[1] This letter is here reprinted from pp. xiii.-xiv. of the 1895 edition of *The Harbours of England*.
[2] Preface to *In Montibus Sanctis*.

as among his masterpieces. The subject—the treatment of sea and shipping in art—had hitherto been almost untouched, save by Ruskin himself (in the first volume of *Modern Painters*). It was handled with the fulness of knowledge and nicety of analysis characteristic of his best work. The style shows his special powers at their best, it is imaginative without being fanciful, and the language, though rich and luxuriant, is free alike from over-emphasis and from over-elaboration. "No book in our language," says Mr. Frederic Harrison in his essay on "Ruskin as Master of Prose," "shows more varied resources over prose-writing, or an English more pure, more vigorous, more enchanting."[1] Never, too—at least in prose—had the beauty and mystery of the sea, or the glory of ships and shipping, received expression so rapturous and yet so penetrating as that which Ruskin in this essay pours forth. The book compelled admiration even in quarters the least favourably disposed. We have quoted in earlier volumes the tirades of the leading literary journal against Ruskin; let us read here its ungrudging tribute to the present work:—

"Since Byron's 'Address to the Ocean,' a more beautiful poem on the sea has not been written than Mr. Ruskin's preliminary chapter. It is a prose poem worthy of a nation at whose throne the seas, like captive monsters, are chained and bound. It is worthy of the nation of Blake and Nelson, of Drake and Howe, and true island hearts will beat quicker as they read. To first appreciate, and first to enable others to appreciate, some fresh and unheeded beauty of the universe, is a gift second only to that of creation. After this book has been mastered and got by heart— as it will be—the waves that lap and wash our cliffs, that now heap on them rough kisses, and now rush on them like hungry leopards, will speak to Englishmen in a fuller and more articulate voice. A great mind has at last come and almost deciphered the meaning of the surge's moan, and the deep sea's shout of madness. The chemist may still look on the sea as a saline draught, and the cosmographer deem it a thing to fill up maps with; but Mr. Ruskin, with his earnest, meditative wisdom, teaches us to see in the exhausted theme of poets and painters a beauty as yet untouched and a mystery as insolvable as eternity."[2]

[1] *Tennyson, Ruskin, Mill, and other Literary Estimates*, 1899, p. 67.
[2] *Athenæum*, July 26, 1856. Reviews appeared also in the *Monthly Christian Spectator*, September 1856 (vol. vi. pp. 568-571, in the course of a paper entitled "An Ocean Colloquy"), and the *Saturday Review*, September 27, 1856. The writer in the latter journal used a phrase which occurs also in the review by Burne-Jones and William Morris of the third volume of *Modern Painters* (Vol. V. p. lx.). Ruskin, said the *Saturday* Reviewer, "has been a Luther in the world of art, protesting against the errors of its teachers, and claiming for all the right of individual reading and understanding of its scripture—the book of Nature—unshackled by the arbitrary interpretation of others."

Ruskin had vowed that he would raise a worthy monument to Turner;[1] and if *The Harbours of England* touches on only one aspect—though not the least characteristic—of the artist's genius, yet it is a noble monument alike of the painter and of the writer, and links, even more definitely than does *Modern Painters*, the names of Turner and Ruskin.

II

The monument which Turner had sought to raise to himself is the subject which has next to occupy us. In the Second Part of this Volume are contained, in their chronological order, all the letters, catalogues, notes, and reports which Ruskin wrote upon the pictures, drawings, and sketches by Turner which passed into the possession of the nation on the artist's death. This connected branch of Ruskin's work occupied a considerable amount of his time and thought, and it is necessary, for the due understanding of the relation of the various pieces to one another, to tell the story in some detail.

Turner died on the 19th of December 1851. Ruskin was at Venice at the time, at work upon *The Stones of Venice* (see Vol. X. p. 38 *n.*). His father at once sent the news to him, and he replied as follows :—

> "*December 28, 1851.*—I received your letter some hours ago, telling me of the death of my earthly Master. I was quite prepared for it, and am perhaps more relieved than distressed by it—though saddened. It will not affect my health, nor alter my arrangements. The sorrow which did me harm was past when I first saw that his mind had entirely failed; but I hope I shall have another letter from you soon, for I cannot tell by this whether it has yet been ascertained that his portfolio is safe or whether—of which I lived in continual dread—he has destroyed anything. I shall not enter into any particulars about pictures to-night—being Sunday—but merely sit down to acknowledge your letter. For *one* thing I was not altogether prepared—the difference of feeling with which one now looks at the paper touched by his hand— the sort of affection which it obtains as that on which something of his life remains. I have the *Farnley*—as you the *Rigi*—beside me, perhaps the most touching picture of the two now; I think it more beautiful than I ever did before. The last sentence of my postscript to the last edition of *Modern Painters* will come true indeed."[2]

[1] See Vol. V., Introduction, p. xvi.

[2] The "postscript" to the fifth edition (1851) of the first volume, remarking on the absence of any work by Turner from the exhibition of that year, etc. : see Vol. III. p. 631.

The contents of Turner's will had not yet reached him, and Ruskin supposed that the master's portfolios would come into the market. His first concern, therefore, was to write to his father with instructions of what he was to buy:—

"*Monday morning*" [*December* 29].—I slept very well, only waking early. I feel it a little more than I thought I should, however—everything in the sunshine and the sky so talks of him. Their Great Witness lost. . . .[1]

"Touching pictures—the first and most important of all are the original sketches of my St. Gothard and Goldau;[2] and, if possible, the original sketches of all the Swiss drawings we have—Mr. Griffith knows which they are—but especially—after the St. Gothard and Goldau—the one of your Schwytz. You speak of sketches in *body colour*, but I never named any in my list.[3] These sketches are in such *pure* thin water-colour that you may crumple them like bank-notes, without harm.[4] There are, I know, unless he has destroyed them, a vast quantity, for which the *public* won't care a farthing. It is just possible that for five or six hundred pounds you might secure the whole mass of them—getting them for from three to four guineas each, or even less. I don't mean all his sketches, but *all his Swiss sketches since 1841*, and if you can do this, I should like my whole remainder, £600, spent in this way, *if necessary*. But if you find that these sketches fetch a price, and you cannot get them *all*, then spend £300 in them—doing the best you can with that sum, but securing, at all events, St. Gothard, Goldau, and Schwytz, and, if they can be found, the parcel which was first shown us in 1841, containing a Lausanne, something in that way [a rough sketch], in purple and blue sunset—very misty, and a bright coloured group of Swiss cottages. I hope Mr. Griffith may recollect the parcel—if not, you must choose those you think best out of the lot. But spend £300 in them, for this reason: I can get *more* of Turner at a cheaper rate thus, than any other way. I understand the meaning of these sketches, and I can work them up into pictures in my head, and reason out a great deal of the man from them which I cannot from the drawings. Besides, no one else will value them, and I should like to show what they are.

"By-the-bye, Griffith mentioned some of Fribourg, which I have

[1] Almost all the intervening passage has already been given: see Vol. X. p. 38 *n*.

[2] Nos. 66 and 65 among the Ruskin Turners (p. 456); for the sketches, see pp. 206, 201. "Your Schwytz" must be one of the drawings of the Lake of Lucerne enumerated in the Index.

[3] Ths refers to an earlier correspondence, in which Ruskin's father had consulted him as to possible purchases.

[4] See below, p. 237.

never seen—very fine; please try to see these, and do try to get
some of those above mentioned: [1] I have been so often disappointed
about these sketches that I feel as if there were some fatality in
them."

Ruskin was in a double sense to be disappointed again. The sketches
and drawings left by Turner were not to pass into the possession of
his disciple and interpreter, and they were to be treated with scanty
respect by those whose property they became. But all this was not
yet known by Ruskin, and his instructions to his father continued in
many letters. Some extracts from these may be given, as containing
aperçus on Turner's work in this sort, and referring to sketches now
accessible in the National Gallery:—

"(*December* 29.)—. . . Invest in *mountain* drawings of any sort
you like best yourself, as I cannot give you any specific directions
further than these:—

"Please do not buy for *me* any very highly laboured, or popular
drawing, especially if large; the popular drawings are nearly always
bad, though our Coblentz and Llanthony,[2] for instance, are both
first-rates—especially the first, and would be popular also; but, in
general, a drawing much run after will be bad.

"Any drawing which has a bad name among picture-dealers is
sure to be worth having at the price it will go for; and very nearly sure
to be a first-rate in its way; as, for instance, our Winchelsea and
Gosport.[3] So if you see any *odd* drawings with ugly figures—*spoiling*
them, as the picture-dealers call it—*going very cheap, pick them up.*

"But the chief thing is to get mountains. A mountain drawing
is always, to me, worth just three times one of any other subject,
and I have not enough, yet: the only two *thorough* ones that I
have are the St. Gothard and the Lake Lucerne last got from
Munro; the Rigi is divine as an evening thought, but the mountain
form is heavy; the other Lake Lucerne feeble; the Harlech a
little slight, and distant.[4] I want drawings as like the St. Gothard
as possible; and, if it may be, in Switzerland or North Italy; if
not, in Cumberland, Wales, or Scotland; but *don't buy, on any account,*

[1] Many of the sketches of Fribourg and Lausanne may now be seen in the National
Gallery, while others are stored in tin boxes there.
[2] For the Coblentz, see below, p. 454; for the Llanthony, Vol. III. p. 402 (Plate 8),
and below, p. 590.
[3] For these, see below, pp. 437, 439.
[4] "The St. Gothard" is "The Pass of Faido" (see below, p. 456); "the Lake
Lucerne last got from Munro" is probably the "Fluelen," see p. 459; for the Rigi,
see Index, p. 603; the "other Lake Lucerne" is presumably the "Town from the
Lake," see Index, p. 602; the Harlech was afterwards sold by Ruskin: see Index,
below, p. 601.

any in South Italy, Rome, Florence, or Naples; *nor none* in the East,—Greece, India, or Holy Land. Nor none on the Rhine, unless you should see something especially delighting you.

"I now recollect two more sketches I especially want. One was part of the Goldau batch, with a little bridge at foot of a great overhanging rock—so [a rough sketch]; the other, a great arched single bridge between two walls of rock. Mr. Griffith may perhaps recollect his saying to me, 'What would Turner make of it?'—it is very blue in colour.

"So now I must leave you to do the best you can for me, remembering that I would always rather have *two* slight or worn drawings than one highly finished one. The thought is the thing. Buy *mountains*, and buy *cheap*, and you cannot do wrong. I am just as glad I am not in England. I should be coveting too much—and too much excited—and get ill. I must now go to my work, and keep my thoughts away from these things."

"(*December* 31.)—I can give you one test in case any drawings should come before you—quite infallible. Whenever the colours are vivid—and laid on in many patches of sharp *blotty* colour—not rubbed —you may be sure the drawing is valuable. For Turner never left his colours fresh in this way unless he was satisfied; and when *he* was satisfied, *I* am.

"*All drawings with black skies*, without exception, are fine—like our Winchelsea. (The Land's End, though to me unsatisfactory, is assuredly a fine drawing; its sky is black, but too laboured. Windus has a black picture of Fowey Harbour; this is also fine, but I should not like it, because people are being drowned in the water, and we have enough of that in Slaver.) And nearly all in which the clouds are worked into *dark blue* as a *storm* colour are bad, like the Bamborough, which you may recollect had an indigo sky. Compare —taking them down from the wall—first, Schwytz and Richmond (Surrey): you will see the Schwytz is throughout *rubbed*—no colour has an edge nor any purity. Look at the way the blue is dashed on in the woman's shawl, and the light distant sky in the Richmond; and the edges of the trees, look at the *thin* fresh colour in them. *Whenever* you see the colour thus laid on—the drawing is fine.

"Look, again, at the way it goes on behind the tower and trees in the Winchelsea, and all over that sky; and look how the distant castle is painted in the Dudley, and the mountain distance on the left in the St. Gothard: all *blots*. Whenever the colour is so left, it is a sure sign that Turner was satisfied. When he was not, he worked on, and stippled and rubbed. Not but that in his very finest drawings—our Constance and Rigi, for instance—he stippled up

his first thoughts with exquisite care; but you cannot be *sure* of
the universally rubbed and stippled drawings; they *may* be elabora-
tions of a fine thought—or corrections of a blunder. The fresh
drawings are *sure*. I only name these tests in case of any drawings
going cheap; for the great thing is to get *mountains*. *They* are
almost always sure to be invaluable, and of other subjects — the
brighter the colours the better. . . .

 "*P.S.*—Observe the remarks on Turner's execution, on last page,
refer only to the drawings of his middle period—noticed in *Pre-
Raphaelitism*[1] as that in which he most erred, and to the failing draw-
ings of his last Swiss series. In buying early drawings in the
colourless Yorkshire manner—like our Richmond, Yorkshire — you
cannot err. They are all faultless, though none of them rise to
such achievement as he purchased afterwards by occasional error,
and his first Swiss series — ours, Bicknell's and Munro's — are
quite priceless."

 A few days later Ruskin heard that he had been appointed an
executor by Turner, and the contents of the will—with its bequest of
pictures and drawings to the nation, and of the bulk of his other
property to found a Charitable Institution for Decayed Artists—be-
came known. There was no legacy to Ruskin, except of nineteen
guineas to him (as also to each of the other executors) to buy a
mourning ring. "Nobody can say," wrote Ruskin's father, "you were
paid to praise."[2] Ruskin's father, who was at home, sent his son a
very interesting description of Turner's treasures:—

 "I have just been through Turner's house with Griffith. His labour
is more astonishing than his genius. There are £80,000 of oil pictures,
done and undone. Boxes, half as big as your study table, filled with
drawings and sketches. There are copies of Liber Studiorum to fill
all your drawers and more, and house walls of proof plates in reams—
they may go at 1s. each. . . .

 "Nothing since Pompeii so impressed me as the interior of Turner's
house; the accumulated dust of forty years partially cleared off; daylight
for the first time admitted by opening a window on the finest produc-
tions of art buried for forty years. The drawing-room has, it is reckoned,
£25,000 worth of proofs, and sketches, and drawings, and prints. It is
amusing to hear dealers saying there can be no Liber Studiorums—when
I saw neatly packed and well labelled as many bundles of Liber Studiorum
as would fill your entire bookcase, and England and Wales proofs in

[1] See Vol. XII. p. 389.
[2] W. G. Collingwood's *Life of Ruskin*, 1900, p. 136.

packed and labelled bundles like reams of paper, as I told you, piled nearly to ceiling. . . .[1]

"The house must be as dry as a bone—the parcels were apparently quite uninjured. The very large pictures were spotted, but not much. They stood leaning, one against another, in the large low rooms. Some *finished* go to nation, many unfinished *not:* no frames. Two are given unconditional of gallery building—*very fine:* if (and this is a condition) *placed beside Claude.* The style much like the laying on in Windmill Lock in dealer's hands, which, now it is cleaned, comes out a real beauty. I believe Turner loved it. The will desires all to be framed and repaired, and put into the best showing state; as if he could not release his money to do this till he was dead. The top of his gallery is one ruin of glass and patches of paper, now only just made weather-proof. . . .

"I saw in Turner's rooms, *Geo. Morlands* and *Wilsons,* and *Claudes,* and *portraits* in various styles, *all by Turner.* He copied every man, was every man first, and took up his own style, casting all others away. It seems to me you may keep your money, and revel for ever and for nothing among Turner's Works." [2]

Ruskin himself (January 1) confessed to being "at first a little pained at all the sketches being thus for ever out of my reach; yet I am so thoroughly satisfied and thankful for the general tenour of the will that I can well put up with my own loss. Indeed I shall gain as much as I lose—in the power of always seeing all his works in London, free of private drawing-rooms. If the rest of the executors would only make me curator of the gallery I should be perfectly happy." So again (December 30), "I am very thankful to God for giving me some power over that which, above all things in the world, I should desire to have power over—as well as for the feeling that though Turner would do me no favour, he had some trust in my feeling towards him." "I understand now" (January 6), he added, "his continual and curious hesitation in parting with a picture; he was always doubtful if he had money enough for his great purpose, and yet wanting to keep as many pictures together as possible." Ruskin was enthusiastic and eager to take up the duties and opportunities which seemed to be opening before him. He planned to leave his work at Venice and pay a flying visit to London. This

[1] The *Liber Studiorum* proofs did not ultimately pass to the nation, but remained the property of the next-of-kin. It is said that they were offered to Gambart, the dealer, for £10,000; but as he was not given an opportunity of inspecting them in detail, he declined the offer. They then were sent to auction, and fetched £30,000.

[2] Letters dated February 19 and 21, 1852; reprinted from W. G. Collingwood's *Life of Ruskin,* 1900, p. 174.

idea, on second thoughts, he abandoned. His father pressed him to undertake a Life of Turner. This idea, also, on reflection, he abandoned;[1] it would be work enough to plan and build and arrange and interpret the great Turner Gallery:—

> "*5th January* [1852].— . . . I have been thinking about writing Turner's life, but have nearly made up my mind to let it alone, merely working in such bits of it as please me with *Modern Painters*. Biography is not in my way. Besides, I should be too long about it; there will be a dozen lives of him out before mine would be ready. It would be curious if I got the whole collection of his works to illustrate, and explain, and build the gallery for—and so take the position of his Interpreter to future generations."

That position Ruskin was to hold, but not in the way he dreamed of. For it soon appeared that the will was to be contested. Ruskin did not think that the opposition would be serious; still less did it enter his head that all Turner's main purposes would be defeated. He made no doubt that the pictures would, in accordance with the painter's wish, be kept together, and that a Turner's Gallery would, as he directed, be built to receive them. The only question which seemed open to him was who should have the designing and ordering of the Gallery. On this subject he wrote a letter to his father which is of interest as the germ of much that is contained in the present volume:—

> "*January* 1 [1852].—I don't think there is much fear of the relations oversetting the will; first, because the interest of the nation is so concerned that the entire public feeling will be against them; and secondly, because, if what is reported be true, the only near relations he has have no legal claim upon him. I hope and believe that the National Gallery people *won't* build a new wing, but will leave us to do it; and that it will be a year or two before it is begun, and that then I shall have the management of it—(this between you and me)—for I would build such a gallery as should set an example for all future picture galleries. I have had it in my mind for years. I would build it in the form of a labyrinth, all on ground storey, but with ventilation between floor and ground; in form of labyrinth, that in a small space I might have the gallery as long as I chose—lighted from above—opening into larger rooms like beads upon a chain, in which the larger pictures should be seen at their right distance, but *all on the line*, never one picture above another. Each picture with its light properly disposed

[1] But see below, pp. vi., 554–555.

for it alone—in its little recess or chamber. Each drawing with its own golden case and closing doors—with guardians in every room to see that these were always closed when no one was looking at *that* picture. In the middle of the room—glass cases with the sketches, if any, for the drawing or picture, and proofs of all engravings of it. Thus the mass of diffused interest would be so great that there would never be a crowd anywhere: no people jostling each other to see two pictures hung close together. Room for everybody to see everything. The roof of double plate-glass of the finest kind, sloping as in Crystal Palace, but very differently put together: no *drip*.

"£50,000 would do it all splendidly, and leave £30,000 for interest, for repairs, and servants' salaries."[1]

Ruskin was never to build this labyrinthine Turner Gallery. We most of us, said Goethe, begin life by conceiving magnificent buildings which we intend to erect, but we are satisfied at the close of life if we have cleared away a small portion of the ground. Ruskin's Turner Gallery, with its spacious dispositions for the due display of the artist's works in all sorts, was destined, no less than Turner's own gift to his profession, to be a Fallacy of Hope; but Ruskin was able, as we shall presently see, to do a good deal towards clearing away obstacles to the exhibition of a portion at least of the master's drawings.

The story of the last and saddest of all Turner's Fallacies of Hope belongs rather to the life of Turner, than to that of Ruskin. But some account of his will is necessary in order to explain Ruskin's part in the matter, and the succession of the various catalogues and other writings here collected. The reader requires, moreover, to bear in mind the fate of Turner's bequest in perusing many passages of bitter irony or invective in Ruskin's works.

The purposes which Turner had, at one time or another, in view in making his will were, roughly speaking, as follow: (1) he left various small legacies to his relatives and other persons intimately connected with him.

(2) He bequeathed to the National Gallery "the following pictures or paintings by myself, namely, *Dido Building Carthage*, and the picture formerly in the Tabley Collection . . . subject to, for, and upon the following reservations and restrictions only; that is to say, I direct that the said pictures or paintings shall be hung, kept, or placed, that is to say, Always between the two pictures painted by Claude, the Seaport and Mill."[2]

[1] When the will came to be proved, Turner's property was valued at £140,000.
[2] The Turners are Nos. 498 and 479 ("Sun rising in a mist") in the National Gallery; the Claudes, Nos. 14 and 12.

(3) To the Royal Academy he bequeathed a sum of money for the purposes of a dinner on his birthday, of endowing a Professorship in Landscape, and of awarding every two or three years a Turner's Gold Medal to the best landscape.

(4) "As to my finished Pictures, except the Two mentioned in my will, I give and bequeath the same unto the Trustees of the National Gallery, provided that a room or rooms are added to the present National Gallery, to be, when erected, called Turner's Gallery, in which such pictures are to be constantly kept, deposited, and preserved." In the meanwhile the whole contents of his house in Queen Anne Street (including therefore unfinished pictures as well as finished) were to be kept intact. If the National Gallery did not build the Gallery within ten years, the bequest was to lapse, and the house was to be used as a Turner Gallery.

(5) Lastly and principally, he directed that the residue of his estate, real and personal, should be devoted to establishing "a Charitable Institution for the maintenance and support of Poor and Decayed Male Artists, being born in England and of English Parents only and lawful issue." This portion of his will was dated 1832, as also the bequest of the two pictures to be hung beside the two by Claude. The appointment of Ruskin as a Trustee and Executor was contained in a later codicil of 1848.

The documents thus roughly summarised were voluminous and obscure. Turner had not employed a solicitor to draft his will, but seems to have called in the assistance of solicitors' clerks. His style in writing was always misty, and of all forms of obscurity that induced by the employment of legal phraseology by laymen is the most unintelligible. One thing, however, was clear; the main purpose of Turner's will was contrary to the Charitable Uses Act (9 George II. c. 36) by which the Statutes of Mortmain were extended to gifts to charities. The will was contested accordingly by the next-of-kin, and a long Chancery suit was in prospect. Ruskin, feeling that this was business for which he was little fitted, renounced the executorship.[1] "To enable me to work quietly," he wrote to his father from Venice (February 17, 1852), "I must beg you to get me out of the executorship; as the thing now stands it would be mere madness in me to act, and besides, I should get no good by it." For some years the disposition of Turner's property was held in suspense. His countrymen, wrote Ruskin bitterly, buried, "with threefold honour, his body in St. Paul's, his pictures at Charing Cross, and his purposes in Chancery."[2]

[1] See below, p. 81.
[2] Preface to *Modern Painters,* vol. iii. (Vol. V. p. 4).

So the matter rested till 1856, when a compromise was agreed to by the parties, to which effect was given by a decree of the Court of Chancery, dated March 19, 1856. The Royal Academy received £20,000. The Carthage and the Sun rising in a Mist went to the National Gallery to hang beside the Claudes. The next-of-kin, whom Turner certainly intended to get next to nothing, got the bulk of the property (except the pictures); the Charity for Decayed Artists—the one thing upon which the testator's mind was steadily fixed from first to last in his confusing dispositions—was entirely overthrown. The part of the decree, however, which more immediately concerns us, relates to the pictures. By the settlement arrived at, "all the pictures, drawings, and sketches by the testator's hand, without any distinction of finished or unfinished, are to be deemed as well given for the benefit of the public."

It was at this point that Ruskin's interest in the matter revived. Though he had renounced his executorship, he still felt himself under a trust to Turner's memory to do what he could to promote the due arrangement and display of the works which had come into possession of the nation. The works in Turner's rooms and portfolios coming within the description of the decree were to be selected by referees, and handed over to the Trustees of the National Gallery. This was done in the autumn of 1856, and Ruskin's work was then to commence.

Here, then, we return to the biographical thread already briefly indicated above (p. xvii.). In the early spring of 1856 the third and fourth volumes of *Modern Painters* were off his hand, but he was still as busy as ever. His classes at the Working Men's College were in progress, and to this work he had added that of active assistance in promoting the building of the Science Museum at Oxford, and in April he went there to deliver an address to the workmen engaged upon this practical revival of Gothic Architecture; to these activities we must return later in the volume (XVI.), in which his writings on the Museum are included. Next he had his *Academy Notes* to write. This done, he was ready for a holiday once more, and on May 14 he started with his parents for Switzerland. Some account of this tour is given in the Introduction to the fifth volume of *Modern Painters* (Vol. VII.)—a work which at each stage received inspiration from the mountains. Hearing when he was abroad that the Turner sketches and pictures and drawings had at last been handed over to the National Gallery, he hurried back to the scene of action.

There now ensued a succession of the Letters, Reports, and Catalogues which are reprinted in this volume, and some explanations are necessary to show their order and purpose.

(1) First, came a letter to the *Times*, October 28, 1856 (pp. 81–85 in this volume), in which Ruskin gave a preliminary account of the treasures now belonging to the nation. In the same letter he offered suggestions with regard to the best way of making the drawings and sketches accessible. With the oil-pictures, as explained in a subsequent letter (here pp. 87–88), he was not concerned; their arrangement was in the very competent hands of Mr. Wornum. But Ruskin felt that no one would treat the *drawings* "with more scrupulous care, or arrange them with greater patience" than he would himself. He had doubts, as we have seen (above, p. xxiii.), whether anybody else would deem them of any value at all—an estimate which, so far as the official world was concerned, was to be sorrowfully fulfilled. He offered accordingly to undertake the task of sorting and arranging the whole collection of drawings and sketches. A few weeks later Ruskin followed up his letter to the *Times* by a private one to Lord Palmerston, who had just become Prime Minister, and with whom he had some acquaintance.[1] A copy of this letter has been found among Ruskin's papers, and is here printed (p. 85). It is dated December 13, 1856. Lord Palmerston must have promptly brought Ruskin's offer before the favourable notice of the Trustees of the Gallery, for early in February he was authorised by them to begin work as he proposed. This work, as we have said, occupied a considerable portion of Ruskin's time during the early months of 1857, and thereafter until May 1858.

(2) Meanwhile the Trustees and Directors on their part had begun to exhibit some of Turner's works. By the middle of November, 1856, a selection of thirty-four oil-pictures, which had been cleaned, varnished, and framed, was opened to public exhibition in some of the lower rooms of Marlborough House (at that time assigned to the Science and Art Department).[2] Ruskin thereupon set to work upon a descriptive and explanatory catalogue. He worked hard, and the hard work told on him, for he notes in his diary that he felt symptoms

[1] See *Præterita*, iii. ch. ii. § 29.
[2] A review of the exhibition appeared in the *Athenæum* of November 15, 1856.

of a nervous breakdown. The pamphlet was issued on January 12, 1857, and was entitled:—

Notes on the Turner Gallery at Marlborough House, 1856.

The pamphlet occupies pp. 89–181 in this volume.

This catalogue includes one, at least, of Ruskin's finest descriptive passages, and is indeed full of those qualities, " of which," as a critic of the time truly observed, " he cannot divest himself in the slightest sketch or most matter-of-fact catalogue."[1] The pamphlet passed rapidly through several editions, the latest issue including notices of some pictures added to the Exhibition since the appearance of the first editions. The text in this volume follows that of the latest edition, but includes all the notices that appeared in any of the editions, the variations being recorded either in footnotes or in the Bibliographical Note (p. 94).

Next, the Trustees " considered it desirable that a certain number of the coloured finished drawings should be exhibited as soon as frames could be prepared for them." In February 1857, 102 drawings were therefore exhibited on screens in Marlborough House; many of the *Liber Studiorum* drawings were exhibited also. For this exhibition, which was intended to be temporary only, Ruskin prepared no catalogue. A brief reference to it will, however, be found in the preface to the *Notes on the Turner Gallery* (see below, p. 97). Nor was Ruskin responsible for the selection; the Director of the National Gallery was assisted therein by a small committee, including Clarkson Stanfield, R.A., and David Roberts, R.A.

(3) Ruskin was strongly opposed to the manner of exhibition adopted in this first display of Turner's water-colours. The drawings included some of the most delicate and important of the whole series, and he pointed out the injury likely to result from continuous exposure to light, but he did not confine himself to negative criticism. He had already in his first letter to the *Times* proposed a plan for keeping the more delicate and finished drawings, previously protected with glass, in closed cases (see below, p. 84). He explained the plan in more detail in the appendix to his *Notes on the Turner Gallery* (below, p. 180). The *National Gallery Report* for 1857 states:—

" Mr. Ruskin having proposed a plan for keeping such drawings, previously protected with glass, in closed cases; at the same time, by other

[1] The *Economist*, January 31, 1857. Reviews also appeared in the *Athenæum*, January 24, 1857 (hostile); and the *Art Journal*, February 1857, vol. iii. (new series), p. 67.

XIII.

arrangements, affording facilities for inspecting them; the Trustees have authorised his carrying out, to a certain extent, the method suggested, in order that they may judge of its fitness on a larger scale, and in reference to the conservation and convenient inspection of drawings in museums generally."

In pursuance of this authority, Ruskin selected for glazing and placing in sliding frames in cabinets, one hundred of the drawings and sketches. He provided the mahogany cabinets for these First Hundred drawings at his own expense; "with good help," he says, "from Richard Williams of Messrs. Foord's."[1] For these selected drawings he wrote the catalogue which is No. 3 in Part II. of this volume (pp. 183–226):—

> Catalogue of the Turner Sketches in the National Gallery. Part I. For private circulation.

He must have done this work soon after completing the *Notes on the Turner Gallery*. The first edition contained notes on only twenty-five pictures; the second omitted one of these, but added seventy-six others, thus bringing the total number up to One Hundred. The text in this edition contains that of both editions, the variations being noted as before.

This catalogue—which in its original form is among the rarer Ruskiniana—is reprinted as Ruskin wrote it, for it has a distinct unity and sequence of its own; but the reader should understand that of the drawings described in it, some are not now in the National Gallery, having been lent to provincial galleries; while others, discarded by Ruskin in his later arrangements, have only during the last few years been reframed. The order of arrangement has, moreover, been changed, and many of the numbers as given in the catalogue have been altered. After each drawing, therefore, its present number and, in the case of those removed from the Gallery, its present place of exhibition (where ascertainable) have been added.

Ruskin's plan for framing the drawings and placing them in closed cabinets has been the means of saving most of those in the National Gallery from fading. It is worth noting that another collector, the late Mr. Henry Vaughan, subsequently made it a condition of his bequest of Turner drawings to the National Galleries of Scotland and Ireland, that they should be publicly exhibited only during one month in each

[1] *Præterita*, iii. ch. i. § 12. Messrs. Foord, formerly in Wardour Street, were for many years Ruskin's framers.

year, and that the month of least light (January); at other times
they were to remain in cabinets such as Ruskin devised.

(4) The Hundred drawings, as thus arranged and catalogued, were
not exhibited to the public; they were prepared, as already explained,
for the inspection of the Trustees. The plan was approved, and Ruskin
was authorised to carry it out on a more extended scale, and in this
process the arrangement of the First Hundred was broken up. In the
end cabinets were provided for 400 drawings. These remained· at the
National Gallery, where they are still to be seen. Ruskin did not,
however, at the time prepare any catalogue for them; it was not till
his catalogue of 1881 (No. 7, below, p. xxxix.) that any list of them
was printed for public use.

Ruskin's work at the time was next devoted to a catalogue of a
different selection. On the adoption by the Trustees of his plan for
the arrangement in cabinets of the larger portion of the best Turner
drawings, those first placed on the walls in Marlborough House were
withdrawn from exhibition. It was, however, considered desirable that
besides the collection of drawings arranged in cabinets, and not therefore
always visible to every comer, there should be arranged for permanent
exhibition a selection of Turner's sketches and drawings, "calculated (in
Ruskin's words) to exhibit his methods of study at different periods,
and to furnish the general student with more instructive examples than
finished drawings can be." Ruskin accordingly selected and arranged for
this purpose various drawings (in addition to the 400 mentioned above).
For this selection he wrote and printed a catalogue, entitled :—

*Catalogue of the Sketches and Drawings by J. M. W. Turner, R.A.,
exhibited in Marlborough House in the year 1857–1858.* Accom-
panied with Illustrative Notes.

This is the catalogue which is No. 4 in Part II. of this volume (pp. 227–
316). A second edition of the pamphlet was issued in the following
year. The first edition noted only 100 frames (214 drawings); the
second included a Supplemental Series, bringing up the number to 153
frames (338 drawings). The text in this volume includes, again, that of
both editions, the variations being noted as before.[1]

The reader's attention must be taxed to follow here again the future

[1] The catalogue was reviewed in the *Literary Gazette,* November 6 and 20, 1858,
and to the first article Ruskin wrote a reply, here reprinted (pp. 329–338).

fortunes of this collection. This second set of drawings selected by
Ruskin is sometimes referred to by him as the "Kensington Series."
The reason is this. Owing to the want of space at the National
Gallery (which at that time housed the Royal Academy also), the
greater part of the English pictures had for some time been exhibited
at Marlborough House. That house was at the end of 1859 allotted
to the Prince of Wales. The British portion of the National Gallery
was accordingly removed to the South Kensington Museum, where it
remained until the enlargement of the Gallery in Trafalgar Square in
1876. The Turner oil-pictures had been removed to Trafalgar Square
in 1861, owing to the necessity of complying with a clause in Turner's
will. The exhibited portion of the Turner drawings remained at South
Kensington till the later year.

The return of these drawings to the National Gallery was followed
by a rearrangement. The "Kensington Series" was renumbered
throughout. Ruskin's order of arrangement was broken up. Some
drawings comprised in it were no longer permanently exhibited, but
were transferred to take their place in the Cabinet Series of Four
Hundred. There was room, because of them sixty drawings at a time
were and are exhibited in desks, being changed for a different set of
sixty every three months, the remainder being kept in closed cabinets
and accessible to students only. It will thus be understood that this
second catalogue of Turner drawings does not correspond, any more
than the catalogue of the First Hundred, to any order of arrange-
ment, exhibition, or numbering now visible at the National Gallery.
After each drawing, here as before, its present number in the Gallery
is indicated.

(5) Ruskin's work, meanwhile, in examining, sorting, and framing
the drawings and sketches in the National Gallery, went on, and during
the winter of 1857–1858 it was unremitting.[1] Ruskin was assisted in
the work by Mr. Williams, as aforesaid, and by Mr. George Allen.
"I was at work altogether on this task," says Mr. Allen in a com-
munication to the editors, "for eight months. Mr. Ruskin was very
jealous of any one but his own assistants touching the drawings,
lest harm should befall them. After our day's work at the Gallery
Mr. Ruskin and I used to take the measurements of drawings to

[1] It is understood that several sketches which, from the nature of their subjects,
it seemed undesirable to preserve, were burned by Ruskin, on the authority of the
Trustees (see W. M. Rossetti's *Rossetti Papers*, 1903, p. 383). On one of the parcels
in a tin box at the National Gallery Ruskin has written: "Valueless. Two or three
grotesque figures left in it."

Denmark Hill, when I cut with my own hands about 800 thick *passe-partout* mounts—these were taken to the Gallery and the drawings inserted there." He gave an account of his labours in the Preface to the fifth volume of *Modern Painters.* He worked, he said, "every day, all day long, and often far into the night;" and "I have never in my life," he added, "felt so much exhausted as when I locked the last box, and gave the keys to Mr. Wornum, in May 1858." His account of his stewardship was, however, rendered to the Trustees two months earlier. This, not hitherto republished, is the fifth piece in Part II. of the present volume (pp. 317–325):—

> *Mr. Ruskin's Report on the Turner Drawings in the National Gallery,* dated March 27, 1858.

It is here printed from the *Report of the Director of the National Gallery,* 1858. The same Report contains the following expression of thanks to Ruskin:—

> "The voluminous collection of drawings has been carefully examined and partly arranged by Mr. Ruskin, to whom the Trustees and the public are indebted for his indefatigable attention in this long and difficult undertaking. The plan which Mr. Ruskin originally proposed for the preservation of the more delicate coloured drawings from the effects of light, by placing them in cases fitted to contain a given number, has been carried out. A selection of other drawings, requiring only to be carefully mounted, will in due time be made."

A perusal of this Report will give a clear idea of the immense amount of careful work which was involved in the duty which Ruskin had undertaken.[1] That it was not unattended with some of the friction and jealousies which attend upon divided responsibilities appears from a letter to Mr. Wornum, then Keeper of the Gallery:—

<div align="right">"(LONDON, 1857.)</div>

> "MY DEAR WORNUM,—I *believe* you are confusing the *Rivers of England* with the *Ports* or *Harbours.* The drawing I mean is the *Portsmouth,* with big ship of line in middle. It *was* covered almost

[*Rough sketch of Turner's "Portsmouth."*]

all over.

> "I am sorry to find you putting yourself in something of an antagonistic attitude, as if I wished to bring a charge against you. If I could go on working with you, and look after the drawings

[1] See also the letter to Professor Norton, given below, p. 324 *n.*

myself—I heartily would. I cannot, because I am ill, and I don't
think you have the time. If you chose to help in the matter you
might get a person appointed under you who would save you all the
trouble, and you would have the credit of making the collection
available. If you like to keep it shut up, and have all the trouble
of looking after it yourself, it is your affair. If I cared for the public
I should make a fuss about the drawings being useless. I don't—
and don't think they deserve to have the drawings after their treat-
ment of Turner. I have done and said enough to quit myself of
responsibility.

"The matter now rests with the Trustees and you. It was in
consequence of a letter from me that Mr. Cowper came to look what
was the matter—and I believe I have done all now that the public,
or Turner's ghost, or my own responsibility require.

"I am glad to hear your report of the fine drawings and un-
mounted parcels,

"And remain,
"Faithfully yours,
"J. RUSKIN." [1]

But the toil was not all wearisomeness and vexation. A pleasant
glimpse of Ruskin at work in the National Gallery in these years is
given in the memoirs of his friend, Stacy Marks, R.A. They had
previously been in correspondence, and then Ruskin wrote, "If you
come down to the National Gallery any day, and ask the policeman
for me, we may meet, and at least know each other's faces":—

"I went (says Marks) and found the eloquent exponent of Turner in
rooms in the basement of the building, surrounded by piles of sketch-books
and loose drawings by the master, which he was arranging, mounting, and
framing,—a congenial employment, a labour of love, to which he devoted
months of time, with no recompense beyond the pleasure which the occupa-
tion afforded him. I can remember little of our conversation except that it
was chiefly about Turner and his work. I had gone to the Gallery with
an ill-defined feeling of awe of the great man I was about to see, but this
was dissipated directly I had shaken hands with him. There was none
of the posing of the genius; I found him perfectly simple, unaffected, kindly,
and human. [2]

But if the work was not all vexation, neither was it all pleasure.
Ruskin speaks in *Modern Painters* of his sorrow at the bad condition

[1] This letter is reprinted from pp. 31–33 of *Letters on Art and Literature by John Ruskin*, edited by Thomas J. Wise, privately printed 1894.
[2] *Pen and Pencil Sketches*, by Henry Stacy Marks, R.A., 1894, vol. ii. p. 165.

of so many of the drawings, and of his "anxiety and heavy sense of responsibility."[1] To these feelings must be added his disappointment at the uncertainties and delays on the part of the Trustees, or rather of the Government, in making due provision for the display of Turner's bequest.

(6) The disposition of Turner's pictures and drawings led from time to time to questions and criticisms in Parliament and the Press. Some letters by Ruskin dealing with such questions are collected in pp. 327–345.

(7) But the patience and care which Ruskin had promised were not exhausted. In his old age he returned to the task which had occupied so much of his time and energy in middle manhood. The two catalogues of Turner drawings which he had previously prepared were both out of date. To the drawings in the cabinets there was no catalogue, and even their arrangement in the cabinets, though more systematic, was (and is) not completely consistent. The arrangement of the drawings on the walls of the rooms of what Ruskin called "the cellar" of the Gallery was (and is) in no intelligible order. He determined to tackle the task again. Ruskin's final catalogue was not such as he had intended. His design seems to have been to revise and incorporate his earlier catalogues of 1857–1858. This appears from a collection of the earlier catalogues in the possession of Mr. William Ward, which were put together for Ruskin's use, and in which he made various annotations and revisions. Some remarks have been included from this source in the present volume (see, e.g., pp. 371, 379, 383 nn., and p. 624). But Ruskin's new catalogue was prevented by ill-health, and he ultimately contented himself with a scheme for a rearrangement of the drawings, instead of preparing a new descriptive catalogue. He hoped against hope that the Treasury would find the money, and the authorities of the Gallery have the will, to rearrange the collection systematically and exhibit it worthily. His hopes were not to be realised, but he did his part by recasting (on paper) the whole collection, as then available, and arranging the drawings "in an order which might conveniently become permanent." This order was set forth, and explained, in the catalogue which is No. 7 in Part II. of this volume (pp. 347–388):—

Catalogue of the Drawings and Sketches by J. M. W. Turner, R.A., at present exhibited in the National Gallery. Revised and Cast into Progressive Groups, with Explanatory Notes. 1881.

Of this catalogue there were several editions. The text in this

[1] Preface (§ 3) to *Modern Painters*, vol. v.

volume contains that of all of them (except that the index is merged in one of a more general character); the variations being described as usual.

Here, once more and for the last time, the reader will understand that this catalogue does not correspond to any actual arrangement in the Gallery. The order which Ruskin thought might conveniently become permanent has not in fact been adopted; and indeed it would in any case now require revision, for since 1881 the Trustees have framed and hung a large number of additional drawings and sketches. It will thus be seen that of Ruskin's three catalogues of the Turner drawings and sketches, the first two (Nos. 3 and 4 here) describe certain drawings in an order which no longer exists, and the third (No. 7) describes them in an order which has never yet existed. To give Ruskin's Notes in a manner conforming with the present state of the collection was the object of the rearranged catalogue, prepared by one of the present editors, in the first volume of *Ruskin on Pictures* (1902). It was not consonant with the general scheme of this edition thus to rearrange Ruskin's writings; but an Index is given at the end of the present volume which will, it is hoped, meet the difficulty described above, and make the volume available for use or reference in connexion with the National Gallery. In the Index the existing arrangement and distribution of the Turner drawings and sketches are first described; and then the National Gallery's exhibition is enumerated in the existing numerical order of the drawings, with references to the pages in the present volume where each drawing is mentioned or noted by Ruskin.

The reader is already wearied, I cannot doubt, by so long a story of the wanderings of the Turner drawings. But if it is tiresome to follow this retrospect, what must not Ruskin's own vexation have been at the time, at seeing, as he did, his own work, in large measure, wasted; the drawings, to him so priceless, treated as of little account, and dispersed from pillar to post; and, what was worse still, Turner's own wishes and directions almost entirely disregarded. Turner's bequest, wrote Ruskin bitterly, was valued "not even at so much as the space of dead brick wall it would cover; his work being left for years packed in parcels at the National Gallery, or hung conclusively out of sight under the shadowy iron vaults of Kensington." "I have never found more than two people (students excepted)," he adds, "in the room occupied by Turner's drawings at Kensington, and one of the two, if there *are* two, always looks as if he had got in by mistake."[1]

[1] *Cestus of Aglaia*, § 4, and compare, below, p. 341.

The artist left his oil-pictures to the nation on condition that they should be hung together in a Turner gallery. There is no such gallery. The room allotted to the pictures at Trafalgar Square is far too small to display properly even those which are selected for exhibition. The pictures are not kept together, and works which were meant by the artist to be seen in connexion with each other are widely dispersed. Many have been sent to provincial galleries, and to this distribution there is in itself no serious objection to be made; but in carrying it out, the authorities have taken no thought of the connexion between various works, such as Ruskin pointed out.[1] Other pictures are hung in rooms at the National Gallery which are not open to the public, because there is no space for them in the exhibition galleries.[2]

The treatment of the sketches and drawings has been more contemptuous. Their wanderings and seclusion during so many years have been already described. Of late years there has been some improvement. Many have been framed and are permanently exhibited at the National Gallery. Six collections have been arranged for loan to provincial galleries, in addition to the collection which Ruskin procured for Oxford.[3] But several thousands still remain, stowed away in eleven tin boxes, in the cellars of the National Gallery. An inspection of these treasures is full of great, if melancholy, interest. What Ruskin's father said, on examining Turner's house, must occur to every one who goes through these boxes in which so much of the artist's life's work is buried: the industry of the man was as great as his genius. The biographical interest of these buried drawings, sketches, and note-books is great; they contain records of his movements and methods and ideas of which no biographer has as yet properly availed himself. Many of the note-books are particularly interesting as showing how constantly Turner was trying to express himself in another art than that which had become nature to him: they are full of verses, and Turner would often make as many beginnings or studies or versions of a poem, as of a picture or of a drawing. Other note-books are filled with notes for Turner's Academy lectures, with geometrical drawings and extracts from books which he had been reading—among others from the *Treatise on the Art of Painting* by Gerard de Lairesse with whom Browning "parleyed." The contents of the boxes need not here be described in detail, for they correspond with the general account of the Turner Bequest given by Ruskin at several places in this volume; to go through them

[1] See below, pp. 107, 160 n.
[2] See below, p. 160 n.
[3] For particulars, see below, pp. 560, 608.

is to have the excitement of a "surprise packet"; for though a certain
amount of the pieces are of very slight interest, and some of them are
of none, yet the greater portion is of drawings or sketches in no way
less remarkable than most of those which are accessible to the public.
Here one may see many of the original pen sketches for the artist's
classical compositions, and numerous pencil studies for *Liber Studiorum*;
many books full, as Ruskin described, of studies of sails and shipping;
and several, also, of figure studies from the life: these confirm what
Ruskin says, that it was not inability to draw the figure which made
so many of the figures in the artist's landscapes so very bad. Among
the curiosities of the tin box collection is a large album into which
are pasted several of the earliest tinted sketches. The book is inscribed
at the beginning "Bought at Dr. Monro's Sale"; Turner hoarded
everything, and bought back, it will thus be seen, his earliest essays.
The note-books had for the most part been carefully labelled by the
painter—as thus, "79. Skies," "84. Studies for Pictures. Copies of
Wilson," "18. Studies in the Louvre." The book last mentioned con-
tains some careful copies, on a small scale, of pictures in that collection,
and is of further interest as including critiques on some of them: these
are probably the artist's only essays as an art critic. There was method,
it is clear, in the apparent disorder of Turner's belongings; whatever
was the work he was engaged on at the time, he was able to refer to
his numbered sketch-books, where every kind of material from nature
was stored. It is only by going through this material in bulk, as it is
to be found in the tin boxes, that one can obtain a correct impression of
the enormous quantity of such material which the artist's industry had
accumulated.

Any one who was free to arrange the contents of the boxes could
bring together in most instructive series the kind of work which the
artist did on any given tour. Before setting out, he carefully read
up his route — often getting some travelled friend to prepare an
itinerary for him, marking especially what towns had good inns, and
putting down notes of picturesque places or effects of which he had
heard or read. There are several books filled with itineraries of this
sort. Then the artist equipped himself with sketch-books of all sorts
and sizes. Some are small enough to go into the waistcoat pocket,
and on every journey they must have been constantly in the artist's
hand. Sometimes they are filled with very rough scrawls and hiero-
glyphics; such as were made, perhaps, when he was in the coach.
Sometimes the thumbnails are of exquisite delicacy and firmness: such
are those in two or three little books containing bits of architecture

and sculpture done in Rome, labelled by the artist "Details—Rome." Then come the larger sketch-books, used when the artist was settled at his inn; these contain sometimes pencil sketches of great delicacy, carried far to completion; and sometimes bolder and rougher outlines, to serve as memoranda of the leading lines in a composition. The sketches in colour were made sometimes in books, sometimes on the thin pieces of paper, such as are described by Ruskin (below, p. 237): these the artist used to carry in rolls in his coat-pockets. That all the pieces thus left by Turner should be exhibited is neither to be hoped for nor desired; but surely it would be possible and instructive to arrange in a show-case sample leaves or sheets made on some given tour, so as to exemplify all the different methods employed by the artist for recording facts and preserving impressions.

There are also hundreds, perhaps thousands, of pieces which for their intrinsic beauty well deserve to be made available to the public. Many of these are pencil drawings done with the utmost care; others are water-colour sketches—of Switzerland, and Italy, of the French rivers, of Venice —which are in no way inferior to most of those already framed and exhibited. It may be roughly estimated that 30 per cent. of the pieces still stowed away are of real value, and might, under more favourable circumstances, be utilised for the benefit of the public. There is more than one of the tin boxes which would of itself furnish forth a most representative and valuable Turner Exhibition.

To those who are interested in the work of Ruskin, as well as to those who admire Turner, an inspection of these tin boxes is a somewhat disheartening experience. They show how much of Ruskin's labour has been thrown away, no less than how little of Turner's hopes and wishes has been regarded. Ruskin, as we have seen, spent lavishly of his time and trouble (and also, it may be added, of his money) in arranging the Turner Bequest. Every one of the 19,000 odd pieces was carefully examined. Whenever he cut up a sketch-book, in order to exhibit a sample leaf, the remaining leaves were carefully laid out, each in its sheet of blue paper. Larger pencil drawings, when of any interest, were either laid down on thick paper, or were fixed in card-board mounts. They were then tied up in brown-paper bundles, each of which bore a reference number obviously corresponding to a general catalogue or schedule of the collection referred to by Ruskin in his Report (see below, p. 322). This schedule has disappeared.[1] The brown-paper wrappers remain, and the accumulations of the dust

[1] Possibly it was attached to the Director's Report for the year (1858), and an economical Treasury declined to sanction its being printed.

of fifty years have not always obliterated Ruskin's memoranda. A few of these may be worth transcribing:—

> " A. B. 290. Scottish Pencils. Of very great value; too large for mounting or exhibition till there is more room."

That day has never come, though some of these pencil drawings are very fine.

> "No. 178. Very valuable early pencils, containing original sketches of Kirkstall and Egglestone, of the Yorkshire Series; Dunstanborough of the Liber; Alnwick and Boston of England, and Bamborough (large). A beautiful Sedburgh; Whitby, Tynemouth, Melrose, etc. Three taken out; namely, York, Boston, and Kirkstall Crypt."

It is surely a pity that the rest of these beautiful pencil drawings should be condemned to oblivion. Many of Ruskin's memoranda refer to the gradual destruction of the drawings; the note

<p style="text-align:center">" MILDEW.—J. R."</p>

occurs with painful frequency. One bundle of very fine water-colour sketches, of the late period, is thus noted. Mr. George Allen, who (as already stated, p. xxxvi.) assisted Ruskin in his arrangement of the sketches, well recollects Ruskin's indignation at finding that some of the Turner collection had been put under tarpaulin in an exposed place during the enlargement of the Gallery; he employed Mr. Allen to go through the sketches and wipe off the mildew with a sable brush. In a printed letter Ruskin refers to this matter. "I should have tried to get abroad again before this," he wrote in May 1862 to Rawdon Brown, "but found they had let all the Turner drawings get mildewed at the . National Gallery during its repairs. So I stayed to get the mildew off as well as I could, and henceforth I've done with the whole business; and have told them they must take it off, themselves, next time, or leave it on—if they like."[1] I regret to say that it is left on; though the statement that "*all* the Turner drawings" are mildewed was happily only an epistolary exaggeration. Some of the bundles are

[1] *Letters from John Ruskin to Various Correspondents*, privately printed 1892, p. 43, reprinted in a later volume of this edition. Among Ruskin's letters to his father is the following draft of a "Memorandum sent to Lord St. Leonards," showing that he sought to interest that ex-Chancellor in the matter :—

> "1. I have always understood that in the arrangement of Mr. Turner's property which was agreed upon by the parties to the suit, the pictures which were to be taken by the public were to be taken under, and subject to, the conditions prescribed by the testator.
>
> "2. That the public became, by that arrangement, possessors of a larger number of pictures than the testator intended, does not appear to me to invalidate the obligation to carry out the conditions attached to the possession of the smaller number.
>
> "3. I believe if these conditions be not speedily complied with, the injuries

badly touched; and as these include a few not so noted by Ruskin, it seems that the evil has spread since 1862. It is suggested that the time has come when steps should be taken to arrest it, and to rescue this part of the Turner Bequest from long neglect and oblivion.

The drawings and sketches which Ruskin mounted or laid down should all be framed and glazed, and placed in cabinets similar to those which contain the "Four Hundred" (pp. 319–320). If the nation is too poor to afford mahogany such as Ruskin provided, plain deal would do. Hundreds of the sketches already mounted are of exquisite beauty, especially many of the Venetian and French River Series; they include several which Ruskin selected for the hundred sketches first arranged in 1857 (see below, pp. 191, 192, 194, 196 *nn.*). Pieces of inferior interest should, as he suggested, be bound up in volumes (p. 324). Many other pieces might, as I have already suggested, be exhibited in show-cases, if hereafter an adequate Turner Gallery should be provided. There is, for instance, in one of the tin boxes a packet of studies for *Liber Studiorum;* some of these should be shown beside the drawings already in the Gallery. Another box contains the original sketches for some of the French drawings given by Ruskin to the University of Cambridge; these sketches should be lent to the University. Other boxes contain sketches and studies for several of the pictures in the National Gallery; they should be exhibited in cases beside the pictures, or in an adjoining room. So, again, there is in one of the boxes a copy of Rogers' *Poems,* which Turner used when he was preparing his vignettes; he has on the margin of several pages made little notes of intended illustrations. It would be of interest to show this book beside the vignettes. Turner and Ruskin have both passed away; the neglect of the Turner Bequest which Ruskin deplored still remains, and it has seemed the duty of the editors thus to record the fact.

III

The Third Part of the Volume contains the Notes written by Ruskin to illustrate the exhibition of his drawings by Turner held in London in 1878.

The Ruskin collection of Turners began in early years—about 1838,

which the pictures in question are sustaining by their present mode of exhibition will materially diminish the value of the national property in them.

"4. A large part, in my opinion the most valuable part of the works in question, consisting of water-colour drawings, cannot be exhibited at Kensington, nor can the public derive any advantage from them or make any use of them until a proper gallery is erected for their preservation and exhibition.

"*July* 10, 1861."

it seems—with the Richmond Bridge, Surrey; Ruskin describes the delight of himself and his father at the acquisition of this specimen of Turner's work in *Præterita* (ii. ch. i. § 12), where also a year or two later the purchase of a second—the Gosport—is recorded. Next, as a present to Ruskin on his twenty-first birthday, came the Winchelsea (forty guineas) (*ibid.*, § 13). The fourth—the Harlech—was bought for seventy guineas, but at the price also of some bitterness between father and son (*ibid.*, § 15).

A year or two later, in circumstances described by Ruskin in the Epilogue of his *Turner Notes* (below, p. 475), an opportunity occurred of securing several of Turner's later and most beautiful drawings at very reasonable prices. Ruskin succeeded in coaxing two out of his father, the Lucerne and the Coblentz; but he wanted many more, and one—the Splügen—most especially. It was not to be, however, and Ruskin kept his vexation and disappointment to himself. An extract from his diary of 1844 shows how strong his yearnings were:—

> "*April 13th.*—Into town to see Munro's Collection—and made myself very unhappy for two of them—the Splügen and Zurich—would give the world for them. I shall have them some time, however, if I live."

The Splügen he lived to have, though not till towards the close of his working years. The words that he "would give the world for them" are not mere hyperbole. Pictures, as he said, were living friends, and more than such to him.[1] And of Turner's genius, then comparatively little known or understood, he felt that he, and he perhaps alone, was fully appreciative. "The pleasure of a new Turner to me," he said in his autobiography,[2] "nobody ever will understand, and it's no use talking of it." Turner's drawings were, in a sense, his stock-in-trade; or, to vary the metaphor, his sacred books, which it was his mission to interpret, to illustrate, to reveal to a blind generation. But something must be allowed also to the love of acquisition. "I am always laying up for myself," he says, "treasures upon earth with the most eager appetite." "The pleasure of collecting was," he argues, "a perfectly natural and legitimate one, and all the more because it is possible only when the riches are very moderate."[3] A year or two later than 1844, as a letter from his father shows, the son had revealed his hoarded grievance:—

[1] See Vol. X. p. 436 *n.*
[2] *Præterita*, ii. ch. iv. § 82.
[3] *Fors Clavigera*, Letters 24 and 34.

"You said,' writes J. J. Ruskin (October 4, 1847), "we could not by a whole summer give you a tenth of the pleasure that to have left you a month in the Highlands in 1838 would have done, nor by buying Turner's and Windus' gallery give you the pleasure that two Turners would have done in 1842, you having passed two or three years with a sick longing for Turner. I take blame to myself for not sending you to the Highlands in 1838, and not buying you a few more Turners, but the first I was not at all aware of, and [as to] the second I freely confess I have been restrained from my very constitutional prudence and fear, and in case I may fall into the same mistake, I wish to hide no motive from you. I have, you know, my dearest John, two things to do—to indulge you, and to leave you and mama comfortably provided for; but if you have any longings like 1842 I should still be glad to know them, whilst I honour you for the delicacy of before suppressing the expression of them."

This exchange of views, or the prosperity of the elder Ruskin's business, or the growing fame of the son, or all causes combined, must have relaxed the purse-strings in following years; for the Turner Collection at Denmark Hill increased rapidly. Ruskin had hoped, as we have seen (above, p. xxiii.), that Turner's death would have brought many drawings and sketches into the market, and he was now able to count with more confidence on his father's willingness to buy. That hope was disappointed; but it seems that Ruskin's father made up for it by buying other Turners. Thus, Ruskin had at one time in his possession Turner's Margate sketch-book;[1] this was bought from the artist's housekeeper, Mrs. Booth.

We have read already Ruskin's hints to his father on the purchase of Turners, written on first hearing of the painter's death. He soon returned to the subject, and his father, it seems, had again explained the prudential reasons which had kept him back:—

"[VENICE], 23rd January [1852].

". . . What you say of your former motives for not buying Turners is very just—and indeed it is curious, the way in which I forget at one time the motives which actuated me at another, and only see the motives which *ought* to have actuated me. Were my life to come over again, for these last ten years, I would devote myself altogether to Turner — the man, I mean—recording every sentence that he spoke, and collecting every picture that came in my way. But I cannot recollect the kind of feelings I had, when I had not a single Turner, or thought the Richmond perhaps the only one I should ever have.

[1] See below, p. 470.

"I am, however, now likely to be perhaps more quiet than you suppose. I never liked travelling—my hope was at one time to *live* in Switzerland, but not to travel much—and now I am not so careful where I live. I do not think I shall ever be able to be a strong climber on the hills—and without that power, the sight of them would sometimes be less pleasure than pain. I rather fancy I may have partly brought on the feebleness of circulation which now makes me nervous and unfit for work by my long walks as well as my mental labour, and I do not intend to take any more hard climbs for several years; and when a man is thirty-three, and likely to lie by for several years, it is very possible he may not care to scramble much more.

"This spring in Switzerland, with mama and you, I shall walk *with you* only—or Effie—and be with you all day, going on a little with my book, and looking on the Alps as inaccessible. And as for travelling in Italy—it is now really too painful. Everything is being destroyed, and I should become a misanthrope of the bitterest temper if I were to live or travel much here. Wherever *my home is*, I shall stay much more quietly than you might think. Indeed I never was a rambler in the common sense. My delight was always to *stay* in places that I loved; and I am sure that neither my mother nor you can recollect my wishing to leave *any* place when I was comfortably settled among hills.

"Be this as it may, I should certainly hope now and then to be able to buy a Turner, for some years to come, if I do not succeed in getting them at the sale—for they are to me Nature and art in one—all that I best love in nature with all that I most revere in art. I am *content* with my collection *now*, as I said, but the exquisite pleasure that every new one gives me is like a year added to my life, and a permanent extension of the sphere of life.

"However, I can talk of this afterwards—it is too broad a subject for a letter. I will begin my catalogue *raisonnée* to-night, and go on with it bit by bit.

"I should divide all Turners into four classes :—

1. Those which I would give *any* price for if I *had* it to give.

2. Those which I would give anything in reason for.

3. „ „ „ something for—if they went cheap.

4. Those which I would not buy at all at any price they are ever likely to go for.

"Class 1st. 1. Munro's Lake Lucerne, morning.
2. Munro's Pass of Splügen.
3. Fawkes's Vignettes from History of Cromwell—or Commonwealth.
4. Fawkes's 4 Studies of Birds: Ringdove, Kingfisher, Heron, Peacock.[1]

For these above, if at any time they came into the market, I should think no price I could afford too dear.

"Class 2nd. 1. Munro's Lake of Zug.
2. Munro's Lucerne, by moonlight, from the river.
3. Bicknell's Lake Lucerne.
4. Windus's Lake Lucerne.
5. Munro's Kussnacht.
6. Windus's Arona, Lago Maggiore.
7. Fawkes's Mont Cenis—and Sallenches.
8. Such sketches as may be found of mountain subjects—especially Swiss—among Turner's stores. The three of our St. Gothard, Goldau, and Schwytz, should have gone into first class.
9. Grenoble—mentioned in one of my late letters—at Hampstead.
10. Weathercote Cove, Yorkshire Series.
11. Ivy Bridge.

I have named them as they came into my head, rather than in order of value.[2] The sketches should have been first, and then 1, 2, 3, 5, 9.

"Class 3rd. The drawings above named are those which I *want*, and which, some time in my life, if I can, I hope to possess at all events a few of. I cannot hope that I can get them all, but they are my *mark*—high-water mark. Those which I next name are the ones which, in case any of them came in your way at a reasonable price, I should be sorry to let go, but not vexed about, while I should certainly be grieved if any of the 1st or 2nd Class escaped me. So do not be alarmed at the largeness of the 3rd Class. I

[1] Munro's "Lake Lucerne, morning" is "The Dark Rigi," see below, pp. 477, 483; for the "Splügen," see p. 487. For Cromwell relics at Farnley Hall, see Vol. XII. p. lv. Ruskin never had an opportunity of acquiring any of Turner's Cromwell vignettes from Farnley; but in 1852, as appears from a letter preserved at Brantwood, he acquired Turner's frontispiece to "Fairfaxiana" (see below, Index I., p. 600).
[2] Of the drawings in "Class 2," several are mentioned later in this volume. The "Lake of Zug," and the "Arona" came into Ruskin's possession.

shall here put opposite to each the price which I should think cheap
for them.

1. Any *Yorkshire* drawings 80 to 100
2. Llanberis (now Windus's) 120
3. Lower force of Tees (Munro's) . . 150
4. Coventry (Munro's) 120
5. Carnarvon (Munro's) 120
6. Ulleswater (Munro's) 120
7. Fawkes's Coliseum, Rome . . . 120
8. Schaffhausen Fall (Windus's) . . . 100

"These are the best I know, but I shall better and more shortly
describe this list by giving you the negatives—*i.e.*, those which I never
should think of buying. For I don't mean you to add up all the above
list and say—it will be so much—does John think of spending all
that? No; of the drawings named, probably not one fourth will
come into my reach. Fawkes's are very unlikely *ever* to come into
the market—and especially the Cromwell Vignettes. I merely name
those of which, if any occurred, I should think it desirable to obtain
them, in preference to others, if I could afford it.

"I should *never* buy these —:

1. Any vignettes.
2. Eastern or Italian drawings—the Coliseum above named is
 a rare exception.
3. Any "Southern Coast" drawings—a set highly valued by
 dealers.
4. Any Rhine drawings.
5. Oberwesel; Heidelberg; — Virginia Water; — Hampton
 Court; Blenheim; Windsor; Bedford; Stoneyhurst;
 Yarmouth; Bamborough; Fowey Harbour (Windus's);
 Malvern Abbey; Holy Island; Folkestone.
6. Oils—of any description whatsoever—except only Bicknell's
 Ivy Bridge, which, if it ever went cheap, is very beauti-
 ful, and I am much obliged to you for offering £300 for
 the Salt-ash, which is a highly curious and interesting
 picture, but not worth more.

"I send you the end of Murano at last."[1]

Several of the drawings mentioned in this letter came afterwards into
Ruskin's possession, so that his instructions must have fallen on

[1] That is, the end of ch. iii. in vol. ii. of *The Stones of Venice.*

willing ears. The Splügen was not, however, Ruskin's only disappointment. Turner, it should be understood, was on very friendly terms with the Ruskin family. His familiar intercourse with Ruskin's father and mother is referred to in *Prœterita* and *Dilecta;* and extracts from Ruskin's diary given in this edition have illustrated the painter's regard for Ruskin himself. In later years he told an anecdote to Mr. George Allen, which illustrates the painter's desire to see his drawings kept together, and the son's disappointment at his father's backwardness in taking full advantage of the exceptional opportunities they enjoyed for acquiring the artist's works. "One day," said Ruskin, "Turner came to me with a bundle in a dirty piece of brown paper under his arm. It contained the whole of his drawings for the *Rivers of France.* 'You shall have the whole series, John,' said he, 'unbroken, for twenty-five guineas apiece.' And my father actually thought I was mad to want them!" Ruskin never quite overcame the feeling of estrangement which these disappointments engendered; and the old city merchant himself would have been sorely vexed had he lived to realise how for once his shrewdness was at fault, and what a fine investment he had in this case missed. Some years later Ruskin paid £1000 for seventeen of the sixty-two drawings (see below, p. 462). These he presented to Oxford. He found other opportunities of adding to his collection at the dispersal of the Dillon and Munro collections in 1869 and 1877 respectively.

The first catalogue of Ruskin's Turners in existence is that which he drew up in 1860 for Mr. Thornbury, and which is here reprinted (Appendix iii. 1, pp. 556–557). It consisted of some eighty to one hundred drawings and sketches, and was the collection which Ruskin used to show, as has been described in an earlier volume, to visitors at Denmark Hill. To be shown the collection by the owner himself was a memorable experience. We have seen what it meant to an earnest art student (Vol. V. p. xlviii.), and how much it was appreciated by Mrs. Browning (p. xlvii.). "When one got him," writes Dr. Furnivall, "to show his Turners to charming women like Mrs. William Cowper (now Lady Mount-Temple), Lady Goderich (now the Marchioness of Ripon), Mrs. Charles Buxton (once Emily Holland), and the like, it was indeed a pleasure to see him and them: the pictures had on those days fresh colour and fresh light."[1] We can reconstruct some of the talk which Ruskin wove around his Turners from a little lesson which he sent

[1] "Forewords" to the privately-printed volume (1890), *Two Letters concerning "Notes on the Construction of Sheepfolds."*

to his father from Venice, and which has already been printed here
(above, p. xxv.). But no written notes can reproduce the grace and
charm of Ruskin's own conversational discourses. Of the arrogance
and intolerance which critics found in his writings, especially when
he was laying down the law on pictures, there was in his private
intercourse no trace. Sometimes he would indulge in set mono-
logue, and then, according to Rossetti, all his written words seemed
feeble and uninspired by comparison. At other times he would be
interrogative, whimsical, or perverse; and always the gay was mixed
with the grave. On days when Ruskin was away or especially busy,
Mr. Allen would be told off to show the treasures. "There was
one of his Turners," says Mr. Allen, "which Mr. Ruskin was not
proud of. He used to say to me 'Don't show it, or, if you do, tell
them it's a bad one.' This was the Rochester. 'My father gave it
to me once,' said Mr. Ruskin, 'just to bring me home a fortnight
earlier from abroad, and it's the worst Turner I have.'"[1]

Some of the drawings were on the walls; Ruskin mentions in
Modern Painters those which he had before him in his study as he
wrote;[2] others were in the breakfast and drawing rooms.[3] They were
protected by covers.[4] These were of dark green calico, made to fit the
frames, easily lifted off and on; they were always in use at Brantwood
in Ruskin's time, and are still, when the house is closed; for Ruskin
was convinced that water-colours deteriorated seriously under direct
sunlight. Mr. Allen remembers some experiments made by Cozens,
the engraver, which Ruskin saw, and which seemed conclusive.[5] This
is a subject fully treated by Ruskin himself in the pieces collected
in Appendix vii. (pp. 589–593). Others of his drawings he kept in
cabinets which he had contrived for the purpose, and which he used also
in the National Gallery, and in his Drawing School at Oxford.

The Thornbury Catalogue (*circa* 1860) represents Ruskin's collection
of Turners at its fullest, and on the whole at its choicest state. In

[1] "Ruskin and his Books" in the *Strand Magazine*, December 1902, vol. xxiv.
p. 714. Ruskin's father bought the "Rochester" in 1858 while the son was in
Switzerland.
[2] Vol. V. p. 170.
[3] See *Præterita*, ii. ch. viii. § 150 and *n*.
[4] "He submitted," says Mr. Frederic Harrison, "with a murmur to the rule of
the house, which, on the Sabbath day, covered his beloved Turners with dark screens"
("Memories of John Ruskin," *Literature*, February 3, 1900). This, says Mr. Allen,
is a mistake. "Mr. Harrison perhaps visited Denmark Hill on Sunday, and, noticing
that the drawings were covered, concluded that this was a piece of Sunday obser-
vance;" but the Turners were habitually protected by screens from direct sunlight
(*Strand Magazine*, December 1902, p. 714).
[5] *Ibid.*, p. 714.

the following year it was depleted by generous gifts to the Universities. To Oxford he presented thirty-six drawings and sketches, including drawings of the series made by Turner for *The Rivers of France;* to Cambridge he gave a collection of twenty-five, representing Turner's successive styles. The address of thanks, with the great seal of Oxford University, is dated March 23, 1861; the Catalogue of the Cambridge collection is dated May 28. The list of the Oxford drawings is here printed in Appendix iii. 3 (p. 559); and the Cambridge Catalogue in Appendix iii. 2 (pp. 557–558). It is well within the mark to say that the present value of these two collections is £10,000. The collection of Turner Drawings at Oxford is especially fine, and is perhaps not as well known as it deserves to be.

In 1870 Ruskin was appointed Slade Professor at Oxford, and in the same year he moved from London to Brantwood. His Turners were now divided between his rooms at Oxford and his house in the Lakes. He had bought several new drawings, but he presented to the University a further set of drawings and sketches from his collection (Appendix iii. 3, p. 559 *n.*); this latter gift was made to the Drawing School, and the drawings included in it are in the cabinets in that school, and not with the other Turners. One of the drawings included in this gift—the Junction of the Greta and the Tees—cost him, he confesses, many a pang.[1]

At a later date Ruskin was instrumental in securing for the University, on permanent loan from the National Gallery, a magnificent collection of 251 sketches and drawings.[2] The drawings and sketches were selected by Ruskin, and the catalogues prepared by him (Appendix iii. 4, pp. 560–568). He refers in *The Art of England* (§ 2) to "the now unequalled collection possessed by the Oxford schools of Turner drawings and sketches, completed as it has been by the kindness of the Trustees of the National Gallery at the intercession of Prince Leopold."

Like other collectors, Ruskin frequently exchanged, bought, and

[1] See below, p. 444; and compare *Fors Clavigera,* Letter 62 : "I find I can't bear to look at them in the gallery, because they are mine no more."

[2] The transaction is thus recorded in the *Report of the Director of the National Gallery for 1878* : "In conformity with a request made by His Royal Highness Prince Leopold on behalf of the Curators of the University Galleries, Oxford, 249 drawings and sketches by Turner, together with eight sketch-books, specially selected from those not ordinarily exhibited to the public, have, with the approval of the Trustees of the National Gallery, been lent to the University Galleries at Oxford." In a later report (for 1890, p. 6) the loan is stated to have been made "at the request of Professor Ruskin." The actual number of pieces is 251 (exclusive of some note-books).

sold. There was a nucleus, however, among his Turner collection which was constant. Of the 83 drawings in the Thornbury Catalogue, 23 remained with him to the end. In the year 1869, however, when he was leaving his house at Denmark Hill, after the death of his parents, he had, as it were, a clearance sale. He himself drew up the auction catalogue, and it is accordingly reprinted here (Appendix iii. 5, pp. 569–572). In 1882 he intended to sell some more Turner Drawings (Appendix iii. 6, p. 573), but he placed a private reserve on them, employing Mr. Arthur Severn to buy them in if necessary. Only one or two drawings reached the reserve price; the others accordingly returned to Brantwood.

In 1878 Ruskin was induced by Mr. Huish, of the Fine Art Society, to exhibit his collection (as it then existed) in London. The catalogue which he wrote for this exhibition is Part III. of the present volume:—

> *Notes by Mr. Ruskin.* Part I.—On his drawings by the late J. M. W. Turner, R.A. Part II.—On his own handiwork illustrative of Turner. 1878.

The notes on this exhibition, though the drawings were afterwards in part dispersed, will always be of peculiar interest to readers of Ruskin. The drawings include those which he most valued, which he had before him when he wrote his books, and which surrounded him on his death-bed. They were exhibited at the rooms of the Fine Art Society in Bond Street. The exhibition was timed to open early in March. Ruskin had completed the preface on the 12th of February, and the Notes proper on the 21st. He had more to say, but he was suddenly stricken by illness, and the catalogue, as first published, was in an unfinished state. Ruskin gradually recovered, and later issues of the catalogue contained successive additions and alterations. The principal variants are noted under the text, so that the reader of this volume may have before him all that is interesting in the successive editions, while other variations are enumerated in the Bibliographical Note (pp. 398–402).[1]

In noting these variations it is well to bear in mind a distinction which Ruskin himself drew, namely, that between actual inflammation of the brain and "the not morbid, however dangerous, states of more or less excited temper, and too much quickened thought, which gradually led up to the illness, accelerating in action during the eight or ten days preceding the actual giving way of the brain (as may

[1] The exhibition and Ruskin's "Notes" were noticed in many of the papers; most fully in the *Times,* March 20, 1878.

be enough seen in the fragmentary writing of the first edition of my notes on the Turner Exhibition."[1] A collation of the various readings has therefore, in this instance, a peculiar and a painful interest. More than once we may trace the author, beginning on a quiet note, and in full command of his literary powers; afterwards passing into a condition of heightened feeling, which gradually led to loss of reserve and command over form, until he had to break off and lay down the pen, under pressure of distinct illness. But the attack was as short as it was sudden, and a careful reading of this catalogue in its successive stages brings vividly home to the reader how narrow is the partition between the inspiration of genius and the inflammation of disease. It must have been only a few days before Ruskin broke down that he penned the exquisite and much quoted passage at the end of the Preface (p. 410); and it was immediately on his recovery that he completed the Epilogue, conceived in the vein of easy reminiscence which afterwards gave so much charm to *Prœterita*.

The text here reprinted is that of the tenth, eleventh, and twelfth thousands of the catalogue, which contained Ruskin's Notes in their final and fullest form. They included also Notes on Ruskin's "Handiwork illustrative of Turner." The drawings, etc., there described, were arranged by Ruskin during his convalescence and added to the exhibition.

In 1879 there was an exhibition of Ruskin's own Drawings, arranged by Professor Norton, at Boston and at New York. To this, Ruskin sent many pieces which had not been shown in London, together with twenty-five which had there been shown. The catalogue, compiled by Professor Norton, was for the most part a reprint of the London one of 1878—the compiler fitting Ruskin's remarks in some cases to different drawings. Such portions of the catalogue as were contributed by Ruskin in the form of titles or notes not comprised in the London catalogue, are here reprinted (Appendix vi., pp. 582–588).

In 1900, after Ruskin's death, his collection of Turner Drawings was again exhibited in Bond Street. A few miscellaneous items, not included in the earlier exhibition, were then shown; the descriptions of these in the catalogue of 1900 are here inserted for the sake of completeness. There are many references in other of Ruskin's writings to the Turner Drawings in his collection; references to such passages are here given in footnotes.

Of the miscellaneous papers and letters collected in the Appendix, some have already been referred to. The first Appendix (pp. 539–553)

[1] *Fors Clavigera* (February 1880, Letter 88).

contains a reprint of Ruskin's evidence to the National Gallery Site Commission in 1857. The Commissioners, it will be seen, had read Ruskin's *Notes on the Turner Gallery*, and his evidence went over much the same ground as that covered in his appendix to those *Notes* (pp. 173–181).

Appendix II. contains notes on Turner's character which Ruskin sent to Mr. Thornbury as hints for that gentleman's *Life of Turner*. Ruskin himself, as we have seen, at one time entertained the idea of writing a life of the artist; and, though the idea was abandoned, he recurred to it at various times, and, during the years 1855 to 1860, collected from other friends of Turner a good deal of biographical material. Much of this he afterwards lent to Mr. Thornbury. Other portions of it he embodied many years later in *Dilecta;* much remains in MS., and some of this is included in the volume of this edition containing that work. Ruskin wrote generously of Mr. Thornbury's work, which, though containing much valuable material, is lamentably formless, ill-arranged, and often inaccurate. He was of opinion, as we have seen,[1] that "anybody" could do a biography of Turner; but nobody has yet done it adequately. At a later period Ruskin hoped to persuade M. Ernest Chesneau to undertake the task anew. M. Chesneau died before he was able to do it, and material which Ruskin supplied to him for the purpose appears to have been lost or destroyed; at any rate the editors have been unable to trace it.

In Appendix III. are collected several minor catalogues of Turner Drawings, drawn up at various times by Ruskin. These have been already mentioned.

Another catalogue, to which Ruskin contributed notes on some drawings by Turner, may here be mentioned. This is:—

> *Catalogue of the first Exhibition of Pictures and Water-colour Drawings, etc., at Douglas, Isle of Man. . . . With original notes by Professor Ruskin.* 1880. Douglas: James Brown and Son.

The notes in question are here given on pp. 429, 445, 448, 457.

The next Appendix (IV.) contains several letters on copies of Turner's drawings. To copies of pictures in general Ruskin was strongly opposed. He expressed his opposition to the National Gallery Site Commission (see below, p. 549). But at a later time his rule against copying came to admit many exceptions. He employed several artists, as we shall see in a later volume, to make copies of pictures; and

[1] Vol. V. p. xvi.

as we see in this volume (p. 530), he attached great educational importance to copies of Turner's drawings. He presented several of these copies to public institutions in which he was interested—such as the Ruskin Museum at Sheffield, and the Whitelands Training College at Chelsea. Some remarks by him on copies of Turner presented to the latter are reserved for a later volume, as they could not be detached for use here without destroying the unity of his Notes on "The Ruskin Cabinet" at that College.

As the great authority on Turner, Ruskin was often referred to for his opinion on the genuineness of works purporting to be by the master. Letters dealing with this subject are given in Appendix V.

Appendix VI. has been mentioned above (p. lv.); the last Appendix (VII.) contains some controversial pieces written on the effect upon water-colour drawings of exposure to light. This subject was much in Ruskin's mind during the arrangement of the Turner Drawings in the national collection; the writings in question contain also incidental references to particular drawings.

The indices to this volume are somewhat elaborate; and will, it is hoped, add to its utility and completeness as a collection of Ruskin's scattered writings on Turner's works.

The first Index brings together all the works by Turner which at any time were in Ruskin's collection.

The second Index is to the Sketches and Drawings by Turner in the National Gallery. It is arranged in numerical order, the numbers being those attached to the frames in the Gallery. The reader will thus be able to identify and collate, without difficulty, Ruskin's various references to the drawings. In order to make the index more complete, references are given not only to this volume but to passages in other works by Ruskin, where any considerable mention is made of the drawings. The index does not include the oil-pictures, because Ruskin's notes on these were arranged in the numerical order which still obtains in the Gallery.

In *Ruskin on Pictures*, volume i. (1902) there was a further index of Turner Drawings arranged by *subjects;* this will be incorporated in the General Index to the edition; the aim of the *numerical* index here being to make the present volume available for reference in the National Gallery.

With regard to the *manuscripts* of the pieces collected in this volume, that of *The Harbours of England* is among the Pierpont Morgan

MSS. It was included in one of the bound volumes containing *Modern Painters* (see Vol. V. p. 433). A collation of it with the text shows that careful revision which has been fully illustrated in previous volumes. A few passages from the MS. are cited in notes; see, for instance, pp. 15, 20, 24. There also exists (in Mr. Allen's possession) the author's proof of *The Harbours;* a piece of this is facsimiled at p. 33; while pages of the MS., one of them containing sketches by the author of Venetian sails, are facsimiled at pp. 18, 28.

The only other piece in this volume of which the MS. is known to exist, or which has been accessible to the editors, is the *Notes by Mr. Ruskin on his Drawings by Turner, and on his own Handiwork illustrative of Turner.* Of this, the MS. of the Introduction and of the Notes on Nos. 25–51 is at Brantwood; this portion of the MS., which was that for the first edition, is written, in a fairly firm hand, on twenty-eight sheets of ruled white foolscap. The beautiful passage at the end of the Introduction was written out twice by Ruskin, and was again slightly revised in proof. This page of the MS. is here facsimiled (p. 410). The MS. of the Turner Notes, from No. 52 onwards, including the whole of Ruskin's Notes "on his own handiwork," is in the possession of Mr. H. Beaumont, who acquired it, together with a series of letters from Ruskin, referring to the Exhibition and the Notes, from Mr. Huish. One or two extracts from this correspondence are cited below (see pp. 399, 400).

Among the Allen MSS. there is the first draft of a portion of the letter to the *Literary Gazette* (November 13, 1858) on the Turner Bequest. An extract from the MS. is given on p. 330; it is of interest as showing the care that Ruskin bestowed on everything that he wrote.

To a copy of the Catalogue of the Sketches and Drawings by Turner, exhibited in Marlborough House in the year 1857–1858, with annotations by Ruskin, reference has already been made (see above, p. xxxix.).

The *illustrations* consist of three classes—(1) Turner's plates for *The Harbours of England;* (2) such of Turner's drawings and sketches in the National Gallery as were reproduced in the illustrated edition of Ruskin's Catalogue of 1881; and (3) some additional illustrations here introduced, from drawings by Turner, either in the National Gallery or in Ruskin's collection.

The original plates for *The Harbours of England*, which still exist, though they are worn and have been retouched, are represented in this

INTRODUCTION

edition by photogravures from early impressions of the originals. In order to suit the size of the page, it has been necessary to reduce them by about one-third.

In the illustrated edition (1899) of Ruskin's last catalogue of the Drawings and Sketches by Turner in the National Gallery, eight pieces were reproduced by half-tone process. One of these pieces (a Swan, No. 609) is not included in the present volume, because the same subject was given in *Lectures on Landscape*, where in this edition it will again be found. The other seven pieces are reproduced in this volume by photogravure on a larger scale than in the Illustrated Catalogue. Of one of the Turner sketches in the National Gallery— a sketch of a Windmill (No. 601) which Ruskin recommended to all students for repeated copying (see below, p. 302), he commissioned Mr. Allen to make an etching. This plate, hitherto unpublished, is here included.

The other illustrations refer to the Ruskin collection of Turner Drawings. The photographic reproductions of engravings given in the Illustrated Edition of the Catalogue of 1878 are not here given. The edition was not prepared by Ruskin; many of the plates were very poor; and they were in no case made from the original drawings; they were reproductions of plates previously published in other books. Three of the most interesting drawings in Ruskin's collection are here reproduced from the originals (Coblentz, Constance, and the Pass of the Splügen). Two others (Fluelen and Bellinzona) are represented in a different way. Ruskin, as we have seen, had at one time a scheme for publishing some sort of representation of Turner's drawings in the size of the originals. To reproduce Turner's drawings faithfully was, he always felt, impossible (see Vol. VI. p. 4), though modern processes render it possible to give more or less satisfactory memoranda. At the time of which we are speaking, Ruskin's idea was to reproduce the leading lines in the drawings. Two plates which he thus prepared are in existence, and it is these (hitherto unpublished) which are here given. The Fluelen was etched by Ruskin on the steel; the Bellinzona was traced by Ruskin from the original, and thence etched by Mr. George Allen. The plates in this edition are photogravures from impressions of the etchings; the Fluelen is reduced from 19×12; the Bellinzona, from 11×9.

Two other plates remain to be noticed. The *frontispiece* is a photogravure from the picture by Turner of himself at the age of 17. The picture, which is at Brantwood, is described at p. 473 of this volume; it is in oils ($20\frac{1}{2} \times 16\frac{1}{4}$). Finally, the plate opposite p. 409 is

a photogravure from a drawing by Ruskin of Dawn (June 1873), as seen from his windows at Brantwood, and as described in the Preface to his Catalogue of 1878. The drawing, which is in water-colour (13×8), is in the collection of Mr. George Allen. It was shown at the Ruskin Exhibition at the Royal Society of Painters in Water-Colour, 1901 (No. 215), and was reproduced (by half-tone process) to illustrate an article on " John Ruskin as Artist " in the *Argosy* for March 1901.

E. T. C.

PART I

THE HARBOURS OF ENGLAND

HARBOURS OF ENGLAND.

ENGRAVED BY THOMAS LUPTON,

FROM ORIGINAL DRAWINGS MADE EXPRESSLY
FOR THE WORK BY

J. M. W. TURNER, R.A.

WITH ILLUSTRATIVE TEXT

BY

J. RUSKIN,

AUTHOR OF "MODERN PAINTERS."

LONDON:
PUBLISHED BY
E. GAMBART AND CO., 25 BERNERS STREET, OXFORD STREET.
1856.

[*Bibliographical Note.*—In 1825 Lupton, the engraver, projected a serial publication entitled *The Ports of England*, and for this Turner undertook to supply all the drawings (as appears from a letter of Lupton to Ruskin). But both artist and engraver lacked the opportunity required to carry the undertaking to a successful conclusion, and three numbers only were completed. Each of these contained two engravings. Part I., introducing *Scarborough* and *Whitby*, appeared in 1826; Part II., with *Dover* and *Ramsgate*, in 1827; and in 1828 Part III., containing *Sheerness* and *Portsmouth*, closed the series. To ornament the covers of these parts, Turner designed a vignette, which was printed upon the centre of the front wrapper of each. As *The Ports of England* is an exceptionally scarce book, and as the vignette can be obtained in no other form, a facsimile of it is here given on p. 6. The original drawing was presented by Ruskin to the Fitz-William Museum, at Cambridge, where it may now be seen (see below, p. 557). Twenty-eight years afterwards (that is, in 1856, five years after Turner's death) these six Plates, together with six new ones, were published by Messrs. E. Gambart and Co., at whose invitation Ruskin consented to write the essay on Turner's marine painting which accompanied them.

First Edition (1856).—The title-page of the book on its first appearance was as printed on the preceding page.

Folio, pp. viii. + 53. The Preface (here, pp. 9–11) occupies pp. iii.–vi.; the List of Plates (here p. xv.), p. vii.; the Introductory matter, pp. 1–27; then come the Plates with the descriptions, pp. 29–53. The imprint on the reverses of the half-title and of the last page is "London : printed by Spottiswoode and Co. | New Street Square." Issued in green cloth, with uncut edges, the words "Harbours | of England | by | J. M. W. Turner" (enclosed in an ornamental frame) being impressed on the front cover. Also in crimson cloth, with gilt edges; the title "Harbours | of | England | by | Turner & Ruskin" (enclosed in an ornamental frame of a different design) being impressed on both covers. Price 42s.

The plates were engraved in mezzotint by Thomas Lupton; six had already been published as described above. All the Plates were lettered (in addition to the titles as given in this edition), "Drawn by J. M. W. Turner, Esqr., R.A. Engraved by Thos. Lupton [Plates 2, 10, and 12 "Thomas Lupton"]. London : published *May 7th*, 1856, by E. Gambart and Co., 25 Berners St., Oxford St." Some copies were issued with the Plates on India paper. Artists' Proofs of the Plates were also published (accompanied by the Text on larger paper) in a cloth portfolio with black leather label on the side, lettered in gilt "The | Harbours | of | England | by | Turner & Ruskin. | Artists' Proofs." The six Plates which had originally appeared in *Ports of England*, have engraved lettering, the other six being unlettered.

Second Edition (1857).—This is undated, but it seems to have been issued by Messrs. Gambart and Co. in 1857. There are no alterations worth noting, except that the date was removed from Ruskin's preface; the pages were

1826

Fig. 1

now x. + 53 (the half-title being numbered). Issued in blue cloth. The delicate Plates already exhibit signs of wear in this edition.

Third Edition (1859).—The copyright (which had not been retained by Ruskin) now passed from Messrs. Gambart to Messrs. Day and Sons, who published an undated edition in or about 1859. It was an exact reprint of

the Second, except that the publisher's name on the title-page now ran —"London | published by | Day & Son, Lithographers to the Queen | 6 Gate Street, Lincoln's Inn Fields "—and the imprint—"Wyman and Sons, Printers, | Great Queen Street, Lincoln's Inn Fields, | London, W.C." Issued in blue cloth. Also in crimson cloth, with the title omitted from the design upon the back cover. Plates 3 and 12 bear no imprint. So-called "Proofs" were also issued in a portfolio.

Fourth Edition (1872).—The book now changed hands again, the steel plates and copyright being sold at Hodgson's sale-rooms in 1868 to Mr. Allman for the sum of £14, 10s. The title - page of the next edition was :—

> The | Harbours of England. | Engraved by Thomas Lufton [*sic*] | from original drawings made expressly for the work by | J. M. W. Turner, R.A. | With | Illustrative Text | by | J. Ruskin, | Author of "Modern Painters" | New Edition. | London : | T. J. Allman, 463, Oxford Street.

Quarto (leaving a much smaller margin round the plates); otherwise the same as the second edition, except that the imprint (at the foot of p. 53) is "Billing, Printer, Guildford, Surrey." Issued in red cloth, ornamented with black rules; and lettered on the front cover "Turner and Ruskin's | Harbours of England," and "Harbours of England" up the back. Plate 1 (Dover) was used as a frontispiece, although the List of Plates gave its position as in previous editions ; the publisher's imprint was removed from the Plates.

Fifth Edition (1877).—Messrs. Smith, Elder & Co. had now purchased the copyright, and on November 29, 1877, they issued an edition with the following title-page :—

> The | Harbours of England | Engraved by Thomas Lupton | from original drawings made expressly for the work by | J. M. W. Turner, R.A. | With Illustrative Text | by John Ruskin, LL.D. | Author of "Modern Painters," etc. etc. | New Edition. | London : Smith, Elder & Co., 15 Waterloo Place. | 1877.

Imperial quarto. Similar to the second edition, except that the date (April 1856) is reinserted at the end of the preface. The imprint (at the foot of p. 53) is " London : printed by Spottiswoode and Co., New Street Square and Parliament Street." Issued in green cloth, lettered on the front cover and up the back "Harbours of England, Turner & Ruskin." Price 25s. The Plates in this edition were retouched by Mr. Charles A. Tomkins, but they were already sadly worn and in this edition they are very poor. They are lettered as before, but with the following imprint—"London : Smith, Elder & Co., 15 Waterloo Place."

The first edition is held in much greater esteem than any of its successors. Artists' proofs have been sold for eleven to twelve guineas ; proofs for three to four guineas, and ordinary copies for two guineas. The second edition can be obtained for less than thirty shillings ; others fetch only a third of that amount or less.

Sixth Edition (1895).—The copyright of the book subsequently passed from Messrs. Smith, Elder & Co. to Ruskin, and in 1895 a new edition was issued, uniform with the other small green-cloth volumes of Ruskin's Works. The title-page is :—

> The | Harbours of England. | By | John Ruskin, | Honorary Student of Christ Church, and Honorary Fellow | of Corpus Christi College, Oxford. | With | Thirteen Illustrations by | J. M. W. Turner, R.A. | Edited by | Thomas J. Wise, | Editor of | "A Complete Bibliography of the Writings of John Ruskin," | etc. etc. | George Allen, Sunnyside, Orpington, | and | 156, Charing Cross Road, London. | 1895. | [All rights reserved.]

Crown 8vo, pp. xxvi. +134. The imprint (on the reverse of the title-page) is "Printed by Ballantyne, Hanson & Co., At the Ballantyne Press," and at the foot of p. 134 "Printed by Ballantyne, Hanson & Co., Edinburgh and London." The "Editor's Preface" occupies pp. ix.-xviii. It is mainly bibliographical, and the information contained in it is embodied in this Bibliographical Note. Turner's vignette for *The Ports of England* (given above) faced p. x. A note on a passage, now added from the author's proof, occupied pp. xiv.-xvi., and is here given as a note to p. 33. Some remarks on an allusion to Shelley occupied pp. xvi.-xvii. ; these are given as a footnote to the passage in question (see below, p. 16). The "Author's Original Preface" occupies pp. xxi.-xxv. ; the Text, pp. 1-134. Issued on May 11, 1895, price 7s. 6d. (3000 copies printed); also 250 large-paper copies at 15s.

The Plates in this edition were reproduced on a smaller scale (reduced from 8¾ × 6 to 5¼ × 3½) "by the photogravure process from a selected set of early examples; and, in addition, the Plates so prepared have been carefully worked upon by Mr. Allen himself." Sets of prints from the original steel plates are also sold in a portfolio (10s. 6d.).

Re-issued in 1902, marked "Seventh Thousand."

Variæ Lectiones.—There are few variations in the text to record. In the sixth edition (here followed) a passage in the MS., omitted from the previous editions, was for the first time inserted, as stated above. In § 5, line 19, all previous editions read "'flit or soar,'" but "'flit' or 'soar'" seems the right reading. In § 22, line 15, "fig. 1" now becomes "fig. 2," and so, lower down, "fig. 2" becomes "fig. 3." § 40, line 7, "Hakewell" in all previous editions, here altered to "Hakewill." Plate v., page 59, line 6, "harbours" in all previous editions, here corrected to "harbour." Plate viii., line 13, the small edition of 1895 misprinted "drawing" for "drawings" ; line 16, all previous editions misprinted "Comb" for "Combe."

The numbering of the paragraphs in the Introductory Essay (pp. 13-49) is here inserted.]

PREFACE

Among the many peculiarities which distinguished the late J. M. W. Turner from other landscape painters, not the least notable, in my apprehension, were his earnest desire to arrange his works in connected groups,[1] and his evident intention, with respect to each drawing, that it should be considered as expressing part of a continuous system of thought. The practical result of this feeling was that he commenced many series of drawings,—and, if any accident interfered with the continuation of the work, hastily concluded them,—under titles representing rather the relation which the executed designs bore to the materials accumulated in his own mind, than the position which they could justifiably claim when contemplated by others. The *River Scenery* was closed without a single drawing of a rapidly running stream; and the prints of his annual tours were assembled, under the title of the *Rivers of France*, without including a single illustration either of the Rhone or the Garonne.[2]

The title under which the following plates are now presented to the public, is retained merely out of respect to this habit of Turner's. Under that title he commenced the publication, and executed the vignette for its title-page, intending doubtless to make it worthy of taking rank with, if not far above, the consistent and extensive series of the

[1] [On this subject, see *Modern Painters*, vol. v. pt. ix. ch. xi. § 30 and *n*.]
[2] For particulars of the *River Scenery*, 1827, see below, p. 382 ; the drawings are in the National Gallery. The *Rivers of France* is made up of Turner's "Annual Tours" 1833-1834-1835 : see below, p. 613.]

9

Southern Coast, executed in his earlier years. But pro-
crastination and accident equally interfered with his purpose.
The excellent engraver Mr. Lupton,[1] in co-operation with
whom the work was undertaken, was unfortunately also
a man of genius, and seems to have been just as capricious
as Turner himself in the application of his powers to the
matter in hand. Had one of the parties in the arrange-
ment been a mere plodding man of business, the work
would· have proceeded ; but between the two men of talent
it came very naturally to a stand. They petted each other
by reciprocal indulgence of delay; and at Turner's death,
the series, so magnificently announced under the title of
the *Harbours of England*, consisted only of twelve plates,
all the· less worthy of their high-sounding title in that,
while they included illustrations of some of the least im-
portant of ·the · watering-places, they did not include any
illustration whatever of such harbours of England as Liver-
pool, Shields, Yarmouth, or Bristol. Such as they were,
however, I was requested to undertake their illustration.
As the offer was made at a moment when much nonsense,
in various forms, was being written about Turner and his
works ; and among the twelve plates there were four *
which I considered among the very finest that had been
executed from his marine subjects, I accepted the trust;
partly to prevent the really valuable series of engravings
from being treated with injustice, and partly because there
were several features in them by which I could render
more intelligible some remarks I wished to make on Turner's
marine painting in general.

These remarks, therefore, I have thrown together, in
a connected form; less with a view to the illustration of
these particular plates, than of the general system of ship-
painting which was characteristic of the great artist. I

* Portsmouth, Sheerness, Scarborough, and Whitby.

[1] [See Vol. IX. p. 15.]

have afterwards separately noted the points which seemed
to me most deserving of attention in the plates them-
selves.

Of archæological information the reader will find none.
The designs themselves are, in most instances, little more
than spirited sea-pieces, with such indistinct suggestion of
local features in the distance as may justify the name
given to the subject; but even when, as in the case of the
Dover and Portsmouth, there is something approaching
topographical detail, I have not considered it necessary to
lead the reader into inquiries which certainly Turner him-
self never thought of; nor do I suppose it would materially
add to the interest of these cloudy distances or rolling seas,
if I had the time—which I have not—to collect the most
complete information respecting the raising of Prospect
Rows, and the establishment of circulating libraries.

DENMARK HILL, *April*, 1856.

THE HARBOURS OF ENGLAND

1. Of all things, living or lifeless, upon this strange earth, there is but one which, having reached the mid-term of appointed human endurance on it, I still regard with unmitigated amazement. I know, indeed, that all around me is wonderful—but I cannot answer it with wonder : —a dark veil, with the foolish words, NATURE OF THINGS, upon it, casts its deadening folds between me and their dazzling strangeness. Flowers open, and stars rise, and it seems to me they could have done no less. The mystery of distant mountain-blue only makes me reflect that the earth is of necessity mountainous ;—the sea-wave breaks at my feet, and I do not see how it should have remained unbroken. But one object there is still, which I never pass without the renewed wonder of childhood, and that is the bow of a Boat. Not of a racing-wherry, or revenue cutter, or clipper yacht; but the blunt head of a common, bluff, undecked sea-boat, lying aside in its furrow of beach sand. The sum of Navigation is in that. You may magnify it or decorate as you will: you do not add to the wonder of it. Lengthen it into hatchet-like edge of iron,— strengthen it with complex tracery of ribs of oak,—carve it and gild it till a column of light moves beneath it on the sea,—you have made no more of it than it was at first. That rude simplicity of bent plank, that can breast its way through the death that is in the deep sea, has in it the soul of shipping. Beyond this, we may have more work, more men, more money ; we cannot have more miracle.

2. For there is, first, an infinite strangeness in the perfection of the thing, as work of human hands. I know

nothing else that man does, which is perfect, but that. All his other doings have some sign of weakness, affectation, or ignorance in them. They are overfinished or underfinished; they do not quite answer their end, or they show a mean vanity in answering it too well.

But the boat's bow is naïvely perfect: complete without an effort. The man who made it knew not he was making anything beautiful, as he bent its planks into those mysterious, ever-changing curves. It grows under his hand into the image of a sea-shell; the seal, as it were, of the flowing of the great tides and streams of ocean stamped on its delicate rounding. He leaves it when all is done, without a boast. It is simple work, but it will keep out water. And every plank thenceforward is a Fate, and has men's lives wreathed in the knots of it, as the cloth-yard shaft had their deaths in its plumes.

3. Then, also, it is wonderful on account of the greatness of the thing accomplished. No other work of human hands ever gained so much. Steam-engines and telegraphs indeed help us to fetch, and carry, and talk; they lift weights for us, and bring messages, with less trouble than would have been needed otherwise; this saving of trouble, however, does not constitute a new faculty, it only enhances the powers we already possess. But in that bow of the boat is the gift of another world. Without it, what prison wall would be so strong as that "white and wailing fringe" of sea? What maimed creatures were we all, chained to our rocks, Andromeda-like, or wandering by the endless shores, wasting our incommunicable strength, and pining in hopeless watch of unconquerable waves! The nails that fasten together the planks of the boat's bow are the rivets of the fellowship of the world. Their iron does more than draw lightning out of heaven, it leads love round the earth.

4. Then also, it is wonderful on account of the greatness of the enemy that it does battle with. To lift dead weight; to overcome length of languid space; to multiply or systematise a given force; this we may see done by

the bar, or beam, or wheel, without wonder. But to war
with that living fury of waters, to bare its breast, moment
after moment, against the unwearied enmity of ocean,—the
subtle, fitful, implacable smiting of the black waves, provok-
ing each other on, endlessly, all the infinite march of the
Atlantic rolling on behind them to their help,—and still
to strike them back into a wreath of smoke and futile foam,
and win its way against them, and keep its charge of life
from them;—does any other soulless thing do as much as
this?

5. I should not have talked of this feeling of mine about
a boat, if I had thought it was mine only; but I believe
it to be common to all of us who are not seamen. With
the seaman, wonder changes into fellowship and close affec-
tion; but to all landsmen, from youth upwards, the boat
remains a piece of enchantment; at least unless we entangle
our vanity in it, and refine it away into mere lath, giving
up all its protective nobleness for pace. With those in
whose eyes the perfection of a boat is swift fragility, I have
no sympathy.[1] The glory of a boat is, first its steadiness
of poise—its assured standing on the clear softness of the
abyss; and, after that, so much capacity of progress by
oar or sail as shall be consistent with this defiance of the
treachery of the sea. And, this being understood, it is
very notable how commonly the poets, creating for them-
selves an ideal of motion, fasten upon the charm of a boat.
They do not usually express any desire for wings, or, if
they do, it is only in some vague and half-unintended phrase,
such as "flit" or "soar," involving wingedness. Seriously,
they are evidently content to let the wings belong to Horse,

[1] [The MS. of *The Harbours* shows throughout a process of compression and sim-
plification in revision. An instance may here be given :—
 " . . . refine it away into mere paint and lath ; giving up all its power
 and protective and inclusive nobleness for mere grace. With those in whose
 eyes the perfection of a boat is a swift weakness, and the art of rowing
 another species of balancing as on the tight-rope or plank, in continual peril,
 I have no sympathy. The glory . . ."
Compare *Stones of Venice*, vol. i. (Vol. IX. p. 258), where Ruskin contrasts the beauty
of "a broad, strong, sea boat" with "a race boat, a mere floating chisel."]

or Muse, or Angel, rather than to themselves; but they all,
somehow or other, express an honest wish for a Spiritual
Boat. I will not dwell on poor Shelley's paper navies, and
seas of quicksilver, lest we should begin to think evil of
boats in general because of that traitorous one in Spezzia ↙
Bay;[1] but it is a triumph to find the pastorally minded
Wordsworth imagine no other way of visiting the stars
than in a boat "no bigger than the crescent moon";* and
to find Tennyson — although his boating, in an ordinary
way, has a very marshy and punt-like character—at last,
in his highest inspiration, enter in where the wind began
"to sweep a music out of sheet and shroud." †

6. But the chief triumph of all is in Dante. He had
known all manner of travelling; had been borne through
vacancy on the shoulders of chimeras,[2] and lifted through
upper heaven in the grasp of its spirits; but yet I do not
remember that he ever expresses any positive *wish* on such
matters, except for a boat.

> "Guido, I wish that Lapo, thou, and I,
> Led by some strong enchantment, might ascend
> A magic ship, whose charmèd sails should fly
> With winds at will where'er our thoughts might wend,
> So that no change, nor any evil chance
> Should mar our joyous voyage; but it might be
> That even satiety should still enhance
> Between our souls their strict community :

* Prologue to *Peter Bell.*
† *In Memoriam,* ci.

[1] ["The *Don Juan* was no 'traitorous' craft. Fuller and more authentic informa-
tion is to hand now than the meagre facts at the disposal of a writer in 1856 ; and
we know that the greed of man, and not the lack of seaworthiness in his tiny vessel,
caused Percy Shelley to

' . . . Suffer a sea change
Into something rich and strange.'

"There is, unhappily, no longer any room for doubt that the *Don Juan* was wilfully
run down by a felucca whose crew coveted the considerable sum of money they believed
Byron to have placed on board, and cared nothing for the sacrifice of human life in
their eagerness to seize the gold" (Editor's Note in edition of 1895). For Shelley's
"paper navies" and "seas of quicksilver" see the "Letter to Maria Gisborne," lines
72–81 ; and compare "The Boat on the Serchio."]

[2] [Probably an allusion to Dante's descent into Malebolge on the back of Geryon :
Inferno, xvii. 79 *seq.*]

> And that the bounteous wizard then would place
> Vanna and Bice, and our Lapo's love,
> Companions of our wandering, and would grace
> With passionate talk, wherever we might rove,
> Our time, and each were as content and free
> As I believe that thou and I should be."[1]

And of all the descriptions of motion in the *Divina Commedia*, I do not think there is another quite so fine as that in which Dante has glorified the old fable of Charon by giving a boat also to the bright sea which surrounds the mountain of Purgatory, bearing the redeemed souls to their place of trial; only an angel is now the pilot, and there is no stroke of labouring oar, for his wings are the sails.

> "My preceptor silent yet
> Stood, while the brightness that we first discerned
> Opened the form of wings: then, when he knew
> The pilot, cried aloud, 'Down, down; bend low
> Thy knees; behold God's angel: fold thy hands:
> Now shalt thou see true ministers indeed.
> Lo! how all human means he sets at nought;
> So that nor oar he needs, nor other sail
> Except his wings, between such distant shores.
> Lo! how straight up to heaven he holds them reared,
> Winnowing the air with those eternal plumes,
> That not like mortal hairs fall off or change.'
>
> "As more and more toward us came, more bright
> Appeared the bird of God, nor could the eye
> Endure his splendour near: I mine bent down.
> He drove ashore in a small bark so swift
> And light, that in its course no wave it drank.
> The heavenly steersman at the prow was seen,
> Visibly written blessed in his looks.
> Within, a hundred spirits and more there sat."[2]

[1] [Dante's Sonnet "to Guido Cavalcanti." Ruskin quotes Shelley's translation; but there are some alterations. Thus in line 8, Shelley wrote "hearts," not "souls"; and in line 10, "and my gentle love" not "and our Lapo's love." In the MS. draft Ruskin leaves the translation to be supplied afterwards, noting "Guido, I wish that Lapo, etc., 7th leaf from end in Rossetti's." Rossetti's translation of the sonnet is included in the collection of *The Early Italian Poets*, which was published with Ruskin's assistance in 1861, but which had been written some years earlier (see W. M. Rossetti's *Dante Gabriel Rossetti*, 1895, vol. i. p. 105). Rossetti had apparently shown Ruskin at this time some of his MS., and perhaps he pointed out further the inaccuracy in the tenth line of Shelley's translation. The Italian is "Con quella ch' è sul numero del trenta," which Rossetti translates "And her the thirtieth on my roll," explaining in a note, "That is, his list of the sixty most beautiful ladies of Florence, referred to in the *Vita Nuova* (§ 6); among whom Lapo Gianni's lady, Lagia, would seem to have stood thirtieth."]

[2] [*Purgatorio*, ii. 25–45 (Cary's translation).]

XIII.

7. I have given this passage at length, because it seems
to me that Dante's most inventive adaptation of the fable
of Charon to Heaven has not been regarded with the
interest that it really deserves; and because, also, it is a
description that should be remembered by every traveller
when first he sees the white fork of the felucca sail shining
on the Southern Sea. Not that Dante had ever seen such
sails;* his thought was utterly irrespective of the form of
canvas in any ship of the period; but it is well to be able
to attach this happy image to those felucca sails, as they
now float white and soft above the blue glowing of the
bays of Adria. Nor are other images wanting in them.
Seen far away on the horizon, the Neapolitan felucca has
all the aspect of some strange bird stooping out of the
air and just striking the water with its claws; while the
Venetian, when its painted sails are at full swell in sun-
shine, is as beautiful as a butterfly with its wings half-
closed.† There is something also in them that might
remind us of the variegated and spotted angel wings of
Orcagna, only the Venetian sail never looks majestic; it is
too quaint and strange, yet with no peacock's pride or
vulgar gaiety,—nothing of Milton's Dalilah:

"So bedecked, ornate and gay
Like a stately ship
Of Tarsus, bound for the Isles

* I am not quite sure of this, not having studied with any care the forms
of mediæval shipping; but in all the MSS. I have examined the sails of the
shipping represented are square.[1]
† It is not a little strange that in all the innumerable paintings of Venice,
old and modern, no notice whatever had been taken of these sails, though
they are *exactly* the most striking features of the marine scenery around the
city, until Turner fastened upon them, painting one important picture, "The
Sun of Venice," entirely in their illustration.[2]

[1] [Dante has many references to sails (e.g., *Inf.* vii. 13 ; xxi. 15 ; xxvii. 81 ; xxxiv.
48 ; *Purg.* i. 1 ; xii. 5 ; xx. 93 ; xxii. 63 ; *Conv.* i. 3, ll. 34-35 ; iv. 28, ll. 18, 20, 55,
60, 62-63), but in only one instance does he particularise, viz. in *Inf.* xxi. 15, where he
mentions *terzeruolo ed artimon* ("mizen and mainsail"), and this is in a description of
Venetian ships. It is possible that Dante may have seen the felucca sail, which is
probably far older than his day, being of Arab origin.]
[2] [No. 535 in the National Gallery. See below, p. 163.]

Dante had even seen such sails — his thoughts
of the form of canvas in my
; but it is a ~~passage which~~ will
to be able ~~to attach~~ this happy
image to those felucca
sails, as they now float
white and soft above the
blue glowing of the sea;
Nor are other images
wanting in them.

A PAGE OF THE MS. OF "THE HARBOURS OF ENGLAND" (§ 7)

Of Javan or Gadire,
With all her bravery on, and tackle trim,
Sails filled, and streamers waving." [1]

That description could only have been written in a time of vulgar women and vulgar vessels. The utmost vanity of dress in a woman of the fourteenth century would have given no image of " sails filled or streamers waving"; nor does the look or action of a really "stately" ship ever suggest any image of the motion of a weak or vain woman. The beauties of the Court of Charles II., and the gilded galleys of the Thames, might fitly be compared; but the pomp of the Venetian fisher-boat is like neither. The sail seems dyed in its fulness by the sunshine, as the rainbow dyes a cloud; the rich stains upon it fade and reappear, as its folds swell or fall; worn with the Adrian storms, its rough woof has a kind of noble dimness upon it, and its colours seem as grave, inherent, and free from vanity as the spots of the leopard, or veins of the seashell.

8. Yet, in speaking of poets' love of boats, I ought to have limited the love to *modern* poets; Dante, in this respect, as in nearly every other, being far in advance of his age. It is not often that I congratulate myself upon the days in which I happen to live; but I do so in this respect, that, compared with every other period of the world, this nineteenth century (or rather, the period between 1750 and 1850) may not improperly be called the Age of Boats; while the classic and chivalric times, in which boats were partly dreaded, partly despised, may respectively be characterised, with regard to their means of locomotion, as the Age of Chariots, and the Age of Horses.

For, whatever perfection and costliness there may be in the present decorations, harnessing, and horsing of any English or Parisian wheel equipage, I apprehend that we can from none of them form any high ideal of wheel conveyance; and that unless we had seen an Egyptian king bending his bow with his horses at the gallop, or a Greek

[1] [*Samson Agonistes*, 712.]

knight leaning with his poised lance over the shoulder of
his charioteer, we have no right to consider ourselves as
thoroughly knowing what the word "chariot," in its noblest
acceptation, means.

9. So, also, though much chivalry is yet left in us, and
we English still know several things about horses, I believe
that if we had seen Charlemagne and Roland ride out
hunting from Aix, or Cœur de Lion trot into camp on
a sunny evening at Ascalon, or a Florentine lady canter
down the Val d'Arno in Dante's time, with her hawk
on her wrist, we should have had some other ideas even
about horses than the best we can have now. But most
assuredly, nothing that ever swung at the quay sides of
Carthage, or glowed with crusaders' shields above the bays
of Syria, could give to any contemporary human creature
such an idea of the meaning of the word Boat, as may be
now gained by any mortal happy enough to behold as
much as a Newcastle collier beating against the wind. In
the classical period, indeed, there was some importance
given to shipping as the means of locking a battle-field
together on the waves; but in the chivalric period, the
whole mind of man is withdrawn from the sea, regarding
it merely as a treacherous impediment, over which it was
necessary sometimes to find conveyance, but from which
the thoughts were always turned impatiently, fixing them-
selves in green fields, and pleasures that may be enjoyed
by land—the very supremacy of the horse necessitating the
scorn of the sea, which would not be trodden by hoofs.[1]

10. It is very interesting to note how repugnant every

[1] [The MS. contains here an additional passage:—
"... hoofs. It is very curious how, with this general love of land, is
found the love of the music of birds, which our rough seamanship obliges
so many of us to forgo all our lives, and which many besides are ready
to neglect somewhat for a more wind-like and sea-like melody ; Æolian
trembling, or long drawn choral fall—the
 'Hallelujah, as the sound of seas.'
No mediæval poet could possibly have written that line. The spirit of
Blake is in it; the ear of mankind had never until his time been set to
the music of the sea. It is very interesting ..."
The line is Milton's (*Paradise Lost*, x. 642), and Blake is, of course, the admiral.]

oceanic idea appears to be to the whole nature of our principal English mediæval poet, Chaucer. Read first the Man of Lawe's Tale, in which the Lady Constance is continually floated up and down the Mediterranean, and the German Ocean, in a ship by herself; carried from Syria all the way to Northumberland, and there wrecked upon the coast; thence yet again driven up and down among the waves for five years, she and her child; and yet, all this while, Chaucer does not let fall a single word descriptive of the sea, or express any emotion whatever about it, or about the ship. He simply tells us the lady sailed here and was wrecked there; but neither he nor his audience appear to be capable of receiving any sensation, but one of simple aversion, from waves, ships, or sands. Compare with his absolutely apathetic recital, the description by a modern poet of the sailing of a vessel, charged with the fate of another Constance:

" It curled not Tweed alone, that breeze—
For far upon Northumbrian seas
 It freshly blew, and strong;
Where from high Whitby's cloistered pile,
Bound to St. Cuthbert's holy isle,
 It bore a bark along.
Upon the gale she stooped her side,
And bounded o'er the swelling tide
 As she were dancing home.
The merry seamen laughed to see
Their gallant ship so lustily
 Furrow the green sea foam." [1]

11. Now just as Scott enjoys this sea breeze, so does Chaucer the soft air of the woods; the moment the older poet lands, he is himself again, his poverty of language in speaking of the ship is not because he despises description, but because he has nothing to describe. Hear him upon the ground in Spring:

" These woodes elsè recoveren greene,
That drie in winter ben to sene,

[1] [Marmion, ii. 1.]

> And the erth waxeth proud withall,
> For sweet dewes that on it fall,
> And the poore estate forget,
> In which that winter had it set:
> And than becomes the ground so proude,
> That it wol have a newe shroude,
> And maketh so queint his robe and faire,
> That it had hewes an hundred paire,
> Of grasse and floures, of Inde and Pers,
> And many hewes full divers:
> That is the robe I mean ywis,
> Through which the ground to praisen is." [1]

12. In like manner, wherever throughout his poems
we find Chaucer enthusiastic, it is on a sunny day in the
"good greenwood," [2] but the slightest approach to the sea-
shore makes him shiver; and his antipathy finds at last
positive expression, and becomes the principal foundation
of the Frankeleine's Tale, in which a lady, waiting for
her husband's return in a castle by the sea, behaves and
expresses herself as follows:—

> " Another time wold she sit and thinke,
> And cast her eyen dounward fro the brinke;
> But whan she saw the grisly rockes blake,
> For veray fere so wold hire herte quake
> That on hire feet she might hire not sustene
> Than wold she sit adoun upon the grene,
> And pitously into the sea behold,
> And say right thus, with careful sighes cold.
> ' Eterne God, that thurgh thy purveance
> Ledest this world by certain governance,
> In idel, as men sein, ye nothing make.
> *But, lord, thise grisly fendly rockes blake,*
> *That semen rather a foule confusion*
> *Of werk, than any faire creation*
> Of swiche a parfit wise God and stable,
> Why han ye wrought this werk unresonable?'" [3]

The desire to have the rocks out of her way is indeed
severely punished in the sequel of the tale; but it is not
the less characteristic of the age, and well worth meditating

[1] [*Romaunt of the Rose*, 57–70.]
[2] [*Lady of the Lake*, iv. 12.]
[3] [*Frankeleine's Tale*, 129–144.]

upon, in comparison with the feelings of an unsophisticated modern French or English girl among the black rocks of Dieppe or Ramsgate.

On the other hand, much might be said about that peculiar love of *green fields and birds* in the Middle Ages; and of all with which it is connected, purity and health in manners and heart, as opposed to the too frequent condition of the modern mind—

> "As for the birds in the thicket,
> Thrush or ousel in leafy niche,
> Linnet or finch—she was far too rich
> To care for a morning concert to which
> She was welcome, without a ticket." *

13. But this would lead us far afield, and the main fact I have to point out to the reader is the transition of human grace and strength from the exercises of the land to those of the sea in the course of the last three centuries.

Down to Elizabeth's time chivalry lasted; and grace of dress and mien, and all else that was connected with chivalry. Then came the ages which, when they have taken their due place in the depths of the past, will be, by a wise and clear-sighted futurity, perhaps well comprehended under a common name, as the ages of Starch; periods of general stiffening and bluish-whitening, with a prevailing washerwoman's taste in everything; involving a change of steel armour into cambric; of natural hair into peruke; of natural walking into that which will disarrange no wristbands; of plain language into quips and embroideries; and of human life in general, from a green race-course, where to be defeated was at worst only to fall behind and recover breath, into a slippery pole, to be climbed with toil and contortion, and in clinging to which, each man's foot is on his neighbour's head.

* Thomas Hood.[1]

[1] [*Miss Kilmansegg and her Precious Leg* ("Her Honeymoon"). The third line is "The linnet," etc.; and in the last, "any ticket." For another reference to the poem, see below, p. 520 and *n.*]

14. But, meanwhile, the marine deities were incorruptible. It was not possible to starch the sea; and precisely as the stiffness fastened upon men, it vanished from ships. What had once been a mere raft, with rows of formal benches, pushed along by laborious flap of oars, and with infinite fluttering of flags and swelling of poops above, gradually began to lean more heavily into the deep water, to sustain a gloomy weight of guns, to draw back its spider-like feebleness of limb, and open its bosom to the wind, and finally darkened down from all its painted vanities into the long, low hull, familiar with the overflying foam; that has no other pride but in its daily duty and victory; while, through all these changes, it gained continually in grace, strength, audacity, and beauty, until at last it has reached such a pitch of all these, that there is not, except the very loveliest creatures of the living world, anything in nature so absolutely notable, bewitching, and, according to its means and measure, heart-occupying, as a well-handled ship under sail in a stormy day. Any ship, from lowest to proudest, has due place in that architecture of the sea; beautiful, not so much in this or that piece of it, as in the unity of all, from cottage to cathedral, into their great buoyant dynasty. Yet, among them, the fisher-boat, corresponding to the cottage on the land (only far more sublime than a cottage ever can be), is on the whole the thing most venerable. I doubt if ever academic grove were half so fit for profitable meditation as the little strip of shingle between two black, steep, overhanging sides of stranded fishing-boats.[1] The clear, heavy water-edge of ocean rising and falling close to their bows, in that unaccountable way which the

[1] [Here, again, an instance may be given of the way in which Ruskin excised and compressed in revising. The MS. reads:—

"I do not think that ever academic grove was half as fit for true meditation as the little strip of shingle between two black, steep, overhanging sides of fishing-boats basking in the beach sun; scenting that beach æther, partly salt, partly embittered by the fresh sea-weed, with vague additions from fish cooked, or uncookable, and noble prevalence of tar, and slight film of smoke from the deck chimney, and a dash of the downs brought through the hollow of the cliffs, even to the very beach. The clear, heavy . . ."]

sea has always in calm weather, turning the pebbles over
and over as if with a rake, to look for something, and then
stopping a moment down at the bottom of the bank, and
coming up again with a little run and clash, throwing a
foot's depth of salt crystal in an instant between you and
the round stone you were going to take in your hand; sigh-
ing, all the while, as if it would infinitely rather be doing
something else. And the dark flanks of the fishing-boats
all aslope above, in their shining quietness, hot in the
morning sun, rusty and seamed with square patches of
plank nailed over their rents; just rough enough to let
the little flat-footed fisher-children haul or twist themselves
up to the gunwales, and drop back again along some stray
rope; just round enough to remind us, in their broad and
gradual curves, of the sweep of the green surges they know
so well, and of the hours when those old sides of seared
timber, all ashine with the sea, plunge and dip into the
deep green purity of the mounded waves more joyfully than
a deer lies down among the grass of spring, the soft white
cloud of foam opening momentarily at the bows, and fading
or flying high into the breeze where the sea-gulls toss and
shriek,—the joy and beauty of it, all the while, so mingled
with the sense of unfathomable danger, and the human
effort and sorrow going on perpetually from age to age;
waves rolling for ever, and winds moaning for ever, and
faithful hearts trusting and sickening for ever, and brave
lives dashed away about the rattling beach like weeds for
ever; and still at the helm of every lonely boat, through
starless night and hopeless dawn,[1] His hand, who spread
the fisher's net over the dust of the Sidonian palaces, and
gave into the fisher's hand the keys of the kingdom of
heaven.[2]

15. Next after the fishing-boat — which, as I said, in

[1] [This is the passage which gave its title to the picture by Mr. Frank Bramley,
A.R.A., " A Hopeless Dawn," now in the Tate Gallery, No. 1627.]
[2] [Matthew xvi. 19.]

the architecture of the sea represents the cottage, more
especially the pastoral or agricultural cottage, watchful over
some pathless domain of moorland or arable, as the fishing-
boat swims humbly in the midst of the broad green fields
and hills of ocean, out of which it has to win such fruit as
they can give, and to compass with net or drag such flocks
as it may find,—next to this ocean-cottage ranks in interest,
it seems to me, the small, over-wrought, under-crewed, ill-
caulked merchant brig or schooner; the kind of ship which
first shows its couple of thin masts over the low fields or
marshes as we near any third-rate seaport; and which is
sure somewhere to stud the great space of glittering water,
seen from any sea-cliff, with its four or five square-set sails.
Of the larger and more polite tribes of merchant vessels,
three-masted, and passenger-carrying, I have nothing to say,
feeling in general little sympathy with people who want to
go anywhere; nor caring much about anything, which in
the essence of it expresses a desire to get to other sides of
the world; but only for homely and stay-at-home ships,
that live their life and die their death about English rocks.
Neither have I any interest in the higher branches of com-
merce, such as traffic with spice islands, and porterage of
painted tea-chests or carved ivory; for all this seems to me
to fall under the head of commerce of the drawing-room;
costly, but not venerable. I respect in the merchant service
only those ships that carry coals, herrings, salt, timber, iron,
and such other commodities, and that have disagreeable
odour, and unwashed decks. But there are few things more
impressive to me than one of these ships lying up against
some lonely quay in a black sea-fog, with the furrow traced
under its tawny keel far in the harbour slime. The noble
misery that there is in it, the might of its rent and strained
unseemliness, its wave-worn melancholy, resting there for
a little while in the comfortless ebb, unpitied, and claim-
ing no pity; still less honoured, least of all conscious of
any claim to honour; casting and craning by due balance
whatever is in its hold up to the pier, in quiet truth of

time; spinning of wheel, and slackening of rope, and swinging of spade, in as accurate cadence as a waltz music; one or two of its crew, perhaps, away forward, and a hungry boy and yelping dog eagerly interested in something from which a blue dull smoke rises out of pot or pan; but dark-browed and silent, their limbs slack, like the ropes above them, entangled as they are in those inextricable meshes about the patched knots and heaps of ill-reefed sable sail. What a majestic sense of service in all that languor! the rest of human limbs and hearts, at utter need, not in sweet meadows or soft air, but in harbour slime and biting fog; so drawing their breath once more, to go out again, without lament, from between the two skeletons of pier-heads, vocal with wash of under wave, into the grey troughs of tumbling brine; there, as they can, with slacked rope, and patched sail, and leaky hull, again to roll and stagger far away amidst the wind and salt sleet, from dawn to dusk and dusk to dawn, winning day by day their daily bread; and for last reward, when their old hands, on some winter night, lose feeling along the frozen ropes, and their old eyes miss mark of the lighthouse quenched in foam, the so-long impossible Rest, that shall hunger no more, neither thirst any more,[1]—their eyes and mouths filled with the brown sea-sand.

16. After these most venerable, to my mind, of all ships, properly so styled, I find nothing of comparable interest in any floating fabric until we come to the great achievement of the 19th century. For one thing this century will in after ages be considered to have done in a superb manner, and one thing, I think, only. It has not distinguished itself in political spheres; still less in artistical. It has produced no golden age by its Reason; neither does it appear eminent for the constancy of its Faith. Its telescopes and telegraphs would be creditable to it, if it had not in their pursuit forgotten in great part how to see

[1] [Revelation vii. 16.]

clearly with its eyes, and to talk honestly with its tongue. Its natural history might have been creditable to it also, if it could have conquered its habit of considering natural history to be mainly the art of writing Latin names on white tickets.[1] But, as it is, none of these things will be hereafter considered to have been got on with by us as well as might be; whereas it will always be said of us, with unabated reverence,

"THEY BUILT SHIPS OF THE LINE."

17. Take it all in all, a Ship of the Line is the most honourable thing that man, as a gregarious animal, has ever produced. By himself, unhelped, he can do better things than ships of the line; he can make poems and pictures, and other such concentrations of what is best in him. But as a being living in flocks, and hammering out, with alternate strokes and mutual agreement, what is necessary for him in those flocks, to get or produce, the ship of the line is his first work. Into that he has put as much of his human patience, common sense, forethought, experimental philosophy, self-control, habits of order and obedience, thoroughly wrought handwork, defiance of brute elements, careless courage, careful patriotism, and calm expectation of the judgment of God, as can well be put into a space of 300 feet long by 80 broad. And I am thankful to have lived in an age when I could see this thing so done.

18. Considering, then, our shipping, under the three principal types of fishing-boat, collier, and ship of the line, as the great glory of this age; and the "New Forest" of mast and yard that follows the winding of the Thames,[2] to be, take it all in all, a more majestic scene, I don't say merely than any of our streets or palaces as they now are,

[1] [So in *Deucalion* (ch. xii.) Ruskin says that "great part of the supposed scientific knowledge of the day is simply bad English, and vanishes the moment you translate it"; compare *ibid.* ("Living Waves").]
[2] [Ruskin uses this phrase again in *Modern Painters*, vol. v. pt. xi. ch. ix. §§ 7, 8, "that mysterious forest below London Bridge."]

Above these most venerable to my mind of all things
properly so styled. I find nothing of ~~especially~~ comparable.
any floating fabric — until we come to the
Achievement of the 19th Century. For, one
this century will in after ages be considered to have
done in a Superb manner, and One thing, I think,
It has not distinguished itself. ~~by any means~~, in P
~~matter~~; still less in artistical. It has produced
golden age by its ~~Reasonings~~; neither does it
eminent ~~in the attainments~~ for the constancy of its faith. Its Teles
Telegraphs would be creditable to it; if it has
~~forgotten in great part~~ ~~plain~~ ~~understood the uses of seeing~~ how to see, with it, ~~to do just~~
to talk ~~with~~ honestly with its Tongue. . Its natural history might
have been creditable to it also, if it could have conquered its
habit of considering the natural history to be mainly the
of ~~writing~~ Latin names on ~~types~~ white tickets. But as
none of these things will be hereafter considered to have
~~got on with us~~ ~~done by it~~ as well as might be; ~~but~~ whereas it will always
said of ~~it~~ us, with unabated Reverence.
"The Built Ships of the Line"

but even than the best that streets and palaces can generally be; it has often been a matter of serious thought to me how far this chiefly substantial thing done by the nation ought to be represented by the art of the nation; how far our great artists ought seriously to devote themselves to such perfect painting of our ships as should reveal to later generations—lost perhaps in clouds of steam and floating troughs of ashes—the aspect of an ancient ship of battle under sail.

19. To which, I fear, the answer must be sternly this: That no great art ever was, or can be, employed in the careful imitation of the work of man as its principal subject. That is to say, art will not bear to be reduplicated. A ship is a noble thing, and a cathedral a noble thing, but a painted ship or a painted cathedral is not a noble thing. Art which reduplicates art is necessarily second-rate art. I know no principle more irrefragably authoritative than that which I had long ago occasion to express: "All noble art is the expression of man's delight in God's work; not in his own."[1]

"How!" it will be asked, "Are Stanfield, Isabey,[2] and Prout necessarily artists of the second order because they paint ships and buildings instead of trees and clouds?" Yes, necessarily of the second order; so far as they paint ships rather than sea, and so far as they paint buildings rather than the natural light, and colour, and work of years upon those buildings. For, in this respect, a ruined building is a noble subject, just as far as man's work has therein been subdued by nature's; and Stanfield's chief dignity is his being a painter less of shipping than of the seal of time or decay upon shipping.* For a wrecked ship,

* As in the very beautiful picture of this year's Academy, "The Abandoned."

[1] [In *The Stones of Venice*, vol. i., "All noble ornamentation," etc. (Vol. IX. p. 70). The definition is repeated in *Modern Painters*, vol. v. pt. ix. ch. ii. § 1.]

[2] [For Stanfield see *Modern Painters*, vol. i. (Vol. III. p. 226 *n.*). For his picture "The Abandoned," in the Academy of 1856, see *Academy Notes* for that year, No. 94 (vol. xiv.). Jean Baptiste Isabey (1767–1855) was court painter under Napoleon I., Louis XVIII., and Charles X. For Prout in this connexion, see below, § 31.]

or shattered boat, is a noble subject, while a ship in full
sail, or, a perfect boat, is an ignoble one; not merely be-
cause the one is by reason of its ruin more picturesque
than the other, but because it is a nobler act in man to
meditate upon Fate as it conquers his work, than upon
that work itself.

20. Shipping, therefore, in its perfection, never can be-
come the subject of noble art; and that just because to
represent it in its perfection would tax the powers of art
to the utmost. If a great painter could rest in drawing
a ship, as he can rest in drawing a piece of drapery, we
might sometimes see vessels introduced by the noblest
workmen, and treated by them with as much delight as
they would show in scattering lustre over an embroidered
dress, or knitting the links of a coat of mail. But ships
cannot be drawn at times of rest. More complicated
in their anatomy than the human frame itself, so far as
that frame is outwardly discernible; liable to all kinds of
strange accidental variety in position and movement, yet
in each position subject to imperative laws which can only
be followed by unerring knowledge; and involving, in
the roundings and foldings of sail and hull, delicacies of
drawing greater than exist in any other inorganic object,
except perhaps a snow wreath,*—they present, irrespective
of sea or sky, or anything else around them, difficulties
which could only be vanquished by draughtsmanship quite
accomplished enough to render even the subtlest lines of
the human face and form. But the artist who has once
attained such skill as this will not devote it to the drawing
of ships. He who can paint the face of St. Paul will not

* The catenary and other curves of tension which a sail assumes
under the united influence of the wind, its own weight, and the par-
ticular tensions of the various ropes by which it is attached, or against
which it presses, show at any moment complexities of arrangement to
which fidelity, except after the study of a lifetime, is impossible.[1]

[1] [On the subject of catenary curvature, see *Modern Painters*, vol. iv. (Vol. VI.
p. 329).]

elaborate the parting timbers of the vessel in which he is wrecked ; and he who can represent the astonishment of the apostles at the miraculous draught will not be solicitous about accurately showing that their boat is overloaded.

21. " What ! " it will perhaps be replied, " have, then, ships never been painted perfectly yet, even by the men who have devoted most attention to them ? " Assuredly not. A ship never yet has been painted at all, in any other sense than men have been painted in " Landscapes with figures." Things have been painted which have a general effect of ships, just as things have been painted which have a general effect of shepherds or banditti ; but the best average ship-painting no more reaches the truth of ships than the equestrian troops in one of Van der Meulen's battle-pieces [1] express the higher truths of humanity.

22. Take a single instance. I do not know any work in which, on the whole, there is a more unaffected love of ships for their own sake, and a fresher feeling of sea breeze always blowing, than Stanfield's " Coast Scenery." [2] Now, let the reader take up that book, and look through all the plates of it at the way in which the most important parts of a ship's skeleton are drawn, those most wonderful junctions of mast with mast, corresponding to the knee or hip in the human frame, technically known as " Tops." Under its very simplest form, in one of those poor collier brigs, which I have above endeavoured to recommend to the reader's affection, the junction of the top-gallant-mast with the topmast, when the sail is reefed, will present itself under no less complex and mysterious form than this in Fig. 2, a horned knot of seven separate pieces of timber, irrespective of the two masts and the yard ; the whole balanced and involved in an apparently inextricable web of chain and rope, consisting of at least sixteen ropes

[1] [Adam Frans Van der Meulen (1632–1690), employed by Louis XIV. to paint his military exploits. The galleries of the Louvre and of Versailles contain the pictures. There is a " Hunting Party " by him in the National Gallery, No. 1447.]

[2] [For a fuller reference to this work, see the note in Vol. VI. p. 16.]

about the top-gallant-mast, and some twenty-five crossing
each other in every imaginable degree of slackness and slope
about the topmast. Two-thirds of these ropes are omitted in

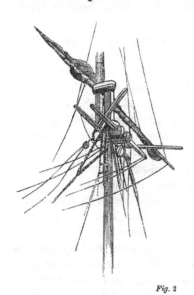

the cut, because I could not
draw them without taking more
time and pains than the point
to be illustrated was worth;
the thing, as it is, being drawn
quite well enough to give some
idea of the facts of it. Well,
take up Stanfield's "Coast
Scenery," and look through it
in search of tops, and you will
invariably find them repre-
sented as in Fig. 3, or even
with fewer lines; the example
Fig. 3 being one of the tops
of the frigate running into
Portsmouth harbour, magnified
to about twice its size in the

Fig. 2 plate.

23. "Well, but it was im-
possible to do more on so small a scale." By no means: but
take what scale you choose, of Stanfield's or any other marine
painter's most elaborate painting, and let me
magnify the study of the real top in proportion,
and the deficiency of detail will always be found
equally great: I mean in the work of the higher
artists, for there are of course many efforts at
greater accuracy of delineation by those painters
of ships who are to the higher marine painter
what botanical draughtsmen are to the land-
scapists; but just as in the botanical engraving
the spirit and life of the plant are always lost,

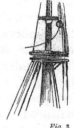

Fig. 3

so in the technical ship-painting the life of the ship is always
lost, without, as far as I can see, attaining, even by this sacri-
fice, anything like completeness of mechanical delineation.

Respecting this lower kind of ship-painting, it is always matter of wonder to me that it satisfies sailors. Some years ago I happened to stand longer than pleased my pensioner guide before Turner's "Battle of Trafalgar," at Greenwich Hospital; a picture which, at a moderate estimate is simply worth all the rest of the hospital, ground, walls, pictures and models put together. My guide supposing me to be detained by indignant wonder at seeing it in so good a place, assented to my supposed sentiments

Crucified Truth !

Muse of Prudence : JR

A PAGE OF THE PROOF SHEETS OF "THE HARBOURS OF ENGLAND" (§ 24)

At least, I never saw the ship drawn yet which gave me the slightest idea of the entanglement of real rigging.[1]

24. Respecting this lower kind of ship-painting, it is always matter of wonder to me that it satisfies sailors. Some years ago I happened to stand longer than pleased my pensioner guide before Turner's "Battle of Trafalgar," at Greenwich Hospital; a picture which, at a moderate estimate, is simply worth all the rest of the hospital—ground—walls—pictures and models put together.[2] My guide, supposing me to be detained by indignant wonder at seeing it in so good a place, assented to my supposed sentiments by muttering in a low voice: "Well, sir, it *is* a shame that that thing should be there. We ought to 'a 'ad a Uggins; that's sartain."[3] I was not surprised that my sailor friend should be disgusted at seeing the *Victory* lifted nearly right out of the water, and all the sails of the fleet blowing about to that extent that the crews might as well have tried to reef as many thunder-clouds. But I was surprised at his perfect repose of respectful faith in "Uggins," who appeared to me—unfortunate landsman as I was—to give no more idea of the look of a ship of the line going through the sea, than might be obtained from seeing one of the correct models at the top of the hall[4] floated in a fishpond.

[1] [For Ruskin's own drawing (1854) of the jib of the Calais packet, see *Præterita*, ii. ch. x., and Vol. V. p. xxxi.]

[2] [In eds. 1–5 the words "a picture . . . put together" were omitted, the passage reading " . . . Greenwich Hospital; and my guide . . ." The proof-sheets of the first edition, worked upon by Ruskin, were given by him to his old nurse Anne (see *Præterita*, i. § 30). She subsequently gave them to Mr. Allen. They had been submitted, as usual, to W. H. Harrison, who marked them freely with notes and suggestions. To this passage he appears to have taken so decided an objection that its author was prevailed upon to delete it. But, whilst deferring thus to Harrison's judgment, Ruskin wrote in the margin, below the cancelled passage : "*Sacrificed to the Muse of Prudence. J. R.*" The accompanying illustration is a facsimile of the portion of the proof-sheet described above. In the edition of 1895 it was reduced to fit the smaller page. For another reference to the same picture see below, p. 170.]

[3] [William John Huggins (1781–1845), marine painter to William IV. There are two pictures of the Battle of Trafalgar by him in the King's Gallery at Kensington Palace (recently transferred from Hampton Court).]

[4] [The models of ships exhibited in the "Painted Hall" of Greenwich Hospital.]

25. Leaving, however, the sailor to his enjoyment, on such grounds as it may be, of this model drawing, and being prepared to find only a vague and hasty shadowing forth of shipping in the works of artists proper, we will glance briefly at the different stages of excellence which such shadowing forth has reached, and note in their consecutive changes the feelings with which shipping has been regarded at different periods of art.

(1) *Mediæval Period.* The vessel is regarded merely as a sort of sea-carriage, and painted only so far as it is necessary for complete display of the groups of soldiers or saints on the deck: a great deal of quaint shipping, richly hung with shields, and gorgeous with banners, is, however, thus incidently represented in 15th-century manuscripts, embedded in curly green waves of sea full of long fish; and although there is never the slightest expression of real sea character, of motion, gloom, or spray, there is more real interest of marine detail and incident than in many later compositions.

26. (2) *Early Venetian Period.* A great deal of tolerably careful boat-drawing occurs in the pictures of Carpaccio and Gentile Bellini, deserving separate mention among the marine schools, in confirmation of what has been stated above, that the drawing of boats is more difficult than that of the human form. For, long after all the perspectives and fore-shortenings of the human body were completely understood, as well as those of architecture, it remained utterly beyond the power of the artists of the time to draw a boat with even tolerable truth. Boats are always tilted up on end, or too long, or too short, or too high in the water. Generally they appear to be regarded with no interest whatever, and are painted merely where they are matters of necessity. This is perfectly natural: we pronounce that there is romance in the Venetian conveyance by oars, merely because we ourselves are in the habit of being dragged by horses. A Venetian, on the other hand, sees vulgarity in a gondola, and thinks the only true romance

is in a hackney coach. And thus, it was no more likely
that a painter in the days of Venetian power should pay
much attention to the shipping in the Grand Canal, than
that an English artist should at present concentrate the
brightest rays of his genius on a cab-stand.

27. (3) *Late Venetian Period.* Deserving mention only
for its notably negative character. None of the great
Venetian painters, Tintoret, Titian, Veronese, Bellini, Gior-
gione, Bonifazio, ever introduce a ship if they can help it.
They delight in ponderous architecture, in grass, flowers,
blue mountains, skies, clouds, and gay dresses; nothing
comes amiss to them but ships and the sea. When they
are forced to introduce these, they represent merely a dark-
green plain, with reddish galleys spotted about it here and
there, looking much like small models of shipping pinned
on a green board. In their marine battles, there is seldom
anything discernible except long rows of scarlet oars, and
men in armour falling helplessly through them.

28. (4) *Late Roman Period.* That is to say, the time
of the beginning of the Renaissance landscape by the
Caracci, Claude, and Salvator. First, in their landscapes,
shipping begins to assume something like independent char-
acter, and to be introduced for the sake of its picturesque
interest; although what interest could be taken by any
healthy human creature in such vessels as were then painted
has always remained a mystery to me. The ships of Claude,
having hulls of a shape something between a cocoa-nut and
a high-heeled shoe, balanced on their keels on the top of
the water, with some scaffolding and cross-sticks above, and
a flag at the top of every stick, form perhaps the *purest*
exhibition of human inanity and fatuity which the arts
have yet produced. The harbours also, in which these
model navies ride, are worthy of all observation for the
intensity of the false taste which, endeavouring to unite
in them the characters of pleasure-ground and port, de-
stroys the veracity of both. There are many inlets of
the Italian seas where sweet gardens and regular terraces

descend to the water's edge; but these are not the spots where merchant vessels anchor, or where bales are disembarked. On the other hand, there are many busy quays and noisy arsenals upon the shores of Italy; but Queens' palaces are not built upon the quays, nor are the docks in any wise adorned with conservatories or ruins. It was reserved for the genius of Claude to combine the luxurious with the lucrative, and rise to a commercial ideal, in which cables are fastened to temple pillars, and lighthouses adorned with rows of beaupots. It seems strange also that any power which Salvator showed in the treatment of other subjects utterly deserts him when he approaches the sea. Though always coarse, false, and vulgar, he has at least energy, and some degree of invention, as long as he remains on land; his terrestrial atrocities are animated, and his rock-born fancies formidable. But the sea air seems to dim his sight and paralyze his hand. His love of darkness and destruction, far from seeking sympathy in the rage of ocean, disappears as he approaches the beach; after having tortured the innocence of trees into demoniac convulsions, and shattered the loveliness of purple hills into colourless dislocation, he approaches the real wrath and restlessness of ocean without either admiration or dismay, and appears to feel nothing at its shore except a meagre interest in bathers, fishermen, and gentlemen in court dress bargaining for state cabins. Of all the pictures by men who bear the reputation of great masters which I have ever seen in my life (except only some by Domenichino), the two large "Marines" in the Pitti Palace, attributed to Salvator, are, on the whole, the most vapid and vile examples of human want of understanding.[1] In the folly of Claude there is still a gleam of grace and innocence; there is refreshment in his childishness, and tenderness in his inability. But the folly of Salvator is disgusting in its very nothingness: it is like the vacuity of a plague-room in an

<hr/>

[1] [For Ruskin's detestation of Domenichino, see Vol. III. p. 184 n. ; for Salvator's "Marines" in the Pitti, Vol. III. pp. 517–518.]

hospital, shut up in uncleansed silence, emptied of pain and motion, but not of infection.

29. (5) *Dutch Period.* Although in artistical qualities lower than is easily by language expressible, the Italian marine painting usually conveys an idea of three facts about the sea,—that it is green, that it is deep, and that the sun shines on it. The dark plain which stands for far away Adriatic with the Venetians, and the glinting swells of tamed wave which lap about the quays of Claude, agree in giving the general impression that the ocean consists of pure water, and is open to the pure sky. But the Dutch painters, while they attain considerably greater dexterity than the Italian in mere delineation of nautical incident, were by nature precluded from ever becoming aware of these common facts; and having, in reality, never in all their lives seen the sea, but only a shallow mixture of sea-water and sand; and also never in all their lives seen the sky, but only a lower element between them and it, composed of marsh exhalation and fog-bank; they are not to be with too great severity reproached for the dulness of their records of the nautical enterprise of Holland. *We* only are to be reproached, who, familiar with the Atlantic, are yet ready to accept with faith, as types of sea, the small waves *en papillote*, and peruke-like puffs of farinaccous foam, which were the delight of Backhuysen[1] and his compeers. If one could but arrest the connoisseurs in the fact of looking at them with belief, and, magically introducing the image of a true sea-wave, let it roll up to them through the room,—one massive fathom's height and rood's breadth of brine, passing them by but once,—dividing, Red Sea-like, on right hand and left,—but at least setting close before their eyes, for once in inevitable truth, what a sea-wave really is; its green mountainous giddiness

[1] [For another reference to this painter's seas, compare *Modern Painters*, vol. i. (Vol. III. pp. 497–498). Compare also the reference (*ibid.*, p. 85) to "the various Van somethings and Back somethings, more especially and malignantly those who have libelled the sea."]

of wrath, its overwhelming crest—heavy as iron, fitful as flame, clashing against the sky in long cloven edge,—its furrowed flanks, all ghastly clear, deep in transparent death, but all laced across with lurid nets of spume, and tearing open into meshed interstices their churned veil of silver fury, showing still the calm grey abyss below; that has no fury and no voice, but is as a grave always open, which the green sighing mounds do but hide for an instant as they pass. Would they, shuddering back from this wave of the true, implacable sea, turn forthwith to the papillotes? It might be so. It is what we are all doing, more or less, continually.

30. Well, let the waves go their way; it is not of them that we have here to reason; but be it remembered, that men who cannot enter into the Mind of the Sea, cannot for the same reason enter into the Mind of Ships, in their contention with it; and the fluttering, tottering, high-pooped, flag-beset fleets of these Dutch painters have only this much superiority over the caricatures of the Italians, that they indeed appear in some degree to have been studied from the high-pooped and flag-beset nature which was in that age visible, while the Claude and Salvator ships are ideals of the studio. But the effort is wholly unsuccessful. Any one who has ever attempted to sketch a vessel in motion knows that he might as easily attempt to sketch a bird on the wing, or a trout on the dart. Ships can only be drawn, as animals must be, by the high instinct of momentary perception, which rarely developed itself in any Dutch painter, and least of all in their painters of marine. And thus the awkward forms of shipping, the shallow impurity of the sea, and the cold incapacity of the painter, joining in disadvantageous influence over them, the Dutch marine paintings may be simply, but circumstantially, described as the misrepresentation of undeveloped shipping in a discoloured sea by distempered painters. An exception ought to be made in favour of the boats of Cuyp, which are generally well

floated in calm and sunny water;[1] and, though rather punts or tubs than boats, have in them some elements of a slow, warm, square-sailed, sleepy grandeur—respectable always, when compared either with the flickering follies of Backhuysen, or the monstrous, unmanly, and, *à fortiori*, unsailorly absurdities of metaphysical vessels, puffed on their way by corpulent genii, or pushed by protuberant dolphins,[2] which Rubens and the other so-called historical painters of his time were accustomed to introduce in the mythology of their court-adulation; that marvellous Faith of the 18th century, which will one day, and that not far off, be known for a thing more truly disgraceful to human nature than the Polynesian's dance round his feather idol, or Egyptian's worship of the food he fattened on. From Salvator and Domenichino it is possible to turn in a proud indignation, knowing that theirs are no fair examples of the human mind; but it is with humbled and woful anger that we must trace the degradation of the intellect of Rubens in his pictures of the life of Mary of Medicis.*

31. (6) *Modern Period.* The gradual appreciation of the true character both of shipping and the ocean, in the

* "The town of Lyons, seated upon a chariot drawn by two lions, *lifts its eyes towards heaven,* and admires there—'les nouveaux Epoux,'—represented in the character of Jupiter and Juno."—*Notice des Tableaux du Musée Impérial,* 2nde partie, Paris, 1854, p. 235.[3]
"The Queen upon her throne holds with one hand the sceptre, in the other the balance. Minerva and Cupid are at her sides. Abundance and Prosperity distribute medals, laurels, 'et d'autres récompenses,' to the Genii of the Fine Arts. Time, crowned with the productions of the seasons, leads France to the—Age of Gold!"—p. 239.
So thought the Queen, and Rubens, and the Court. Time himself, "crowned with the productions of the seasons," was, meanwhile, as Thomas Carlyle would have told us, "quite of another opinion."
With view of arrival at Golden Age all the sooner, the Court determine

[1] [For Ruskin's appreciation of Cuyp's rendering of calm water, see *Modern Painters,* vol. i. (Vol. III. p. 520.]
[2] [The particular reference is to No. 2100 in the Louvre : see Vol. XII. p. 472.]
[3] [No. 2091 in the Louvre, the next pictures described being Nos. 2099 and 2100. For another reference to this series of pictures (painted for Queen Marie de Médicis, wife of Henry IV. and regent during the minority of her son Louis XIII.), see Vol. XII. pp. 472, 473.]

works of the painters of the last half century, is part of
that successful study of other elements of landscape, of
which I have long laboured at a consistent investigation,
now partly laid before the public;[1] I shall not, therefore,
here enter into any general inquiry respecting modern sea-
painting, but limit myself to a notice of the particular feel-
ings which influenced Turner in his marine studies, so far
as they are shown in the series of plates which have now
been trusted to me for illustration.

Among the earliest sketches from nature which Turner
appears to have made, in pencil and Indian ink, when a
boy of twelve or fourteen, it is very singular how large
a proportion consists of careful studies of stranded boats.[2]
Now, after some fifteen years of conscientious labour, with
the single view of acquiring knowledge of the ends and
powers of art, I have come to one conclusion, which at
the beginning of those fifteen years would have been very
astonishing to myself—that, of all our modern school of
landscape painters, next to Turner, and before the rise
of the Pre-Raphaelites, the man whose works are on the
whole most valuable, and show the highest intellect, is
Samuel Prout. It is very notable that also in Prout's
early studies, shipping subjects took not merely a promi-
nent, but I think even a principal, place.[3]

32. The reason of this is very evident: both Turner
and Prout had in them an untaught, inherent perception
of what was great and pictorial. They could not find it
in the buildings or in the scenes immediately around them.

to go by water; "and Marie de Medicis gives to her son the government
of the state, under the emblem of a vessel, of which he holds the rudder."

This piece of royal pilotage, being on the whole the most characteristic
example I remember of the Mythological marine above alluded to, is ac-
cordingly recommended to the reader's serious attention.

[1] ["Truth of Water" formed the subject of Section v. in Part ii. of the first
volume of *Modern Painters* Ruskin intended to elaborate the subject in a further
volume, supplementary to that work : see Preface to its fifth volume, § 5.]
[2] [Compare on this subject the catalogue below, p. 257.]
[3] [See the Essay on Prout, in Vol. XII. pp. 309, 310.]

But they saw some element of real power in the boats. Prout afterwards found materials suited to his genius in other directions, and left his first love; but Turner retained the early affection to the close of his life, and the last oil picture which he painted, before his noble hand forgot its cunning, was the Wreck-buoy.[1] The last thoroughly perfect picture he ever painted,[2] was the *Old Téméraire*.

The studies which he was able to make from nature in his early years, are chiefly of fishing-boats, barges, and other minor marine still life; and his better acquaintance with this kind of shipping than with the larger kind is very marked in the Liber Studiorum, in which there are five careful studies of fishing-boats under various circumstances; namely, Calais Harbour, Sir John Mildmay's Picture, Flint Castle, Marine Dabblers, and the Calm;[3] while of other shipping, there are only two subjects, both exceedingly unsatisfactory.

33. Turner, however, deemed it necessary to his reputation at that period that he should paint pictures in the style of Vandevelde;[4] and, in order to render the resemblance more complete, he appears to have made careful drawings of the different parts of old Dutch shipping. I found a large number of such drawings among the contents of his neglected portfolios at his death;[5] some were clearly not by his own hand, others appeared to be transcripts by him from prints or earlier drawings; the quantity altogether was very great, and the evidence of his prolonged attention to the subject more distinct than with respect to any other element of landscape. Of plants, rocks, or architecture, there were very few careful pieces of anatomical study. But several drawers were entirely filled with these memoranda of shipping.

[1] [Exhibited at the Academy in 1849; now in the possession of Mrs. George Holt: see also below, § 35.]

[2] [But see below, p. 168, *Notes on the Turner Gallery*.]

[3] [The drawings for two of these plates—"Flint Castle" and "Marine Dabblers"—are in the National Gallery, Nos. 496, 509.]

[4] [Compare *Pre-Raphaelitism*, in Vol. XII. pp. 372–373.]

[5] [See again, below, p. 257. Examples of his memoranda of shipping may be seen in the National Gallery, Nos. 528, 533, 534, 535.]

34. In executing the series of drawings for the work known as the Southern Coast,[1] Turner appears to have gained many ideas about shipping, which, once received, he laid up by him for use in after years. The evidence of this laying by of thought in his mind, as it were in reserve, until he had power to express it, is curious and complete throughout his life; and although the Southern Coast drawings are for the most part quiet in feeling, and remarkably simple in their mode of execution, I believe it was in the watch over the Cornish and Dorsetshire coast, which the making of those drawings involved, that he received all his noblest ideas about sea and ships.

35. Of one thing I am certain; Turner never drew anything that could be *seen*, without having seen it. That is to say, though he would draw Jerusalem from some one else's sketch,[2] it would be, nevertheless, entirely from his own experience of ruined walls: and though he would draw ancient shipping (for an imitation of Vandevelde, or a vignette to the voyage of Columbus[3]) from such data as he could get about things which he could no more see with his own eyes, yet when, of his own free will, in the subject of Ilfracombe,[4] he, in the year 1818, introduces a shipwreck, I am perfectly certain that, before the year 1818, he had *seen* a shipwreck, and, moreover, one of that horrible kind— a ship dashed to pieces in deep water, at the foot of an inaccessible cliff. Having once seen this, I perceive, also, that the image of it could not be effaced from his mind. It taught him two great facts, which he never afterwards forgot; namely, that both ships and sea were things that broke to pieces. *He never afterwards painted a ship quite in fair order.* There is invariably a feeling about his vessels of strange awe and danger; the sails are in some way loosening, or flapping as if in fear; the swing of the hull,

[1] [Published at intervals between 1814 and 1826.]
[2] [In Finden's *Illustrations of the Bible:* see below, pp. 447–448.]
[3] [In illustration of Rogers' *Poems;* see below, p. 381.]
[4] [In No. 9 of *The Southern Coast.*]

majestic as it may be, seems more at the mercy of the sea than in triumph over it; the ship never looks gay, never proud, only warlike and enduring. The motto he chose, in the Catalogue of the Academy, for the most cheerful marine he ever painted, the Sun of Venice going to Sea, marked the uppermost feeling in his mind:

> " Nor heeds the Demon that in grim repose
> Expects his evening prey." [1]

I notice above [2] the subject of his last marine picture, the Wreck-buoy, and I am well persuaded that from that year 1818, when first he saw a ship rent asunder, he never beheld one at sea, without, in his mind's eye, at the same instant, seeing her skeleton.

36. But he had seen more than the death of the ship. He had seen the sea feed her white flames on souls of men; and heard what a storm-gust sounded like, that had taken up with it, in its swirl of a moment, the last breaths of a ship's crew. He never forgot either the sight or the sound. Among the last plates prepared by his own hand for the Liber Studiorum, (all of them, as was likely from his advanced knowledge, finer than any previous pieces of the series, and most of them unfortunately never published, being retained beside him for some last touch—for ever delayed,) perhaps the most important is one of the body of a drowned sailor, dashed against a vertical rock in the jaws of one merciless, immeasurable wave. [3] He repeated the same idea, though more feebly expressed, later in life, in a small drawing of Grandville, on the coast of France. The sailor clinging to the boat in the marvellous drawing of Dunbar is another reminiscence of the same kind. He hardly ever painted a steep rocky coast without some fragment of a

[1] [See below, p. 163.]
[2] [§ 32, p. 41.]
[3] [One of the very rare proofs of this plate was in Ruskin's collection : see below, *Notes on his Drawings by Turner*, No. 72, p. 461. It is described in *Modern Painters*, vol. v. pt. ix. ch. xi. § 31 *n*. "The small drawing of Grandville" was also in Ruskin's collection ; No. 39 in Thornbury's list : see below, p. 557. The drawing of Dunbar was engraved in vol. ii. of Sir Walter Scott's *Provincial Antiquities of Scotland* (1826).]

devoured ship, grinding in the blanched teeth of the surges,
—just enough left to be a token of utter destruction. Of
his two most important paintings of definite shipwreck I
shall speak presently.

37. I said that at this period he first was assured of
another fact, namely, that the *Sea* also was a thing that broke
to pieces. The sea up to that time had been generally
regarded by painters as a liquidly composed, level-seeking
consistent thing, with a smooth surface, rising to a water-
mark on sides of ships; in which ships were scientifically
to be embedded, and wetted, up to said water-mark, and
to remain dry above the same. But Turner found during
his Southern Coast tour that the sea was *not* this: that
it was, on the contrary, a very incalculable and unhorizontal
thing, setting its "water-mark" sometimes on the highest
heavens, as well as on sides of ships;—very breakable into
pieces; half of a wave separable from the other half, and
on the instant carriageable miles inland;—not in any wise
limiting itself to a state of apparent liquidity, but now
striking like a steel gauntlet, and now becoming a cloud,
and vanishing, no eye could tell whither; one moment a
flint cave, the next a marble pillar, the next a mere white
fleece thickening the thundery rain.[1] He never forgot those
facts; never afterwards was able to recover the idea of
positive distinction between sea and sky, or sea and land.
Steel gauntlet, black rock, white cloud, and men and masts
gnashed to pieces and disappearing in a few breaths and
splinters among them;—a little blood on the rock angle,
like red sea-weed, sponged away by the next splash of the
foam, and the glistering granite and green water all pure
again in vacant wrath. So stayed by him, for ever, the
Image of the Sea.[2]

[1] [In quoting this description of a wave, in *Frondes Agrestes* (see Vol. III. p.
570 *n.*), Ruskin revised it thus—"one moment, a flint cave,—the next, a marble
pillar,—the next, a fading cloud." For another short description of waves, see
Stones of Venice, vol. i. (Vol. IX. p. 272).]

[2] [And afterwards Turner had personal experience of the frenzy of a storm: see
the anecdote told by Ruskin in his *Notes on the Turner Gallery*, below, p. 162.]

38. One effect of this revelation of the nature of ocean to him was not a little singular. It seemed that ever afterwards his appreciation of the calmness of water was deepened by what he had witnessed of its frenzy, and a certain class of entirely tame subjects were treated by him even with increased affection after he had seen the full manifestation of sublimity. He had always a great regard for canal boats, and instead of sacrificing these old, and one would have thought unentertaining, friends to the deities of Storm, he seems to have returned with a lulling pleasure from the foam and danger of the beach to the sedgy bank and stealthy barge of the lowland river. Thenceforward his work which introduces shipping is divided into two classes; one embodying the poetry of silence and calmness, the other of turbulence and wrath. Of intermediate conditions he gives few examples; if he lets the wind down upon the sea at all, it is nearly always violent, and though the waves may not be running high, the foam is torn off them in a way which shows they will soon run higher. On the other hand, nothing is so perfectly calm as Turner's calmness. To the canal barges of England he soon added other types of languid motion; the broad-ruddered barques of the Loire, the drooping sails of Seine, the arcaded barques of the Italian lakes slumbering on expanse of mountain-guarded wave, the dreamy prows of pausing gondolas on lagoons at moon-rise; in each and all commanding an intensity of calm, chiefly because he never admitted an instant's rigidity. The surface of quiet water with other painters becomes FIXED. With Turner it looks as if a fairy's breath would stir it, but the fairy's breath is not there.

39. So also his boats are intensely motionless, because intensely capable of motion. No other painter ever floated a boat quite rightly; all other boats stand on the water, or are fastened in it; only his *float* in it. It is very difficult to trace the reasons of this, for the rightness of the placing on the water depends on such subtle curves and shadows in

the floating object and its reflection, that in most cases the
question of entirely right or entirely wrong resolves itself
into the "estimation of an hair":[1] and what makes the
matter more difficult still, is, that sometimes we may see
a boat drawn with the most studied correctness in every
part, which yet will not swim; and sometimes we may find
one drawn with many easily ascertainable errors, which yet
swims well enough; so that the drawing of boats is some-
thing like the building of them, one may set off their lines
by the most authentic rules, and yet never be sure they
will sail well. It is, however, to be observed that Turner
seemed, in those southern coast storms, to have been some-
what too strongly impressed by the disappearance of smaller
crafts in surf, and was wont afterwards to give an uncom-
fortable aspect even to his gentlest seas, by burying his
boats too deeply.

40. When he erred, in this or other matters, it was not
from want of pains, for of all accessories to landscape, ships
were throughout his life those which he studied with the
greatest care. His figures, whatever their merit or demerit,
are certainly never the beloved part of his work;[2] and
though the architecture was in his early drawings careful,
and continued to be so down to the Hakewill's Italy series,[3]
it soon became mannered and false whenever it was prin-
cipal. He would indeed draw a ruined tower, or a distant
town, incomparably better than any one else, and a stair-
case or a bit of balustrade very carefully; but his temples
and cathedrals showed great ignorance of detail, and want
of understanding of their character.[4] But I am aware of
no painting from the beginning of his life to its close,
containing *modern* shipping as its principal subject, in which
he did not put forth his full strength, and pour out his
knowledge of detail with a joy which renders those works,

[1] [*Merchant of Venice*, iv. 1.]
[2] [On the subject of Turner's figure-painting, see below, pp. 151–157.]
[3] [Published in 1820 : see below, p. 427.]
[4] [Here, again, see below, pp. 158–159, 285, 499, 509.]

as a series, among the most valuable he ever produced.
Take for instance:

1. Lord Yarborough's Shipwreck.
2. The Trafalgar, at Greenwich Hospital.
3. The Trafalgar, in his own gallery.
4. The Pas de Calais.
5. The large Cologne.
6. The Havre.
7. The *Old Téméraire*.[1]

I know no fourteen pictures by Turner for which these
seven might be wisely changed; and in all of these the
shipping is thoroughly principal, and studied from existing
ships. A large number of inferior works were, however,
also produced by him in imitation of Vandevelde, represent-
ing old Dutch shipping; in these the shipping is scattered,
scudding and distant, the sea grey and lightly broken.
Such pictures are, generally speaking, among those of least
value which he has produced. Two very important ones,
however, belong to the imitative school: Lord Ellesmere's,
founded on Vandevelde;[2] and the Dort, at Farnley, on Cuyp.
The latter, as founded on the better master, is the better
picture, but still possesses few of the true Turner qualities,
except his peculiar calmness, in which respect it is un-
rivalled;[3] and if joined with Lord Yarborough's Shipwreck,

[1] [Of these pictures, 1 is "The Wreck of the *Minotaur* on the Haak sands, at the
mouth of the Texel, Dec. 1810" (painted for Lord Yarborough after 1810), now in
the present Earl's possession; for 2 (painted for George IV.), see above, p. 33 ; 3 is
No. 480 in the National Gallery; for 4 (Royal Academy, 1827)—"Now for the
Painter"—see Vol. XII. p. 380 ; 5 (in the collection of Mr. Naylor) is the picture
which Turner temporarily obliterated out of consideration for Lawrence (see Vol. XII.
p. 131); with regard to 6, no oil picture of this subject is known to the editors—the
reference is probably to the drawing in the *Rivers of France* series, No. 158 in the
National Gallery ; 7 is No. 524 in the National Gallery (see below, p. 167, and above,
§ 32).]
[2] [See Vol. XII. p. 373, for this picture.]
[3] [This picture was exhibited at the Academy in 1818. It was included in the
collection of Farnley Turners exhibited in London in 1902. Ruskin's note upon
it, when he visited Farnley in 1851 (see Vol. XII. p. liv.) was as follows :—
"Dort. Large oil. Dated 1818. Very fine in distant effect—but a
mere amplification of Cuyp : the boat with figures almost copied from
him. But the water, much more detailed, is not at all as like water as
Cuyp's : there are far more streaks and spots on it than can properly be

the two may be considered as the principal symbols, in Turner's early oil paintings, of his two strengths in Terror and Repose.

41. Among his drawings, shipping, as the principal subject, does not always constitute a work of the first class; nor does it so often occur. For the difficulty, in a drawing, of getting good colour is so much less, and that of getting good form so much greater, than in oil, that Turner naturally threw his elaborate studies of ship form into oil, and made his noblest work in drawing rich in hues of landscape. Yet the Cowes, Devonport, and Gosport, from the England and Wales (the Saltash is an inferior work) united with two drawings of this series, Portsmouth and Sheerness, and two from Farnley, one of the wreck of an Indiaman, and the other of a ship of the line taking [in] stores,[1] would form a series, not indeed as attractive at first sight as many others, but embracing perhaps more of Turner's peculiar, unexampled, and unapproachable gifts than any other group of drawings which could be selected, the choice being confined to one class of subject.

42. I have only to state, in conclusion, that these twelve drawings of the Harbours of England are more representable by engraving than most of his works. Few parts of them are brilliant in colour; they were executed chiefly in brown and blue, and with more direct reference to the future engraving than was common with Turner. They are also small in size, generally of the exact dimensions of the plate, and therefore the lines of the compositions are not spoiled by contraction; while finally, the

accounted for, the eye is drawn entirely to the surface, and it looks like wet sand—no depth in it nor repose. I never saw any of his work with so little variety of tone in it as this; or so thoroughly ill painted. The distant city and boats are all drawn in a heavy brown and grey—quite cold and uninteresting. The sky is the best part of the picture, but there is a straggly and artificial look in its upper clouds, quite unusual with Turner. His name and the date are written on a log at the right-hand corner, and reflected in the water."]

[1] [For the Cowes, Devonport, Gosport, and Saltash, see *Modern Painters*, vol. i. (Vol. III. pp. 547, 549; p. 545; p. 409; p. 542). The Gosport was in Ruskin's collection: see below, p. 439. For the "Ship of the Line taking in Stores," see Vol. XII. p. 386, and Plate xxi.]

touch of the painter's hand upon the wave-surface is far
better imitated by mezzotint engraving than by any of the
ordinary expedients of line. Take them all in all, they
form the most valuable series of marine studies which have
as yet been published from his works; and I hope that
they may be of some use hereafter in recalling the ordinary
aspect of our English seas, at the exact period when the
nation had done its utmost in the wooden and woven
strength of ships, and had most perfectly fulfilled the old
and noble prophecy—

> " They shall ride,
> Over ocean wide,
> With hempen bridle, and horse of tree."
> —*Thomas of Ercildoune.*[1]

[1] [Compare *Academy Notes*, 1859, under No. 369 (Vol. XIV.), where the last line
is quoted again, of Mr. Hook's " Luff, Boy !"; also *Queen of the Air*, § 39, where the
lines of this " Merlin prophecy " are again quoted.]

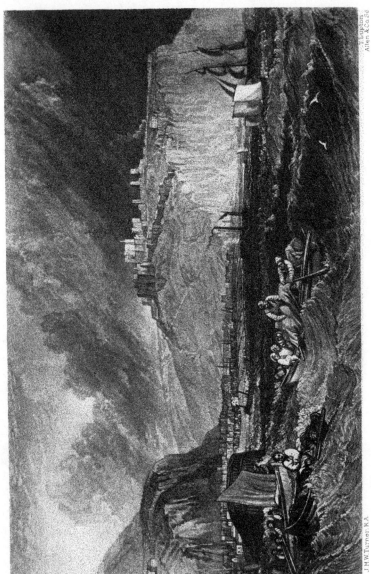

J.M.W.Turner. R.A.

Thurston
Allen & Co. Sc

I.—DOVER[1]

THIS port has some right to take precedence of others, as being. that assuredly which first exercises the hospitality of England to the majority of strangers who set foot on her shores. I place it first therefore among our present subjects; though the drawing itself, and chiefly on account of its manifestation of Turner's faulty habit of local exaggeration, deserves no such pre-eminence. He always painted, not the place itself, but his impression of it, and this on steady principle; leaving to inferior artists the task of topographical detail; and he was right in this principle, as I have shown elsewhere,[2] when the impression was a genuine one; but in the present case it is not so. He has lost the real character of Dover Cliffs by making the town at their feet three times lower in proportionate height than it really is; nor is he to be justified in giving the barracks, which appear on the left hand, more the air of a hospice on the top of an Alpine precipice, than of an establishment which, out of Snargate street, can be reached, without drawing breath, by a winding stair of some 170 steps; making the slope beside them more like the side of Skiddaw than what it really is, the earthwork of an unimportant battery.

This design is also remarkable as an instance of that restlessness which was above noticed[3] even in Turner's least stormy seas. There is nothing tremendous here in scale of wave, but the whole surface is fretted and disquieted by torturing wind; an effect which was always increased during the progress of the subjects, by Turner's habit of

plate
below. The plate was first published in
[2] [See *Modern Painters*, vol. iv. ch. ii. (Vol. VI. pp. 27-47).]
[3] [See p. 44.]

51

scratching out small sparkling lights, in order to make the plate "bright," or "lively."* In a general way the engravers used to like this, and, as far as they were able, would tempt Turner farther into the practice, which was precisely equivalent to that of supplying the place of healthy and heart-whole cheerfulness by dram-drinking.

The two seagulls in the front of the picture were additions of this kind, and are very injurious, confusing the organisation and concealing the power of the sea. The merits of the drawing are, however, still great as a piece of composition. The left-hand side is most interesting, and characteristic of Turner: no other artist would have put the round pier so exactly under the round cliff. It is under it so accurately, that if the nearly vertical falling line of that cliff be continued, it strikes the sea-base of the pier to a hair's breadth. But Turner knew better than any man the value of echo, as well as of contrast,— of repetition, as well as of opposition.[1] The round pier repeats the line of the main cliff, and then the sail repeats the diagonal shadow which crosses it, and emerges above it just as the embankment does above the cliff brow. Lower, come the opposing curves in the two boats, the whole forming one group of sequent lines up the whole side of the picture. The rest of the composition is more commonplace than is usual with the great master; but there are beautiful transitions of light and shade between the sails of the little fishing-boat, the brig behind her, and the cliffs. Note how dexterously the two front sails † of the brig are brought on the top of the white sail of the fishing-boat to help to detach it from the white cliffs.

* See the farther explanation of this practice in the notice of the subject of "Portsmouth" [p. 64].

† I think I shall be generally more intelligible by explaining what I mean in this way, and run less chance of making myself ridiculous in the eyes of sensible people, than by displaying the very small nautical knowledge I possess. My sailor friends will perhaps be gracious enough to believe that I *could* call these sails by their right names if I liked.

[1] [On echo, or repetition, in composition, see also *Elements of Drawing*, §§ 197–199.]

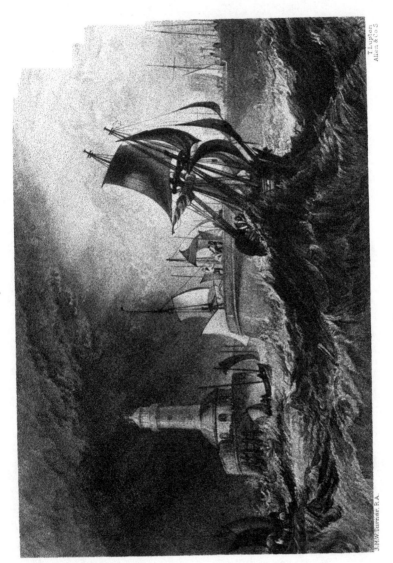

J.M.W. Turner. R.A.

T. Lupton
Allen & Co. S.

Ramsgate.

II.—RAMSGATE [1]

THIS, though less attractive, at first sight, than the former plate, is a better example of the master, and far truer and nobler as a piece of thought. The lifting of the brig on the wave is very daring; just one of the things which is seen in every gale, but which no other painter than Turner ever represented; and the lurid transparency of the dark sky, and wild expression of wind in the fluttering of the falling sails of the vessel running into the harbour, are as fine as anything of the kind he has done. There is great grace in the drawing of this latter vessel: note the delicate switch forward of her upper mast.

There is a very singular point connected with the composition of this drawing, proving it (as from internal evidence was most likely) to be a record of a thing actually seen. Three years before the date of this engraving Turner had made a drawing of Ramsgate for the Southern Coast series. That drawing represents the *same day*, the *same moment*, and the *same ships*, from a different point of view. It supposes the spectator placed in a boat some distance out at sea, beyond the fishing-boats on the left in the present plate, and looking towards the town, or into the harbour. The brig, which is near us here, is then, of course, in the distance on the right; the schooner entering the harbour, and, in both plates, lowering her fore-topsail, is, of course, seen foreshortened; the fishing-boats only are a little different in position and set of sail. The sky is precisely the same, only a dark piece of it, which is too far to the right to be included in *this* view, enters into the wider

[1] [The drawing for this plate is No. 377 in the National Gallery. The plate was first published in *The Ports of England* in 1827 ; the Ramsgate in the *Southern Coast* was in No. 13 of that work (1824). The drawing was sold at Christie's in 1875.]

distance of the other, and the town, of course, becomes a more important object.

The persistence in one conception furnishes evidence of the very highest imaginative power. On a common mind, what it has seen is so feebly impressed, that it mixes other ideas with it immediately; forgets it—modifies it—adorns it,—does anything but keep *hold* of it. But when Turner had once seén that stormy hour at Ramsgate harbour-mouth, he never quitted his grasp of it. He had *seen* the two vessels; one go in, the other out. He could have only seen them at that one moment—from one point; but the impression on his imagination is so strong, that he is able to handle it three years afterwards, as if it were a real thing, and turn it round on the table of his brain, and look at it from the other corner. He will see the brig near, instead of far off: set the whole sea and sky so many points round to the south, and see how they look, so. I never traced power of this kind in any other man.[1]

[1] [This aspect of Turner's genius is treated also by Ruskin in *Pre-Raphaelitism* (Vol. XII. pp. 379–384), and *Modern Painters*, vol. iv. (Vol. VI. p. 41); and on Turner's "reminiscences," see below, under "Margate" and "Portsmouth," pp. 61, 63.]

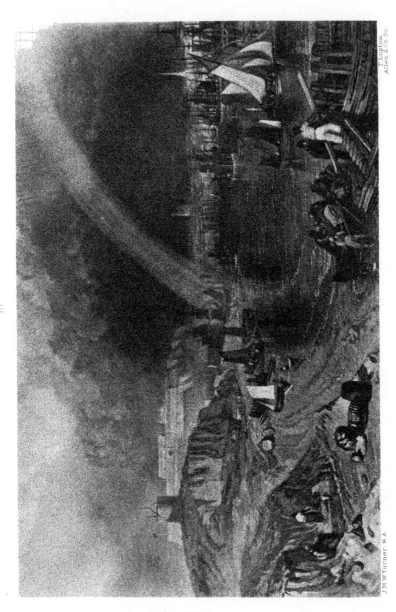

J.M.W.Turner, R.A

T.Lupton
Allen & Co. Sc.

Pl mouth

III.—PLYMOUTH [1]

THE drawing for this plate is one of Turner's most remarkable, though not most meritorious, works: it contains the brightest rainbow he ever painted, to my knowledge; not the best, but the most dazzling. It has been much modified in the plate. It is very like one of Turner's pieces of caprice to introduce a rainbow at all as a principal feature in such a scene; for it is not through the colours of the iris that we generally expect to be shown eighteen-pounder batteries and ninety-gun ships.

Whether he meant the dark cloud (intensely dark blue in the original drawing), with the sunshine pursuing it back into distance; and the rainbow, with its base set on a ship of battle, to be together types of war and peace, and of the one as the foundation of the other, I leave it to the reader to decide. My own impression is, that although Turner might have some askance symbolism in his mind, the present design is, like the former one, in many points a simple reminiscence of a seen fact.*

However, whether reminiscent or symbolic, the design is, to my mind, an exceedingly unsatisfactory one, owing to its total want of principal subject. The fort ceases to be of

* I have discovered, since this was written, that the design was made from a vigorous and interesting sketch by Mr. S. Cousins, in which the rainbow and most of the ships are already in their places. Turner was, therefore, in this case, as I have found him in several other instances, realising, not a fact seen by himself, but a fact as he supposed it to have been seen by another.[2]

[1] [The drawing for this plate is in the collection of Mrs. Ruston, of Lincoln.]

[2] [See above, p. 42. Lupton in the letter cited below (p. 68 n.) wrote: "The very beautiful drawing of Plymouth with the rainbow was made from a finished sketch of the place by Mr. Samuel Cousins, R.A., whose sketch-book I lent Mr. Turner for that purpose."]

importance because of the bank and tower in front of it; the ships, necessarily for the effect, but fatally for themselves, are confused, and incompletely drawn, except the little sloop, which looks paltry and like a toy; and the foreground objects are, for work of Turner, curiously ungraceful and uninteresting.

It is possible, however, that to some minds the fresh and dewy space of darkness, so animated with latent human power, may give a sensation of great pleasure, and at all events the design is worth study on account of its very strangeness.

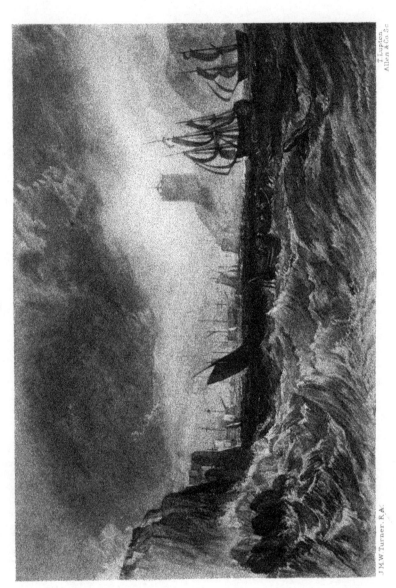

IV:—CATWATER[1]

I HAVE placed in the middle of the series those pictures which I think least interesting, though the want of interest is owing more to the monotony of their character than to any real deficiency in their subjects. If, after contemplating paintings of arid deserts or glowing sunsets, we had come suddenly upon this breezy entrance to the crowded cove of Plymouth, it would have gladdened our hearts to purpose; but having already been at sea for some time, there is little in this drawing to produce renewal of pleasurable impression: only one useful thought may be gathered from the very feeling of monotony. At the time when Turner executed these drawings, his portfolios were full of the most magnificent subjects—coast and inland,—gathered from all the noblest scenery of France and Italy. He was ready to realise these sketches for any one who would have asked it of him, but no consistent effort was ever made to call forth his powers; and the only means by which it was thought that the public patronage could be secured for a work of this kind, was by keeping familiar names before the eye, and awakening the so-called "patriotic," but in reality narrow and selfish, associations belonging to well-known towns or watering-places. It is to be hoped, that when a great landscape painter appears among us again, we may know better how to employ him, and set him to paint for us things which are less easily seen, and which are somewhat better worth seeing, than the mists of the Catwater, or terraces of Margate.

[1] [The drawing for this plate is in the collection of Mr. Ralph Brocklebank.]

V.—SHEERNESS [1]

I LOOK upon this as one of the noblest sea-pieces which Turner ever produced. It has not his usual fault of over-crowding or over - glitter; the objects in it are few and noble, and the space infinite. The sky is quite one of his best: not violently black, but full of gloom and power; the complicated roundings of its volumes behind the sloop's mast, and downwards to the left, have been rendered by the engraver with notable success; and the dim light entering along the horizon, full of rain, behind the ship of war, is true and grand in the highest degree. By comparing it with the extreme darkness of the skies in the Plymouth, Dover, and Ramsgate, the reader will see how much more majesty there is in moderation than in extravagance, and how much more darkness, as far as sky is concerned, there is in grey than in black. It is not that the Plymouth and Dover skies are false,—such impenetrable forms of thunder-cloud are amongst the commonest phenomena of storm; but they have more of spent flash and past shower in them than the less passionate, but more truly stormy and threatening, volumes of the sky here. The Plymouth storm will very thoroughly wet the sails, and wash the decks, of the ships at anchor, but will send nothing to the bottom. For these pale and lurid masses, there is no saying what evil they may have in their thoughts, or what they may have to answer for before night. The ship of war in the distance is one of many instances of Turner's dislike to draw *complete* rigging; and this not only because he chose to give an idea of his ships having seen rough service, and being crippled; but also because in men-of-war he liked

[1] [The drawing for this plate (first published in *The Ports of England* in 1828) is No. 380 in the National Gallery.]

58

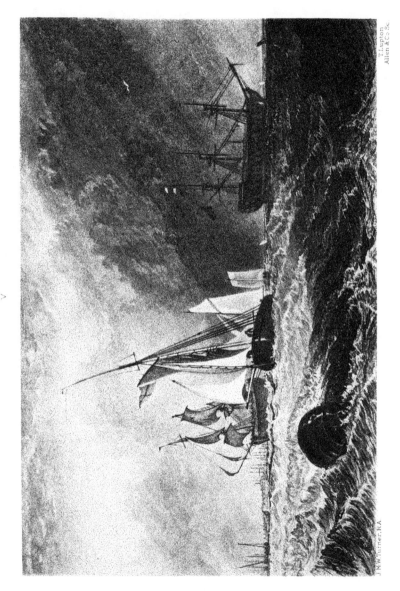

J.M.W.Turner, R.A.

T.Lupton
Allen &Co.Sc.

Sheerness

the mass of the hull to be increased in apparent weight and
size by want of upper spars. All artists of any rank share
this last feeling. Stanfield never makes a careful study of
a hull without shaking some or all of its masts out of it
first, if possible. See, in the Coast Scenery, Portsmouth
harbour, Falmouth, Hamoaze, and Rye old harbour;[1] and
compare, among Turner's works, the near hulls in the
Devonport, Saltash, and Castle Upnor, and distance of
Gosport.[2] The fact is, partly that the precision of line in
the complete spars of a man-of-war is too formal to come
well into pictorial arrangements, and partly that the chief
glory of a ship of the line is in its aspect of being "one
that hath had losses."[3]

The subtle varieties of curve in the drawing of the sails
of the near sloop are altogether exquisite; as well as the
contrast of her black and glistering side with those sails,
and with the sea. Examine the wayward and delicate play
of the dancing waves along her flank, and between her and
the brig in ballast, plunging slowly before the wind; I
have not often seen anything so perfect in fancy, or in
execution of engraving.

The heaving and black buoy in the near sea is one of
Turner's "echoes," repeating, with slight change, the head
of the sloop with its flash of lustre. The chief aim of this
buoy is, however, to give comparative lightness to the
shadowed part of the sea, which is, indeed, somewhat over-
charged in darkness, and would have been felt to be so,
but for this contrasting mass. Hide it with the hand, and
this will be immediately felt. There is only one other of
Turner's works which, in its way, can be matched with this
drawing, namely, the Mouth of the Humber in the River
Scenery.[4] The latter is, on the whole, the finer picture; but
this by much the more interesting in the shipping.

[1] [Plates, Nos. 15, 1, 22 and 24 in Stanfield's *Coast Scenery*, 1836.]
[2] [For the Devonport and Gosport (in Ruskin's collection), see below, pp. 438,
439; for other references to Saltash and Castle Upnor, see Vol. III. p. 542.]
[3] [*Much Ado about Nothing*, iv. 2.]
[4] [See above, p. 9 n.; the drawing is in the National Gallery, No. 378 : see below,
p. 383.]

VI.—MARGATE [1]

This plate is not, at first sight, one of the most striking of the series; but it is very beautiful, and highly characteristic of Turner.* First, in its choice of subjects: for it seems very notably capricious in a painter eminently capable of rendering scenes of sublimity and mystery, to devote himself to the delineation of one of the most prosaic of English watering-places—not once or twice, but in a series of elaborate drawings, of which this is the fourth. The first appeared in the Southern Coast series, and was followed by an elaborate drawing on a large scale, with a beautiful sunrise; then came another careful and very beautiful drawing in the England and Wales series; and finally this, which is a sort of poetical abstract of the first. Now, if we enumerate the English ports one by one, from Berwick to Whitehaven, round the island, there will hardly be found another so utterly devoid of all picturesque or romantic interest as Margate. Nearly all have some steep eminence of down or cliff, some pretty retiring dingle, some roughness of old harbour or straggling fisher-hamlet, some fragment of castle or abbey on the heights above, capable of becoming a leading point in a picture; but Margate is simply a mass of modern parades and streets,

* It was left unfinished at his death, and I would not allow it to be touched afterwards, desiring that the series should remain as far as possible in an authentic state.

[1] [The drawing for this plate is, by Ruskin's gift, in the University Galleries at Oxford : see p. 559. Another drawing of Margate was engraved in No. 12 of the *Southern Coast* published in 1824, but drawn about 1822. The "elaborate drawing" (16¾ × 25½) is signed in the same year ; it was originally in the Windus Collection, and is now in the possession of Mrs. Fordham. The one in *England and Wales* appeared in No. 14 (1832). It was drawn about 1830, and is now in Lord Northbourne's collection. For Turner's later sketches at Margate, see below, p. 470.]

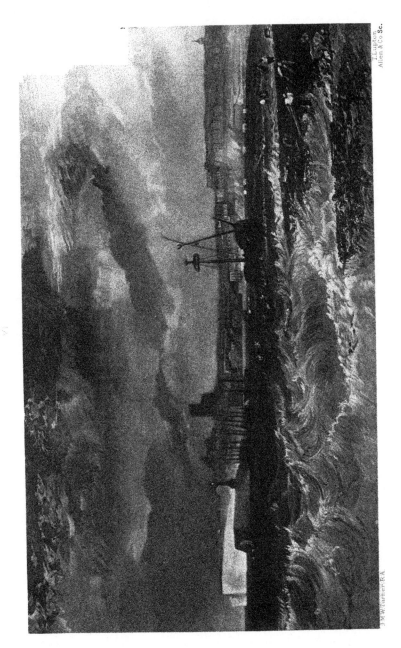

ate

with a little bit of chalk cliff, an orderly pier, and some bathing-machines. Turner never conceives it as anything else; and yet for the sake of this simple vision, again and again he quits all higher thoughts. The beautiful bays of Northern Devon and Cornwall he never painted but once, and that very imperfectly. The finest subjects of the Southern Coast series—the Minehead, Clovelly, Ilfracombe, Watchet, East and West Looe, Tintagel, Boscastle—he never touched again; but he repeated Ramsgate, Deal, Dover, and Margate, I know not how often.

Whether his desire for popularity, which, in spite of his occasional rough defiances of public opinion, was always great, led him to the selection of those subjects which he thought might meet with most acceptance from a large class of the London public, or whether he had himself more pleasurable associations connected with these places than with others, I know not; but the fact of the choice itself is a very mournful one, considered with respect to the future interests of art. There is only this one point to be remembered, as tending to lessen our regret, that it is possible Turner might have felt the necessity of compelling himself sometimes to dwell on the most familiar and prosaic scenery, in order to prevent his becoming so much accustomed to that of a higher class as to diminish his enthusiasm in its presence. Into this probability I shall have occasion to examine at greater length hereafter.

painfully to their natural formality. It is certainly provok-
ing to find the great painter, who often only deigns to be-
stow on some Rhenish fortress or French city, crested with
Gothic towers, a few misty and indistinguishable touches of
his brush, setting himself to indicate, with unerring toil,
every separate square window in the parades, hotels, and
circulating libraries of an English bathing-place.

The whole of the drawing is well executed, and free
from fault or affectation except perhaps in the somewhat
confused curlings of the near sea. I had much rather have
seen it breaking in the usual straightforward way. The
brilliant white of the piece of chalk cliff is evidently one of
the principal aims of the composition. In the drawing the
sea is throughout of a dark fresh blue, the sky greyish blue,
and the grass on the top of the cliffs a little sunburnt, the
cliffs themselves being left in the almost untouched white
of the paper.

VII

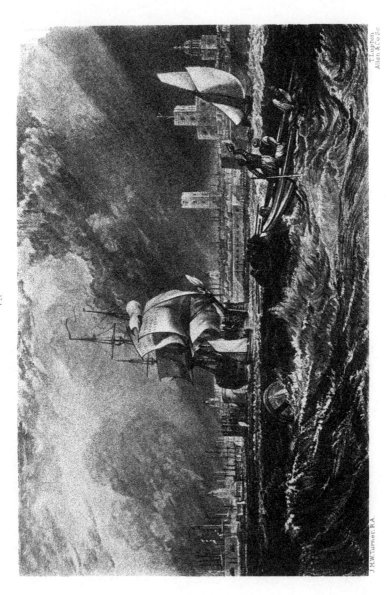

J.M.W.Turner. R.A.

T.Lupton.
Allen & Co Sc

Portsmouth

VII.—PORTSMOUTH [1]

THIS beautiful drawing is a *third* recurrence by Turner to his earliest impression of Portsmouth, given in the Southern Coast series. The buildings introduced differ only by a slight turn of the spectator towards the right; the buoy is in the same spot; the man-of-war's boat nearly so; the sloop exactly so, but on a different tack; and the man-of-war, which is far off to the left at anchor in the Southern Coast view, is here nearer, and getting up her anchor.

The idea had previously passed through one phase of greater change, in his drawing of "Gosport" for the England, in which, while the sky of the Southern Coast view was almost cloud for cloud retained, the interest of the distant ships of the line had been divided with a collier brig and a fast-sailing boat. In the present view he returns to his early thought, dwelling, however, now with chief insistence on the ship of the line, which is certainly the most majestic of all that he has introduced in his drawings.

It is also a very curious instance of that habit of Turner's before referred to (p. 42), of never painting a ship quite in good order. On showing this plate the other day to a naval officer, he complained of it, first that "the jib * would not be wanted with the wind blowing out of harbour," and, secondly, that "a man-of-war would never have her foretop-gallant sail set, and her main and mizen topgallants furled:—all the men would be on the yards at once."

* The sail seen, edge on, like a white sword, at the head of the ship.

[1] [The drawing for this plate (first published in *The Ports of England* in 1828) is No. 379 in the National Gallery. The Portsmouth in the *Southern Coast* appears in No. 15 (1826); it is now in the collection of Mr. F. Stevenson; the Gosport in *England and Wales* was in No 11 (1831).]

I believe this criticism to be perfectly just, though
it has happened to me, very singularly, whenever I have
had the opportunity of making complete inquiry into any
technical matter of this kind, respecting which some pro-
fessional person had blamed Turner, that I have always
found, in the end, Turner was right, and the professional
critic wrong, owing to some want of allowance for possible
accidents, and for necessary modes of pictorial representa-
tion. Still, this cannot be the case in every instance ; and
supposing my sailor informant to be perfectly right in the
present one, the disorderliness of the way in which this ship
is represented as setting her sails, gives us farther proof
of the imperative instinct in the artist's mind, refusing to
contemplate a ship, even in her proudest moments, but as
in some way overmastered by the strengths of chance and
storm.

The wave on the left hand beneath the buoy, presents
a most interesting example of the way in which Turner
used to spoil his work by retouching. All his truly fine
drawings are either done quickly, or at all events straight
forward, without alteration: he never, as far as I have ex-
amined his works hitherto, altered but to destroy. When
he saw a plate look somewhat dead or heavy, as, compared
with the drawing, it was almost sure at first to do, he used
to scratch out little lights all over it, and make it "spark-
ling"[1]; a process in which the engravers almost unanimously
delighted,* and over the impossibility of which they now
mourn, declaring it to be hopeless to engrave after Turner,
since he cannot now scratch their plates for them. It is
quite true that these small lights were always placed beauti-
fully; and though the plate, after its "touching," generally

* Not, let me say with all due honour to him, the careful and skilful
engraver of these plates, who has been much more tormented than helped
by Turner's alterations.[2]

[1] [Compare below, p. 531.]
[2] [For a lively account of Lupton's sufferings in this respect, see Thornbury's
Life, pp. 196–198, ed. 1877.]

looked as if ingeniously salted out of her dredging-box by an artistical cook, the salting was done with a spirit which no one else can now imitate. But the original power of the work was for ever destroyed. If the reader will look carefully beneath the white touches on the left in this sea, he will discern dimly the form of a round nodding hollow breaker. This in the early state of the plate is a gaunt, dark, angry wave, rising at the shoal indicated by the buoy—Mr. Lupton has fac-similed with so singular skill the scratches of the penknife by which Turner afterwards disguised this breaker, and spoiled his picture, that the plate in its present state is almost as interesting as the touched proof itself; interesting, however, only as a warning to all artists never to lose hold of their first conception. They may tire even of what is exquisitely right, as they work it out, and their only safety is in the self-denial of calm completion.

VIII.—FALMOUTH [1]

THIS is one of the most beautiful and best-finished plates of the series, and Turner has taken great pains with the drawing; but it is sadly open to the same charges which were brought against the Dover, of an attempt to reach a false sublimity by magnifying things in themselves insignificant. The fact is that Turner, when he prepared these drawings, had been newly inspired by the scenery of the Continent; and with his mind entirely occupied by the ruined towers of the Rhine, he found himself called upon to return to the formal embrasures and unappalling elevations of English forts and hills. [2] But it was impossible for him to recover the simplicity and narrowness of conception in which he had executed the drawings of the Southern Coast, or to regain the innocence of delight with which he had once assisted gravely at the drying of clothes over the limekiln at Combe Martin, or pencilled the woodland outlines of the banks of Dartmouth Cove. [3] In certain fits of prosaic humourism, he would, as we have seen, condemn himself to delineation of the parades of a watering-place; but the moment he permitted himself to be enthusiastic, vaster imaginations crowded in upon him: to modify his old conception in the least, was to exaggerate it; the mount of Pendennis is lifted into rivalship with Ehrenbreitstein, and hardworked Falmouth glitters along

[1] [The drawing for this plate is in the collection of Mrs. Newall.]
[2] [Compare *Pre-Raphaelitism* (Vol. XII. pp. 376–377).]
[3] [Combe Martin was in No. 14 of the *Southern Coast* (1825). The drawing is now, by Ruskin's gift, in the University Galleries at Oxford: see below, p. 560. Dartmouth Cove was in No. 1 of *England and Wales* (1827); the drawing is in the collection of Mr. Holbrook Gaskell.]

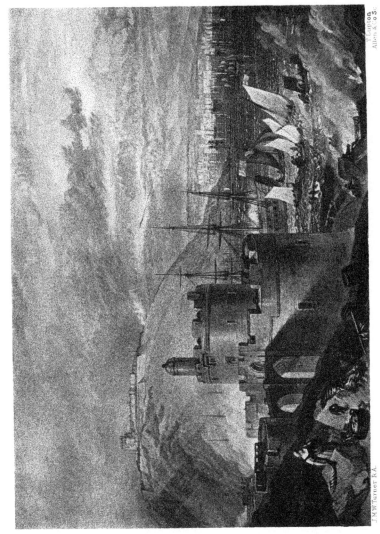

VII

J.M.W.Turner R.A.

T.Lupton
Allen & Co S.

Falmouth

the distant bay, like the gay magnificence of Resina or Sorrento.[1]

This effort at sublimity is all the more to be regretted, because it never succeeds completely. Shade, or magnify, or mystify as he may, even Turner cannot make the minute neatness of the English fort appeal to us as forcibly as the remnants of Gothic wall and tower that crown the Continental crags; and invest them as he may with smoke or sunbeam, the details of our little mounded hills will not take the rank of cliffs of Alp, or promontories of Apennine; and we lose the English simplicity, without gaining the Continental nobleness.

I have also a prejudice against this picture for being disagreeably noisy. Wherever there is something serious to be done, as in a battle piece, the noise becomes an element of the sublimity; but to have great guns going off in every direction beneath one's feet on the right, and all round the other side of the castle, and from the deck of the ship of the line, and from the battery far down the cove, and from the fort on the top of the hill, and all for nothing, is to my mind eminently troublesome.

The drawing of the different wreaths and depths of smoke, and the explosive look of the flash on the right, are, however, very wonderful and peculiarly Turneresque; the sky is also beautiful in form, and the foreground, in which we find his old regard for washerwomen[2] has not quite deserted him, singularly skilful. It is curious how formal the whole picture becomes if this figure and the grey stones beside it are hidden with the hand.

IX.—SIDMOUTH [1]

THIS drawing has always been interesting to me among Turner's sea pieces, on account of the noble gathering together of the great wave on the left,—the back of a breaker, just heaving itself up, and provoking itself into passion, before its leap and roar against the beach. But the enjoyment of these designs is much interfered with by their monotony: it is seriously to be regretted that in all but one the view is taken from the sea; for the spectator is necessarily tired by the perpetual rush and sparkle of water, and ceases to be impressed by it. It would be felt, if this plate were seen alone, that there are few marine paintings in which the weight and heaping of the sea are given so faithfully.

For the rest it is perhaps more to be regretted that we are kept to our sea-level at Sidmouth than at any other of the localities illustrated. What claim the pretty little village has to be considered as a port of England, I know not; but if it was to be so ranked, a far more interesting study of it might have been made from the heights above the town, whence the ranges of dark-red sandstone cliffs stretching to the south-west are singularly bold and varied. The detached fragment of sandstone which forms the principal object in Turner's view has long ago fallen, and even while it stood could hardly have been worth the honour of so careful illustration.

[1] [The drawing for this plate was at Agnew's Gallery in 1892 (formerly in the Bolckow Collection). The drawing was, however, afterwards altered, as appears from a letter to Ruskin from Lupton, who wrote (May 30, 1855) : "The drawing of Sidmouth was selected by Mr. Turner. I confess to you I thought it was unsatisfactory as a view at the time, and I obtained from a young artist residing there a sketch of the place which I afterwards showed to Mr. Turner, and from which he materially altered his original drawing." Ruskin was probably at Sidmouth in 1839.]

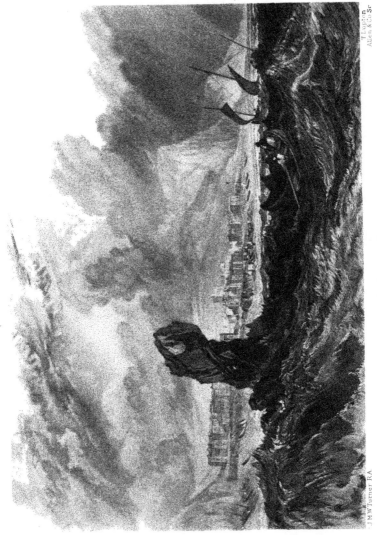

J.M.W.Turner R.A.

T.Lupton
Allen & Co Sr

Sidmouth

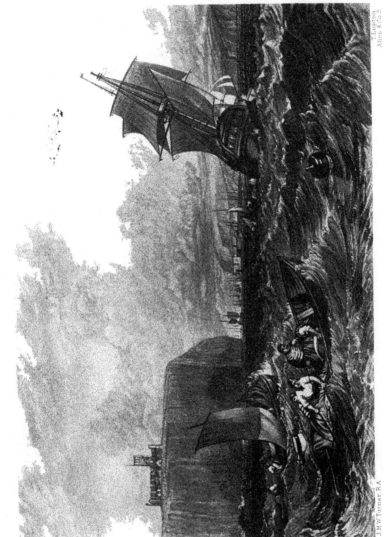

J.M.W.Turner. R.A.

T.Lupton
Alice R.G.S.

Whitby

As an expression of the general spirit of English coast
scenery, this plate must be considered the principal one of
the series. Like all the rest, it is a little too grand for its
subject; but the exaggerations of space and size are more
allowable here than in the others, as partly necessary to
convey the feeling of danger conquered by activity and com-
merce, which characterises all our northerly Eastern coast.
There are cliffs more terrible, and winds more wild, on other
shores; but nowhere else do so many white sails lean against
the bleak wind, and glide across the cliff shadows. Nor do
I know many other memorials of monastic life so striking
as the abbey on that dark headland. We are apt in our
journeys through lowland England, to watch with some
secret contempt the general pleasantness of the vales in
which our abbeys were founded, without taking any pains
to inquire into the particular circumstances which directed
or compelled the choice of the monks, and without reflect-
ing that, if the choice were a selfish one, the selfishness is
that of the English lowlander turning monk, not that of
monachism; since, if we examine the sites of the Swiss
monasteries and convents, we shall always find the snow
lying round them in July; and it must have been cold
meditating in these cloisters of St. Hilda's when the winter
wind set from the east. It is long since I was at Whitby,[2]
and I am not sure whether Turner is right in giving so
monotonous and severe verticality to the cliff above which

the abbey stands; but I believe it must have some steep places about it, since the tradition which, in nearly all parts of the island where fossil ammonites are found, is sure to be current respecting them, takes quite an original form at Whitby, owing to the steepness of this rock. In general, the saint of the locality has simply turned all the serpents to stone; but at Whitby, St. Hilda drove them over the cliff, and the serpents, before being petrified, had all their heads broken off by the fall!

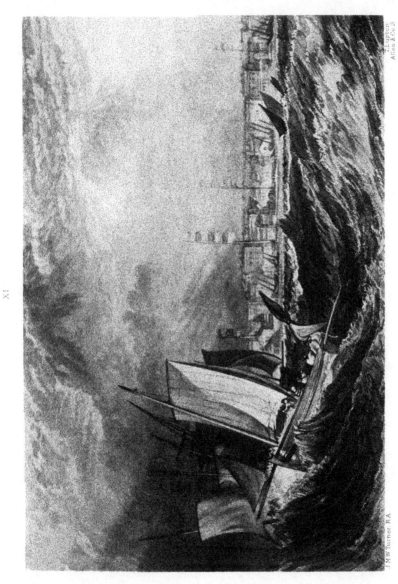

XI

J.M.W.Turner. R.A.

J.Lupton
Allen & Co. 5

Deal

XI.—DEAL[1]

I HAVE had occasion,* elsewhere, to consider at some length, the peculiar love of the English for neatness and minuteness: but I have only considered, without accounting for, or coming to any conclusion about it; and, the more I think of it, the more it puzzles me to understand what there can be in our great national mind which delights to such an extent in brass plates, red bricks, square kerbstones, and fresh green paint, all on the tiniest possible scale. The other day I was dining in a respectable English "Inn and Posting-house," not ten miles from London, and, measuring the room after dinner, I found it exactly twice and a quarter the height of my umbrella. It was a highly comfortable room, and associated, in the proper English manner, with outdoor sports and pastimes, by a portrait of Jack Hall, fisherman of Eton, and of Mr. C. Davis on his favourite mare; but why all this hunting and fishing enthusiasm should like to reduce itself, at home, into twice and a quarter the height of an umbrella, I could not in any wise then, nor have I at any other time been able to ascertain.

Perhaps the town of Deal involves as much of this question in its aspect and reputation, as any other place in Her Majesty's dominions: or at least it seemed so to me, coming to it as I did,[2] after having been accustomed to the boat-life at Venice, where the heavy craft, massy in build and massy in sail, and disorderly in aquatic economy, reach with their mast-vanes only to the first

* *Modern Painters,* vol. iv. chap. i.

[1] [The drawing for this plate was formerly in the Leyland Collection.]
[2] [For Ruskin's sojourn at Deal, see above, p. xix.]

71

stories of the huge marble palaces they anchor among. It was very strange to me, after this, knowing that whatever was brave and strong in the English sailor was concentrated in our Deal boatmen, to walk along that trim strip of conventional beach, which the sea itself seems to wash in a methodical manner, one shingle-step at a time; and by its thin toy-like boats, each with its head to sea, at regular intervals, looking like things that one would give a clever boy to play with in a pond, when first he got past petticoats; and the row of lath cots behind, all tidiness and telegraph, looking as if the whole business of the human race on earth was to know what o'clock it was, and when it would be high water,—only some slight weakness in favour of grog being indicated here and there by a hospitable-looking open door, a gay bow-window, and a sign intimating that it is a sailor's duty to be not only accurate, but "jolly."

Turner was always fond of this neat, courageous, benevolent, merry, methodical Deal. He painted it very early, in the Southern Coast series,[1] insisting on one of the tavern windows as the principal subject, with a flash of forked lightning streaming beyond it out at sea like a narrow flag. He has the same association in his mind in the present plate; disorder and distress among the ships on the left, with the boat going out to help them; and the precision of the little town stretching in sunshine along the beach.

[1] [The plate was published in No. 15 of that work, 1826.]

XII

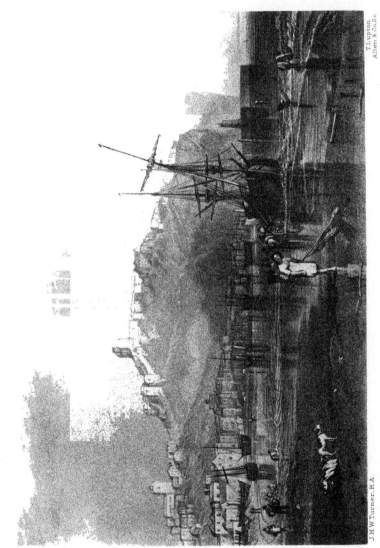

J.M.W.Turner, R.A.

Scarborough

T. Lupton.
Allen & Co. Sc.

XII.—SCARBOROUGH[1]

I HAVE put this plate last in the series, thinking that the reader will be glad to rest in its morning quietness, after so much tossing among the troubled foam. I said in the course of the introduction, that nothing is so perfectly calm as Turner's calmness;[2] and I know very few better examples of this calmness than the plate before us, uniting, as it does, the glittering of the morning clouds, and trembling of the sea, with an infinitude of peace in both. There are one or two points of interest in the artifices by which the intense effect of calm is produced. Much is owing, in the first place, to the amount of absolute gloom obtained by the local blackness of the boats on the beach; like a piece of the midnight left unbroken by the dawn. But more is owing to the treatment of the distant harbour mouth. In general, throughout nature, Reflection and Repetition are *peaceful* things;[3] that is to say, the image of any object, seen in calm water, gives us an impression of quietness, not merely because we know the water must be quiet in order to be reflective; but because the fact of the repetition of this form is lulling to us in its monotony, and associated more or less with an idea of quiet succession, or reproduction, in events or things throughout nature:—that one day should be like another day, one town the image of another town, or one history the repetition of another history, being more or less results of quietness, while dissimilarity and non-succession are also, more or less, results of interference and

[1] [The drawing for this plate (first published in *The Ports of England* in 1826) is No. 169 in the National Gallery.]
[2] [See above, p. 45.]
[3] [Compare *Elements of Drawing*, § 197 ("The Law of Repetition"), where Ruskin quotes this passage and illustrates it further.]

disquietude. And thus, though an echo actually increases the quantity of sound heard, its repetition of the notes or syllables of sound, gives an idea of calmness attainable in no other way; hence the feeling of calm given to a landscape by the notes of the cuckoo. Understanding this, observe the anxious *doubling* of every object by a visible echo or shadow throughout this picture. The grandest feature of it is the steep distant cliff; and therefore the dualism is more marked here than elsewhere; the two promontories or cliffs, and two piers below them, being arranged so that the one looks almost like the shadow of the other, cast irregularly on mist. In all probability, the more distant pier would in reality, unless it is very greatly higher than the near one, have been lowered by perspective so as not to continue in the same longitudinal line at the top, — but Turner will not have it so; he reduces them to exactly the same level, so that the one looks like the phantom of the other; and so of the cliffs above.

Then observe, each pier has, just below the head of it, in a vertical line, another important object, one a buoy, and the other a stooping figure. These carry on the double group in the calmest way, obeying the general law of vertical reflection, and throw down two long shadows on the near beach. The intenseness of the parallelism would catch the eye in a moment, but for the lighthouse, which breaks the group and prevents the artifice from being too open. Next come the two heads of boats, with their two bowsprits, and the two masts of the one farthest off, all monotonously double, but for the diagonal mast of the nearer one, which again hides the artifice. Next, put your finger over the white central figure, and follow the minor incidents round the beach; first, under the lighthouse, a stick, with its echo below a little to the right; above, a black stone, and its echo to the right; under the white figure, another stick, with its echo to the left; then a starfish,* and a white

* I have mentioned elsewhere that Turner was fond of this subject of Scarborough, and that there are four drawings of it by him, if not more,

spot its echo to the left; then a dog, and a basket to double its light; above, a fisherman, and his wife for an echo; above them, two lines of curved shingle; above them, two small black figures; above them, two unfinished ships, and two forked masts; above the forked masts, a house with two gables, and its echo exactly over it in two gables more; next to the right, two fishing-boats with sails down; farther on, two fishing-boats with sails up, each with its little white reflection below; then two larger ships, which, lest his trick should be found out, Turner puts a dim third between; then below, two fat colliers, leaning away from each other, and two thinner colliers, leaning towards each other; and now at last, having doubled everything all round the beach, he gives one strong single stroke to gather all together, places his solitary central white figure, and the Calm is complete.

It is also to be noticed, that not only the definite repetition has a power of expressing serenity, but even the slight sense of *confusion* induced by the continual doubling is useful; it makes us feel not well awake, drowsy, and as if we were out too early, and had to rub our eyes yet a little, before we could make out whether there were really two boats or one.

I do not mean that every means which we may possibly take to enable ourselves to see things double, will be always the most likely to ensure the ultimate tranquillity of the scene, neither that any such artifice as this would be of avail, without the tender and loving drawing of the things themselves, and of the light that bathes them; nevertheless the highest art is full of these little cunnings, and it is only by the help of them that it can succeed in at all equalling the force of the natural impression.

One great monotony, that of the successive sigh and

under different effects, having this much common to the four, that there is always a starfish on the beach.[1]

[1] [See *Pre-Raphaelitism*, Vol. XII. p. 382.]

vanishing of the slow waves upon the sand, no art can render to us. Perhaps the silence of early light, even on the "field dew consecrate"[1] of the grass itself, is not so tender as the lisp of the sweet belled lips of the clear waves in their following patience. We will leave the shore as their silver fringes fade upon it, desiring thus, as far as may be, to remember the sea. We have regarded it perhaps too often as an enemy to be subdued; let us, at least this once, accept from it, and from the soft light beyond the cliffs above, the image of the state of a perfect Human Spirit,—

> " The memory, like a cloudless air,
> The conscience, like a sea at rest."[2]

[1] [*Midsummer Night's Dream*, v. 2. The words are quoted also in *Modern Painters*, vol. iv. (Vol. VI. p. 445).]
[2] [*In Memoriam*, xciv.]

PART II

TURNER'S WORKS AT THE NATIONAL GALLERY

LETTERS TO THE "TIMES" ON THE TURNER BEQUEST

(1856, 1857)

[*Bibliographical Note.*—The first of these letters appeared in the *Times* under the title "Mr. Ruskin on the Turner Bequest"; the second, without a heading (p. 12, col. 2).

The two letters were reprinted in *Arrows of the Chace*, 1880, vol. i. pp. 117–126, the title here given to the second being supplied.

In the first letter there were several slight variations in the reprint. Thus, on page 82, line 6 (as here printed), "neither" was substituted for "not"; line 11, "Rogers' poems" became "Rogers' Poems" (a mistake, for the drawings referred to include the illustrations to the *Italy* as well as to the volume of *Poems*); in line 10 (and so lower down) the numerals of the *Times* were printed in words; line 21, a misprint is corrected in this edition; line 27, "composition" and "outline" were misread for "compositions" and "outlines."]

THE TURNER BEQUEST

To the Editor of the " Times " [1]

[1856]

SIR,—As active measures are being now [2] taken to give
the public access to the pictures and drawings left by the
late Mr. Turner, you will perhaps allow me space in your
columns for a few words respecting them.

I was appointed by Mr. Turner one of his executors.
I examined the will, and the state of the property needing
administration, and, finding that the questions arising out
of the obscurity of the one and the disorder of the other
would be numerous and would involve a kind of business
in which I had no skill or knowledge, I resigned the office; [3]
but in the course of the inquiry I catalogued the most
interesting of the drawings which are now national property,
and respecting these the public will, I think, be glad of
more definite information than they at present possess. [4]
They are referable mainly to three classes.

 1. Finished water-colour drawings.
 2. Studies from nature, or first thoughts for pictures; in
 colour.
 3. Sketches in pencil or pen and ink.

[1] [From the *Times* of October 28, 1856.]
[2] [This refers to the first exhibition of Turner's pictures at Marlborough House, in
November 1856: see above, Introduction, p. xxxii.]
[3] [See above, Introduction, p. xxx.]
[4] [This letter contains only the results of a preliminary examination of the
drawings and sketches: for Ruskin's final report, see below, p. 319.]

The drawings belonging to the two latter classes are in various stages of completion, and would contain, if rightly arranged, a perfect record of the movements of the master's mind during his whole life. Many of them were so confused among prints and waste-paper that I could not collect nor catalogue them all in the time I had at my disposal; some portfolios I was not able even to open. The following statement, therefore, omits mention of many, and I believe even of some large water-colour drawings. There are in the first class 45 drawings of the " Rivers of France "; 57 illustrating Rogers' poems; 23 of the " River Scenery " and " Harbours of England "; 4 marine vignettes; 5 middle-sized drawings (including the beautiful " Ivy Bridge "); and a drawing, some 3 feet by 2, finished with exquisite care, of a scene in the Val d'Aosta; total, 135.

It would occupy too much of your space if I were to specify all the various kinds of studies forming the second class. Many are far carried, and are, to my mind, more precious and lovely than any finished drawings; respecting some, there may be question whether Turner regarded them as finished or not. The larger number are slight[1] sketches, valuable only to artists, or to those interested in the processes of Turner's mind and hand. The total number of those which I catalogued as important is 1,757.

The sketches of the third class are usually more elaborate than the coloured ones. They consist of studies from nature, or for compositions, in firm outlines, usually on gray paper, heightened with white. They include, among other subjects, more or less complete, 50 of the original drawings for the Liber Studiorum, and many of the others are of large folio size. The total of those I consider important is 1,322. Now, the value of these sketches to the public consists[2] greatly, first, in the preservation of each, as far as possible, in the state in which Turner left it; secondly, in their

[1] ["Light" in the *Times* and in *Arrows of the Chace*—an obvious misprint.]
[2] [The total number of drawings of all three classes (of which Ruskin here notes 3214 as important) which are now exhibited in one way or another is not more than 1550: see below, p. 608.]

careful arrangement and explanation; thirdly, in convenience of general access to them. Permit me a word on each of these heads.

Turner was in the habit of using unusual vehicles, and in the coloured studies many hues are wrought out by singular means and with singular delicacy—nearly always in textures which the slightest damp (to which the drawings would necessarily be subjected in the process of mounting) would assuredly alter. I have made many experiments in mounting, putting coloured drawings, of which I had previously examined the tones, into the hands of the best mounters, and I have never yet had a drawing returned to me without alteration. The vast mass of these sketches, and the comparative slightness of many, would but too probably induce a carelessness and generalization in the treatment they might have to undergo, still more fatally detrimental to them.

Secondly, a large number are without names, and so slight that it requires careful examination and somewhat extended acquaintance with Turner's works to ascertain their intention. The sketches of this class are nearly valueless till their meaning is deciphered, but of great interest when seen in their proper connexion. Thus there are three progressive studies for one vignette in Rogers' *Italy* (Hannibal passing the Alps[1]), which I extricated from three several heaps of other mountain sketches with which they had no connexion. Thirdly, a large number of the drawings are executed with body colour, the bloom of which any friction or handling would in a short period destroy. Their delicate tones of colour would be equally destroyed by continuous exposure to the light, or to smoke and dust.

Drawings of a valuable character, when thus destructible, are in European museums hardly accessible to the general public. But there is no need for this seclusion. They should be enclosed each in a light wooden frame, under a

[1] [One of these "progressive studies" is now No. 209 in the National Gallery; the finished vignette being No. 207. Another study is at Oxford : see below, p. 564 (No. 95).]

glass the surface of which a raised mount should prevent
them from touching. These frames should slide into cases,
containing about 12 drawings each, which would be portable
to any part of the room where they were to be seen. I
have long kept my own smaller Turner drawings in this
manner; 15 frames going into the depth of about a foot.
Men are usually accused of " bad taste," if they express any
conviction of their own ability to execute any given work.
But it would perhaps be better if in people's sayings in
general, whether concerning others or themselves, there were
less taste, and more truth; and I think it, under the cir-
cumstances, my duty to state that I believe none would
treat these drawings with more scrupulous care, or arrange
them with greater patience, than I should myself; that I
am ready to undertake the task, and enter upon it instantly;
that I will furnish, in order to prove the working of the
system proposed, 100 of the frames, with their cases, at my
own cost; and that within six weeks of the day on which
I am permitted to begin work, (illness or accident not in-
terfering,) I will have the 100 drawings arranged, framed,
accompanied by a printed explanatory catalogue, and ready
for public inspection.[1] It would then be in the power of
the commissioners entrusted with the administration of this
portion of the national property to decide if any, or how
many more of the sketches, should be exhibited in the same
manner, as a large mass of the less interesting ones might
be kept as the drawings are at the British Museum, and
shown only on special inquiry.

I will only undertake this task on condition of the entire
management of the drawings, in every particular, being en-
trusted to me; but I should ask the advice of Mr. Carpenter,
of the British Museum,[2] on all doubtful points, and entrust
any necessary operations only to the person who mounts the
drawings for the British Museum.

[1] [For this catalogue, see below, pp. 185–226.]
[2] [William Hookham Carpenter, for many years Keeper of the prints and drawings
at the British Museum. He died in 1866.]

I make this offer[1] in your columns rather than privately, first, because I wish it to be clearly known to the public; and also because I have no time to make representations in official ways, the very hours which I could give to the work needing to be redeemed by allowing none to be wasted in formalities.

<div align="right">I am, Sir, your obedient servant,

J. Ruskin.</div>

Denmark Hill, *Oct.* 27.[2]

[1] [For the subsequent history of this offer, see above, Introduction, p. xxxiv.]

[2] [Ruskin followed up this public letter by a private one to the Prime Minister, with whom he had some acquaintance. The latter, which has not hitherto been published, was in the following terms :—

<div align="right">" Denmark Hill, *13th December,* 1856.</div>

"My Lord,—I am little used to the formalities of business, and I pray your pardon if I do wrong in addressing you; but I believe rather that I did wrong some time since in making an offer connected with the public service through an irregular channel. Will you permit me, in as short and few words as I can, to lay it before your Lordship?

"The number of drawings and sketches, by the late J. M. W. Turner, now belonging to the nation, amounts to several—I believe to many—thousands. They were left by him in disorder, and the interest attaching to them depends in great degree on the mode of their arrangement, while farther, there are a large number of them whose subjects are at present unknown, but which, having devoted a great part of my life to inquiries into the mode of Turner's studying from nature, I believe myself to be able, more or less, to elucidate. I am willing to arrange and catalogue these sketches, making the catalogue as far as I can explanatory, and furnishing printed copies of it at my own expense to all public institutions in such number as Her Majesty's Government may judge necessary. I am farther ready to prepare and frame, for exhibition to the public, a hundred of the sketches, at my own cost, in order to show the practical working of the system on which I should wish them to be shown. It would then be in the power of the Government to direct or modify, as they saw good, the carrying out of the system in question, which, as I have already explained it in a letter which the Trustees of the National Gallery honoured me by their permission to lay before them, I will not trouble your Lordship by detailing here.

"This I am ready to do, on condition of having the Curatorship, without salary, of the sketches in question, so that no operation in mounting, framing, or otherwise preparing them for exhibition could take place without my concurrence; my own directions respecting them being subject to the approval of that member of the Government who is responsible for the safety of the National Collection.

"I do not know if your Lordship attaches much importance to statements of *motives:* but, as I have spent great part of my life in endeavours to explain, and to vindicate the value of the works of Turner, I do not think I am deceiving myself, and assuredly I am not endeavouring to deceive *you,* in stating that my motives for making this offer are, first, that I heartily

desire the sketches may be taken care of, and believe I should take more
loving care of them than any one else; secondly, that I desire they should
be useful to the public, and believe I could make them *more* useful by the
way I would arrange them; and lastly, that I should have pleasure in the
work itself. On this last ground I have good hope that the results I should
obtain in a given period would not be less satisfactory than if the work were
entrusted to a salaried officer.

" Finally, as the simplest test of my fitness for the task, I may perhaps
be permitted to refer to the preservation and arrangement of my own col-
lection, now the third in importance among the private Turner collections
of England.

"I am, my Lord,
 "With sincere respect,
 " Your Lordship's humble and obedient servant,
 "JOHN RUSKIN.

" *To* THE LORD VISCOUNT PALMERSTON."]

II

THE TURNER BEQUEST AND THE NATIONAL GALLERY

To the Editor of the " Times" [1]

[1857]

Sir,—I am sorry that accident has prevented my seeing the debate of Friday last [2] on the vote for the National Gallery until to-day. Will you permit me, thus late, to correct the statement made by Lord Elcho, that I offered to arrange Turner's pictures, or could have done so as well as Mr. Wornum? [3] I only offered to arrange the sketches, and that I am doing; but I never would have undertaken the pictures, which were in such a state of decay that I had given up many for lost; while, also, most of them belonged to periods of Turner's work with which I was little acquainted. Mr. Wornum's patience and carefulness of research in discovering their subjects, dates of exhibition, and other points of interest connected with them, have been of the greatest service; and it will be long before the labour and judgment which he has shown in compiling, not only this, but all the various catalogues now used by the public at our galleries, will be at all justly appreciated. I find more real, serviceable, and trustworthy facts in one of these catalogues, than in half a dozen of the common collections of lives of painters. [4]

[1] [From the *Times* of July 9, 1857.]
[2] [July 3, 1857, upon the vote of £23,165 for the National Gallery.]
[3] [Mr. Ralph Nicholson Wornum, who succeeded Mr. Uwins, R.A., as Keeper of the National Gallery in 1855, and retained that office till his death in 1878 : see above, Introduction, p. xxxvii.]
[4] [For a note on Mr. Wornum's Catalogue, see below, p. 95 *n*.]

Permit me to add further, that during long residence in
Venice I have carefully examined the Paul Veronese lately
purchased by the Government.[1] When I last saw it, it
was simply the best Veronese in Italy, if not in Europe,
(the "Marriage in Cana" of the Louvre is larger and more
magnificent, but not so perfect in finish); and, for my own
part, I should think no price too large for it; but putting
my own deep reverence for the painter wholly out of the
question, and considering the matter as it will appear to
most persons at all acquainted with the real character and
range of Venetian work, I believe the market value of the
picture ought to be estimated at perhaps one-third more
than the Government have paid for it. Without doubt the
price of the Murillo lately purchased at Paris was much
enhanced by accidental competition; under ordinary cir-
cumstances, and putting both the pictures to a fair trial of
market value, I believe the Veronese to be worth at least
double the Murillo; in an artistical point of view, the latter
picture could not be put in any kind of comparison what-
ever with the Veronese.

I am, Sir, your obedient servant,

J. RUSKIN.

OXFORD, *July* 7.

[1] ["The Family of Darius at the feet of Alexander after the Battle of Issus,"
purchased at Venice from the Pisani collection in 1857. Lord Elcho (afterwards the
10th Earl of Wemyss) had complained in the course of the debate that the price,
£13,650, paid for this picture, had been excessive; and in reply allusion was made
to the still higher price (£23,000) paid for the "Immaculate Conception" of Murillo,
purchased for the Louvre by Napoleon III., in 1852, from the collection of Marshal
Soult. For other references to the purchase of the great Veronese, see below,
pp. 244, 287, 552.]

II

NOTES ON THE TURNER COLLECTION OF OIL-PICTURES

AT THE NATIONAL GALLERY

(Formerly at Marlborough House)

NOTES

ON

THE TURNER GALLERY AT MARLBOROUGH HOUSE

1856

BY

JOHN RUSKIN, M.A.

AUTHOR OF "MODERN PAINTERS," "STONES OF VENICE," "SEVEN LAMPS OF ARCHITECTURE," ETC.

LONDON:

SMITH, ELDER & CO., 65, CORNHILL.

1857

[*Bibliographical Note.*—Of this catalogue there were several editions.

First Edition (1857).—The title-page of the first (issued on January 12, 1857) is as on the preceding page. Octavo, pp. iv.+88. The "Notes on the Turner Collection" (here pp. 99–172) occupy pp. 1–80, the "Appendix" (here pp. 173–181), pp. 81–88. The imprint (at the foot of the last page) is "London: printed by Smith, Elder and Co., Little Green Arbour Court, E.C." There are no headlines, the pages containing the Notes being headed with the numbers of the pictures described, whilst those of the Appendix are numbered centrally. A Catalogue of Smith, Elder & Co.'s publications occupies four numbered pages at the end. Issued in green paper wrappers, with the title-page (enclosed in an ornamental ruled frame) reproduced upon the front cover; "Price One Shilling" being added at the foot. Page 4 of the wrapper is filled with an advertisement of "Mr. Ruskin's Works on Art."

Second and *Third Editions* (1857).—These editions (issued in February 1857) are exact reprints of the First—with two exceptions: (1) the date of the Exhibition was altered from "1856" to "1856–1857," and remained so in subsequent issues; (2) the number of the edition was added to the title-page and to the front cover of the wrapper.

Fourth Edition (1857).—The title-page of this edition (issued in March 1857) was different, thus :—

Notes | on | the Turner Collection | at Marlborough House. | 1856–1857. | By John Ruskin, M.A., | Author of "Modern Painters," "Stones of Venice," "Seven Lamps of | Architecture," etc. | Fourth Edition, Revised, | With a Preface.—London : | Smith, Elder & Co., 65 Cornhill. | 1857. | *Price One Shilling*.

Octavo, pp. viii. +88. "Preface to Fourth Edition" (here pp. 95–98) occupies pp. v.–viii. : otherwise the particulars given above of the first edition apply here. There were some slight alterations in the text (see next page).

Fifth Edition (1857).—The title-page of this edition (issued in July 1857) agrees with that of the fourth except (1) for the alteration of the number of the edition, and (2) that the words "with a Preface" were omitted. The Preface was altered, and the text considerably revised and increased (see below); the "Notes" occupying pp. 1–82, the Appendix, pp. 83–91. For some copies, presumably issued later, the covers were reprinted with the words "Elements of Drawing" added after "Seven Lamps of Architecture." The title-page remained the same.

A Reprint (1902) of the Catalogue is contained, together with other matter, in the following work :—

Ruskin on Pictures | A Collection of Criticisms by John | Ruskin not heretofore Re-printed | and now Re-edited and | Re-arranged | Vol. I. | Turner at the National Gallery and | In Mr. Ruskin's Collection [London | George Allen, 156, Charing Cross Road | 1902 | [*All rights reserved*].

Crown 8vo, pp. xx. + 468. The Preface by the editor (E. T. Cook) occupies pp. i.–xvi. ; Contents, pp. xvii.–xviii. ; List of Plates, pp.¹ xix.–xx. ; and the Text of the Catalogue here described, pp. 1–77. There are editorial notes under the text, the substance of which is here incorporated. Issued (November 29, 1902) in the usual green cloth, uniform with the "Small Complete Edition" of Ruskin's Works, price 7s. 6d. (2000 copies printed.)

Extracts from this Catalogue, as also from the others collected in this volume, are contained in the following work :—

Turner and Ruskin | An exposition of the work of | Turner from the writings | of Ruskin | edited | with a biographical note on Turner | By Frederick Wedmore] Ninety-one illustrations | In Two Volumes | Vol. I. [Vol. II.] | London | George Allen, 156, Charing Cross Road | 1900 | *All rights reserved*

Imperial quarto ; vol. i., pp. xxxii. + 156 ; vol. ii., pp. xii. + 157–364. Issued (December 7, 1900), price 7 guineas (850 copies) ; also 160 copies on Arnold's unbleached hand-made paper, with the plates on India paper, at 15 guineas.

Variæ Lectiones.—*Preface:* in ed. 4 this was headed "Preface to the Fourth Edition"; lines 1–13 ("Although the following notes . . . a more effectual way") did not appear, the preface beginning "The reader may be surprised to find no notice taken in the following pages of Turner's drawings. But any account . . ." Note to line 8, see p. 95 *n.* Page 96, fourth line from bottom, "Dumblane" for "Dunblane" in all previous editions. Page 96, line 5, for "as stated at p. 37 (now p. 130)" ed. 4 reads "as already stated." Page 97, the passage "The chronological . . . namely" reads thus in ed. 4 : "I have only to add, that since this pamphlet was written, I have seen the two pictures referred to at p. 34—'Rome' and 'What you Will'—and they entirely establish the conclusion there stated. . . ."
Page 100, lines 5, 6, the words "forms" and "colours" were italicised in eds. 1–4.
Page 101, No. "459" misprinted "454" in eds. 1–4 ; author's footnote, "1797" misprinted "1779" in eds. 1–4.
No. 466, line 1 (see p. 102 *n.*) ; page 103, line 5, for "in the manner of," eds. 1–4 read "like."
No. 471, lines 1 and 2 (see p. 104 *n.*).
No. 476, page 110 (see page 110 *n.*).
Page 113, line 5, "the preceding page" here substituted for "this page."
No. 477, page 119, line 7, for ". . . and Hesperides, or the Python of No. 488 (see note on the picture), while the Rizpah . . . ," eds. 1–4 read " . . . and Hesperides. Another picture, also in the possession of the nation, 'Rizpah' . . . will show the same." Eds. 1–4 similarly omitted the number after the latter picture. The "Rizpah" and the "Python" had clearly been hung during the interval between the publication of eds. 4 and 5 respectively.
No. 483, page 120, line 9 (see note there).
No. 488, page 122. The note on this picture was added in ed. 5.
No. 499, page 125, in the quotation from Turner's verses, the word "ensanguined" was omitted, and a blank space left, in eds. 1 and 2 ; page 125, line 26, for "the view of Coniston Fell, now numbered 461," eds. 1–4 read "a view of Coniston Fell."
Page 128, lines 1, 2 (see note there).
No. 505 (see p. 132 *n.*).
No. 508, page 137, line 21 (see note there) ; page 138, line 11 (see note there).
No. 509. The note on this picture was included in ed. 5 only. No. 511. This was omitted in ed. 5 (see note on p. 139).
No. 516, line 6 (see p. 140 *n.*) ; page 145, line 7, "522" misprinted "521" in eds. 1–4 (so also lower down, p. 151).
Page 146, line 23, the word "play" italicised in eds. 1–4 ; page 147, line 12 (see note there).
No. 520 (see notes on p. 149).
No. 519. The author's footnote was in ed. 5 only.
No. 524 (p. 158) was in eds. 1–4 referred to as No. 522, and therefore preceded No. 523. The headlines showed a corresponding variation.
No. 530 (p. 161), differently placed in eds. 1–4, as noted on p. 110. The passage "The following anecdote . . . had struck me before" was added in ed. 5 ; eds. 1–4 reading instead of "Interesting, however, as this picture is in marking . . . ," "The picture belongs to the nation, and, when exhibited, will be interesting as marking . . ." ; and on p. 162, fourth line from end, eds. 1–4 read "even so" for "even thus."
No. 534, p. 164 (see note there).
No. 524, page 170 (see note there).
Appendix, page 173, the footnote omitted in eds. 4 and 5 ; page 179, the footnote added in eds. 4 and 5 ; page 180, line 22, eds. 1–3 read "(headed)" after "frame."]

PREFACE

ALTHOUGH the following notes refer only to a portion of the great series of the works of Turner which are now exhibited at Marlborough House, they will be found copious enough to mark all the principal stages of his progress, and characters of his design; and they will sufficiently indicate to the reader what kind of excellence is to be looked for, even in the pictures of which no special notice is taken. Among these undescribed ones * there are indeed some of the greatest efforts of the master; but it is just on account of their great excellence that I do not choose to add any account of them to these rough notes; hoping to describe and illustrate them elsewhere in a more effectual way.[1] Nor is any notice taken in the following

* All the information absolutely necessary to the understanding of their subjects will be found in the Official Catalogue, admirably arranged by Mr. Wornum, and that at a cost of labour which its readers will not readily appreciate, for Turner was constantly in the habit of inventing classical stories out of his own head, and it requires Mr. Wornum's extensive reading and determined inductive methods[2] to prove the non-existence of any real tradition of the subject. See, for instance, the note on the No. 495, in the Official Catalogue.[3]

[1] [Among the undescribed pictures which would probably come in this category are the "Frosty Morning: Sunrise" (No. 492); the "Meuse: Orange-Merchantman going to pieces" (No. 501), for a passing reference to which see *Modern Painters*, vol. v. pt. ix. ch. ix. § 4; "Hero and Leander" (No. 521), for which see *Modern Painters*, vol. i. (Vol. III. p. 242), and vol. v. pt. viii. ch. iv. § 18 *n.*; some of the later Venices (see Vol. III. p. 250); and "Rain, Steam, and Speed" (for which see *Dilecta*). Ruskin did not, however, describe and illustrate any of these pictures, as here promised. He was thinking partly, no doubt, of *Modern Painters*, of which the fifth volume was still in preparation when these notes were written. Its scope underwent several changes (see the author's preface to vol. v.), but at this time he had another project in his mind, namely, a catalogue of Turner's works with illustrations on a large scale: see author's preface to vol. iii. of *Modern Painters* (Vol. V. p. 9 *n.*).]
[2] [Hitherto printed "inducting merits," an obvious misprint.]
[3] [For another reference to Wornum, see above, p. 87. His Catalogue of the National Gallery (Foreign Schools) was first published in 1847; that of the British

pages of the Turner drawings ; for any account of these
at present would be premature; the number belonging to
the nation is very great; and it will require prolonged exa-
mination to trace the connection and significance of many
of the subjects. Besides, the drawings, as stated at p. 130,
are nearly all faultless; simple in purpose, perfect in exe-
cution, and absolute in truth ; and perhaps, even when
I am able to give any account of them, the reader may
find some monotony in my description of works in which
there is little to explain, less to dispute, and nothing to
accuse.

One point, however, requires notice—namely, that the
original sketches in sepia for the Liber Studiorum are not
to be considered as Turner *drawings* at all.[1] They are
merely hasty indications of his intention, given to the
engraver to guide him in his first broad massing out of
the shade on the plate. Turner took no care with them,
but put his strength only into his own etching on the plate
itself, and his after touching, which was repeated and ela-
borate, on the engraver's work. The finer impressions of
the plates are infinitely better than these so-called originals,
in which there is hardly a trace of Turner's power, and
none of his manner. The time bestowed in copying them
by some of the students is wholly wasted; they should
copy the engravings only ; and chiefly those which were
engraved, as well as etched, by Turner himself. The best
of the series are the " Grande Chartreuse," " Source of
Arveron," " Ben Arthur," " Æsacus," " Cephalus," " Rizpah,"
" Dunblane," " Raglan," " Hindhead," and " Little Devil's
Bridge," with the unpublished "Via Mala"[2] and "Crow-
hurst," not generally accessible. The Via Mala, Æsacus,
Arveron, and Raglan, were engraved by Turner; and I

Schools including the Turner collection, in 1856-1857. The former was rewritten by
Sir F. Burton in 1892 ; the current issue of the latter is still founded on Wornum's
work. No. 495 is " Apuleia in search of Apuleius."]
 [1] [Compare p. 338 below, and on the educational value of the *Liber* generally, see
Elements of Drawing (Vol. XV.).]
 [2] [Elsewhere, and more correctly, called " The Swiss Bridge on the St. Gothard " :
see Vol. VI. p. 40.]

believe the Crowhurst also. Of the drawings at present exhibited, the Vignettes to the Italy, and the Rivers of France series, on grey paper, exhibit his power at its utmost. The "St. Maurice," and "Caudebec" are, I think, on the whole, the finest drawings in the room. The Oke-hampton, Norham, and More Park, of the River Scenery, are consummate examples of a somewhat earlier time. The Arsenal at Venice, and the vignette with the fish on the shore, are equally excellent instances of the later manner.[1]

The chronological arrangement of the whole series of pictures will now sufficiently enable the reader to test the conclusion stated in the earlier editions of this notice,[2] namely, that the change which led to the perfect develop-ment of Turner's power took place in 1820—a conclusion very interestingly confirmed by the advice of the *Athenæum* to its readers in 1851. "Whoever wishes to possess a single Turner, will, if he has true taste, take care to secure, if he can, a picture of a period before 1820." The *Athenæum*, though it had always, and has to this day, a curious gift of getting wrong with precision, was not at this time much below the current standard of popular knowledge respecting Turner; and this passage, occurring in its obituary of him, in the number for December 27th, 1851, indicates sufficiently how little Turner had been understood by the public up to the very hour of his death. I trust that the privilege which the nation owes to that death, of studying in detail the works it once despised,*

* I would direct especial attention to the series of the Rivers of France[3] which (as well as the great England series) was stopped for want of public encouragement; I suppose the *Athenæum* alludes to this circumstance when it speaks in the same article of the "excess of contemporary admiration"; or perhaps it intended a reference rather to the fact that the "*Old Téméraire,*"

[1] [The "Arsenal at Venice" is No. 371 : see *Stones of Venice,* vol. iii. (Vol. XI. p. 363). The other drawings mentioned are Nos. 205, 129, 165, 175, 168. For the last, "More Park," see below, p. 577. The drawing of "Crowhurst" has since been added to the Gallery, by Mr. Henry Vaughan's bequest, No. 868.]

[2] [See below, pp. 127–128.]

[3] [Nos. 101–160 in the collection of drawings.]

may diffuse the knowledge of art widely enough to pre-
vent the recurrence, in other cases, of so great an injustice.

during the first days of its exhibition at the Royal Academy, might have
been bought for a hundred and fifty guineas; and that no offer was made
for it.[1]

[1] [This story, current at the time, was, however, afterwards shown to be incorrect:
see the letter from a would-be purchaser in Thornbury's *Life*, p. 462 in the 1877
edition, and the note on p. 168, below.]

NOTES ON THE TURNER COLLECTION

THE works of Turner are broadly referable to four periods, during each of which the painter wrought with a different aim, or with different powers.

In the first period, 1800–1820, he laboured as a student, imitating successively the works of the various masters who excelled in the qualities he desired to attain himself.

In his second period, 1820–1835, he worked on the principles which during his studentship he had discovered; imitating no one, but frequently endeavouring to do what the then accepted theories of art required of all artists—namely, to produce beautiful compositions or ideals, instead of transcripts of natural fact.

In his third period, 1835–1845, his own strong instincts conquered the theories of art altogether. He thought little of "ideals," but reproduced, as far as he could, the simple impressions he received from nature, associating them with his own deepest feelings.

In 1845 his health gave way, and his mind and sight partially failed. The pictures painted in the last five years of his life are of wholly inferior value. He died on the 19th of December 1851.

These, then, being the broad divisions of his career, we will take the pictures belonging to each in their order;* first dwelling a little on the general characteristics of each epoch.

* The number, or numbers of the pictures under discussion, will be found at the top of each page, so that the reader will merely have to turn forward, or back, to the number he is looking for.

I. CHARACTERISTICS OF THE FIRST PERIOD, OR THAT OF STUDENTSHIP

[1800–1820]

GENERALLY, the pictures belonging to this time are notable for their grey or brown colour, and firm, sometimes heavy, laying on of the paint. And this for two reasons. Every great artist, without exception, needs, and feels that he needs, to learn to express the forms of things before he can express the colours of things; and it much facilitates this expression of form if the learner will use at first few and simple colours. And the paint is laid on firmly, partly in mere unskilfulness (it being much easier to lay a heavy touch than a light one), but partly also in the struggle of the learner against indecision, just as the notes are struck heavily in early practice (if useful and progressive) on a pianoforte. But besides these reasons, the kind of landscapes which were set before Turner as his models, and which, during nearly the whole of this epoch, he was striving to imitate, were commonly sober in colour, and heavy in touch. Brown was thought the proper colour for trees, grey for shadows, and fog-yellow for high lights. "Child Roland to the dark tower came," [1] and had to clear his way through all the fog; twenty years of his life [2] passed before he could fairly get leave to see. It follows that the evidences of invention, or of new perception, must be rarer in the pictures of this period than in subsequent ones. It was not so much to think brilliantly, as to draw accurately, that Turner was trying; not so much to invent new things, as to rival the old. His own perceptions are traceable only by fits and fragments through the more or less successful imitation.

It is to be observed, however, that his originality is

[1] [*King Lear,* Act iii. sc. 4, l. 187.]

[2] [The reference is to the first twenty years of Turner's artistic career, not to the years of his life, as he was born in 1775.]

enough proved by the fact that these pictures of his studentship, though they nearly all are imitations, are none of them *copies*. Nearly every other great master in his youth copied some of the works of other masters ; but Turner, when he wanted to understand a master's merits, instead of copying, painted an original picture in the required style. Instead of copying a Vandevelde, he went to the sea, and painted *that*, in Vandevelde's way. Instead of copying a Poussin, he went to the mountains, and painted *them*, in Poussin's way. And from the lips of the mountains and the sea themselves, he learned one or two things which neither Vandevelde nor Poussin could have told him ; until at last, continually finding these sayings of the hills and waves on the whole the soundest kind of sayings, he came to listen to no others.[1]

II. PICTURES OF THE FIRST PERIOD

459.[2] MOONLIGHT. A STUDY AT MILLBANK * (1797).

It will be seen by reference to the classification of Turner's work, just given, that I do not consider the painter to have been in existence before the year 1800. That is to say, there is nothing in his drawings before that year,

* Exhibited in the large room of the old Royal Academy in 1797. At this time, Turner was studying architecture chiefly. The titles of the other subjects exhibited that year were :—

279. Fishermen coming ashore at sunset, previous to a gale.
427. Transept of Ewenny Priory, Glamorganshire.
450. Choir of Salisbury Cathedral.
464. Ely Cathedral. South Transept.
517. North porch of Salisbury Cathedral.

[1] [On the subject of Turner's study of Vandevelde and Poussin, compare *Pre-Raphaelitism*, § 37 (Vol. XII. p. 372), and *Modern Painters*, vol. iii. ch. xviii. ("Of the Teachers of Turner").]

[2] [The numbers are still the same, and all the pictures described in this catalogue are now in the National Gallery, except where otherwise noted.]

which gives definite promise of any extraordinary excellence: precision of line, watchful sympathy with casual incident, and a delicate, though feeble rendering of some effects of atmospheric gradation, are all that can be usually traced in them: his contemporary oil-paintings are much rarer, and I cannot give any account of their general character. This example is an imitation of the Dutch moonlights, but closely studied from the real moon, and very true in expression of its glow towards the horizon; for the rest, its heavy and leaden sky, feeble execution, and total absence of apparent choice or arrangement in the form of boats and buildings, as they make it singular in demerit, so they make it precious as an example of the unpresumptuous labour of a great man in his youth. And the Trustees have judged well in showing it among these mighty pictures:[1] for the sorrowful moonlight on the Thames and its gloomy city, as it was his youth's study, was one of the last sights which sank before his dying eyes.

466. View in Wales (about 1800).[2]

This picture has been rightly described[3] as "a direct imitation of Wilson"; but Wilson is treated with injustice in the next sentence: "it might be mistaken for a work of that master." It does not yet, in any single point, approximate to Wilson's power—nor, even in his strongest time, did Turner (in oil) give serenely warm tones of

[1] [The "Moonlight," now very much darkened, is no longer exhibited in the Turner Gallery. It may, however, be seen in a small room adjoining, where it is at present (1904) hung.]

[2] [This is one of the pictures removed from the National Gallery; it is now at Stoke-upon-Trent.]

[3] [In an unofficial catalogue, sold at that time by permission of the Trustees at the entrance of the Gallery. The catalogue in question appeared in two forms: *The National Gallery of Painting and Sculpture, with a catalogue of the Turner Collection now on view at Marlborough House* (H. G. Clarke & Co.), and *The Turner Gallery, with a catalogue of the Vernon Collection of Painting and Sculpture now on view at Marlborough House* (H. G. Clarke & Co.). Eds. 1–4 read "is" for "has been"; the words "in the catalogue" were added after "described"; and the title of this catalogue was shortly given in a note; but in ed. 4 Ruskin added "It is not an official catalogue, and will I hope soon be superseded by a careful and accurate one arranged by Mr. Wornum."]

atmosphere with Wilson's skill.[1] This work is a sufficiently poor imitation of Wilson's commonest qualities; and it is interesting to see what those common qualities are. We are promised a view in Wales; but, because it is to be idealized, and in the manner of Wilson, it has not a single Welsh character. The ground is not rocky — but composed, in the classical manner, of lumps of clay; the river is not a mountain stream, but a classical stream, or what is called by head gardeners a "piece of water"; the hills are neither moorland, nor crag, nor pasture-land, but the Italian tufted pattern; and the building on the top of them is turned from a plain Welsh church into that remarkable tower with no bells in it, nor door, nor window, which served all the old landscapists from generation to generation;—Claude and Domenichino—Cuyp, and Wouvermans, and Berghem — Tempesta and Vernet — using it one after another, like a child's coral, to cut their teeth upon. The white figures are set, we observe, in an orthodox manner, to relieve the principal dark, by precept and example of Sir Geo. Beaumont, Sir F. Bourgeois, etc.[2] A few somewhat careless scratches in the foreground, to the right, reveal, at last, a little beneficent impatience — for which Heaven be praised. For there is an impatience of genius as well as a patience—and woe worth the man who could have painted such a picture as this without being tired of it!

468. VIEW ON CLAPHAM COMMON (1802 ?).

The manner of this painting, though still leaning to Wilson's, is much complicated with that of Morland, whom Turner was studying about this time very admiringly. The somewhat affected rolling and loading of the colour in the

[1] [For Ruskin's appreciation of Richard Wilson, see *Modern Painters*, vol. i. (Vol. III. p. 189), and *The Art of England*, § 166.]

[2] [For Sir George Beaumont, see *Modern Painters*, vol. i. (Vol. III. p. 45). Sir Peter Francis Bourgeois (1756–1811), R.A., was a pupil of Loutherbourg, and a painter of landscapes, battle-scenes, and sea-pieces. He bequeathed his collection of pictures to Dulwich College; including several of his own works.]

sky is founded altogether on Morland.[1] Nevertheless, this picture is really a study from Nature; possessing therefore some noble qualities of tree form. It is evidently left unfinished in the foreground.

471. JASON (1802).

Very characteristic of Turner's increasing power in his first period, and showing high imaginative faculty.[2] The passage in the note,* from the second volume of *Modern Painters*, refers to the reminiscence of this picture in the Liber Studiorum;[3] but it applies also, though not so strongly,

* "In Retsch's illustrations to Schiller's ʻKampf mit dem Drachen,' we have an instance, feeble indeed, but characteristic, and suited to our present purpose, of the detailing and finishing action of the fancy. The dragon is drawn from head to tail, vulture eyes, serpent teeth, forked tongue, fiery crest, armour, claws, and coils as grisly as may be; his den is drawn, and all the dead bones in it, and all the savage forest-country about it far and wide; we have him from the beginning of his career to the end, devouring, rampant, victorious over whole armies, gorged with death; we are present at all the preparations for his attack, see him receive his death-wound, and our anxieties are finally becalmed by seeing him lie peaceably dead on his back.

"All the time we have never got into the dragon heart, we have never once had real sense of the creature's being; it is throughout nothing but an ugly composition of claw and scale. Now take up Turner's Jason, (Liber Studiorum) and observe how the imagination can concentrate all this, and infinitely more, into one moment. No far forest-country, no secret path, nor cloven hills; nothing but a gleam of pale horizontal sky, that broods over pleasant places far away, and sends in, through the wild overgrowth of the thicket, a ray of broken daylight into the hopeless pit. No flaunting plumes nor brandished lances, but stern purpose in the turn of the crestless helmet, visible victory in the drawing back of the prepared right arm behind the steady point. No more claws, nor teeth, nor manes, nor stinging tails. We

[1] [On the subject of Turner's study of Morland and other painters, compare *Modern Painters*, vol. iii. (Vol. V. pp. 407–408.).]

[2] [In eds. 1–4 the following passage occurred in place of the sentence given above:—

"I have not seen this picture for several years, and cannot, in its present position, see it at all; but I remember it as very characteristic of Turner's increasing power in his first period, and showing high imaginative faculties. In very sunny days a keen-eyed spectator may discern, even where the picture hangs now, something in the middle of it like the arch of an ill-built drain. This is a coil of the dragon beginning to unroll himself. The passage . . ."

The position of the picture was obviously altered between the issues of eds. 4 and 5.]

[3] [No. 461 in the Turner water-colours.]

to the picture itself, and will perhaps help the reader to
enter better into Turner's meaning. It should, however, be
added, that this showing only a part of the dragon's body,
and thereby increasing our awe, is one of the instances in
which Turner's mysticism first developed itself; just as the
entire conception is the first notable evidence of the love of
horror which formed one of the most important elements
in his mind. Of which, more presently.[1]

472. CALAIS PIER * (1803).[2]

This picture is the first which bears the sign manual
and sign mental of Turner's colossal power. The " Jason "
might have been painted by a man who would not, in the
rest of his career, have gone beyond Salvator. But here
we have the richest, wildest, and most difficult composition
—exquisite appreciation of form and effect in sea and sky
—and the first indication of colour, properly so called, in
the fish.† This makes the picture of immense importance

have the dragon, like everything else, by the middle. We need see no more
of him. All his horror is in that fearful, slow, griding upheaval of the single
coil. Spark after spark of it, ring after ring, is sliding into the light, the
slow glitter steals along him step by step, broader and broader, a lighting
of funeral lamps one by one, quicker and quicker; a moment more and he
is out upon us, all crash and blaze, among those broken trunks;—but he will
be nothing then to what he is now." [Vol. IV. pp. 259, 260.]

 * Turner's title of this picture, in the Academy Catalogue of 1803, was
"Calais Pier, with French Poissardes preparing for sea, an English packet
arriving." An elaborate engraving was undertaken from it by Mr. Lupton,
and was carried forward with infinite patience nearly to completion, when
Turner got tired of his own composition; doubled the height of the sails,
pushed some of the boats further apart, and some nearer together; intro-
duced half-a-dozen more; and at last brought the whole thing into irrepar-
able confusion—in which it was left. Any person happening to possess a
proof of this plate in its later states, will be much edified by comparing it
with the picture.[3]
 † The reader will find an important anecdote, touching upon these fish,
in my pamphlet on Pre-Raphaelitism. I owe it to Mr. Lupton: but have
made a mistake respecting the time during which Turner had lost sight of

 [1] [See below, p. 118.]
 [2] [For other references to this picture, see pp. 107, 110, 111 n., 152, 170 n., 283, 418.]
 [3] [See note on *Pre-Raphaelitism*, § 43, in Vol. XII. p. 378.]

in the history of Turner's progress; for the rest of it is still
painted nearly on the old Wilsonian principles: that is to
say, the darks are all exaggerated to bring out the lights;
(the post, for instance, in the foreground, is nearly coal
black, relieved only with brown)—all the shadows are coal
black,—and the greys of the sky sink almost into night
effect. And observe, this is not with any intention of
giving an impressive effect of violent storm. It is very
squally and windy; but the fishing-boats are going to sea,
and the packet is coming in in her usual way, and the
flat fish are a topic of principal interest on the pier. No-
body is frightened, and there is no danger. The sky is
black only because Turner did not yet generally know
how to bring out light otherwise than by contrast. But
in those aforesaid flat fish, light is coming in another way:
by colour and gradation. Note the careful loading and
crumbling of the paint to the focus of light in the nearer
one; and the pearly playing colour in the others.

It may be well to advise the reader that the "Eng-
lish packet" is the cutter in the centre, entering the har-
bour; else he might perhaps waste some time in trying
to discover the *Princess Maud* or *Princess Alice* through
the gloom on the left. The figures throughout will repay
examination; none are without individuality and interest.
It will be observed, perhaps, that the fisherman at the
stern of the boat just pushing from the pier, seems un-
reasonably excited in bidding adieu to his wife, who looks
down to him over the parapet; but if the spectator closely
examines the dark bottle which he shakes at her, he will
find she has given it him only half full of Cognac. She
has kept the rest in her own flask.

The sky is throughout very noble, as well as the indi-
cation of space of horizon beyond the bowsprit of the

his own picture before the circumstance took place. I should have written
"several years" instead of "several months." [1]

[1] [See, again, *Pre-Raphaelitism*, § 43 (Vol. XII. p. 378), and compare *ibid.*, pp. 380–
381.]

vessel outside the harbour. In a dark day the finer passages on this side of the picture are, however, quite invisible.

476. SHIPWRECK (1805).

I cannot find any record of the exhibition of this picture, and take its date, therefore, on the authority of the published catalogue.[1] There appears, however, to be about as much as two years would give of difference in style between this and the "Calais Pier"; the principal changes being in the more delicate and mysterious grey, instead of the ponderous blackness; and the evidently more stern and pathetic temper of the maturing mind.

Although there is much to be regretted in the present position of this picture—as of all the rest—there is, in this one instance, an advantage in its nearness to a characteristic work of Turner's late period, so that we may learn much from a comparison of the two. Stand a little towards the centre of the room, where you can look alternately from the "Shipwreck" to the "Phryne" (522),[2] and consider the general character of each subject. In the first, there is the utmost anxiety and distress of which human life is capable: in the second, the utmost recklessness and rapture. In the first, a multitude's madness in despair: in the second, a multitude's madness in delight. In the first, the Nature is an infinity of cloud and condemnation: in the second, an infinity of light and beneficence. In the first, the work of man is in its lowest humiliation — the wreck disappearing from the sea like a passing shadow: in the second, the work of man is in its utmost pride; in endlessness of accumulation, and perfectness of persistence; temple beyond temple, pillar above pillar, tower crowning tower; a universe of

[1] [The picture was not exhibited. It was originally purchased by Sir John Fleming Leicester, afterwards Lord de Tabley, and was subsequently exchanged by him for the "Sun Rising in a Mist" (No. 479); which latter picture Turner afterwards bought back, in order to include it among his bequest to the nation : it was one of the two which were always to hang beside two by Claude (see above, p. xxix.).]

[2] [The "Phryne" is no longer in the National Gallery. It has been sent to Oldham.]

triumphal Peace. Time, in the first, has death and life in its every moment: in the second, it exists only to be laughed away. Here, the ocean waves are playing with a ship of war: there, two dogs are playing with a crystal ball. And, in the one picture, the pleasant boughs wave, and the sun lightens, and the buildings open their glorious gates upon the track of guilt: and, in the other, the sea asks for, and the heavens allow, the doom of those in whom we know no evil.

Do not think that I am forcing the meaning of these two pictures. They were not indeed painted with any thought of their comparison or opposition; but they indicate two opposite phases of the painter's mind, and his bitter and pitying grasp of this world's ways. The "Shipwreck" is one only of many, in which he strove to speak his sympathy with the mystery of human pain. The other is definitely painted as an expression of the triumph of Guilt. Do not think those two dogs playing with the crystal ball are meaningless. Dogs don't usually play with crystal balls. Turner intended you to notice them specially. They mean the lower or sensual part of human nature, playing with the World. Look how the nearest one, the graceful greyhound, leaps at it!—watch its wild toss and fairy fragility of colour: then look out on that illimitable space of courts and palaces, into which the troop of flying girls are rushing down! That is the world which Phryne plays with. Turner never painted such another distance for infinity or for completeness: observe, none of these palaces are in ruins; Turner liked ruins for his own part, but Phryne did not. She would have built Thebes again if they would have let her;[1] she was not one to go the way of ruins. And if you still doubt his meaning, look to the Academy Catalogue of 1838, and you will find a sentence

[1] [The refusal of the offer is told by Pliny (*N. H.* xxxiv. 8). She offered to rebuild at her own expense the city of Thebes which Alexander had destroyed, provided that this inscription was placed on the walls: *Alexander diruit, sed meretrix Phryne refecit.* Both this story, and that of Æschines' birth, are set out in the *Classical Dictionary* of Lemprière, a work with which Turner was familiar. It is often objected that

added to the account of the picture.[1] " Phryne going to the
bath as Venus. *Demosthenes taunted by Æschines ;*"—Note
that;—the man who could have saved Greece taunted by
the son of the harlot !"[2]

There is something very strange and sorrowful in the
way Turner used to hint only at these under meanings of
his; leaving us to find them out, helplessly; and if we did
not find them out, no word more ever came from him.[3]
Down to the grave he went, silent. "You cannot read me;
you do not care for me; let it all pass; go your ways."

Touching the actual painting of the figures in this
"Phryne," we shall have more to say presently,[4] our busi-
ness, now, being with the "Shipwreck"; in which, however,
note for future animadversion, that the crew of the nearer
boat prove infinitely more power of figure-painting than
ever landscape painter showed before. Look close into it:
coarse it may be; but it comes very nearly up to Hogarth
in power of expression. Look at that ghastly woman's face
and those helpless arms; and the various torpor and terror,
and desolate agony, crushed and drenched down among the
rending planks and rattling oars. Think a little over your
"landscapes with figures." Hunt up your solitary fishermen
on river banks; your Canaletto and Guardi[5] crowds in pro-
jecting dominoes and triangular hats; your Claudesque
nymphs and warriors; your modern picturesque groups of

Turner had no deep mythological meanings in his classical compositions, for that
Lemprière was his only source of inspiration. Such criticism shows a want of
acquaintance with that book, for the author nearly always adds to his bald versions
of the myths an interpretation, according to his lights, of their physical and moral
meanings.]
 [1] [The "sentence" was the title given to the picture by Turner in the catalogue.
The picture is of an extensive landscape with some magnificent baths in the middle
distance, and a crowd of figures in the foreground; among them Phryne as Venus
is conspicuous in her chariot to the extreme right. Demosthenes and Æschines are
on the opposite side of the foreground. The figures thus supply two illustrations
of "the triumph of guilt"—the renown of Phryne, the courtesan; the taunting of
Demosthenes by Æschines, a harlot's son.]
 [2] [Demosthenes, *De Corona*, § 166 (Bekker).]
 [3] [Compare what Ruskin says of Turner, "as silent as a granite crest," in
Modern Painters, vol. iv. (Vol. VI. p. 275).]
 [4] [See below, p. 151.]
 [5] [For another reference to Francesco Guardi (1712-1793), see *Modern Painters*,
vol. v. pt. ix. ch. i. § 3.]

striped petticoats and scarlet cloaks; and see whether you can find *one* piece of true human action and emotion drawn as that boat's crew is, before you allow yourself again to think that Turner could not paint figures. Whether he always *would* paint them or not is another question.

The sea painting, in both this and the "Calais Pier," is, I think, much over-rated. It is wonderful in rendering action of wave; but neither the lustre of surface nor nature of the foam—still less of the spray—are marked satisfactorily. Through his whole life, Turner's drawing of large waves left them deficient in lustre and liquidity; and this was the more singular, because in calm or merely rippled water, no one ever rendered lustre or clearness so carefully. But his sympathies (and he sympathised with everything) were given to the rage of the wave, not to its shining; and as he traced its toss and writhe, he neglected its glow. The want of true foam drawing is a worse fault; none of the white touches in these seas have, in the least, the construction or softness of foam; and there is no spray anywhere. In reality, in such a sea as this of the shipwreck, the figures even in the nearest boat would have been visible only in dim fragments through the mist of spray; and yeasty masses of spume would have been hanging about the breakers like folds of cloth, and fluttering and flashing on the wind like flights of birds. Turner was still close bound by the old theories of the sea; and, though he had looked at it long enough to know the run and the leap of it, dared not yet lay the foam on its lips. He did better afterwards; (see No. 530).[1]

But there is a worse fault in this shipwreck than the want of spray. Nobody is *wet*. Every figure in that boat is as dry as if they all were travelling by waggon through the inland counties. There is no sense, in the first place, of their clothes clinging to their bodies; and, in the second

[1] [Eds. 1–4 omit the words in brackets and proceed with the account of No. 530, to be found further on in this edition (p. 161), "In the year 1842 . . . I wish they'd been in it." The anecdote supplied by Mr. Kingsley is, however, omitted in eds. 1–4 (see below, pp. 161–162).]

place, no surface is reflective. When smooth things are wet, they shine; wood becomes as reflective as a mirror; and, therefore, when we see that the knee of the boy who lies down on the box to catch at some one over the boat's side, casts no reflection on the wood, the whole of the scene becomes purely mythical and visionary: and it is no longer a sea, but some coiling, white, dry material in which the boat is imbedded. Throughout the work, the firm, black shadows, unbroken by any flashes of lustre, and the dead greys, unmingled with any reflected or glancing colour, are equally inconsistent with the possibility of anything's being wet.

Nothing can show more distinctly the probationary state of Turner's mind at the period; he had not yet been able to quit himself of the old types in any one way—had not even got so far as to understand that the sea was a damp element. I used once to think Homer's phrase, "wet water,"[1] somewhat tautological; but I see that he was right, and that it takes time to understand the fact.*

* Writing lately to my friend Mr. Brierly[2] (with whose most faithful and brilliant drawings of our navy in the Baltic the public are already so familiar), in order to make some inquiries respecting the ships in the "Calais Pier," I alluded to this singular defect in both the sea pieces. The following extract from Mr. Brierly's note in reply is most valuable and suggestive:—

"Your remark about nobody being wet caused me to look again more particularly at the 'Shipwreck,' when another idea also occurred to me. In anything of a breeze, and particularly half a gale of wind, as we have here, the lower parts of all sails of such boats as these get thoroughly wetted by the spray dashing into them, so that the upper canvas being dry, is several shades lighter, and greyer or cooler, than the wet portion; always excepting when there has been heavy rain to wet the sails equally. This will strike you in any ordinary breezy weather, when you see boats knocking about at Spithead, and if the sun is shining through the sails, the transparent wet parts give a very beautiful effect."

Not only has Turner missed this effect in the "Calais Pier"—when the weather is just the thing for it (I think we might fairly suppose in the "Shipwreck" the sails to be wet all over)—but I remember no instance of

1 [ὑγρὸν ὕδωρ, *Odyssey*, iv. 458.]
2 [Sir Oswald Brierly (1817–1894) was present, as the guest of Keppel, at all the operations of the allied fleets in the Baltic. In 1855 he published a series of fifteen large lithographs executed from his drawings. Brierly was appointed marine painter to Queen Victoria in 1874, and was knighted in 1885.]

With all these drawbacks (which I dwell upon in order
more effectually to overthrow the idea of these being

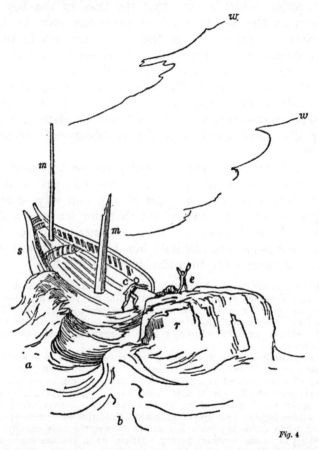

Fig. 4

Turner's greatest works, and this his greatest style — a
notion gravely interfering with our power of judging any

Turner's seizing it in any subsequent picture—so much did the old con-
ventionalism weigh upon him.

I owe to Mr. Brierly, however, not only the pointing out of this error,
but of a principal beauty in the sea of the "Shipwreck"—the exact truth,
namely, of the lines of the *wake* of the large boat running back to the left
from her stern. Very few painters would have noticed these.

of his work)—with all these drawbacks and shortcomings, the work is far in advance of anything that had been done before. The reader may perhaps have some pleasure in comparing Claude's idea of a shipwreck with Turner's. The woodcut on the preceding page—a facsimile of a shipwreck in the Liber Veritatis *—will enable him to do so at his ease. As, however, we have been endeavouring to elucidate the meaning of Turner verbally, perhaps it is unfair to Claude to leave him wholly unexplained. The following references may assist the reader in making out the subject:—

s.—The ship.

m, m.—Masts of the ship, entirely denuded of rigging by the violence of the gale.

r.—The rock, on which the ship has struck so violently that she has broken one end entirely off, the rest of her remaining quite uninjured.

a, b.—The sea.

e.—An enraptured passenger, who has escaped from the ship.

c.—The captain, who has seen everything out of the ship, and is preparing to follow the enraptured passenger.

w, w.—The wind.

477. THE GODDESS OF DISCORD IN THE GARDENS OF THE HESPERIDES † (1806).[1]

In the year 1802, Turner seems to have visited Switzerland for the first time; up to that date, no Swiss subject appears in the catalogues as having been exhibited by him; but in 1803, besides the Calais Pier, we find "24. Bonneville, Savoy, with Mont Blanc. 110. The Opening of the Festival of the Vintage at Mâcon. 237. Château de St. Michael, Bonneville, Savoy. 384. St. Hugo denouncing vengeance on the Shepherds of Cormayeur, in the Val d'Aosta. And 396. Glacier and Source of the Arveron";

* No. 72.

† Exhibited at the British Institution in 1806, under the title, "The Goddess of Discord choosing the Apple of Contention in the Gardens," etc.

[1] [For a further discussion of this picture, see *Modern Painters*, vol. v. pt. ix. ch. x., "The Nereids' Guard," and Plate 78; also *Lectures on Landscape*, §§ 69–71.]

showing with what enthusiasm he entered on the new fields opened to him in the Alps.

This wonderful picture of the Hesperides is, however, the first *composition* in which Turner introduced the mountain knowledge he had gained in his Swiss journey: and it is a combination of these Swiss experiences, under the guidance of Nicolas Poussin, whose type of landscape has been followed throughout. Nearly all the faults of the picture are owing to Poussin; and all its virtues to the Alps. I say *nearly* all the faults of the picture, because it would not be fair to charge Poussin wholly with its sombre colour, inasmuch as many of his landscapes are beautifully golden and deep blue. Possibly the Goddess of Discord may have had something to do with the matter; and the shadow of her presence may have been cast on laurel bough and golden fruit; but I am not disposed to attribute such a piece of far-fetched fancy to Turner at this period;[1] and I suppose it to be partly owing to the course of his quiet practice, partly to his knowledge of the more sombre pictures of Poussin rather than of the splendid ones, and partly to the continued influence of Wilson and Morland, that the garden of the Hesperides is so particularly dull a place. But it is a sorrowful fault in the conception that it should be so.

Indeed, unless we were expressly assured of the fact, I question whether we should have found out that these were gardens at all, as they have the appearance rather of wild mountain ground, broken and rocky; with a pool of gloomy water; some heavy groups of trees, of the species grown on Clapham Common; and some bushes bearing very unripe and pale pippins — approaching in no wise the beauty of a Devonshire or Normandy orchard, much less that of an orange grove, and, least of all, of such fruit as goddesses would be likely to quarrel for.

But there are much worse errors in the picture than these. We may grant the grey colour to Turner's system;

[1] [In the last volume of *Modern Painters*, however, Ruskin adopts the hypothesis here discarded: see pt. ix. ch. x. §§ 22, 23.]

we may accept the wild ground as the only kind of garden which would be probable under Atlas; though the places which Discord seeks, and the dragons guard, are usually of a nature at once brighter and baser. But we cannot accept the impossibilities of mountain form into which the wretched system of Poussin's idealism moulded Turner's memory of the Alps. It is not *possible* that hill masses on this scale, should be divided into these simple, steep, and stone-like forms. Great mountains, however bold, are always full of endless fracture and detail, and indicate on the brows and edges of their cliffs, both the multitudinousness, and the deeply wearing continuance, of the force of time, and stream, and tempest. This evidence of subdivision and prolonged endurance is always more and more distinct as the scale increases; the simple curves which are true for a thousand feet are false at three thousand, and falser at ten thousand; and the forms here adopted by Turner are not mountain forms at all, but those of small fragments of limestone, with a few loose stones at the top of them, magnified by mist into mountains. All this was the result of Idealism. Nature's mountains were not grand, nor broad, nor bold, nor steep enough. Poussin only knew what they should be, and the Alps must be rough-hewn to his mind.

Farther, note the enormous torrent which roars down behind the dragon, above the main group of trees. In nature, that torrent would have worn for itself a profound bed, full of roundings and wrinkled lateral gulphs. Here, it merely dashes among the squared stones as if it had just been turned on by a New River company. And it has not only had no effect on its bed, but appears quite unable to find its way to the bottom, for we see nothing more of it after it has got down behind the tree tops. In reality, the whole valley beneath would have been filled by a mass of rounded stones and débris by such a torrent as that.

But farther. When the streams are so lively in the distance, one might at least expect them not to be stagnant in the foreground, and if we may have no orderly

gravel walks, nor gay beds of flowers in our garden, but
only large stones and bushes, we might surely have had
the pleasantness of a clear mountain stream. But Poussin
never allowed mountain streams; nothing but dead water
was proper in a classical foreground; so we have the brown
pool with a water-lily or two, and a conventional fountain,
falling, not into a rocky trough, or a grassy hollow, but
into a large glass bowl or tureen. This anticipation of the
beauties of the Soulages collection,[1] given in charge to the
dragon together with his apples, "Glass, with care," is
certainly not Poussin's fault, but a caprice of Turner's own.

In the published catalogue[2] the reader will find it stated
that the "*colour* and texture of this picture are as rich and
sound as the ideas are noble, and universally intelligible."
The ideas *are* noble indeed; for the most part:—noble in
spite of Poussin, and intelligible in spite of Marlborough
House darkness; but the statement that the colour is rich
only shows what curious ideas people in general have about
colour. I do not call it a work in colour at all. It is a
simple study in grey and brown, heightened with a red
drapery, and cooled with a blue opening in the sky. But
colour, properly so called, there is as yet none; nothing
but the usual brown trees near, grey trees far off, brown
stonework, and black shadow. And it is another notable
proof of the terrible power of precedent on the strongest
human mind, that just as Vandevelde kept Turner for
twenty years from seeing that the sea was wet,[3] so Poussin
kept Turner for twenty years from seeing that the Alps were
rosy, and that grass was green. It would be a wonderful
lesson for us all if we could for a moment set a true piece
of Swiss foreground and mountain beside that brown shore
and those barren crags. The moss arabesques of violet and

[1] [The Soulages collection of works of decorative art, subsequently acquired for
the South Kensington Museum, was at this time being exhibited at Marlborough
House.]

[2] [The reference is to the unofficial catalogue already mentioned in the note to
p. 102.]

[3] [See above, p. 111.]

silver; the delicate springing of the myrtille leaves along the clefts of shade, and blue bloom of their half seen fruit; the rosy flashes of rhododendron-flame from among the pine roots, and their crests of crimson, sharp against the deep Alpine air, from the ridges of grey rock; the gentian's peace of pale, ineffable azure,[1] as if strange stars had been made for earth out of the blue light of heaven; the soft spaces of mountain grass, for ever young, over which the morning dew is dashed so deep that it looks, under the first long sun-rays, like a white veil falling folded upon the hills; wreathing itself soon away into silvery tresses of cloud, braided in and out among the pines, and leaving all the fair glades and hillocks warm with the pale green glow of grassy life, and whispering with lapse of everlasting springs. Infinite tenderness mingled with this infinite power, and the far away summits, alternate pearl and purple, ruling it from their stainless rest. A time came when the human heart, whose openings we are watching, could feel these things, but we must not talk too much of its achievements yet.

There is, however, one image in the landscape which, in its kind, is as noble as may be—the dragon that guards and darkens it; a goodly watch-tower he has; and a goodly pharos he will make of it at midnight, when the fire glares

[1] [A letter signed "Y. L. Y." appeared in the *Athenæum* of February 7, 1857, in which this expression was criticised. The following reply from Ruskin appeared in the *Athenæum* of February 14, 1857 :—

"THE GENTIAN

"DENMARK HILL, *Feb.* 10.

"If your correspondent 'Y. L. Y.' will take a little trouble in inquiring into the history of the gentian, he will find that, as is the case with most other flowers, there are many species of it.
(*Gentiana acaulis*) because it grows, under in England as on the Alps. And he has (*Gentiana verna*) shaped like a that flower grows unwillingly, i sider it, therefore, as specially Alpine scenery, while its beauty, to my mind, far exceeds that of the darker species.
"I have, etc.,
"J. RUSKIN."

The letter has previously been reprinted in *Arrows of the Chace*, 1880, vol. i. p. 304. For Ruskin's love of the gentian, see Vol. II. p. 431.]

hottest from the eyes of the ghastly sentinel. There is something very wonderful, it seems to me, in this anticipation, by Turner, of the grandest reaches of recent inquiry into the form of the dragons of the old earth. I do not know at what period the first hints were given of the existence of their remains; but certainly no definite statements of their probable forms were given either by Buckland, Owen, or Conybeare[1] before 1815; yet this saurian of Turner's is very nearly an exact counterpart of the model of the Iguanodon, now the guardian of the Hesperian Gardens of the Crystal Palace, wings only excepted, which are, here, almost accurately, those of a pterodactyle. The instinctive grasp which the healthy imagination takes of *possible* truth, even in its wildest flights, was never more marvellously demonstrated.*

I am very anxious to get this picture hung in better light, in order that the expression of the dragon's head may be well seen, and all the mighty articulations of his body, rolling in great iron waves, a cataract of coiling strength and crashing armour, down among the mountain rents.[2] Fancy him moving, and the roaring of the ground under his rings; the grinding down of the rocks by his toothed whorls; the skeleton glacier of him in thunderous march, and the ashes of the hills rising round him like smoke, and encompassing him like a curtain!

I have already alluded[3] to the love of the terrible grotesque which mingled in no small measure with the love of the beautiful in Turner's mind, as it did in Tintoret's. The

* Compare *Modern Painters*, vol. iii. ch. viii. §§ 12, etc. [Vol. V. pp. 141 *seq.*]

[1] [For Buckland, see Vol. I. p. 211; for Sir Richard Owen, F.R.S. (1804–1892), see *Sesame and Lilies*, § 33; his published researches on the subject here in question date from 1840 onwards. William Daniel Conybeare (1787–1857), geologist and Dean of Llandaff (father of W. J. Conybeare, joint author of the *Life of St. Paul*), was the first to describe the *ichthyosaurus*, in the *Geological Society's Transactions*, 1822, pp. 558–594. The *iguanodon* was discovered by Gideon Algernon Mantell (1790–1852) in 1825 (*Philosophical Transactions*, cxv. 179).]

[2] [The picture is now hung "on the line."]

[3] [See above, p. 105.]

reader will find farther inquiries into this subject in the eighth chapter of the third volume of *Modern Painters*,[1] and I need only notice here the peculiar *naturalness* which there is in Turner's grotesque, and the thirst for largeness which characterizes his conception of animals as well as landscapes. No serpent or dragon was ever conceived before, either so vast, or so *probable*, as these of the Jason and Hesperides, or the Python of No. 488 (see note on the picture), while the "Rizpah, the Daughter of Aiah"[2] (464) shows the same grasp of terror exerted in another direction, and connecting the English landscape painter, bred as he was in the cold and severe classical school, with the German interpreters of fantastic or pathetic superstition.

483. GREENWICH HOSPITAL (1809).

I never know whether most to venerate or lament the strange impartiality of Turner's mind, and the vast cadence of subjects in which he was able to take interest. Who could have supposed that a man capable of climbing those crags of Atlas, would be found next year sauntering in Greenwich Park:[3] that from the fiery dragon he would have turned to peaceful fawns and hinds—from the rolling of the Atlantean storm-cloud, to the smoke of London chimneys —from the apples of the Hesperides, to the Cider Cellar. So it is, however. He does not show one whit less care, patience, or exertion of power in painting this reach of the river round the Isle of Dogs, than that cataract down the cliff of dragons: nay, in some respects, the Deptford distance is more elaborate, and certainly the more skilful, for Turner at this time understood it better. But what a sorrowful matter it is, that the man who could paint thus was allowed to divide his strength between vulgarity of fact

[1] [In this edition, Vol. V. pp. 130–148.]
[2] [Now exhibited at Liverpool.]
[3] [Compare what is said on this subject in *The Harbours of England*, above, pp. 57, 61.]

and gracefulness of fiction; that he was permitted so long to think that in order to be fine, it was necessary to be false; and that no one had sense or feeling enough to say to him, "Paint me the Rhone as truly as you have painted the Thames—and the Simplon as you have painted Richmond Hill—and Rouen Cathedral as you have painted Greenwich Hospital!" He found his way at last to these things: but not till many and many a year had been wasted on Greenwich and Bligh Sands.[1]

485. ABINGDON, BERKSHIRE (1810?).

A very beautiful example of the painter's most skilful work in his first period: the main lesson to be derived from it being the dignity of the simplest objects, when truly painted, under partial concealment by aerial effects. They must be truly painted, observe, first; the forms given must be studied with exquisite care, but veiled as far as is needful to give them largeness and mystery.

To so singular an extent will the forms of things come out gradually *through* the mist, as you look long at Turner's effects of this kind, that many of his admirers have thought that he painted the whole scene first with all its details, and then threw the mist over it. But it is not so; and it cannot be done so: all efforts to copy Turner on such a plan will end in total discomfiture. The misty effect is indeed partly given by breaking one colour over another; but the forms of objects are not thus rendered indistinct; if they were, the picture would look as if it had been rubbed over

[1] [Eds. 1–4 add :—
"It is of no use to write any notes on this picture where it is hung at resent. I value Turners as much as most people, and am far-sighted; but that picture of Greenwich, if to its possession we ndition that it was to be hung six feet above the eye—much less if it were condemned to such a position as it is in at present."
The picture is now hung "on the line." The same subject was treated in *Liber Studiorum*. The original drawing for the plate is No. 493 in the water-colour collection at the National Gallery.]

with blue paint accidentally, after it was finished, and every spectator would wish to clear off the upper colour and see what was underneath. The misty appearance is given by resolvedly confusing, altering, or denying the form at the moment of painting it; and the virtue of the work is in the painter's having perfectly clear and sharp conception of all that he chooses to compose, alter, or deny: so that his very confusion becomes suggestive—his alteration decorative—and his denial affirmative: and it is because there is an idea with and in—not *under*—every touch, that we find the objects rising into existence as we gaze.

487. CATTLE IN WATER (1811 ?).[1]

I imagine this to be one of the very few instances in which Turner made a *study* in oil.[2] The subject was completed afterwards in a careful, though somewhat coarse drawing, which defines the Norman window in the ruined wall, and is one of many expressions of Turner's feeling of the contrast between the pure rustic life of our own day, and the pride and terror of the past.[3] This idea was more developed in the Liber Studiorum subject of the crypt of Kirkstall Abbey, with the cows lying down under the pillars, by the stagnant pool; again, in the Norham Castle of the Liber Studiorum, (nearly duplicated in the Norham of the River Scenery): and again in the Winchelsea Gate of the Liber Studiorum.[4] In France, churches are constantly turned into corn-markets:[5] we in England are content with turning castles into cow-houses.

[1] [Now removed to the Corporation Gallery at Sheffield. The full title is "A Ruin. Cattle in Water. A Sketch. Evening"; and the dimensions are 1 foot 11¼ inches high by 2 feet 4½ inches wide.]

[2] [For other studies in oil, see below, pp. 266, 367. Turner used to say that he did not like sketching in oil, as he "always got the colour too brown" (see Thornbury's *Life*, 1877, p. 93).]

[3] [A contrast brought out in Turner's numerous drawings of St. Agatha's Abbey, Easby.]

[4] [The drawings for the plates here mentioned are Nos. 484, 480, and 488 in the water-colour collection.]

[5] [As, for instance, St. André at Chartres: see Vol. XI. p. 126 *n*.; and compare what Ruskin says of St. Julien at Tours, Vol. I. p. 430.]

488. Apollo killing the Python [1811].[1]

I will not here say much of this, which is one of the
very noblest of all Turner's works, and therefore, I do not
scruple to say, one of the noblest pictures in the world:
only the reader ought to be warned that its nobleness is in
the serpent and the landscape; not in the human figure,
which might justly offend him at the first glance, and cause
him to neglect the great work in the rest of the design.
He may perhaps be glad also to be told where the dragon's
head is, down behind the rock in the dark angle, the jaws
wide open, and the teeth or tusks bared; (they are, rightly,
like saurians' teeth; not like serpents' fangs). One of the
most wonderful things in the picture is the way in which
the structure of the writhed coil of the dragon's tail dis-
tinctly expresses mortal agony — not mere serpentine con-
volution:—note also how in the last lash of it, he has struck
the two stones high into the air, weighing about a hundred
to a hundred and fifty tons each. Turner, as noticed below,
was the first painter who ever dared to draw *flying* stones;
—all previous pictorial conception, at its boldest, had not
gone beyond *falling* ones.

489. Cottage destroyed by an Avalanche (1812?).

If the reader will look back for a moment to the
Abingdon, with its respectable country house, safe and slow
carrier's waggon, decent church spire, and nearly motionless
river, and then return to this Avalanche, he will see the
range of Turner's sympathy, from the quietest to the wildest
of subjects. We saw how he sympathized with the anger
and energy of waves: here we have him in sympathy with
anger and energy of stones. No one ever before had con-
ceived a stone in *flight*, and this, as far as I am aware, is

the first effort of painting to give inhabitants of the lowlands any idea of the terrific forces to which Alpine scenery owes a great part of its character, and most of its forms. Such things happen oftener and in quieter places than travellers suppose. The last time I walked up the Gorge de Gotteron, near Fribourg,[1] I found a cottage which I had left safe two years before, reduced to just such a heap of splinters as this, by some two or three tons of sandstone which had fallen on it from the cliff. There is nothing exaggerated in the picture; its only fault, indeed, is that the avalanche is not vaporous enough. In reality, the smoke of snow rises before an avalanche of any size, towards the lower part of its fall, like the smoke from a broadside of a ship of the line.

496. BLIGH SANDS (1815).[2]

The notice of it in the published Catalogue[3] is true and good. It is a fine picture of its class; and has more glow in its light, and more true gloom in its dark, than the great sea-pieces we have already seen. But the subject is, to me, wholly devoid of interest: the fishing-boats are too far off to show their picturesque details; the sea is too low to be sublime, and too dark to be beautiful; and the shore is as dull as sand can be. And yet, were I to choose between this picture and the next, I would infinitely rather have the bit of sand and sea-gulls than the " Carthaginian Empire."

[1] [In the summer of 1856; Ruskin was also at Fribourg in 1854 (see Vol. V. p. xxxii.).]

[2] [The full title is "Bligh Sands, near Sheerness. Fishing-Boats Trawling." Though not exhibited till 1815, the picture must have been painted before 1809, as it appears in the catalogue of Turner's own gallery printed in that year.]

[3] [The catalogue mentioned in the note on p. 102. The following is the notice referred to by Ruskin: "In this picture Turner is back again by the flat shore of Sheppey, with the shattered green water coming up under an eastern wind, and the gulls dipping about the margin—as true in its way and as unadorned in its truth as the 'Abingdon.' The painter has come home again from the region of the avalanche and the eternal snows of the Alps to his old Thames and his tarry boats and broad-shouldered trawler, and put his whole soul into the flat sand and bright ripple, and bit of old buoy-chain and glancing gulls, as if he had never left them and had no wish to leave them."]

499. The Decline of the Carthaginian Empire [1]
(1817).

This picture was painted as the sequel to that in Trafalgar Square [2] which is far the finer of the two, and was exhibited in the same year (1815) as the "Bligh Sands," and the celebrated "Crossing the Brook." [3] This 1817 picture I think one of the deepest humiliations which Turner's art ever sustained. It is, in fact, a work in the sickness of change; giving warning of revolution of style and feeling, without, as yet, any decisive possession of the new principles: while the writers for the press were quite right in their description of its design, — "Claude was undoubtedly the model, aided by architectural drawings." It is, in fact, little more than an accumulation of Academy students' outlines, coloured brown. If we were to examine the figures and furniture of the foreground, piece by piece, we should indeed find much that was interesting, and much that no one but Turner could have done, but all wrought evidently for show, and with painful striving to set forth something that was not in his heart, and that never could get there. The passage in the note, at p. 130, from the first volume of *Modern Painters* will show the reader what place I have given, from the first, to this and other pictures of its kind: but, of all that I know, this is the worst; its raw brown colour giving the city the appearance of having been built of stamped leather instead of stone. It is as if the brown demon, who was just going to be exorcised for ever, were putting out all his strength for the total destruction of a great picture by way of final triumph. The preparation for transition is seen in the noble colouring of the sky, which is already Turnerian of the second

[1] [Now transferred to the Manchester City Art Gallery.]

[2] [The one in Trafalgar Square (No. 498) was one of the two bequeathed by Turner on condition that they were placed beside the two selected ones by Claude (see above, p. xxix.). Those two, therefore, were from the first exhibited at the National Gallery.]

[3] [No. 497. For notices of it see *Modern Painters*, vol. i. (Vol. III. pp. 241, 297 587); *Pre-Raphaelitism*, § 33 (Vol. XII. p. 367); and in this volume, p. 276.]

period; beautiful, natural, and founded on no previous work of art.

The text which Turner gave with this picture in the Academy catalogue of the period was as follows:—

"The Decline of the Carthaginian Empire. Rome, being determined on the overthrow of her hated rival, demanded of her such terms as might either force her into war, or ruin her by compliance. The enervated Carthaginians, in their anxiety for peace, consented to give up even their arms and their children.

> At Hope's delusive smile
> The chieftain's safety and the mother's pride
> Were to the insidious conqueror's grasp resigned;
> While o'er the western wave the ensanguined sun,
> In gathering huge, a stormy signal spread,
> And set portentous."

This piece of verse, Turner's own, though, it müst be confessed, not poetically brilliant, is at least interesting in its proof that he meant the sky—which, as we have seen, is the most interesting part of the picture—for a stormy one.[1]

This is the third quotation from the "Fallacies of Hope" which occurs in the Academy catalogues. The course of his mind may be traced through the previous poetical readings very clearly. His first was given in 1798 (with the view of Coniston Fell, now numbered 461) from *Paradise Lost*, and there is a strange ominousness— as there is about much that great men do—in the choice of it. Consider how these four lines, the first he ever

[1] [Ruskin refers again to the significance of the lines here quoted in *Modern Painters*, vol. v. pt. ix. ch. xi. § 31 *n.* For other references to the verses (from his own "Fallacies of Hope") which Turner printed as mottoes for his pictures, see pp. 159, 163. The "Fallacies of Hope," though "not poetically brilliant," contain enough lines of passable merit to refute the extreme opinion which is often taken of Turner's illiteracy. The lines affixed, for instance, to "Hannibal crossing the Alps" (National Gallery, No. 490, Royal Academy, 1812) compare not unfavourably with the blank verse current in Turner's youth (see on this subject, Sir Walter Armstrong's *Turner*, p. 110).]

chose, express Turner's peculiar mission as distinguished from other landscapists :—

> "Ye mists and exhalations, that now rise
> From hill, or steaming lake, dusky or grey,
> Till the sun paint your fleecy skirts with gold,
> In honour to the world's great Author rise." [1]

In this and the next year, with views of Dunstanborough, Norham, and Fountain's Abbey, etc., came various quotations, descriptive of atmospheric effects, from Thomson, interspersed with two or three from Milton, and one from Mallet.

In 1800, some not very promising "anon" lines were attached to views of Dolbadern and Caernarvon Castles. Akenside and Ossian were next laid under contribution. Then Ovid, Callimachus, and Homer. At last, in 1812, the "Fallacies of Hope" begin, *apropos* of Hannibal's crossing the Alps [No. 490]: and this poem continues to be the principal text-book, with occasional recurrences to Thomson, one passage from Scott, and several from Byron. We shall come upon most of these as we pursue our round of the pictures: at least when all which are now national property are exhibited. The "Childe Harold" [No. 516], which is the only picture at present in a good light,[2] is an important proof of his respect for the genius of Byron.

[1] [Quoted by Turner in the catalogue for his picture of " Morning on the Coniston Fells " (now No. 461 in the National Gallery) in the Royal Academy of 1798. Compare pp. 316, 406, below, and *Modern Painters*, vol. v. pt. ix. ch. x. § 3, where Ruskin again notices the significance of the lines as an indication of the artist's bent.]

[2] [The reader will remember that the above notes were written in 1856–1857, when a portion only of the Turner pictures was publicly exhibited, and then under disadvantageous conditions, at Marlborough House.]

III. CHARACTERISTICS OF THE SECOND PERIOD, OR THAT OF MASTERSHIP

[1820-1835]

The reader may perhaps suppose that I limit Turner's course of conception too arbitrarily in assigning a single year as the period of its change. But the fact is, that though the human mind is prepared for its great transitions by many previous circumstances, and much gradual accumulation of knowledge, those transitions may, and frequently do, take place in a moment. One glance of the eye, one springing aside of a fancy, may cast a spark on the prepared pile; and the whole theory and practice of past life may be burnt up like stubble; and new foundations be laid, in the next hour, for the perpetual future toil of existence. This cannot, however, take place, with the utmost sharpness of catastrophe, in so difficult an art as that of painting: old habits will remain in the hand, and the knowledge necessary to carry out the new principles needs to be gradually gathered; still, the new conviction, whatever it be, will probably be expressed, within no very distant period from its acquirement, in some single picture, which will at once enable us to mark the old theories as rejected, at all events, then, if not before. This condemning and confirming picture is, in the present instance, I believe, the Bay of Baiæ [No. 505].

For, in the year 1819, Turner exhibited the "Orange Merchant," and "Richmond Hill," both in his first manner. In 1820, "Rome from the Vatican" (503):[1] which is little more than a study of materials in the view of Rome from the Loggie, expressed in terms of general challenge to every known law of perspective to hold its own, if it could, against the new views of the professor, on that subject. In 1821,

[1] [Now exhibited at Liverpool.]

nothing: a notable pause. In 1822, "What you will":
a small picture.[1] In 1823 came the "Bay of Baiæ."

Why I put the real time of change so far back as
1820 will appear, after I have briefly stated the characters
in which the change consists.

Pictures belonging to the second period are technically
distinguished from those of the first in three particulars:—

1. Colour takes the place of grey.
2. Refinement takes the place of force.
3. Quantity takes the place of mass.

First, Colour appears everywhere instead of grey. That
is to say, Turner had discovered that the shaded sides of
objects, as well as their illumined ones, are in reality of
different, and often brilliant colours. His shadow is, there-
fore, no longer of one hue, but perpetually varied; whilst
the lights, instead of being subdued to any conventional
level, are always painted as near the brightness of natural
colour as he can.

Secondly, Refinement takes the place of force. He had
discovered that it is much more difficult to draw tenderly
than ponderously, and that all the most beautiful things
in nature depended on definitely delicate lines. His effort
is, therefore, always, now, to trace lines as finely, and
shades as softly, as the point of the brush and feeling of
hand are capable of doing; and the effects sought are them-
selves the most subtle and delicate which nature presents,
rarely those which are violent. The change is the same as

[1] [In eds. 1–4 the above passage stood thus :—
 "In 1820, 'Rome from the Vatican': a picture which I have not seen.
In 1821, *nothing:* a notable pause. In 1822, 'What you will': a picture
I have not seen either, and which I am very curious about, as it may
dispute the claims of first assertion with its successor. In 1823 came 'The
Bay of Baiæ.'"
In the preface to the fourth edition Ruskin wrote :—
 "I have only to add, that since this pamphlet was written, I have seen
the two pictures referred to . . .—'Rome' and 'What you will'—and that
they entirely establish the conclusion there stated that the change which
led to the perfect development of Turner's power took place in 1820."
 "What you will"—a landscape with many figures—was formerly in Chantrey's
collection; and afterwards in the Swinburne Collection.]

from the heavy touch and noisy preferences of a beginner in music, to the subdued and tender fingering or breathing of a great musician—rising, however, always into far more masterful stress when the occasion comes.

Thirdly, Quantity takes the place of mass. Turner had also ascertained, in the course of his studies, that nature was infinitely full, and that old painters had not only missed her pitch of hue, but her power of accumulation. He saw there were more clouds in any sky than ever had been painted; more trees in every forest, more crags on every hill side ; and he set himself with all his strength to proclaim this great fact of Quantity in the universe.[1]

Now, so long as he introduced all these three changes in an instinctive and unpretending way, his work was noble; but the moment he tried to idealize, and introduced his principles for the sake of display, they led him into depths of error proportioned exactly to the extent of effort.[2] His painting, at this period, of an English town, or a Welsh hill, was magnificent and faultless, but all his idealism, mythology, romance, and composition in general, were more or less wrong. He erred through all, and by reason of all—his great discoveries. He erred in *colour;* because not content with discerning the brilliancy of nature, he tried to enhance that brilliancy by every species of coloured accessary, until colour was killed by colour, and the blue skies and snowy mountains, which would have been lovely by themselves, were confused and vulgarized by the blue dresses and white complexions of the foreground figures. He erred in *refinement*, because, not content with the natural tenderness of tender things, he strove to idealize even strong things into gentleness, until his architecture became transparent, and his ground ghostly; and he erred finally, and chiefly, in *quantity*, because, in his enthusiastic perception of the fulness of nature, he did not allow for

[1] [Compare *Modern Painters,* vol. iv. (Vol. VI. pp. 352–353), where this point is enforced and illustrated.]

[2] [Ruskin constantly notices this : see *Modern Painters,* vol. iii. (Vol. V. p. 48) ; and *Pre-Raphaelitism,* § 55 (Vol. XII. p. 385).]

the narrowness of the human heart; he saw, indeed, that there were no limits to creation, but forgot that there were many to reception; he thus spoiled his most careful works by the very richness of invention they contained, and concentrated the materials of twenty noble pictures into a single failure.*

The oil-pictures exhibited in the Academy, as being always more or less done for show, and to produce imposing effect, display these weaknesses in the greatest degree; the drawings in which he tried to do his best are next in failure, but the drawings in which he simply liked his subject, and painted it for its own simple sake, are wholly faultless and magnificent.[1]

All the works of this period are, however, essentially Turnerian; original in conception, and unprecedented in

* The reader who has heard my writings respecting Turner characterized as those of a mere partizan, may be surprised at these expressions of blame and perhaps suppose them an indication of some change of feeling. The following extract from the first volume of *Modern Painters* will show that I always held, and always expressed, precisely the same opinions respecting these Academy compositions:—

"The 'Caligula's Bridge,' 'Temple of Jupiter,' 'Departure of Regulus,' 'Ancient Italy,' 'Cicero's Villa,' and such others, come they from whose hand they may, I class under the general head of 'nonsense pictures.' There never can be any wholesome feeling developed in these preposterous accumulations, and where the artist's feeling fails, his art follows; so that the worst possible examples of Turner's colour are found in pictures of this class. . . . Neither in his actual views of Italy has Turner ever caught her true spirit, except in the little vignettes to Rogers' *Poems*. The 'Villa of Galileo,' the nameless composition with stone pines, the several villa moonlights, and the convent compositions in the voyage of Columbus, are altogether exquisite; but this is owing chiefly to their simplicity; and, perhaps, in some measure, to their smallness of size. None of his large pictures at all equal them; the 'Bay of Baiæ' is encumbered with material, it contains ten times as much as is necessary to a good picture, and yet is so crude in colour as to look unfinished. The 'Palestrina' is full of raw white, and has a look of Hampton Court about its long avenue; the 'Modern Italy' is purely English in its near foliage; it is composed from Tivoli material, enriched and arranged most dexterously, but it has not the virtue of the real thing."—*Modern Painters*, Vol. I. p. 131, 3rd edition, 1846.[2]

[1] [Compare *Modern Painters*, vol. iii. (Vol. V. p. 62).]
[2] [Part ii. sec. i. ch. vii. §§ 42, 43; in this edition, Vol. III. pp. 241-243. Compare also *Modern Painters*, vol. iii. ch. xviii. § 8 (Vol. V. p. 391).]

treatment; they are, therefore, when fine, of far greater value than those of the first period; but as being more daring they involve greater probabilities of error or failure.

One more point needs notice in them. They generally are painted with far more enjoyment. Master now of himself and his subjects, at rest as to the choice of the thing to be done, and triumphing in perpetually new perceptions of the beauty of the nature he had learned to interpret, his work seems poured out in perpetual rejoicing; his sympathy with the pomp, splendour, and gladness of the world increases, while he forgets its humiliation and its pain; they cannot now stay the career of his power, nor check the brightness of his exultation. From the dens of the serpent and the dragon he ascends into the soft gardens and balmy glades; and from the roll of the waggon on the dusty road, or labour of the boat along the stormy shore, he turns aside to watch the dance of the nymph, and listen to the ringing of the cymbal.

IV. PICTURES OF THE SECOND PERIOD

505. THE BAY OF BAIÆ (1823).[1]

The Turnerian quotation with this picture,

"Waft me to sunny Baiæ's shore,"

marks the spirit of exultation of the second period very interestingly, and the immediate result of it, as bearing on this subject, seems to be a discordance in the temper of contemplation. We have an accumulation of ruins, regarded

[1] [For further references to this picture, see pp. 127, 144, 155; and *Modern Painters*, vol. i. (Vol. III. p. 492); and vol. v. pt. ix. ch. xi. §§ 12, 26.]

with the utmost cheerfulness and satisfaction. The gods sit
among the ruins, but do not attempt to mend any, having
apparently come there as tourist gods. Though there are
boats and figures on the shore, and a shepherd on the left,
the greater part of the landscape is very desolate in its
richness—full of apples and oranges, with nobody to eat
them; of pleasant waters, with nobody to drink; of pleasant
shades, with nobody to be cool; only a snake and a rabbit
for inheritors of all that dominion of hill and forest:—we
perceive, however, with consternation, by the two streams
which have been diverted from the river to fall through
the arches of the building near the bridge, that Nobody
must have succeeded in establishing a mill among the ruins.
Concerning which, it must be remembered that, though
Turner had now broken through accepted rules of art, he
had not broken through the accepted laws of idealism; and
mills were, at this time, necessary and orthodox in poetical
landscape, being supposed to give its elements, otherwise
ethereal and ambrosial, an agreeable earthy flavour, like
truffles in pies.

If, however, we examine who these two figures in the
foreground are, we shall presently accept this beautiful
desolation of landscape with better understanding.[1] The
general reader may be glad to be reminded that the
Cumæan Sibyl, Deiphobe, being in her youth beloved by
Apollo, and the god having promised to grant her what-
ever she would ask, she, taking up a handful of earth,
asked that she might live for as many years as there were
grains of dust in her hand. She obtained her petition, and
Apollo would have given her also perpetual youth, in return
for her love; but she denied him, and wasted into the long
ages; known at last only by her voice.[2] We are rightly

[1] [Eds. 1–4 add here:—
 "The published catalogue misses out just the important words in
 Turner's description of his picture, "The Bay of Baiæ, *with the Story of
 Apollo and the Sibyl.*"]
[2] [Compare *Modern Painters*, vol. v. pt. ix. ch. xi. § 26, where Ruskin refers to this
passage and picture; and for the Cumæan Sibyl, see *Ariadne Florentina*, §§ 211 *seq.*]

led to think of her here, as the type of the ruined beauty of Italy; foreshowing, so long ago, her low murmurings of melancholy prophecy, with all the unchanged voices of her sweet waves and mountain echoes. The fable seems to have made a strong impression on Turner's mind, the picture of the "Golden Bough"[1] being a sequel to this; showing the Lake of Avernus, and Deiphobe, now bearing the golden bough—the guide of Æneas to the shades. In both these pictures there is a snake in the foreground among the fairest leafage, a type of the terror, or temptation, which is associated with the lovely landscapes; and it is curious that Turner seems to have exerted all his strength to give the most alluring loveliness to the soft descents of the Avernus Lake.

There is a curious sign of the remaining influences of the theories of idealism on Turner in the treatment of the stone pines in the "Bay of Baiæ." It was a rule at this period that trees and all other important features of landscape were to be idealized, and idealization consisted in the assemblage of various natural beauties into a whole, which was to be more beautiful than nature; accordingly, Turner takes a stone pine to begin with, and keeps its general look of close shade and heaviness of mass; but as boughs of stone pine are apt to be cramped and rugged, and crampedness and ruggedness are un-ideal, he rejects the pine nature in the branches, and gives them the extremities of a wych elm! We shall see presently his farther progress in pine painting.[2]

The main fault of the composition is, however, in the over indulgence of his new triumph in quantity. I suppose most observers, when first they come before this picture, are struck mainly by the beautiful blue distant sea and dark trees, which latter they probably dislike; the rest of the work appears to them a mere confusion of detail,

[1] [No. 371 in the National Gallery Collection; now removed to Dublin. For another reference to the picture, see p. 159. A study for it is No. 860 in the water-colour collection at the National Gallery.]

rich, indeed, but hardly worth disentangling. The following procedure will, I think, under these circumstances be found serviceable. Take a stiff piece of pasteboard, about eight inches square, and cut out in the centre of it an oblong opening, two and a half inches by three. Bring this with you to the picture, and standing three or four feet from it, according to your power of sight, look through the opening in the card at the middle distance, holding the card a foot or two from the eye, so as to turn the picture, piece by piece, into a series of small subjects. Examine these subjects quietly, one by one; sometimes holding the opening horizontal, sometimes upright, according to the bit you are examining, and you will find, I believe, in a very little while, that each of these small subjects becomes more interesting to you, and seems to have more in it, than the whole picture did before.

It is of course both a merit and a marvel, that these separate pieces should be so beautiful, but it is a great fault that they should be so put together as to destroy their interest: not that they are ill composed, but there is simply a surfeit of material. No composition whatever could render such a quantity digestible; nay, the very goodness of the composition is harmful, for everything so leads into everything else, that without the help of the limiting cardboard it is impossible to stop—we are dragged through arch after arch, and round tower after tower, never getting leave to breathe until we are jaded;* whereas, in an ill-composed picture, such as one of Breughel's,[1] we feel in a moment that it is an accumulation of pretty fragments; and, accepting it on these terms, may take one bird or tree at a time, and go over as much of the picture as we like, keeping the rest till to-morrow.

* On the incapacity of the imagination to receive more than a certain quantity of excitement, see farther, *Modern Painters*, vol. iii. ch. x. § 14.[2]

[1] [Jan Brueghel (or less correctly, Breughel), 1568–1625, landscape and *genre* painter; not elsewhere referred to by Ruskin.]

[2] [In this edition, Vol. V. p. 182, and compare *ibid.*, pp. xix.-xx.]

The colour of this picture, take it all in all, is unsatis-
factory; the brown demon is not quite exorcised: and
although, if the foliage of the foreground be closely exa-
mined, it will be found full of various hue, the greens are
still too subdued. Partly, the deadness of effect is owing
to change in the colour; many of the upper glazings, as in
the dress of the Apollo, and in the tops of the pine-trees,
have cracked and chilled; what was once golden has become
brown; many violet and rose tints have vanished from the
distant hills, and the blue of the sea has become pale.*
But as far as regards refinement in drawing, this picture
nobly represents the work of the middle period. Examine,
for example, carefully, the drawing of the brown tendrils
and lighter leaves which encompass the stem of the tree
on the left, then the bough drawing, spray by spray, in
the trees themselves, then the little bit of bay underneath
the Castle of Baiæ, just close to the stems; go back after-
wards to the "View on Clapham Common" [No. 468], and
you will feel the change sufficiently.

It is because instances of this refinement, together with
the excessive delight in quantity, are already seen in the
"Richmond Hill," exhibited in 1819 (in possession of the
nation),[1] that I think the origin of Turner's second manner
cannot be put later than 1820.

507. SCENE FROM BOCCACCIO (1828).

Turner's title in the Academy Catalogue is, " Boccaccio
relating the Tale of the Bird-cage."[2]

Of the peculiar, and almost the only serious weakness of

* I do not at present express any opinion as to the degree in which
these changes have been advanced or arrested by the processes to which the
pictures have recently been subjected, since the light in which they are
placed does not permit a sufficient examination of them to warrant any
such expression [1856–1857].

[1] [No. 502 in the National Gallery.]
[2] [The picture shows a shady glen, with figures lounging about; a bird-cage is
a prominent object in the foreground, but there is no such tale in the *Decameron*.]

Turner's mind, brought out as it was in his second period, with respect to *figures*, this, and the Shadrach, Meshach, and Abednego (517), are very lamentable instances. I shall allude again to both these pictures[1] in analyzing his figure treatment in the Phryne; but except as subjects for curious study, they are of no value whatsoever.

508. ULYSSES DERIDING POLYPHEMUS (1829).[2]

I have just given my reason for dating the commencement of Turner's second manner as far back as 1820. But as in his first period it takes about ten years before he shows his full power in that manner, as in the "Abingdon" and "Bligh Sands"; so in this second phase, it takes nearly ten years before he feels entirely at ease, and brings all his resources into play. The Yorkshire, and River Scenery drawings, 1819 to 1826, are still very quiet in colour; the commencement of the England series, 1827, marked fuller development of the second manner; yet all the drawings of 1827 and 1828 (Launceston, Buckfastleigh, Valle-Crucis, Okehampton, etc.), are restrained to grey and brown companionship with the Yorkshire group; but in 1829, this "Polyphemus" asserts his perfect power, and is, therefore, to be considered as the *central picture* in Turner's career. And it is in some sort a type of his own destiny.

He had been himself shut up by one-eyed people, in a cave "darkened with laurels"[3] (getting no good, but only evil, from all the fame of the great of long ago)—he had seen his companions eaten in the cave by the one-eyed people—(many a painter of good promise had fallen by Turner's side in those early toils of his); at last, when his own time had like to have come, he thrust the rugged pine-trunk—all ablaze—(rough nature, and the light of it)—into the faces of the one-eyed people, left them tearing

[1] [See below, p. 157. The two pictures referred to remain in the National Gallery, but are not exhibited.]
[2] [For other references to this picture, see below, p. 447; *Modern Painters*, vol. iv. (Vol. VI. p. 381), vol. v. pt. ix. ch. xi. §§ 4, 31 *n.*; and *Queen of the Air*, § 39.]
[3] [*Odyssey*, ix. 183.]

their hair in the cloud-banks—got out of the cave in a humble way, under a sheep's belly—(helped by the lowliness and gentleness of nature, as well as by her ruggedness and flame)—and got away to open sea as the dawn broke over the Enchanted Islands.[1]

The printed catalogue[2] describes this picture as "gorgeous with *sunset* colours." The first impression on most spectators would, indeed, be that it was evening, but chiefly because we are few of us in the habit of seeing summer sunrise.[3] The time is necessarily morning—the Cyclops had been blinded as soon as he slept; Ulysses and his companions escaped when he drove out the flock in the early morning, and they put instantly to sea. The somewhat gloomy and deeply coloured tones of the lower crimson clouds, and of the stormy blue bars underneath them, are always given by Turner to skies which rise over any scene of death, or one connected with any deathful memories.* But the morning light is unmistakeably indicated by the pure whiteness of the mists, and upper mountain snows, above the Polyphemus; at evening they would have been in an orange glow;[4] and, for more complete assurance still, if the reader will examine the sky close to the sun, on the right of it, he will find the horses of Apollo drawn in fiery outline, leaping up into the sky and shaking their crests out into flashes of scarlet cloud. The god himself is formless, he *is* the sun. The white column of smoke which rises from the mountain slope is a curious instance

* For instances, see *Modern Painters*, vol. iv. ch. xviii. § 24. [Vol. VI. p. 381.]

[1] [The references are to the *Odyssey*, book ix.]

[2] [The catalogue mentioned in the note on p. 102.]

[3] [Compare what Ruskin says on this subject, both by precept and statement of his practice, in *Two Paths*, § 137; *Eagle's Nest*, § 101; *Fors Clavigera*, Letter 60, and *Academy Notes*, 1859, under No. 900. Of Turner's habitual early rising Ruskin had collected some interesting anecdotes; see the matter added in this edition to *Dilecta*.]

[4] [The passage "and, for more complete assurance . . . the sun" appeared only in ed. 5. In talking of this picture to one of the editors thirty years later, Ruskin explained that the horses were formerly more visible than they have since become.]

of Turner's careful reading of his text. (I presume him to
have read Pope only.)

> "The land of Cyclops lay in prospect near,
> The voice of goats and bleating flocks we hear,
> And from their mountains rising smokes appear."

Homer says simply:—"We were so near the Cyclops'
land that we could see smoke, and hear the voices, and the
bleating of the sheep and goats."[1] Turner was, however, so
excessively fond of opposing a massive form with a light
wreath of smoke (perhaps almost the only proceeding which
could be said with him to have become a matter of recipe),[2]
that I do not doubt we should have had some smoke at
any rate, only it is made more prominent in consequence of
Pope's lines. The Cyclops' cave is low down at the shore
—where the red fire is—and, considering that Turner was
at this time Professor of Perspective to the Royal Academy,
and that much outcry has lately been raised against supposed
Pre-Raphaelite violations of perspective law,[3] I think we
may not unwarrantably inquire how our Professor supposed
that *that* Cyclops could ever have got into *that* cave.

For the naval and mythological portion of the picture,
I have not much to say: its real power is in its pure nature,
and not in its fancy. If Greek ships ever resembled this
one, Homer must have been a calumnious and foul-mouthed
person in calling them continually "black ships";[4] and the
entire conception, so far as its idealism and water-carriage
are concerned, is merely a composition of the Lord Mayor's
procession with a piece of ballet-scenery. The Cyclops is
fine, passionate enough, and not disgusting in his hugeness;
but I wish he were out of the way, as well as the sails and
flags, that we might see the mountains better. The island

[1] [*Odyssey*, ix. 166, 167.]

[2] [Eds. 1–4 add a note: "See, for very marked example, vignette of 'Gate of
Theseus,' in illustrations to Byron." The vignette is in vol. v. of the *Works of
Byron*, 1834.]

[3] [The reference is to criticisms in the *Times*, to which Ruskin replied in a letter
to that journal: see Vol. XII. p. 322.]

[4] [e.g., *Odyssey*, viii. 34, νῆα μέλαιναν.]

rock is tunnelled at the bottom — on classical principles. The sea grows calm all at once, that it may reflect the sun; and one's first impression is that Leucothea is taking Ulysses right on the Goodwin Sands. But,—granting the local calmness,—the burnished glow upon the sea, and the breezy stir in the blue darkness about the base of the cliffs, and the noble space of receding sky, vaulted with its bars of cloudy gold, and the upper peaks of the snowy Sicilian promontory, are all as perfect and as great as human work can be. This sky is beyond comparison the finest that exists in Turner's oil-paintings. Next to it comes that of the "Slaver";[1] and third, that of the *Téméraire*.

509. THE LORETTO NECKLACE.[2]

A very noble work, spoiled curiously by an alteration of the principal tree. It has evidently been once a graceful stone pine, of which the spreading head is still traceable at the top of the heavy mass: the lower foliage has been added subsequently, to the entire destruction of the composition.

As far as I know, whenever Turner altered a picture, he spoiled it; but seldom so distinctly as in this instance.

511. VIEW OF ORVIETO (1830).

Once a very lovely picture, and still perfect in many parts; the tree, perhaps, the best bit of foliage painting in the rooms. But it is of no use to enter into circumstantial criticism, or say anything about its details, while it hangs in its present place. For all serious purposes, it might just as well be hung at the top of Saint Paul's.[3]

[1] [Formerly in Ruskin's collection; now in the Museum of Fine Arts, Boston, Massachusetts. See Vol. III. p. 571, and Plate 12.]

[2] [Now transferred to Dundee. The picture was exhibited at the Academy in 1829. The necklace has been placed by a peasant on the neck of a girl seated by his side, under the shade of trees on the left; on the right, on the summit of a hill, are the Basilica and town of Loretto; in the distance a view of the Adriatic.]

[3] [The note on this picture was omitted in the fifth edition of the pamphlet; doubtless for the reason indicated in the text. The picture is now well hung.]

516. CHILDE HAROLD'S PILGRIMAGE (1832).[1]

Turner's quotation was the one given in the Catalogue,[2] which, also, truly describes the general motives of the picture. It *was*, once, quite the loveliest work of the second period, but is now a mere wreck. The fates by which Turner's later pictures perish are as various as they are cruel;[3] and the greater number, whatever care be taken of them, fade into strange consumption and pallid shadowing of their former selves. Their effects were either attained by so light glazing of one colour over another, that the upper colour, in a year or two, sank entirely into its ground, and was seen no more; or else, by the stirring and kneading together of colours chemically discordant, which gathered

[1] [For another reference to this picture, see *Modern Painters*, vol. v. pt. ix. ch. xi. § 26.]

[2] [The reference here is to the official catalogue by Mr. Wornum, mentioned in the note on p. 95. The quotation and description are as follow:—

"And now, fair Italy,
Thou art the garden of the world, the home
Of all art yields and nature can decree—
Even in thy desert what is like to thee?
Thy very weeds are beautiful, thy waste
More rich than other climes' fertility,
Thy wreck a glory, and thy ruin graced
With an immaculate charm which cannot be defaced."
—*Canto* iv. 26.

"A mountainous landscape with a winding river; to the right a broken bridge; on the left a pile of ruins; in the foreground a solitary stone pine, and a party of pleasure, seated on the river bank. In this picture, Italy, ancient and modern, are both represented: the ancient ruin, the medieval convent and walled town, the modern life. The time is evening, the sun is going down beyond the mountains, but still tinging them with a warm and beautiful light, and shining alike upon the glorious wreck of the past, and on the fascinating out-door life, the feasting and dancing, of the present Italy. The Italian air, land, and foliage, all are vividly realized."]

[3] [Eds. 1–3 here read: ". . . cruel; the best work of the middle time, 'Cologne,' free from all taint of idealism, and as safe and perfect as the day it was painted, was torn to rags on a railway two years ago"—a statement corrected in ed. 4 by a note "I rejoice to be able, on the best authority, to contradict the statement, made in the earlier editions, of the destruction of the beautiful 'Cologne' by a railway accident." The "Cologne," exhibited in 1826, is in the collection of Mr. John Naylor, of Leighton Hall, Shropshire. It was this picture that so injured the effect of two portraits by Lawrence, near to which it hung in the Academy, that Turner darkened it upon varnishing day with a coat of lamp-black in water-colour: see *Lectures on Architecture and Painting*, § 104 (Vol. XII. p. 131), and *Fors Clavigera*, Letter xxvi.; see also above, p. 47.]

into angry spots; or else, by laying on liquid tints with too much vehicle in them, which cracked as they dried; or solid tints, with too little vehicle in them, which dried into powder and fell off; or painting the whole on an ill-prepared canvas, from which the picture peeled like the bark from a birch-tree; or using a wrong white, which turned black; or a wrong red, which turned grey; or a wrong yellow, which turned brown. But, one way or another, all but eight or ten of his later pictures have gone to pieces, or worse than pieces—ghosts, which are supposed to be representations of their living presence. This "Childe Harold" is a ghost only. What amount of change has passed upon it may be seen by examining the bridge over the river on the right. There either was, or was intended to be, a drawbridge or wooden bridge over the gaps between the two ruined piers. But either the intention of bridge was painted over, and has penetrated again through the disappearing upper colour; or (which I rather think) the realization of bridge was once there, and is disappearing itself. Either way, the change is fatal; and there is hardly a single passage of colour throughout the cool tones of the picture which has not lost nearly as much. It would be less baneful if all the colours faded together amicably; but they are in a state of perpetual revolution; one staying as it was, and the others blackening or fading about it, and falling out with it, in irregular degrees, never more by any reparation to be reconciled. Nevertheless, even in its present state, all the landscape on this right hand portion of the picture is exquisitely beautiful—founded on faithful reminiscences of the defiles of Narni, and the roots of the Apennines, seen under purple evening light. The tenderness of the mere painting, by which this light is expressed, is not only far beyond his former work, but it is so great that the eye can hardly follow the gradations of hue; it can feel, but cannot trace them. On what mere particles of colour the effect depends may be well seen in the central tower of the distant city, on the hill beyond the bridge.

The side of it turned away from the light receives a rosy
reflection from the other buildings in the town; and this re-
flection will be found, on looking close, to be expressed with
three touches of vermilion, laid on the blue distant ground,
the touches being as fine as the filament of a feather. Their
effect depends on their own perfect purity, and on the blue
ground showing between them; they must be put on pre-
cisely in the right place and quantity at once, and be left;
they cannot be stirred or disturbed afterwards, or all would
be lost. The common ideas about oil-painting—that it is a
daubing and ponderous process—that it admits of alteration
to any extent—that a touch is to be gradually finished up,
or softened down, into shape; and so on—are at once, and
most wholesomely, set at nought by such work as this.[1] It
is very interesting to walk back from this " Childe Harold "
to the " View on Clapham Common "[2] and observe the
intensity of the change of subject and method: the thick,
plastered, rolling white paint of the one, and the silvery
films of the other; the heavy and hot yellow of the one,
and the pale rosy rays of the other, touched with pencillings
so light, that, if the ground had been a butterfly's wing,
they would not have stirred a grain of its azure dust.

The respective skill of each piece of painting may be
practically tested by any artist who likes to try to copy
both. The early work will be found quite within reach;
but the late work wholly unapproachable. He would be
a rash painter, whatever his name, whatever his supposed
rank, who should accept a challenge to copy as much as
three inches square of any part of that " Childe Harold "
distance.

But the change in choice of subject is more remarkable
still. Age usually makes men prosaic and cold; and we
look back to the days of youth as alone those of the burn-
ing vision and the brightening hope: we may perhaps gain

[1] [For other instances of delicate effects of the kind here mentioned, see *Elements
of Drawing*, § 71 n.]
[2] [No. 468; above, p. 103.]

in kindness and unselfishness, but we lose our impressibleness. The old man may praise and help the youth's enthusiasm—may even be wise enough to envy it—but can seldom share it: the sympathy which he grants to the passion or the imagination of younger hearts, is granted with a smile, and he turns away presently to his brave prose of daily toil, and brave dealing with daily fact. But in Turner, the course of advancing mind was the exact reverse of this: we find him, as a boy, at work, with heavy hand and undiverted eye, on the dusty Clapham Common road: but, as a man in middle life, wandering in dreams in the Italian twilight. As a boy, we find him alternately satirical and compassionate: all-observant of human action, sorrow, and weakness: curious of fishermen and fisherwives' quarrels—watchful of Jason's footstep over the dry bones to the serpent's den. But as the man in middle life, he mocks no more—he fears, he weeps no more: his foregrounds now are covered with flowers; the dust and the dry dead bones are all passed by: the sky is calm and clear — the rack of the clouds, and rending of the salt winds are forgotten. His whole soul is set to watch the wreaths of mist among the foldings of the hills; and listen to the lapse of the river waves in their fairest gliding. And thus the richest and sweetest passages of Byron, which usually address themselves most to the imagination of youth, became an inspiration to Turner in his later years: and an inspiration so compelling, that, while he only illustrated here and there a detached passage from other poets, he endeavoured, as far as in him lay, to delineate the whole mind of Byron. He fastened on incidents related in other poems; this is the only picture he ever painted to illustrate the poet's own mind and pilgrimage.

And the illustration is imperfect, just because it misses the *manliest* characters of Byron's mind: Turner was fitter to paint Childe Harold when he himself could both mock and weep, than now, when he can only dream: and, beautiful as the dream may be, he but joins in' the injustice

144 THE TURNER BEQUEST

too many have done to Byron, in dwelling rather on the passionate than the reflective and analytic elements of his intellect.[1] I believe no great power is sent on earth to be wasted, but that it must, in some sort, do an appointed work: and Byron would not have done this work, if he had only given melody to the passions, and majesty to the pangs, of men. His clear insight into their foibles; his deep sympathy with justice, kindness, and courage; his intense reach of pity, never failing, however far he had to stoop to lay his hand on a human heart, have all been lost sight of, either in too fond admiration of his slighter gifts, or in narrow judgment of the errors which burst into all the more flagrant manifestation, just because they were inconsistent with half his soul, and could never become incarnate, accepted, silent sin, but had still to fight for their hold on him.[2] Turner was strongly influenced, from this time forward, by Byron's love of nature; but it is curious how unaware he seems of the sterner war of his will and intellect; and how little this quiet and fair landscape, with its delicate ruin, and softened light, does in reality express the tones of thought into which Harold falls oftenest, in that watchful and weary pilgrimage.

The failure, both as a picture and as a type, is chiefly on the left hand, where the scene is confused, impossible, and unaffecting. I believe most spectators will enjoy the other portions of the composition best by treating it as I have asked them to do the "Bay of Baiæ"; using, however, a somewhat larger opening for sight, so as to include at need the two reaches of the river.

There are some noticeable matters, here also, in the drawing of the stone pine. We saw that those in the "Bay of

[1] [An injustice which Ruskin set himself to correct in *Fiction, Fair and Foul:* see §§ 56 *seq.* ; and for another reference to Byron, see below, p. 447.]

[2] [See, for instance, the lines in *Manfred:*—

> " I have ceased
> To justify my deeds unto myself,
> The last infirmity of evil—"

The whole passage (Act i. sc. 2) is illustrative of what Ruskin here says of the poet's sympathy with and analytic grasp of a soul struggling with evil.]

Baiæ" had no resemblance to the real tree, except, as I said, in shade and heavy-headedness. But this pine has something of the natural growth of the tree, both in its flatter top and stiffer character of bough : and thus, though the leaves are not yet right pine leaves, naturalism is gradually prevailing over idealism. One step farther, and in the third period we find the pine in the "Phryne" (No. 522) wholly unconventionalized, and perfect in expression of jagged leaf. The wild fantasticism in the twisting of the bough is, however, studied from the Scotch fir, not the stone pine; for Turner had not had, for a long time, any opportunity of studying pines, and was obliged to take the nearest thing he could get from nature; when his conventional round mass with witch-elm sprays, was for ever forbidden to him. But through all these phases of increasing specific accuracy, the bough drawing, considered as a general expression of woody character, was quite exquisite. It is so delicate in its finish of curves, that, at first, the eye does not follow them; but if you look close into the apparently straight bough, the lowest and longest on the left of this pine in the "Childe Harold," you will find there is not a single hair's-breadth of it without its soft changes of elastic curve and living line. If you can draw at all accurately and delicately, you cannot receive a more valuable lesson than you will by outlining this bough, of its real size, with scrupulous care, and then outlining and comparing with it some of the two-pronged barbarisms of Wilson * in the tree on the left of his "Villa of Mæcenas" (No. 108).

* For farther illustration of this subject, see *Modern Painters*, vol. iii. ch. ix. § 14, etc. [Vol. V. p. 162.]

V. GENERAL CHARACTERISTICS OF THE THIRD PERIOD

[1835-1845]

As Turner became more and more accustomed to, and satisfied in, the principles of art he had introduced, his mind naturally dwelt upon them with less of the pride of discovery, and turned more and more to the noble subjects of natural colour and effect, which he found himself now able to represent. He began to think less of showing or trying what he *could* do, and more of actually doing this or that beautiful thing. It was no more a question with him how many alternations of blue with gold he could crowd into a canvas, but how nearly he could reach the actual blue of the Bay of Uri, when the dawn was on its golden cliffs. I believe, also, that in powerful minds there is generally, towards age, a return to the superstitious love of Nature which they felt in their youth: and assuredly, as Turner drew towards old age, the aspect of mechanical effort and ambitious accumulation fade from his work, and a deep imaginative delight, and tender rest in the loveliness of what he had learned to see in Nature, take their place. It is true that when goaded by the reproaches cast upon him, he would often meet contempt with contempt, and paint, not, as in his middle period, to prove his power, but merely to astonish, or to defy, his critics. Often, also, he would play with his Academy work, and engage in colour tournaments with his painter-friends; the spirit which prompted such jests or challenges being natural enough to a mind now no longer in a state of doubt, but conscious of confirmed power. But here, again, the evil attendant on such play, or scorn, becomes concentrated in the Academy pictures; while the real strength and majesty of his mind are seen undiminished only in the sketches which he made

during his summer journeys for his own pleasure, and in the drawings he completed from them.

Another notable characteristic of this period is, that though the mind was in a state of comparative repose, and capable of play at idle moments, it was, in its depth, infinitely more serious than heretofore—nearly all the subjects on which it dwelt having now some pathetic meaning. Formerly he painted the *Victory* in her triumph, but now the *Old Téméraire* in her decay; formerly Napoleon at Marengo, now Napoleon at St. Helena; formerly the Ducal Palace at Venice, now the Cemetery at Murano; formerly the Studies[1] of Vandevelde, now the Burial of Wilkie.[2]

Lastly, though in most respects this is the crowning period of Turner's genius, in a few, there are evidences in it of approaching decline. As we have seen, in each former phase of his efforts, that the full character was not developed till about its central year, so in this last the full character was not developed till the year 1840, and that character involved, in the very fulness of its imaginative beauty, some loss of distinctness; some absence of deliberation in arrangement; and, as we approach nearer and nearer the period of decline, considerable feebleness of hand. These several deficiencies, when they happen to be united in one of the fantasies struck out during retouching days at the Academy, produce results which, at the time they appeared, might have justified a regretful criticism, provided only that criticism had been offered under such sense of the painter's real greatness as might have rendered it acceptable or serviceable to him; whereas, being expressed in terms as insulting to his then existing power as forgetful

[1] [In eds. 1–4 "Life," instead of "Studies" an instance of Ruskin sacrificing on revision a more effective contrast for a more accurate statement.]

[2] [The pictures here referred to are: "The Death of Nelson," No. 480 in the National Gallery, exhibited 1808, and the "*Old Téméraire*," No. 524, exhibited 1839; the vignette for Rogers' *Italy* (1830), No. 204 in the water-colours, and "The Exile and the Rock Limpet," No. 529, exhibited 1842; a Venice such as No. 370 in the National Gallery (1833), and the "Campo Santo" (for which see Vol. III. p. 251 n.), exhibited in 1842; the "Studies of Vandevelde" were such as the "Dutch Boats in a Gale" (for which see Vol. XII. p. 373), exhibited in 1801.]

of his past, they merely checked his efforts, challenged his caprices, and accelerated his decline.

Technically speaking, there are few trenchant distinctions between works of the second and third period. The most definite is, that the *figures* of the second period have faces and bodies more or less inclining to flesh colour; but in the third period the faces at least are white-looking like chalked masks (why we shall inquire presently), and the limbs usually white, with scarlet reflected lights. It is also to be observed that after the full development of the third manner, in 1840, no more foliage is satisfactorily painted, and it rarely occurs in any prominent mass.

VI. PICTURES OF THE THIRD PERIOD

[1835–1845]

520. APOLLO AND DAPHNE (1837).

Although this, like nearly all the works prepared for the Academy, is injured by excessive quantity, and is painfully divided into two lateral masses, with an unimportant centre, those lateral masses are nearly unequalled in beauty of mountain drawing. By looking back to the "Hesperides," and comparing the masses of mountain there with these, the *naturalism* of the last period will be easily felt. All these mountains in the "Daphne" are possible—nay, they are almost reminiscences of real ranges on the flanks of Swiss valleys; the few scattered stones of the Hesperides have become innumerable ridges of rock; the overhanging cliffs of the Hesperides have become possible and beautiful slopes; the dead colours of the Hesperides are changed into

azure and amber. The reader will find farther references
to the mountain drawing of this " Daphne " in *Modern
Painters ;* [1] but it would take too much space to insist
upon them here.[2]

It is necessary, however, that the reader should in this
case, as in that of the " Bay of Baiæ," understand Turner's
meaning in the figures, and their relation to the landscape.[3]
Daphne was the daughter of the river Peneus, the most
fertilizing of the Greek rivers, by the goddess Terra (the
earth). She represents, therefore, the spirit of all foliage,
as springing from the earth, watered by rivers ;—rather than
the laurel merely. Apollo became enamoured of her, on
the shore of the Peneus itself—that is to say, either in the
great vale of Larissa, or in that of Tempe. The scene is
here meant for Tempe, because it opens to the sea : it is
not in the least *like* Tempe, which is a narrow ravine :
but it expressed the accepted idea of the valley as far as
Turner could interpret it, it having long been a type to us
moderns of all lovely glens or vales descending from the

[1] [The reference given in eds. 1–4 was "vol. i. third edition, p. 296," in ed. 5,
"vol. i., fifth edition, p. 294." See in this edition Vol. III. pp. 453, 461. See also,
for other references to the picture, Vol. III. p. 337 (the acanthus leaves on the
capital); Vol. V. p. 391 (where, however, the picture is classed with the painter's
"meaningless classical compositions"); Vol. VI. p. 353 (the mountain drawing
again); and *Modern Painters,* vol. v. pt. vi. ch. x. § 20 (its luxuriance of detail). It
should be noted that throughout *Modern Painters* Ruskin calls the picture " Daphne
and Leucippus."]

[2] [Eds. 1–4 add : "as it may be long before the picture is placed where any of its
more subtle merit can be seen."]

[3] [The lines quoted by Turner in the Academy Catalogue were these :—

" Sure is my bow, unerring is my dart ;
But, ah ! more deadly his who pierced my heart.
.
As when the impatient greyhound, slipt from far,
Bounds o'er the glebe to course the fearful hare,
She, in her speed, does all her safety lay ;
And he, with double speed, pursues the prey."
—Ovid's *Metamorphoses.*

The translation is Dryden's, and for the meaning of the fable Turner doubtless
consulted Lemprière (see above, p. 108 *n.*). The references in Ruskin's text are to the
Metamorphoses, book i. 463–464 (*Figat tuus omnia, Phœbe, Te meus arcus, ait*); 533
(*Ut canis in vacuo leporem cum Gallicus arvo,* etc.); 544 (*Spectans Peneidas undas*);
and, in the last lines, 577–583.]

mountains to the sea. The immediate cause of Apollo's servitude to Daphne was his having insulted Cupid, and mocked at his arrows. Cupid answered, simply, " Thy bow strikes all things, Apollo, but mine shall strike *Thee.*"

The boy god is seen in the picture behind Apollo and Daphne. Afterwards, when Daphne flies and Apollo pursues, Ovid compares them to a dog of Gaul, coursing a hare—the greyhound and hare Turner has, therefore, put into the foreground. When Daphne is nearly exhausted, she appeals to her father, the river Peneus—"gazing at his waves"—and he transforms her into a laurel on his shore. That is to say, the life of the foliage—the child of the river and the earth—appeals again to the river, when the sun would burn it up; and the river protects it with its flow and spray, keeping it green for ever.

So then the whole picture is to be illustrative of the union of the rivers and the earth; and of the perpetual help and delight granted by the streams, in their dew, to the earth's foliage. Observe, therefore, that Turner has put his whole strength into the expression of the roundings of the hills under the influence of the torrents; has insisted on the loveliest features of mountain scenery when full of rivers, in the quiet and clear lake on the one side, and the gleaming and tender waterfalls on the other: has covered his foreground with the richest foliage, and indicated the relations of the whole to civilization in the temples and village of the plain. It was quite natural that Turner should suppose Tempe a larger vale than it is, from Ovid's own description of the rivers meeting in it. "There the rivers meet: Spercheus crowned with poplar; and disquieted Enipeus, and aged Apidanus, and gentle Amphrysus, and Æas, and the other rivers, who, where the impulse urges them, lead to the sea their waves, wearied with winding; only Inachus is not there: he, hidden in the cave, increases his springs with weeping."

519. REGULUS LEAVING ROME (1837 *).

A picture very disgraceful to Turner, and as valueless as
any work of the third period can be; done wholly against
the instincts of the painter at this time, in wicked relapse
into the old rivalry with Claude.[1] The great fault is the
confusion of the radiation of light from the sun with its re-
flection—one proof, among thousands of other manifest ones,
that truth and greatness were only granted to Turner on
condition of his absolutely following his natural feeling, and
that if ever he contradicted it, that moment his knowledge
and his art failed him also.

522. PHRYNE GOING TO THE BATH (1838).[2]

We have already ascertained the meaning, and noted the
principal beauty of this picture, which, however, we must
pause at again, for it is a work of primal importance, as re-
presentative of the last labours of Turner. No other work,
so far studied, exists of his third period, and, by rare good
fortune, of all the pictures dating after 1820 in the posses-
sion of the nation, this is the least injured. I cannot trace
positive deterioration in any part of it, except the sky; and
I believe it to be otherwise very nearly safe, and accurately
representative of what the painter's later work was when it
first appeared in the Academy, and was intended by him to
remain. And this being so, the question is suggested to us
very forcibly, what could be meant by those chalk-faced and
crimson-limbed figures, and what was his theory respecting
the function of figures in landscape?[3]

* Exhibited in 1837, but, I believe, painted some years before.[4]

[1] [But see Vol. XII. p. 408.]
[2] [Now transferred to Oldham. See above, pp. 107–109.]
[3] [On the subject of Turner's figures, compare *Modern Painters*, vol. i. (Vol. III.
p. 325).]
[4] [Exhibited at the British Institution in that year; now transferred to Dublin.
The picture is said to have been painted at Rome in 1829.]

I think, in the first place, the reader will admit, from
what he has seen of the earlier Turner paintings, that he is
distinguished from all other modern landscape painters by
his strong human sympathy.[1] It may be a disputed point
—and I do not care here to agitate it — whether Claude's
" St. George and the Dragon," or his " Moses and the Burn-
ing Bush," or Salvator's " Finding of Œdipus," or Gaspar
Poussin's " Dido and Æneas,"[2] are expressive of such sym-
pathy or not; but, among modern painters, it is indisput-
able that the figures are merely put in to make the pictures
gay, and rarely claim any greater interest than may attach
to the trade of the city, or labour of the field. Sometimes
lovers in a glade, or gypsies on a common, or travellers
caught in rain, may render more sentimental or dramatic
the fall of shade or shower; but, beyond this, no motive for
sympathy is ever presented, and, for the most part, the
scarlet bodice, or rustic blouse, are all that we are supposed
to require, to give us the sense of motion in the street, or
life in the landscape. But we have seen that in almost
every one of Turner's subjects there is some affecting or
instructive relation to it in the figures; that the incident he
introduces is rarely shallow in thought, but reaches either
tragedy, as in the " Hesperides," or humour, as in the
" Calais Pier "; and that in his first carrying out of these
thoughts he showed a command of human expression no
less striking than his grasp of pictorial effects. How is it
then, that, in his time of fully developed strength, the figure
has become little more than a chalk puppet?
 First. The usual complaints made about his *bad* figure-
drawing arise, in reality, from the complainant's not being
sufficiently sensible of the nobleness of *good* figure-drawing.

[1] [To this aspect of Turner's mind, Ruskin returned in *Modern Painters*, vol. v.
pt. ix. ch. xi. Compare also Vol. VI. p. 26, and Vol. XII. pp. 368, 371.]
[2] [Ruskin describes and ridicules Claude's " St. George and the Dragon" in *Modern
Painters*, vol. v. pt. ix. ch. v. § 13; and "Moses at the Burning Bush," in *Modern
Painters*, vol. iii. ch. xviii. § 26 (Vol. V. p. 403). For a reference to Salvator's
" Œdipus," see *ibid.*, vol. iii. ch. ix. § 9 (Vol. III. p. 159), and vol. v. pt. vi. ch. viii.
§ 7. For Poussin's "Dido and Æneas" (No. 95 in the National Gallery), see Vol. III.
pp. 277, 577, 588 *n.*, and Vol. IV. p. 243.]

Figures cannot be drawn even moderately or endurably well, unless the whole life be given to their study; and *any* figure which a professed landscape painter can paint, is still so far from the standard of real truth and excellence, that it is better no serious attempt whatever should be made in that direction. Each figure in Callcott's landscapes, for instance, while it sets itself up for being right, is so miserably inferior to the worst and idlest outline of Mulready or Wilkie, that it only sickens the heart of any man who feels what figure-painting should be; much more if he thinks of Titian or Veronese: the first impulse of such a just judge would be to snatch up a brush, and dash the palsied bit of draperied doll half out, and give it a pair of red dots for eyes, and so leave it—*claiming* thus to be no more than it really is—abortive and despicable. And thus it is, for one reason, that just as Turner feels the more and more what figures should be, he paints them less and less.

Secondly. Supposing that the power of figure-drawing were attainable by the landscape painter, the time necessary to complete the delineation of a crowd in one foreground would be more than is necessary in general for all the landscapes of the year. Supposing those figures in the "Phryne" properly and completely painted, certainly no more than that one picture could have been painted in the year. Now the main power of Turner's mind was in its fertility of conception; and it would have been wrong, even if it had been possible, for him to leave myriads of beautiful landscape imaginations unrecorded, while he was rounding shoulders and ankles from academy models. But, once grant that the figures are to be left sketchy, and it rests with those who blame Turner to show that any other way of sketching them is better than his. They have now a fair opportunity of trying. Let them copy the landscape of this "Phryne" as it is; then put in the figures in their own improved way: and I believe they will find they have spoiled their picture.

Thirdly. Whenever figures are brilliantly dressed, or in

full light in a sunny landscape, they always lead the eye, and throw the rest of the scene into more or less retiring colour. Now, in pursuit of his newly discovered facts about colour, Turner had reached the top of his scale, or nearly so, in the sky, and the foliage, and the hills; he felt, however, still that the figures ought to lead the light — and nothing *would* lead it, in pictures of so high a key, but absolute white, and masses of pure colour, which accordingly he gives them. I think, however, this was an error, correspondent exactly to the error on the opposite side, which made the early landscapists paint their shades too black, to *throw out* their lights. So Turner paints his figures too white, to *subdue* his lights. Both carried out a principle, true in itself, too far.

I say this of Turner with diffidence, however, not having yet made up my mind about these later figures; only I know that he never raised his figures to so high a key in his drawings, and I think the result was in these more satisfactory.

Fourthly. Although there is much to shock, and more to surprise the eye in this late figure-painting, there are merits in it which serious study would show to be of a high order. The colours used are too violent; but the choice of these colours, and the adjustment of their relations, are always right. Pure vermilion does not rightly represent the transparent scarlets of flesh; but the fact that transparent scarlets *are* in flesh, instead of grey and brown, is a noble fact, which it was better to perceive and declare, however imperfectly, than, for the sake of affronting nobody, to keep to the old and generally accepted colours. And the infinitudes of gradation, and accurately reflected colour, which Turner has wrought into these strange figure groups, are nearly as admirable as the other portions of this work; only the admirableness is of a kind which is only artistical, and only to be perceived by artists, so that I do not trouble the general reader by further insisting on it. Without any artistical knowledge, however, he may perceive

one kind of merit in these figures — their freedom, fire, and frequent grace of action ; and a little watching of this involved troop of girls, tossing the white statue of Cupid far into the air out of the midst of them, will enable the spectator to conceive for himself, merely a little rejecting or modifying the Turnerian eccentricities, what such a wild flight of Greek girl-gladness must have been, infinitely more earnestly and justly than any, the most careful and perfect Academy drawing (that I have seen) by modern hands.

Lastly. Notwithstanding his deep sympathy and imaginative power, there was, throughout Turner's later life, an infirmity in his figure conception which has always been to me, out of the whole multitude of questions and mysteries that have come across me concerning art, the most inexplicable. With the most exquisite sense of grace and proportion in other forms, he continually admits awkwardnesses and errors in his figures which a child of ten years old would have avoided. Sometimes, as in his drawing of Gosport,[1] he twists a head right round upon the shoulders : constantly he makes the head half a foot too high, as in the figure of Apollo in the "Bay of Baiæ" : legs that will not join the trunk are frequent also : but his favourite mismanagement of all is, putting one eye an inch or two higher than the other. As I have just stated, this is, for the most part, wholly inexplicable to me : all that I can guess respecting it is, that he had got so much into the habit of weaving natural forms—rocks, boughs, and waves —into exactly the shapes that would best help his composition, that when he came to an unsubdueable form in man or animal, he could not endure the resistance, and lifted features out of their places as he would have raised or dropped one window in a tower whose equalities tormented him ; and wrung a neck as remorselessly as he would have twisted a bough, to get it into the light or shade he

[1] [See below, p. 439.]

wanted. I do not mean, of course, to advance this as an
excuse for the proceeding, but as a conceivable motive for
it. The infirmity which prevented his being hurt by such
derangements, was, I believe, essential to his having become
a landscape painter at all. If he had had as fine an eye
for human beauty as he had keen interest in human feeling,
he would assuredly have been drawn into pure historical
painting: and we should have had (oil-painting not being
properly understood among us) a series of imperfectly exe-
cuted figure subjects, uniting Tintoret's fancy with Vero-
nese's colour, but hollow and false in conception, because
figure models suggestive of colour do not exist in the real
life around us, and he would have pursued a false ideal,
like Etty. He was not permitted thus to waste his life,
but his escape from such a fate was, I believe, very narrow.
He studied figure-painting carefully, and not unsuccessfully,
for some time ; and when he was about seventeen, painted
a portrait of himself, which will bear no very disadvan-
tageous comparison with the earlier and firmly handled
portraits of Watson and Raeburn.* A picture of a smith's
shop,[1] which seems to have been painted, soon after, in
emulation of Wilkie, perhaps convinced him of his weak-
ness in more delicate figure-drawing, and delivered him for
ever to the teaching of the clouds and hills. With what
intent, or against how great a sense of failure he persisted

* This portrait he gave to his housekeeper, who bequeathed it to me,
and it is now in my possession, fortunately in a perfect state of preserva-
tion. The likeness must have been a striking one, for all who knew
Turner well can trace the features and the glance of the old man through
the glow of youth ; and recognize the form of the grey forehead under
the shadow of the long flowing chestnut hair. The portrait, also by his
own hand, painted later in life, in the National collection, is less striking
in resemblance.[2]

[1] [No. 478 in the National Gallery. Exhibited at the Academy in 1807 and
sold. Turner seems to have had an affection for the picture, for he bought it back in
1827.]
[2] [No. 458. For the portrait in Ruskin's collection, see below, p. 473. It is
reproduced as the frontispiece to this volume. To Raeburn Ruskin does not else-
where refer. George Watson (1767-1837) was President of the Scottish Academy.]

in occasional experiments on the figure, such as the "Boc-
caccio" and "Shadrach,"[1] I cannot tell; but the infirmity
increased with age: and in the "Ariadne" of No. 525, the
public may see, as far as I am aware, the worst figure that
Turner ever painted, and perhaps that was ever painted by
anybody. I have not the least wish to conceal Turner's
defects (or any one else's); on the contrary, I think the
denial of defects in heroes, one of the most baneful abuses
of truth of which the world is guilty. But though the
faults of a great or good man should never be extenuated,
they should be much forgiven, and at times forgotten. It
is wrong and unwise to expose defects in a time or place
when they take away our power of feeling virtues; and I
should be glad if all these figure-pictures, with the "Fall
of Carthage," the "Regulus,"[2] and one or two of the last
works (between 1845 and 1850), were placed in a con-
demned cell, or chamber of humiliation, by themselves;
always, however, in good light, so that people who wished
to see the sins of Turner, might examine them to their
entire satisfaction—but not exhibited where they only serve
to prompt and attract ridicule, suggest doubts of real excel-
lence, and mingle pain with enjoyment, and regret with
admiration.

I cannot, however, leave this Phryne without once more
commending it to the reader's most careful study. Its
feeling is exquisite; the invention of incident quite end-
less—from the inlaid marbles of the pavement to the out-
most fold of fading hills, there is not a square inch of the
picture without its group of fancies: its colour, though
broken in general effect, is incomparably beautiful and bril-
liant in detail; and there is as much architectural design
and landscape gardening in the middle distance as would
be worth, to any student of Renaissance composition, at
least twenty separate journeys to Genoa and Vicenza. For

[1] [For these pictures see above, pp. 135–136.]
[2] [These pictures have been consigned to provincial galleries. The "Fall" (No. 499) is at Manchester; "Regulus leaving Rome" (No. 519), at Dublin.]

those who like towers better than temples, and wild hills
better than walled terraces, the second distance, reaching to
the horizon, will be found equally rich in its gifts.

523. AGRIPPINA [LANDING WITH THE ASHES OF GER-MANICUS] (1839).

There was once some wonderful light in this painting,
but it has been chilled by time. If it were in a better
place, there would be seen some noble passages in it;[1] but
architecture of the class here chosen is unavailable for pro-
ducing an impressive picture.

524.

I pass by this picture for the moment; we shall return
to it presently.[2]

525. BACCHUS AND ARIADNE (1840).[3]

This 1840 picture is interesting, as the first exhibited
in the Academy which was indicative of definite failure in
power of hand and eye; the trees being altogether ill painted,
and especially uncertain in form of stem. Of the figures I
have spoken already. There are pretty passages in the
distance, but none which can be considered as redeeming;
it should be banished from these walls with all kindly haste.

527. VENICE: THE BRIDGE OF SIGHS (1840).[4]

One of the worst of Turner's later pictures. He had at
this time quite lost the power of painting architectural de-
tail, and his feeling for *Gothic* architecture had never, at any
period of his life, been true, owing to his early education

[1] [This picture is now hung "on the line."]
[2] [See below, p. 167.]
[3] [Now transferred to the Corporation Gallery at Sheffield.]
[Now transferred to Leicester.]

among classical models.[1] He always painted it too white.
He has, besides, altered the proportions of the windows
of the Ducal Palace, thrust the prison out of its line
some points round to the north, and raised the Bridge of
Sighs much too high. But the great singularity of the
picture is, that, with a caprice much resembling many of
Tintoret's, he has striven to be gay where every one else
would have been gloomy, and painted the Bridge of Sighs
in intense light—all white against tender blue, as if it had
been just built of alabaster for a queen to cross at her
bridal. We have seen him get into the same temper be-
side the Lake Avernus. There seemed through all his life
to be one main sorrow and fear haunting him—a sense of
the passing away, or else the destructive and tempting
character of beauty. The choice of subject for a clue
to all his compositions, the "Fallacies of Hope," marked
this strongly; and he would constantly express an extreme
beauty where he *meant* that there was most threatening
and ultimate sorrow. Compare, in the present series, this
picture, the "Golden Bough," the "Phryne," and the "Sun
of Venice."[2]

528. [PEACE]: THE BURIAL OF WILKIE (1842).

Spoiled by Turner's endeavour to give funereal and un-
natural blackness to the sails.[3] There is considerable power
in parts of it, but it has no high merit, nor material interest.

[1] [On this subject, compare below, p. 499; *Modern Painters*, vol. iii. (Vol. V. p. 392), and vol. v. pt. ix. ch. x. § 3 n.]
[2] [For the "Golden Bough," see above, p. 133, and for "Phryne," pp. 107, 151. For the "Sun of Venice," No. 535, see below, p. 163.]
[3] [Turner affixed in the Academy Catalogue the following lines:—

"The midnight torch gleam'd o'er the steamer's side,
And Merit's corse was yielded to the tide."
—*MS. Fallacies of Hope.*

Shortly after Wilkie's death Turner said to his friend Jones, "I suppose no one will do anything to commemorate Wilkie?" "I shall pay a humble tribute," replied Jones, "by making a drawing representing his funeral." "How will you do it?" "On the deck of the vessel, as it has been described to me by persons present, and at the time that Wilkie's body was lowered into the sea." "Well," said Turner,

There are several pictures of this kind in the National collection, which are all but valueless among so many beautiful ones, but which would be precious to students in our provincial towns.[1] Surely it would be well if one or two could thus be set on active and honourable service, instead of remaining, as they must in the principal gallery, subjects for languid contemplation, or vague regret.

529. [WAR] : THE EXILE AND THE ROCK LIMPET (1842).[2]

Once a noble piece of colour, now quite changed, just at the focus of light where the sun is setting, and injured everywhere. The figure is not, however, in reality quite so ill drawn as it looks, its appearance of caricatured length being in great part owing to the strong reflection of the limbs, mistaken by the eye, at a distance, for part of the limbs themselves.

The lines which Turner gave with this picture are very important, being the only verbal expression of that association in his mind of sunset colour with blood, before spoken of :[3]—

> " Ah, thy tent-formed shell is like
> A soldier's nightly bivouac, alone
> Amidst a sea of blood.——
> —— But *you* can join your comrades."

"I will do it as it must have appeared off the coast." Clarkson objected to the unnatural blackness of the sails at the time, and Turner is said to have replied, "If I could find anything blacker than black I'd use it" (Hamerton's *Life of Turner,* p. 292). "It is very like Turner," says Jones, who tells the story, "to have indicated mourning by this means, probably retaining some confused notions of the death of Ægeus and the black sails of the returning Theseus."]

[1] [Many pictures belonging to the National Gallery, including several by Turner, have, since Ruskin wrote, been removed to provincial art galleries. That the "Burial of Wilkie" is not among them, can hardly be regretted. Unfortunately the pictures transferred to other galleries include several—*e.g.,* especially the "Golden Bough" and the "Phryne"—which are spoken of as examples, not of Turner's failure, but of his power, and as requiring, for their proper understanding, to be seen in connexion with others, now separated from them (see on this subject, Introduction, p. xli.]

[2] [No longer exhibited in the public gallery owing to want of space; it is hung in the Board Room. For other references to the picture (under the title "Napoleon" or "Napoleon at St. Helena," see *Modern Painters,* vol. i. (Vol. III. pp. 273, 297, 364, 422, 474); vol. iv. (Vol. VI. p. 381); vol. v. pt. vii. ch. ii. § 16, pt. ix. ch. xi. §§ 30, 31 *nn.*]

[3] [On p. 137. But see p. 125, above.]

The conceit of Napoleon's seeing a resemblance in the limpet's shell to a tent was thought trivial by most people at the time; [1] it may be so (though not to my mind); the second thought, that even this poor wave-washed disk had power and liberty, denied to *him*, will hardly, I think, be mocked at.

530. SNOWSTORM.[2]

In the year 1842 this picture was thus described by Turner in the Academy Catalogue:—

"Snowstorm. Steamboat off the harbour mouth making signals, and going by the lead. The author* was in this storm the night the *Ariel* left Harwich."

It was characterized by some of the critics of the day as a mass of "soapsuds and whitewash." Turner was passing the evening at my father's house on the day this criticism came out: and after dinner, sitting in his arm-chair by the fire, I heard him muttering low to himself at intervals, "Soapsuds and whitewash!" again, and again, and again. At last I went to him, asking "why he minded what they said?" Then he burst out;—"Soapsuds and whitewash! What would they have? I wonder what they think the sea's like? I wish they'd been in it."

The following anecdote[3] respecting this picture, and the conversation with Turner which arose out of the circumstance, were communicated to me by my friend the

* Note Turner's significant use of this word, instead of "artist."

[1] [Thus *Punch* (1844, vol. vi. p. 200) had ridiculed the picture as "The Duke of Wellington and the Shrimp," adding as motto—

"And can it be, thou hideous imp,
That life is, ah! how brief, and glory but a shrimp?"

And Thackeray in *Ainsworth's Magazine* (vol. i., 1842, p. 322) had remarked that "when the pictures are re-hung, as sometimes I believe is the case, it might perhaps be as well to turn these (the Napoleon and the Wilkie) upside down, and see how they would look *then*." The old painter felt these attacks acutely (see *Modern Painters*, vol. v. pt. ix. ch. xii. § 12).]

[2] [For further notices of this picture, see *Modern Painters*, vol. i. (Vol. III. pp. 297, 534, 571); vol. v. pt. ix. ch. xii. § 4 *n.*; and compare pp. 44, 110, above.]

[3] [The anecdote is given again in *Modern Painters*, vol. v. pt. ix. ch. xii. § 4 *n.*]

XIII. L

Rev. W. Kingsley, of Sidney College, Cambridge.[1] I give simply the words of his letter: there can be no need of insisting, in any wise, on the singular value of the record they contain.

"The story I told you about the 'Snowstorm' was this: —I had taken my mother and a cousin to see Turner's pictures, and, as my mother knows nothing about art, I was taking her down the gallery to look at the large 'Richmond Park,' but as we were passing the 'Snowstorm' she stopped before it, and I could hardly get her to look at any other picture; and she told me a great deal more about it than I had any notion of, though I have seen many sea storms. She had been in such a scene on the coast of Holland during the war. When, some time afterwards, I thanked Turner for his permission for her to see his pictures, I told him that he would not guess which had caught my mother's fancy, and then named the picture; and he then said, 'I did not paint it to be understood, but I wished to show what such a scene was like; I got the sailors to lash me to the mast to observe it; I was lashed for four hours, and I did not expect to escape, but I felt bound to record it if I did. But no one had any business to like the picture.' 'But,' said I, 'my mother once went through just such a scene, and it brought it all back to her.' 'Is your mother a painter?' 'No.' 'Then she ought to have been thinking of something else.' These were nearly his words; I observed at the time he used 'record'[2] and 'painting,' as the title 'author' had struck me before."

Interesting, however, as this picture is, in marking how far the sense of foaming mystery, and blinding whiteness of surf and salt, now influenced Turner's conception of the sea, rather than the old theories of black clouds relieving termi-nated edges of waves, the sea is, however, even thus, not quite right: it is not yeasty *enough*: the linear wave-action

[1] [The Reverend William Towler Kingsley, rector of South Kilverton, Thirsk; late Fellow and Tutor of Sidney Sussex College, Cambridge. See also below, pp. 335, 370 n., 533–536.]

[2] [Compare p. 535, below.]

is still too much dwelt upon, and confused with the true foam.

535. THE "SUN OF VENICE" GOING TO SEA (1843).[1]

Il Sole di Venezia is supposed to be the name of the fishing-boat. (I have actually seen this name on a boat's stern.) The nomenclature is emphasized by a painting of Venice, with the sun rising, on the mainsail of the boat, which, if the picture were hung lower,[2] the reader would find to be itself a little vignette. The compliment to the Venetian fisher as an artist is, however, a little overstrained. I have never seen any elaborate landscape on the sails, but often the sun, moon, and stars, with crosses and chequer patterns—sometimes a saint or madonna, rather more hard-featured than mainland saints.*

If the reader will look back from this picture to the "Ulysses," he will be struck by the apparent persistence of Turner's mind in the same idea of boat beauty; only the Venetian example is incomparably the loveliest, its sails being true in form and set, and exquisitely wrought in curve. The prevailing melancholy of Turner's mind at the time was, however, marked in the motto; Academy Catalogue, 1843:—

> Fair shines the morn, and soft the Zephyr blows;
> Venetia's fisher spreads his sail so gay,
> "Nor heeds the demon that in grim repose
> Expects his evening prey." †

* The reader will find nearly every variety of these sails drawn with unerring accuracy, and affectionate fidelity, in the later pictures of Mr. E. W. Cooke, and some account of their general character in my notes on the *Harbours of England.*[3]

† Turner seems to have revised his own additions to Gray, in the catalogues, as he did his pictures on the walls, with much discomfiture to the

[1] [For further references to this picture, see *Modern Painters*, vol. i. (Vol. III. pp. 250, 545); *Harbours of England*, p. 43, above ; and *Stones of Venice*, vol. i. App. ii. (Vol. IX. p. 435). . Pencil notes of parts of the picture, made by Ruskin at the Academy in 1843, were shown at the Ruskin Exhibition, Manchester, 1904 (No. 137). "He forgot, or ignored, the rule forbidding visitors at the Exhibition to copy the pictures. These are the sketches he made, and for making them was expelled from the gallery" (*Catalogue of the Ruskin Exhibition*, p. 47).]

[2] [The picture is now hung low.]

[3] [See above, p. 18; for E. W. Cooke's Venetian fishing-boats, see *Academy Notes*, 1856, No. 583 (Vol. XIV.).]

. The sea in this picture was once exquisitely beautiful: it is not very severely injured, but has lost much of its transparency in the green ripples. The sky was little more than flake white laid with the pallet-knife; it has got darker, and spotted, destroying the relief of the sails. The buildings in the distance are the ducal palace, dome of St. Mark's, and on the extreme left the tower of San Giorgio Maggiore. The ducal palace, as usual, is much too white, but with beautiful gradations in its relief against the morning mist. The marvellous brilliancy of the arrangement of colour in this picture renders it, to my mind, one of Turner's leading works in oil.

534. SAN BENEDETTO (1843).

This picture was exhibited in 1843, under the title of " San Benedetto, looking towards Fusina." [1] But the " San Benedetto " is a mistake of Turner's; there being no church

printer and the public. He wanted afterwards to make the first lines of this legend rhyme with each other; and to read :—

" Fair shines the morn, the Zephyr " (west wind) " blows a gale " ;
Venetia's fisher spreads his painted sail.

The two readings got confused, and, if I remember right, some of the

[1] [Eds. 1-3 read :—
"This picture is wrongly named in the published catalogue. The 'Approach to Venice,' painted in 1844, to illustrate Byron's lines [*Childe Harold*, iv. 27], was sold on the Academy walls, and is not among the pictures belonging to the nation. This one was exhibited in 1843," etc.
The picture is called in the official catalogue " Approach to Venice, looking towards Fusina," which correctly describes the scene, though as explained above the picture was otherwise named at the time of its first exhibition. For another reference to the picture, which was one of Ruskin's favourites, see *Modern Painters*, vol. i. (Vol. III. pp. 250, 251 *n*.). Writing to his father from Venice in 1852, he says :—
" 5th January.— . . . A curious thing happened to me on Saturday afternoon—I was rowing back from Fusina; and exactly at the very spot, and very time—five minutes before sunset—of Turner's picture, my old favourite —'San Benedetto looking towards Fusina'—to my great surprise there was, in the very place where he had put it in that picture, the very boat, one of a kind I had not seen before in Venice, a sort of covered waggon with a great curved rudder (I tried to draw it but did it so badly that I was ashamed, and cut it off). I asked my boatman directly whether it went regularly to Fusina. 'It used to do,' he said; it was the cheap passage boat to Padua before the railroad, but was now of course no more used except sometimes for luggage. So it was by mere accident, a most lucky one, that I got this little illustration of Turner's putting everything in its

nor quarter belonging to that saint on either side of the
Giudecca, or in any possible way included in this view.
The church of San Benedetto is deep in the town, close to
the Ca' Grimani; and the only way of accounting for the
title given, is that Turner might have half remembered the
less frequently occurring name of St. Biagio, under whose
protection the "fondamenta"—or block of houses on the
left of this picture—with some spacious barracks, are verily
placed. St. Biagio has no church, however; and the nearest
one which, by any stretch of imagination, could be gathered
into this view, is the little Santa Eufemia. The buildings
on the right are also, for the most part, imaginary in their
details, especially in the pretty bridge which connects two
of their masses: and yet, without one single accurate de-
tail, the picture is the likest thing to what it is meant for
—the looking out of the Giudecca landwards, at sunset—of
all that I have ever seen. The buildings have, in reality,
that proportion and character of mass, as one glides up the
centre of the tide stream: they float exactly in that strange,
mirage-ful, wistful way in the sea mist—rosy ghosts of
houses without foundations; the blue line of poplars and
copse about the Fusina marshes shows itself just in that
way on the horizon; the flowing gold of the water, and
quiet gold of the air, face and reflect each other just so;

catalogues read "soft the Zephyr blows a gale" and "spreads his painted
sail so gay"—to the great admiration of the collectors of the Sibylline
leaves of the "Fallacies of Hope."[1]

own place. For it was only in that picture, with its especial reference
to Fusina, that that boat could have been used. It never would have
been seen in any other part of Venice. Most likely Turner had come by it
and gone by it—"the *cheap* passage boat."
The original sketch for the picture is in the gallery; No. 69 in the water-colour col-
lection: see below, p. 215.]
 [1] [The passage from "The Bard" (ii. 2), which Turner used, is :—

 " Fair laughs the Morn, and soft the Zephyr blows,
 While proudly riding o'er the azure realm
 In gallant trim the gilded Vessel goes ;
 Youth on the prow, and Pleasure at the helm ;
 Regardless of the sweeping Whirlwind's sway,
 That, hushed in grim repose, expects his evening prey."]

the boats rest so, with their black prows poised in the midst
of the amber flame, or glide by so, the boatman stretched
far aslope upon his deep-laid oar.

Take it all in all, I think this the best Venetian picture
of Turner's which he has left to us; for the "Approach to
Venice" (of 1844), which was beyond all comparison the
best, is now a miserable wreck of dead colours.[1] *This* is
tolerably safe. The writer of the notes in the published
catalogue[2] is mistaken in supposing that the upper clouds
have changed in colour; they were always dark purple,
edged with scarlet; but they have got chilled and opaque.
The blue of the distance has altered slightly, making the
sun too visible a spot; but the water is little injured, and
I think it the best piece of surface painting which Turner
has left in oil colours. One of the strongest points in his
Venice painting is his understanding of the way a gondola
is rowed, owing to his affectionate studies of boats when
he was a boy, and throughout his life.[3] No other painters
ever give the thrust of the gondoliers rightly; they make
them bend affectedly—very often impossibly—flourishing
with the oar as if they stood up merely to show their
figures. Many of our painters even put the oar on the
wrong side of the boat.* The gondolier on the left side
of this picture, rowing the long barge, is exactly right, at
the moment of the main thrust. Nevertheless, considered
as a boatman, Turner is seriously to be blamed for allow-
ing the fouling of those two gondolas in the middle of the
picture, one of which must certainly have gone clear through
the other before they could get into their present position.

* The stern, or guiding oar of the gondola, is always on the right-hand
side. For more detailed account of the modes of rowing in Venice, see
Stones of Venice, vol. ii. Appendix I. [Vol. X. p. 441.]

[1] [The picture, now in the collection of Mrs. Moir, was shown at the Royal Jubilee
Exhibition, Manchester, 1887.]
[2] [The unofficial catalogue referred to in the note on p. 102.]
[3] [Compare *The Harbours*, above, pp. 40, 41, 45.]

549. UNDINE GIVING THE RING [TO MASANIELLO] (1846).

I shall take no notice of the three pictures painted in the period of decline.[1] It was ill-judged to exhibit them: they occupy to Turner's other works precisely the relation which *Count Robert of Paris* and *Castle Dangerous* hold to Scott's early novels.[2] They are also in positions which render it impossible to point out to the reader the *distinctive* characters in the execution, indicative of mental disease; though in reality these characters are so trenchant that the time of fatal change may be brought within a limit of three or four months, towards the close of the year 1845.

524. THE FIGHTING *TÉMÉRAIRE* * (1839).

I return to this picture, instead of taking it in its due order; and I think I shall be able to show reason for

* "The Fighting *Téméraire* tugged to her last berth, to be broken up [1838]."—*Acad. Catalogue.*[3]

[1] [The three pictures referred to are "Undine," "The Angel Standing in the Sun," No. 550, and "The Hero of a Hundred Fights," No. 551. They remain in the National Gallery, but are no longer publicly exhibited. In the first picture, Undine, the Water Nymph, surrounded by other nymphs, is rising from the waves, while to the right Masaniello is stooping to receive a ring from her; in the distance to the left, Vesuvius in eruption—a reference to the short-lived triumph of Masaniello, who led the fishermen's revolt at Naples in 1647, and for nine days ruled the city as chosen chief. The picture was much ridiculed by the critics. The subject of "The Angel Standing in the Sun" is from Revelation xix. 17, 18. To "The Hero of a Hundred Fights" (exhibited in 1847), Turner appended in the catalogue the following explanatory note: "An idea suggested by the German invocation upon casting the bell: in England called tapping the furnace.—Fallacies of Hope."]

[2] [Compare below, p. 409, and *Modern Painters*, vol. iv. (Vol. VI. p. 398).]

[3] [Turner added in the catalogue an adaptation from Campbell's "Ye Mariners of England":—

 "The flag which braved the battle and the breeze
 No longer owns her."

For other references to this picture, see above, *Harbours of England*, § 32, p. 41; *Modern Painters*, vol. i. (Vol. III. pp. 247, 249 n., 275, 286, 299, 364, 422); vol. iv. (Vol. VI. p. 381); and vol. v. pt. vii. ch. ii. § 16, pt. ix. ch. ix. § 8. And for the history of the *Téméraire*, *Dilecta*, pts. i. and ii.

The subject of the picture was suggested to Turner by Clarkson Stanfield. They

pleading that, whatever ultimate arrangement may be adopted for the Turner Gallery, this canvas may always close the series. I have stated in the *Harbours of England* that it was the last picture he ever executed with his *perfect power*;[1] but that statement needs some explanation. He produced, as late as the year 1843, works which, take them all in all, may rank among his greatest; but they were great by reason of their majestic or tender conception, more than by workmanship; and they show some failure in distinctness of sight, and firmness of hand. This is especially marked when any vegetation occurs, by imperfect and blunt rendering of the foliage; and the "*Old Téméraire*" is the last picture in which Turner's execution is as firm and faultless as in middle life;—the last in which lines requiring exquisite precision, such as those of the masts and yards of shipping, are drawn rightly, and at once. When he painted the "*Téméraire*," Turner could, if he had liked, have painted the "Shipwreck" or the "Ulysses" over again; but, when he painted the "Sun of Venice," though he was able to do different, and in some sort more beautiful things, he could not have done *those* again.

I consider, therefore, Turner's period of central power, entirely developed and entirely unabated, to begin with the "Ulysses," and close with the "*Téméraire*"; including a period, therefore, of ten years exactly, 1829–1839.

The one picture, it will be observed, is of sunrise; the other of sunset.

were going down the river by boat, to dine, perhaps, at Greenwich, when the old ship, being tugged to her last berth at Deptford, came in sight. "There's a fine subject, Turner," said Stanfield. This was in 1838. Next year the picture was exhibited at the Academy, but no price was put upon it. A would-be purchaser offered Turner 300 guineas for it. He replied that it was his "200-guinea size" only, and offered to take a commission at that price for any subject of the same size, but with the "*Téméraire*" itself he would not part. Another offer was subsequently made from America, which again Turner declined. He had already mentally included the picture, it would seem, amongst those to be bequeathed to the nation; and in one of the codicils to his will, in which he left each of his executors a picture to be chosen by them in turn, the "*Téméraire*" was excepted from the pictures they might choose.]
[1] [See above, p. 41.]

The one of a ship entering on its voyage; and the other of a ship closing its course for ever.

The one, in all the circumstances of its subject, unconsciously illustrative of his own life in its triumph.

The other, in all the circumstances of its subject, unconsciously illustrative of his own life in its decline.

I do not suppose that Turner, deep as his bye-thoughts often were, had any under meaning in either of these pictures: but, as accurately as the first sets forth his escape to the wild brightness of Nature, to reign amidst all her happy spirits, so does the last set forth his returning to die by the shore of the Thames:[1] the cold mists gathering over his strength, and all men crying out against him, and dragging the old "fighting *Téméraire*" out of their way, with dim, fuliginous contumely.

The period thus granted to his consummate power seems a short one. Yet, within the space of it, he had made five-sixths (or about 80) of the England drawings; the whole series of the Rivers of France—66 in number; for the Bible illustrations, 26; for Scott's works, 62; for Byron's, 33; for Rogers', 57; for Campbell's, 20; for Milton's, 7; for Moore's, 4; for the Keepsake, 24; and of miscellaneous subjects, 20 or 30 more; the least total of the known drawings being thus something above 400:—allow twelve weeks a year for oil-painting and travelling, and the drawings (wholly exclusive of unknown private commissions and some thousands of sketches) are at the rate of one a week through the whole period of ten years.

The work which thus nobly closes the series is a solemn expression of a sympathy with seamen and with ships, which had been one of the governing emotions in Turner's

[1] [It was a few years before his death that Turner rented the upper part of the house, No. 119 Cheyne Walk, Chelsea, which still stands. Its low roof commanded two of the finest reaches on the London Thames. He had a way cut through to the roof, and a balcony fixed up to sit behind, commanding sunrises, sunsets, and moonlit waters, as well as a foreshore and other surroundings highly picturesque. For Ruskin's account of his closing hours, see *Lectures on Architecture and Painting*, § 106, Vol. XII. p. 133]

mind throughout his life. It is also the last of a group
of pictures, painted at different times, but all illustrative
of one haunting conception, of the central struggle at Tra-
falgar. The first was, I believe, exhibited in the British
Institution in 1808, under the title of "The battle of
Trafalgar, as seen from the mizen shrouds of the *Victory*"
(480). A magnificent picture, remarkable in many ways,[1]
but chiefly for its endeavour to give the spectator a com-
plete map of everything visible in the ships *Victory* and
Redoutable at the moment of Nelson's death-wound. Then
came the "Trafalgar," now at Greenwich Hospital, repre-
senting the *Victory* after the battle; a picture which, for
my own part, though said to have been spoiled by ill-
advised compliances on Turner's part with requests for
alteration, I would rather have, than any one in the
National Collection.[2] Lastly, came this "*Téméraire*," the
best memorial that Turner could give to the ship which
was the *Victory's* companion in her closing strife.*

The painting of the "*Téméraire*" was received with a
general feeling of sympathy. No abusive voice, as far as I
remember, was ever raised against it. And the feeling was
just; for of all pictures of subjects not visibly involving
human pain, this is, I believe, the most pathetic that was

* She was the second ship in Nelson's line; and, having little pro-
visions or water on board, was what sailors call "flying light," so as to be
able to keep pace with the fast-sailing *Victory*. When the latter drew upon
herself all the enemy's fire, the *Téméraire* tried to pass her, to take it in
her stead; but Nelson himself hailed her to keep astern. The *Téméraire*
cut away her studding-sails, and held back, receiving the enemy's fire
into her bows without returning a shot. Two hours later, she lay with
a French seventy-four gun ship on each side of her, both her prizes, one
lashed to her mainmast, and one to her anchor.

[1] [Eds. 1–4 read :—
 "It is a magnificent picture in his early manner; it is in the nation's
 possession, and ought surely to have been exhibited in this series instead
 of the 'Calais Pier' [472], being remarkable in many ways," etc.
The picture is now exhibited in the National Gallery.]
[2] [For another reference to this picture, see above, *Harbours of England*, § 24,
p. 33.]

ever painted. The utmost pensiveness which can ordinarily be given to a landscape depends on adjuncts of ruin: but no ruin was ever so affecting as this gliding of the vessel to her grave. A ruin cannot be, for whatever memories may be connected with it, and whatever witness it may have borne to the courage or the glory of men, it never seems to have offered itself to their danger, and associated itself with their acts, as a ship of battle can. The mere facts of motion, and obedience to human guidance, double the interest of the vessel: nor less her organized perfectness, giving her the look, and partly the character of a living creature, that may indeed be maimed in limb, or decrepit in frame, but must either live or die, and cannot be added to nor diminished from—heaped up and dragged down—as a building can. And this particular ship, crowned in the Trafalgar hour of trial with chief victory—prevailing over the fatal vessel that had given Nelson death—surely, if ever anything without a soul deserved honour or affection, we owed them here. Those sails that strained so full bent into the battle—that broad bow that struck the surf aside, enlarging silently in steadfast haste, full front to the shot — resistless and without reply — those triple ports whose choirs of flame rang forth in their courses, into the fierce revenging monotone, which, when it died away, left no answering voice to rise any more upon the sea against the strength of England—those sides that were wet with the long runlets of English life-blood, like press-planks at vintage, gleaming goodly crimson down to the cast and clash of the washing foam—those pale masts that stayed themselves up against the war-ruin, shaking out their ensigns through the thunder, till sail and ensign drooped—steep in the death-stilled pause of Andalusian air, burning with its witness-cloud of human souls at rest,—surely, for these some sacred care might have been left in our thoughts —some quiet space amidst the lapse of English waters?

Nay, not so. We have stern keepers to trust her glory

to—the fire and the worm. Never more shall sunset lay golden robe on her, nor starlight tremble on the waves that part at her gliding. Perhaps, where the low gate opens to some cottage-garden, the tired traveller may ask, idly, why the moss grows so green on its rugged wood; and even the sailor's child may not answer, nor know, that the night-dew lies deep in the war-rents of the wood of the old *Téméraire*.

APPENDIX

As the number of pictures now at Marlborough House is large enough to give the reader some idea of the value of the entire collection, the following notes respecting what I believe to be the best mode of exhibiting that collection, may perhaps be useful.

The expediency of protecting oil-pictures, as well as drawings, by glass, has been already fully admitted by the Trustees of the National Gallery, since the two Correggios, the Raphael, the Francias, the Perugino, the John Bellini,[1] and Wilkie's "Festival," are already so protected.* And of all pictures whatsoever, Turner's are those which must suffer most from the present mode of their exposure.[2] The effects of all the later paintings are dependent on the loading of the colour; and the white, in many of the high lights,

* I am at a loss to determine what the standard of excellence may be which is supposed to warrant the national expenditure, in addition to the price of the picture, of at least two pounds ten shillings for plate glass; since I observe that Garofalo's "St. Augustine" reaches that standard; but Titian's "Bacchus and Ariadne" does not; this picture being precisely, of all in the gallery, the one which I should have thought would have been first glazed, or first, at all events, after that noble Perugino; for the acquisition of which, by the way, the Trustees are to be most earnestly thanked.[3] [Note in eds. 1–3 only; see below, p. 179 n.]

[1] [The pictures which were thus among the first to be protected by glass are Correggio's "Mercury, Venus, and Cupid" (No. 10) and "Ecce Homo!" (No. 15); Raphael's "St. Catherine" (No. 168); Francia's "Virgin and Child" and "Pietà" (Nos. 179, 180); Perugino's mentioned in note 3, below; and Bellini's "Doge Loredano" (No. 189).]

[2] [The process of protecting the pictures in the National Gallery with glass was continued year by year, and has for some time been completed. See on the subject, Vol. XII. p. 409.]

[3] [The reference is to the "Virgin and Child, Michael, and Raphael," No. 288, purchased for the Gallery in 1856 for £3571 from the Duke Melzi of Milan. For another reference to the picture, see *Verona and its Rivers*, § 26.]

stands out in diminutive crags, with intermediate craters and ravines: every one of whose cellular hollows serves as a receptacle for the dust of London, which cannot afterwards be removed but by grinding away the eminences that protect it—in other words, destroying the handling of Turner at the very spots which are the foci of his effects. Not only so, but the surfaces of most of his later pictures are more or less cracked; often gaping widely: every fissure offering its convenient ledge for the repose of the floating defilement.

Now, if the power of Turner were independent of the *pitch* of his colour, so that tones sinking daily into more pensive shade might yet retain their meaning and their harmony, it might be a point deserving discussion, whether their preservation at a particular key was worth the alleged inconvenience resulting from the use of glass. In the case of Wilkie's "Festival," for instance [No. 122], the telling of his story would not be seriously interfered with, though the nose of the sot became less brilliantly rubicund, and the cloak of his wife sank into a homelier grey. But Turner's work is especially the painting of sunshine: it is not merely *relative* hue that he aims at, but absolute assertion of *positive* hue; and when he renders the edge of a cloud by pure vermilion or pure gold, his whole meaning is destroyed if the vermilion be changed into russet, and the gold into brown. He does not intend to tell you that sunsets are brown, but that they are burning; scarlet, with him, means scarlet, and in nowise dun colour, or dust colour; and white means white, and by no means, nor under any sort of interpretation, black.

But farther. The frequent assertion that glass interferes with the effect of oil-pictures is wholly irrelevant. If a painting cannot be seen through glass, it cannot be seen through its own varnish. Any position which renders the glass offensive by its reflection, will in like manner make the glaze of the surface of the picture visible instead of the colour. The inconvenience is less distinct, there being often

only a feeble glimmer on the varnish, when there would be a vivid flash on the glass, but the glimmer is quite enough to prevent the true colour's being seen ; while there is this advantage in the glass, that it tells the spectator *when* he cannot see ; whereas the glimmer of the varnish often passes, with an inattentive observer, for a feeble part of the real painting, and he does not try to get a better position.

Glass has another advantage, when used to cover the recent paintings of Turner, in giving a delicate, but very precious softness to surfaces of pigment which, in his later practice, he was apt to leave looking too much like lime or mortar.

The question of the acceptance of glass as a protection for pictures is, however, intimately connected with another : namely, whether we are to continue to hang them above the eye. Of course, as long as a picture is regarded by us merely as a piece of ostentatious furniture, answering no other purpose than that of covering the walls of rooms with a dark tapestry worth a thousand guineas a yard, it is of no consequence whether we protect them or not. There will always be dealers ready to provide us with this same costly tapestry, in which we need not be studious to preserve the designs we do not care to see. If the rain or the rats should make an end of the Tintoret which is now hung in the first room of the Louvre at a height of fifty feet from the ground,[1] it will be easy to obtain from the manufactories of Venice another Tintoret, which, hung at the same height, shall look altogether as well; and if any harm should happen to the fish in the sea-piece of Turner[2] which hangs above his "Carthage" in the National Gallery, a few bold dashes of white may replace them, as long as the picture remains where it is, with perfect satisfaction to the public. But if ever we come to understand

[1] [*i.e.*, in 1856 ; see Vol. XII. p. 411 for the particulars.]
[2] [The "Sun Rising in a Mist," No. 479, one of the two bequeathed by Turner on condition that they were placed beside two by Claude. The picture is now hung on the line.]

that the function of a picture, after all, with respect to mankind, is not merely to be bought, but to be seen, it will follow that a picture which deserves a price deserves a place; and that all paintings which are worth keeping, are worth, also, the rent of so much wall as shall be necessary to show them to the best advantage, and in the least fatiguing way for the spectator.

It would be interesting if we could obtain a return of the sum which the English nation pays annually for park walls to enclose game, stable walls to separate horses, and garden walls to ripen peaches; and if we could compare this ascertained sum with what it pays for walls to show its art upon. How soon it may desire to quit itself of the dishonour which would result from the comparison I do not know; but as the public appear to be seriously taking some interest in the pending questions respecting their new National Gallery,[1] it is, perhaps, worth while to state the following general principles of good picture exhibitions.

1st. All large pictures should be on walls lighted from above; because light, from whatever point it enters, must be gradually subdued as it passes further into the room. Now, if it enters at either side of the picture, the gradation of diminishing light to the other side is generally unnatural; but if the light falls from above, its gradation from the sky of the picture down to the foreground is never unnatural, even in a figure piece, and is often a great help to the effect of a landscape. Even interiors, in which lateral light is represented as entering a room, and none as falling from the ceiling, are yet best seen by light from above: for a lateral light contrary to the supposed direction of that in the picture will greatly neutralize its effect; and a lateral light in the same direction will exaggerate it. The artist's real intention can only be seen fairly by light from above.

2nd. Every picture should be hung so as to admit of its horizon being brought on a level with the eye of the

<hr />

[1] [The reference is to the appointment of the National Gallery Site Commission. For Ruskin's evidence see below, pp. 539–553.]

spectator, without difficulty, or stooping. When pictures
are small, one line may be disposed so as to be seen by a
sitting spectator, and one to be seen standing, but more
than two lines should never be admitted. A *model* gallery
should have one line only; and some interval between
each picture, to prevent the interference of the colours of
one piece with those of the rest—a most serious source of
deterioration of effect.

3rd. If pictures were placed thus, only in one low line,
the gorgeousness of large rooms and galleries would be lost,
and it would be useless to endeavour to obtain any im-
posing architectural effect by the arrangement or extent of
the rooms. But the far more important objects might be
attained, of making them perfectly comfortable, securing
good light in the darkest days, and ventilation without
draughts in the warmest and coldest.

4th. And if hope of architectural effect were thus sur-
rendered, there would be a great advantage in giving large
upright pictures a room to themselves. For as the per-
spective horizon of such pictures cannot always be brought
low enough even for a standing spectator, and as, whether
it can or not, the upper parts of great designs are often
more interesting than the lower, the floor at the further
extremity of the room might be raised by the number of
steps necessary to give full command of the composition;
and a narrow lateral gallery carried from this elevated daïs,
to its sides. Such a gallery of close access to the flanks of
pictures like Titian's Assumption or Peter Martyr would
be of the greatest service to artists.[1]

5th. It is of the highest importance that the works of
each master should be kept together.[2] No great master
can be thoroughly enjoyed but by getting into his humour,
and remaining long enough under his influence to under-
stand his whole mode and cast of thought. The contrast

[1] [Ruskin was questioned on this point by the National Gallery Site Commission:
see below, p. 543.]
[2] [Ruskin did not extend this principle to the case of the annual exhibitions of
contemporary pictures, for reasons stated in *Fors Clavigera*, Letter lxxix.]

XIII. M

of works by different masters never brings out their merits ; but their defects : the spectator's effort (if he is kind enough to make any) to throw his mind into their various tempers, materially increases his fatigue—and the fatigue of examining a series of pictures carefully is always great, even under the most favourable circumstances.[1] The advantage thus gained in peace of mind and power of understanding, by the assemblage of the works of each master, is connected with another, hardly less important, in the light thrown on the painter's own progress of intellect and methods of study.

6th. Whatever sketches and studies for any picture exist by its master's hand, should be collected at any sacrifice ; a little reciprocal courtesy among Governments might easily bring this about : such studies should be shown under glass (as in the rooms appropriated to drawings in the Louvre), in the centre of the room in which the picture itself is placed. The existing engravings from it, whatever their merit or demerit (it is often a great point in art education to demonstrate the *last*), should be collected and exhibited in a similar manner.

7th. Although the rooms, if thus disposed, would never, as aforesaid, produce any bold architectural effect (the tables just proposed in the centre of each room being especially adverse to such effect), they might be rendered separately beautiful, by decoration so arranged as not to interfere with the colour of the pictures. The blankness and poverty of colour are, in such adjuncts, much more to be dreaded than its power ; the discordance of a dead colour is more painful than the discordance of a glowing one : and it is better slightly to eclipse a picture by pleasantness of adjunct, than to bring the spectator to it disgusted by collateral deformities.

8th. Though the idea of a single line of pictures, seen by light from above, involves externally, as well as internally,

[1] [On this subject compare Vol. XII. pp. 403, 413 n.]

the sacrifice of the ordinary elements of architectural splen-
dour, I am certain the exterior even of this long and low
gallery could be rendered not only impressive, but a most
interesting school of art. I would dispose it in long
arcades; if the space were limited, returning upon itself
like a labyrinth:[1] the walls to be double, with passages
of various access between them, in order to secure the
pictures from the variations of temperature in the external
air; the outer walls to be of the most beautiful British
building stones—chiefly our whitest limestone, black marble,
and Cornish serpentine, variously shafted and inlaid; be-
tween each two arches a white marble niche, containing a
statue of some great artist; the whole approximating, in
effect, to the lower arcades of the Baptistery of Pisa, con-
tinued into an extent like that of the Pisan Campo Santo.
Courts should be left between its returns, with porches
at the outer angles, leading one into each division of the
building appropriated to a particular school; so as to save
the visitor from the trouble of hunting for his field of
study through the length of the labyrinth: and the smaller
chambers appropriated to separate pictures should branch
out into these courts from the main body of the building.

9th. As the condition that the pictures should be placed
at the level of sight would do away with all objections to
glass as an impediment of vision (who is there who cannot
see the Perugino in the National Gallery?),* all pictures
should be put under glass, firmly secured and made air-
tight behind. The glass is an important protection, not only
from dust, but from chance injury. I have seen a student

* I cannot but permit myself, though somewhat irrelevantly, to con-
gratulate the Trustees on their acquisition of this noble picture: it at once,
to my mind, raises our National Gallery from a second-rate to a first-rate
collection. I have always loved the master, and given much time to the
study of his works; but this is the best I have ever seen.[2]

1 [See on this subject the letter given in the Introduction, above, p. xxviii.]
2 [This note was substituted in eds. 4 and 5 for the note on p. 173 above.]

in the Vernon Gallery [1] mixing his colours on his pallet knife, and holding the knife, full charged, within half an inch, or less, of the surface of the picture he was copying, to see if he had matched the colour. The slightest accidental jar given to the hand would have added a new and spirited touch to the masterpiece.

10th. Supposing the pictures thus protected, it matters very little to what atmosphere their frames and glasses may be exposed. The most central situation for a National Gallery would be the most serviceable, and therefore the best. The only things to be *insisted* upon are a gravel foundation and good drainage, with, of course, light on the roof, uninterrupted by wafts of smoke from manufactory chimneys, or shadows of great blocks of houses.

11th. No drawing is worth a nation's keeping if it be not either good, or documentarily precious. If it be either of these, it is worth a bit of glass and a wooden frame. All drawings should be glazed, simply framed in wood, and enclosed in sliding grooves in portable cases. For the more beautiful ones, golden frames should be provided at central tables; turning on a swivel, with grooves in the thickness of them, into which the wooden frame should slide in an instant, and show the drawing framed in gold. The department for the drawings should be, of course, separate, and like a beautiful and spacious library, with its cases of drawings ranged on the walls (as those of the coins are in the Coin-room of the British Museum), and convenient recesses, with pleasant lateral light, for the visitors to take each his case of drawings into. Lateral light is best for drawings, because the variation in intensity is small, and of little consequence to a small work ; but the shadow of the head is inconvenient in looking close at them, when the light falls from above.

12th. I think the collections of Natural History should

[1] [Mr. Vernon presented his collection of British pictures to the National Gallery in 1847. For many years they were kept together, in accordance with his request, and exhibited in a separate room, the Vernon Gallery.]

be kept separate from those of Art.[1] Books, manuscripts, coins, sculpture, pottery, metal-work, engravings, drawings, and pictures, should be in one building; and minerals, fossils, shells, and stuffed animals (with a perfect library of works on natural history), in another, connected, as at Paris, with the Zoological Gardens.

It would of course be difficult to accomplish all this, but the national interest is only beginning to be awakened in works of art; and as soon as we care, nationally, one half as much for pictures as we do for drawing-room furniture, or footmen's liveries, all this, or more than this, will be done—perhaps after many errors and failures, and infinite waste of money in trying to economize; but I feel convinced we shall do it at last: and although poor Turner might well, himself, have classed the whole project, had he seen his pictures in their present places, among the profoundest of the Fallacies of Hope, I believe that even from the abyss of Marlborough House he will wield stronger influence than from the brilliant line of the Academy; that this dark and insulted "Turner Gallery" will be the germ of a noble and serviceable "National Gallery," and that to the poor barber's son of Maiden Lane we shall owe our first understanding of the right way either to look at Nature, or at Art.

[1] [The separation of the two branches of the British Museum was effected in the years 1880–1833 by the removal of the Natural History collections to the new building at South Kensington.]

III

CATALOGUE OF

THE TURNER SKETCHES IN THE
NATIONAL GALLERY

PART I

CATALOGUE

OF THE

TURNER SKETCHES

IN THE

NATIONAL GALLERY

PART I

LONDON:
PRINTED BY SPOTTISWOODE & CO.
NEW STREET SQUARE
1857

[*Bibliographical Note.*—Of this issue there were two editions. The title-page of both was the same (as here on the preceding page).

First Edition (1857).—This issue (which is among the rarer Ruskin-iana) contained only a portion of the intended Catalogue: octavo, p. 20. The Preface ("Prefatory") occupies pp. 3–8; the "Catalogue," pp. 9–20. At the foot of the last page is the imprint "London: Printed by Spottis-woode and Co., New Street Square." There are no headlines, the pages being numbered centrally. The Catalogue contains notes on 25 pictures, but these are not in all cases the same as the first 25 in ed. 2 (see below). Issued stitched and without wrappers.

Second Edition (1857).—Of this edition (limited to 100 copies) the col-lation is: octavo, pp. ii.+50. A half-title—"Catalogue of the Turner Sketches in the National Gallery, Part I.," with blank reverse, occupies pp. i.-ii.; title-page, with blank reverse, pp. 1–2; "Prefatory," pp. 3–49; the last page is blank, but for the imprint in the centre—"London: Printed by Spottiswoode and Co., New Street Square." No headlines, as before: issued stitched, without wrappers.

Variations between the two Editions.—No. "8. On the Rhine" in ed. 1 becomes No. 11 in ed. 2 (with the words "The same subject, nearer" added after the title); No. 8 being replaced in ed. 2 by "Coblentz, with the Bridge over the Moselle"—a drawing which was not described in ed. 1; while No. 11 in ed. 1 was discarded in ed. 2. It is here restored. For some conse-quential alterations in the text of Nos. 9 and 10 in ed. 2, see below, pp. 194, 195 *nn.*

Edition 1 did not contain 21 (Zurich), 22 (Zurich), 24 (Lucerne from the lake), 25 (Mont Pilate), and 28 (Arth); with the result that 23 (Lucerne), 26 (Lucerne), 27 (Goldau), 29 (Kussnacht), and 30 (Meggen), at which point the early edition ended, were in that edition Nos. 21, 22, 23, 24, and 25 re-spectively. These alterations, again, involved some small variations in the text: see below, pp. 201, 202, *nn.*; also in No. 27 (p. 202, line 3)—in ed. 1, No. 23—that edition added the words "by Turner" after "Realised"; and in No. 29 (last line)—in ed. 1, No. 24—that edition read "1845" for "1843."

In this edition, in No. 28 (p. 202) "Aart" is corrected to "Arth"; and in No. 30 (p. 203) "Lungren" to "Lungern." In No. 57 (p. 212) "stem" in previous eds. is corrected to "stern."

The contents of both editions were *reprinted* (1902) in the volume *Ruskin on Pictures* already described (above, p. 93). In that work the Catalogue of the Turner Gallery (oil pictures) was reprinted in its original form; but the various catalogues of the water-colours (in this volume, Part II. Nos. iii., iv., and vii.) were not; their contents were rearranged, so as to collect under the title of each drawing all the references to it.

In this edition, the present position and number of each sketch, where ascertainable, are added after Ruskin's note. "*N. G.*" stands, of course, for National Gallery; "*Oxford*" means the loan collection in the Ruskin Drawing School (see below, pp. 560–568).]

PREFATORY

THE principal object I have had in view in the arrangement of these sketches has been to exemplify a method by which the collections of drawings existing in European galleries might be rendered completely serviceable to the public, without compromising their safety. As matters stand at present, the studies by the great masters, which exist in the museums of Florence, Paris, and London, cannot be seen by the public, either with ease to themselves or with security to the drawings. If the curators rightly estimate the value of the works intrusted to them, they avoid, as far as possible, bringing out the best, except to specially worthy and favoured visitors; to the young student and the general public such drawings are, and ought to be, on the present system inaccessible, since they must not be exposed to the handling of the ignorant or inadvertent. Not only so, but both in Paris and Florence it frequently happens that the first-class drawings cannot be seen at all, owing to the absence of the curators or other accidental hindrances; and those which may be seen cannot be studied at leisure, bound as they are in volumes which must continually be required by other visitors, or, if separately mounted, exposed to dust and accidental injury all the while they are being examined. In the Louvre, it is true that a certain number—a very small proportion of the whole collection—are placed on tables under glass; but in such circumstances the light is only good or sufficient for the one or two that happen to be near the windows; the rest are seen imperfectly and with difficulty, and some of their most delicate execution is lost sight of altogether.

I believe the method in which the first hundred of the

Turner sketches are now arranged will be found to do away with all these inconveniences. The visitor has five or ten drawings at once put at his disposal, which he can take one by one in his hand into the best light and place as he chooses, and which he can copy or describe at his ease, without interfering with any one else's examination of other portions of the series, and with no fear of injury to the drawing, protected as it is completely from dust, and from all accident except that of a heavy fall, which might indeed break the glass or strain the frame, but could not injure the sketch, which does not touch the glass anywhere. And while there are these advantages in this method considered with reference only to the safe exhibition of drawings in general, there is a farther one in it considered as a means of preserving those of Turner. It is a fact, already well known to the curators of museums, that works in water-colour lose vigour and value if they are exposed to light;[1] and Turner's are, of all drawings, those in which such loss must be at once most extensive and fatal, owing to the excessive thinness and tenderness of the tints on which their chief effects depend. There is of course no objection to a drawing being placed in a strong light (not, of course, the direct rays of the sun) while it is actually under examination; but it is quite unnecessary that it should continually be exposed to the glow of summer heat while no one is looking at it; and I am perfectly certain that the precious vignettes to the Italy and the drawings for the Rivers of France and Rivers of England, now exhibiting in Marlborough House, will suffer seriously even from their exposure during the present year.[2]

It would be quite easy to arrange a most precious and interesting series of sketches for the general public, consisting chiefly of pencil and chalk drawings, which would not suffer from the light, together with a certain number of the

[1] [On this subject see further Appendix vii., below, pp. 589–593.]
[2] [The reference is to the first Exhibition of Turner Sketches and Drawings in 1857 : see above, pp. xxxiii., 96.]

less important water-colour drawings, while the more valuable works in colour might be arranged with perfect safety in this manner, and seen on proper application, as the prints are at the British Museum.[1]

The series of sketches which I have chosen to illustrate the possible arrangement are precisely those which presented the greatest difficulties; for they are among the largest and the brightest in colour, requiring therefore a broad white margin to give them sufficient relief. This necessitates a stronger and heavier frame than will usually be required; in general, frames about two-thirds of this size will be quite large enough, and the cases will therefore be far less cumbrous and more conveniently portable.

The sketches themselves require some slight explanation of their character, before their value will be completely felt. They are not, strictly speaking, sketches from nature, but plans or designs of the pictures which Turner, if he had had time, would have made of each place. They indicate, therefore, a perfectly formed conception of the finished picture; and they are of exactly the same value as memoranda would be, if made by Turner's own hand, of pictures of his not in our possession. They are just to be regarded as quick descriptions or reminiscences of noble pictures; every touch in them represents something complete and definite; and, for the most part, as much is done with the given number of touches and quantity of colour as is possible to be done by human hand. They are all of the period in which Turner's work is full of the most characteristic excellencies, and they are all interesting in subject, being of well-known and beautiful scenes. I look upon them as in some respects more valuable than his finished drawings, or his oil pictures; because they are the simple records of his first impressions and first purposes, and in

[1] [See above, p. 180.]

most instances as true to the character of the places they represent as they are admirable in composition; while, in his elaborate drawings and paintings, he too frequently suffered his mind to be warped from its first impression by attempts at idealism.

I believe, however, that nothing but the pencilling in them was done on the spot, and not always that. Turner used to walk about a town with a roll of thin paper in his pocket, and make a few scratches upon a sheet or two of it, which were so much shorthand indication of all he wished to remember. When he got to his inn in the evening, he completed the pencilling rapidly, and added as much colour as was needed to record his plan of the picture.

These rolled sheets of paper (some of them actually the covers of the cheap stitched sketch-books) were always, necessarily, warped and bent by the colouring. But Turner did not in the least care for this, and I think, therefore, that we should not. They are, as I have mounted them, flatter than *he* ever cared to see them, and they are perfectly safe; while any process of mounting which at once secures flatness, necessitates some degree of injury to the colour. I may be able in course of time, by pressure and other expedients, to get them to lie much flatter, but my present object is only to get them securely protected, and allow them to be quickly visible.

I have arranged these hundred so as to form a connected series, illustrative of a supposed tour up the Rhine, and through Switzerland, to Venice and back. The suggestions offered in the text, of the probable circumstances under which Turner might have made the drawings, give the reader a just idea of the painter's general manner of setting about his work, though the conjecture may of course be wrong or right, with respect to any given sketch.

CATALOGUE

1. TRÉPORT.

We land on the pier of Tréport, and are delighted by the pretty irregularity of the old church, with its gabled chapels, which we draw on the spot, with one bold zigzag touch for their roofs, and a wriggle for every window. Yet it will not be easy for any one coming after us to give a better idea of the standing of the grey walls on their sea-worn mound, and of the bright chalk cliff beyond them. This cliff is a masterpiece of drawing; it is not possible with the given number of touches to indicate more faithfully the form of a chalk precipice, or the way it breaks into the turf at its brow. The whole sketch is hasty, but very beautiful. [N. G., 276.]

2. TRÉPORT.

We set out for a walk about the town, retaining, however, our first interest in the chapel and cliff; and being disturbed by the military (a couple of lancers), we put them in revengefully in red outlines. [N. G.[1]]

3. TRÉPORT.

We wander still farther from the town, and see old piers and fortifications under amazing effects. The military are still interested in our motions. The officer having held his sword in an unsatisfactory manner towards his legs, is obliged to change its position, and appears now to be carrying two.

Very hasty; but grand in arrangement of colour and interesting in execution. Note the vermilion in the pier in

[1] [This drawing is now (1904) in one of the tin boxes at the National Gallery (see p. xli.); Box Z.]

the foreground laid in very wet and the white lines scraped out with the wooden end of the brush towards the left, carrying the vermilion out at that side.

The object in the middle distance is a fortification with two gates of entrance, and a flagstaff, and the sweeping pencil lines to the right of the flagstaff mean, I believe, that the smoke of a gun was to be there if ever the picture were finished. [*Oxford, No.* 19.]

4. Eu.

Getting tired of the beach, we walk up the country,[1] and obtain a general view of the town of Eu.

The part of the blue touch in the distance, on the left, with a spike to it, means our old friends, the hill and church of Tréport; the darker and level blue means the sea under a fresh breeze. The whole looks quite instantaneously done; but it is not; the dark crumbling touch was laid first, then water was put to it, and it was gradated into the church: lastly, a wet horizontal touch of blue has been added below, to give it more breadth.

The general character of the French cathedral churches, rising out of the towns like a broken but massive group of steep basalt rock, with small pinnacles above, is quite wonderfully seized in this sketch.

The five pink, square-topped cones under the blue sea are the roofs of Louis Philippe's palace.

Having got rid of the military, we are now annoyed by cows, and horses of diligences pulling uphill; which, nevertheless, we mean to make something of, some day. [*N. G.*[2]]

5. Church of Eu.

We continue our walk till it is late, and, returning to town, see the church by moonlight, in the sea fog.

The apse of Eu is one of the most interesting in France

[1] [A favourite walk from Tréport is to Eu, a mile and a half inland. Another sketch of Eu, with Louis Philippe's Château, is No. 665 in the National Gallery.]
[2] [This drawing also is put away in Box Z at the National Gallery.]

in its bold pyramidal structure, being surrounded by a
double range of chapels, with corresponding pinnacles and
double flying buttresses. I am puzzled by the appearance
as of a vineyard or hop-garden in the street below; and
cannot venture positively to state, though I am decidedly
under the conviction, that this remarkable appearance is pre-
sented by the good people of Eu going to evening service.
[*N. G.*, 277.]

6. COBLENTZ.

We have taken the railroad across to Cologne, and the
steamer to Coblentz. We are landed here just opposite
Ehrenbreitstein, and are anxious about our luggage.

I have framed this sketch chiefly for the sake of its
curious composition; the boat with the large sails, behind
the chimney of the steamer, giving massiveness to the
group;—next, as an instance of the delight which Turner
used to take in smoke of steamers, here seen under warm
light;—lastly, because of its interesting indications of figures;
the postillion with his two pairs of horses on the right, the
crowd hurrying over the bridge above, and the group on
the left busy with the luggage. Some carriages are waiting
at the quay close to the steamer. [*N. G.*, 278.]

7. EHRENBREITSTEIN.

We dine at an hotel on the quay, and, after dinner, see
Ehrenbreitstein by sunset from our window.

The expression of the strong Rhine current, as it rushes
under the bridge of boats, is very perfect. This was a
favourite subject of Turner's, there is another drawing of it
under a different effect, in the series of unframed sketches.[1]
I could not frame it, because Turner had torn its edge
half away in the sky.

The bridge of boats is opened on the left hand for a

[1] [See, among those which have been framed since Ruskin wrote, Nos. 650, 671,
692. See also No. 583.]

steamer to pass through,—her smoke is seen down the river. The white diagonal line is the ascent to the fortress. Most interesting and beautiful. [*N. G.*, 279.]

8. COBLENTZ, WITH THE BRIDGE OVER THE MOSELLE.

This drawing does not belong to the same series as those we have hitherto been examining: it was one of ten carried forward by Turner to a somewhat higher finish than his other sketches in the year 1842, in order to give an idea of a series of drawings which he proposed at that time to undertake in illustration of his Continental journeys, and which were to be finished realisations of the subjects shown in the sketches. Of these drawings he made twenty-seven; ten in 1842, five in 1843, ten in 1845, and two in 1850. Many of the sketches for them will be found in the present series. This subject was realised for me in 1842, and the composition of the resultant design is illustrated at some length in my *Elements of Drawing*.[1] [*N. G.*, 280.]

9. ON THE RHINE.[2]

The slightly indicated foreground is a terrace projecting into the river; one figure sitting, and another lying down at the edge of the terrace, a third standing; the whole group indicated by a few red penned lines.

The passage of cooler colour on the left of this drawing is very beautiful. [*N. G.*[3]]

10. ON THE RHINE. The same subject from the river.[4]

Loose and unsatisfactory in treatment in most parts; but interesting in the drawing of the rocks on the hillside

[1] [See §§ 196, 205 of that book; the drawing realised from this sketch is No. 62 in Ruskin's *Notes on his Drawings by Turner:* see below, p. 454; and for particulars with regard to these sketches of 1842 generally, see the Epilogue to those *Notes*, below, pp. 475–485.]

[2] [In ed. 1 this had no title, the note reading :—
"9. The same subject seen from a terrace projecting into the river; one figure . . ."]

[3] [This and the following drawing are put away in Box Z at the National Gallery.]

[4] [In ed. 1 "10. The same subject, farther off."]

on the right; the pencil, and the paler violet touches, with
the full and deep red penned work, being there combined
with consummate skill. Note the rapidity of the first sketch,
in the sweeping touch of pencil forming the loop above
these crags. [*N. G.*[1]]

11. ON THE RHINE. The same subject, nearer.[2]

A perfectly studied and splendid composition. Consider,
one by one, the uses of the various passages of its colour,
especially the introduction of the dark green touches at the
river bank on the right side, as they complete and enclose
the gloom cast down by the cloud, and bring out the bright
colouring of the bank. I cannot determine the objects indi-
cated by red outline on the extreme right. They were
evidently of great importance in Turner's mind; I suppose
them to be parts of a dyke of basalt. [*N. G.*, 281.]

11A. HEIDELBERG.[3]

I have included this sketch in the series rather on ac-
count of the beauty of its subject than for its own merits;
it being very slight, and not in effect much beyond what
other people might have done. The mass of castle is, how-
ever, beautifully indicated. There seems a persuasion in
Turner's mind that the gabled part of the castle should be
rose-coloured, and the tower and wall on the left browner
or warmer; as we find the same division of colour in the
next sketch.

12. HEIDELBERG. From the front of the castle.

Very hasty; but highly interesting in its indication of
the way Turner liked to lead his curves to the main points
of his principal objects. The two large curves in the sky
are outlines of hills, and are merely put there to indicate

[1] [See note 3 on p. 194.]
[2] [This in ed. 1 was No. 8 (see above, p. 186), and the words "The same subject,
nearer" were omitted.]
[3] [This note is here inserted from ed. 1; it was omitted from ed. 2, as explained
above (p. 186). The editors are unable to identify the sketch.]

that in the finished drawing those curves should lead, one
to the main tower of the castle, and one to its first gable,
while the second gable should be the only piece of the
castle relieved against the sky. It is slightly touched with
rose colour, to darken it for the sake of this relief. The
tops of the battlements to the right of it would have been
left in light against the yellow hills, thus connecting the
light of the sky with the white mist on the wood on the
right. You see the battlements are carefully left free from
the rose tint which covers the rest of the castle.

Note, in the position of the dark side of the large tower,
just under the main angle of the fortress, Turner's frequent
habit of sustaining his principal masses one by the other :
also, the careful marking of the balcony to its central
window, and of an interrupting shaft in the fourth of its
six sustaining arches (the seventh arch belonging to a de-
tached terrace in front). The apparently careless sweeps of
purple colour in the water are meant to enclose white sails,
in order to balance the broad light of this house; and the
strong purple touch on the right is one dark sail, necessary
to direct the eye out of the picture on that side; the castle
being otherwise too isolated a mass. [*N. G.*¹]

13. Heidelberg.

View of the castle from above. Very grand in subject,
but chiefly interesting from the use of the quantity of con-
fused blue touches on the left. The castle, I have no
doubt, was drawn first; Turner wished to make it a rich
and complex mass, but it was so much broken up that it
began to want solidity; first, therefore, a pure white cloud
of mist is thrown round it, which gives its unity and sub-
stance; but, if you hide the blue touches with your hand,
you will see that the building is still wanting in massiveness.
The blue touches are then put on, purposely shapeless and
confused, and the castle becomes solid at once by contrast.²

¹ [This sketch, which Ruskin found so instructive, is put away in Box Z at the National Gallery.]
² [The editors are unable to identify this sketch.]

14. HEIDELBERG.

We go a little lower down the hill in the afternoon, and draw the castle from that side of it, now all bathed in golden light.

Very noble in its arrangement of massy form, and in its breadth of glow. [*N. G.*, 282.]

15. HEIDELBERG.

And lastly, we go quickly round to the other side of the castle, and sketch it as seen against the sunset.

This is a perfectly composed picture, and exquisite as far as it goes. Note the beauty of tone in the stream of white mist behind the castle, and the delicate change from the rosy colour of its battlements to the warmer square mass of the foreground which throws it into distance.

The pencilling of the outline sketch is, observe, always treated by Turner as so much grey colour, and allowed for in the after tinting; thus here, the grey pencilling at the bottom becomes an expression of shadow in the middle distance.

The steeple of the tower church is marked in rose colour: one bridge in pencil beneath it, the other long bridge in faint blue beyond it. Our paper was provokingly greasy, in a most important place, just under the sun; we do the best with it we can. [*N. G.*, 283.]

16. This and the two following subjects were in the same book as the preceding ones of Heidelberg. Their locality will eventually be quite ascertainable, but I have not yet had time to determine it.[1] This is one of the slightest sketches of the series, but pretty and instructive in its simple succession of colour;—yellow, rose, and blue.[2]

17. A composition of exquisite beauty, and drawn in Turner's most powerful manner; hasty, but not careless.

[1] [No. 17 is identified in the National Gallery as Heidelberg.]
[2] [The editors are unable to identify this sketch.]

The expression of the picturesque block of architecture about the old church is as perfect as it is possible to render it with the given quantity of work. Observe how the whole is centralised by the single touch of darker vermilion in the centre, and how carefully the dark side is gradated to the distance; terminating with one faint touch of blue at the bottom of the further angle. Cover this blue touch with your finger, and see how much you will lose. Then observe how the two poplars at the turn of the river are used to unite the two masses of buildings; hide them in like manner with the finger, and the picture is instantly cut into two parts.

The laying in of the sky at last is very curious. The tower on the top of the hill had first been outlined with pencil, and painted yellow. Then it was not high enough, and got a new top, with red battlements, and two dark red touches at the side. Not being high enough yet, it got a third top, fainter. Then it was not thick enough; and so when the blue sky was struck (dropped would be a more accurate word) over the whole, the painter left a good breadth of white beyond his outline, besides giving plenty more room for the top of the hill, which was too round, and had to be raised to the right.

The confused blue touches in the middle of the sketch mean hills. [*N. G.*, 284.]

18. This drawing, though somewhat confused and un-satisfactory, contains much that will be interesting to artists in its execution. The finest part of it is the rounded hill in light behind the castle, and the winding valley and river under its cliffs.[1]

19. SCHAFFHAUSEN.

At last we enter Switzerland, and dispose ourselves to take pleasure in simpler and less superb masses of archi-tecture, and in tones of clear and sweet mountain air.

[1] [The editors are unable to identify this drawing.]

This I believe to be rather a memorandum of the castle and bridge of Schaffhausen, by way of material likely to be of use in other compositions, than itself a design for a picture. But it is therefore all the . more interesting, as showing how Turner could not but compose—even when he did not care to do so. The square house is put just under the castle, partly to sustain it, partly to set off its pretty outline; but these two masses being nearly equal, and attracting the eye as such, a third, the oblique sail, is added, and puts all right. But this sail is itself cut vertically into four, that it may carry down the divisions of the house just above, and give them importance enough to neutralise the formality of its central mass. The carrying down the dark right-hand side of the house into a curve, gathered up to the left by half of the sail, is especially Turneresque. Two gables and a chimney carry the diagonal of the sail out of the picture to the right. [*N. G.*, 285.]

20. CONSTANCE.

From the right bank of the Rhine; the Lake of Constance in the distance.

The original sketch of a drawing made in 1842, at his own choice, for delight in the subject, and now in my possession.[1] The sketch is, however, of little importance, except on the ground of Turner's liking it himself. In the drawing made from it, he altered and enriched it exceedingly; the buildings being no more grey, but deep purple.

The introduction of the two boats in front is interesting, as an example of the way in which depth may be given to a picture by the perspective lines of its foreground objects. Remove these two boats, and the town at once loses all its distance, and the river all direction. [*N. G.*, 286.]

21. ZURICH.

We arrive at Zurich, after a long day's journey from Constance. The sun is setting beyond the lake, and the

[1] [No. 63 in Ruskin's *Notes on his Drawings by Turner:* see below, p. 455.]

bridge over the Limmat is crowded with people, intent on aquatic affairs of an unintelligible kind. Realised for Mr. Windus of Tottenham, in 1845. The drawing has since been engraved.[1] [*N. G.*, 287.]

22. ZURICH.

We get out of the crowd as soon as possible, and climb the bastions above the town. Blue and white mists gather over the lake as the sun descends.

Very beautiful in its way, though this belongs to an embarrassing class of Turner's sketches. It is not easy to see the use of carrying them so far, unless these views were to be ultimately completed, nor why the textures should be so highly laboured throughout, while the details wanted for completion are lost sight of.

Realised for Mr. Munro in 1842.[2] [*N. G.*, 289.]

23. LUCERNE.

Arriving at Lucerne, we immediately climb the hill above the Reuss to try if we can see the Alps. No Alps to be seen,. the day being grey and misty and disagreeably hot besides. The form of the Rigi is, however, dimly visible beyond the first branch of the lake; and the old town delights us, especially the wall and towers bent like a bow over the hill behind it, which defended it in the old times of Austrian spears from any attack on the land side.

An elaborate and most precious drawing, all the more valuable, as the characteristic features of Lucerne are now being rapidly destroyed.[3]

Realised for me by Turner in 1842. [*N. G.*, 288.]

[1] [For a reference to the drawing realised from this sketch, see below, p. 476 n.; it was engraved by J. A. Prior; the drawing is now in the collection of Mr. R. E. Tatham.]

[2] [For particulars see, again, Epilogue to Ruskin's *Notes on his Drawings by Turner*, (p. 483, below; the drawing is now in the collection of Mr. J. Irvine Smith.]

[3] [For the rapid destruction of Lucerne at this time, see *Modern Painters*, vol. iv. Vol. VI. p. 456). The drawing realised from this sketch was afterwards sold by Ruskin in circumstances described in the Epilogue to his *Notes on his Drawings by Turner*: see p. 482.]

24. LUCERNE. From the lake.

After dinner we take a boat, and begin sketching the town from the water. The weather clears gradually, and as we watch the mountains come one by one out of the haze, we are much diverted from our work, and draw the town but carelessly.

Realised by his own choice in 1845. The drawing is now in my possession.[1]

25. MONT PILATE.

The evening gets so beautiful that we give up our sketch of the town, and row out into the lake; Mont Pilate glowing in ruby red, as the sun sets.

Wonderfully beautiful. The perspective of the right-hand shore, which gives distance and magnitude to the Mont Pilate, the use of the oblique line of the boat to keep the eye from resting on the formal oblong of the lake boundaries, and the long reflections of the fragment of blue cloud are all intensely Turneresque. [*N. G.*, 290.]

26. LUCERNE LAKE.

Having[2] set out for an excursion among the hills, we sleep at Brunnen, and are sorry to find, next morning, on walking down to the quay, that bad weather is coming on; the lake looking very hazy, and mischievous clouds forming under the Rothstok on the right hand.

27. GOLDAU.

The bad weather does come on;[3] but we persist in our excursion; and, after getting very wet at Schwytz, are

[1] [The finished drawing is now in the collection of Mrs. Newall : see Index, below, p. 602. The sketch cannot be identified with certainty, but there is one very like the description among the tin boxes (Z).]
[2] [In ed. 1 this was No. 22, and the text read "We set out . . . among the hills ; we sleep . . ." This sketch, again, cannot be identified.]
[3] [In ed. 1 this was No. 23.]

rewarded by seeing the clouds break as we reach the ridge of Goldau, and reveal the Lake of Zug under a golden sky. Realised for me in 1843.[1] [*N. G.*, 98.]

28. ARTH.

We sleep at Arth, and are up, and out on the lake, early in the morning; to good purpose. The sun rises behind the Mythens, and we see such an effect of lake and light, as we shall not forget soon.

Elaborate and lovely.

Realised for Mr. Munro in 1843.[2] [*N. G.*, 97.]

29. KUSSNACHT.

We breakfast at Kussnacht, and afterwards[3] go fishing on the Lake of Lucerne. The village, seen from the boat, presents this pleasant aspect; the clouds of last night melting away gradually from the hills.

Realised for Mr. Munro in 1843.[4] [*Oxford*, 47.]

30. MEGGEN.

The evening is quite cloudless and very lovely; the air clear, owing to the past storms. We much enjoy a walk on the Lucerne shore, Mont Pilate showing blue in the distance. Three large boats rowing from Lucerne show as dark spots on the golden lake. The cows, finding the flies troublesome, stand deep in the water.

[1] [The drawing in question is No. 65 in Ruskin's *Notes on his Drawings by Turner:* see below, pp. 456, 484. A photogravure of it is at p. 190 in vol. ii. of *Turner and Ruskin.* It was also engraved, by J. Cousen, in vol. iv. of *Modern Painters* (Plate 50). The drawing is there described and discussed at length (ch. xviii.); it is now in the collection of Mr. George Coats. The scene is that of the rocky valley caused by the fall of the Rossberg. Turner has chosen his position on some of the higher heaps of ruin, looking down towards the Lake of Zug. The spire of the tower of Arth is seen in the distance.]

[2] [Afterwards in Ruskin's collection, No. 64 in his *Notes*, where it is called "Lake of Zug": see below, pp. 455, 484. The drawing, in which some considerable alterations were introduced, was etched by Ruskin and mezzotinted by Lupton in vol. v. of *Modern Painters* (Plate 87); it is now in the collection of Sir Donald Currie, G.C.M.G. The Zug (Arth, from the Lake of Zug) was a companion drawing to the Goldau. For some remarks on the sketches for these two drawings, see *Modern Painters*, vol. v. pt. ix. ch. xi. § 31 *n.* With reference to the alterations, it may be added that in the MS. Catalogue of 1880 (see p. xxxix.) Ruskin noted under No. 28 above, "Mine far lovelier."]

[3] [No. 24 in ed. 1, where for "afterwards," "next morning" is read.]

[4] [The drawing in the Munro collection passed into that of the late Mr. C. A. Swinburne, of Andover, who paid 970 gs. for it in 1878. In 1904 it was sold at Christie's for 720 gs.]

Most instructive: the connection of the two dark banks by the boats giving continuity and quietness to the composition; the red cows completing its glow, and by their spottiness preventing the eye from dwelling too much on the three spots of boats.

Beyond Mont Pilate is the opening to the Lake of Lungern and Bernese Alps, indicated by the white light in the distance. The inscription on the right is, I believe, "Megen," the name of a little town on the right bank of the lake, thus alluded to in Ebel's Guide:[1] "Hauteur, 10 myriametres; Chapelle de Meggen. Vue delicieuse sur les Alpes que cotoie la route, et sur les Alpes d'Engelberg, et de Berne." [*N. G.*, 43.[2]]

31. THE RIGI AT DAWN.

We might imagine many excursions in the neighbourhood of Lucerne, before we exhausted Turner's sketches there;[3] I have therefore only chosen five more from among about thirty executed between 1840 and 1843. This one is of Mont Rigi, seen from the windows of his inn, "La Cygne," in the dawn of a lovely summer's morning; a fragment of fantastic mist hanging between us and the hill. Realised for his own pleasure in 1842. The drawing is in the possession of Mr. Munro.[4] [*N. G.*, 96.]

32. BRUNNEN, FROM LAKE LUCERNE.

We arrive at Brunnen early in the morning, and see the two Mythens above Schwytz, in clear weather this time.

Very elaborate and beautiful, the dark slope of the hills on the right especially. Note the value of the little violet

[1] [Ebel's Guide to Switzerland first appeared in German at Zürich in 1793. For particulars of the very numerous editions, translations, and adaptations of it, see Coolidge's *Swiss Travel and Guide-books*.]

[2] [Called in the National Gallery "Lake of Lucerne, from Kussnacht."]

[3] [See, for instance, in the National Gallery collection, Nos. 651, 658, 670, 675, 704, 705, 769, 834.]

[4] [The drawing is the "Dark Rigi" referred to in the Epilogue to Ruskin's *Notes on his Drawings by Turner*: see p. 483, below. It was acquired by the late Mr. C. A. Swinburne in 1878 for 590 gs., and in 1904 was sold at Christie's for 820 gs. A photogravure of it is at p. 348 in vol. ii. of *Turner and Ruskin*. The editors are unable to identify the sketch.]

touch of light behind their central darkest ridge. Realised for me in 1845.[1]

33. LAKE LUCERNE.

The upper reach of it, looking towards Tell's Chapel, from the hill above Brunnen.

The delicate, light, and sharply drawn clouds of this sketch are peculiarly beautiful, and it was realised by Turner in 1842, with great care. The drawing is in the possession of Mr. Munro.[2]

34. LAKE LUCERNE.

The lower reach of it, looking from Brunnen towards Lucerne. A careless sketch, but realised very beautifully for Mr. Windus in 1845. The drawing has been since engraved.[3]

35. THE RIGI AT SUNSET.

The same view as No. 31, by evening instead of morning light. I cannot tell why Turner was so fond of the Mont Rigi, but there are seven or eight more studies of it among his sketches of this period.[4] This one was realised for his own pleasure in 1842. The drawing is in my possession.[5] [*N. G.*, 45.]

36. We bid farewell to Lucerne as the morning reddens Mont Pilate; hardly anything of the lake visible; and it is so early that no one is stirring except just about the boats. A blotted and careless drawing, but so pretty in subject as to be worth including in the series. There is body-colour white, touched in the mist beyond the lake, and over the

[1] [See below, p. 476 *n.*, and the Index, p. 598. Ruskin thought the drawing inferior to the sketch (see the letter cited below, p. 206 *n.*), and parted with it. The editors are unable to identify the sketch.]

[2] [For further references to the drawing see below, pp. 477, 483, 516; it is now in the possession of Mrs. Newall. The editors are unable to identify the sketch.]

[3] [See also below, p. 476 *n.* Some particulars of this drawing (in which the little lake steamer is shown) are given by Thornbury, p. 467. It is now in the possession of Mrs. Williams. It was engraved by R. Wallis, and is given at p. 87 of R. N. Wornum's *The Turner Gallery*, 1859. This sketch also cannot be identified.]

[4] [See in the National Gallery, Nos. 423 (*b*) and 674. Other sketches of the Rigi are in the tin boxes and among those lent to provincial galleries.]

[5] [Called in the National Gallery "The Rigi from Lucerne." The story of the drawing made from it—the "Red Rigi"—is told in the Epilogue to Ruskin's *Notes on his Drawings by Turner*: see below, pp. 477, 483.]

second tower. This is very rare in Turner's water-colour sketches. I believe the second tower was meant to be the first, and when he put the other in farther to the left, he could not make up his mind to part with the first one.[1] [*N. G.*, 768.]

37. THE VILLAGE OF FLUELEN.

We sleep at Fluelen; and going out for our usual walk before breakfast, find the effect of morning mist on the lake quite enchanting.

The blue touches in the foreground indicate the course of the river to the lake, through its marshy delta.

The massy square building is a large private house, almost a tower, and perhaps in the shell of its walls ancient; but Turner has much exaggerated its elevation.[2]

Realised for Mr. Munro in 1845.[3] The subject was one very dear to Turner, he having made one of his earliest and loveliest drawings (of great size also), for Mr. Fawkes of Farnley, from this very shore. [*N. G.*, 99.]

38. THE LAKE LUCERNE FROM FLUELEN.

Just when we are going to start for St. Gothard, we find that the misty morning has broken into a cloudy day, and that assuredly it is soon going to rain. We are much discomposed at this aspect of affairs, as seen from our inn window, but make a hasty blot of it, nevertheless, as the diligence horses are putting to; and the blot is a grand one. [*N. G.*, 773.]

39. SCENE ON THE ST. GOTHARD.[4]

And certainly, before we have much passed Altorf, it comes on to rain to purpose. Fine things in the way of precipices and pines at this part of the road, as far as we

[1] [Called in the National Gallery "Lucerne and Mount Pilatus."]

[2] [Compare on this point p. 460 *n.*]

[3] [The drawing made for Mr. Munro was subsequently acquired by Ruskin, in exchange for the drawing made from sketch No. 39 (see next page). The Fluelen is No. 70 in his *Notes on his Drawings by Turner:* see p. 458, below. It was sold at Christie's in 1882 (see p. 573).]

[4] [Called in the National Gallery "Pass of the St. Gothard: First Bridge above Altdorf."]

can see them from under our umbrella. This sketch was
realised by Turner for me in 1845, but I having unluckily
told him that I wanted it for the sake of the pines, he
cut all the pines down, by way of jest, and left only the
bare red ground under them. I did not like getting wet
with no pines to shelter me, and exchanged the drawing
with Mr. Munro for the realisation of No. 37.[1] [*N. G.*, 100.]

40. THE PASS OF FAIDO.

We cross the St. Gothard in rain, very uncomfortably,
the weather not beginning to clear till we are nearly half-
way down the Italian side, close to Faido, when the sun
comes out on the brown stones of the Ticino's bed in a
most satisfactory manner; the Ticino is swoln with the
rain, and threatens in many places to carry the road away,
though its waters are still pure, having nothing but gneiss
and granite to dash over.

This was a favourite sketch of Turner's. He realised
it for me in 1843, with his fullest power; and the resultant
drawing is, I believe, the greatest work he produced in the
last period of his art. It is etched, and copiously analysed
in the fourth volume of *Modern Painters*.[2]

By comparison of the etching with this sketch, it will
be seen that the foreground on the right-hand side is much
altered. In this sketch the turn of the road, and pillar at
the angle of the wall, are drawn as they exist in reality; in
the drawing a piece of road is introduced from a study of
Turner's, made on the St. Gothard at least thirty years

[1] [See above, p. 205. In a letter to his father a few years later (Altdorf, Nov. 27,
1861) Ruskin says :—
"I walked three times yesterday to the bridge with the pines, which
Turner cut away, when he made the drawing which I exchanged with Munro.
In many respects, I find that the realised drawing was always *liker the place*
than the sketch ; though in this instance the pines were cut down ; the
bridge is really carefully drawn in the finished drawing ; and being a formal
and ugly one, disappointed me—the sketch having suggested one far more
picturesque. It was the same at Brunnen (the yellow and green one). In
the sketch there were no ugly hotels ; in the drawing he put them in and
spoiled his subject."]

[2] [See introduction to that volume for the references (Vol. VI. p. xxv.). The
drawing is No. 66 in Ruskin's *Notes on his Drawings by Turner:* see below, p. 456,
where further particulars are noted.]

previously. The warm colour given to the rocks is exactly right; they are gneiss, with decomposing garnets, giving them the brightest hues of red and yellow ochre.[1] [*Oxford*, 29.]

41. THE DESCENT TO ITALY.[2]

The weather having completely cleared, we approach Bellinzona in the glowing light of a cloudless evening.

Nothing can possibly be more wonderful than this study, either in truth of mountain line, or beauty of composition. I do not know one which shows the difference between Turner and all other painters more completely; for instance, assuredly any other artist would have made the buildings on the hill in the middle distance as dark, or darker than the hill on which they stand, in order to show them better against the mist; but how tenderly Turner has marked that, though all are in shadow, (the ray of light over the hill striking quite above them,) the buildings are a little paler and warmer, as well as more exposed to diffused light, than the rock they stand upon.

The figures are wonderfully put in, directing the eye to the towers above, and giving distance to the road. The piece of quiet light river on the right is quite wonderful in effect at a little distance. The sketch is in all respects one of a thousand. [*N. G.*, 453.]

42. BELLINZONA, FROM THE NORTH.

The town of Bellinzona is, on the whole, the most picturesque in Switzerland, being crowned by three fortresses, standing on isolated rocks of noble form, while the buildings are full of beautiful Italian character. Turner went to the place several times, and made many studies there; but on the occasion of this visit, he seems to me to have been not in his usual health. The valley beneath the rocks is marshy and hot; and there is an indolence in the way this and the

[1] [Ruskin brought home an actual specimen of the rock, which he used to be fond of showing to visitors, in order that they might compare it with the drawing in his collection.]

[2] [This sketch is included also in Ruskin's next catalogue, where it is No. 336 : see p. 315, below.]

three following subjects are executed, which exactly resembles the character of work done under the languor of slight malaria fever. They were all in one book; and two of them (44 and 45) are more elaborate than most of the other subjects in it, but sickly and heavy in elaboration.

In this subject, note the colour used in spots for the tiled tops of the battlements under sunshine. Most artists paint tiles much too red; this peculiar amber hue is their exact colour. Compare No. 62.[1]

43. BELLINZONA.

Beautiful as a subject, but less interesting as a sketch than most of the series. It is a good example, however, of Turner's architectural touch when he was careless. The opalescent peak of mountain behind the central castle is well given, however.[1]

44. BELLINZONA.

Grandly fancied; but poor Turner has been quite ill, and could not draw the distant fortress; having got it into a great mess, he redeems it very nearly by the two dark cypresses, quite marvellously put in, and giving depth and largeness to all that purple-grey distance. [N. G., 764.]

45. BELLINZONA.

Though we are not well, we mean to make a nice sketch of this, and take more pains than usual about the green banks of rock under the walls, besides drawing an Italian gentleman's house on the right, and his trellis of vines, and above all, his gateposts, which remind us of home, in our best manner; and we put some nice trees, and mist under them, beyond. But it is all of no use; the illness gets the better of us; we get quite wearied in the crowd, leave the kneeling figures in despair, and, when the time comes for us to put in our sky, make a complete mess of it. [N. G., 772.]

[1] [Turner's sketches of Bellinzona are very numerous, and there are several in the tin boxes, but the editors are unable to identify with any certainty Nos. 42 and 43.]

46. View from the Castle of Bellinzona.

Early next morning, feeling a little better, we climb to the top of the castle, and try to draw the valley as it opens to the Lago Maggiore. We cannot manage it, and rub the colours about till all assume an expression of malaria fog, which we did not intend. We try to brighten matters by touches of raw vermilion without any better success, and go down sulkily to breakfast. [*N. G.*, 765.]

47. Bellinzona, from the South.

Our morning walk has nevertheless done us good; and as we leave the town, and look back to it, we get a vigorous memorandum of the bridge over the Ticino.[1]

48. Bellinzona, from the West.[2]

This beautiful drawing belongs to another series, and has no connection in point of time with the group we have just reviewed. I do not know when this drawing was executed, but it was shown by Turner, among others, in the year 1842, and was realised for Mr. Munro in 1843; but the realisation was not equal to the sketch.[3] [*N. G.*, 84.]

49. The Approach to Lago Maggiore from Bellinzona.[4]

This wonderful study, one of the most perfect in the series, is done on paper as thin as that of a bank-note. Note how the vermilion on the rocks in the torrent, in the lowest left-hand corner, gives sunshine to all the mass of warm colour in the rest of the foreground. A flock of sheep are passing the bridge; and the Ticino zigzags irregularly through the plains below, leaving logs of pine scattered on its sand-banks.

Every way admirable and instructive. [*N. G.*, 93.]

[1] [This sketch, again, cannot be identified.]
[2] [Called in the National Gallery "Bellinzona, from the Road to Locarno."]
[3] ["Bellinzona" is not, however, included in the list which Ruskin afterwards drew up (see below, p. 483) of the drawings shown by Turner in 1842.]
[4] [Called in the National Gallery "Lago Maggiore, from near Magadino."]
XIII. o

50. HEAD OF THE LAGO MAGGIORE.[1]

At Magadino the steamer is waiting for us to take us
down the Lago Maggiore to Sesto Calende.

This study is drawn on the same thin paper as No. 49,
and yet the drawing of the distant mountains is more com-
plete than in any other of these hundred sketches.

I can find no memoranda made lower down, on the
Lago Maggiore, nor at Milan, nor at Verona, so that we
must go on to Venice without any farther pause. ƒV. G.,
94.]

51. THE APPROACH TO VENICE. From the land side,
before the railroad bridge was built.[2]

The line of green posts marks the edge of the deep
water channel which led from Mestre to the opening of
the Grand Canal. Very noble. [N. G., 51.]

52. THE DUCAL PALACE AND RIVA DEI SCHIAVONI.
From the water.

Careless, but rich in subject, and showing attention to
little things which escape artists who make more elaborate
drawings: the exact look of the foreshortened lion on the
pillar, for instance, and the depression of the two last win-
dows of the façade of the Ducal Palace. [N. G., 52.]

53. RIVA DEI SCHIAVONI, FROM SAN GIORGIO MAG-
GIORE.

Very exquisite in colour and gradation, and the placing
of the boats, and drawing the nets. [N. G., 53.]

[1] [Called in the National Gallery " Mountains of Bellinzona, from Magadino."]
[2] [Called in the National Gallery " The Approach to Venice. Sunset."]

54. RIVA DEI SCHIAVONI, FROM THE TRAGHETTO PER CHIOGGIA.[1]

It is low water, and the exposed beach is carefully expressed in the middle distance. Note that even in the apparently hasty passage on the left the painter has carefully marked the separate knots of the furled felucca sail. Any one else, in a hurry, would assuredly have drawn one continuous line for the sail, and then the dots or lines across it; it is much more difficult, and implies more deliberate purpose, to draw the sail itself in broken dots all the way down, implying that, where it is tied to the yard, the yard and sail together are so slender as to be lost sight of. [*N. G.*, 54.]

55. RIVA DEI SCHIAVONI. Looking towards the Madonna della Salute, which is seen in the extreme distance; the Church of San Giorgio between the two sails on the left.[2]

The composition of these sails and groups of ships leading the eye into the distance is very beautiful. [*N. G.*, 55.]

56. RIVA DEI SCHIAVONI. From the Fondamenta Ca' di Dio.[3]

This sketch is very beautiful, and to be noted especially for the way the two gleams of light on the water are left, portions of an under colour, which is prepared to receive the cool darker tint above, and to shine through it waveringly, while these fragments of it are left in luminous opposition.

It is to the painter's decisive use of these preparatory tints, and his perfect knowledge of the result which the superimposed tint is to produce, that his colouring owes a great part of its effect. [*N. G.*, 56.]

[1] [Called in the National Gallery "The Salute, from S. Giorgio Maggiore."]
[2] [Called in the National Gallery "Shipping on the Riva degli Schiavoni."]
[3] [Called in the National Gallery, "Riva degli Schiavoni, from near the Public Gardens."]

57. Riva dei Schiavoni. In the first twilight,* with the Bridge over the Rio dell' Arsenale.

The beak of a gondola shoots out from beneath the bridge. I have chosen this sketch chiefly for the sake of this incident; for a gondola is in nothing more striking to a stranger than in the unexpected dart of its beak—apparently by its own impulse, (the rower not being seen until the stern of the boat appears)—from under the arch of a bridge, seen as this is in strong light, while the boat's beak is always dark, if not black; and it is interesting to find Turner fixing on this as the leading incident of a composition. [*N. G.*, 57.]

58. Bridge over the Rio dell' Arsenale.[1]

A companion to the last sketch, only the gondolier is here entering instead of going out. The gondolier's head is rubbed out; the painter evidently sketched his figure as standing, and then remembered that he must have stooped to go under the bridge, and, at the short distance of the boat's stern from it, could not yet have risen. This is part of the expression of swiftness of motion; the boat which has entered at speed is always at least ten feet within the bridge before the gondolier can completely rise. [*N. G.*, 58.]

59. The Cemetery and Church of St. Michele di Murano.[2]

In a full flushed second twilight. Exquisitely beautiful for tender colour and atmosphere. [*N. G.*, 59.]

* I call the "first" twilight that which immediately precedes the sunset; the "second" twilight, a peculiar flush, like a faint reflection of the sunset, which succeeds the first twilight, after some minutes.

[1] [Called in the National Gallery "Bridge on the Riva degli Schiavoni."]
[2] [Identified in the National Gallery (more probably) as "San Giorgio Maggiore." The revised title is given in Ruskin's last catalogue; see p. 373.]

60.* The Head of the Grand Canal. Afternoon.
Bad weather coming on. [*N. G.*, 60.¹]

61. The Steps of the Church of La Salute.

The first idea of the engraved picture of "The Grand
Canal,"² and interesting as a vigorous memorandum of the
dark green reflection of the gondola. [*N. G.*, 61.]

62. The Grand Canal, looking back to the Salute.

A study of local colour, showing the strong impression
on the painter's mind of the opposition of the warm colour
of the bricks and tawny tiles to the whiteness of the marble,
as characteristic of Venice. He is not, however, right in
this conception.³ When, in ancient days, the marble was
white, the brick was covered with cement and frescoes; and
the lapse of time, which has caused the frescoes to fall away,
has changed the marble to a dark or tawny colour.

The colour of the tiles in this sketch is exactly true,
when seen under afternoon sunlight. Painters are apt usu-
ally to represent them of too pure a red. [*N. G.*, 62.]

63. The Casa Grimani on the Grand Canal.

Very careless; but admitted into the series as being one
of those used for the materials of the oil picture of
"Shylock,"⁴ and as showing a different method of study
from most of the others. [*N. G.*, 63.]

* These next sketches (60 to 69 inclusive) were on leaves of one
drawing-book, apparently consecutive, and made in the course of two or
three days. The other Venetian ones were on separate pieces of paper.

¹ [Called in the National Gallery "Entrance to Grand Canal."]
² ["Venice, from the porch of Madonna della Salute," now in the Metropolitan
Museum, New York; engraved by Miller, 1838. See below, p. 498.]
³ [Compare below, p. 499.]
⁴ [Exhibited at the Academy in 1837; once in Ruskin's collection: see below,
p. 605.]

64. The Lower Extremity of the Grand Canal at Twilight, with the Dome of the Church of San Simeon Piccolo.[1]

A noble sketch; injured by some change which has taken place in the coarse dark touches on the extreme left. [*N. G.*, 64.]

65. Venetian Fishing-Boat.

I am not certain of the locality of this sketch;[2] but it is a very interesting one in the distinctness and simplicity of its forms. The reason of the great prominence given to the sail of the boat is, that its curved and sharp characters may give the utmost possible amount of opposition to the absolutely rectangular outline of the building.
The sky is very beautiful. [*N. G.*, 65.]

66. Moonrise.[3]

A highly-finished study, but the locality is here also uncertain. There are so many campaniles in Venice of the class to which this tower belongs, that it is almost impossible to identify one of them under Turner's conditions of mystery, especially as he alters the proportions indefinitely, and makes the towers tall or short just as it happens to suit the sky. [*N. G.*, 66.]

67. General View of the Giudecca.

With the churches of the Redentore and St. Giorgio. Very beautiful. [*N. G.*, 67.]

68. Looking down the Giudecca.

That is to say, looking from the lagoon into this great thoroughfare of Venice, the way its current runs. As we

[1] [Called in the National Gallery "Grand Canal (Sunset)."]
[2] [Called in the National Gallery "Venice: suburb towards Murano."]
[3] [Called in the National Gallery "Venice: suburb."]

are here at the outskirts of the city, and looking towards its centre, we should perhaps say in any other town we were looking "up" the street of it; but the direction of the current must, I suppose, regulate our mode of parlance in Venice. [*N. G.*, 68.]

69. Looking up the Giudecca. Sunset.

The original sketch of the oil picture of "San Benedetto, looking towards Fusina."[1] [*N. G.*, 69.]

70. Venice.

Just after sunset. The position of the city is indicated by the touches of white in the vermilion cloud.

I cannot make out the long purple object like a wall in the middle distance. But I imagine, from the position of the sun, that the subject is a reminiscence of a return from Torcello towards Venice.[2]

The clouds are remarkable as an example of Turner's frequent practice of laying rich colour on a wet ground, and leaving it to gradate itself as it dried, a few subsequent touches being, in the present instance, added on the right hand. Although the boat in the centre seems a mere scrawl, the action of the gondolier (at the left-hand side) is perfectly given in his forward thrust. [*N. G.*, 70.]

71. Scene in the Tyrol.[3]

The twenty sketches which are above selected from the series which Turner made at Venice, are generally characterised by a depth of repose, and a delicacy of colour which would cause any one who had not seen other examples of Turner's work to suppose that tranquillity and tenderness were the only characters of nature which the artist would

[1] [No. 534 (oil pictures) in the National Gallery : see above, p. 164, and for another reference to the sketch, below, p. 373.]

[2] [Called in the National Gallery "Venice, from Fusina."]

[3] [Called in the National Gallery "Ravine and Tower."]

ever care to express. I have, therefore, arranged in immediate sequence upon them some of his mountain drawings, in which force of colour, and energy both of form and effect, might induce us, in like manner, to suppose that these qualities had been the principal objects of his aim throughout his artistical life.

The subject which now introduces us to the Tyrolese defiles is indicated in colour only, without any of the pendrawing, or elaboration of texture which Turner always gave to the sketches he cared much for. Many such memoranda of colour exist among his loose papers; but their subjects are usually so little defined, that I have only admitted this one into the present series as an example of the class. It is, however, a very interesting one in its simplicity of gradation. It is curious how much of its glow depends on the two rude dashes of green in the bottom at the left; and how much of its size and distance on the mere indications of the level bed of the stream in the hollow.

There is, of course, too little detail to admit of the locality being verified; there are hundreds of such places among the Tyrolese Alps. [*N. G.*, 71.]

72. SCENE ON A PASS OF THE HIGHER ALPS.[1]

I consider this, take it in all, the grandest sketch in the whole series, and purpose, therefore, to discover its subject, and then to illustrate it at length. I will say no more of it at present than that it deserves the spectator's closest attention, and the artist's most reverent study. I rather believe the subject to be on the St. Gothard, as the drawing was on a leaf of the book which furnished Nos. 41, 44, 46, and 47.

The white object on the right of the bridge, with the sloping roof, is a gallery built to protect the road from an avalanche. [*N. G.*, 72.]

[1] [Called in the National Gallery "Bridge, Alpine Pass"; and by Ruskin in his last catalogue, "The Red Gorge": see below, p. 371. Ruskin did not, however, carry out his intention to describe the sketch more fully.]

73. VILLAGE IN THE HIGHER ALPS.[1]

I do not know the subject of this sketch; but there is enough detail to enable me to make it out some day: it follows at present sufficiently well in our series, as an expression of the look of the grey villages of the higher Alps in the midst of the stony débris of their passes. A considerable torrent descends under two bridges, between the mills on the right; and the breadth of effect in the half-grey, half-rosy light which touches the village is very beautiful.

I have no doubt that this study was made on the same journey as No. 97, though I found it in another parcel; but it is not, I think, any Allée Blanche or Col de Ferret village. [*N. G.*, 74.]

74. FORTRESS.[2]

This, next to No. 72, is the noblest study in the series, displaying all Turner's power of modulation in subtle colours, and all his power of drawing, in the work in the rocks. In certain conditions of granitic rock, one of the chief characters of its water-worn mass is to divide into steps,—not long and continuous, as in limestones, but in narrow vertical bands or columns,—of which two are seen here in the high precipice on the right, and another has been taken possession of by the small secondary stream, whose undulations over the steps of it, exquisitely drawn and touched with blue reflections of the sky, are seen in the middle of the grey shadow; the water is hardly traceable above, its own spray forming a visible mist where the sun strikes, and hiding the stream. His strong sense of such granite structure in this particular rock is shown chiefly by the pencilling along the edge of the farthest precipice, where sloping lines in an almost equi-distant succession, indicate the jags of the cliff at its most exposed angle: I have no doubt that if Turner had ever realised this, he would have completely

[1] [Called in the National Gallery " Alpine Village under Precipice."]
[2] [Called by Ruskin in his last catalogue "The Via Mala": see below, p. 371. The sketch seems to have been taken from above Thusis, looking back.]

developed this structure through the mist, though he could not do so in his sketch without making that part of it inharmoniously conspicuous.

I was obliged, in mounting this drawing, just to catch its lower edge and no more; for Turner had actually used the white jags at the margin of the paper as part of the expression of the foam. As a composition, the drawing is remarkable for containing the utmost expression of height which it is possible to get at the given distance, and in the given space. Required to show a vertical rock so near, that a castle, on the farthest edge of it, shall show its tiles and windows,—you cannot possibly make it look higher than Turner has. The way in which he has done this too is specially interesting, because it contains so point-blank a denial of the common idea that yellow is an approaching colour and blue a retiring one;[1] the foreground being here wholly blue, and the farthest mass the strongest yellow. [*N. G.*, 73.]

75. THE VALLEY OF THE SPLÜGEN.[2]

We descend to Coire, and look back from near Ragatz to the higher hills.

Very remarkable as an example of Turner's occasional delight in a perfectly straight road, seen for four or five miles of its length at once. He realised this sketch at his own choice with great care; the drawing is now in the possession of Mr. Munro.[3] [*N. G.*, 75.]

76. DESCENT FROM THE ALPS.[4]

I am not sure where we are; but certainly on a good road, and in a comfortable chaise. The pen-drawing under

[1] [See, for a criticism of this idea, *Elements of Drawing*, § 184. It is accepted by Mr. Kingsley in a note given below, p. 534.]

[2] [Called in the National Gallery " Approach to the Splügen Pass."]

[3] [The drawing in question, long coveted by Ruskin (see *Præterita*, ii. ch. iv. §§ 71, 72, and the Introduction above, p. xlvi.), was presented to him by a number of his friends in May 1878 : see below, p. 487, and Plate xxv.]

[4] [Called in the National Gallery "Alpine Pass, with Cascade and Rainbow."]

the rainbow, where the road comes down the hill, is very free and beautiful; and the heap of stones at the top of the waterfall, on the left, one of the best bits of sketching in this series. [*N. G.*, 76.]

77. RIVER SCENE, WITH FORTRESS.[1]

Another subject which temporarily embarrasses me; but it is clearly a recognisable one, and of considerable interest; the fortress walls on the right being grand, and the city, or opposite citadel, of great extent. As a drawing, it is a valuable lesson in composition; if you hide the block timbers above the river with your hand, the fortress immediately becomes thin and flimsy; but when the lines of the timber are put in, as you can see through them everywhere, the fortress walls become instantly firm and solid by the contrast. [*N. G.*, 77.]

78. RIVER SCENE.[2]

An example of Turner's slightest work in his grandest temper. There is no laziness, and no failure; but intense haste and concentration of power; every line and blot being of value. Note, for instance, the use of the thin white touches through the grey of the river, and of the touches out in the distance, which actually create the stream out of nothing. The truth of the radiating lines in the dark rock on the left, and the noble curves of the fortress on the right from its vertical wall, would need an essay of several pages, and the help of many diagrams, to illustrate properly. [*N. G.*, 78.]

79. RIVER SCENE. Evening.[3]

I have arranged these unknown subjects together, merely because they belong to one class of scenery, and are all

[1] [Called in the National Gallery "Alpine Fortress and Torrent."]
[2] [Called in the National Gallery "River Scene, with Château."]
[3] [Called in the National Gallery "Fortress and Torrent."]

studies in Turner's best method of work. I fear that the localities of some may be hardly ascertainable: but the reader may be assured that they are all studies from real places, and I shall be grateful for any hint and help which travellers may be able to give me, leading to their identification. [*N. G.*, 79.]

80. SCENE IN THE TYROL.[1]

The grandest subject, if we include quantity and picturesqueness as elements of grandeur, in all the series. I wish I knew where it is, and who the baron was who first perched himself on that overhanging rock on the left. I hope to illustrate this drawing at length, as well as Nos. 72 and 78.[2] [*N. G.*, 80.]

81. SCENE WITH TORRENT AND FORTRESS.[3]

These next two subjects may also probably be in the Tyrol. I have no doubt of ultimately discovering them. This one is singularly grand and simple in conception; its colour exquisitely pure, and its execution at once delicate and vigorous;—it is not possible to do more with the given number of touches. Note especially how the main promontory of rock is thrust forward merely by the gleam of white paper left at its foot in the rosy dash of colour.

Nothing can be more magnificent than the standing of the buildings on the rock, the firm irregularity of their battlements, and the indications of sloping cleavage in the cliff itself.

The grey mass in the foreground is the dark side of a piece of rock hanging over the torrent, which is indicated in its descent under the bridge by a few touches of blue. This sketch cannot be too long or patiently studied. [*N. G.*, 48.]

[1] [Called by Ruskin in his last catalogue "Miner's Bridge" (see below, p. 371); and in the National Gallery "Alpine Scene, Village and Bridge."]
[2] [This intention, however, was not fulfilled.]
[3] [Called simply "Fortress" in Ruskin's last catalogue (see below, p. 372); identified in the National Gallery as "Castle near Meran."]

82. Scene with City and Fortress.[1]

Far inferior to the last, this is still of great beauty and interest, remarkable chiefly for the extent of space in the calm water on the right, attained with hardly any labour. Turner has got into some scrape which provoked him excessively as he drew the nearest wall of the fortress, the paper being there deeply dented with his knife as he effaced the work; these indentations produce a slight shadow, which gives part of the effect to the drawing: if the paper were smoothed by being mounted, the intention of the painter would be lost in that part of the drawing. [N. G., 82.]

83. The next eight subjects are from two towns, I believe in eastern Switzerland, but they will be quite easily identified.[2]

This is a very interesting composition, owing to the way in which the yellow foreground turns the river, while it carries down its principal lines. Hide the two figures and scratched lines at the bottom, and see how the space and length of river are lost. Note the fearless straight lines of road or terrace in the further hill, leading the eye to the grey bridge which was to be the point of the whole. [N. G., 83.]

84. Walking a little nearer the town towards those terraces, we turn back, and looking down the river, see the sunset. The ease, power, and value of the pencil lines which trace the river shore, and the quantity of sunlight which is got through the golden colour almost at a dash, by the gradation to the white at the lower shore, renders this one of the most curious drawings in the series.[3] [N. G., 49.]

[1] [Called in the National Gallery "Village and Castle on the Rhine."]
[2] [Ruskin identified them on his Continental tour in 1858 (see Preface, § 3, to vol. v. of Modern Painters). This sketch is now called "Baden (Switzerland), looking South" (see below, No. 85).]
[3] [In his last catalogue (see below, p. 372) Ruskin called this drawing also "Baden"; it is, however, identified as "Fribourg" in the National Gallery.]

85. We arrive at the town, but, before entering it, walk a little way to the other side of the bridge gate, in order to sketch its towers in their gathered group under the fortress.

I do not know a more careful outline drawing of Turner than this.[1] [*N. G.*, 85.]

86. General view of the second of the two towns. The united breadth and tenderness of this slight suggestion of a noble subject, render it to my mind very interesting, The clear look of the distant mountain range is rare in Turner's work at this period; but the same clearness of effect occurs in the following series of studies, 87–89.[2] [*N. G.*, 86.]

87. The same town,[3] from the other side of its bridge gate. Nobly composed. Note the use of the distant grey mountain range in binding the white houses together into a mass. [*N. G.*, 87.]

88.[4] The same town from the approach to the bridge. A beautiful instance of serpentine continuity in composition; beginning with the red figures, the line of it winds over the bridge, back to the left in the town, up to the right by the first wall—then away to the left down into the dark shadow of the river, and returns up to the right along the mountain range, to their utmost summit. Hide the red figures, which are added to the serpent to form its head, and see how the composition loses.]*V. G.,* 88.]

89.[5] Exquisitely beautiful. A separate study of the little fishing house which occurs in the great view, No. 87.

[1] [This is " Baden (Switzerland), looking North."]
[2] [This and the next three sketches are of Rheinfelden ; 86. " Looking across the Rhine."]
[3] [" Rheinfelden, looking up the Rhine."]
[4] [" Rheinfelden, from the end of the Bridge."]
[5] [" Rheinfelden, the covered bridge." The series of Turner's sketches at the Swiss Baden and Rheinfelden, Nos. 83–90, are referred to in *Modern Painters*, vol. v. pt. ix. ch. xi. § 30 *n*. Ruskin went to Rheinfelden immediately after arranging the Turner

The piece of building on the left, between the bridges, is peculiarly massive and grand. ¡V. *G.*, 89.]

90.[1] Entrance to the town over the bridge. I have only framed it as a completion of the series of views of this city. It is a thoroughly bad sketch (for Turner); every way slovenly and substanceless. [*N. G.*, 90.]

91. LAUSANNE. The valley between the lower and higher towns.[2]

Careful and beautiful; and very characteristic of Turner's way of getting views of things which nobody else would have thought of. The foreground appears to be one of the narrow paths through the vineyards,—steps on the right going down to other terraces. The green hill beyond is the ridge which the Geneva road descends, between two rows of trees which Turner has carefully indicated. Beyond this, again, is the blue outline of the Dent d'Oches on the other side of the lake. The character of the quaint Swiss roof of the cathedral tower is admirably rendered on the left. [*N. G.*, 91.]

92. THE PROMENADE OF LAUSANNE.[3]

We have here the avenue itself which was in the distance of the last subject,—a carriage and four driving down on the left, one postillion only, in the foreign fashion; the cathedral is seen through the trees, and the outline line of the Mont Combin in the distance beyond the lake. The walk in front of us is one of the favourite resorts of the townspeople; a nurse with two children is sketched on the left. [*N. G.*, 92.]

sketches in the National Gallery, and made drawings of his own, "with servile accuracy," in order to trace the exact modifications made by Turner in composing his subjects. The upper sketch in Plate 82 of *Modern Painters* is of No. 87; the lower is of the same view as that in No. 80.]

[1] ["Rheinfelden: Entrance to the covered Bridge."]
[2] [Called in the National Gallery "Lausanne, looking East."]
[3] [Called in the National Gallery "Lausanne, looking East from the Terrace."]

93. The Valley of Lausanne.[1]

Included in the series chiefly to show the different views which Turner would take of the same subject at different times; it is far inferior, as a study, to the Nos. 91 and 94. The foreground, especially the white object in it, is wholly unintelligible. [*N. G.*, 50.]

94. Lausanne.

It draws towards evening as we wander about the ravine, and the cathedral towers fade in the tender light. We prepare to cross the bridge and ascend to the higher town. Very beautiful; almost unique, in this series of sketches, for quietness of colour; its bank of purple and plumy trees, against the golden light, is drawn with great care and completion. [*N. G.*, 44.]

95. The Lake of Geneva and Dent d'Oche. By sunset: from above the town.

Out and out the worst sketch in the whole series; disgracefully careless and clumsy, but too beautiful in subject to be left out. Interesting also in its noticing of the long cypress-like lines of reflection, cast down so unaccountably from the crags. I am nearly certain Turner made the sketch on account of the curious echo which these reflections give to the cypresses. [*N. G.*, 95.]

96. The Ramparts of Geneva. From the upper town.[2]

These fortifications are now destroyed, and this sketch is valuable as a record of the lovely effect which the clear, green, and living water of the Rhone gave to the old moats; its strong current being carried through all of them on this

[1] [Called also in Ruskin's last catalogue "Lausanne" (see below, p. 372), but identified in the National Gallery as "Fribourg."]
[2] [In Ruskin's last catalogue called "Fort l'Ecluse" (see below, p. 372); in the National Gallery, "Fort de l'Ecluse, from the Old Walls of Geneva."]

side of the city. The mountain opening in the distance is that through the Jura, at Fort l'Écluse, where the Rhone escapes from the valley of Geneva.

Entirely majestic and beautiful in conception. The shadow of the clouds on the Jura, and the rosy light on the hills behind their darkness, to the right, are peculiarly true and lovely. Observe how the bastion in the centre is drawn, owing its whole material existence to little more than the one gleam of light on its angle, obtained by a touch of the brush through the wet colour, running a little of the tint to its edge, in a dark line which rounds the top of the wall. ¡V. *G.*, 42.]

97. THE ALLÉE BLANCHE. From the foot of the Glacier de Miage.[1]

A noble drawing, though not much like the place, which I only recognise by the peculiar outlines on the right hand. But its exquisite gradations of colour, and the perfect expression of the retiring ridge which leads up to the left-hand peak, make this one of the best mountain drawings in the series.

Hide the touch of dark blue in the distance, and see what becomes of it all. [*N. G.*, 47.]

98. MARTIGNY.[2]

So I believe, at least: but the pencil marks in the ruin are not so conclusive as I should like to have them.

The excessive haste with which the colour has been thrown on the sketch, not in the least coinciding with the pencil outlines, and yet the subtlety of the effects wrought as the wash was laid on, render this memorandum very interesting. ¡V. *G.*, 81.]

[1] [Called in the National Gallery "The Allée Blanche, looking to the Col de la Seigne." Ruskin was there in 1849; for his descriptions, see Introduction to Vol. V. p. xxv.]
[2] [Called in the National Gallery "Martigny and Château."]
XIII.

99. VEVAY.

One is really provoked with Turner for not having completed the foreground of this lovely drawing, which most travellers in Switzerland will recognise with delight.

It is interesting to see how in putting in the red outlines, Turner always avoids his first pencilled ones. Thus he uses his outline of the roof in pencil, in the largest house, for the shadow of the roof, when he adds the crimson. The poplars in the distances are "Old Vevay." ¡N. G., 46.]

100. THE LAKE OF GENEVA.[1]

We return to Lausanne, and take our places by the night diligence for France. The sun goes down as we ascend the hill above the town. We look back to the mountains of Savoy, under the last glow; and bid farewell to them. [N. G., 41.]

[1] [Called in Ruskin's last catalogue " Dent d'Oches, from Lausanne " (see below, p. 372); in the National Gallery, " Lausanne, looking over the Lake of Geneva."]

IV

CATALOGUE OF TURNER SKETCHES AND DRAWINGS

(1857–1858)

CATALOGUE

OF THE

SKETCHES AND DRAWINGS

BY

J. M. W. TURNER, R.A.

EXHIBITED IN

MARLBOROUGH HOUSE

IN THE YEAR 1857-8.

ACCOMPANIED WITH ILLUSTRATIVE NOTES.

BY JOHN RUSKIN, M.A.

LONDON:
PRINTED BY SPOTTISWOODE AND CO.
NEW-STREET SQUARE.

1857.

Price One Shilling.

[*Bibliographical Note.*—Of this Catalogue there were two editions, and of the second edition there were two impressions (a variation not noticed in the *Bibliography* by Wise and Smart).

First Edition (1857).—Title-page, as given here on the preceding page. Octavo, pp. 54. The imprint (at foot of the reverse of title-page, and in the centre of a blank page, 54) is "London : Printed by Spottiswoode and Co., New Street Square." The Introductory Remarks (here pp. 235–249) occupy pp. 3–14; the Catalogue, pp. 15–53. The Scriptural mottoes at the end (see below, p. 316) are in Latin. The headlines on the left-hand pages are "Catalogue, etc.," those on the right-hand pages correspond with the divisions of the book, "Introductory Remarks," "Period of Development," "First Style," "Second Style," "Third Style." Issued as a "stabbed" pamphlet, without wrappers; at the end is a leaf with an advertisement of Mr. Wornum's *Catalogue* of the British School (see above, p. 95).

Second Edition (1858).—The title-page is an exact reprint of that of the first, except that the date is altered from "1857" to "1858." The words "Second Edition" do not appear upon it. The imprint is at the foot of the last page only. Octavo, pp. 76; "Introductory Remarks," pp. 3–14; Catalogue, pp. 15–76; of which pp. 58–76 ("Supplemental Series") contained new matter. The Scriptural mottoes at the end are in English. Issued in two forms—(*a*) "stabbed," without wrappers; and (*b*) sewn in green paper covers, with the title-page (enclosed in a plain ruled frame) reproduced upon the front.

Second Edition, second impression (1858).—After revising and enlarging the Catalogue for its second edition, Ruskin had gone abroad. When the edition was issued, his assistant, Mr. William Ward, noticed some errors in it, and forwarded them to Ruskin, who was then in Italy. Ruskin made the necessary corrections, and as the type of the second edition was still standing, had a corrected impression struck off. It is this second impression which is described in the *Bibliography* by Wise and Smart (No. 65, vol. i. pp. 74–76). The variations between it and the first impression of ed. 2 are enumerated below; the story is told in two of Ruskin's *Letters to William Ward* (vol. i. pp. 39–43 in the privately-printed edition of 1893, reprinted in a later volume of this edition).

A large portion of the contents of this Catalogue were *reprinted* with Ruskin's consent in the second edition (1877) of *The Life of J. M. W. Turner, R.A.*, by Walter Thornbury, ch. xlvii. pp. 505–525. This reprint includes several of the Introductory Remarks, and the notes on frames 1–5, 20–22, 25–29, 44–51, 53–55, 59, 72–79, 81, 83, 92–95, 97, 111, 112, 116, 118, 134, 152, 153.

A portion of the Introductory Remarks was *reprinted* by Ruskin

himself in *The Laws of Fésole* (1877), ch. viii. §§ 19 to end. Some altera-
tions then made are described in footnotes to the text here (see below,
pp. 242, 244–249).

The whole of the contents of this Catalogue were *reprinted*—in an entirely
rearranged form, to accord with the present arrangement and numbering
of the National Gallery collection—in vol. i. of *Ruskin on Pictures* (1902):
see above, p. 186.

Variations between the First and Second Editions.—Besides the addition of
the "Supplemental Series" and other differences already described, several
alterations were made in the second edition. In the matter of setting, all
the numbers in ed. 1—those of the drawings as well as of the frames—were
printed in black-faced type; this was confusing, and gave the pages an
ugly appearance; in ed. 2 the numbers of the drawings were distinguished
from those of the frames by being printed (as in this edition) in italics. In
the text, the alterations were as follows :—

Introductory Remarks, p. 235, lines 17–19 (of this edition), the words "I
can hardly . . . education" were added in ed. 2; § 4, line 4, ed. 1
inserts "not being exhibited *this* year;" § 5, line 5, see p. 237 *n.*; p. 245,
line 15, in the reference to "45," ed. 2 erroneously printed the figures in
italics, the true reference being to the frame, not to the drawing, so
numbered.

Catalogue.—At the beginning of the "Note" (p. 250) ed. 1 reads "The
series now exhibited consists of 228 drawings, in 107 frames; but numbers
. . ."; line 6 of the "Note," the words "The numbers . . . small type"
are omitted in ed. 1, which reads ". . . no harm. When, therefore, two
or more . . ."

Frame 6, the sentence "The words written . . . line engraving" were
added in ed. 2.

Frame 15, for "Interior" ed. 1 reads "Study of Interior."

Frame 16, ed. 1 described a different drawing (see below, p. 257 *n.*),
which was numbered "27" (whereas in ed. 2 the drawings included in the
frame were not numbered at all; this caused a consequent alteration of the
numbers of the drawings throughout the catalogue).

Frame 17, in ed. 1 the drawings are differently arranged—27 and 28 here
are 29 and 30 there, and 29 here is 28 there. Also for "Diagram" ed. 1
reads "Study."

Frame 18, the words "Observe . . . dark side" are in ed. 1 printed as
a footnote, which for "these last" reads "these studies Nos. 32, 33."

Frame 21, the words "The study . . . No. 16" were added in ed. 2;
and, in the title of the next drawing, ed. 1 reads "Study of a Stream" for
"Bed of a Stream."

Frame 23, ed. 1 reads "Study near Grenoble," and the footnote was
added in ed. 2.

Frame 32, the words "two studies . . . 126, 127" were added in ed. 2.

Frame 33 (see note on p. 266, below).

Frame 34, ed. 1 omits "Having . . . " down to "No. 66," and reads "Exemplifying . . . ," and in the next line, "often" for "sometimes."

Frame 38, after "cast of thought" ed. 1 reads "I suppose them to have been made in Savoy about 1810."

Frame 41, the words "The first sketch . . . No. 16" and "on the shutter . . . but one" were added in ed. 2.

Frame 42, the words "The first sketch . . . No. 16" were added in ed. 2 ; as also the words at the end, "; only observe . . . series."

Frame 44, in ed. 1 different (see note on p. 269, below); in ed. 2 "Folkstone" for "Folkestone."

Frame 45, the footnote added in ed. 2.

Frame 50, the drawings instead of being given progressive numbers were numbered 87, 87a, 87b, 87c : this caused further consequential alterations.

Frame 53, the words " Compare . . . next window " were added in ed. 2, and for "expression," ed. 1 reads "drawing."

Frame 55, the words "of which the engraving . . . present collection" were added in ed. 2.

Frame 59, in the footnote ed. 1 ends at "concerning them"; and for "various" reads "considerable interspersion of." The whole of the text after the words "blackbirds' nests" was added in ed. 2; ed. 1 there continuing "Frames No. 59a to 59g" (see note on p. 278, below).

Frame 60, ed. 1 reads " Pencil Outlines, for Park Subjects."

Frame 61, ed. 1 reads "Pencil Outlines of River Scenery."

Frame 62, ed. 1 reads " Pencil Outlines of a Village and Castle."

Frame 65, for "No. 115," ed. 1 reads "This sketch," and for "No. 117" it reads "No. 116" : see p. 281.

Frame 66, for a mistake here, see p. 281 n., below.

Frame 68, ed. 1 contains the note on "Shields" now in the text (see p. 281, below); ed. 2 substituted a note on "Okehampton"; so in Frame 69, ed. 1 reads "in copying a piece, either of the Dover or this, they . . ."; ed. 2, "in copying a piece, either of the Dover, Okehampton, or this, they . . ."; and a little lower down, ed. 1 reads "The moonlight [i.e., in the Shields] will let them into few of his secrets, but it also contains good practice in the distances, and ships, low on the left" instead of the concluding words in the text.

Frame 72, for a mistake in ed. 2, see below, p. 285 n.

Frame 86 was different in ed. 1 (see below, p. 292 n.).

Frame 96, for a mistake in ed. 2, see below, p. 296 n.

Frame 100, for "last thoughts" ed. 1 reads "last drawings," and omits the words "See the notice . . . supplemental series." Ed. 1 then reads and continues with the passage "Throughout his life he had been pre-eminently the painter of clouds. All other features . . . " (as at the end of ed. 2 : see p. 316, below).

Frame 111, line 1, previous editions read " Pictures" for "Picture."

Frame 126, the reference "Compare No. 32" has hitherto been erroneously given as to the drawing and not to the frame.

Variations between the First and Second Impressions of the Second Edition.—
The principal error in the first impression was in Frame 68. Ruskin had

intended to substitute the drawing of Okehampton for that of Shields, but had, in fact, forgotten to do so. The first impression, therefore, contained a description of Okehampton (see below, p. 282 n.) ; this was cancelled in the second impression, and a revised note on Shields restored from the first edition. In Frame 69 there was a consequential alteration, as there again the first impression of ed. 2 had contained a reference to Okehampton (see above). The other variations between the earlier and the later impression are as follow :—

Frame 59, page 275, line 16, "local colours" in the earlier altered to "local colour"; page 275, last lines, the words "The corresponding . . . perspective" added in the later ; page 277, line 2, a comma inserted after "bridge."

Frame 73, line 20, a comma inserted after "train."

Frame 101, line 21, "all omissions" altered to "omission itself"; line 23, "all omissions should assist" altered to "every rejection should give value to."

Frame 104, line 3, "and" altered to "or."

Frame 106, considerably altered, see p. 299 n.

Frame 109, "Church of SS. Giovanni e Paolo" substituted for "Convent of the Quattro Coronati."

Frame 144, "First Sketches of the England Subjects" placed after "Lancaster," so as to apply to both subjects; in the earlier impression "First Sketches of the England Subject" after "Carew Castle" (which was printed with inverted commas).

The *text in this edition* is that of the second impression of the second edition. The numbering of the paragraphs in the Introductory Remarks is here introduced. On p. 255, No. 8, line 2, "Munro" is corrected to "Monro." Some additions are made to the text on p. 258.]

CATALOGUE, Etc.

INTRODUCTORY REMARKS

1. The delicate and finished drawings, exhibited at first in Marlborough House, being of a character peculiarly liable to injury from exposure to light, and it having been judiciously determined by the trustees that they should be framed and arranged for exhibition in a manner calculated to secure their protection when not actually under inspection, as well as to render their examination ultimately more convenient to the public, a selection has been made in their stead from Turner's sketches and drawings, calculated to exhibit his methods of study at different periods, and to furnish the general student with more instructive examples than finished drawings can be. The finished drawing is the result of the artist's final knowledge, and nothing like it can be produced by the scholar till he possesses knowledge parallel in extent; but an artist's sketches show the means by which that knowledge was acquired.

I can hardly use terms strong enough to express the importance I should myself attach to this exhibition of Turner's sketches, as a means of artistical education.

2. A few words respecting the relation which the selected examples bear to the entire body of the works in the National Collection may be of service before proceeding to enumerate the separate subjects. This relation I can state definitely, because, by the permission of the Trustees, I have had access to the drawings, in order to select a hundred[1] to exemplify the method of framing suggested in

[1] [Those in the preceding catalogue, pp. 191–226.]

my notes on the Turner Gallery; and I am therefore en-
abled both to state the general character of the collection,
and to mention some of the reasons which have influenced
the arrangement of those now publicly exhibited. But it
must be distinctly understood that I alone am answerable
for any statements made in this catalogue, and that it has
no official or authoritative character whatsoever.

3. The drawings by Turner in the National Collection
are referable to four principal classes:—

(1). Finished drawings, executed, with very few excep-
tions, with a direct view to publication by en-
graving.

(2). Drawings made by Turner for his own pleasure, in
remembrance of scenes or effects that interested
him; or else with a view to future use, but not
finished beyond the point necessary to secure such
remembrance or service, and not intended for sale
or sight.

(3). Studies for pictures or important drawings: consist-
ing of broad sketches of the intended effect, and
experimental modifications of minor details.

(4). Sketches and studies from nature, made to gain
knowledge or accumulate materials.

4. The first class, that of the finished drawings, consists
(including vignettes) of about 200 examples, of which the
best were exhibited in the spring of 1857. And I con-
gratulate the public on their being exhibited no longer.[1] For
it is an ascertained fact that water-colour drawings are liable
to injury from continued exposure to light; and the series
of the Rivers of France, and of the "Italy" vignettes, are
unique in method, and in certain characters of excellence,
among Turner's works. It would certainly, therefore, be
inexpedient to allow them to be deteriorated by exposure,

[1] [See above, p. 188. Only a few of the finished drawings are now permanently
exhibited.]

when it is quite possible to keep them safe for centuries, without interposing more difficulties in the way of their examination than have always existed, and must necessarily exist, respecting all valuable manuscripts or books of drawings in a national museum. The right way to think of these finer Turner drawings is as forming a precious manuscript of 200 leaves, which must not be rashly exposed or handled; but which may always be examined without restriction by those who are seriously interested in it. Three of them are, however, retained in the present series as examples of their class.[1]

5. The second group of drawings, consisting of those made by Turner for his own pleasure, form a much larger proportion of the collection. There are about 400 small drawings in colour on grey paper, of which some 150 are of the very highest interest and value : thirty-four characteristic examples[2] of these are now selected for (I believe) permanent exhibition, the remainder being set aside with the finished drawings for safer arrangement. From those of slighter execution thirty-three are selected ; among which are included examples of the brightest colouring : the number of such drawings in the collection rendering the partial deterioration of these a matter of less consequence. This class (which we may generally speak of as the "delight-drawings"), includes, in the second place, a mass of not fewer than 600 sketches in pure water colour on thin white paper ; in most cases so slight as to be hardly intelligible, but in others wrought nearly into complete drawings.[3] These, from

[1] [The three were "Dover" (N. G., 418) : engraved in *The Harbours*, see p. 51, above ; "North Shields" (N. G., 419) ; and "Rochester" (N. G., 420). They are now included in the Cabinet collection, and are not permanently exhibited on the walls.]

[2] [Ed. 1 reads "twelve of them, the least brilliant in colour, are now selected for (I believe) permanent exhibition," etc. The twelve were those now numbered 426 (four sketches), 428 (four sketches), and 434 (four sketches). Additional drawings of this class were afterwards selected for exhibition ; hence ed. 2 was revised as in the text.]

[3] [It was from this class of drawings that Ruskin selected his First Hundred in the preceding Catalogue ; see the general account of them there, pp. 189–190, above.]

the delicacy of their tints, are peculiarly liable to fade, and
the best of them are therefore already placed in protective
frames; but sixteen characteristic examples of the whole
class are included in the present selection in the frames
93 to 100.

6. The third class, or that of studies,[1] is, as will be
supposed, more limited in extent than the preceding one,
and of less interest, except to artists. It contains studies
of most of the vignettes to Rogers's poems, for some of
the England drawings and Liber Studiorum, and for a con-
siderable number of oil pictures. A few examples only are
given in this series, out of those which are brought nearest
to completion. Four, in the frames 88 and 89, are very
beautiful.

7. The fourth class includes the great mass of the col-
lection. I cannot yet state the quantity even approximately,
there being often many sketches on both sides of one sheet
of paper. Of these a selection has been made as completely
illustrative as possible; and, respecting them, one or two
points deserve especial notice.

8. There seems to be an impression on the minds of
many of the students at Marlborough House, which it is of
no small importance that they should get quit of,—the im-
pression, namely, that Turner's merit consists in a peculiar
style or manner, which, by reverent copying, may be caught
from him; and that when they have once mastered this
"dodge," and got into the way of the thing, they will all

[1] [See *Modern Painters*, vol. v. pt. viii. ch. iv., where Ruskin divides the sketches
of painters under three heads, viz.—(1) experimental, (2) determinant, and (3)
commemorative. By experimental sketches, he means those "in which they are
assisting an imperfect conception of a subject by trying the look of it on paper in
different ways. By the greatest men this kind of sketch is hardly ever made; they
conceive their subjects distinctly at once, and their sketch is not to try them, but
to fasten them down. . . . Among the nineteen thousand sketches by Turner—
which I arranged in the National Gallery—there was, to the best of my recollection,
not one. In several instances the work, after being carried forward a certain length,
had been abandoned and begun again with another view; sometimes also two or
more modes of treatment had been set side by side with a view to choice. But there
were always two distinct imaginations contending for realization—not experimental
modifications of one."]

become Turners directly. Now they cannot possibly be under a graver or more consummate mistake. Turner's merit consists neither in style, nor in want of style, nor in any other copiable or communicable quality. It consists in this,—that, from his tenth year to his seventieth, he never passed a day, and seldom an hour, without obtaining the accurate knowledge of some great natural fact; and, never forgetting anything he once knew, he keeps expressing this enormous and accumulated knowledge more and more redundantly; so that you cannot understand one line of his work unless you know the fact it represents, nor any part of the merit or wonderfulness of his work till you have obtained a commensurate part of the knowledge which it contains. You cannot admire, nor even see Turner, until your admiration shall consist primarily in Recognition of the facts he represents, as being facts known to you as well as to him. This is true not of Turner only, but of all great artists; but especially of Turner, in so far as every one of his pictures is a statement of new facts; so that you must take another day's hard work with Nature before you can read it (other artists representing the same thing over and over again). And this being so, it is not only hopeless to attain any of his power by mere imitation of his drawings, but it is even harmful to copy them unintelligently, because they contain thousands of characters which are mere shorthand writing for things not otherwise representable in the given space or time; and which, until long looking at Nature has enabled you to read the cipher, will be in your imitations of them absurd and false.

9. For instance, in the sketch in the left-hand upper corner of the frame No. 74, the boat lying on the shore on the right has a little crooked line thrown out from its stern, which gives a peculiar look of ease and rest to it as it lies. But if you concluded that you might always throw out a crooked line from the stern of a boat on the shore, to make it rest easily, you would only make yourself and your boat ridiculous. For the crooked line in this sketch

is the edge of the depression in the mud which is com-
monly formed under stranded boats by the tide, where the
mud is soft and deep. It is characteristic and right here
in the harbour ; but if you put it to a boat on a shingly
beach or rocky shore, you would spoil your drawing.

10. Once understand this character of great work, and
of Turner's most of all great work ; namely, that, just like
good writing or good speaking, its value depends primarily
on its matter, and on its manner only so far as it best
sets forth and impresses the matter; and you will see at
once how you may really hope to follow and rival Turner.
You have nothing to do but to give up all other thoughts
and pursuits, and set yourself to gather and remember facts
from Nature day by day. You must not let an hour pass
without ascertaining something; and you must never forget
anything you have ascertained. You must persevere in this
work all your life; filling score after score, hundred after
hundred, of note-books with your accumulated memoranda ;
having no other thought, care, nor ambition than how to
know more, and know it better; and using every drawing
you make to live by, merely as a piece of practice in setting
down what you have learned. And by the time you are
between fifty and sixty, supposing you also to have a
natural capacity for art, such as occurs about once in
Europe in two centuries, you will be able to make such a
little grey paper sketch as that in No. 74. Such in merit,
I mean, not such in manner, for your manner then will be
your own; and precisely in proportion to the quantity you
know and the genius you possess, will be the certainty of
its being a manner different from Turner's, but as great in
that different way. I had written in that last sentence
" quite different from Turner's," and I scratched out the
" quite." For there is much misapprehension abroad in the
world of art respecting the possible variety of styles. Nearly
all the great varieties of style result from errors or failures
on the part of the painter, not from his originality. All
the greatest men approximate in style, if they are working

towards the same ends. A sculptor's drawing is not and ought not to be like a painter's, because the colour element does not enter into his aim; but one painter's ought to be, in many respects, like another's; and as art is better understood, there will be an infinitely closer resemblance of manner in its leading masters. For instance, Etty's manner, so far as it is Etty's, is wrong; had he been a better painter, he would have been liker Paul Veronese. Rubens's manner, so far as it is Rubens's, is wrong; had he been a better painter, he would have been liker Tintoret. Rembrandt's manner, so far as it is Rembrandt's, is wrong; had he been a better painter, he would have been liker Titian. Turner's manner is at present peculiar, because he has created landscape painting, and is its only master. The stride he has made beyond Claude and Ruysdael is precisely as great as the stride which Giotto made beyond the old Byzantine brown triptychs; and the murmurs against him are precisely the old Margheritone murmurs against the newly-born fact and life;[1] but Turner, when once he is understood, will be healthily imitated by many painters, on the conditions of parallel toil which have just been stated, and form a school of landscape, like Giotto's of religious painting, branching down into its true posterity and descendantship of Leonardos and Peruginos.

11. The series of drawings now exhibited will be more useful than any others that could have been selected in convincing the public of this truth respecting the extent of Turner's study; but they will be useful no less in showing the method of this study, in the distinct separation of records of form from records of colour, and in the enormous importance attributed to form,[2] and to skill in what is

[1] [" Among the other old painters, in whom the praises justly accorded to Cimabue, and Giotto, his disciple, for those advances in art which were rendering their names illustrious through all Italy, awakened alarm for their own reputation, was a certain Margaritone, of Arezzo, a painter, who, with the others that had held the first place in art during that unhappy age, now perceived that the works of these masters must well-nigh extinguish his fame" (Vasari's *Lives*, Bohn's translation, 1855, vol. i. p. 88). There is a picture by Margaritone in the National Gallery (No. 564).]

[2] [Compare below, p. 507.]

XIII.

properly termed "drawing."[1] For there were current universally during Turner's lifetime, and there are still current very commonly, two great errors concerning him; errors which not merely lose sight of the facts, but which are point-blank contradictory of the facts:—It was thought that he painted chiefly from imagination, when his peculiar character, as distinguished from all other artists, was in always drawing from memories of seen fact, as we shall ascertain in the course of our examination of the drawings here catalogued. And it was commonly thought that he was great only in colouring, and could not draw; whereas his eminent distinction above other artists, so far as regards execution, was in his marvellous precision of touch,[2] disciplined by practice of engraving, and by perpetual work with the hard lead pencil point on white paper.

12. Now, there are many truths respecting art which cannot be rightly stated without involving an appearance of contradiction, and those truths are commonly the most important. There are, indeed, very few truths in any science which can be fully stated without such an expression of their opposite sides, as looks, to a person who has not grasp of the subject enough to take in both the sides at once, like contradiction. This law holds down even to very small minutiæ in the physical sciences. For instance, a person ignorant of chemistry hearing it stated, perhaps consecutively, of hydrogen gas, that it was "in a high degree combustible, and a non-supporter of combustion," would probably think the lecturer or writer was a fool; and when the statement thus made embraces wide fields of difficult investigation on both sides, its final terms invariably appear contradictory to a person who has but a narrow acquaintance with the matter in hand.

13. For instance, perhaps no two more apparently

[1] [From here down to the end of the Introductory Remarks the text was, with certain alterations, reprinted in The Laws of Fésole, ch. viii. § 19 to end of the chapter. The principal alterations are described in later footnotes.]
[2] [In The Laws of Fésole, "graphic" is inserted before "touch."]

contradictory statements could be made in brief terms than these :—

(1) The perfections of drawing and colouring are inconsistent with one another.
(2) The perfections of drawing and colouring are dependent upon one another.

And yet both these statements are true.

The first is true, because, in order that colour may be right, some of the markings necessary to express perfect form must be omitted ; and also because, in order that it may be right, the intellect of the artist must be concentrated on that first, and must in some slight degree fail of the intenseness necessary to reach the relative truth of form ; and *vice versâ.* The truth of the second proposition is much more commonly disputed ;[1] and it is this which I hope the student will be convinced of by the present exhibition of Turner's works.

14. Observe, it is a twofold statement. The perfections of drawing and colouring are reciprocally dependent upon each other, so that

(A) No person can draw perfectly who is not a colourist.
(B) No person can colour perfectly who is not a draughtsman.

A. No person can draw * perfectly who is not a colourist. For the effect of contour in all surfaces is influenced in nature by gradations of colour as much as by gradations of shade ; so that if you have not a true eye for colour, you

* The term "drawing" is here used as signifying "the art of applying light and shade so as to express form"; and it is in this sense that artists and writers on art usually employ it. Of course mere dexterity of the hand is independent of any power of colouring.

[1] [The rest of this sentence and the footnote to § 14 were omitted in *The Laws of Fésole.*]

will judge of the shades wrongly. Thus, if you cannot see the changes of hue in red, you cannot draw a cheek or lip rightly; and if you cannot see the changes of hue in green or blue, you cannot draw a wave. All studies of form made with a despiteful or ignorant neglect of colour lead to exaggerations and misstatements of the form-markings; that is to say, to bad drawing.

B. No person can colour perfectly who is not a draughtsman. For brilliancy of colour depends, first of all, on gradation; and gradation in its subtleties cannot be given but by a good draughtsman. Brilliancy of colour depends next on decision and rapidity in laying it on; and no person can lay it on decisively, and yet so as to fall into, or approximately fall into, the forms required, without being a thorough draughtsman. And it is always necessary that it should fall into a predeterminate form, not merely that it may represent the intended natural objects, but that it may itself take the shape, as a patch of colour, which will fit it properly to the other patches of colour round about it. If it touches them more or less than is right, its own colour and theirs will both be spoiled.

15. Hence it follows that all very great colourists must be also very great draughtsmen. The possession of the Pisani Veronese[1] will happily enable the English public and the English artist to convince themselves how sincerity and simplicity in statements of fact, power of draughtsmanship, and joy in colour, were associated in a perfect balance in the great workmen of Venice; while the series of Turner's studies which are brought before them here[2] will show them with what intensity of labour his power

[1] [For other references to the purchase of "The Family of Darius," from the Pisani family, see above, p. 88; below, pp. 287, 552; and *Academy Notes*, 1857, (Vol. XIV.) For other references to the picture, see *Academy Notes*, 1858; *Modern Painters*, vol. v. pt. viii. ch. iv. § 18; *Lectures on Landscape*, § 68.]

[2] [For "brought before them here," *The Laws of Fésole* reads "which are now accessible in the same gallery."]

of draughtsmanship had to be maintained by the greatest colourist of the modern centuries.

16. I do not think there can be much need for me to insist on the command over form manifested in these drawings. It was never recognised by the public in the *paintings* of Turner, simply because its manifestation was too subtle; the truth of eye and strength of hand that struck the line were not noticed, because the line itself was traced in almost invisibly tender colour. But when the same line is struck in black chalk, or with the steel pen, I should think that nearly all persons at all cognizant of the practice of art would see the force of it; and as far as I know the existing examples of painters' drawings, the galleries of Europe may be challenged to produce one sketch that shall equal the chalk study No. 45, or the feeblest of the pen and ink memoranda in the 71st and following frames.[1]

17. This was not merely the result of a peculiar gift for art; it was, as the public will now see, the result of never ceasing discipline. Hundreds of sketch-books of various sizes exist in the national collection, filled by Turner in his youth with pencil drawings, of which those in the frame No. 3 are characteristic specimens. Having first gone through this labour with the hard pencil point, he proceeds to use the softer pencil for shading; and two volumes are filled with drawings such as those in the frames 22 to 32.

18. Soon afterwards he made himself a master in etching and mezzotint engraving; the plate of the Source of the Arveron (placed temporarily in the Gallery for the purpose of completing the evidence of his modes of study), is only an average specimen of his engraving; and from that time forward to his death, he used the hard-point—pen, pencil, or chalk—for at least two out of three of all his drawings; and at the very time—between 1840 and 1845—when all the world was crying out against him for his want of drawing, even his coloured sketches from nature were distinguished from all coloured sketches that had ever been made

[1] [The three paragraphs §§ 16–18 are not given in *The Laws of Fésole*.]

before, by the continual use of the pen outline to secure
form.

19. One point only remains to be generally noticed,—
that the command of means which Turner acquired by this
perpetual practice, and the decision of purpose resulting from
his vast power at once of memory and of design, enabled
him nearly always to work straightforward upon his draw-
ings, neither altering them, nor using any of the mechanical
expedients for softening tints so frequently employed by
inferior water-colour painters. Many traditions indeed are
afloat in the world of art respecting extraordinary processes
through which he carried his work in its earlier stages ; and
I think it probable that in some of his elaborately completed
drawings, textures were prepared, by various mechanical
means, over the general surface of the paper, before the
drawing of detail was begun. Also, in the large drawings
of early date, such as No. 41 in this Gallery, the usual ex-
pedients of sponging and taking out colour by friction have
certainly[1] been employed by him ; but it appears only ex-
perimentally, and that the final rejection of all such ex-
pedients was the result of their trial experiment ; for in all
the rest of the national collection the evidence is as clear
as it is copious, that he went straight to his mark ; in early
days finishing piece by piece on the white paper (see Nos.
13 and 14), and, as he advanced in skill, laying the main
masses in broad tints, and working the details over these,
never effacing or sponging, but taking every advantage of
the wetness of the colour, when first laid, to bring out soft
lights with the point of the brush, or scratch out bright
ones with the end of the stick, so driving the wet colour
in a dark line to the edge of the light ; a very favourite
mode of execution with him, for three reasons : that it at
once gave a dark edge, and therefore full relief, to the
piece of light ; secondly, that it admitted of firm and angular
drawing of forms ; and, lastly, that as little colour was re-
moved from the whole mass (the quantity taken from the

[1] [For "certainly," "often" is substituted in *The Laws of Fésole*.]

light being only driven into the dark), the quantity of hue in the mass itself, as broadly laid, in its first membership with other masses, was not much affected by the detailing process.

20. When these primary modifications of the wet colour had been obtained, the drawing was proceeded with exactly in the manner of William Hunt, of the old Water-Colour Society (if worked in transparent hues), or of John Lewis (if in opaque);[1] that is to say, with clear, firm, and unalterable touches one over another, or one into the interstices of another; NEVER disturbing them by any general wash; using friction only where roughness of surface was locally required to produce effects of granulated stone, mossy ground, and such like; and rarely even taking out minute lights; but leaving them from the first, and working round and up to them, and very frequently drawing thin, dark outlines merely by putting a little more water into the wet touches, so as to drive the colour to the edge as it dried; the only difference between his manipulation and William Hunt's being in his inconceivably varied and dexterous use of expedients of this kind,—such, for instance, as drawing the broken edge of a cloud merely by a modulated dash of the brush, defining the perfect forms with a quiver of his hand; rounding them by laying a little more colour into one part of the dash before it dried, and laying the warm touches of the light, *after* it had dried, outside of the edges. In many cases, the instantaneous manipulation is quite inexplicable;[2] for instance, I cannot conceive by what treatment of the colour he obtained the dark and exquisitely broken edge of wave in the first drawing in the frame No. 65.

21. It is quite possible, however, that, even in the most advanced stages of some of the finished drawings, they may have been damped, or even fairly put under water and wetted through, so as to admit of more work with the

[1] [On this question of *technique*, see *Academy Notes*, 1859.]
[2] [The words "for instance . . . No. 65" are omitted in *The Laws of Fésole*.]

wooden end of the brush;[1] nay, they may even have been
exposed to strong currents of water, so as to remove super-
fluous colour, without defiling the tints anywhere; only
most assuredly they never received any friction such as
would confuse or destroy the edges and purity of separate
tints. And all I can *assert* is that in the national collec-
tion there is no evidence of any such processes. In the
plurality of the drawings the evidence is, on the contrary,
absolute, that nothing of the kind has taken place; the
greater number being executed on leaves of books, neither
stretched nor moistened in any way whatever; or else on
little bits of grey paper, often folded in four, and some-
times with the coloured drawings made on *both* sides of a
leaf. The coarser vignettes are painted on sheets of thin
drawing paper; the finer ones on smooth cardboard, of
course without washing or disturbing the edges, of which
the perfect purity is essential to the effect of the vignette.

22. I insist on this point at greater length, because, so
far as the direct copying of Turner's drawings can be use-
ful to the student (working from nature with Turner's
faithfulness being the *essential* part of his business), it will
be so chiefly as compelling him to a decisive and straight-
forward execution. I observed that in the former exhibition
the students generally selected those drawings for study
which could be approximately imitated by the erroneous
processes of modern water-colour, and which were therefore
exactly those that showed them least of Turner's mind, and
taught them least of his methods. They will not run so
much risk of this now; for except the few early tinted
experimental sketches, and the large drawings of Edin-
burgh and Fort Rock, there are, I believe, none on the
walls which can be copied at all but in the right way.

23. The best practice, and the most rapid appreciation
of Turner, will be obtained by accurately copying those in
body-colour on grey paper; and when once the method is

[1] [The words "so as to admit . . . the brush" are omitted in *The Laws of Fésole*.]

understood, and the resolution made to hold by it, the
·student will soon find that the advantage gained is in more
directions than one. For the sum of work which he can
do will be as much greater, in proportion to his decision,
as it will be in· each case better, and, after the first efforts,
more easily, done. He may have been appalled by the
quantity which he sees that Turner accomplished; but he
will be encouraged when he finds how much any one may
accomplish, who does not hesitate, nor repent. An artist's
time[1] and power of mind are lost chiefly in deciding what
to do, and in effacing what he has done: it is anxiety that
fatigues him, not labour; and vacillation that hinders him,
not difficulty. And if the student feels doubt respecting
his own decision of mind, and questions the possibility of
gaining the habit of it, let him be assured that in art, as
in life, it depends mainly on simplicity of purpose. Turner's
decision came chiefly of his truthfulness; it was because he
meant always to be true, that he was able always to be
bold. And you will find that you may gain his courage,
if you will maintain his fidelity. If you want only to make
your drawing fine or attractive, you may hesitate indeed,
long and often, to consider whether your faults will be for-
given or your fineries perceived. But if you want to put
fair fact into it, you will find the fact shape it fairly for
you; and that in pictures, no less than in human life, they
who have once made up their minds to do right will have
little place for hesitation, and little cause for repentance.

[1] [For "time," "nerve" is substituted in *The Laws of Fésole*, where also Ruskin
transposed some of the following words thus: "it is anxiety, not labour, that fatigues
him; and vacillation, not difficulty, that hinders him."]

PERIOD OF DEVELOPMENT

NOTE.—Numbers are written on the frames only,[1] because it seemed desirable that no dark points, such as would be formed by numerals large enough to be serviceable, should be set near the more delicate of the drawings; and it was necessary, of course, to observe the same system, even in cases where the numerals would have done no harm. The numbers of the frames are printed in this catalogue in larger type; and those of the drawings in small type.[2]

1.[3]

1. VIEW ON THE RIVER AVON. A sketch from nature, about the year 1791.

It should be kept in mind that Turner's work is separated by differences of style into five groups, corresponding to five periods of his life. He was born in 1775, and died

[1] [This is still the case.]
[2] [The original editions continued :—
 "And when two or more drawings are put in one frame, their numbers are first put in the relative positions of the drawings, thus—

<div align="center">

19 Number of frame.

</div>

34,	*35,*	*36,*	*37,* } Numbers of drawings in their
38,	*39,*	*40,*	*41,* } relative position in the frame.

"The reader thus sees without difficulty that No. 35 is the second drawing in the upper row, No. 40 the third in the second row, and so on; he will then find the drawings catalogued and described in numerical order."
In this edition, it has not been thought worth while to give up the space necessary for this arrangement; but in cases where there could be a doubt as to the relative position of the drawings in the frames, an explanatory note is supplied.]
[3] [The arrangement of the drawings in this frame is 2, 1, 3.]

in 1851. His time of real work extends over sixty years. from 1790 to 1850, and is properly to be divided thus:[1]—

Period of Development . . . 1790–1800.
„ The First Style . . . 1800–1820.
„ The Second Style . . . 1820–1835.
„ The Third Style . . . 1835–1845.
„ Decline 1845–1850.

In order to aid the memory (and the matter is worth remembering), it may be as well to include the fifteen years of childhood and boyhood in the period of development; which will give a singular order of diminution in length to the five periods, thus:—

Development . . 1775–1800 . Twenty-five years.
First Style . . 1800–1820 . Twenty years.
Second Style . . 1820–1835 . Fifteen years.
Third Style . . 1835–1845 . Ten years.
Decline . . . 1845–1850 . Five years.

It may also be generally observed that the period of development is distinguished by its hard and mechanical work; that of the first style by boldness of handling, generally gloomy tendency of mind, subdued colour, and perpetual reference to precedent in composition;[2] that of the second style by delicate deliberation of handling, cheerful moods of mind, brilliant colour, defiance of precedent, and effort at ideal composition; that of the third period by swiftness of handling, tenderness and pensiveness of mind, exquisite harmony of colour, and perpetual reference to nature only, issuing in the rejection alike of precedents and idealisms.

The period of decline is distinguished by impurity of colour, and uncertainty of purpose and of handling. The drawings belonging to it may be known at once by their

[1] [For other classifications of this kind, see above, p. 99, and below, p. 407.]
[2] [See *Modern Painters*, vol. v. pt. ix. ch. x. §§ 1, 2, where Ruskin refers to this passage, and analyses more at length Turner's gloom.]

surface being much rubbed and disturbed, and by the colours not having sharp edges.

I have not as yet found any drawings in the collection prior to 1790; nor any important examples of the period of decline. The exhibited series ranges only from 1790 to 1845.

This view on the Avon is as juvenile in character as a drawing well can be. It is not, however, as far as I can judge by the laying in of the sky, earlier than the two coloured pieces beside it, which are on leaves out of the same book. [*N. G.*, 523 (*a*).]

2. NORTH-WEST VIEW OF MALMESBURY ABBEY. 1791. So described on the back in Turner's early writing.

It was a favourite subject with him in after-life; and it has here had the boy's best work on it, besides being well looked at as he worked. Note the playing of the shadows on the trunks of the trees on the left. [*N. G.*, 523 (*b*).]

3. VIEW FROM COOK'S FOLLY (so described on the back), "looking up the river Avon, with Wallis Wall and the Hot Wells."

In all these drawings, feeble as they are, the power of composition already manifests itself. His love of continuity leads him to duplicate his vessel in each river sketch, in order to lead us down or up the river; and the trees with tablefork boughs, in the manner of Wilson, already meet with a graceful and Homeric interchanging of branches.* How accurate, for a boy, the drawing of the rigging of the large ship, with the shadows of the sails on each other! This emergence of a ship in full sail from beneath a bank was a favourite idea with him, even to his latest time. [*N. G.*, 523 (*c*).]

* See *Modern Painters*, vol. iii. p. 190.[1]

[1] [In this edition, Vol. V. p. 241, where Ruskin cites the Homeric phrase, of olive trees, "changing their branches with each other."]

2.

4. THE MEWSTONE. Showing some progress in laying colour, and interesting as the first thought of one of his best known works.[1] [*N. G.*, 401.]

3.

5. TOWER OF ST. MARY REDCLIFFE, BRISTOL.

6. TRANSEPT AND TOWERS OF YORK CATHEDRAL.

7. TOWER OF BOSTON, LINCOLNSHIRE.

These three drawings are fair examples of his pencil studies of architecture. Four or five sketch-books, containing not fewer than a hundred leaves each, are filled with drawings of this kind; and I believe the work to have been of the greatest service in steadying and refining his touch.

It will be observed that, throughout, the sketches are made not for effect but for *information;* a little bit of each portion of the building being completely drawn, the rest indicated. All Turner's sketches from nature are made on this great principle; though the kind of information sought, and the shorthand by which it is stated, vary with the subject and the period.

The total absence of any apparent feeling for bold or gloomy effect, and the delight in delicacy and precision of form, are very singular, when regarded as the first manifestations of the mind which was to conceive the "Death of the Python."[2] [*N. G.*, 524 (*a*), (*b*), (*c*).]

4.

8. MALMESBURY ABBEY. Sketch in pencil, of the same date as the three preceding ones, but showing in the trees the power of composition he had already reached, as well as his landscape "touch" at this period. [*N. G.*, 402.]

[1] ["The Mewstone, Plymouth Sound," engraved in *The Southern Coast*, 1816. The drawing is now, by the Vaughan Bequest, in the National Gallery at Dublin.]
[2] [No. 488 (oil pictures) : see above, p. 122.]

5.

9. First sketch from nature of the subject in the Liber Studiorum. "KIRKSTALL ABBEY." [*N. G.*, 403.]

10. First sketch from nature of the subject in the Liber Studiorum. "HOLY ISLAND." [*N. G.*, 404.]

Those who are familiar with the compositions of the Liber will be surprised to see how they were founded on the sketches of his boyhood. The Holy Island was published in 1808, the Kirkstall in 1812; while both of these sketches have been made about 1795.

The upper one has been intended for a coloured drawing, and left off, luckily, just as it was begun. So we see how we ought to begin coloured drawings when we are young,—in little bits: first the cows, which are to be warm; and then the piece of distance outside the building, which is to be cold; and so gradually to work from one to the other.

6.

11. SKETCH OF THE TOWN OF LEEDS.

12. SKETCH OF BOLTON ABBEY (about 1800).

The first was soon realised in a small drawing; the second not till long afterwards. The Bolton, in the England series, was published in 1827. I am very glad to have found this original sketch of it, which those who know the drawing, or even the engraving, will regard with deep interest. The words written on the water are, I think, "beautiful ripple" (spelt "riple"). How perfectly he wrought out this written purpose may be better seen in the etching of this part of the subject published in my third volume of *Modern Painters*,[1] than in the known line engraving. The Leeds is one of the most minutely finished pencil outlines in the collection. [*N. G.*, 525 (*a*), (*b*).]

[1] [Plate 12, called "The Shores of Wharfe": in this edition, Vol. V. p. 395.]

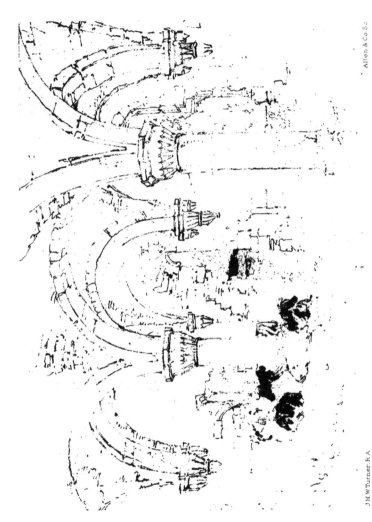

Kirkstall Abbey

n the sketch in the National Gallery. No 4(

J.M.W.Turner.R.A Allen & Co Sc

7.[1]

13. LARGE FIRE-ENGIN (*sic*) IN COALBROOK DALE.

14. COPPER WORK AT SWANSEA.

15. FIRE-ENGIN, COALBROOK DALE.

16. IRON FOUNDRY, MAIDLY WOOD, AT THE TOP OF THE HILL.

17. LARGEST FIRE-ENGINE OF COALBROOK DALE.

18. MR. MORRIS'S FIRE-ENGIN, NEAR GLASMOUNT.

Thus all described on the backs. There are about fifty-five more cards, devoted to the manufacturing picturesque. Compare the drawing of Leeds, No. *11.* [*N. G.*, 526.]

8.

19. VIEW OF THE SAVOY CHAPEL. One, I believe, of a series of drawings executed by Turner for Dr. Monro, for half-a-crown a day and his supper.[2]

Observe, we have, first, the boy's frank trial at nature, colour, and all, Nos. *1–4.* Then the colour is in a great degree abandoned, and the pencil drawing mastered by itself. Now the light and shade is taken up in pure grey, also by itself. [*N. G.*, 405.]

9.

20. VIEW OF TIVOLI. A drawing of the same class, and not one of the best, but remarkable as already showing perfect appreciation of the unison of rock forms in their main curves; a fact of which most artists remain uncognizant even to their latest days. Note how these rocks sweep up from the waterfall as if they would rise together to some point in the sky.[3] [*N. G.*, 527.]

[1] [13 and 14 in the first row; 15 and 16 in the second; 17 and 18 in the third.]

[2] [Dr. Monro, of Adelphi Terrace, one of George III.'s doctors, was Turner's early patron; see also below, p. 405. "There," said Turner, on one occasion in after years to David Roberts, pointing to Harrow, "Girtin and I have often walked to Bushey and back to make drawings for good Dr. Monro at half-a-crown apiece and a supper" (Alaric Watts: Memoir of Turner, prefixed to Bohn's *Liber Fluviorum*, 1853, p. xi.).]

[3] [For another note on this drawing, see below, p. 366.]

10.

21. STUDY OF SHIPPING. The student may see in this
drawing (an example, in its manner, of some hundreds made
by Turner at the period, though few were so large) what
work had to be gone through before Fighting *Téméraires*
could be painted.[1] [*N. G.*, 528.]

11.

22. PART OF THE CIRCULAR PORTICO OF ST. PETER'S,
ROME. A great advance is observable in the treatment of
this subject, which is singularly large and impressive. It is,
however, as far as I remember, considerably exaggerated in
scale in proportion to the figures. [*N. G.*, 529.]

12.

23. EARLY STUDY OF A COTTAGE. Very notable already
for a kind of irised gradation of tender colour, quite unpre-
cedented in English art at the time. [*N. G.*, 530.]

13.

24. EARLY STUDY OF A COTTAGE ROOF. Beautiful in
variety and brilliancy of touch, and another example of his
firm way of laying on his colour, step by step, on the white
paper. Compare the next drawing, No. *25.* [*N. G.*, 531.]

14.

25. CARISBROOK CASTLE. Much more highly finished
than the last example, and completing the evidence of
Turner's habit of colouring his drawings, at this time, inch
by inch. [*N. G.*, 532.]

15.

26. INTERIOR. Apparently feeble, but drawn with in-
tensest care, and full of instructive subtleties. Note, for
instance, the warm reflected light from the copper pan on
the lower part of the blue jug. [*N. G.*, 406.]

[1] [Compare what Ruskin says above, in *The Harbours of England*, p. 41.]

J.M.W.Turner·R.A. Allen & Co. Sc.

The Gate of Carisbrook Castle

From the sketch in the National Gallery No 532

16.

See the account of the contents of this frame under that of frame No. 59.[1] [*N. G.*, 407.]

17.

27, 28. SKETCHES OF BOATS IN GREY.

29. ANALYTICAL DIAGRAM OF A DUTCH BOAT. The drawings in the series commencing at this point are of a far more advanced character than any of the preceding ones; the painter's advance at this time being oftener by leaps than paces. The drawing No. *29* is formal; but firm and complete, good for service to any extent. The two smaller ones are considerably later, and very masterly.[2] [*N. G.*, 533.]

18.

30. FORESHORTENED STUDY OF SAILING BOAT.

31. FORESHORTENED STUDY OF HEAD OF ROW BOAT.

32. FORESHORTENED STUDY OF STERN OF ROW BOAT.

Observe the fidelity of these last in colour, aerial effect, and form, all at once: it is curiously proved by a slight circumstance. The light falls a little *on* the stern: therefore a little *from* the bow. It struck therefore at an oblique angle on the side of the boat nearest the bow; and the reflected light is feeble on the dark side. But it struck at a steep angle on the lighted side near the stern; and the reflected light is strong on the dark side. We shall see the fruit of all this stiff boat-drawing presently. [*N. G.*, 534.]

[1] [In ed. 1 Frame 16 contained a different drawing :—
"EARLY DRAWING OF A LANDSCAPE. Many pieces of this kind were made by him for the regular market, resembling, as nearly as might be, the works of other popular painters of the day, while he persevered secretly in his own peculiar studies. The heavy and broad touch required for this market supply was probably of use in keeping him from exaggerations of subtlety."
This "drawing of a landscape" cannot now be identified.]
[2] [Here, again, compare *Harbours of England*, p. 41.]

XIII. R

19.[1]

33–39. Successive Studies of a Shipwreck.

40. Stranded Boat.

All that we have seen Turner do hitherto might have been, to all appearance, accomplished by any one else as industrious. But no one else *is* as industrious. He has drawn ships, well put together, as other people might, but never do, until he can draw ships going to pieces as other people would fain, but never can.

I believe even those who have not seen a shipwreck, must recognise, by the instinct of awe, the truth of these records of a vessel's ruin.]V. *G.*, 535.]

20.

41, 42. Two Memoranda of Coast Scenery... I hope the reader observes the steady perseverance of the painter in always sketching for information, and not for the sketches' sake. The inscriptions on these outlines do not improve their effect, but they preserve the important facts. Some words I must leave to the deciphering of the ingenious reader; but thus much is legible:—"Sky darkish purple; rolling clouds, warm; [hill] a warm lighter orange rocks, warm ochre; purple shadow [in which the fishing relieved]; brilliant orpiment sails, excepting the (hieroglyphic for upright sail) white, beautifully reflected in the sand, with the sky and white figures streaming down. * * * Straw and Fish. Boy with Dog-fish. Women sorting."[2]

Note the intense resolve to have the facts, not only of the place, but of the moment: the boy with his dog-fish to be in his own place; nobody else instead of him; and he not to be moved anywhere else. [*N. G.*, 536.]

[1] [33–36 in the upper row; 37–40 in the lower.]
[2] [The words inserted above in square brackets are deciphered from the drawing; the spaces were left blank by Ruskin.]

J.M.W.Turner.R.A.

Allen & Co. Sc.

At Ivy Bridge

From the sketch in the National Gallery. No. 406

21.

43. SKETCH FROM NATURE OF THE SUBJECT OF THE OIL PICTURE OF "IVY BRIDGE." As interesting as No. *12,* being in like manner, the first idea of one of his most important works, a grand oil picture now in the possession of E. Bicknell, Esq., of Herne Hill.[1] The study for the drawing in this gallery is in frame No. 16. [*N. G.,* 408.]

44. BED OF A STREAM. One of the most instructive pieces of evidence I could find of the local finishing of his drawings; and as remarkable for precision of touch as for predetermination of design. Note especially the dark greyish-brown dash of shadow from the right, diagonally cast to the top of the white stones, at once defining them in light, and with true outlines; and look how transparent the pool of the stream is becoming, and how bright its fall, by help only of a few well-placed touches of brown and grey.

This sketch should be copied again and again by all students who wish to understand Turner; limiting themselves to precisely his number of touches to bring out the result, as they would be limited in a problem at chess to mate in so many moves.[2] [*N. G.,* 409.]

22.

45. STUDY OF SCOTCH FIR.

46. STUDY OF WILLOW. Two examples of an extensive series of drawings made in Scotland; as far as I can judge, about the year 1800. It has already been stated[3] that several volumes are filled with pencil drawings of this kind, completely worked out in light and shade. This enormous

[1] [For the oil picture of "Ivy Bridge," see *Modern Painters,* vol. i. (Vol. III. p. 244). The drawing of Ivy Bridge is No. 556 in the Gallery (No. 74 in this catalogue).]

[2] [For Ruskin's interest in chess, see Vol. VI. p. 85 *n.* ; compare p. 272, below.]

[3] [See above, pp. 238, 240.]

quantity of pencil shading gave him perfect evenness of
execution, besides exercising him thoroughly in the virtue
of all others most necessary to a painter,—Patience.

We see, gradually, how we are to proceed in order to
become good painters. First, five or six volumes full of
pencil drawings of architectural detail. Next, a year or so
of grey tinting at half-a-crown a day. Next, a year or
two of pencil shading, carrying our work well up to the
paper's edge; and chess problems in colour going on all
the while. The action of his hand is, however, cramped a
good deal in this foliage, and throughout the foregrounds
of the drawings belonging to this Scottish series. It is not
till this stiffness of hand is conquered that we can consider
the period of Development as past, and that of the First
Style begun. This step we shall see in the next drawing.
[N. G., 537.]

FIRST STYLE

23.

47. NEAR GRENOBLE. If the reader will compare the handling of the foliage in this drawing with that in *45* and *46*, he will see the transition from imperfect work to that of the formed master. From this time forward we shall see him advance in truth and in tenderness, but we cannot much in power.

This, with the following eighteen drawings, form part of a series illustrative of Turner's first Continental journey. I cannot at present ascertain in what year the journey was taken; but the painting of "Bonneville, Savoy," was exhibited in 1803 with "Calais Pier," and four other foreign subjects. There was no foreign subject exhibited, or, as far as I know, painted, by him before that year; so that the six paintings from Continental scenery all at once, must surely be the expression of a burst of enthusiasm on first going abroad. I think, therefore, that I cannot be wrong in supposing the journey to have taken place in the autumn of 1802 (it was autumn, for one of the exhibited pictures was the "Festival upon the opening of the Vintage of Maçon"); but I will not venture to say that these pencil drawings were made on the spot, or even in that year. They are of very peculiar character, much more formal and complete than his sketches from nature were usually (if ever); and have been, it seems to me, finished after returning home,* with some reference to the taste of the public,

* I have since ascertained this to be the fact, having discovered the original sketches of most of them—mere outlines, each made on the spot in about three minutes.[1]

[1] [These are among the contents of the tin boxes; compare the Introduction, above, pp. xlii.–xliii.]

or of his patrons; perhaps, in some cases, to show before-
hand the plan of some prepared picture. The subject, No.
48, for instance, is the original idea of a large water-colour
drawing, executed for Sir John Swinburne, and still in his
possession.

It adds to the difficulty of defining the precise nature
of these drawings, that they had been all purchased from
Turner, and mounted, in a more orderly fashion than, as far
as I know, *he* ever achieved in business of this kind, in a
large folio volume. The title was, however, written beneath
each subject in Turner's hand, and in Turner's French, of
which I give a specimen or two *literatim*. The volume had
come to sale, and been bought back by Turner; it retains
still its auction ticket. The drawings have sustained ter-
rible injury already by friction in the play of the massy
volume, being in some cases nearly half effaced; so that it
was absolutely necessary to arrange them in another manner.
[*N. G.*, 538.]

24.

48. On the Lake of Brientz. Subject executed for
Sir John Swinburne. The drawing is large (about 3 feet
by 2, as far as I remember), bold, and very beautiful; but,
like the sketch, inclines rather to a gloomy view of Swiss
landscape, and is very self-denying in the matter of snow.
The horizontal line of mist above the lake is here very true
and lovely. [*N. G.*, 539 (*a*).]

49. Vevay. ("Lac de Genève, from Vevay.") The
mountains in the distance are very carefully faithful in con-
tour, and not in the least exaggerated. The absence of ex-
aggeration is, indeed, very characteristic of all these drawings,
as compared with those of any other artist. Compare the
subdued and quiet forms of the mountains in this drawing
with any common Swiss one of the head of the Lake of
Geneva. [*N. G.*, 539 (*b*).]

25.

50. Convent of the Great St. Bernard. ("Le Sumit (*sic*) de Mont Bernard.") These drawings, No. *57* excepted, are now arranged so as to form an illustration of a little tour of Mont Blanc from Vevay to Grenoble. They were all out of order in the book, so that the real course of Turner's journey cannot be known. The Lake of Brientz (No. *48*), came last.

This, his first sketch of the St. Bernard, was afterwards used as the foundation of the vignette to "The Descent" in Rogers's *Italy*.[1]]*V. G.*, 540 (*a*).]

51. City of Aosta. Turner has been especially struck by the levelness of the plain in which Aosta is built, in the midst of the Alps. He has taken unusual pains to mark this character, and its classicalness as opposed to the wild Swiss peaks above. Remember, this was the first sight he ever had of Italy. [*N. G.*, 540 (*b*).]

26.

52. Roman Gate at Aosta, with Street of the Town. Turner has been rather puzzled by the Swiss cottages, which were not reconcilable with academical laws of architecture. He sits down to his triumphal arch with great zeal, and a satisfied conscience. [*N. G.*, 541 (*a*).]

53. Roman Gate at Aosta, with the Alps. ("Le Arc de Triumph (*sic*), Ville de Aoust.") These studies are the materials used in the vignette of Aosta, Rogers's *Italy*.[2] [*N. G.*, 541 (*b*).]

27.

54· Castle of Aosta.]*V. G.*, 542 (*a*).]

55. Castle of Aosta. This drawing, which I found in another parcel, is placed with the pencil study of which

[1] [The vignette which heads "The Descent" in Rogers' poem is, however, of "The Battle of Marengo." The reference is rather to the preceding vignette, "The Great St. Bernard," No. 211 in the National Gallery.]
[2] [No. 203 in the National Gallery.]

it is the amplification, that it may be seen how much the painter was yet hampered by old rules and formal precedents. He is still trying to tame the Alps into submission to Richard Wilson; but finds the result unsatisfactory, and leaves it unfinished.

But I am much puzzled by the feebleness of the drawing, and could almost imagine it a pupil's copy from one of Turner's. The laying in of the clouds, however, cannot but be his; and it is to be noted in general, that while, during his first period, his handling was bold both in pencil and oil-colour, his water-colours were frequently delicate, and even, as in the present instance, timid, in the extreme. [*N. G.*, 542 (*b*).]

28.

56. GLACIERS OF GRINDELWALD. [*N. G.*, 543 (*a*).]

57. FALLEN TREES. The glaciers are out of their place in our tour; but it is well that we should see them, and the shattered trunks beneath, just after the meek classicalism of No. *55.* No hope of taming the Alps, or softening them, in these.

I cannot make out, in the sketch of Grindelwald, where he has got to in the valley, or whether he means the upper white peaks for Alp or glacier. If he intends them for Alp, they are exaggerated,—if for ice, I do not understand how he has got pines to come between the two masses.

The other sketch is marked by him simply "G. C." (meaning Grande Chartreuse). It is very noble. [*N. G.*, 543 (*b*).]

29.

58. THE ASCENT TO CORMAYEUR. ("Ville de Salle, Valley de Aust.* La Côte Sud de Mont Blanc.") Perfectly true to the spot, as indeed most of these drawings are.

* It is amusingly characteristic of Turner that all his mistakes in spelling are economical. Many bad spellers waste their letters; but Turner never. Engin for engine; Aust for Aoste, or Aouste; sumit for summit, or sommite; Iser for Isère; Le Alps for les Alpes; Chatruse for Chartreuse, etc.

59. VALLEY OF THE ISÈRE. ("Valley de Iser.") Coming down from the Alps the road through the valley appears to us disagreeably long and straight. We resolve to have a steady look at it; on which it occurs to us that, nevertheless, it will draw. [*N. G.,* 544 (*a*), (*b*).]

30.

60. THE ROAD FROM VOREPPE TO GRENOBLE. Careless, but grand in toss of mountain form, and in the noble contradiction of the slope from the left by the diagonal light of the Alp seen through the gap in the distance. [*N. G.,* 545 (*a*).]

61. MONT BLANC, SEEN UP THE VAL D'ISÈRE, FROM FORT ST. LOUIS. As we shall see presently, when Turner wants to give value to a vertical line, he adds verticalness somewhere else; and when he wants to insist on a graceful one, adds gracefulness somewhere else.[1] So here, wanting to insist on the plain's flatness, he adds flatness in the walls. He always attaches infinitely more value to sympathy than to contrast; it was one of his leading principles as a composer. [*N. G.,* 545 (*b*).]

31.

62. THE ALPS, SEEN ON THE APPROACH TO GRENOBLE. ("Le Alps, approcant Grenoble.") Very grand in rolling sky, and the original (combined with one or two other studies) of the well-known Liber Studiorum subject.[2] But this sketch is far truer and finer in hill form than the one in the Liber. [*N. G.,* 546 (*a*).]

63. GRENOBLE, WITH MONT BLANC. First rate in hill and cloud drawing, and in the way the wall runs up the hillside to the tower. [*N. G.,* 546 (*b*).]

[1] [See below, on these and similar points, pp. 284 (No. *72*), 285 (No. *134*) and 286 (No. *139*).]
[2] [See No. 479 in the National Gallery.]

32.

64. GRENOBLE. Exquisitely realised by ˌhim in a large
drawing now in the possession of Mrs. Holford, ˌof Hamp-
stead;[1] two studies for the drawing are placed in the inner
room, in the frames 126, 127. [*N. G.*, 547 (*a*).]

65. GRENOBLE. Less valuable than most of the series,
but interesting in the way he climbs from the near building
on the right to the fort above, along the winding wall.
[*N. G.*, 547 (*b*).]

33.

See notice of this drawing at the end of the article on
No. 120.[2] [*N. G.*, 548.]

34.

66. STUDY IN OILS OF A MOUNTAIN STREAM, FROM
NATURE. Having seen in the preceding views the discipline
through which he put himself in pure light and shade in
the year 1802, we proceed to examine the work resulting
from it.

No. *66* exemplifies the kind of work which, as I have
just said, he did for his own instruction only; sometimes
in oils during the first period. It was usually subdued, as
this is, in colour, seeking rather for general breadth of tone;
and carefully reserving force for one or two points, as here
for the two black touches in front.

The stone drawing is consummate. [*N. G.*, 410.]

[1] [For another reference to this drawing see above, Introduction, p. xlix. It is
apparently one of two drawings of Grenoble now in the collection of Sir Donald
Currie, G.C.M.G.]

[2] [Ed. 1 contained a note on a different drawing, thus:—

"67. Pencil Sketch for a Drawing of an English Park and Castle. Having
seen . . . from it [as in the text under 66].

"No. 67 is an average example of his subsequent mode of setting down from
nature the arrangements of compositions intended to be of importance. His
coloured sketches were usually for his own instruction chiefly; but this kind
of pencil drawing was only made with special view to a drawing or picture.
Note the particularly conscientious statement respecting the 'nettles' in the
right-hand lower corner."

This drawing is not now among those which are exhibited.]

35.

67. EDINBURGH, FROM THE CALTON.[1] Characteristic of his important drawings at this time, and very noble. Exhibited in 1804.[2] [*N. G.*, 549.]

36.

68. STUDY IN BODY-COLOUR OF A GATE WITH CATTLE.[3] Thoroughly grand; and most valuable as an instance of the strange subjects he would sometimes try his strength upon, as if by their severe lines and poverty of surface to enhance his after enjoyment of soft curves and blended colours. [*N. G.*, 550.]

37.

69. FUNERAL OF SIR THOMAS LAWRENCE. Sketch from memory. Included in the series only as an instance of weakness.[4] [*N. G.*, 551.]

38.

70. CONTAMINES, SAVOY. This and the two following drawings are out of a large volume containing a series of Swiss subjects, treated with greater power than the Grenoble ones, but less carefully. They are generally more gloomy in cast of thought. They contain the original sketches of the Chamouni drawings at Farnley, and of the Chamouni subjects in the Liber Studiorum. [*N. G.*, 552.]

39.

71. First sketch for the Liber Studiorum subject,[5] "SOURCE OF THE ARVERON." Evidently made in going up the Montanvert during a minute or two of pause to take breath. [*N. G.*, 553.]

[1] [Compare Ruskin's *Notes on his Drawings by Turner*, No. 85, p. 465, below.]
[2] [At the Royal Academy.]
[3] [Now described as "Newall Hall, near Farnley."]
[4] [Not an early drawing. It is inscribed " Funeral of Sir Thos. Lawrence, P.R.A., Jan. 21, 1830. Sketch from memory. J. M. oyal Academy in 1830.]
[5] [See No. 879 in the National Gallery.]

40.

72. FLANK OF THE VALLEY OF CHAMOUNI. A rough sketch made at the same time as the other, but looking down the valley towards Mont Blanc.

He made a more elaborate sketch of this, and afterwards realised it for Mr. Fawkes, of Farnley. He combined the foreground of this one with the pines of No. *71* in the Liber Studiorum.

A fine impression of the plate from the Liber (engraved by himself) is temporarily placed beside No. *71* for the sake of comparison.[1] [*N. G.*, 554.]

41.

73. BATTLE OF FORT ROCK (I believe he meant Fort Bard), in the Val d'Aosta.

The most striking drawing of the first period in existence; but a little overlaboured, and too much divided in the Alpine distance; and, on the whole, poor in colour. I have not time to analyse so important a work at present. The first sketch of its scene, from nature, is in frame No. 16.

Exhibited in 1815.[2]

There is nearly a duplicate of it at Farnley, on the shutter of the last room but one. [*N. G.*, 555.]

[1] [The Farnley drawing is engraved in Vol. III. of this edition, opposite p. 238. The impression of the plate, lent by Ruskin, still hangs in the National Gallery; it is a very choice example. Ruskin had bought several early impressions of the *Liber* plates from Lupton.]

[2] [At the Royal Academy, No. 192, with the following quotation from "Fallacies of Hope":—

"The snow-capt mountain, and huge towers of ice,
Thrust forth their dreary barriers in vain:
Onward the van progressive forced its way
Propelled; as the wild Reuss, by native glaciers fed,
Rolls on impetuous, with every check gains force
By the constraint upreared; till, to its gathering powers
All yielding, down the pass wild Devastation pours
Her own destructive course. Thus rapine stalk'd
Triumphant; and plundering hordes, exulting, strew'd,
Fair Italy, thy plains with woe."

This drawing was found after Turner's death, blocking up a window in an out-house, and placed there no doubt to save window tax. For a further note, see p. 422 of this volume. The Farnley drawing was sold in 1890 for £1050.]

42.

74. Ivy Bridge. Characteristic, in its increasing refinement, of the close of the first period. The engraving from it was published in 1821. The first sketch for it is in frame No. 16. [*N. G.*, 556.]

We shall now examine a series of the minor studies made by Turner for the parts or incidents of his larger works. These studies of figures, animals, furniture, shipping, etc., were made by him in quantities during all the periods of his art; but I think it will be most convenient, as well as most interesting, if we examine them all together, so as to get some notion of their general range. We may, however, treat them chronologically so far as to take first in order the noble chalk and crayon studies made chiefly during the first period; only observe the drawing in No. 44 has been changed since the first arrangement of the sketches: so that the valuable finished work it now contains is an interpolation in this series.[1]

43.

75, 76. Two Studies of a Figure, for Picture of the Deluge. I do not know how far the placing of the anatomical detail is right in these figures, but for the *mode* of rendering the muscular markings in the chest of the second, and for freedom of cast and line in both, I remember no drawing by the best figure-masters that can much beat them. [*N. G.*, 557.]

44.

77. Folkestone. Finished drawing of a favourite subject. He painted it afterwards still more elaborately; this second drawing is in the possession of Sir John Hippisley, Bart.[2] [*N. G.*, 558.]

[1] [In ed. 1 Frame 44 contained:—
"Sketch of a Group of Figures for Picture of Hannibal. Very grand; much too artificially composed, but that was the fault of the teaching of the age more than his."
This drawing is not now among those which are exhibited.]
[2] [Now in the collection of Mr. E. Nettlefold, signed and dated 1824. For another reference to the present drawing, see below, p. 365.]

45.

78. Study of a Cutter. I have never seen any chalk sketch which for a moment could be compared with this for soul and power.[1] Note, among other wonderfulnesses of it, the way the two sails are gradated, each with one zig-zag touch; one of deepening grey, the other of fading white.

I should, think that the power of it would be felt by most people; but if not, let those who do not feel its strength, try to copy it. And if, after trying, they begin to wonder how such a thing was ever done, let them be assured that the way to No. *78* lies through No. *21;** and that there is NO OTHER way. *N. G.*, 559.]

46.

79. Study of a Pilot Boat. What its companion is among chalk sketches, this is, as far as I know, among sepia ones; having no rival in its kind. The figure of the old sailor throwing the coil of cable is, without exception, the most wonderful piece of energetic action I have ever seen rendered by means so simple, even Tintoret's work not excepted.

These drawings were on leaves of a folio book, which, for the most part, is dashed over with such things on both sides of its thin grey leaves; the peculiar ingenuity of the arrangement being that each leaf has half of *one* sketch on its front, and half of *another* on its back, so that mounting one whole sketch must generally hide the halves of two. The farther advantage of the plan is that the white chalk touches, on which everything depends, rub partly off every time the leaves are turned; besides that a quantity of the said chalk, shattered by Turner's energetic thrusts

* Frame No. 10: placed beside this sketch of the cutter.[2]

[1] [See above, p. 245; and below, p. 337.]
[2] [No longer the case, but the other drawing (N. G., No. 528) hangs not far off.]

with it, is accumulated in a kind of Alpine débris in the joints, shaking out, and lodging in unexpected knots of chalk, indigestion whenever the volume is shut; and, to make the whole thing perfect, the paper is so thin and old that it will hardly bear even the most loving handling, much less the rack and wear of turning backwards and forwards on a mount, if attached by one edge.

The best that can be done with it is to mount—as all the drawings of this series are mounted, by the extreme edges merely, the most important drawings; hiding, without injury to them, the least important; and cataloguing them carefully for reference if required. The two leaves here shown have only two or three sea-pieces at the backs of them; but half the stern of the pilot boat is unfortunately left on the opposite leaf—sacrificed to the unities. It would have spoiled a whole harbour full of ships on the other side if it had been taken away. [*N. G.*, 560.]

47.

80. MARINE. [*N. G.*, 561 (*a*).]

81. MARINE. [*N. G.*, 561 (*b*).]

48.

82. MARINE. [*N. G.*, 562 (*a*).]

83. MARINE. [*N. G.*, 562 (*b*).]

Four studies for pictures of about the same date, 1803 or 1804, as the preceding folio drawing. Very fine.

49.

84. STUDY OF AN ARM-CHAIR. In oils. He painted a

and anything else that came in his that
liked to have drawn, when he was
[*N. G.*, 563.]

50.

85–88. STUDIES FROM FOUR DIFFERENT POINTS OF THE SAME GROUP OF DOCK LEAVES. I think meant for the farmyard, with cart, in the Liber Studiorum.[1] [*N. G.*, 411.]

51.

89–92. VARIOUS STUDIES OF VEGETATION. Note the foreshortened leaf of laurel, and the memorandum, " Water sorrel, etc. *June.*"[2] [*N. G.*, 564.]

52.

93. STUDY OF SHEEP. Very fine. [*N. G.*, 412.]

53.

94. STUDY OF PIGS. [*N. G.*, 565 (*a*).]

95. STUDY OF DONKEYS. [*N. G.*, 565 (*b*).]

Both wonderful, quite beyond telling. There is an etching of Rembrandt's which approaches the upper study, but by no means equals it. Examine it for a quarter of an hour through a magnifying-glass and you will see something of what it is. Compare also the drawings in frame No. 16 in the next window. The expression of the head of the donkey-foal with one modulated touch of brown, is another chess problem [3] which may be earnestly recommended to students.

54.

96, 97. STUDIES OF MARKET-WARE. Two leaves from a pocket-book filled at Rotterdam. [*N. G.*, 413.]

[1] [See No. 507 in the National Gallery.]

[2] [Other memoranda may be deciphered: "Horse-C. full yellow green when young, but darker more advanced," "laurel dark green shining leaf, young shoot light yellow."]

[3] [See above, note on drawing No. *44* in this catalogue, p. 259.]

55.

98. VIEWS IN ROUEN. [*N. G.*, 566 (*a*).]

99. STUDY OF NORMAN CAPS. [*N. G.*, 566 (*b*).]

Two leaves from a pocket-book filled in Normandy.
The No. *98* is interesting, because it contains, at the lower
right-hand corner, the first sketch from nature of the lovely
subject, painted in the "Rivers of France," "Rouen from
St. Catherine's Hill," of which the engraving is placed be-
neath it.[1] The posts of the gateway on the left, the dili-
gence in the road, the village and poplars, will all be found
indicated in the little pencil drawing: and this may serve
to explain to the reader in some degree the importance I
attach to the pencil drawings of this kind, introduced in the
supplementary frames in the present collection.

56.

100. SKETCHES ON THE SEINE. Note the inscriptions
of incidents, "sheep; saw-pit;" etc. [*N. G.*, 414 (*a*).]

101. STUDIES FROM CLAUDE. There are very few of this
kind of sketch, chiefly from Claude and Titian; from the
latter in rude colour, with comments; forming a continuous
volume, which cannot be broken up for the sake of exhibit-
ing a leaf. [*N. G.*, 414 (*b*).]

57.

102. STUDY OF (MULE'S?) SKELETON. [*N. G.*, 567 (*a*).]

103. STUDY OF SKELETON. Used in the Liber Studi-
orum plate of the Devil's Bridge, of which a good im-
pression is placed temporarily below the studies, to show
how the sketch was employed.[2] [*N. G.*, 567 (*b*).]

[1] [The drawing for the *Rivers of France* was in Ruskin's collection, No. 56: see
below, p. 451.]
[2] [This fine impression from Ruskin's collection is now framed between the two
studies; for the *Liber* drawing, see No. 476 in the National Gallery; compare also
No. 73 in Ruskin's Turners, p. 461.]

XIII.

58.

104. STUDY OF DEAD DUCKS. [*N. G.*, 568.]

59.

105. STUDY OF TEAL, FLYING. It is well to have these
two drawings side by side, because they are entirely charac-
teristic of the manners of the first and second periods. The
darkness and breadth of No. *104* belong to the first, and
the brightness, refinement, and active energy in the drawing
of the living bird to the second.

No words are strong enough to express the admirableness
of the sketch No. *105.* There is only one other equal to
it in the National Collection,[1] and I believe only one in the
world superior to it,—of a ringdove at Farnley.[2] There are,
however, many studies of game by Turner, besides this ring-
dove, at Farnley.

The peculiar execution by which the spotted brown plu-
mage is expressed, and the wonderful drawing and colour
reached at one touch, as far as they are consistently pos-
sible, render these bird drawings of Turner more utterly
inimitable than, so far as I know, anything else he has
done.

But he loved birds, and was kind to them (as he was
to all living creatures, whatever the world may have said
of him). It will not be thought in after years one of the
least important facts concerning him, that, living at his
cottage at Twickenham, he was nicknamed "Blackbirdy"
by the boys, because of his driving them away from his
blackbirds' nests.* [*N. G.*, 415.]

* Life of Turner by Alaric A. Watts, given as an introduction to Bohn's
Liber Fluviorum, containing some interesting facts, with various popular mis-
understandings concerning them; as well as some traditions of entirely apo-
cryphal character: for instance, the well-known story of Turner's trying to
eclipse Wilkie by heightening the colours of his own "Blacksmith's Forge."

[1] [Namely, No. 375.]
[2] [For other references to the drawing at Farnley, see below, p. 370; a letter cited
in Vol. XIV. (*Notes on Prout and Hunt,* No. 145), and in a later volume, *An Oxford
Lecture,* § 4.]

Opposite to these studies of birds are now placed[1] some supplementary sketches of the same kind, in the frames Nos. 122,[2] and 123. The uppermost contains examples of his rapid memoranda of groups that pleased him, caught as he stood looking into his poultry yard; the central one, two studies of swans, fine beyond all expression. The woodcut at the side is a facsimile of a swan in the first plate of Retsch's outlines of "Pegasus in Harness"[3]: it will serve to show the reader in the most complete way how a swan ought *not* to be drawn, as Turner's will show the most perfect possible result attainable with the given number of touches. Observe especially the grand respect of Turner for local colour,—the swan's black beak being to him, as it would be to every simple and honest observer, one of the main points in the creature; while the German, taught that local colour is "unideal," misses the whole character of his bird, blinding himself by his vanity.

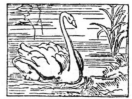

Fig. 5

Observe in the lower of Turner's two sketches how grandly he has indicated the agitation of the water, as partly the means of expressing the anger of the bird. The corresponding curves in Retsch's work are entirely false, and out of perspective.

The writer of the life assures us "there is no doubt of the correctness of the story;" but there happens to be just as much doubt of it as may arise from the fact of there being no bright colours *in* the "Blacksmith's Forge." It was indeed painted in emulation of the "Village Politicians," but Wilkie's picture, exhibited in 1806, could not sustain severe injury from the colour of Turner's exhibited in 1807.[4]

1 [The arrangement does not now obtain.]

2 [No. 122 in this catalogue is No. 609 in the National Gallery. The drawing is reproduced in *Lectures on Landscape*, where (§§ 55, 56) a further account of it is given. No. 123 is No. 440 in the National Gallery.]

3 [*Schiller's Pegasus im Joche nebst Andeutungen zu den Umrissen von Moriz Retzsch*, Stuttgart, 1833. For other references to Retsch, see Vol. IV. p. 259; *Elements of Drawing*, §§ 97, 257; and *Art of England*, § 101.]

4 [The story, which first appeared in Allan Cunningham's Life of Wilkie, was repeated in the *Athenæum*, and was copied thence into the memoir of Turner by Alaric A.

The frame No. **16** is one of great importance. I have
put the two studies of animals in it that they may catch
the eye, by the strangeness of their introduction, and allow
no one to pass the frame. For the sketch of a tree in the
centre of it is out of one of his books filled in Devonshire
—on the Tamar, and is indeed the theme afterwards ampli-
fied into the beautiful group on the left in "Crossing the
Brook";*[1] the one on the left of the two lower drawings

* The following extracts from the diary of Mr. Cyrus Redding,[2] who
had the privilege of companionship with Turner in some of his Devonshire
excursions, are very interesting in the circumstances mentioned respecting
this picture, and in the account they give of Turner's way of studying the
sea; nor less so in the rare justice of Mr. Redding's appreciation of his
genius.

"Some have said Turner was not conscious of his own superiority. I be-
lieve he was conscious of it. I believe him, too, the first landscape painter
that has existed, considering his universality of talent. That he did not
share in everyday susceptibilities, nor build upon things which the mass of
artists esteem, is to his honour rather than demerit. His mind, too, was
elevated. He did not wish to appear what he was not. He exhibited
none of the servile crawling spirit of too many of his brethren. He was
charged with being niggardly, but he had no desire to live in any other
way than that to which he had been habituated, for he dared to be singular.
His wealth he made for devotion to a better purpose than giving dilettanti
parties, and assembling in his drawing-room bevies of visitors to no good
purpose. He had no inclination for assortment with idlers uselessly. Con-
cealed beneath his homely exterior, there was a first-rate intellect. He was
aspiring in art, and knew the small value of thinking after others in social
compliances. A painter said to me that an artist could often see something
amiss in his own picture,—he could not tell what, but Turner would in-
stantly explain the defect; a single glance at the canvas from his eye was
enough. He spoke little, but always to the point. He disregarded many
things said about him and his peculiarities as unworthy, compared with the
worth he set upon his labours. The most despicable individuals are those
who make life a burden to accommodate themselves to the world's idle
notions. That he could, when he pleased, deviate from his usual habits I can
answer.

"I was one at a picnic party of ladies and gentlemen, which he gave

Watts, prefixed to Bohn's edition of Turner's *Liber Fluviorum*, 1853, p. xviii. For
Turner's "Blacksmith's Forge," No. 478 in the National Gallery, see above, p. 156.
Wilkie's "Blind Fiddler" (N. G., 99) was exhibited in 1807, but was not hung next to
Turner's "Blacksmith's Forge."]

[1] [For other references to the picture, see Vol. III. p. 241 n.]

[2] [Ruskin here strings together extracts from vol. i. pp. 203–205, 201–202, and
199–200 of *Fifty Years' Recollections, Literary and Personal, with Observations on Men
and Things*, by Cyrus Redding, 1858.]

is the sketch from nature of the "Ivy Bridge" (Frame
No. 42), and that on the right of the bridge, and rock
beyond it, from which he composed the scene of combat

in excellent taste at Mount Edgcumbe. There we spent a good part of a
fine summer's day. Cold meats, shell-fish, and good wines abounded. The
donor of the feast, too, was agreeable, terse, blunt, almost epigrammatic
at times, but always pleasant for one not given to waste his words, nor
studious of refined bearing. We visited Cothele on the Tamar together,
where the furniture is of the time of Henry VII. and VIII. The woods
are fine, and the views of some of the headlands round which the river
winds are of exceeding beauty. In one place he was much struck, took
a sketch, and when it was done, said: 'We shall see nothing finer than
this if we stay till Sunday; because we can't.'

"It was the last visit he paid to the scenery of the Tamar, before he
quitted the west. It was to the honour of several of the inhabitants of
Plymouth that boats, horses, and tables were ready for his use during the
time he remained.

"I remember one evening on the Tamar, the sun had set, and the
shadows became very deep. Demaria, looking at a seventy-four lying under
Saltash, said: 'You were right, Mr. Turner, the ports cannot be seen.
The ship is one dark mass.'

"'I told you so,' said Turner, 'now you see it—all is one mass of shade.'

"'Yes, I see that is the truth, and yet the ports are there.'

"'We can take only what we see, no matter what is there. There are
people in the ship—we don't see them through the planks.'

"On looking at some of Turner's subsequent works, I recently perceived
several bits of the scenery we had visited introduced into fancy pictures.
Meeting him in London, one morning, he told me that if I would look in
at his gallery I should recognize a scene I well knew, the features of which
he had brought from the west. I did so, and traced, except in a part of
the front ground, a spot near New-bridge on the Tamar, we had visited
together. It is engraved, called 'Crossing the Brook,' and is now in
Marlborough House.[1]

"We once ran along the coast to Borough or Bur Island in Bibury Bay.
There was to be the wind-up of a fishing account there. Our excuse was to
eat hot lobsters fresh from the water to the kettle. The sea was boisterous
—the morning unpropitious. Our boat was Dutch built, with outriggers
and undecked. It belonged to a fine old weather-beaten seaman, a Captain
Nicols. Turner, an artist half Italian named Demaria, an officer of the
army, Mr. Collier, a mutual friend, and myself, with a sailor, composed the
party. The sea had that dirty puddled appearance which often precedes
a hard gale. We kept towards Rame Head to obtain an offing, and when
running out from the land the sea rose higher, until, off Stokes Point, it
became stormy. We mounted the ridges bravely. The sea in that part
of the channel rolls in grand furrows from the Atlantic, and we had run
about a dozen miles. The artist enjoyed the scene. He sat in the stern

[1] [Now No. 497 in the National Gallery.]

in the Fort Bard (Frame No. 41). The other two small drawings in this frame are leaves of the book described under the head of Frame No. 116.[1]

sheets intently watching the sea, and not at all affected by the motion. Two of our number were ill. The soldier, in a delicate coat of scarlet, white, and gold, looked dismal enough, drenched with the spray, and so ill that, at last, he wanted to jump overboard. We were obliged to lay him on the rusty iron ballast in the bottom of the boat, and keep him down with a spar laid across him. Demaria was silent in his suffering. In this way we made Bur Island. The difficulty was how to get through the surf, which looked unbroken. At last we got round under the lee of the island, and contrived to get on shore. All this time Turner was silent, watching the tumultuous scene. The little island, and the solitary hut it held, the bay in the bight of which it lay, and the dark long Bolthead to seaward, against the rocky shore of which the waves broke with fury, made the artist become absorbed in contemplation, not uttering a syllable. While the shell-fish were preparing, Turner, with a pencil, clambered nearly to the summit of the island, and seemed writing rather than drawing. How he succeeded, owing to the violence of the wind, I do not know. He probably observed something in the sea aspect which he had not before noted. We took our picnic dinner and lobsters, and soon became merry over our wine on that wild islet."

[1] [Ed. 1 contains at the end of the "First Style" the following additional matter :—

"Frames No. 59A to 59G.

"SEVEN SKETCHES FROM NATURE IN ROME.

"Noble, and showing the delight in quantity of detail, which is characteristic of the opening second period. But I do not know Rome well enough to illustrate them rightly."

These sketches were doubtless some of those afterwards included in the "Supplemental Series": see below, pp. 297–299.]

SECOND STYLE

[1820–1835]

The drawing which closed our series of subordinate studies introduced us to the work of the second period.

It has been stated[1] that the peculiarity of this period—the central one of the painter's life—consists in its defiance of precedent, its refinement, brilliancy of colour, and tendency to idealism. Only a few finished drawings characteristic of the time exist in the National Collection.

60.

106, 107. OUTLINES OF PARK SUBJECTS. [*N. G.*, 569.]

61.

108, 109. OUTLINES OF EGREMONT. *N. G.*, 416, 417.[2]]

62.

110, 111. OUTLINES OF COCKERMOUTH CASTLE.

These six drawings are made with consummate care and thoughtfulness of composition. The introduction of the large stones to give foundation and height to the castles in *110, 111,* is peculiarly Turneresque. But every line is studied, and deserves study. The first (No. *106*) is the least careful; but if anybody will try to copy the deer they will soon find out its value. There are very few of this high quality in the National Collection. I am not certain of their date, but should suppose it about 1823 or 1824. [*N. G.*, 570.]

[1] [See above, p. 251.]
[2] [But No. 417 is now called "Cockermouth."]

63.

112. STUDY OF A SKY, WITH A CATHEDRAL TOWER,
AND EVENING MIST ON THE MEADOWS.

113. MOONLIGHT, ON CALM SEA. Both of these were
engraved by himself.[1] The ragged edge of the second is
left visible, that the student may see the mode of the
drawing's execution. It will be thought at first it has
been strained on a block, and taken off; but on looking
close it will be seen that it has never been strained, but is
done on the back of a piece of a paper which has folded
up a parcel; and the brush has continually caught on the
edges of the folds as it was struck across them.

It is not necessary to make drawings always on paper
that has come off parcels; but it *is* necessary to be able to
do so; and if a drawing cannot be done thus on loose paper,
it cannot be done on strained paper. ¡V. *G.,* 571.]

64.

114. STUDY OF A STORM. Below it is placed tem-
porarily an impression of the plate engraved from it by
Turner himself.[2] It will serve to show how much steady
intention and conception there was in his slightest work.
We are soon coming now to the slighter sketches, and per-
haps shall be able better to interpret them after seeing how
much Turner meant by those grey dashes of colour in *114.*
[*N. G.,* 572.]

65.

115. RUNNING WAVE IN A CROSS-TIDE; EVENING.[3]

116. TWILIGHT ON THE SEA.

117. SUNSHINE ON THE SEA IN STORMY EVENING. I
do not know the cause of the appearance, in clear green

[1] [The engravings of Nos. 112–114 belong to an excessively rare series of small
mezzotints, sometimes called the "Sequels to the *Liber Studiorum*," engraved by
Turner's own hand. They were never published, and the plates were found at Queen
Anne Street at his death.]

[2] [It is still in its place.] [3] [See above, p. 247.]

waves, of darkness at the thin edge, when they crest without foaming, or before foaming ; but it is perpetual in them, and yet curiously unnoticed by artists. No. *115* has been made entirely for the sake of it. In the No. *117* the darkness of the sea at the left is the *reflection*, not the shadow, of the rolling cloud. The afternoon sunshine streams under the arch of cloud over the dark edge of the sea, and strikes on the sea waves at the right hand.

Consummate in thought and execution as far as it is carried. The white paper is left deep down in the central drawing, to show the mode of execution. [*N. G.*, 573.]

66.

118. BREAKING WAVE ON BEACH.

119. SUNSET ON THE SEA.

120. COASTING VESSELS.

All on grey paper, and of consummate work. I wish he had always painted the sea in his great pictures as truly as that wave in *118.*[1] [*N. G.*, 574.]

67.

121. DOVER. Drawing made for the series of the *Harbours of England*. It is partly illustrated in my written text to the plates.[2] [*N. G.*, 418.]

68.

122. NORTH SHIELDS. From the *Harbours of England*. An inferior drawing, containing, however, fine passages in the distance on the left.[3] [*N. G.*, 419.]

[1] [Ed. 2 reads "117" (which was the right number in ed. 1); in ed. 2 the numbers were varied, and Ruskin forgot to change the figure here.]

[2] [See above, p. 51 ; and compare below, p. 366.]

[3] [The "Shields" was engraved not in the *Harbours of England*, but in the "Rivers" (1824). In ed. 1 the note was :—

"SHIELDS. From the *Rivers of England*. But not by any means one of his best moonlights. It is too violent in effect."

Before ed. 2 was published Ruskin intended (but forgot) to withdraw the "Shields"

69.

123. ROCHESTER. From the *Rivers of England*. Ugly in subject, but one of his consummate drawings, and the best example for students of all the three. If, however, they can at all succeed in copying a piece, either of the Dover, Shields, or this, they will have reached some understanding of Turner; whereas they may copy many of the oil pictures without clearly seeing in what his greatness consisted. ¿*V. G.*, 420.]

70.

124–127. FOUR ELABORATE SKETCHES FOR DRAWINGS OF THE RIVERS OF FRANCE. Of the highest quality of the second period, and magnificent in all respects. *125* is the original study of the view from the terrace of St. Germain;[1] in many respects better than the drawing. And who had ever before discerned the nobleness of a winding wall, as Turner has done in the drawing No. *127?* ¿*V. G.*, 575.]

71.

128. CALAIS HARBOUR. FISHING-BOATS GOING OUT.

129. CALAIS HARBOUR. Another experiment on the same subject.

130. FORT ROUGE, CALAIS. SCHOONER COMING OUT IN A BREEZE.

131. CALAIS SANDS. FISHERS GETTING BAIT.

These, with the eight following subjects, are examples of his grandest sketching towards the close of the second

from exhibition and substitute the "Okehampton." Accordingly in the first impression of ed. 2 the note ran :—

"OKEHAMPTON. From the *Rivers of England*. Perfectly beautiful in every respect, and entirely characteristic of Turner's best work in the central period."

The mistake was discovered, and in the second impression of ed. 2 the note stood as above.]

[1] [These are the "Sketches on the Seine" (mentioned below, p. 363). The "View from St. Germain" is No. 146 in the National Gallery.]

period; in some respects, therefore, the grandest work in grey that he did in his life, his touch in after years being less firm; while the composition is at present more easy and natural than in his earlier drawings.

The two upper sketches of Calais Harbour, however, so much resemble in feeling the great Calais Harbour painting,[1] that it might at first be thought they were trials of arrangement for it; but they are later work by many years, which is proved (among other evidence) by the smoke of the steamer in No. *129*, there being no packets but sailing ones in 1803.

These sketches are very interesting in the way the original pencilling on the spot is partly employed, and partly crossed out, by the pen work. Thus, in *128*, the pencil is left to indicate the timbers which support Fort Rouge, but the square sail is drawn right over the zigzag which indicates the pier on the left; and in *129*, a square sail indicated in pencil in the same place is given up, and never touched with the pen. Though, however, more shown in this drawing than usual, the principle is one of those which Turner held most fixedly and constantly. Whatever material a touch may have been made with,—colour, pencil, or chalk, —he will either use it or contradict it, but he never will repeat it. He will either leave his pencil mark to stand alone for timbers, or draw right across it, and let it stand for nothing; but he never will draw a pen line above it, and let it stand for half and half with ink. So in colour. He will either leave a colour as it is, or strike another over it to change it; but never lay two touches over each other of the same tint. The principle is well known as essential to good colouring; but it is not so generally known as essential to the good penning in of a pencil sketch that the pen should never go over a pencil line. The shake of the sails in the wind, in either of these Calais Harbour sketches, is, I should think, enough to cool the gallery on hot days.

[1] [See above, p. 105; and for Turner's studies of Calais, see *Pre-Raphaelitism*, Vol XII. pp. 380, 381.]

But in all respects these four sketches are inestimable: not
the least precious drawing being the No. *131,* in which, as
an indication of the pace at which they were all done,
observe the two dark lines of curving wave on the left,
struck from beneath, both drawn into loops, as with one
dash of the pen. Then note the attention of mind as this
dashing was done. The first wave on the left breaks
slightly, and has only a few white dots at its edge; the
second completely, and has a great many. After this has
broken there are only low waves on the sand, and all the
curved lines are therefore drawn lightly! [*N. G.,* 421.]

72.

132. EVREUX.

133. MARKET-PLACE, LOUVIERS.

134. VERNON.

135. VERNON; and some place beside, topsy-turvy.

All magnificent. Note in the Evreux, respecting the
matters we have just now been speaking of, how carefully
the white is laid on the cathedral so as to leave the pencil
touches to stand for buttress shadows. The running flock
of sheep to the right are intended to get rid of the vertical
stability of the cathedral, which Turner had rather more of
than he liked. It is quite wonderful also how the dots of
white in these sheep increase the look of space in the city,
which he had rather less of than he liked. He never
throughout his life was pleased with things that stood quite
straight up; and though contented enough with a village
or a cottage, when he drew a city, he liked a large one.
Usually he sets all his cathedral and church towers from
three to six feet off the perpendicular, being provoked with
them for not behaving gracefully, like ships in a breeze.
But the flock of sheep is here a more prudential expedient
to obtain his beloved obliquity.

133. Market-Place and Church of Louviers. Not good; an instructive example of his want of feeling for Gothic architecture when seen near.[1]

134. Vernon. Two studies on one sheet. The lowermost one is the bridge in the distance of the upper one, seen the other way. The massive look of the rectangular houses on the bridge is purposely increased by the opposition of the sharp points of the boats; it is a favourite artifice of Turner's. The three round packages, on the contrary, repeat and increase the look of multitudinousness in the bridge arches.

These buildings on the bridge are mills; the wheels are indicated in the arches below, and more plainly in the next sketch.

This is very characteristic of France; the water-power of the French rivers, irrespective of tide, being much greater than of ours.

135. Vernon; from farther below the bridge. Observe, in the last sketch, the way the oval packages, with the figure above them, point up through the bridge; and compare the use of the great crest-shaped rudders of boats in this one. These groups of radiating lines are to give connection between the foreground and bridge in each case; without them they would run in two painfully separate and parallel lines. The figures in No. *129*[2] are arranged in similar lines, to help in sending the boat well out of the harbour. ¡V. *G.*, 422.]

73.

136. Marly. Realized for the "Keepsake."

137. Near St. Germain, looking up the Seine.

[1] [For another note on this drawing, see below, Ruskin's *Notes on his Drawings*, No. 63 R., p. 530; and for Turner's failure to do justice to Gothic architecture, see above, p. 158, and below, p. 499.]

[2] [Here, again, ed. 2 read "128" by mistake, Ruskin forgetting to alter the number.]

138. CASTLE OF THE FAIR GABRIELLE. Also realized for the "Keepsake."[1]

139. NEAR ST. GERMAIN, LOOKING DOWN THE SEINE.

The plan of composition in *137* is very curious. A double group of trees, with *one* circle beneath it, carrying the eye out to the left; a treble group of trees, with *two* circles beneath it (wheels of diligence), carrying the eye out to the right; a man in the middle, with a couple of circles, one on each arm, to join the groups; the windows of the diligence to repeat and multiply the arches of the building on the hill; the galloping horses to oppose vertical stability, as the sheep in No. *132*. *138* is more careless in work than the rest, but most careful in composition, and highly interesting as an example of Turner's favourite scheme of carrying his main masses by figure foundations, like the rich sculptured bases to Lombardic pillars. Two figures to the two trees on left; many figures to many trees in centre; two figures to two trees on right; two black figures bowing to each other from opposite sides of the avenue, to increase its symmetry of shade. In each case the figures extend below to nearly the breadth to which the trees branch above. We have first an upright lover to an upright tree; a graceful lady, with flowing train, to graceful tree with bending top; a completely recumbent group in centre to completely impendent foliage of centre; sloping lines converging below on the right, for sloping boughs converging above on the right. The artifice is concealed and relieved by one bold diagonal line begun by the child in the centre, and carried by a straight tree-trunk to the top of the picture. *139* is also rather careless, but marvellous in expression of the course of stream by the gradated laying on of white. The postillion straddling up the hill is essential to sustain the group of tall trees. The black

[1] [For the drawing of "Marly" (engraved in the *Keepsake*, 1832), see *Modern Painters*, vol. i. (Vol. III. pp. 173, 593); for "The Château de la Belle Gabrielle" (an imaginary composition engraved in the *Keepsake*, 1834), *ibid.*, pp. 239, 587.

figure in the centre, by its excessive darkness, balances postillion and trees together; then the dark island leads the dark masses out of the picture. ¡V. *G.*, 423.]

74.

140. AMBLETEUSE?

141. DIEPPE.

142. MEMORANDA OF BOULOGNE, AMBLETEUSE, AND VI-MARAUX.

143. BRIDGE OF BOATS AND UPPER BRIDGE AT ROUEN.

141 is the most delicate pen and ink sketch among this series of drawings, exquisitely beautiful in action of sails. *140* is one of the most laconic in line,[1] and the other two among the most economic in paper. ¡V. *G.*, 424.]

75.

144–146. SKETCHES OF ROOMS AT PETWORTH. I am not sure of the date of these, or of the drawings in the next frame, but I believe them to be considerably earlier in the central period than the French sketches we have been examining. But as we are now coming to a series of coloured drawings on grey paper, these may fitly be considered together with the others; and it is well to close our examples of the second period with some thoroughly characteristic drawings, rather than with those which approximate to the third: and the brilliancy, not without slight harshness, of these studies, is quite peculiar to the second time; the colour of the third period, however pure, being always soft. .

The study of curtains is very like a bit of Tintoret's work in oil, quite Venetian in the enrichment of colour in the shadows. The Pisani Veronese,[2] together with the grand Turner studies of local colour, of which these three are so singular examples, will, I hope, establish on a firmer basis

[1] [For a reference to *140*, see above, p. 239.]

[2] [See above, pp. 88, 244, 552.]

the practice of colour in England. There is a curious illus-
tration, by the way, in the Veronese, of the statement I
gave of his general principle of local colour in *Modern
Painters;* * the black tresses in the ermine being reinforced
in blackness towards the *light,* so that the last touch comes
with an edge blacker than ink against the full white, while
the delicate violets of the princess's robe are reinforced in
the *shadow.* Observe also how straightforward Veronese is,
like Turner, in all his work—the unfinished and forgotten
figures in the distance on the left showing his method, and
the absolute decision as to what he was going to do before
a touch was laid. ⟨V. *G.*, 576.]

76.

147–150. FOUR EVENING STUDIES AT PETWORTH.[1] The
first and last so severe in tone as almost to take the char-
acter of the first period, but all noble. ⟨V. *G.*, 425.]

77.

151–154. FOUR SUBJECTS SKETCHED FOR THE "RIVERS
OF FRANCE." These four drawings, belonging to the third
period, are placed with those from Petworth in order to
mark the peculiar use of the pen characteristic of Turner's
most advanced work. He was about to enter on the pur-
suit of effects of colour more soft and illusive than any
that he had yet attempted; and precisely in proportion to
this softness of general effect was the firm retention of form
by the pen drawing in all his careful memoranda. Multi-
tudes of slighter sketches occur without it, but nearly all the
best drawings of the period have it definitely; and its pre-
sence instantly marks a work of the advanced time, though
the work may be of the advanced time without having it,
as *154* in this frame. *153* is a beautiful and characteristic
example of the treatment. See note on *177.* ⟨V. *G.*, 426.]

* Vol. iv. Chap. iii. §§ 14, 16. [Vol. VI. pp. 60, 61.]

[1] [For Turner's visits to Petworth, see *Dilecta,* § 1.]

THIRD STYLE

[1835–1845]

78.

155–158. FOUR FRENCH SUBJECTS, I believe, on the Meuse, *157* being certainly Dinant. These, with those placed below on the same screen,[1] form a perfectly typical illustration of the great work of the early third period— glowing in colour, deep in tenderness and repose. The upper and lower frames give examples of the slighter drawings, and the central frame of perfect ones. [*N. G.*, 427.]

79.

159. HAVRE (?)

160. ROUEN.

161. ST. GERMAIN (?)

162. QUILLEBŒUF.

Four of the very highest quality. It is impossible to have a drawing containing more of the essence of all that is best in Turner than the Havre. The subtlety of gradation of grey light from behind the fort to the left; of shadow at the edge of the fort itself; of rosy colour from the dark edge of the lightest cloud; of green in the water, caused not by reflection, but by the striking of the rainy sunshine on its local colour, and the placing of the boat's flag, and the radiating lines of the rain, to express the drift of breeze which is coming out of the light of the sky, are all in his

[1] [This refers only to the temporary exhibition of the drawings at Marlborough House.]

noblest manner. It may be copied for ever with advantage,
—never with success.

160. It is raining in the *distance* of No. *159 ;* but here,
between us and the lights, making the forms indistinct, ex-
pressed only by outline. In the St. Germain, we have an
effect of misty morning; and in the Quilleboeuf, of a grey
and colourless day. [*N. G.*, 428.]

80.

163. CITY, WITH PORT.

164. SUNSET.

. *165.* CASTLE AND MOAT.

166. TOWN, WITH BRIDGE.

All rich in colour, but not first-rate drawings. *165* is
the best, and may be considered, in its dependence for effect
on the drawbridge, as a lesson how to give the utmost pos-
sible value to the smallest possible number of grains of
black chalk. [*N. G.*, 429.]

81.

167–170. FOUR FRENCH SUBJECTS. Except the first,
Tancarville, I do not as yet know the subjects. They
are examples of the inferior work of the period. Turner
wasted much time because he could not resist the impulse
to make a coloured sketch of everything he saw; and it
was only occasionally, when he was undisturbed by new
ideas or visions, that he finished his work rightly. But all
are equally instructive respecting modes of execution: ob-
serve, especially, that, however great his hurry, he prepares
his under colour rightly, and then throws another tint
over it to *leave* in perfect purity even such a little light as
the wake of the dabchick in *170,* which anybody else
would have taken out afterwards. [*N. G.*, 430.]

82.

171. CHALK ROCKS ON THE MEUSE.

172–174. UNKNOWN.[1]

Very grand in thought; but second rate and hasty in execution. [*N. G.*, 431.]

83.

175. TWILIGHT.

176. BRIDGE ON MOUNTAIN PASS.

177. THE GREAT FORTRESS. I have seen, at different times, at least twenty drawings by Turner of this wonderful place, and have never been able to find out where it is. If any traveller can tell me, I should be grateful.[2] I think No. *153* is the same place; at all events No. *153* is the place I want to find the name of.

178. TWILIGHT, WITH SETTING MOON. [*N. G.*, 432.]

84.

179. HONFLEUR.

180. A TURN IN A FRENCH ROAD.

181. STUDY OF FORTRESS.

182. HONFLEUR.

180 is inserted to show the painter's interest in anything odd, or characteristic of a foreign country. [*N. G.*, 433.]

85.

183. SCENE ON LOIRE (?)

184. PORT OF HONFLEUR.

[1] [The subject of the second sketch is
[2] [In his diary of 1859 Ruskin made a note, "
Passau," but this he subsequently struck through; the id

185. FRENCH RIVER BOATS.

186. RIVER SCENE, WITH TOWER.

These four, with the Havre, are the most consummate drawings exhibited in the present collection.[1] I shall not say anything of them specially; partly because the explanation of any one rightly would take too much space in the catalogue; partly because they are of that highest class of art which can only be thoroughly felt after years of labour. But students may test their progress in drawing, in colour, and in feeling, simply by the degree of admiration they honestly feel for these sketches.

The qualities, perhaps, which will last be suspected in them are their intense refinement and care. It may therefore be advisable at once to take a magnifying-glass to look at the drawbridges in No. *184,* and (if studying practically) to draw the purple castle in No. *183* on the right, without the white dot in its tower, to see what becomes of it under that deprivation. [*N. G.,* 434.]

86.

187. THEATRE AT DIJON.

188. AVENUE.

189. TOWER IN TWILIGHT.

190. ROOM AT PETWORTH.

The last drawing, though it looks unfinished, will be found on examination peculiarly interesting; and to students helpful, in the rapid expression of the varying surfaces of the sculpture by laying thicker white in the right places while the colour is wet.

189 is very noble.[2] [*N. G.,* 435.]

[1] [*i.e.,* in the collection described in this particular catalogue.]
[2] [Frame 86 was different in ed. 1, containing only "Four Studies of River Boats." There was no note on them.]

87.

191, 192. TWO STUDIES FOR THE VIGNETTE OF THE
" APPARITIONS AT SUNSET,"[1] in illustration of Rogers's
" Voyage of Columbus."

We have had no specimens hitherto of his trials of
effects for pictures; they are not in general interesting; so
that these with the four following examples, which are as
pretty as could easily be found, will be enough for illustra-
tion. [*N. G.*, 577.]

88.

193, 194. TWO UNFINISHED VIGNETTES. [*N. G.*, 578.]

89.

195, 196. TWO UNFINISHED VIGNETTES. [*N. G.*, 579.]

90.

197, 198. STUDIES OF SWISS COSTUME.

Figure studies of the *first* period. We return to these
studies, belonging to the earlier half of the first period, that
the reader may see at a glance the transitions between the
first, second, and third styles, before we examine the sketches
in the finally developed third style itself. [*N. G.*, 580.]

91.

199. FRENCH DANCE IN SABOTS. Figure study of the
second period.

200. FISHERMEN ON THE LOOK OUT. Figure study of
the *third* period, when its style was finally developed.

The exquisite purity and tenderness of hue in this lower
drawing will not be felt as it ought to be, until the one
above it is hidden with the hand. [*N. G.*, 581.]

[1] ["The Vision of Columbus," No. 395 in the National Gallery.]

92.

201. Villeneuve, looking from Chillon towards Vevay.

202. Gallery on the Splügen.

203. Vevay, looking across the Lake to Meillerie.

Examples of pencil memoranda of finest late time; taken in three degrees of haste. The first, tolerably careful, with the future position of clouds entirely arranged; *203*, sketched in angry haste, because the tower of the church had been first drawn too big, and too far to the right, its ghost still appearing on the right; and *202*, an instance of the slightest notes he thought it worth while to take. [*N. G.*, 582.]

93.

204. Fortress: Evening. [*N. G.*, 436.]

205. Lausanne, in Rosy Sunset. [*N. G.*, 437.]

I do not know the subject of the first sketch, but both are intensely characteristic of Turner's modes of thought in his last period; simplicity of effect, and tenderness with depth of colour prevailing over all detail. The green-blue waters of the Lake of Geneva delighted him always, and the sketch *205* has been made for the sake of their contrast with the rosy light.

94.

206. Coblentz, with the Bridge over the Moselle.

207. Coblentz, with the Bridge of Boats over the Rhine.

This last was a favourite sketch of Turner's.[1] [*N. G.*, 583.]

[1] [See in the National Gallery collection, Nos. 279, 650, 671.]

95.

208. FLUELEN (HEAD OF LAKE LUCERNE).

209. LAKE LUCERNE, LOOKING FROM KUSSNACHT TO-
WARDS THE BERNESE ALPS; MONT PILATE ON THE RIGHT,
DARK AGAINST SUNSET.

Two examples of his most rapid memoranda in colour
of conceptions that pleased and interested him at his most
powerful time. It is worth while pausing to analyse the
first. The little darker spot on the middle of the cliff on
the left is a chapel with a small belfry, and it will be
noticed that the yellow colour leaves a white light at the
belfry and on the flat shore below. The sun was to be
just above the chapel, and to show a stream of white light
down from behind it. Then just above the chapel to the
right the pencil markings form a loop; the touch being
struck upwards first, and then zigzagged down to the right.
This is because that touch goes right round the edge of a
ravine, cut into the hill beyond the chapel. It follows it
round, and indicates a piny slope by the zigzag. Both
touches would have been drawn from the top downwards,
if there had been two hills, one in front of the other,
instead of a ravine cut into the single mass.

Then one running touch draws the outline of the great
cliff, and another within it the edge of its precipice; after-
wards followed with the violet colour, leaving light on the
summit. The blue lake horizon, with a clump of trees, is
indicated by one dash of the brush, with more water added
afterwards to thin it. But I never could understand how
this is done—and he does it constantly—without disturb-
ing the white spots of broken light. [*N. G.*, 584.]

96.

210. UNKNOWN.[1]

211. LAKE OF ANNECY (?). Instances of the sharp and

[1] [The place is Landeck, in Tyrol.]

thin drawing he sometimes used to secure important forms, even in this his great colour period. The sloping beds of limestone in the promontory, in *211*,[1] are wonderfully articulated. [*N. G.*, 585.]

97.

212. San Giorgio Maggiore. Venice.

213. Santa Maria della Salute. Venice. His thoughts, towards the close of his life, were continually hovering between Venice and the Lake of Lucerne. These drawings, however, are probably of a somewhat earlier date, but were referred to or used by him as materials in his late Venetian paintings. [*N. G.*, 586.]

98.

214. Bridge on the Riva dei Schiavoni.

215. The Lagoon between San Giorgio and the Cantieri.

Two leaves from his last sketch-book at Venice. [*N. G.*, 587.]

99.

216. Sunset, Lake Lucerne.

217. Night, Zurich. [*N. G.*, 588.]

100.

218–220. Morning on the Lake Lucerne. Three subjects taken above Brunnen, near the centre of the lake, and generally illustrative of the character of his last thoughts. See the notice of the last drawing in the Supplemental Series. [*N. G.*, 589.]

[1] [Here, again, there was a mistake in ed. 2, which read *205*, Ruskin having forgotten to alter the number.]

THE following drawings have been lately added to the series, as further illustrative of points deserving especial notice :—

101.

221. VIEW OF ROME. This exquisite pencil sketch is the most finished I could find in a book of studies from nature at Rome, made in the year 1819. It is a perfect example of Turner's most deliberate pencil drawing, and no terms of admiration can be too high for it. It differs from ordinary studies of the kind, first by its excessive accuracy in what *is* represented, there being literally not a movement of the pencil point over the thousandth part of an inch without meaning,[1] nor without specific expression of some poplar, or cypress, or battlement, or statue; and secondly, by its subtle choice of what is *not* to be represented, and graceful omissions of unhelpful objects. The noblest outlines of the groups of buildings are always grouped in masses, and relieved by the omission of lines which would interfere with them behind, this omission being accounted for by the introduction of rays of light or wreaths of mist.

It is to be observed of sketching generally, that as it is physically impossible to draw everything (for to make a perfect drawing of all the visible details in such a subject as this would occupy many months instead of a few hours), omission itself should be rendered as serviceable as possible : all that is drawn should be at once interesting and harmonious ; every rejection should give value to concentration ; and all vacancies contribute to repose. [*N. G.*, 590.]

[1] [For a criticism on this passage, and Ruskin's reply, see below, p. 334.]

102.

222. Rome. The Bridge and Castle of St. Angelo.
Exquisite, beyond description, in the loveliness of the colour
on the distant hills; perhaps the most instructive piece of
practice for the students of colour which can be found
among the sketches. The finished Dover and Rochester
are too difficult for them; the early studies, such as No.
24 or No. *44,* though they are the first which ought to be
copied, have not the master's power entirely exerted in
them; here it is exerted, but in so simple and visible a
way, as to admit in some degree of being followed in its
processes. [*N. G.,* 591.]

103.

223. Rome from Monte Mario. Also very beautiful
in colour in the middle distance. [*N. G.,* 592.]

104.

224. Rome from the Barberini Villa.[1] Consummate
as a piece of fine drawing of distant city. The four sketches,
221–224, cannot be too carefully studied or too frequently
copied. Every student should do each of them three or
four times over. [*N. G.,* 593.]

105.

225. Rome. Nymphæum of Alexander Severus. Fine
in effect, but careless. [*N. G.,* 594.]

106.

226. Rome. The Claudian Aqueduct. Also more
hasty than his work is usually. It is just possible that

[1] [Now described as "Rome from the Gardens of the Villa Lanti." For further
notes on the group to which this and these other Roman drawings belong, see
p. 378.

these two studies may be actual sketches of the effects as they passed, which, in colour, are rare things among his works; he hardly ever sketched[1] a changeful colour effect except from memory. See the notice of frame No. 112 (in the first room[2]), and of the smallest sketches in the revolving frames in the desks at the windows (116, 118). [*N. G.*, 595.]

107.

227. ROME. THE COLOSSEUM. First-rate. The position of every piece of the distant wall that appears through the arches in the nearer one is studied with elaborate attention to composition; raising the broken masses a little, or advancing them, or drawing them back, as it suits his purpose. The slightly sketched stones on the left, and arrangement of sky, are absolutely necessary to redeem the formality of the circular mass. [*N. G.*, 596.]

108.

228. ROME. BASILICA OF CONSTANTINE. A noble study for its breadth of colour. [*N. G.*, 597.]

109.

229. ROME. CHURCH OF SS. GIOVANNI E PAOLO. [*N. G.*, 598.]

110.

230. ROME. ARCHES OF CONSTANTINE AND TITUS. [*N. G.*, 599.]

[1] [The earlier impression of ed. 2 was here different :—
" . . . ; he hardly ever sketched a colour effect except from memory, knowing that before the deliberate processes necessary to secure the true colours could be got through, the effect would have changed twenty times over. He therefore almost always wrote the colours down in words, and laid in the effect at home, fixing his mind on a given moment of it, and given positions of cloud. For memoranda of this kind see the frame No. 112, in the first room, and the smallest . . ."]

[2] [The references are to the original arrangement at Marlborough House.]

111.

231. STUDY FOR THE OIL PICTURE OF THE LOGGIE, beside which this frame is placed.[1]

232. A FOREGROUND AT ROME.

The motive of this last study has been the occurrence of the real living acanthus among the fallen Corinthian capitals; it is very characteristic of Turner to be interested in such an accident as this. [*N. G.*, 600.]

112.[2]

FOUR LEAVES FROM A SKETCH-BOOK FILLED ON THE WAY TO AND FROM SCOTLAND, BY SEA, ON THE OCCASION OF GEORGE THE FOURTH'S VISIT TO EDINBURGH.

These are the first examples given in this series from Turner's smaller note-books, on which, however despised they may be by persons who look only for the attractive qualities of drawing, his peculiar eminence as a painter chiefly depended. It was in these that his observations of nature were accumulated, day by day, and moment by moment, until his mind became an inexhaustible treasury of natural facts, which imagination might afterwards arrange and combine at her pleasure.

There are two hundred and forty-seven of these books in the National Collection containing from fifty to ninety leaves each, nearly always drawn upon on both sides.[3]

The leaves *233* and *235* in this frame are good examples of his mode of studying skies. He rarely, as already stated, sketched from them in colour, perceiving that the colours changed much too fast to be set down with fidelity; and considering all imperfect and untruthful colour memoranda

[1] [The reference is to the temporary exhibition at Marlborough House. The picture—"Rome from the Vatican; Raffaelle accompanied by La Fornarina, preparing his pictures for the decoration of the Loggia"—exhibited at the Academy in 1820, is No. 503 in the National Gallery collection, but has been removed to Liverpool.]

[2] [233 in the upper row; 234–236 in the lower.]

[3] [See above, p. 238.]

as simply deceptive and harmful. His method was to outline as fast as possible the forms, and write down the colours of the clouds, in any sky effect which interested him; afterwards, if he thought it desirable, he appears deliberately to have made a study of the sky in colour, as he remembered it; but he never tried to pursue at the instant the changes of coloured clouds.

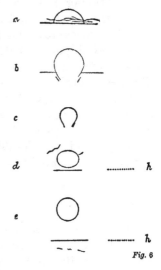

Fig. 6

The leaf *235* is a note of changes of effect at sunrise, and means as follows (see the figure at the side of this page).[1]

a. When the sun was only half out of the sea, the horizon appeared sharply traced across its disk; vapour slightly obscuring its light at the lower part.

b. When the sun had risen so as to show three-quarters of its diameter, its light was so great as to conceal the sea horizon, consuming it away, as it were, in a reversed cone of light.

c. When on the point of detaching itself from the horizon, the sun still consumed away the line of the sea, where it touched it.

[1] [This leaf is engraved accurately in *Modern Painters*, vol. v. pt. viii. ch. iv. § 7, as an example of sketch-memoranda of facts. "When the sketch is made merely as a memorandum, it is impossible to say how little, or what kind of drawing, may be sufficient for the purpose. It is of course likely to be hasty from its very nature, and unless the exact purpose be understood, it may be as unintelligible as a piece of shorthand writing. For instance, in the corner of a sheet of sketches made at sea, among those of Turner, at the National Gallery, occurs this one. . . . I suppose most persons would not see much use in it. It nevertheless was probably one of the most important sketches made in Turner's life, fixing for ever in his mind certain facts respecting the sunrise from a clear sea-horizon. Having myself watched such sunrise occasionally, I perceive this sketch to mean as follows :—[here follows an explanation similar to that given in the text above.] This memorandum is for its purpose entirely perfect and efficient, though the sun is not drawn carefully round, but with a dash of the pencil; but there is no affected or desired slightness. Could it have been drawn round as instantaneously, it would have been. The purpose is throughout determined ; there is no scrawling, as in vulgar sketching."]

d. Having fairly detached itself by a distance of about a quarter of its diameter from the horizon, the sea-line (*h*) again appeared; but the risen orb seemed at first flattened by refraction into an oval.

e. Having risen a distance equal to its own diameter above the sea line *h*, the orb appeared round.

The leaves *234* and *236* are examples of the sketches of coast and shipping made throughout the volume from which these leaves are taken. The whole coast line, from the Thames mouth to Edinburgh, is thus drawn in successive portions as it showed itself, and similarly all the way back, its aspect of course changing with the accidental variations of distance between the vessel and the land. Every group of ships and of clouds that was the least interesting or available, is noted in like manner. *ϳ*V. *G.*, 438.]

113.[1]

TEN LEAVES FROM A BOOK OF SKETCHES ON THE RHINE AND MEUSE. *242* and *243* are of Huy; *244, 245, 246*, of Dinant, on the Meuse; the rest I do not know; but I would recommend to all students the repeated copying of the beautiful sketch of the windmill *237*,—every line in it is precious. *ϳ*V. *G.*, 601.]

114.[2]

Six leaves from a sketch-book on the Lake of Geneva.

247. JUNCTION OF THE RHONE AND ARVE.

248. STUDIES OF BOATS.

249. LAUSANNE FROM THE NORTH.[3]

250. LAUSANNE FROM THE EAST.

[1] [237–241 in the upper row; 242–246 in the lower.]
[2] [247, 248 in the upper row; 249, 250 in the middle row; 251, 252 in the lower.]
[3] [This sketch, again, is facsimiled in *Modern Painters*, vol. v. (pt. viii. ch. iv. Fig. 98), where (§§ 8–15) it is analysed in detail.]

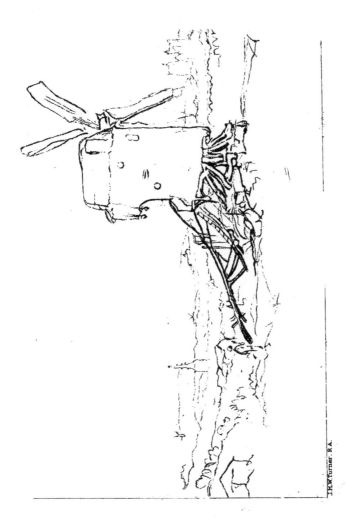

The Windmill

From the sketch in the National Gallery. No. 601

J.M.W.Turner. R.A.

251. Geneva from the West.

252. Geneva from the West at a greater distance.

As the fortifications drawn in these sketches do not now exist (having been thrown down, it is said, in order to find employment for the watchmakers, in a time of slack trade), these memoranda of the earlier aspect of the city are all the more valuable; as sketches, they are of the noblest kind, as lovely in composition as they are expressive in touch.

In the distance of *251*, the Mole shows its summit above the cloud; the Little Salève appears on the right; in *252*, the slope of the Voirons is seen on the left, and part of the Great Salève on the right. [*N. G.*, 439.]

115.[1]

Twelve leaves from a sketch-book at Venice. All these leaves have equally elaborate sketches on their other sides, and the sketch-book contains 92 pages. The subjects are as follows :—

253. Sta. Maria della Salute. (St. Mary's of Health.*)

254. The Custom House.

255. St. Mark's Place.

* Or "of healing." Built in thanksgiving for deliverance from the plague. The English public sometimes lose and sometimes exaggerate the value of the names of foreign places and things, owing to their foolish habit of not habitually translating them. A traveller in the Alps expects you to think he has done great things when he declares that he went across a place which his guide called a "*mauvais pas,*" but would hardly be so self-complacent if he would state the fact in the simpler and more intelligible terms that his guide called it—a "bad step." So also we habitually speak of the "Grand Canal," and attach a somewhat pompous idea to the expression, merely because we translate the Italian "*Il Canal Grande,*" by the English phrase nearest it in sound, though quite different in sense. The Venetians called it simply what it was, "The Great Channel," and we should try to get into the habit of thinking of it in the same way, though I retain the usual phrase for convenience.

[1] [Here again the drawings are numbered consecutively from row to row.]

256. Casa Grimani and the Rialto.

257. St. George's and St. Mary's of Health.

258. The Grand Canal, from Casa Foscari to the Rialto.

259. Riva degli Schiavoni, with St. Mark's and St. Zachary's.

260. The Doge's Palace and Mint.

261. The Fruit Market.

262. The Coal Market.

263. The Rialto, with the West Side of the Grand Canal.

264. The Rialto, with the East Side of the Grand Canal. [*N. G.*, 602.]

116.

In the desks at the windows:[1]

Three Leaves exemplifying the Character of his Note-Books.

The book from which *265* and *266* are taken contains 270 leaves, all drawn on both sides; but there are only about ninety as full of subject as these examples. These leaves measure four and a half inches by three; one of them contains seven subjects on one side, and four on the reverse; and the other has ten subjects on one side, and five on the reverse. Taking the lowest average of ten subjects for each leaf there are, therefore, at least 900 subjects in the third part of the book. Turn the frame first so that it may lie towards your right hand in the depression of the desk; then read the leaves as above.

265 has seven subjects from Andernach on the Rhine, showing stormy sunsets and drifts of cloud, all completely

[1] [Now (1904) in an inner room at the National Gallery, which is opened to visitors at special request. So also with Frames 117, 118, and 119.]

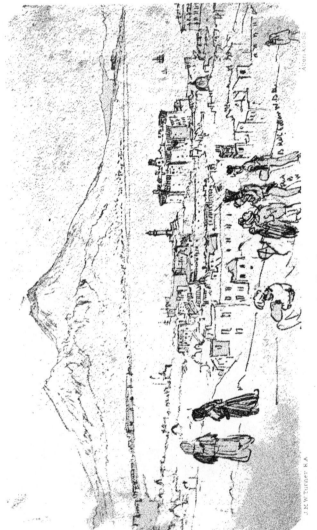

At Naples

From the sketch-book in the National Gallery No 604

J.M.W.Turner R.A

designed; the best, that on the left in the second row from
the bottom, only measures one inch and a half in length
by three quarters of an inch in height.

The leaf *266* has also Rhine subjects.

267 shows a most interesting outline sketch near the
Borromean Islands on Lago Maggiore. The effects, names
of towns, etc., are written on it: thus (in the sky), "Light,"
"Blue clouds," "Rays," "Cloudy, yet none below the moun-
tains," "Gueriano"? on left, "Laveno" on right (names of
villages). (On the lake): "Sea green with dark waves."
"Boats have the (hieroglyphic for awning) over the edge,
close seat behind for the tiller, which is changed, the Mag-
giore one had the tiller (another hieroglyphic), the steersman
sat on the spare oar."

Observe in the hieroglyphic for the awning Turner's in-
tensity of habitual accuracy, in marking by the two dots
a, *b*, the thicker timbers, at the sides of the boat
in which the bent laths which carry the awning
are inserted. This side of the leaf contains four
subjects, its reverse four slighter ones. He has

Fig. 7

written the words "Rosa," "Gothard," over, what he sup-
posed to be, the respective mountains: neither of them is
however visible from this part of Lago Maggiore; he has
mistaken lower peaks for them. [*N. G.*, 603.]

117.

In the same desk:

268, 269. Two Leaves of a Note-Book filled at
Naples. [*N. G.*, 604.]

118.

In the other desk:

270. Studies from Claude and in France.

Lay the frame to the right hand.

Then the uppermost subject is a beautiful little view
of Dieppe. The second from the top, a scene on Dieppe

beach, with two fish-wives quarrelling; during the course of the discussion Mr. Turner has noted their costume, thus:

Fish-wife on the left.	*Fish-wife on the right.*
" W." (white) cap.	" W. (white) cap."
" W." (white) shoulder kerchief.	* * * (illegible) "with red sparks."
" G." (green) bodice.	" White garters."
" R." (red) gown.	" Each, a fish-knife."
" W. P." white petticoat.	
(To the right of her feet) " B. (black) stockings."	

I do not know where the two lower subjects are; the uppermost has no legend but " Timber," and the lowest only " Old W. (woman) washing fish." [*N. G.*, 605.]

119.

In the same desk:

271. VIEWS OF DRESDEN.

This leaf had to go in an upright frame, because one of the views on each of its sides is topsy-turvy, and can only be seen by looking at it laterally. The helmet-shaped fragment is a note of the shape of the bust on a tomb. [*N. G.*, 606.]

120.

272. THE ARCH OF TITUS. The original sketch for the large oil picture in the same room.[1]

273. THE ARCH OF TITUS, FROM THE SIDE. From a book containing ninety-two leaves of similar studies, on both sides of the leaves, any one of which he could, if he had chosen, have wrought into a picture like this large one: the details of all the bas-reliefs of all the subjects, figure by figure, and the letters of all the inscriptions, copied letter by letter as he could see them on the moulding surfaces, being

[1] [A reference to the original arrangement at Marlborough House. The picture —"Forum Romanum," with the Arch of Titus—is No. 504 in the National Gallery collection, but is now removed to Chester.]

put down in compact masses of notation, filling another ninety-two leaf book on both sides of the leaves. All this work was done as mere rest and by-play, while his mind was mainly given in the same manner to such drawings as *101* and *102*, which are also nothing more than leaves of a sketch-book, containing forty leaves of such drawings; many drawn on both sides—never meant to be seen by any one, and merely done for their service.

These small studies—as well as No. *221*, and multitudes of similar ones—are done on *very* thin white paper, rubbed over with charcoal or black lead!—the lights being taken out with bread or indian rubber. They require the greatest care in handling, as a rough touch may produce a new light on them of highly undesirable brilliancy.

2. His studies at Rome were certainly made more intensely on account of his early training in architectural drawing, and consequent affection for the classical architecture he had so profoundly studied. In the last room,[1] where the Liber Studiorum are, the frame No. 33 contains one of the diagrams thrown together in a huge portfolio to be used (I believe) in his Academy lectures.[2] It is literally

[1] [Again a reference to the temporary exhibition at Marlborough House. The diagram referred to (N. G., 548) is now permanently exhibited in the National Gallery.]

[2] [Turner was Professor of Perspective at the Royal Academy from 1808 to 1837; but he only lectured during two or three years. Ruskin refers again to the elaborate diagrams prepared for the lectures in *Modern Painters*, vol. v. pt. ix. ch. xii. § 4 *n*. The lectures themselves are said to have been barely intelligible, from Turner's difficulty in expressing his ideas in words (see Thornbury, pp. 269, 270); but this is not the impression one derives from reading the reports. See, for instance, one reported in *The Morning Herald* of January 25, 1816, though the reporter does indeed criticise the Professor's manner of referring to his diagrams. The passage, which is of interest in connexion with what Ruskin says above, is as follows:—"The Professor, after entering into an explanation of a few of the principal rules in optics, which were of most service to painting, concluded his discourse by producing various architectural drawings, and applied several of his preceding principles to them; among which was one of Carlton House, as a specimen of *parallel* perspective; one of the Admiralty, as an example of *geometrical* perspective; and a drawing of some circular ruins, for the purpose of demonstrating *curvilinear* perspective. Before the Professor took leave of the students for the evening, he wished again to impress upon their minds, the absolute necessity of the knowledge of the science; for though the painter (said he), who trusts only to his eye, may not be guilty of any glaring error, yet he must ever proceed with doubt and uncertainty. If Mr. Turner would illustrate his lecture, by personally pointing out in the drawing the part alluded to in his lecture, it would probably prove more advantageous to the students than the present mode of displaying them." This criticism may probably be explained by Turner's reluctance

intended for nothing more than a diagram;* but it, and all
the rest, are done entirely with his own mighty hand; and
elaborate attention is always paid to the disposition of
shadows and (especially) reflected lights. Huge perspectives
and elevations of the Dome of St. Paul's lie in this port-
folio side by side with studies of the reflections on glass
balls (see the frame No. 121); and measured gleams of
moonlight on the pillar of Trajan, with dispositions of
chiaroscuro cast by the gaoler's lantern on the passages
of Newgate. [*N. G.*, 607.]

121.

274. STUDIES OF LIGHT AND SHADE IN AND ON HOLLOW
GLASS BALLS: first empty, and then half-filled with liquid.
One ball is first, in each case, drawn by itself, and then
two in contact, with each other's reflections. [*N. G.*, 608.]

122.

275, 276. ANGRY SWANS. See No. 59. [*N. G.*, 609.]

123.

277–280. STUDIES OF POULTRY. See No. 59. [*N. G.*,
440.]

The drawings which now follow are of miscellaneous

* This drawing was the last added, completing the series of drawings
exhibited in Marlborough House, in number 339, exclusive of the originals of
the Liber Studiorum.

to depart from his written text. On one occasion, the lecture consisted only of the
following sentence: "Gentlemen, I've been and left my lecture in the hackney
coach." A story told by David Roberts may also be recalled. Turner's health was
once proposed by an Irishman who had attended the lectures on perspective, on
which he complimented the artist. "Turner made a short reply in a jocular way, and
concluded by saying, rather sarcastically, that he was glad this honourable gentle-
man had profited so much by his lectures as thoroughly to understand perspective, for
it was more than he did" (James Ballantine's *Life of David Roberts, R.A.*, 1866,
p. 238.)]

character, having been chosen for addition to the exhibited collection, one by one, in the course of further examination of the unexhibited drawings.

124.

281. BUCKINGHAM GATE? (HUNGERFORD BRIDGE).[1] An early beginning of a drawing intended for completion, and admirably illustrative of the painter's method of work as opposed to common water-colour drawing; namely, his completing each portion of the work as it proceeded (knowing so precisely what he had to do that he never troubled himself to get rid of the white paper round the place where he was drawing, as inferior workmen are so fond of doing); and also, his getting all his results as far as possible by leaving the lights from the beginning; not taking them out afterwards. It will be found, with considerable surprise I should think by most of our modern water-colour painters, that the ropes of the vessels are left in light through all the various stages of the work: not one taken out afterwards. *[V. G.,* 441.]

125.

282. SOURCE OF THE ARVERON. Also the beginning of a drawing intended for completion: it is of the same date as the sketches. Remarkable for the wash of grey over the whole surface, leaving the glacier only in light, before the upper colours are added. [*N. G.,* 610.]

126.

283. STUDY FOR THE DRAWING OF GRENOBLE. Compare No. 32. The same treatment of general under-tone is exemplified here, and in the most exquisite way. [*N. G.,* 611.]

[1] [The water-gate—near the former Hungerford Bridge—still stands, at the bottom of Buckingham Street, though now embedded in the Embankment Gardens.]

127.

284. Another study, or perhaps an abandoned commencement, of the drawing of Grenoble.[1] [*N. G.*, 612.]

128.

285. A MOUNTAIN STREAM. Painted in oil, evidently from nature. Very beautiful, and of unusual character, his finished studies from nature in *colour* being rare.[2] [*N. G.*, 561A, oil collection.]

129.

286. STUDY OF MASTS AND RIGGING. Of the middle period, showing how the kind of work of No. *21* was carried on throughout his life. [*N. G.*, 614.]

130.

287. BOAT IN HEAVY SEA.

288. BOAT SWAMPED IN SURF.

Finished studies of things remembered. [*N. G.*, 615.]

131.

289, 290. THREE STUDIES FOR A PICTURE OF A SHIP ON FIRE. The idea seems to have been at first abandoned, and a few years later returned to, but differently and more awfully treated. See the unfinished oil picture in the last room but one.[3] [*N. G.*, 616.]

[1] [For another note on these two studies of Grenoble (N. G., 611, 612), see below, p. 366.]

[2] [Compare above, pp. 121, 266.]

[3] [A reference, again, to the temporary exhibition. The picture is "A Fire at Sea," No. 558 in the National Gallery; for a reference to it, see *Modern Painters*, vol. v. pt. viii. ch. iv. § 18.]]

132.

291. SUNSET. I do not know the town: there is a cemetery in the foreground. Very fine.

292. TWILIGHT. One of the Petworth drawings. [*N. G.,* 442.] [1]

133.

293. TOWN ON THE LOIRE (I believe Saumur).

294. HUY, ON THE MEUSE, FROM ABOVE THE CHÂTEAU.

295. DINANT, ON THE MEUSE.

The two last magnificent in thought, and all three in execution. [*N. G.,* 617.]

134.

296. ORLEANS: THE THEATRE AND CATHEDRAL.

297. NANTES: PROMENADE NEAR THE CHÂTEAU.

These are both variations of subjects designed for the "Rivers of France," and engraved in that series.[2] They are not to be considered as studies for them, but as examples of Turner's way of turning a subject this way and that in his mind. He makes a sketch of Orleans Cathedral from a given corner of a street, and at a given hour of the afternoon. A year or two afterwards, perhaps, he looks at the sketch, and thinks he would like to try it about twenty yards more to the left, and half-an-hour later, or an hour earlier; in which cases he is nearly sure to put in the same figures in some different position.[3] This study of Orleans is about an hour earlier in the afternoon than the engraved one, and a hundred yards further down the street. It is

[1] [The present frame No. 442 includes also the contents of another frame, as described in this catalogue, namely, No. 135.]

[2] [The engraved drawings were given by Ruskin to Oxford: see below, p. 559.]

[3] [On this subject of Turner's recurrences, see *Pre-Raphaelitism* (Vol. XII. pp. 379 seq.); *Modern Painters*, vol. iv. (Vol. VI. pp. 42, 43); and above, pp. 53, 63.]

by no. means so beautiful as the engraved one; but the
Nantes is far prettier, being an idea of a finer day. The
engraved drawing is of a bleak grey afternoon, and taken
from the end of the walk, where the colossal statues be-
come principal objects, and they are not interesting ones.
[*N. G.*, 618.]

<center>135.</center>

298. PROMENADE AT NANTES.

299. DRESSING FOR TEA.

Compare *298* with *297*, and note in the lower one the
subtle effects of firelight: don't miss the Cat. [*N. G.*, 442.]

<center>136.</center>

300. HAVRE (?).

301. HARFLEUR.

302. CAUDEBEC.

303. SAUMUR.

All of highest quality; the second peculiarly beautiful.[1]
[*N. G.*, 443.]

<center>137.</center>

304. SAUMUR.[2]

305. MONT JEAN.

306. STUDY FOR A DRAWING OF (SAUMUR?), MADE FOR
THE " KEEPSAKE." [3]

All first-rate. [*N. G.*, 619.]

<center>138.</center>

307–310. STUDIES ON THE LOIRE AND MEUSE.

310 is Huy; the others I am not sure of. All are of

[1] [The two drawings 301 and 303 are now transposed in the frame.]
[2] [For a note on this sketch, see Ruskin's *Notes on his Drawings*, 64 R., below,
p. 530.]
[3] [" Saumur " was engraved in the *Keepsake* for 1831.]

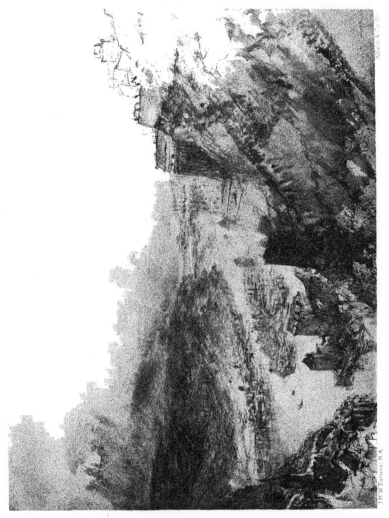

J M W Turner. R A

Grenoble

From the drawing in the National Gallery. No 447

exquisite beauty. The effect of morning light in *309*, and the tenderness of the few simple touches and hues that produce it, may be studied with never-ending gain. [*N. G.,* 444.]

139.

311. STUDY OF TOWN ON LOIRE.[1]

312. THE CARRARA MOUNTAINS, FROM SARZANA. [*N. G.,* 620.]

140.

313. VIGNETTE OF TURBOT AND MULLET. [*N. G.,* 445.]

141.

314. VIGNETTE OF MACKEREL.[2] [*N. G.,* 445.]

142.

315. SWISS FORTRESS.[3] [*N. G.,* 446.]

316. GRENOBLE. [*N. G.,* 447.]

Two of the best of his last sketches on white paper.

143.

317. CALM.

318. FRESH BREEZE.

Perfectly noble and masterly examples of his pen studies. [*N. G.,* 621.]

[1] [In his MS. Notes of 1881 Ruskin says of 311 : "Grey outlines, glorious," and of 312, "infinitely beautiful."]

[2] [The two drawings 313 and 314 are now in one frame, and are described as "Marine Study of a Buoy, Gurnet, and Dog-fish," and "Seaside Study, with Mackerel in the Foreground."

[3] [Now described on the frame as "Drachenfels" on the Rhine. Ruskin, however, in his catalogue of 1881 retained his first name for it.]

144.

319. CAREW CASTLE.

320. LANCASTER. First sketches of the England subjects.[1]

Before passing to the last of the supplementary series of sketches, I should like the reader to return for a moment or two to the painter's early work, in order so to deepen the impression, which is indeed the principal one, this Exhibition should leave upon his mind — of the primal and continual necessity of point drawing;[2] that is to say, work with the pencil, chalk, or pen, in order to secure material enough of natural facts, and precision enough in touch with colour. From first to last, Turner's chief distinction as a manipulator, from all other landscape painters, was in this perpetual use of the hard pencil: let us turn, therefore, before we leave the rooms, to a group of examples entirely illustrative of this specialty of practice.

The drawing of Carew Castle, of which the engraving is placed above the sketch,[3] has always borne a high reputation in the England Series: I do not join in this popular estimate of it, but at all events it is one of the most elaborate works of his middle time; yet it is founded entirely on this severe pencil sketch, made at least thirty years previously; the Carew being published in 1834, while this drawing cannot be much later than 1800. [*N. G.,* 622.]

145.

321. CAERNARVON CASTLE. [*N. G.,* 448.]

322. WELLS CATHEDRAL. [*N. G.,* 449.]

Drawings of the same date as *309* (or very little later) but never realised.

[1] [Carew Castle was in No. 17 of *England and Wales;* Lancaster, in No. 1.]
[2] [See above, pp. 242, 245.]
[3] [By some oversight the engraving was not shown (or not shown at first), and is not now in the Gallery: see in the *Letters to Ward* (reprinted in a later volume of this edition), the letter of July 9, 1858.]

146.

323, 324. Two Bridge Subjects. Both marvellously beautiful. The uppermost, though more hasty, is of the best time.[1] [*N. G.*, 623.]

147.

325. Cologne Cathedral.

326. On the Rhine.

Magnificent sketches on the spot, of his finest time. [*N. G.*, 624.]

148.

327–330. Sketches at and near York. Of the highest possible quality of pencil sketching. (Middle time.) [*N. G.*, 450.]

149.

331–334. Companions to the Foregoing. [*N. G.*, 451.]

150.

335. On the Rhine. A study on brown paper; of very late date. [*N. G.*, 452.]

151.

336. Bellinzona. Out of a sketch-book of very late date.[2] [*N. G.*, 453.]

152.

337. Fribourg. (Canton Fribourg.) Sketched on, I believe, his last Swiss journey (1845). [*N. G.*, 454.]

153.

338. Fribourg. Companion to the foregoing. [*N. G.*, 455.] Out of a book containing fourteen sketches of this

[1] [The upper drawing is of Kirkby Lonsdale Bridge.]

[2] [This is the drawing already described as No. 41 in the earlier catalogue: see above, p. 207.]

city; all more or less elaborate; and showing the way in
which he used the pencil and pen together, up to the
latest hour of his artist's life. The lesson ought surely not
to be lost upon us when we consider that from Turner,
least of all men, such indefatigable delineation was to have
been expected; since his own special gift was that of ex-
pressing mystery, and the obscurities rather than the de-
finitions of form. If a single title were to be given, to
separate him from others, it ought to be "the painter of
clouds": this he was in earliest life; and this he was, in
heart and purpose, even when he was passing days in
drawing the house roofs of Fribourg; for the sketches
which at that period he liked to be asked to complete were
such as those in the hundredth frame, of soft cloud wreath-
ing above the deep Swiss waters.

All other features of natural scenery had been in some
sort rendered before;—mountains and trees by Titian, sun
and moon by Cuyp and Rubens, air and sea by Claude.
But the burning clouds in their courses, and the frail
vapours in their changes, had never been so much as
attempted by any man before him. The first words which
he ever wrote, as significative of his aim in painting, were
Milton's, beginning "Ye mists and exhalations."[1] And the
last drawing in which there remained a reflection of his
expiring power, he made in striving to realise, for me, one
of these faint and fair visions of the morning mist, fading
from the Lake Lucerne.[2]

"There ariseth a little cloud out of the sea, like a man's hand."
"For what is your life?"[3]

[1] [See above, p. 126, and below, p. 406.]
[2] [Compare No. 100 above, p. 296. For the realised drawing, see below, p. 476 n.,
where Ruskin calls it "a faint Lucerne, with floating vapours."]
[3] [1 Kings xviii. 44 and James iv. 14 ("For what is your life? It is even a vapour,
that appeareth for a little time, and then vanisheth away.") In ed. 1 the texts
were given in Latin (see the Vulgate):—

"Ascendebat de mari nubecula parva, quasi vestigium hominis."
"Quæ est enim vita vestra?"]

V

REPORT ON THE TURNER DRAWINGS IN THE NATIONAL GALLERY

(1858)

[*Bibliographical Note.*—This document, not hitherto republished, is reprinted from Appendix No. 7, pp. 67–69 of the *Report of the Director of the National Gallery to the Lords Commissioners of Her Majesty's Treasury, dated 5th April 1858.*]

MR. RUSKIN'S REPORT ON THE TURNER DRAWINGS IN THE NATIONAL GALLERY

THE Drawings by Turner in the possession of the Nation may most conveniently be given account of under three heads: —

(1) Drawings arranged for immediate exhibition, or which it is desirable so to arrange.
(2) Drawings which can only be exhibited in the event of the enlargement of the National Gallery.
(3) Drawings which it is not advisable to exhibit with the body of the collection, but of which a portion might be distributed with advantage among Provincial Schools of Art.

CLASS I

The number of drawings of this class placed on the walls of Marlborough House has been already stated in Mr. Wornum's Catalogue of the Pictures of the British School.[1] I confine myself here to an account of those in the National Gallery, which, with few exceptions, have not yet been exhibited. Four hundred of these have been selected for general exhibition, including all the best and most highly finished drawings,[2] 200 of which are already secured in light frames of holly, covering deal, and enclosed in portable mahogany cases, in a mode which I believe will render

[1] [See above, p. 95 n. The number was 102 (exclusive of *Liber* drawings).]
[2] [The four hundred here referred to are those in the Cabinets; they still bear the numbers 1–400. They included the greater part of the Hundred which Ruskin first arranged and described, pp. 191–226.]

them conveniently accessible to the public. The remaining 200 will be also framed, and ready for exhibition, before the 15th of May.

The 200 already mounted and framed consist of [1]—

No. 1–25. Twenty-five pencil drawings of Alpine subjects, of great value.

No. 26–100. Seventy-five coloured sketches on white paper.

No. 101–120. Twenty finished water-colour drawings on white paper, forming the series known as the "Rivers of England," with a portion of that known as the "Ports of England."

No. 121–156. Thirty-six finished water-colour drawings on grey paper, forming a portion of the series known as the "Rivers of France."

No. 157–200. Forty-four sketches in water-colour on grey paper, of great value, connected in subjects and treatment with the series of "Rivers of France."

The 200 drawings which will be prepared for exhibition before the 15th of May, will include the vignettes illustrative of Rogers's *Poems;* 25 studies of mountain scenery in Scotland and Switzerland; 15 large water-colour sketches on grey paper, chiefly illustrative of Venice; and a selection of most precious drawings from Nature at Rome and Naples.

In addition to these 400 drawings prepared for framing, 600 of less value have been mounted in a manner calculated to permit their being shown and handled without injury, their surfaces being protected from friction by raised mounts, which also display the sketches to advantage. Four hundred more will be similarly prepared for exhibition before the middle of May, forming a series of 1,000, to accompany which, together with the series in the frames, I am preparing an illustrative catalogue; [2] this, however, I cannot satisfactorily

[1] [The following numbering does not coincide with that which now obtains; see Index II.]

[2] [The illustrative catalogue here promised was never written, because the authorities did not at the time care to frame or exhibit any of the 1000 drawings in question. Ruskin, however, identified the greater part of them, and presumably furnished the

finish till I have more at leisure examined the remainder of the drawings in the national collection; but a short catalogue, giving the subjects of the drawings, as far as I have ascertained them, will be furnished this spring.

In order to render this series of 1400 drawings completely available to the public, nothing more is now necessary than the appropriation of a room to them, and the appointment of an attendant to give out the cases of drawings, as in the print-room of the British Museum. The observance of such regulations of admission as are adopted in the reading-room of that establishment will be necessary; but no further restrictions need be imposed on the exhibition of the drawings.

authorities with the catalogue of subjects here mentioned as being nearly ready. From the reserve of 1000 drawings thus prepared by Ruskin in 1858, and from the pieces described in the following pages, the authorities framed and exhibited 240 at the National Gallery in 1885 and 1890; lent 250 at Ruskin's request to his Drawing School at Oxford in 1878 (see below, p. 560); and, at various dates from 1869 onwards, put in circulation among provincial galleries six collections, comprising in all 319 pieces.]

XIII.

CLASS II

DRAWINGS WHICH CAN ONLY BE EXHIBITED IN THE EVENT OF THE ENLARGEMENT OF THE NATIONAL GALLERY

It is difficult to suggest any satisfactory mode of arrangement for the large sketches and drawings, about 200 in number — many of them very noble. They had been much crushed and otherwise ill - treated by Turner, and were nearly all worm - eaten, or more or less decayed. I have, therefore, had them laid down on strong paper, and they are now all safe for the present; but they cannot be shown to the public, even in large portfolios, without sustaining in a short time irreparable injury. Supposing a proper gallery to be built for the exhibition of drawings in general, it would be easy to place these larger examples in glazed panels on the walls, but I can imagine no other means of showing them.

By far the larger portion of the collection, however, consists of pocket note - books, containing pencil sketches on both sides of every leaf. Owing to the dilapidated state of the bindings, the pages in many instances could not be turned or examined without injury to their contents. When this was the case, I have first numbered the pages, and written on the bottom of each leaf the number of the volume to which it belongs in the schedule.[1] I have then taken off the binding, carefully separated the leaves, placed each leaf in a folded piece of smooth paper, and fastened the whole firmly between pasteboards, thus securing the drawings from all injury for the present. Whatever number of them it may hereafter be thought desirable to

[1] [With regard to this schedule, see above, Introduction, p. xliv.]

exhibit, may now be mounted, and shown without difficulty; only this final arrangement cannot but be a work of time. The mode of mounting adopted, though it conceals one side of the leaf, does not injure the drawing so hidden; and if it should be thought desirable, any of the leaves may be afterwards removed from the mounts, and attached by their edges in the usual way; but I thought that where the quantity of drawings was so large, the attainment of ease and safety in the handling might justify, at least for the present, the concealment of drawings on the reverses of leaves.

Thirty - six of the note - books, containing collectively 3,132 leaves, most of them drawn on both sides, have been thus divided, and all the note-books, 267 in number, have been examined, and their principal contents (in subject) stated on their envelopes for convenience of reference. My attention has been principally turned during the present season to the pencil drawings, because I saw that these were likely to suffer much more injury, if left unprotected, than could, under any ordinary circumstances, happen to the coloured ones; and many of these pencil sketches have been mounted, not as being specially interesting, but merely because they had been left by Turner in confusion; and I wanted to get them out of the way of chance injury at once, so as to leave free room for other operations. A large quantity of very beautiful studies of skies in colour, beginnings of drawings in colour, early finished drawings and studies in Indian ink, are put aside for the present in safe parcels, as I have not yet had time to deal with them.[1] Most of these, being of considerable size, would require, after being mounted, large cabinets to hold them, and I thought it best to defer the planning of these cabinets until some determination had been arrived at respecting the new Galleries.[2]

[1] [See on this subject, the Introduction, pp. xli.-xlv.]
[2] [The reference is to the question then pending about the removal, or enlargement, of the National Gallery: see below, p. 539.]

CLASS III

DRAWINGS AVAILABLE FOR DISTRIBUTION

The remainder of the collection consists of drawings of miscellaneous character, from which many might be spared with little loss to the collection in London, and great advantage to students in the Provinces. Five or six collections, each completely illustrative of Turner's modes of study, and successions of practice, might easily be prepared for the Academies of Edinburgh, Dublin, and the principal English manufacturing towns.[1]

Among these loose parcels there are also large numbers of sketches so slight or careless as to possess hardly any value. It is difficult at present to determine the extent of this inferior class, as many drawings which at first appear useless, will be found to possess documentary interest in connexion with others. Ultimately, however, there will certainly be a large mass which it would not be desirable to exhibit with the rest of the collection, as their inferiority would cast unjust discredit on the finer works with which they were associated. I should therefore recommend them to be bound in volumes, and shown only on special application. They ought not to be scattered or parted with, because they form illustrations, often dependent as much on their quantity as on their style, of the habits of life and tones of temper, and, too often, errors of judgment, of the greatest landscape painter who ever lived.[2]

JOHN RUSKIN.

27th March 1858.[3]

[1] [Ten years later, as already stated, a beginning was made in the adoption of this suggestion.]

[2] [See, on this subject, the Introduction, above, p. xli.]

[3] [In letters to Professor Charles Eliot Norton, Ruskin gives some further particulars; in one of these he writes:—

"[*February* 28, 1858.]— . . . To show you a little state my mind is in, I have facsimiled for you, as nearly as I could, one of the 19,000

of work a great many leaves
being slighter — some blanks but
a great many also elaborate in the
highest degree — some containing
ten exquisite compositions on each
side of the leaf — thus —
each no bigger than
this —

and with about that quantity of
work in each — but every touch of
it inestimable, done with his
whole soul in it. Generally
the slighter sketches are
written over everywhere: as in
the example enclosed, every
incident being noted that was
going on at the moment of
the sketch

sketches. It, like most of them, is not *a* sketch, but a group of sketches, made on both sides of the leaf of the note-book. The size of the leaf is indicated by the red line,—on the opposite leaf of the note-paper is the sketch on the other side of the leaf in the original. The note-books vary in contents from 60 to 90 leaves : there are about two hundred books of the kind (300 and odd, of note-books in all), and each leaf has on an average this quantity of work, a great many leaves being slighter, some blank, but a great many also elaborate in the highest degree, some containing ten exquisite compositions on each side of the leaf, thus [see facsimile], each no bigger than this,—and with about that quantity of work in each, but every touch of it inestimable, done with his whole soul in it. Generally the slighter sketches are written over everywhere, as in the example enclosed, every incident being noted that was going on at the moment of the sketch. The legends on one side, you will see, 'Old wall, Mill, Wall, Road, Linen drying.' Another subject, scrawled through the big one afterwards, inscribed, 'Lauenstein (?).' The words under 'Children playing at a well' I can't read. The little thing in the sky of the one below is the machicolation of the tower."

This extract is here reprinted from the text of the letter as given in *The Atlantic Monthly*, June 1904, vol. 93, p. 800. It had previously appeared, with some differences, in a *List of the Drawings . . . by Turner . . . shown in connection with Mr. Norton's Lectures on Turner and his Work, at the Parker Memorial Hall, Boston:* University Press, Cambridge, 1874, p. 11 ; and was thence reprinted, with the facsimile here reproduced, in *Arrows of the Chace*, 1880, i. p. 123.]

VI

LETTERS TO THE PRESS ON
THE EXHIBITION OF THE TURNER
DRAWINGS

(1858, 1859, 1876)

[*Bibliographical Note.*—These letters have previously been reprinted in *Arrows of the Chace*, 1880, vol. i. pp. 127–152.

The concluding portion of the first letter (§§ 7, 8, 9) was also reprinted, with some alterations, as Appendix iv. of *The Two Paths* (1859). The alterations were as follows :—

§ 7, line 3, the reprint began "I must ask you . . . ," the words "with more diffidence" being omitted ; line 5, the words "and to one omission," were omitted ; § 8, line 5, of " Mr. Kingsley's No. 3," see p. 336 *n.* ; Ruskin's footnotes omitted ; § 9, line 1, for "have italicized," *Two Paths* reads "put in italics" ; § 9, line 18, a footnote was added ; § 9, last line, " a " substituted for " an."

In this edition the paragraphs are numbered for convenience of reference, and in § 7, line 16, " *Poems* " is read for " poems." In the third letter a misprint has been corrected : see p. 345 *n.*]

THE TURNER SKETCHES AND DRAWINGS

To the Editor of the " Literary Gazette " [1]

[1858]

1. SIR,—I do not think it generally necessary to answer criticism; yet as yours is the first sufficient notice which has been taken of the important collection of sketches at Marlborough House, and as your strictures on the arrangement proposed for the body of the collection, as well as on some statements in my catalogue, are made with such candour and good feeling, will you allow me to offer one or two observations in reply to them? The mode of arrangement to which you refer as determined on by the trustees has been adopted, not to discourage the study of the drawings by the public, but to put all more completely at their service. Drawings so small in size and so delicate in execution cannot be seen, far less copied, when hung on walls. As now arranged, they can be put into the hands of each visitor, or student, as a book is into those of a reader; he may examine them in any light, or in any position, and copy them at his ease. The students who work from drawings exhibited on walls will, I am sure, bear willing witness to the greater convenience of the new system. Four hundred drawings are already thus arranged for public use; [2]

[1] [From the *Literary Gazette*, November 13, 1858, under the title here given. The letter was written in reply to a criticism, contained in the *Literary Gazette* of November 6, 1858, on Ruskin's *Catalogue of the Turner Sketches and Drawings exhibited at Marlborough House 1857–1858* (here pp. 227–316). The subjects of complaint made by the *Gazette* sufficiently appear from this letter. They were, briefly, first, the mode of exhibition of the Turner Drawings proposed by Ruskin in his official report (here pp. 319–324); and, secondly, two alleged hyperboles and one omission in the Catalogue itself.]

[2] [*i.e.*, the Four Hundred Drawings in Cabinets, then (as now) in the National Gallery; see above, Introduction, p. xxxv.—a distinct series from the 339 described in the Marlborough House Catalogue.]

framed, and disposed in eighty portable boxes, each contain-
ing five sketches, so that eighty students might at once be
supplied with five drawings apiece. The oil paintings at
Marlborough House, comprising as they do the most splendid
works which Turner ever produced, and the 339 drawings
exhibited beside them, are surely enough for the amusement
of loungers,—for do you consider as anything better than
loungers those persons who do not care enough for the
Turner drawings to be at the trouble of applying for a
ticket of admission, and entering their names in a book,—
that is to say, who will not, to obtain the privilege of
quiet study of perfect art, take, once for all, as much
trouble as would be necessary to register a letter, or book,
or parcel?

2. I entirely waive for the moment the question of ex-
posure to light. I put the whole issue on the ground of
greatest public convenience. I believe it to be better for
the public to have two collections of Turner's drawings
than one; nay, it seems to me just the perfection of all
privilege to have one gallery for quiet, another for disquiet;
one into which the curious, idle, or speculative may crowd
on wet or weary days, and another in which people de-
sirous of either thinking or working seriously may always
find peace, light, and elbow-room.[1] I believe, therefore, that
the present disposition of these drawings will be at once
the most convenient and the most just, even supposing
that the finest works of Turner would not be injured by
constant exposure. But that they would be so admits of
no debate.[2] It is not on my judgment, nor on any other
unsupported opinion, that the trustees have acted, but in

[1] [In the first draft this passage was different:—
 ". . . another for disquiet—one where that portion of the public which
 is simply curious, idle, or speculative may crowd on wet or dirty days, wait-
 ing in steamy patience for passing showers, and, while they wait, picking up
 in the meantime as much amusement as they can from Turner's vermilion or
 white; and another gallery where, when they really wish to have a steady
 look at Turner, they may get it in peace in good light, un-nudged by elbow
 and unvexed by dust or damp. I believe, therefore, . . ."]
[2] [See above, pp. 83, 188; and below, pp. 589–593.]

consideration of facts now universally admitted by persons who have charge of drawings. You will find that the officers both of the Louvre and of the British Museum refuse to expose their best drawings or missal-pages to light, in consequence of ascertained damage received by such drawings as have been already exposed; and among the works of Turner I am prepared to name an example in which, the frame having protected a portion while the rest was exposed, the covered portion is still rich and lovely in colours, while the exposed spaces are reduced in some parts nearly to white paper, and the colour in general to a dull brown.

3. You allude to the contrary chance that some hues may be injured by darkness. I believe that some colours are indeed liable to darken in perpetual shade, but not while occasionally exposed to moderate light, as these drawings will be in daily use; nor is any liability to injury, even by perpetual shade, as yet demonstrable with respect to the Turner drawings; on the contrary, those which now form the great body of the national collection were never out of Turner's house until his death, and were all kept by him in tight bundles or in clasped books; and all the drawings so kept are in magnificent preservation, appearing as if they had just been executed, while every one of those which have been in the possession of purchasers and exposed in frames are now faded in proportion to the time and degree of their exposure; the lighter hues disappearing, especially from the skies, so as sometimes to leave hardly a trace of the cloud-forms. For instance, the great Yorkshire series is, generally speaking, merely the wreck of what it once was.* That water-colours are not injured by darkness is also sufficiently proved by the exquisite preservation of missal paintings, when the books containing them

* The cloud-forms which have disappeared from the drawings may be seen in the engravings.[1]

[1] [See on this subject, p. 381 n, below.]

have been little used. Observe, then, you have simply this
question to put to the public: "Will you have your
Turner drawings to look at when you are at leisure, in a
comfortable room, under such limitations as will preserve
them to you for ever, or will you make an amusing ex-
hibition of them (*if* amusing, which I doubt,) for children
and nursery-maids; dry your wet coats by them, and shake
off the dust from your feet upon them, for a score or two
of years, and then send them to the waste-paper merchant?"
That is the simple question; answer it, for the public, as
you think best.

4. Permit me to observe farther, that the small interest
manifested in the existing Turner collection at Marlborough
House does not seem to justify any further effort at ex-
hibition. . There are already more paintings and drawings
placed in those rooms than could be examined properly in
years of labour. But how placed? Thrust into dark
corners, nailed on spare spaces of shutters, backs of doors,
and tottering elongations of screens; hung with their faces
to the light, or with their backs to the light, or with their
sides to the light, so that it "rakes" them, (I use an excel-
lent expression of Sir Charles Eastlake's,) throwing every
irregularity of surface into view as if they were maps in
relief of hill countries; hung, in fine, in every conceivable
mode that can exhibit their faults, or conceal their mean-
ing, or degrade their beauty. Neither Mr. Wornum nor I
are answerable for this; we have both done the best we
could under the circumstances; the public are answerable
for it, who suffer such things without care and without
remonstrance. If they want to derive real advantage from
the treasures they possess, let them show some regard for
them, and build, or at least express some desire to get
built, a proper gallery for them. I see no way at present
out of the embarrassments which exist respecting the dis-
position of the entire national collection; but the Turner
gallery was intended by Turner himself to be a distinct
one, and there is no reason why a noble building should

not be at once provided for it. Place the oil pictures now at Marlborough House in beautiful rooms, each in a light fit and sufficient for it, and all on a level with the eye; range them in chronological order; place the sketches at present exhibited, also in chronological order, in a lateral gallery; let illustrative engravings and explanations be put in cases near them; furnish the room richly and gracefully, as the Louvre is furnished, and I do not think the public would any longer complain of not having enough to amuse them on rainy days.

5. That we ought to do as much for our whole national collection is as certain as that we shall not do it for many a year to come, nor until we have wasted twice as much money as would do it nobly in vain experiments on a mean scale. I have no immediate hope in this matter, else I might perhaps ask you to let me occupy your columns with some repetition, in other words (such repetition being apparently always needed in these talking days), of what I have already stated in the Appendix to my Notes on the oil-pictures[1] at Marlborough House. But I will only, being as I say hopeless in the matter, ask you for room for a single sentence :—

"If ever we come to understand that the function of a picture, after all, with respect to mankind, is not merely to be bought, but to be seen, it will follow that a picture which deserves a price deserves a place; and that all paintings which are worth keeping, are worth, also, the rent of so much wall as shall be necessary to show them to the best advantage, and in the least fatiguing way for the spectator.

"It would be interesting if we could obtain a return of the sum which the English nation pays annually for park walls to enclose game, stable walls to separate horses, and garden walls to ripen peaches; and if we could compare this ascertained sum with what it pays for walls to show its art upon."

6. I ask you to reprint this, because the fact is that if either Mr. Wornum at the National Gallery, or Mr. Carpenter[2] at the British Museum, had as much well-lighted

[1] [See above, pp. 175–176.]
[2] [See above, p. 84 n.]

wall at their disposal as most gentlemen's gardeners have, they could each furnish the public with art enough to keep them gazing from one year's end to another's. Mr. Carpenter has· already made a gallant effort with some screens in a dark room; but in the National Gallery, whatever mode of exhibition may be determined upon for the four hundred framed drawings, the great mass of the Turner sketches (about fifteen thousand, without counting mere colour memoranda) must lie packed in parcels in tin cases, simply for want of room to show them. It is true that many of these are quite slight, and would be interesting to none but artists. There are, however, upwards of five thousand sketches in pencil outline,* which are just as interesting as those now exhibited at Marlborough House; and which might be constantly exhibited, like those, without any harm, if there were only walls to put them on.

7. I have already occupied much of your space. I do not say too much, considering the importance of the subject, but[1] I must with more diffidence ask you to allow me yet leave to reply to the objections you make to two statements and to one omission in my Catalogue, as those objections would otherwise diminish its usefulness. I have asserted that in a given drawing (named as one of the chief in the series), Turner's pencil did not move over the thousandth of an inch without meaning;[2] and you charge this expression with extravagant hyperbole. On the contrary, it is much within the truth, being merely a mathematically accurate description of fairly good execution in either drawing or engraving. It is only necessary to measure a piece

* By the way, you really ought to have given me some credit for the swivel frames in the desks of Marlborough House, which enable the public, however rough-handed, to see the drawings on both sides of the same leaf.[3]

[1] [The rest of this letter, with the exception of § 10, and with some slight alterations, was reprinted in The Two Paths, Appendix iv., "Subtlety of Hand." For a summary of the alterations, see above, "Variæ Lectiones," p. 328.]

[2] [See above, under Frame No. 101, p. 297.]

[3] [The identical frames, each containing examples of the sketches in pencil outline to which the letter alludes, may be seen in the windows of the lower rooms of the National Gallery, now devoted to the exhibition of the Turner drawings.]

of any ordinarily good work to ascertain this. Take, for instance, Finden's engraving at the 180th page of Rogers's Poems,[1] in which the face of the figure, from the chin to the top of the brow, occupies just a quarter of an inch, and the space between the upper lip and chin as nearly as possible one-seventeenth of an inch. The whole mouth occupies one-third of this space, say, one-fiftieth of an inch; and within that space both the lips and the much more difficult inner corner of the mouth are perfectly drawn and rounded, with quite successful and sufficiently subtle expression. Any artist will assure you, that in order to draw a mouth as well as this, there must be more than twenty gradations of shade in the touches; that is to say, in this case, gradations changing, with meaning, within less than the thousandth of an inch.

8. But this is mere child's play compared to the refinement of any first-rate mechanical work, much more of brush or pencil drawing by a master's hand. In order at once to furnish you with authoritative evidence on this point, I wrote to Mr. Kingsley,[2] tutor of Sidney-Sussex College, a friend to whom I always have recourse when I want to be precisely right in any matter; for his great knowledge both of mathematics and of natural science is joined, not only with singular powers of delicate experimental manipulation, but with a keen sensitiveness to beauty in art. His answer, in its final statement respecting Turner's work, is amazing even to me; and will, I should think, be more so to your readers. Observe the successions of measured and tested refinement; here is No. 1:

"The finest mechanical work that I know of is that done by Nobert in the way of ruling lines. I have a series of lines ruled by him on glass, giving actual scales from ·000024 and ·000016 of an inch, perfectly correct to these places of decimals;* and he has executed others as fine as ·000012, though I do not know how far he could repeat these last with accuracy."

* That is to say, accurate in measures estimated in *millionths* of inches.

[1] [From a vignette design by Stothard of a single figure, to illustrate the poem "On a Tear" (Rogers' *Poems*, London, 1834 ed.)]
[2] [See above, p. 162; and below, pp. 370 n., 428, 533–536.]

This is No. 1, of precision. Mr. Kingsley proceeds to No. 2:

> "But this is rude work compared to the accuracy necessary for the construction of the object-glass of a microscope such as Rosse turns out."

I am sorry to omit the explanation which follows of the ten lenses composing such a glass, "each of which must be exact in radius and in surface, and all have their axes coincident"; but it would not be intelligible without the figure by which it is illustrated, so I pass to Mr. Kingsley's No. 3:

> "I am tolerably familiar," he proceeds, "with the actual grinding and polishing of lenses and specula, and have produced by my own hands some by no means bad optical work; and I have copied no small amount of Turner's work, and I still look with awe at the combined delicacy and precision of his hand; *it beats optical work out of sight.*[1] In optical work, as in refined drawing, the hand goes beyond the eye,* and one has to depend upon the feel; and when one has once learned what a delicate affair touch is, one gets a horror of all coarse work, and is ready to forgive any amount of feebleness, sooner than the boldness which is akin to impudence. In optics the distinction is easily seen when the work is put to trial; but here too, as in drawing, it requires an educated eye to tell the difference when the work is only moderately bad; but with "bold" work nothing can be seen but distortion and fog, and I heartily wish the same result would follow the same kind of handling in drawing; but here, the boldness cheats the unlearned by looking like the precision of the true man. It is very strange how much better our ears are than our eyes in this country: if an ignorant man were to be 'bold' with a violin, he would not get many admirers, though his boldness was far below that of ninety-nine out of a hundred drawings one sees."

9. The words which I have italicized in the above extract are those which were surprising to me. I knew that

* In case any of your readers should question the use, in drawing, of work too fine for the touches to be individually, I quote a sentence from my *Elements of Drawing.*[2] "*All* fine colouring, like fine drawing, is delicate; so delicate, that if at last you see the colour you are putting on, you are putting on too much. You ought to feel a change wrought in the general tone by touches which are individually too pale to be seen."

[1] [Doubly emphasised in *The Two Paths,* where the words are printed thus: "*I still look with awe at the combined delicacy and precision of his hand;* IT BEATS OPTICAL WORK OUT OF SIGHT."]

[2] [See the *Elements of Drawing,* Letter iii. on Colour and Composition, § 179.]

Turner's was as refined as any optical work, but had no
idea of its going beyond it. Mr. Kingsley's word "awe,"
occurring just before, is, however, as I have often felt, pre-
cisely the right one. When once we begin at all to under-
stand the work of any truly great executor, such as that
of any of the three great Venetians (Tintoret, Titian, and
Veronese), Correggio, or Turner, the awe of it is something
greater than can be felt from the most stupendous natural
scenery. For the creation of such a system as a high human
intelligence, endowed with its ineffably perfect instruments
of eye and hand, is a far more appalling manifestation of
Infinite Power than the making either of seas or mountains.[1]

After this testimony to the completion of Turner's work,
I need not at length defend myself from the charge of hyper-
bole in the statement that, "as far as I know, the galleries
of Europe may be challenged to produce one sketch[2] that
shall equal the chalk study No. 45,[3] or the feeblest of the
memoranda in the 71st and following frames"; which
memoranda, however, it should have been observed, are
stated at the forty-fourth page[4] to be in some respects "the
grandest work in grey that he did in his life."

For I believe that, as manipulators, none but the four
men whom I have just named (the three Venetians and
Correggio) were equal to Turner; and, as far as I know,
none of these four men put their full strength into sketches.
But whether they did or not, my statement in the Catalogue
is limited by my own knowledge, and as far as I can trust
that knowledge: it is not an enthusiastic statement, but an
entirely calm and considered one. It may be a mistake,
but it is not an hyperbole.

[1] [Compare *Stones of Venice*, vol. ii. (Vol. X. p. 439).]

[2] [The following note is here added to the reprint in *The Two Paths*:—
"A sketch, observe,—not a printed drawing. Sketches are only proper
subjects of comparison with each other when they contain about the same
quantity of work : the test of their merit is the quantity of truth told with
a given number of touches. The assertion in the Catalogue which this letter
was written to defend was made respecting the sketch of Rome, No. 101."]

[3] [No. 45 was a "Study of a Cutter": see above, p. 270, and, for the remark upon
it cited in the text, p. 245.]

[4] [In this edition, p. 283.]

XIII.

10. Lastly, you object that the drawings for the Liber Studiorum are not included in my Catalogue. They are not so, because I did not consider them as, in a true sense, drawings at all;[1] they are merely washes of colour laid roughly to guide the mezzotint engraver in his first process; the drawing, properly so called, was all put in by Turner when he etched the plates, or superadded by repeated touchings on the proofs. These brown "guides"—for they are nothing more—are entirely unlike the painter's usual work, and in every way inferior to it; so that students wishing to understand the composition of the Liber must always work from the plates, and not from these first indications of purpose.[2] I have put good impressions of two of the plates in the same room, in order to show their superiority;[3] and for the rest, thought it useless to increase the bulk of the Catalogue by naming subjects which have been published and well known these thirty years.[4]

Permit me, in conclusion, to thank you for drawing attention to the subject of this great national collection; and, again asking your indulgence for trespassing so far upon your space, to subscribe myself,

<div align="right">Very respectfully yours,</div>

<div align="right">J. RUSKIN.</div>

[1] [Compare the Preface to the Catalogue of the Turner Oil-Pictures, above, p. 96.]

[2] [In a letter to Mr. Norton, written in the same year as this one to the *Literary Gazette*, Ruskin enlarged on the value of these plates: see *Elements of Drawing* (Vol. XV.).]

[3] [See above, pp. 268, 273.]

[4] [The *Literary Gazette* of November 20, 1858, contains a reply to this letter, but as it did not provoke a further letter from Ruskin, it need not be noticed here.]

II

THE TURNER GALLERY AT KENSINGTON

To the Editor of the " Times " [1]

[1859]

Sɪʀ,—At the time of my departure for the Continent some months ago I had heard it was proposed to light the Turner Gallery, at Kensington, with gas; but I attached no importance to the rumour, feeling assured that a commission would be appointed on the subject, and that its decision would be adverse to the mode of exhibition suggested.

Such a commission has, I find, been appointed; and has, contrary to my expectations, approved and confirmed the plan of lighting proposed.

It would be the merest presumption in me to expect weight to be attached to any opinion of mine, opposed to that of any one of the gentlemen who formed the commission; but as I was officially employed in some of the operations connected with the arrangement of the Turner Gallery at Marlborough House, and as it might therefore be supposed by the public that I at least concurred in recommending the measures now taken for exhibition of the Turner pictures in the evening, at Kensington, I must beg your permission to state in your columns that I take no share in the responsibility of lighting the pictures either of Reynolds or Turner with gas; that, on the contrary, my experience would lead me to apprehend serious injury to

[1] [From the *Times*, October 21, 1859, under the heading "The Turner Gallery." For the exhibition of Turner drawings and pictures at the South Kensington Museum, see above, Introduction, p. xxxvi. The exhibition consisted of those formerly at Marlborough House, and now in the National Gallery.]

those pictures from such a measure; and that it is with profound regret that I have heard of its adoption.

I specify the pictures of Reynolds and Turner, because the combinations of colouring material employed by both these painters are various, and to some extent unknown; and also because the body of their colours shows peculiar liability to crack, and to detach itself from the canvas. I am glad to be able to bear testimony to the fitness of the gallery at Kensington, as far as could be expected under the circumstances, for the exhibition of the Turner pictures by daylight, as well as to the excellence of Mr. Wornum's chronological arrangement of them in the three principal rooms.

<div align="center">I am, Sir, your obedient servant,</div>

<div align="right">J. RUSKIN.</div>

DENMARK HILL, *Oct.* 20.

P.S.—I wish the writer of the admirable and exhaustive letter which appeared in your columns of yesterday on the subject of Mr. Scott's design for the Foreign Office would allow me to know his name.[1]

[1] [This refers to a letter signed "E. A. F." (no doubt E. A. Freeman) which appeared in the *Times* of October 19, 1859, advising the adoption of Mr. Gilbert Scott's Gothic design for the Foreign Office in preference to any Classic design. The writer entered at some length into the principles of Gothic and Classic architecture, which he briefly summed up in the last sentence of his letter: "Gothic, then, is national; it is constructively real; it is equally adapted to all sorts of buildings; it is convenient; it is cheap. In none of these does Italian surpass it; in most of them it is very inferior to it." See Ruskin's letters on the Oxford Museum as to the adaptability of Gothic—included in a later volume of this edition. With regard to the cheapness of Gothic, the correspondent of the *Times* had pointed out that while it may be cheap and yet thoroughly good so far as it goes, Italian *must* always be costly.]

III

TURNER'S DRAWINGS

To the Editor of the " Daily Telegraph " [1]

[1876]

SIR,—I am very heartily glad to see the subject of Turner's drawings brought more definitely before the public in your remarks on the recent debate [2] in Parliament. It is indeed highly desirable that these drawings should be made more accessible, and I will answer your reference to me by putting you in possession of all the facts which it is needful that the public should know or take into consideration respecting them, in either judging what has been hitherto done by those entrusted with their care, or taking measures for obtaining greater freedom in their use. Their *use*, I say, as distinguished from the mere pleasure of seeing them. This pleasure, to the general public, is very small indeed. You appear not to be aware that three hundred of the finest examples, including all the originals of the Liber Studiorum, were framed by myself, especially for the public, in the year 1858, and have been exhibited every day, and all day long, ever since in London. But the public never stops a moment in the room at Kensington where they hang; [3] and the damp, filth, and gas (under the

[1] [From the *Daily Telegraph*, July 5, 1876, under the title here given.]

[2] [Lord Francis Hervey had (June 30, 1876) put a question in the House of Commons to Lord Henry Lennox (First Commissioner of Works) as to whether it was the fact that many of Turner's drawings were at that time stowed in the cellars of the National Gallery, and had never been exhibited. The *Daily Telegraph* in a short article on the matter (July 1, 1876) appealed to Ruskin for his opinion on the exhibition of these drawings.]

[3] [On the absence of visitors to the Turner rooms then at Kensington, see also *Sesame and Lilies*, § 101.]

341

342 THE TURNER BEQUEST

former management of that institution *) soiled their frames and warped the drawings, "by friend remembered not."[1]

You have been also misinformed in supposing that "for some years these aquarelles were unreservedly shown, and in all the fulness of daylight." Only the "Seine" series ("Rivers of France"), the "Rivers of England," the "Harbours of England," and the Rogers vignettes (about a hundred drawings in all), were exhibited in the dark underroom of Marlborough House, and a few larger and smaller examples scattered up and down in the room of the National Gallery, including "Fort Bard," "Edinburgh," and "Ivy Bridge."[2] These drawings are all finished, most of them have been engraved; they were shown as the choicest of the collection, and there is no question but that they should always be perfectly accessible to the public. There are no other finished drawings in the vast mass of the remaining material for exhibition and means of education. But these are *all* the drawings which Turner made during his lifetime, in colour, chalk, pencil, and ink, for his own study or delight; that is to say, pencil sketches to be counted by the thousand (how many thousands I cannot safely so much as guess), and assuredly upwards of two thousand coloured studies, many of exquisite beauty ; and all instructive as no other water-colour work ever was before, or has been since; besides the ink and chalk studies for all his great Academy pictures.

There are in this accumulation of drawings means of education in the noblest principles of elementary art and in the most accomplished science of colour for every drawing-school in England, were they properly distributed. Besides

* Now, I trust, under Mr. Poynter and Mr. Sparkes, undergoing thorough reform.[3]

[1] [See *As You Like It*, Act ii. sc. 7 :—
 "Though thou the waters warp,
 Thy sting is not so sharp
 As friend remembered not."]

[2] [For notes of these drawings, see the Catalogue above, pp. 268, 267, 269.]

[3] [Sir Edward J. Poynter, now P.R.A., was then Director, and Mr. Sparkes Head-Master, of the Art School at the South Kensington Museum.]

these, there are the three hundred chosen drawings already named, now at Kensington, and about two hundred more[1] of equal value, now in the lower rooms of the National Gallery, which the Trustees permitted me to choose out of the mass, and frame for general service.

They are framed as I frame exercise-drawings at Oxford, for my own schools. They are, when in use, perfectly secure from dust and all other sources of injury; slide, when done with, into portable cabinets; are never exposed to light, but when they are being really looked at; and can be examined at his ease, measured, turned in whatever light he likes, by every student or amateur who takes the smallest interest in them. But it is necessary, for this mode of exhibition, that there should be trustworthy persons in charge of the drawings, as of the MSS. in the British Museum, and that there should be attendants in observation, as in the Print Room of the Museum, that glasses may not be broken, or drawings taken out of the frames.

Thus taken care of, and thus shown, the drawings may be a quite priceless possession to the people of England for the next five centuries; whereas those exhibited in the Manchester Exhibition were virtually destroyed in that single summer.[2] There is not one of them but is the mere wreck of what it was. I do not choose to name destroyed drawings in the possession of others; but I will name the vignette of the "Plains of Troy" in my own, which had half the sky baked out of it in that fatal year, and the three drawings of "Richmond" (Yorkshire), "Egglestone Abbey," and "Langharne Castle,"[3] which have had by former exposure to light their rose-colours entirely destroyed, and half of their blues, leaving nothing safe but the brown.

[1] [Ultimately 400 drawings were placed in cabinets; see below, p. 357.]

[2] [The Art Treasures Exhibition in 1857, being the year in which the lectures contained in the *Political Economy of Art* were delivered.]

[3] [These drawings, which had been included in the Manchester Exhibition of 1857, were afterwards acquired by Ruskin: see below, p. 592. For a note on "The Plains of Troy," see Ruskin's *Notes on his Drawings by Turner*, below, p. 446; for the "Richmond" and the "Egglestone Abbey," also in Ruskin's collection, see below, p. 430; for "Langharne," p. 441.]

I do not think it necessary to repeat my former statements respecting the injurious power of light on certain pigments rapidly, and on all eventually.[1] The respective keepers of the Print Room and of the Manuscripts in the British Museum are the proper persons to be consulted on that matter, their experience being far larger than mine, and over longer epochs. I will, however, myself undertake to show from my own collection a water-colour of the eleventh century absolutely as fresh as when it was laid— having been guarded from light; and water-colour burnt by sunlight into a mere dirty stain on the paper, in a year, with the matched piece from which it was cut beside it.

The public may, therefore, at their pleasure treat their Turner drawings as a large exhibition of fireworks, see them explode, clap their hands, and have done with them; or they may treat them as an exhaustless library of noble learning. To this end, they need, first, space and proper light—north light, as clear of smoke as possible, and large windows; and then proper attendance—that is to say, well-paid librarians and servants.

The space will of course be difficult to obtain, for while the British public of the upper classes are always ready to pay any money whatever for space to please their pride in their own dining-rooms and ball-rooms, they would not, most of them, give five shillings a year to get a good room in the National Gallery to show the national drawings in. As to the room in which it is at present proposed to place them in the new building, they might just as well, for any good that will ever be got out of them there, be exhibited in a railway tunnel.[2]

And the attendants will also be difficult to obtain. For— and this is the final fact to which I beg your notice—these drawings now in question were, as I above stated, framed by me in 1858. They have been perfectly "accessible"

[1] [See above, pp. 83, 188, 330; and below, pp. 589–593.]

[2] [i.e., the first of the present water-colour rooms at the National Gallery; called elsewhere by Ruskin a "cellar" : see below, p. 355.]

ever since, and are so now, as easily as any wares[1] in the shops of Regent Street are accessible over the counter, if you have got a shopman to hand them to you. And the British public have been whining and growling about their exclusion from the sight of these drawings for the last eighteen years, simply because, while they are willing to pay for any quantity of sentinels to stand in boxes about town and country, for any quantity of flunkeys to stand on boards for additional weight to carriage horses, and for any quantity of footmen to pour out their wine and chop up their meat for them, they would not for all these eighteen years pay so much as a single attendant to hand them the Turner drawings across the National Gallery table; but only what was needful to obtain for two days in the week the withdrawal from his other duties in the Gallery of the old servant of Mr. Samuel Rogers.[2]

I am, Sir, your obedient servant,

J. RUSKIN.

BRANTWOOD, *July* 3.

[1] [Misprinted "works" in the *Daily Telegraph* and *Arrows of the Chace*. Ruskin corrected the error in the following supplementary letter to the *Telegraph* (July 19, 1876) :—

TURNER'S DRAWINGS

To the Editor of the "Daily Telegraph."

"SIR,—In justice to our living water-colour artists, will you favour me by printing the accompanying letter, which I think will be satisfactory to many of your readers, on points respecting which my own may have given some of them a false impression? In my former letter, permit me to correct the misprint of 'works' in Regent Street for 'wares.'

"I have every reason to suppose Mr. Collingwood Smith's knowledge of the subject entirely trustworthy; but when all is conceded, must still repeat that no water-colour work of value should ever be constantly exposed to light, or even to the air of a crowded metropolis, least of all to gaslight or its fumes.

"I am, Sir, yours, etc.,
"J. RUSKIN.

"BRANTWOOD, CONISTON, LANCASHIRE, *July* 16."

"The accompanying letter" was one addressed to Ruskin by Mr. Collingwood Smith, and requesting him to state in a second letter that the remarks as to the effect of light on the water-colours of Turner did not extend to water-colour drawings in general; but that the evanescence of the colours in Turner's drawings was due partly to the peculiar vehicles with which he painted, and partly to the grey paper (saturated with indigo) on which he frequently worked. Ruskin complied with this request by thus forwarding for publication Mr. Collingwood Smith's letter.]

[2] [The late Mr. Edmund Paine, the attendant first in charge of the Turner drawings. He was for many years the servant and amanuensis of Rogers; see P. W. Clayden's *Rogers and his Contemporaries*, vol. ii. pp. 431, 444.]

VII

DRAWINGS AND SKETCHES BY TURNER IN THE NATIONAL GALLERY
CAST INTO PROGRESSIVE GROUPS

(1881)

CATALOGUE

OF THE

DRAWINGS AND SKETCHES

BY

J. M. W. TURNER, R.A.

AT PRESENT EXHIBITED IN THE
NATIONAL GALLERY

REVISED, AND CAST INTO PROGRESSIVE GROUPS, WITH
EXPLANATORY NOTES

BY

JOHN RUSKIN

GEORGE ALLEN, SUNNYSIDE, ORPINGTON, KENT
1881

[*Bibliographical Note.*—Of this Catalogue there are various editions, of which the latest is still current.

First Edition (1881).—The title-page is as here given on the preceding page. Octavo, pp. vii. + 60. The imprint (at foot of the reverse of the title-page) is "Hazell, Watson, and Viney, Printers, London and Aylesbury." The Preface (here pp. 355–356) occupies pp. v.–vii. ; the Introductory Classification (here pp. 357–359), pp. 1–4 ; Primary Synopsis (here pp. 361–362), pp. 5–6 ; Catalogue, pp. 7–51 ; Terminal Index, pp. 53–60. The headlines on each page correspond with these divisions of the book. Issued on December 19, 1881, in buff-coloured paper wrappers, with the title-page (enclosed in a double ruled frame) reproduced upon the front, with the addition of the woodcut of a rose[1] above the publisher's imprint. On p. 4 of the wrapper is this "Notice"—"Mr. Ruskin's Works are published by Mr. George Allen, Sunnyside, Orpington, Kent, who will send priced lists on application." Price 1s. (1000 copies printed.)

Special Edition (1882).—Ruskin's Catalogue was intended for sale in the Turner Water-Colours Rooms at the National Gallery, but the authorities objected to the Preface, which contained reflections on their arrangements (see below, p. 355.) A Special Edition was therefore prepared, omitting the Preface, for sale in the Gallery. There were no other alterations, except that on the wrapper the words "(Special Edition)" were added, and the date was changed to 1882. (1000 copies printed.)

Second Edition (1890).—A reprint of the First, with the exception of the following differences : (1) the words "Second Edition" are added to the title-page and wrapper, and the date became "1890." (2) The imprint reads "Printed by Hazell, Watson, & Viney, Ld., London and Aylesbury." (3) "One Shilling" is placed upon the wrapper below the rule, and the "Notice" on p. 4 is omitted. (4) The wrappers are of a grey colour. (250 copies printed.)

Second issue of the Special Edition (1890).—This corresponds in all respects with the issue last described, except that the Preface is omitted ; and that on the wrapper the words "Special Edition" are inserted above the rose. (250 copies printed.)

[1] This "vignette stamp of roses" first appeared on the title-pages and wrappers of *Fors Clavigera*, and for many years after 1871 was similarly used on many of Ruskin's books issued for him by Mr. Allen. It was drawn by Ruskin from the pattern of the petticoat on Botticelli's "Spring"; its meaning, as used by him, is explained at the beginning of Letter 22 in *Fors Clavigera*.

Third Edition (1899).—The title-page of this edition is different, thus :—

Catalogue | of the | Drawings and Sketches | By | J. M. W. Turner, R.A. | at present exhibited in the | National Gallery | Revised, and Cast into Progressive Groups, with | Explanatory Notes | By | John Ruskin | Third Edition | Revised and Enlarged | London | George Allen, 156, Charing Cross Road | 1899 | *All rights reserved.*

Crown 8vo, pp. 63 (of which the first eight are numbered i.–viii.). "Preface to the Edition of 1881" occupies pp. v.–vi. On p. vii. is the following "List of Illustrations":—

N₀.		PAGE
532.	Gate of Carisbrook Castle	16
408.	Sketch from Nature at Ivy Bridge	16
403.	Kirkstall Abbey	18
604.	Sketches at Naples	19
609.	*Swan Rising from Water* [Angry Swans]¹	21
447.	Grenoble	23
321.	The old Devil's Bridge, Pass of St. Gothard	28
339.	The Town [Tivoli] with its Cascades, and the Campagna . . .	39

Introductory Classification occupies pp. 9–12 ; Primary Synopsis, pp. 13–14 ; Catalogue, pp. 15–53 ; Terminal Index, pp. 54–63. The imprint (at the foot of p. 63) is ."Printed by Ballantyne, Hanson & Co., Edinburgh and London." Issued (in June 1899) in stiffened green paper wrappers, with the following title (in a plain ruled frame) on the front : "Drawings and Sketches | By | J. M. W. Turner, R.A. | at present exhibited in the | National Gallery | Cast into Progressive Groups, with | Explanatory Notes | By | John Ruskin | New Illustrated Edition | London : George Allen | Ruskin House | ," and the price "Eightpence net" outside the frame at the bottom. (1000 copies printed.)

Third issue of the Special Edition (1899).—Simultaneously was issued an edition for sale in the National Gallery, similar in every respect to the one last described, except that the Preface was omitted ; and that on the title-page "National Gallery Edition" was substituted for "Third Edition Revised and Illustrated" ; the words "All rights reserved" were included in brackets ; and on the cover instead of "New Illustrated Edition" were the words "New Illustrated National Gallery Edition." (2000 copies printed.)

In the Third Edition (both issues) the *illustrations* were printed from half-tone blocks, bearing the imprint "Swan Elec. Engr. Co." The same subjects (except No. 609, see p. lviii.) are in the present edition illustrated by photogravure.

The whole of the contents of this Catalogue were *reprinted* (in a rearranged form) in vol. i. of *Ruskin on Pictures* (1902) : see above, p. 186.

Variations in the Text were caused in ed. 3 (both issues) by the alteration of the numbering. In eds. 1 and 2 Ruskin adopted a double system of numbering. On the left-hand sides of the titles of the drawings were the

¹ So printed. "Swan Rising from Water" was the lettering on the plate ; "Angry Swans" is the title on the drawing in the Gallery.

progressive numbers, 1–500, which he proposed in accordance with his suggested new arrangement ; on the right-hand sides were the numbers which the drawings actually bear in the National Gallery, those which formerly belonged to the "Kensington Series" (see above, p. xxxvi.) being further distinguished by the letter "K." All this was found confusing by visitors, and accordingly in the 1899 editions the drawings were numbered (as in the text here, below) on the left-hand sides only, by the National Gallery numbers. This change necessitated the following omissions in ed. 3 of the text of eds. 1 and 2 :—

Group I. (p. 362 of the present edition). At the end of the introductory note : "The numbers on the right hand of the page are those by which they are indicated in the existing arrangement ; the letter K standing for Kensington, to prevent confusion with the numbers of those in cabinets, which were always at the National Gallery."

No. 407 (e) (p. 363 here) eds. 1–2 add after "Battle of Fort Rock" : "now placed in the upper rooms of the Gallery, K. 41." This was omitted in ed. 3, as the drawing in question (No. 555 in the present arrangement) is in the Water-Colour Room below.

Group II. In the last paragraph of the introductory note (p. 364 here) eds. 1 and 2 read : "The entire series is contained in seventy frames, selected, as those of the Scholar's group are, from the collection first arranged for Kensington ; and close . . ."

Group III. At the end of the introductory note (p. 369 here) eds. 1 and 2 add : "The reference numbers in the right-hand column are henceforward to the cabinet frames as at present arranged, unless the prefixed K indicate an insertion of one out of the Kensington Series."

Group IX. In all previous editions Nos. 204 and 207 were transposed.

Terminal Index. The first lines of the introductory note (p. 388 here) read in eds. 1 and 2 : "In the first column are the numbers in the existing arrangement ; in the second the numbers in this Catalogue ; and in the third the page in this Catalogue. The stars indicate . . ." In accordance with the alteration already described, ed. 3 then gives in the first column the National Gallery numbers; in the second the pages of the Catalogue. An explanatory note was also added in ed. 3 after the "Introductory Classification" (see p. 359 n.). In this edition the index is superseded by another of a fuller character (see above, p. xl.).

For an error in ed. 3, see p. 379 n. Also, in Group VII., last drawing but one, "60" was a misprint for "69" ; so also in the text above the list (p. 372, last line).]

PREFACE

THAT in the largest, and, I suppose, richest city of the world, the most delicate and precious water-colour drawings which its citizens possess should be kept in a cellar, under its National Gallery, in which two-thirds of them are practically invisible, even in the few bright days which London smoke leaves to summer; and in which all are exposed to irreparable injury by damp in winter, is a fact which I must leave the British citizen to explain: stating here only that neither Mr. Burton nor Mr. Eastlake are to be held responsible for such arrangement; but, essentially, the public's scorn of all art which does not amuse it; and, practically, the members of the Royal Academy, whose primary duty it is to see that works by men who have belonged to their body, which may be educationally useful to the nation, should be rightly and sufficiently exhibited.

I have had no heart myself, during recent illness, to finish the catalogue which, for my own poor exoneration from the shame of the matter, I began last year.[1] But in its present form it may be of some use in the coming Christmas holidays, and relieve the kindness of Mr. Oldham[2] from unnecessary burden.

The Trustees of the National Gallery will, I trust, forgive my assumption that, some day or other, they may enable their keeper to remedy the evils in the existing arrangement; if not by displacing some of the pictures of inferior interest in the great galleries, at least by adding above their marble pillars and vaulted ceilings, such a dry

[1] [See above, Introduction, p. xxxix.]
[2] [William Oldham, now and for many years past the attendant in the Turner Water-Colour Rooms at the National Gallery—"that good Oldham," Ruskin calls him (*Letters to Ward*, ii. 72).]

and skylighted garret as any photographic establishment, opening a new branch, would provide itself with in the slack of the season. Such a room would be all that could be practically desired for the Turner drawings; and modern English indolence, if assisted in the gratification of its languid curiosity by a lift, would not, I trust, feel itself aggrieved by the otherwise salutary change.

INTRODUCTORY CLASSIFICATION

THE confused succession of the drawings at present placed in the water-colour room of the National Gallery was a consequence of their selection at different periods, by the gradually extended permission of the Trustees, from the mass of the inferior unexhibited sketches in the possession of the nation. I think it best, in this catalogue, to place the whole series in an order which might conveniently become permanent, should the collection be eventually transferred to rooms with sufficient light to see it by: and for the present the student will find no difficulty, nor even a delay of any consequence, in finding the title of any drawing by reference to the terminal index, in which, by the number in the existing arrangement, he is referred to that in the proposed one, followed in the text.[1]

The collection as at present seen consists of four hundred drawings, in wooden sliding frames, contained in portable cabinets; and of about half that number grouped in fixed frames originally intended for exhibition in the schools of Kensington, and in which the drawings were chosen therefore for their instructive and exemplary, more than their merely attractive, qualities. I observed, however, that the number of these partly detracted from their utility; and have now again chosen out of them a consecutive and perfectly magistral group, of which it may safely be recommended that every student of landscape art should copy every one in succession, as he gains the power to do so.

[1] [In the third editions of this catalogue, as already explained (pp. 352–353), the proposed re-numbering was no longer "followed in the text"; but, by inadvertence, the above passage remained unchanged.]

357

This first or "Scholar's group," consists of sixty-five drawings arranged, at present, in thirty frames: but eventually, each of these drawings should be separately framed, and placed where it can be perfectly seen and easily copied.

The drawings originally exhibited at Kensington, out of which this narrower group is now selected, were for several years the only pencil and water-colour drawings by Turner accessible to the public in the National collection. I therefore included among them many samples of series which were at that time invisible, but to which, since the entire mass of drawings is now collected, it is proper that the drawings which, by their abstraction, would break the unity of subjects, should be restored. I have, therefore, in this catalogue, placed in complete order all the important local groups of sketches (in Rome, Naples, Savoy, etc.), and retained in the miscellaneous framed collection only those which could be spared without breaking the sequence of the cabinet drawings. And further, I have excluded from this framed collection some of minor importance, which it seems to me might, not only without loss, but with advantage to the concentrated power of the London examples, be spared, on loan for use in provincial Art schools.

The Kensington series[1] of framed groups, originally numbering 153, has by these two processes of elimination been reduced in the following catalogue to one hundred, of which thirty form the above-described "Scholar's group," absolutely faultless and exemplary. The remainder, of various character and excellence (which, though often of far higher reach than that of the Scholar's group, is in those very highest examples not unaffected by the master's peculiar failings), I have in the following catalogue called the "Student's group"; meaning that it is presented to the thoughtful study of the general public, and of advanced

[1] [For explanation of this phrase, see above, Introduction, p. xxxvi.]

artists; but that it is only with discrimination to be copied, and only with qualification to be praised. Whereas, in the Scholar's group, there is not one example which may not in every touch be copied with benefit, and in every quality, without reserve, admired.

After these two series follow, in this catalogue, the four hundred framed drawings in the cabinets, rearranged and completed by the restorations out of the Kensington series, with brief prefatory explanations of the nature of each group. One or two gaps still require filling; but there being some difficulty in choosing examples fit for the exact places, I publish the list as it stands. The present numbers are given in order in the terminal index.

For many reasons I think it best to make this hand-catalogue direct and clear, with little comment on separate drawings. I may possibly afterwards issue a reprint of former criticism of the collection, with some further practical advice to scholars.

(*The numbers up to* 460 *are in the cabinets; sixty of these are exhibited in the desks, and are changed every three months.*[1])

[1] [This note was inserted in the Third Editions.]

PRIMARY SYNOPSIS

THE following general plan of the new arrangement will facilitate reference in the separate heads of it. The marginal figures indicate the number of frames in each series.

FIRST HUNDRED

GROUP

I.	The Scholar's Group . . .	30
II.	The Student's Group . . .	70
		100

SECOND HUNDRED

III.	Scotland. Pencil. ' (Early) .	15
IV.	Still Life. Colour. (Mid. Time) .	5
V.	Switzerland. Colour. (Early) . .	10
VI.	Mountains. Colour. (Late) . .	50
VII.	Venice. Colour. (Late) . . .	20
		100

THIRD HUNDRED

VIII.	Savoy. Pencil. (Early) . . .	25
IX.	Vignettes to Rogers' *Italy*. (Mid. Time)	25
X.	Rome. (Mid. Time) . . .	30
XI.	Tivoli. (Mid. Time) . . .	5
XII.	Naples. (Mid. Time) . . .	15
		100

FOURTH HUNDRED

GROUP

XIII.	Vignettes to Rogers' *Poems*. (Late)		35
XIV.	Rivers of England. (Late)	. .	15
XV.	Ports of England. (Late)	. .	5
XVI.	Venice. (Latest)	25
XVII.	Various. (Latest)	20

100

FIFTH HUNDRED

XVIII.	Finest Colour on Grey. (Late)	.	25
XIX.	Finest Colour on Grey. (Latest)	.	25
XX.	Studies on Grey for Rivers of France. (Late)	15
XXI.	The Seine	35

100

GROUP I

(*First Hundred*)

THE SCHOLAR'S GROUP

IT consists of sixty-five drawings in thirty frames, originally chosen and arranged for exhibition at Kensington, together with upwards of a hundred more, (as explained in the preface,) out of which this narrower series, doubly and trebly sifted, is now recommended to the learner, for constant examination and progressive practice; the most elementary examples being first given. Their proper arrangement would be on a screen in perfect light, on a level with the eye—the three largest only above the line of the rest. When several drawings are in the same frame, they are lettered *a*, *b*, *c*, etc., either from left to right, or from above downwards.

524 *a*. Tower of St. Mary Redcliffe, Bristol.
 b. Transept and Tower, York Cathedral.
 c. Tower of Boston, Lincolnshire.
448. Carnarvon Castle.

449. Wells Cathedral.
402. Malmesbury Abbey. Sketch from nature for the drawing in the English series.[1]
534 *a.* Study of sailing boat.
 b. Head of rowing boat.
 c. Stern of rowing boat.
533 *a, b.* Sketches of boats in light and shade.
 c. Diagram of a Dutch boat.
528. Study of spars of merchant brig.
531. Study of cottage roof in colour.
532. Gate of Carisbrook Castle. Water-coloured drawing, half-way completed.
408 *a.* Sketch from nature at Ivy Bridge, afterwards realized in the oil picture.
409 *b.* Sketch of the bed of a stream, on the spot, half finished.
407 *a.* Sketch from nature of the tree on the left in "Crossing the Brook."
 b, c. Studies of animals.
 d. Sketch from nature at Ivy Bridge, realized in the finished drawing in this collection.
 e. Sketch from nature in Val d'Aosta, amplified afterwards into the "Battle of Fort Rock."
548. Doric columns and entablature.
529. Part of the portico of St. Peter's.
608. Glass balls, partly filled with water.
 (Study of reflection and refraction.)
575. Four sketches on the Seine, for drawings in the Rivers of France. On grey paper.
621. Two Studies of marine. On grey.
421. Four sketches at Calais. On grey.
423. Four sketches on the Seine.
 a. Marly.
 b. Near St. Germain.
 c. Château of La Belle Gabrielle.
 d. Near St. Germain.
607. Two studies of the Arch of Titus, Rome, on white, stained grey, with lights taken out.
570. Two outline sketches of Cockermouth Castle.
569. Two outline sketches of park scenery.
590. Rome from Monte Mario. Finest pure pencil.
592. Rome from Monte Mario. Pencil outline with colour.
596. Rome. The Coliseum. Colour, unfinished.
559. Study of cutter. (Charcoal.)
560. Study of pilot boat. (Sepia.)
525. Two pencil studies, Leeds, and Bolton Abbey.
450. Four pencil sketches at and near York.
624. Two pencil sketches, at Cologne and on the Rhine.
425. Four sketches in colour at Petworth.
444. Four sketches in colour on the Loire and Meuse.

[1] [In No. 6 of *England and Wales*.]

GROUP II

(First Hundred)

THE STUDENT'S GROUP

The Student's group is arranged so as to exhibit Turner's methods of work, from his earliest to his latest time of power. All his essential characters as an artist are shown in it; his highest attainments, with his peculiar faults;— faults of inherent nature, that is to say; as distinguished from those which, after the year 1845, were signs merely of disease. No work of his declining time is admitted into this series.

It begins (No. 523) with three examples of the earliest efforts by him existing in the National collection of his drawings. Then follow examples of his methods of study with pencil and pen from first to last: then, examples of his work similarly progressive, in transparent colour on white paper; and, finally, examples of his use of body colour on grey paper—a method only adopted late in life, as one proper for none but a consummate master.

The entire series is contained in seventy frames, and closes the first hundred of the frames here permanently catalogued.

523. Three early sketches at Clifton, when he was twelve or thirteen years old. He went on for several years working thus in pencil and colour; then saw the necessity of working in pencil outline only, and never ceased that method of work to the close of life.

622 *a.* Carew Castle. Early pencil outline, after he had determined his method.

 b. Lancaster, of later date. Both drawings realized in the England series.

403. Kirkstall Abbey.

404. Holy Island Cathedral. Subjects[1] realized in the Liber Studiorum.

553. Sketch from nature of the Liber subject, "Source of the Arveron."

554. Sketch from nature for the drawing at Farnley, "Mont Blanc from the Valley of Chamouni."

564. Foreground studies, laurel, etc.

[1] [*i.e.,* "Kirkstall Abbey" and "Holy Island Cathedral"; the drawings for the *Liber* are Nos. 484 and 481.]

413. Studies of market-ware at Rotterdam.
412. Study of sheep.
536. Memoranda of coast incidents.
451. Sketches at York.
416. } Two { Egremont subject.
417. } Frames { „ „
623. Two bridge subjects.
605. Studies from Claude, etc.
602. Twelve leaves from a note-book at Venice (all drawn as richly on the other sides).
438. Four leaves of a note-book on journey to Scotland by sea.
603 *a*. Sketches at Andernach.
 b. Sketches on the Rhine.
 c. Sketches on Lago Maggiore.
 The leaves *a* and *b* are out of a note-book containing 270 such.
604. Sketches at Naples.
606. At Dresden.
566. Sketches in Rouen, with engraving of finished drawing made from one of them.

These twenty drawings (523–566) are enough to show the method of the artist's usual work from nature. He *never sketched in tinted shade but at home*, in making studies for pictures, or for engravers, as in the series of the Liber Studiorum. When he wanted light and shade in painting from nature, he always gave colour also, for it was as easy to him to give the depth of shade he wanted in different tints, as in one; and the result was infinitely more complete and true. The series of water-colour sketches and drawings which next follow, represent, therefore, his progress in colour and chiaroscuro simultaneously; and I have placed under the next following numbers, examples of his water-colour work from the beginning of its effective power to the end. But these are not, as in the Scholar's group, all equally exemplary. The absolutely safe and right models are already given in the Scholar's group: here, there are instances given of methods questionable—or distinctly dangerous, as well as of the best. Thus Turner drew for several years almost exclusively in neutral tint, as in No. 527; but it is not at all certain that this practice should be enforced as academical; and again, the drawing of Folkestone[1]

1 [No. 558; see above, p. 269.]

is an instance of delicacy of work like that of a miniature, applied to a large surface; this is certainly a practice liable to lead to the loss of simplicity and power:—it is one on the whole to be deprecated; and it gravely limited Turner's power of making large and manly drawings, at the time when it was most desirable for public instruction that he should have done so.

The drawings of Edinburgh, and Ivy Bridge, are types of his finest manner, unaffected by this weakness of minute execution. The drawings of Rochester and Dover show his minutest execution rightly applied, and his consummate skill in composition.

527. View of Tivoli. Neutral tint (one of multitudes, which had to be done before the great Tivolis could be).
405. Ruins of the Savoy Chapel. Neutral tint.
530. Early study of a cottage.
542. The Castle of Aosta; in colour, with the pencil study for it below : one of the series out of which Group VIII. (third hundred) was chosen.
609. Angry swans.
565. Study of pigs and donkeys.
568. Study of ducks.
572. Study of storm-clouds ; with the plate afterwards engraved from it by Turner himself beneath.
573. Three Studies at sea.
571. Study of evening and night skies.
419. Shields. Engraved for "Ports of England." [1]
420. Rochester. Engraved for "Rivers of England."
418. Dover. Engraved for "Ports of England."
558. Folkestone. Large drawing unfinished.
549. Edinburgh from the Calton Hill. Finished drawing.
556. Ivy Bridge. Finished drawing.
555. Battle of Fort Rock. Finished drawing.
610. The Source of the Arveron. Unfinished, large.
611. Grenoble. Unfinished, large.
612. Grenoble. „ „

The two last drawings are among the most exquisite fragments existing of his central manner. They are beginnings of a favourite subject, which he seems to have found beyond his power on this scale, and afterwards finished on a reduced one. They may properly close the examples of his work in pure water-colour. Two specimens of his

[1] [" Ports " should be " Rivers of England."]

sketching in oil — a rare practice with him[1] — follow; and then, a magnificent selection from the body-colour drawings of his best time, which contain the most wonderful things he ever did in his own special manner.

613. Folly Bridge and Bacon's Tower : Oxford, 1787.
410. Torrent bed. One of the studies made at the date of Ivy Bridge.
442. Sunset and Twilight: the last at Petworth.
426. Pen outline sketches for the "Rivers of France."
430. Tancarville, and three other French subjects.
429. Four French subjects.
431. Rocks on the Meuse, and three other subjects.
432. Luxembourg, and three other subjects.
433. Two of Honfleur, two unknown.
434. Honfleur, and three other subjects.
435. Dijon, and three other subjects.
576. Interiors.
617. Saumur, Huy, and Dinant.
620 a. Town on Loire ; b. Carrara mountains.
442. Nantes, and Dressing for Tea.
443. Harfleur, Caudebec, and two others.
619. Saumur, and two others.
618. Orleans and Nantes.
427. Dinant, etc.
428. Havre, etc.

Henceforward to the close of the Student's group are placed examples of his quite latest manner: in outline, more or less fatigued and hasty, though full of detail,—in colour, sometimes extravagant—and sometimes gloomy; but every now and then manifesting more than his old power in the treatment of subjects under aerial and translucent effect.

454. Fribourg, Swiss. Pen outline over pencil.
455. Fribourg, Swiss. Pen outline over pencil.
446. Swiss Fortress.
447. Grenoble.
436. Fortress. Evening effect.
437. Lausanne. Sunset.
584. Fluelen and Kussnacht.
585. Lake of Annecy, and Landeck.
586. Venice.
587. Venice.
588. Lucerne and Zurich.
589. Lake Lucerne. Morning.

[1] [See above, pp. 121, 266.]

SECOND HUNDRED

(Cabinet Drawings)

THE second century of the drawings as rearranged, forms a mixed group, containing both early and late work, which I have thrown together in a cluster, in order to make the arrangement of the following three hundred drawings more consistent.

The first thirty drawings of this hundred are all early; and of consummate value and interest. The remaining seventy were made at the time of the artist's most accomplished power; but are for the most part slight, and intended rather to remind *himself* of what he had seen, than to convey any idea of it to others. Although, as I have stated, they are placed in this group because otherwise they would have interfered with the order of more important drawings, it cannot but be interesting to the student to see, in close sequence, the best examples of the artist's earliest and latest methods of sketching.

GROUP III

(Second Hundred)

Fifteen pencil drawings of Scottish scenery made on his first tour in Scotland, and completed afterwards in light and shade, on tinted paper touched with white. Several of his best early coloured drawings were made from these studies, and are now in the great collection at Farnley.

They are all remarkable for what artists call " breadth " of effect, (carried even to dulness in its serene rejection of all minor elements of the picturesque,—craggy chasms, broken waterfalls, or rustic cottages;) and for the labour given in careful pencil shading, to round the larger masses

of mountain, and show the relation of the clouds to them. The mountain forms are always perfect, the clouds carefully modelled; when they cross the mountains they do so solidly, and there is no permission of the interferences of haze or rain. The composition is always scientific in the extreme.

I do not know the localities, nor are they of much consequence. Their order is therefore founded, at present, only on the character of subject; but I have examined this series less carefully than any of the others, and may modify its sequence in later editions of this catalogue. The grand introductory upright one is, I think, of Tummel bridge, and with the one following, 313, shows the interest which the artist felt from earliest to latest days in all rustic architecture of pontifical character.

The four following subjects, 309–537, contain materials used in the Liber composition called "Ben Arthur"; 314 is called at Farnley "Loch Fyne."[1]

311.	Scotland.	(Bridge on the Tummel ?)	306.	Scotland.	Study of trees.	
			346.	Scotland.		
313.	Scotland.	Bridges and village.	347.	Scotland.		
309.	Scotland.	Argyllshire ?	348.	Scotland.		
310.	Scotland.	Argyllshire ?	349.	Scotland.		
307.	Scotland.	Argyllshire ?	312.	Scotland.	Loch Fyne ?	
537.} In one {Scotland.		Study of trees.	314.	Scotland.	Loch Fyne ?	
537.} Frame {Scotland.		Study of trees.	308.	Scotland.		

[1] [In the manuscript catalogue of 1880 (see p. xxxix.) Ruskin notes 314 as "the original of Fawkes' beauty." The following is his note, from his diary of 1851, on the Loch Fyne at Farnley —
"Loch Fyne. Small. Bears date 1815. This drawing extends the *weak* and incipient period of Turner at least to this year. It is beautiful in feeling—a calm summer evening with light blue mists in the hollows of the hills, the water quite still, except for one flake of breeze-touched light crossing the dark reflection of the trees, and two or three lapping waves moving softly to the shore: which have been caused by the last motion of two boats, now lying together still; a fine square piece of rock—the fragment, and a sharp stone seen under the clear water.
"The execution slight, in some places very heavy, especially in the water where it reflects the dark trees: the most distant mountain peak, originally as flimsy, and the vapour about it as sudden and broken in execution, as in Windus's Lake Lucerne, and now all but faded quite away. All painted with indigo and siena, pale blue, green and gold: hardly any colour except a fisherman in highland dress and some women with vigorous red legs and arms. A lovely walk round the shore behind a boat building, and through among some quiet trees to the white gables of some old abbey or tower."]

XIII. 2 A

GROUP IV

(Second Hundred)

STUDIES OF BIRDS AND FISH

Placed immediately after the Scottish series in order to show the singularly various methods of the Master's study. These sketches are, however, at least ten years later in date. They are all executed with a view mainly to colour, and, in colour, to its ultimate refinements, as in the grey down of the birds and the subdued iridescences of the fish.

There is no execution in water-colour comparable to them for combined rapidity, delicacy, and precision —the artists of the world may be challenged to approach them: and I know of only one piece of Turner's own to match them—the Dove at Farnley.[1]

415. Teal.	373. Perch.
375. Teal.	374. Trout and other fish.
(Not yet placed).*	

GROUP V

(Second Hundred)

COLOURED SKETCHES IN SWITZERLAND

These quite stupendous memoranda were made on his first Swiss journey, 1803,[2] and are at the maximum of his early power. Several of very high quality were made from

* I may possibly afterwards, with the permission of the Trustees, be able to supply this gap[3] with a drawing of a Jay, given me by Mr. W. Kingsley, or with some purchased example,—there being no more than these four in the National collection.

[1] [See above, p. 274.]
[2] [More probably 1802 : see above, p. 261, and compare Vol. III. p. 235 n.]
[3] [This was not done. For the Jay, see below, p. 469.]

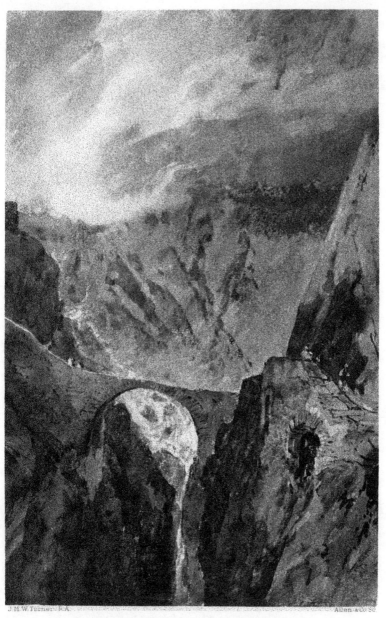

J.M.W.Turner. R.A. Allen & Co 9?

The Old Devil's Bridge, Pass of S.t Gothard
From the sketch in the National Gallery. No 321

those on the St. Gothard: a beautiful one at Farnley from 325; and the greatest of the Liber mountain subjects, from 321, 319, and 322.[1]

324. On the pass of St. Gothard, above Amsteg.
320. The old road, pass of St. Gothard.
321. The old Devil's Bridge, pass of St. Gothard.
323. Bonneville, Savoy.
319. The Source of the Arveron, as it was in 1803.
325. The Mer-de-glace of Chamouni, looking up stream.
322. The Mer-de-glace of Chamouni, looking down stream.
552. Contamines, Savoy.

(Two subjects still wanting to this series may, I believe, be furnished out of the reserves in tin cases.[2])

GROUP VI

(*Second Hundred*)

Fifty sketches on his later Continental journeys, made in pencil outline only on the spot, and coloured from memory.[3] Of the finest quality of pure Turnerian art, which is in sum, as explained in my various university lectures over and over again,[4] *the true abstraction of the colour of Nature as a distinct subject of study*, with only so much of light and shade as may explain the condition and place of the colour, without tainting its purity. In the modern French school, all the colour is taken out of Nature, and only the mud left. By Turner, all the mud

[1] [*i.e.*, the "Swiss Bridge" (see above, p. 96 *n.*) from 321; the "Source of the Arveron" (N. G., No. 879) from 319; and the "Mer de Glace" from 322. In the MS. notes of 1880 (see p. xxxix.) Ruskin notes 319 as the "original of Fawkes," and 321 as "curiously bad." He calls 324 "the great one"; and notes of 325 that Turner was "trying to make it look like sea."]

[2] [For the contents of these cases, see above, Introduction, p. xli. Several drawings of the kind are in the cases.]

[3] [See above, p. 189, in the introduction to 'the first Catalogue of a Hundred Drawings, many of which are included in this group.]

[4] [See, for instance, *Ariadne Florentina*, § 262; but Turner's position as a colourist is not so fully discussed in any of Ruskin's published University lectures as in *Modern Painters*: see the summary given by the author in vol. v. of that work (pt. ix. ch. xi.).]

is taken out of Nature, and only the colour left. Tones of chiaroscuro which depend *upon* colour, are however often given in full depth as in the Nos. 45, 42, 97, and 98.

72. The Red Gorge.	48. Fortress.
47. The Allée Blanche.	82. Fortress.
73. The Via Mala.	78. River scene.
80. Miner's Bridge.	79. River scene.
100. Altorf.	86. Rheinfelden, just above Basle, Swiss.
81. Martigny.	
96. Mont Rigi at dawn.	87. Rheinfelden.
45. Mont Rigi at sunset.	88. Rheinfelden.
42. Fort l'Ecluse.	89. Rheinfelden.
41. Dent d'Oches, from Lausanne.	90. Rheinfelden.
44. Lausanne.	77. Fortress.
50. Lausanne.	43. Lake Lucerne, from Kussnacht.
91. Lausanne.	
92. Lausanne.	290. Mont Pilate, from Kussnacht.
95. Lausanne.	
46. Vevay.	589. Lake Lucerne, from Brunnen.
49. Baden (Swiss).	589. Lake Lucerne, from Brunnen.
83. Baden (Swiss).	289. Zurich.
85. Baden (Swiss).	287. Zurich.
284. Heidelberg.	288. Lucerne.
282. Heidelberg.	285. Schaffhausen.
283. Heidelberg.	286. Constance.
79. Coblentz, Bridge of Boats.	75. Splügen.
583. Coblentz, Bridge of Boats.	94. Bellinzona.
280. Coblentz, Bridge on the Moselle.	99. Fluelen.
	97. Aart.
583. Coblentz, Bridge on the Moselle.	98. Goldau.

GROUP VII

(*Second Hundred*)

TWENTY SKETCHES IN VENICE

Characteristic of Turner's entirely final manner when the languor of age made him careless, or sometimes reluctant in outline, while yet his hand had lost none of its subtlety, nor his eye of its sense for colour. From the last but one (69) he painted the best of his late Academy pictures, now

in the upper gallery,[1] and 58 has itself been carried forward nearly to completion.

51. The Approach to Venice.
52. The Ducal Palace and Riva.
53. The Riva (dei Schiavoni).
54. The Riva, from the Canal of Chioggia.
55. Church of Salute, from the Riva.
56. The Riva, looking west.
57. The Riva, from the outlet of the Canal of the Arsenal.
58. The Canal of the Arsenal.
59. Bridge over the Canal of the Arsenal.
60. San Giorgio.
61. The Steps of the Salute.
62. The Grand Canal, with the Salute.
63. The Casa Grimani.
64. San Simeon Piccolo.
65. Fishing-Boat.
66. Moonrise.
67. The Giudecca, with Church of Redentore.
68. Looking down the Giudecca.
69. Looking up the Giudecca.
70. Farewell to Venice.

[1] [No. 534, p. 164; for another reference to the sketch, see p. 215.]

THIRD HUNDRED

THE third century of drawings consists entirely of sketches or compositions made in Italy, or illustrative of Italian scenery and history. It opens with a group of pencil sketches made in Savoy and Piedmont in 1803, showing the artist's first impressions of the Italian Alps. Then follow the vignettes made to illustrate Rogers' poem of *Italy*, many of which were composed from the preceding pencil sketches; and then follow fifty sketches made on his first visit to southern Italy, divided into three groups, illustrative of Rome, Tivoli, and Naples.

GROUP VIII

(Third Hundred)

TWENTY-FIVE SKETCHES IN SAVOY AND PIEDMONT

With very black, soft pencil, on dark tinted paper, touched with white. Of the highest value and interest. Made, I believe, in 1803;[1] at all events on his first Continental journey: all in complete chiaroscuro, and in his grandest manner. They are absolutely true to the places; no exaggeration is admitted anywhere or in any respect, and the compositions, though in the highest degree learned, and exemplary of constructive principles in design, are obtained simply by selection, not alteration, of forms,—and by the introduction either of clouds, figures, or entirely probable light and shade.

All are rapid and bold; some, slight and impetuous; but they cannot be too constantly studied, or carefully copied,

[1] [See note on p. 370.]

by landscape students, since, whatever their haste, the conception is always entirely realised; and the subject disciplined into a complete picture, balanced and supported from corner to corner, and concluded in all its pictorial elements.

Observe also that although these sketches give some of the painter's first, strongest, and most enduring impressions of mountain scenery, and architecture of classical dignity,— their especial value to the general student is that they are in no respect distinctively *Turnerian*, but could only be known by their greater strength and precision from studies such as Gainsborough or Wilson might have made at the same spots: and they are just as useful to persons incapable of colouring, in giving them the joy of rightly treated shade, as to the advanced colourist in compelling him to reconsider the foundations of effect, which he is too often beguiled into forgetting.

547.	Town of Grenoble.	3.	Chain of Alps of the Chartreuse.
546.	Grenoble, with Mont Blanc.	546.	Alps of the Chartreuse (the
5.	Grenoble, with Mont Blanc.		Liber subject).
545.	Road from Grenoble to Voreppe	544.	Val d'Isère.
9.	Entrance to the Chartreuse.	545.	Val d'Isère, with Mont Blanc.
10.	Entrance to the Chartreuse.	24.	Martigny.
12.	Entrance to the Chartreuse.	540.	Hospice of St. Bernard.
11.	Bridges at the Chartreuse.	22.	Descent to Aosta.
14.	Cascade of the Chartreuse.	540.	Town of Aosta.
17.	Gate of the Chartreuse (looking forward).	541.	East gate of Aosta (*Italy* vignette).
18.	Gate of the Chartreuse (looking back).	541.	Triumphal arch of Aosta.
		23.	Near Aosta.
19.	Gate of the Chartreuse (looking back, farther off).	544.	Ascent to Courmayeur.
		25.	Descent to Ivrea.

GROUP IX

(*Third Hundred*)

The vignettes to Rogers' *Italy* are of Turner's best time, and contain some of his very best work; the more interesting because, with few exceptions, they are quickly,

and even slightly, executed. Whether slight, or carried on
to completion, they are in the highest degree exemplary
to the student of water-colour; one only excepted, the
" Venice,"[1] which, whether painted during some fit of slight
illness, or perhaps hurriedly by candlelight under some un-
expected call from the engraver, is utterly different from the
rest, and wholly unworthy of the painter. This is there-
fore excluded from the series, and placed among the supple-
mentary studies. The total number of vignettes executed by
Turner for Rogers' *Italy* was twenty-five ; but one, the
" Dead-house of St. Bernard," is irrevocably in America,[2] and
the exclusion of the " Venice" leaves the total number in
these cases, twenty-three. To complete them to a symmet-
rical twenty-five I have placed with them, to terminate their
series, the two of the later series executed for Rogers'
Poems which have most in common with the earlier designs
of the *Italy.*

The twenty-three Italian ones are arranged with little
variation from the order in which they are placed as the
illustrations of the poems; the reasons for admitted varia-
tions will be comprehended without difficulty. The two
that are added are bold compositions from materials in
Italy; the last was the illustration of Rogers' line, " The
shepherd on Tornaro's misty brow," beginning a description
of sunrise as the type of increasing knowledge and imagina-
tion in childhood. But there is no such place known as
Tornaro, and the composition, both in the colour of sea and

[1] [No. 391 in the National Gallery : see below, p. 381.]

[2] [Turner's vignette of the " Dead-house of St. Bernard " is now in the collection
of Dr. Magroom of New York. Ruskin refers to its sale in a letter to his father of
January 10, 1852 :—

> "That is a fine price, truly, for the little Vignette of the Dead-house. I
> know the drawing : there is about ten minutes' work of Turner in it, but I
> suppose the dogs by Landseer and figures by Stothard are thought to enhance
> the value. To a collector I suppose they would, and I daresay he will get
> the money for it."

Presumably, therefore, the drawing was first bought by a dealer, and afterwards sold
to America. At some time it must have been lent to Ruskin, for a traced outline of
it (with the dogs as proposed by Landseer), is in his Drawing School at Oxford, and
was shown in the Bond Street Exhibition, together with a facsimile of the engraved
vignette (in which Landseer's dogs were not substituted) : see below, p. 514.]

boldness of precipice, resembles only the scenery of the
Sicilian Islands.

210.	The Lake of Geneva.	214.	Florence.
213.	The Lake of Lucerne (from	221.	Galileo's Villa, Arcetri.
	Tell's Chapel).	202.	Composition.
205.	St. Maurice.	216.	Rome.
212.	Martigny.	218.	St. Peter's.
211.	Hospice of St. Bernard.	219.	The Campagna.
203.	Aosta.	224.	Tivoli. The Temple of the
207.	Hannibal passing the Alps.		Sibyl.
204.	The Battle of Marengo.	222.	Banditti.
215.	The Lake of Como.	201.	Naples.
208.	Isola Bella, Lago Maggiore.	225.	Amalfi.
217.	Verona. Moonlight.	206.	Pæstum.
223.	Padua. Moonlight. The Canal	220.	The Garden.
	for Venice.	230.	The Cliffs of Sicily. Sunrise.

GROUP X

(*Third Hundred*)

THIRTY SKETCHES IN PENCIL, SOMETIMES TOUCHED
WITH COLOUR, AT ROME

This group, with the two following, exemplify the best
drawings made by Turner from Nature. All his powers
were at this period in perfection; none of his faults had
developed themselves; and his energies were taxed to the
utmost to seize, both in immediate admiration, and for
future service, the loveliest features of some of the most
historically interesting scenery in the world.

There is no exaggeration in any of these drawings, nor
any conventionalism but that of outline. They are, in all
respects, the most true and the most beautiful ever made
by the painter; but they differ from the group first given,
(VII.,) in being essentially Turnerian, representing those
qualities of form and colour in which the painter himself
most delighted, and which persons of greatly inferior or
essentially different faculties need not hope for benefit by

attempting to copy. The quantity of detail given in their distances can only be seen, in a natural. landscape, by persons possessing the strongest and finest faculties of sight: and the tones of colour adopted in them can only be felt by persons of the subtlest colour-temperament, and happily-trained colour-disposition. To the average skill, the variously imperfect ocular power, and blunted colour-feeling of most of our town-bred students, the qualities of these drawings are—not merely useless, but, in the best parts of them, literally invisible.

On the other hand, to students of fine faculty and well-trained energy, no drawings in the world are to be named with these fifty, (590–337,) as lessons in landscape drawing:—

590. Rome from Monte Mario (finest pencil).
592. Rome from Monte Mario (partly coloured).
326. Villas on Monte Mario.
263. Stone pines on Monte Mario.
262. The Castle of St. Angelo.
591. The Bridge and Castle of St. Angelo.
255. The Tiber and Castle of St. Angelo.
264. The Tiber and the Capitol.
268. The Tiber and the Apennines.
266. Study in Rome.
332. Foreground in Rome.
600. Foreground in Rome, with living acanthus.
257. Foreground in Rome.
267. St. Peter's, from the West.
259. St. Peter's, from the South (pencil).
273. Coloured sketch of the same subject.
269. St. Peter's and the Vatican.
256. The Colonnade of Bernini (beneath).
258. The Portico of St. Peter's.
253. The Arch of Septimius Severus (pencil on grey).
597. The Basilica of Constantine (colour).
272. The Coliseum and Basilica of Constantine.
331. The Coliseum and Arch of Constantine.
328. The Coliseum and Arch of Titus.
275. The Coliseum—seen near, with flock of goats.
271. The Coliseum (study of daylight colour).
265. The Coliseum in pale sunset, with new moon.
274. The Palatine.
260. The Alban Mount.
327. Rome and the Apennines.

Tivoli: Cascades and Campagna

From the drawing in the Na onal Gallery. No. 339

M.W.Turner. R.A

GROUP XI

(Third Hundred)

Five sketches from nature at Tivoli; three in pencil, two in colour. Unsurpassable.

302. The Temple of Vesta (in distance).
252. The Temple of Vesta (near).
303. General view from the valley.
340. The same subject in colour.
339. The Town with its Cascades, and the Campagna.

GROUP XII

(Third Hundred)

Fifteen sketches,[1] at or near Rome and Naples. The three Campagna ones, with the last four of the Neapolitan group, are exemplary of all Turner's methods of water-colour painting at the acme of his sincere power.[2]

329. Campagna. Warm sunset. Inestimable.
330. Campagna. Slighter, but as fine. Morning.
338. Campagna. Snowy Apennines in distance.
594. Nymphæum of Alexander Severus.
600. Study for the great picture of the Loggie of Vatican.
333. Naples, from the South. (Pencil.)
305. Queen Joanna's Palace and St. Elmo. (Pencil.)
301. Villas at Posilipo. (Pencil.)
304. The Castle of the Egg. Light against dark.
334. The Castle of the Egg. Dark against light.
335. Vesuvius. Beginning of finished drawing.
336. Monte St. Angelo and Capri. Morning.
337. Monte St. Angelo and Capri. Evening.[3]

[1] [This group was not accurately revised by Ruskin: the number of sketches included in it is 13, not 15. In eds. 1 and 2 he had intended to include 15, bearing the numbers (in his proposed rearrangement) 286–300, but "289" was left blank (he had intended, perhaps, to look out another sketch from the reserves in the tin boxes) and "295. Naples and Vesuvius from the North. (Colour.)" had against it no reference to a corresponding number in the actual numbering (here again Ruskin had perhaps looked out an additional sketch). In ed. 3 the blank "289" was omitted, but "295," etc., was by inadvertence retained.]

[2] [In the MS. catalogue of 1880 (see p. xxxix.) Ruskin notes against 332 "divinest colour," and against 334 and 335 "divinest fresh colour."]

[3] [For an additional note on this drawing, see Index II., p. 625 below.]

FOURTH HUNDRED

THE fourth century of drawings are all of the later middle period of Turner's career, where the constant reference to the engraver or the Academy visitor, as more or less the critic or patron of his work, had betrayed him into mannerisms and fallacies which gradually undermined the constitution of his intellect: while yet his manual skill, and often his power of imagination, increased in certain directions. Some of the loveliest, and executively the most wonderful, of his drawings belong to this period; but few of the greatest, and none of the absolutely best, while many are inexcusably faultful or false. With few exceptions, they ought not to be copied by students, for the best of them are inimitable in the modes of execution peculiar to Turner, and are little exemplary otherwise.

The initial group of this class, the thirteenth in consecutive order, contains the best of the vignettes executed in illustration of Rogers' "Pleasures of Memory," "Voyage of Columbus," and other minor poems. In most cases they are far more highly finished than those of the *Italy;* but few show equal power, and none the frank sincerity. The two best of all[1] had much in common with the Italian series, and have been placed with it; but "The Twilight" (226), "Greenwich" (234), "Bolton Abbey" (237), "Vallombré" (243), and "Departure of Columbus" (247), are among the subtlest examples of the artist's peculiar manner at this period; and all, as now arranged up to the number 397, have a pretty connection and sequence, illustrative of the painter's thought, no less than of the poet's.

They have a farther interest, as being the origin of the loveliest engravings ever produced by the pure line; and I hope in good time that proofs of the plates may be

[1] [Namely, "The Garden" (229) and "Tornaro" (230): see above, p. 377.]

exhibited side by side with the drawings.[1] In arranging the
twenty-five excellent ones just described, I have thrown
out several unworthy of Turner -- which, however, since
they cannot be separated from their proper group, follow
it, numbering from 399 to 577; the gaps being filled up
by various studies for vignettes of the *Italy* as well as the
Poems, which I extricated from the heaps of loose sketches
in the tin cases.

GROUP XIII

(Fourth Hundred)

226.	Twilight.	240.	Loch Lomond.
231.	Gypsies.	241.	Jacqueline's Cottage. (Ideal.)
227.	The Native Village.	243.	The Falls of Vallombré. (Ideal.)
234.	Greenwich.	242.	The Alps at Daybreak. (Ideal.*)
235.	The Water-gate of the Tower.	245.	The Captive. (Ideal.)
228.	St. Anne's Hill.	244.	St. Julian's Well. (Ideal.)
229.	St. Anne's Hill.	246.	Columbus at La Rabida.
232.	The Old Oak in Life.	247.	Departure of Columbus.
233.	The Old Oak in Death.	248.	Dawn on the last day of the
236.	The Boy of Egremont.		Voyage.
237.	Bolton Abbey.	249.	Morning in America.
238.	St. Herbert's Isle, Derwent-	250.	Cortez and Pizarro.
	water. (Ideal.)	397.	Datur Hora Quieti.
239.	Lodore.		

Next follow the inferior ones; among which the pretty
"Rialto" is degraded because there is no way over the
bridge, and the "Ducal Palace" for its coarse black and red
colour. So also the "Manor-house," though Mr. Goodall
made a quite lovely vignette from it; as also from the
"Warrior Ghosts."

399.	The English Manor-house.	400.	The War-spirits.
396.	The English School.	395.	The Warrior Ghosts.
398.	The English Fair.	577.	Study for the Warrior Ghosts.
391.	Venice. The Ducal Palace.	577.	Second study for the same vig-
394.	Venice. The Rialto.		nette.
393.	The Simoom.		

* And the figures absurd; but by Rogers' fault, not Turner's. See the
very foolish poem.

[1] [This unfortunately has never been done; such an exhibition would be par-
ticularly interesting as showing (in the case, especially, of the *Italy* vignettes) how
much was added in the engravings; the skies, for instance, were often not indicated
in the drawings (unless, indeed, the indications have faded away : see above, p. 331 *n*.) :
see further on this subject, Vol. III. p. 365 *n*.]

GROUP XIV

(*Fourth Hundred*)

RIVERS OF ENGLAND[1]

This most valuable group consists of fifteen finished drawings, which always remained in Turner's possession, he refusing to sell separately, and the public of his time not caring to buy in mass.

They were made for publication by engraving; and were skilfully engraved; but only in mezzotint. They are of the highest quality, in so far as work done for engraving can be, and all finished with the artist's best skill. Two of the series of fifteen[2] are placed in the Student's group, and room thus made for two of the "Ports," which are consecutive with the following group:—

161. Stangate Creek (on River) Medway.
162. Totnes „ Dart.
163. Dartmouth Dart.
164. Dartmouth Castle „ Dart.
165. Okehampton Castle „ Okement.

[1] [At various dates before 1827 Turner made a series of drawings of English rivers which were engraved, from 1823 onwards, and mostly published. Some of the plates were lettered "Rivers of England"; others, "River Scenery." In 1827 the two series were collected, together with five plates after Girtin, and published in a volume with the following title-page: "*River Scenery by Turner and Girtin, with descriptions by Mrs. Hofland, engraved by eminent engravers from Drawings by J. M. W. Turner, R.A., and the late Thomas Girtin.* 1827." At some date later than 1830 the book was re-issued without text (see the copy in the print-room of the British Museum). Fifteen plates after Turner were published among the "Rivers of England" or "River Scenery," and of these all the drawings, except one, are in the National Gallery. They are: Shields (No. 419), Newcastle-on-Tyne (No. 171), More Park (No. 168), Rochester (No. 420), Norham Castle (No. 175), Dartmouth Castle (No. 164), Okehampton (No. 165), Totnes (No. 162), Brougham Castle (No. 174), Dartmouth (No. 163); the plates from these are lettered "Rivers of England." Also, Stangate Creek (No. 161), Mouth of the Humber (No. 378), Kirkstall Loch (No. 172), and Kirkstall Abbey (No. 173); the plates from these are lettered "River Scenery," as also is the one for which the drawing is not in the Gallery, Warkworth Castle. It will be observed that two drawings in Ruskin's list above were not included in the book, *River Scenery*—namely, the two Arundels. Both were engraved, but one—Arundel Castle, No. 166—was never published, though a few engravers' proofs exist. "The Medway" (No. 378) was not engraved, though the drawing was no doubt intended either for the "Rivers" or the "Ports" series.]

[2] [Namely, Shields (419) and Rochester (420) see above, p. 366.]

166.	Arundel Castle	(on River)	Arun.
167.	Arundel Park	"	Arun.
168.	More Park	"	Colne.
171.	Newcastle	"	Tyne.
173.	Kirkstall Abbey		Aire.
172.	Kirkstall Lock		Aire.
174.	Brougham Castle	"	Lowther.
175.	Norham Castle	"	Tweed.
170.	Whitby.		
169.	Scarborough.		

GROUP XV

(Fourth Hundred)

PORTS OF ENGLAND

Five finished drawings, nearly related in style to the " Rivers "; but nobler, and two of them (" The Humber " and " Sheerness ") among the greatest of Turner's existing works.

The " Whitby " and " Scarborough " belong nominally to this group, but in style they are like the " Rivers," with which I have placed them; of course consulting in these fillings up of series, the necessary divisions into five adopted for the sake of portability. The seven drawings were illustrated in their entirety to the best of my power in the text of the work in which they were published—the *Harbours of England.*[1]

Five finished drawings of very high quality, made for mezzotint engraving, and admirably rendered by Mr. Lupton under Turner's careful superintendence.

378.	The Humber.	380.	Sheerness.
376.	The Medway.	377.	Ramsgate.
379.	Portsmouth.		

[1] [Here Ruskin is not quite accurate. The " Mouth of the Humber " and " Rochester on the Medway " were not included in "The Ports of England " series (completed under the title the *Harbours of England*) ; they were engraved in the series called *River Scenery* (see note on last page).]

384 TURNER'S WORKS AT NATIONAL GALLERY

GROUP XVI

(Fourth Hundred)

Twenty-five sketches, chiefly in Venice. Late time, extravagant, and showing some of the painter's worst and final faults; but also, some of his peculiar gifts in a supreme degree.[1]

351.	The Ducal Palace.	293.	Boats on the Giudecca.
355.	The Custom House.	361.	Steamers.
352.	The Grand Canal.	362.	?
354.	Casa Grimani and Rialto.	363.	Tours.
353.	The Rialto.	364.	?
356.	Grand Canal above Rialto.	365.	?
358.	On the Cross-canal between Bridge of Sighs and Rialto.	366.	?
		367.	?
359.	The same, nearer.	368.	?
357.	Cross-canal near Arsenal.	369.	?
360.	San Stefano.	370.	?
291.	South side of St. Mark's.	371.	Arsenal, Venice.
292.	Ducal Palace.	372.	Fish Market.

GROUP XVII

(Fourth Hundred)

VARIOUS (LATEST)

381.	?	251.	Rome.
382.	?	254.	The Cascades, Tivoli.
383.	Saumur.	257.	Rome.
384.	Namur.	261.	Rome. The Coliseum.
385.	?	270.	Rome.
386.	Château d'Arc?	296.	Studies of Sky.
387.	North Transept, Rouen.	297.	Scotland?
388.	Avignon.	298.	The Tiber.
389.	Namur.	299.	The Capitol from Temple of?
390.	?	300.	Bridges in the Campagna.

[1] [In the MS. catalogue of 1880 (see p. xxxix.) Ruskin notes 356–359 as "Glorious grey group."]

GROUP XVIII

(Fifth Hundred)

FINEST COLOUR ON GREY (LATE)

Twenty-five rapid studies in colour on grey paper. Of his best late time, and in his finest manner, giving more conditions of solid form than have ever been expressed by means at once so subtle and rapid.

101.	Full sails on Seine.	109.	Street with canal.
102.	The breeze beneath the Coteau.	114.	Rouen.
103.	Heavy barges in a gust.	115.	The Grey Castle.
104.	French lugger under the Hêve.	116.	Nantes.
105.	The steamer.	117.	Nantes?
106.	Havre.	118.	Angers?
107.	Havre.	119.	Beaugency.
108.	Harfleur.	120.	Beaugency.
113.	Honfleur in distance.	121.	Château de Blois.
110.	Honfleur? Compare Seine series.	122.	Château Hamelin.
		123.	?
111.	Cherbourg.	124.	?
112.	Cherbourg.	125.	Tours? The Scarlet Sunset.

This last magnificent drawing belongs properly to the next group, which is almost exclusively formed by drawings in which the main element is colour, at once deep and glow-
n colour and
treatment; and in the uniform determination of the artist that every subject shall at least have a castle and a crag in it—if possible a river; or by Fortune's higher favour—blue sea, and that all trees shall be ignored, as shady and troublesome excrescences. In default of locality, I have put here and there a word of note or praise.

GROUP XIX

(Fifth Hundred)

FINEST COLOUR ON GREY (LATEST)

176. Rhine. (Yellow raft essential.)
177. Too red and yellow. Full of power in form.
178. Delicate, and very lovely.
179. Rhine? or Danube? Very grand.
180. Bacharach. Wonderful, but too wild.
181. Best quality—all but the white chalk.
182. Heidelberg. Rosy tower, and a tree or two! Lovely.
183. Such things *are*, though you mayn't believe it.
184. Dinant, Meuse. A mighty one.
185. Dinant. Bronzed sunset. Firm and good.
186. Luxembourg. Splendid.
187. Luxembourg Forced, and poor.
188. Luxembourg. Highest quality.
189. Luxembourg. Supreme of the set, except
190. Luxembourg Probably the grandest drawing of this date.
191. Luxembourg. Too blue and red, but noble.
192. Meuse. Admirable, but incomplete.
193. Coast of Genoa? Good, but dull.
194. Coast of Genoa? Highest quality.
195. Italian Lakes? Supreme of all, for colour.
196. Marseilles? Splendid, but harsh.
197. Riviera? Fine, but a little hard and mannered.
198. Sorrento coast? Sunset. Lovely.
199. Vico? coast of Sorrento. The same type: poorer.
200. The Vermilion Palace.

I know scarcely any of their subjects except the Luxembourgs; and have therefore left them in their first rough arrangement; although subjects probably Genovese and South Italian are mixed with others from Germany and the Rhine.

GROUP XX

(Fifth Hundred)

STUDIES ON GREY FOR "RIVERS OF FRANCE" (LATE)

26. Four studies at Marly and Rouen.
27. Two studies in France and
 Two studies for a picture.
28. Four studies in France.

29. Four studies in France.
30. Two studies at Boulogne and
 Two studies at Ambleteuse.
31. Four studies at Calais.
32. Four studies in France.
33. Four English marine studies.
34. Rouen, in France: two marine studies.
35. On the Rhine, St. Germain, Dieppe, on the Seine.
 (The above ten, pen and ink on grey.)
36. Orleans, Tours (colour on grey).
38. On the Seine? (colour on grey).
39. Luxembourg? Huy on the Meuse (colour on grey).
40. Honfleur, Honfleur? (colour on grey).
37. Liber Studiorum subjects, two Lake of Thun, Mont St. Gothard, Ville
 de Thun (pencil).

GROUP XXI

(*Fifth Hundred*)

THE SEINE

In this series the best drawings are as far as possible put together—geographical order being ignored, rather than mix the second-rate ones with those of entirely satisfactory quality. But the course of subject for the most part is in ascent of the river; and the two vignettes begin and end the whole.

151. Château Gaillard. Vignette.	152.	Vernon.
157. Havre. Sunset in the port.	131.	Rouen, looking up river.
158. Havre. Twilight outside the port.	132.	Rouen, looking down river.
	133.	Rouen Cathedral.
153. Tancarville.	136.	Ponte de l'Arche.
154. Tancarville and Quillebœuf.	137.	Château Gaillard.
127. Quillebœuf.	139.	Mantes.
128. Between Quillebœuf and Villequier.	138.	Between Mantes and Vernon.
	146.	St. Germain.
159. Honfleur.	147.	Bridges of St. Cloud and Sèvres.
126. Harfleur.	148.	Bridge of Sèvres.
129. Caudebec.	156.	Lantern of St. Cloud.
134. Lillebonne.	141.	Barrière de Passy.
135. Lillebonne.	144.	The Flower-market.
130. La Chaise de Gargantua.	143.	The Dog-market.
155. Jumièges.	142.	Pont Neuf.

145.	St. Denis.	150.	Troyes.
140.	The Bridge of Meulan.	160.	Vignette. Light towers of the
149.	Melun.		Hêve.[1]

[1] [Here in the pamphlet follows "Terminal Index," with the following explanatory remarks :—

"In the first column are the numbers in the existing arrangement; in the second the page in this Catalogue. The stars indicate the drawings not included in the revised Catalogue, as adapted rather for exhibition in the provinces."

In fact, however, stars were added to several drawings included in the catalogue; among others, to some in the Scholar's Group itself. The same thing occurred in the earlier editions of the catalogue. The numbers of the excluded drawings are as follow : 1, 2, 4, 6, 7, 8, 13, 15, 16, 20, 21, 43, 71, 74, 76, 84, 93, 209 (marked "Reserved"), 254, 276, 277, 278, 281, 282, 283, 284, 294, 295, 315, 316, 317, 318, 341, 342, 343, 344, 345, 350, 392, 401, 406, 411, 414, 422, 424, 439, 440, 441, 445, 452, 453, 526, 535, 538, 539, 543, 550, 551, 557, 561, 562, 563, 567, 574, 578–582, 593, 595, 598, 599, 601, 614–616. The index (as already explained, p. xl. above) is here given in a more comprehensive form, so as to comprise references to all the catalogues collected in this volume (see below, pp. 607–646).]

PART III

NOTES BY RUSKIN

I

ON HIS DRAWINGS BY TURNER

II

ON HIS OWN HANDIWORK ILLUSTRATIVE OF TURNER

(EXHIBITED AT THE FINE ART SOCIETY'S GALLERIES IN 1878 AND 1900)

NOTES BY MR. RUSKIN.

PART I.

ON HIS DRAWINGS BY THE LATE

J. M. W. TURNER, R.A.

PART II.

ON HIS OWN HANDIWORK

ILLUSTRATIVE OF

TURNER.

THE ABOVE BEING EXHIBITED AT

THE FINE ART SOCIETY'S *GALLERIES*,

148, *NEW BOND STREET.*

1878.

9th Thousand. *Revised Edition.*

Price One Shilling.

[Bibliographical Note.—Of this pamphlet there have been fourteen separate editions, and the bibliography is somewhat complicated.

Summary.—The following brief summary may be acceptable to those who do not desire the further *minutiæ.* Edition No. 1 was incomplete, so far as Ruskin's Notes were concerned, and contained an appendix by Mr. Huish, not here reprinted. No. 2 was a reprint of No. 1. No. 3 included the Epilogue in an unfinished form, and in it were included as addenda, "Further Illustrative Studies" (see pp. 473-474). Nos. 4, 5, and 6 were reprints of No. 3. In No. 7 the Epilogue was revised; Notes by the Rev. W. Kingsley, with occasional remarks by Mr. Ruskin, were added as an appendix (pp. 533-536), Mr. Huish's appendix being now omitted. No. 8 was a reprint of No. 7. No. 9 was enlarged by the inclusion of Part II., being Mr. Ruskin's Notes on a selection of his own drawings. In No. 10 the text was revised. Nos. 11 and 12 were reprints of No. 10. The Illustrated Edition, No. 13, was a reprint of Nos. 10-12, together with Mr. Huish's appendix (and an additional map) from Nos. 1-6. No. 14, issued in 1900, was, so far as it went, a reprint of Nos. 10-12, but with numerous omissions.

Full particulars of the several editions are as follow :—

First Edition (1878).—The title-page is :—

Notes by Mr. Ruskin | on his Drawings by the late | J. M. W. Turner, R.A. | Exhibited at the Fine Art Society's | Galleries, 148, New Bond Street, | March, 1878. | Also | an Appendix containing a list of the | Engraved Works of J. M. W. Turner | exhibited at the same | time.

Octavo, pp. 101. Imprint on reverse of title-page—" Elzevir Press :— Printed by John C. Wilkins, 9 Castle Street, Chancery Lane " ; Contents, p. 3 ; Introduction (here pp. 405-410), pp. 5-10 ; Prefatory Note (here p. 411), pp. 11-12 ; Text of Ruskin's Notes (dated " Brantwood, *February* 21, 1878 "), pp. 13-64 ; Introduction to the Appendix (signed " Marcus B. Huish "), pp. 67-70 ; Appendix, pp. 71-101. Headlines throughout—" Mr. Ruskin's Collection of | Turner Drawings" for the body of the book, and " The Engraved Works of the | Late J. M. W. Turner, R.A.," for the Appendix. Issued in mottled-grey paper wrappers (as also eds. 2-12), with the title-page reproduced upon the front ; " *1st Edition. Price One Shilling* " being added at the foot. On p. 4 of the wrapper is the announcement of Mr. William Ward's Copies of Turner, which is here printed at p. 575, below. In the centre of the reverse of p. 101 is the imprint—" Printed by John C. Wilkins, 9, Castle Street, Chancery Lane "—below an ornamental device with monogram and motto—" Elzevir Press. Opus opificem Probat." In eds. 1-6

the wrapper, title-page, and text have ornamental initial letters, and head-pieces. Inside the front cover and before the title-page a slip was inserted with the following announcement :—

" NOTICE.

" In consequence of Mr. Ruskin's sudden and dangerous illness the latter portion of these Notes is presented in an incomplete state, and the Epilogue remains unwritten.

" *February* 27, 1878."

Second Edition (1878).—A reprint of the First, the number of the edition being altered on the wrapper. With eds. 2–6 were bound up at the end six pages of advertisements—pp. 1–4, advertisements of engravings, etc., on sale by the Fine Art Society ; p. 5, an announcement of an " Illustrated Large Paper Edition of Mr. Ruskin's Notes on the Turner Drawings ; " p. 6, blank.

Third Edition (1878).—The issues were henceforth styled " Thousands " instead of " Editions " upon the wrappers, each issue bearing the number of the *Thousand* and the words " *Revised Edition.*" To this edition were added two pages of *Addenda*, consisting of " Further Illustrative Studies," signed " J. R.," and the Epilogue, " left by Mr. Ruskin in an incomplete state at the time when he was taken ill," was inserted in that state (see below, pp. 475–476 *n.*). There were also a few other alterations in the text. The number of pages became 111 ; the Addenda occupying pp. 65, 66 ; Epilogue, pp. 67–73 ; and Appendix, pp. 75–111. The note respecting Ruskin's illness was omitted in this and later editions.

Fourth, Fifth, and *Sixth Editions* (1878).—Reprints of the Third, with the number of the *Thousand* altered on the wrapper.

Seventh Edition (1878).—This was issued at the end of May, by which time Ruskin was convalescent from his illness. He revised and completed the Epilogue (dated " Brantwood, 10*th May* 1878 ") ; revised the text through-out ; and added a new Appendix, containing notes on some of the Drawings by the Rev. W. Kingsley. The Appendix to the previous editions was omitted. The title-page was accordingly altered, thus :—

Notes by Mr. Ruskin on | his Drawings by the | late J. M. W. Turner, R.A. | Exhibited at the Fine Art Society's | Galleries, 148, New Bond Street, | in the Spring of 1878. | Also | an Appendix containing a few notes | on the Drawings by the | Rev. W. Kingsley.

The number of pages was now 84. Imprint on reverse of title-page— " Elzevir Press : Printed by Charles Whittingham, 9 Castle Street, Chancery Lane." Text of the Notes, pp. 13–67; Addenda, pp. 68, 69; Epilogue, pp. 71–78 ; Appendix, pp. 78–84 (imprint repeated at foot of last page). The headlines vary according to the contents. In this and the subsequent editions the ornamental letters, etc., were omitted. The title-page is re-peated on the front cover.

Some copies purporting to be of the " *Seventh Thousand* " are in fact

remainder-copies of the Third, Fourth, Fifth, or Sixth Edition bound up in Seventh Edition wrappers.

Eighth Edition (1878).—A reprint of the Seventh, with the number of the *Thousand* altered on the wrapper.

Ninth Edition (1878).—This was issued in June, by which time Ruskin had arranged for exhibition, with descriptive notes, a collection of his own Drawings, with other pieces (engravings, etc.) illustrative of Turner. The title-page was accordingly altered, and was as given here on p. 391. The number of pages was now 146 (the first four numbered in Roman). Imprint on reverse of title-page—" Chiswick Press :—Printed by Charles Whitting-ham, | Took's Court, Chancery Lane" (repeated at the foot of the last page ; revised Contents, pp. iii.–iv. ; previous text of the catalogue (now Part I.) reprinted, pp. 5–78 ; Part II. :—Preface (here pp. 487–488), pp. 79, 80; "Notes on my own Drawings and Engravings" (here pp. 489–528), pp. 79–136 ; "Notes respecting future uses of Engravings" (here pp. 529–531), pp. 137–139 ; Appendix, pp. 141–146 (a reprint of pp. 79–84 of the previous edition). The six terminal pages of advertisements were again in-cluded (as also in eds. 10–12).

Of this edition, there were two issues. In the first, the title-page was reproduced on the wrapper, with the words added at the foot—"*9th Thousand. Revised Edition.* | Price One Shilling." In the second, the title-page was somewhat closed up in setting, in order to leave room at the foot for the following addition—"N.B.—The Drawings are arranged in the Gallery as follows :—The Turners commence on the left or south wall beyond the curtain ; Mr. Ruskin's collection begins at the centre of the right hand or north wall and passes on to the centre screen at the statue end." This notice was repeated in eds. 10 and 11, but not in ed. 12.

Tenth Edition (1878).—A reprint of the Ninth, except for the altered number on the wrapper, and a few alterations in Part II. of the text (see "Variæ Lectiones" below).

Eleventh and *Twelfth Editions* (1878).—Reprints of the Tenth, with the number of the *Thousands* altered on the wrapper.

Thirteenth (Illustrated) Edition (1878).—The text of this edition is a ver-batim reprint of the Tenth Edition, with the addition of Mr. Huish's Appen-dix to the Second Edition. The title-page is :—

Notes by Mr. Ruskin | on his Collection of Drawings | by the late | J. M. W. Turner, R.A. | Exhibited at | the Fine Art Society's Galleries ; | also a list of the Engraved Works of that Master | shown at the same

places in the British | Isles illustrated by him | London. | Printed at the Chiswick Press, for | the Fine Art Society, | 148 New Bond Street, | 1878.

Quarto, pp. iv. + 188. "Note on illustrated edition of Mr. Ruskin's Notes," pp. i ii. Imprint on reverse of title-page—" Chiswick Press : Charles

Whittingham, Took's Court, Chancery Lane." Contents, pp. 1, 2. List of
Plates, pp. 3–4, as follows :—

Introduction, pp. 5–10; Prefatory Note, p. 11 ; Text of the Notes, Part I.,
pp. 73–78; Preface to Part II., pp. 79, 80 ; Notes, pp. 81–136 ; Notes re-
specting future uses of Engravings, pp. 137–139 ; Appendix (Mr. Kingsley's
Notes), pp. 141–146 ; Fly-title to " A List of the Engraved Works of the late
J. M. W. Turner, R.A.," pp. 147–148 ; Introduction, pp. 149–152 ; Text of
the List, pp. 153–183 ; Note on the Map showing Turner's Haunts in
England, pp. 185 and 188, pp. 186 and 187 being occupied by the map. On
the leaf facing p. 188 is the device and imprint of the Chiswick Press. The
headlines vary according to the contents of the various divisions of the
book. Issued in half-Roxburgh, top edge gilt, printed on hand-made paper.
The volume is lettered across the back : "Notes by | Mr. Ruskin | on his |
Drawings | by the late | J. M. W. Turner. | The | Fine Art Society." Six
hundred and fifty copies, published at One Guinea and a Half. One hundred
" Proofs " were also issued at Two Guineas and a Half.

The illustrations were in no case from the original drawings, but were
photogravures from engravings of the drawings (or of drawings of the
same subjects : see Ruskin's Ambleside notes, below) published in various
works—Hakewill's *Italy*, Whitaker's *Richmondshire*, Finden's *Byron*, Finden's
Bible, Scott's *Works*, *The Keepsake*, *England and Wales*, *The Rivers of France*,
and *Liber Studiorum*. They are, therefore, not here reproduced. Six of
the drawings, which were thus represented in the Notes, have been repro-
duced elsewhere in Ruskin's Works—viz. "Bolton Abbey" (partly), see
"The Shores of Wharfe" in *Modern Painters*, vols. iii. and iv. (Plates 12
and 12A); "The Lake of Zug" in *Modern Painters*, vol. v. (Plate 87);
"Egglestone Abbey," "Dudley," "Flint," and "Vesuvius Angry," in
Lectures on Landscape. "Okehampton" is in this edition reproduced in
Modern Painters, vol. i. (plate facing p. 410). Some of the drawings are
reproduced in this edition from the originals, and another is represented
by an etching by Ruskin (see above, p. lviii.).

The photogravures, though passable at the time, are hardly up to the
present standard of the process. The Fine Art Society issued a flyleaf
containing the following " Extract from a letter of Mr. Ruskin " :—

"Brantwood, 22 Dec. 1878.
"I am delighted with the Notes in this form. Many of the photographs are very beautiful, and bring out points of composition in the placing of the lights which were not always seen in the drawings themselves so clearly."

Subsequently he presented his copy of the book "To the Ruskin Society of Ambleside, March 3, 1883." This copy contains several notes in Ruskin's handwriting :—

Page 17 : "The opposite plate [Thun] is not from the drawing here described, but from the Liber Studiorum plate subsequently composed from it."

Page 18 (beside No. 10, Bonneville) : "The opposite plate is again not from the study described, but from a finished drawing with figures, of nearly the same date. He drew this favourite subject a third time, late in life."

Page 23 (beside No. 16, Isola Bella) : "The photograph is from a too dark engraving. The drawing is pale yellow and blue."

The plate of No. 19, Narni, he notes as "Extremely good" ; that of No. 20 (Terni) is "Too black." Page 28 (beside No. 25, Heysham) : "The engraving is good, but fearfully spoiled in the black photo." For a note on p. 31 to No. 29, see below, p. 432.

Page 34 (beside No. 32, Dudley Castle) : "This beautiful plate is in some ways more interesting than the drawing."

Of the plate of No. 37 (Gosport) : "Poorly engraved. Blue sky impossible, of course, and sea quite dead and spoiled." For a note on p. 40, see below, p. 441 n. Of the plate of No. 44 (Bolton Abbey) : "Extremely good.' Of No. 45 (Staffa) : ",Very beautiful, and like the drawing." Of 46 (Lochmaben): "A bad engraving." Of 49 (The Plains of Troy) : "Horribly engraved. The original is twice as large." Of No. 50 (Corinth) : "Much too dark.' Of No. 51 (Jerusalem) : "A vile proof." Of No. 56 (Rouen) : "Extremely good." Of No. 64 (Lake of Zug) : "From my own etching with Lupton's mezzotint. Extremely good." Of No. 67 (Arona) : "Very beautiful." On p. 89 (beside 8 R. Lancaster Sands) : "The plate opposite is from the England drawing of same subject—a good photo."

Fourteenth Edition (1900).—The circumstances of this edition were explained in the following "Note concerning the Present Exhibition" :—

"After an interval of twenty-two years the Fine Art Society have again the privilege of exhibiting to the public the collection of Turner drawings which, in 1878, were shown in their galleries through the kindness of Mr. Ruskin. In consenting to a second exhibition, Mr. and Mrs. Arthur Severn, to whom the drawings have been bequeathed, have yielded to a very widely expressed desire that they might be seen a second time by many who enjoyed the great artistic treat when they were here before, and by still more who have grown into manhood since 1878.

"As the drawings will again be accompanied by the Notes which Mr. Ruskin prepared to accompany the exhibition, it is necessary, in consequence of their somewhat fragmentary nature, to recall the circumstances under which they were compiled.

"The exhibition in 1878 was timed to open early in March, and Mr. Ruskin (it will be seen) completed the preface on the 12th, and the Notes proper on the 21st February. He had more to say, but he was suddenly stricken by an alarming illness, and it was not until the 10th of May following that he was able to put together that which appears here as the Epilogue."

The title-page is :—

Notes by John Ruskin | On his Drawings by | J. M. W. Turner, R.A. | Exhibited at | The Fine Art Society's Galleries, | 148, New Bond Street, | 1878 and 1900.

Octavo, pp. 66. The "Note" given above, p. 3; Introduction, pp. 5–11; Prefatory Note, p. 13; Notes, pp. 15–53; Illustrative Studies, etc., pp. 54, 55 ; Addenda (Further Illustrative Studies), pp. 56–57 ; Epilogue, pp. 58–65 ; p. 66 is taken up with an advertisement. Issued in mottled-grey wrappers as before. On p. 1 of the wrapper: "Notes by John Ruskin | On His Water-Colours | By J. M. W. Turner, R.A. | Exhibited at | The Fine Art Society's Galleries, | 148, New Bond Street, | 1878 and 1900. | *Price One Shilling.* | *The Notes can also be purchased of George Allen, Charing Cross Road.*" Pages 2, 3, 4 are occupied with advertisements; at the foot of p. 4 is the imprint—"C. E. Roberts & Co., Printers, 18, Finsbury Street, E.C." Four pages of advertisements are also bound up at the beginning and two at the end. The text of the pamphlet is identical with that of eds. 10–13, so far as it is applicable to the drawings exhibited ; but it also contains additional titles, etc., referring to pieces now first exhibited. (See further under "Variæ Lectiones," at end).

Reprinted (1902) in *Ruskin on Pictures*, vol. i. pp. 295–425.

Variæ Lectiones.—*Contents*, eds. 1 and 2 included no "Tenth Group"; the "Illustrative Studies" were subdivided in eds. 1–6, as explained on p. 461, below ; and instead of "Addenda" and "Epilogue" the List of Contents contained "Appendix:—Portraits of Turner.—Early Engravings, of which the Dates of Production are unknown.—Plates engraved after Turner's death." Part II. first appeared in the List of Contents in ed. 9.

Introduction.—Page 405, line 10, "Munro" in previous editions here altered to "Monro." For the quotation from Milton, see p. 406.

Prefatory Note.—The groups differently arranged in eds. 1–6, see p. 411.

Part I.—*No. 1,* the footnote was first added in ed. 7. *No. 17,* the footnote was first added in ed. 7. *No. 19,* the word *canoros* was misprinted *canaros* in eds. 1–6. *No. 21,* line 11, eds. 1–6 read "This little drawing above represents, within its compass of six inches by five . . ." *No. 23,* see p. 427 *n.* *No. 24,* line 23, for "keenly thoughtful," eds. 1–6 read "keen-thoughtful." *No. 28,* line 9, see p. 431 *n.* ; page 432, line 4, for "across the moorlands," eds. 1–6 read "among the moorland." *No. 29,* see p. 432 *n.* ; line 8, the words "(with No. 28)" were first added in ed. 7. *No. 30,* see p. 433 *n.* *No. 31,* line 10, "made more lovely, as" misprinted in eds. 1–6 "much more lovely, or"; page 435, line 12, eds. 1–6 did not italicise "*pigs,*" and eds. 7–13 transposed the words "*pigs*" and "*draw.*" *No. 32,* line 7, eds. 1–6 misprinted "hasty" as "hardy," and did not italicise the words in line 10 (nor the word "black" in line 16 of No. 33). *No. 42,* last line, see p. 443 *n.* *No. 43,* eds. 1, 2 add at the end "See Notes on

line 17, the reading here is that of eds. 1–6; altered by mistake in ed. 7 , I obtained, belonging to the same period, one on the Loire, quite inestimable (given to Oxford Standard Series, No. 3) . . ." *No. 57,* see p. 452 *n.* *No. 58,* for "See notes in

words altogether. *Tenth Group,* see p. 453 *n.*

Illustrative Studies.—For arrangement of these into groups in eds. 1–6, see p. 461 *n.*; the words "I place first among these" and "namely" were first added in ed. 7.

No. 71, the note was first added in ed. 7. *No. 72*, eds. 1–6 omit "Of which." *No. 73*, eds. 1–6 read "only two other proofs again, I believe." *No. 74*, see p. 461 *n.* *No. 75*, the note first added in ed. 7. *No. 76*, for "also *etched*" eds. 1–6 read "etched"; line 6, for "and of his mind, more," eds. 1–6 read "and of his mind, there is more than in any"; the next four lines were first added in ed. 7. *No. 77*, for "my friend, since dead," eds. 1–6 read "my dead kind friend"; "Cowper" in previous editions, here corrected to "Cooper." *No. 78*, see p. 463 *n.*

From here to the end of the Illustrative Studies the alterations made in eds. 3 or 7 were considerable—this portion of the original text having been written when Ruskin was far from well.

No. 80, eds. 1, 2 add after "advancing method of study' :'—

"Given me by—'I forget by whom'—but I'll find out, and am not the less grateful. I forget ever so much now, when I'm tired."

The next three lines in the text were first added in ed. 7.

No. 81, last two lines, eds. 1–6 italicise "broad" and "Walls."

No. 84, see p. 464 *n.*

No. 85, eds. 1, 2 insert after "where Jeanie goes alone":—

"(Jeanie, that I should have forgotten *you* as well as that Jean of Jeans for a moment, as I was writing the end of my *Fors* for this morning !)" [1]

In line 13, eds. 1–6 print "not" in small capitals. At the end of the text, eds. 1–6 add :—

"Then to the left again—up the hill, St. Giles's prophetic once before Flodden, but now—St. Giles's 'mingled din' only, election of clergymen, somehow, and the Castle—with the 'Kittle nine steps' —and look, my British public—for they need wary walking now, what with that mingled din and the smoke." [2]

No. 86, line 3, see p. 465 *n.* In the next line, after "never one changed," eds. 1–6 add :—

"(so exactly like our British action in the Sea of Marmora,[3] which I in part read the account of to my secretary, Mr. Hilliard,

[1] There is no passage in the published Letters of *Fors* of the time which explains this reference.

[2] For "St. Giles's mingling (not 'mingled') din," see *Marmion*, iv. 24; for "Kittle nine steps," *Redgauntlet*, Letter i. and Note A: it is "a pass on the very brink of the Castle rock."

[3] A sarcastic reference to the uncertain movements of the British fleet at this time. Ruskin was an opponent of Disraeli's policy on the Eastern Question. In one of the letters, undated, to Mr. Huish, which have been mentioned above (p. lviii.), Ruskin wrote to explain the delay in finishing the Notes :—
"The Turkish business and the needful changes in *Fors*, in collision with this, have made me slower than at the worst I expected."
And again, a few days later :—
"If you only knew what I have on my hands just now altogether, you'd be sorry and shocked, and forgive me a great deal."
A passage in the next letter, which is dated February 19 [1878], may refer to the passage above :—
"*Fors* is to come out on the same day, 1st March, you know, and will have a great deal in it to explain the parenthesis which reads so crazy."
The reference is to *Fors* for March 1878 (Letter 87 in the complete series), in which Ruskin states his opposition to the Eastern policy of Disraeli, and his agreement, on that issue, with Gladstone.

and good assistant, Mr. Gould, at their lunch, marking a word or two with pen, for future use.")[1]

No. 87, line 1, eds. 1–6 omit "Only the," and add "Lady Glenorchy carefully" after "before"; line 5, eds. 1–6 add the following paragraph :—

"And now, I take Sir Walter's own pen to write with, given by him to Maria Edgeworth, August 14th, 1825, and lent to me, as *Fors* would have it, by the kindness of its present possessor, Dr. Butler of Harrow,[2]—Pen-holder I should say—I have put one of my own (Lucastes) pens into it—with which he had written the *Heart of Midlothian* and all his novels up to that time. But I take it to tell you to look at thé little scrawled sketch," etc.

No. 88. At the end, eds. 1 and 2 add :—

"(Oh ! Camp.—Camp.—dear Camp., I forgot You too and your grave. This was your master's pen, Camp. ; are not you happy ?[3])

"Stay—you may here like to see one little bit of my own boy's work, again. There's the back of the church, the apse, seen in this Turner sketch on the hill, drawn by me from the street, in 1837, I think,—beside the Scott table."

No. 89. See p 467 *n.*

No. 90. At the end, eds. 1 and 2 add :—

"The reader may, perhaps, again care to see a little water-colour drawing,—'In listening mood she seemed to stand,' (Cour-bould's,[4] I think), which I used to delight in when a child, because there was a boat in it—such a boat ! such an Ellen ! Alas, alas, and such a Fitz James ! Still there's an old-fashioned grace about it, characteristic once more of Scott's time ; and beside it I put my Father's drawing of Conway Castle, which he always told me the story about when he was shaving. Conway Castle, to show how boys were taught to draw in Edinburgh in the olden time.

"And now, dearest Dr. John Brown (and Sibyl),[5] I've done my main work to-day, and end with my perfect love to you, and Rab, and all his friends and your friends, and Faber of the Alps And so I lay aside Sir Walter's pen."

No. 95. See p. 467 *n.*

[1] Lawrence Hilliard was Ruskin's chief secretary at Brantwood from 1876 to 1882; he died in 1887. For some account of him, see W. G. Collingwood's *Life of Ruskin*, p. 343 *n.* Mr. David Gould (for whom, see also p. 526) was at this time assisting Ruskin, as a colourist of engravings, etc.

[2] Not quite accurate. The pen belonged to, and was lent to Ruskin by, Mrs. Butler (a Miss Edgeworth, niece of Maria), wife of the Rev. Arthur Gray Butler, of Oriel, brother of the then headmaster of Harrow. "Lucastes" (where Ruskin had first seen some particular kind of pen), was the residence of his god-daughter, Miss E. C. Oldham, at Hayward's Heath.

[3] Camp., a favourite bull-terrier of Scott's, is seen in Saxon's portrait of him (1805), and in both Raeburn's portraits (1808, 1809). See the list of portraits in the last chapter of Lockhart's *Life of Scott.*

[4] For Corbould, see *Academy Notes*, 1858, 1859. "In listening mood she seemed to stand" (*Lady of the Lake*, Canto i. 17). For the drawing of Conway Castle, see below, p. 489.

[5] For Dr. John Brown, author of *Rab and his Friends*, see Vol. XII. p. xx. The next reference is to another old friend of Ruskin's, Jane, Lady Simon, whom he was in the habit of calling "Sibyl." It is to her also that he no doubt refers as "Jeanie" on the preceding page (No. 85). "Faber of the Alps," the editors are unable to explain; possibly, as Ruskin is here thinking of old friends, "Faber" may have been a misprint for "Forbes," Ruskin's master in Alpine geology (see *Deucalion*).

No. 97, the words "the group . . . Salisbury" were first added in ed. 7 ; "hint" is here substituted for "tint," an obvious misprint.

No. 101, line 3, see p. 468 *n.* ; line 5, eds. 1–6 add at the end :—

> "Of divine play and divine work, especially the sun's play (coming forth as a Bridegroom and rejoicing to run his course [1]), see 'a ray here, and a flash there, and a sparkle of jewels everywhere.'
>
> ("'I think there be—Richmonds in the Field.'[2])
>
> "Compare No. 119, BRIDGE OF ST. MARTIN's (Cloak given). Cross on it. Church spire and Hôtel du Mont Blanc. Convent (which my Father made me draw for him) on the hill. Woman carrying bundle on her head. Wholesome work, in wholesome rest, in the middle cottages with vine trellises, mountains above, chain of the Dorcris and Reperoir.[3]
>
> "Dog, quick, looking on, ready for any duty, like Giotto's pet puppy."[4]

The line "I think . . . Field" is in eds. 1 and 2 only.

No. 105, for "Kilverton," eds. 2–6 read "Kilvington"; eds. 1, 2 read at the end "See Epilogue for description of it"; eds. 3–6 omit the word; ed. 7 and later read "See his terminal notes." *No. 106,* see p. 469 *n.* *No. 107,* for "for three more," eds. 1–6 read "at three." *No. 108,* eds. 1–6 insert "the" before "Fish." *No. 109,* see p. 469 *n.* *No. 112,* see p. 469 *n.* *No. 113,* lines 6 and 7, eds. 1–6 misprinted the words thus : "opening of blue sky beyond. Rain, the veil being withdrawn gradually." The following sentence followed : "If ever I get my Epilogue written, it shall be framed between glasses, like the framed sketches of the Lago Maggiore I did for the National Gallery" (see No. 603, p. 305). *No. 116,* see p. 470 *n.* *No. 120,* see p. 471 *n.*

Addenda.—See notes on pp. 473, 474.

Epilogue.—For the beginning portion in eds. 3–6, see p. 475 *n.*; page 478, line 10, see p. 478 *n.* ; page 479, line 1, for "Says Mr. Griffith," eds. 3–6 read "So says Mr. Griffiths"; line 11, for "and political economy in Art, you see," eds. 3–6 read ", my public, you see"; line 13, after "So," eds. 3–6 read ", now I can't answer for *words* any more"; and continue "the bargain was made between them that if Griffiths could sell ten drawings—these four included and six others—for eighty guineas each, Turner would make the six others from sketches to be shown for choice to the purchasers, and Griffiths . . ."; line 22, eds. 3–6 omit "also"; line 26, eds. 3–6 omit "Mr." ; page 480, line 2, for "came next," eds. 3–6 read "was next in order," omit "but," and also "and" before "I"; lines 13–16, see p. 480 *n.*; footnote, eds. 3–6 insert "at this moment"; lines 17–21, eds. 3–6 read "Then Munro of Novar, and bought the Lucerne (and the Red Righi?),

[1] See Psalms xix. 5. [2] *Richard III.,* v. 4.
[3] Ruskin was here jotting down ideas and recollections as they occurred to him, without staying to make them fully intelligible to others (as, for instance, in the parenthetical allusion to his friends, the Richmonds). He contrasts with "vulgar English play and vulgar English work" (see the note on No. 101 as finally printed, p. 468), the happier life, as it seemed to him, of the Savoy peasants in their beautiful valley—of which the village of St. Martin near Sallenches was typical to him. See the account of it in *Præterita* (ii. ch. xi., " L'Hôtel du Mont Blanc"). "Dorcris" and "Reperoir" are misprints for "Doron" and "Réposoir" (see Vol. V. p. xx., and Vol. VI. p. 301). For the perfect type of lovely play and work, he refers to the passage in the lecture entitled "Work" in *The Crown of Wild Olive* (§ 50), where the words "a ray here . . . jewels everywhere" occur.
[4] For "Giotto's pet puppy," see *Mornings in Florence,* § 132.

2 c

and both Mr. Munro and Mr. Bicknell chose a sketch to be 'realized' —Mr. Bicknell, Lucerne Lake; Mr. Munro, Lucerne Town"; line 23, eds. 3–6 read ". . . going on, five out of the ten drawings were provided for. . . . And three out of the four patterns he had shown . . . "; line 29, eds. 3–6 insert "pretty" before "well"; page 481, line 1, eds. 3–6 read "he knew perfectly well" for "*he* also knew"; line 2, see p. 481 *n.*; line 5, eds. 3–6 omit "to *her* father" after "Cordelia"; line 8, eds. 3–6 read "Coblentz" for "the Ehrenbreitstein, No. 62, here"; line 12, eds. 3–6 omit "a Righi dark in twilight"; line 15, for "The other sketches . . . them," eds. 3–6 read "The tenth sketch . . . it at any price"; line 22, for "the tenth in hand, out of those," eds. 3–6 read "the last in hand, the one"; line 29, "63" was in error printed "62"; page 482, lines 14, 17, see notes there; line 24, for "remained long," "is still, I believe"; page 483 (list of pictures), eds. 3–6 number them differently, those in the printed text being respectively 1, 10, 8, 2, 3, 4, 6, 7, 9, 5, and No. 9 is called "Blue" instead of "Dark"; this causes corresponding differences in subsequent lines; line 19, eds. 3–6 read "Nos. 1, 2, and 5 are, I believe, still in the possession of Mr. Munro's nephew"; line 21, eds. 3–6 omit "long ago" after "sale"; last line, for "correction," eds. 3–6 misread "reflection." Page 484, lines 7–23, this passage was in eds. 3 and 6 placed at the beginning of the Epilogue, as shown on p. 475 below, and there were some minor variations. In line 7, for "these," eds. 3–6 read "them," and in the next line omit "But"; line 12, eds. 3–6 insert "therefore" after "and"; lines 18, eds. 3–6 omit "I think . . . mark of the rest"; line 25, for "so," eds. 3–6 read "The."

Part II.—*Preface*, line 18, "hand-work" in previous editions here corrected to "handiwork." Pages 517–518, see p. 518 *n.* for an alteration between eds. 9–10; this alteration caused the following pages (127–131 in ed. 10) to be "overrun." 23. *R.* (*c*) line 2, the word "society" here inserted. 37. *R.*, in all previous editions the word "(Oxford)" was wrongly placed after this number, instead of after 38. *R.* *40. R.* This note (Lucerne) was first added in ed. 10; and in order not to disturb the subsequent numbering, the foregoing pieces were numbered "39. R. (*b*)" instead of "40. R." See p. 531 *n.* for another variation between eds. 9 and 10.

The *fourteenth edition* (1900), prepared as the catalogue for the exhibition in that year, differs from its predecessors, owing to the contents of the exhibition being in some degree different.

The following pieces in the original exhibition were not shown: Nos. 2, 3, 4, 5, 6, 9, 14, 15, 31, 35, 39, 45, 47, 48, 52, 55, 59, 60–61, 64, 67, 69, 70, 71–79, 81–100, 102, 103, 106, 107, 110–112, 118, 119, 120. The omission of these drawings and sketches caused numerous alterations, which need not be more particularly described.

On the other hand, seven drawings and sketches were shown in 1900 which were not included in the Exhibition of 1878; for these, see below, notes on pp. 416–417, 430, 446, 456. One drawing, not in Ruskin's collection, was also included in the exhibition and catalogue—namely, "27 A. The Drachenfels (from the Fawkes collection)." Several objects connected with Turner were also now shown; for these, see below, p. 474.

Some of the drawings, included in both exhibitions, were renumbered in 1900, and there were also a few trifling alterations made in the text.]

CONTENTS

PART I

PART II

NOTES ON MR. RUSKIN'S DRAWINGS
BY TURNER

INTRODUCTION

THE following main facts respecting the tenour of Turner's life and work may be depended upon, and should be kept in mind, as they are evidenced by, or illustrate, the pieces of his art here shown.

He was born on St. George's Day in 1775. He produced no work of importance till he was past twenty; —working constantly, from the day he could hold a pencil, in steady studentship, with gradually increasing intelligence, and, fortunately for him, rightly guided skill. His true master was Dr. Monro:[1]—to the practical teaching of that first patron, and the wise simplicity of the method of water-colour study in which he was disciplined by him, and companioned by Girtin,[2] the healthy and constant development of the youth's power is primarily to be attributed. The greatness of the power itself, it is impossible to overestimate. As in my own advancing life I learn more of the laws of noble art, I recognize faults in Turner to which once I was blind; but only as I recognize also powers which my boy's enthusiasm did but disgrace by its advocacy.

In the summer of 1797, when he was two-and-twenty, he took, if not actually his first journey, certainly the first

[1] [See above, p. 255.]
[2] [See again, p. 255.]

with fully prepared and cultivated faculties, into Yorkshire and Cumberland.

In the following year he exhibited ten pictures in the Royal Academy, to one of which he attached the first poetical motto he ever gave to a picture. The subject of it was " Morning among the Coniston Fells,"[1] and the lines chosen for it, these,—(Milton's):

> " Ye mists and exhalations, that now rise
> From hill, or steaming[2] lake, dusky or grey,
> Till the sun paint your fleecy skirts with gold,
> In honour to the world's great Author rise."

As I write the words (12th February 1878, in the 80th year since the picture was exhibited), I raise my eyes to these Coniston Fells, and see them, at this moment imaged in their lake, in quietly reversed and perfect similitude, the sky cloudless above them, cloudless beneath, and two level lines of blue vapour drawn across their sun-lighted and russet moorlands, like an azure fesse across a golden shield.

The subjects of the other pictures exhibited in that year, 1798, had better be glanced at in order, showing as they do the strong impression made on his mind by the northern hills, and their ruins.

WENSLEYDALE.

DUNSTANBOROUGH CASTLE.

KIRKSTALL ABBEY.

FOUNTAINS ABBEY.

NORHAM CASTLE.

HOLY ISLAND CATHEDRAL.

AMBLESIDE MILL.

BUTTERMERE LAKE.

THE FERN HOUSE, MICKLEHAM, SURREY.

[1] [No. 461 in the National Gallery.]

[2] [" Steaming" is Milton's word. It was given as "streaming" in the Academy Catalogue, and appeared as such in eds. 1 and 2 of this catalogue. By a slip of memory, Ruskin first called the lines "Thomson's,"—an error corrected in ed. 7 : they are in *Paradise Lost*, bk. v. 185–188. See, again, for references to these lines, pp. 126, 316.]

Four of the pencil drawings, exhibited here among the illustrative sketches, were, I doubt not, made on this journey.[1]

The first group of drawings, 1 to 6, belong to the time of his schooling and show the method of it completely. For simplicity in memory it will be wise, and practically and broadly true, to consider this period as extending to the close of the century, over the first twenty-five years of Turner's life. In 1800 he exhibited his first sacred and epic picture, the " Fifth Plague of Egypt," and his established work and artist-power begin.

It is usual, and I have hitherto complied with the general impression on this matter in my arrangement of his work, to divide its accomplished skill into three periods, early, middle, and of decline.[2] Of course all such arrangement is more or less arbitrary; some virtues are lost, some gained, continually; and, on the whole, the best method of understanding and clearest means of remembering the facts will be simply to divide his art-life by tens of years. The distinctions of manner belonging to each decade are approximately very notable and defined. Here is a brief view of them.

FIRST PERIOD. 1800–1810.

His manner is stern, reserved, quiet, grave in colour, forceful in hand. His mind tranquil; fixed, in physical study, on mountain subject; in moral study, on the Mythology of Homer and the Law of the Old Testament.

SECOND PERIOD. 1810–1820.

His manner becomes gentle and refined in the extreme. He perceives the most subtle qualities of natural beauty in form and atmosphere; for the most part denying himself

[1] [Nos. 77–80 below.]
[2] [See above, pp. 99, 251.]

colour. His execution is unrivalled in precision and care. His mind fixed chiefly on the loveliness of material things; morally, on the passing away of human life, as a cloud, from the midst of them.

THIRD PERIOD. 1820–1830.

A great change gradually takes place, owing to some evil chances of his life, in his moral temper. He begins, after 1825, to exert and exhibit his power wantonly and irregularly, the power itself always increasing, and complete colour being now added to his scale in all conception. His handling becomes again more masculine, the refined work being reserved for particular passages. He forms, in this period, his own complete and individual manner as a painter.

FOURTH PERIOD. 1830–1840.

He produces his most wonderful work in his own special manner,—in the perfect pieces of it, insuperable. It was in this period that I became aware of his power. My first piece of writing on his works was a letter, intended for the papers, written in defence of the picture of "Juliet and her Nurse," exhibited in 1836 (when I was seventeen).[1] The following pictures are examples of his manner at this period, none of them, unhappily, now in anything like perfect preservation, but even in their partial ruin, marvelous. (The perfect pieces which I have called insuperable are the drawings made in the same years, of which examples are given in the collection.)

CHILDE HAROLD *Exhibited in* 1832
THE GOLDEN BOUGH 1834
MERCURY AND ARGUS 1836

[1] [See now Vol. III. pp. 635–640.]

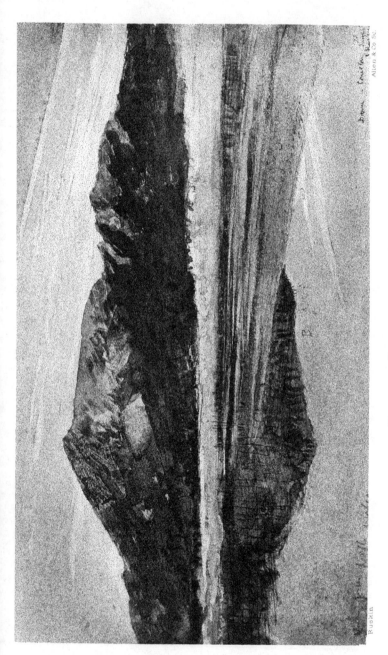

Dawn at Coniston (1873)

From the drawing in the possession of Mr. George Allen

Juliet and her Nurse · *Exhibited in*	1836
Shylock (the Rialto of Venice)	(once mine)	1837
Hero and Leander	1837
Val d'Aosta (Avalanche)	1837
Phryne	1838
Modern Italy	1838
The Slave-Ship (once mine)	1838
The Fighting "Téméraire"[1]	1838

FIFTH AND LAST PERIOD. 1840–1850.

Virtually, the works belonging to this period are limited to the first five years of it. His health, and with it in great degree his mind, failed suddenly in the year 1845. He died in 1851. The paintings of these five closing years are, to the rest of his work, what *Count Robert of Paris* and *Castle Dangerous* are to the Waverley Novels.[2] But Scott's mind failed slowly, by almost imperceptible degrees; Turner's suddenly with snap of some vital chord in 1845. The work of the first five years of the decade is in many respects supremely, and with *reviving* power, beautiful. The "Campo Santo, Venice," 1842, and the "Approach to Venice," 1844,[3] were, when first painted, the two most beautiful pieces of colour that I ever saw from his hand, and the noblest drawings in the present series are of the years 1842 and 1843.

Morning breaks as I write, along those Coniston Fells,

[1] [Of these pictures, "Childe Harold" is in the National Gallery, No. 516 : see above, p. 140 ; "The Golden Bough" (No. 371 in the National Gallery collection) is at Dublin : see above, p. 133 ; "Mercury and Argus" is in Lord Strathcona's collection : see Vol. III. p. 264, and plate opposite p. 638 ; "Juliet" is in that of Colonel O. H. Paine, New York : see Vol. III. p. 636 ; "Shylock" in that of Mr. Ralph Brocklebank : see Vol. III. p. 364 ; "Hero and Leander" (No. 521 in the National Gallery collection) is at Glasgow : see Vol. III. p. 242 ; the "Val d'Aosta" is in the collection of Mr. James Price ; for "Phryne" (No. 522 in the National Gallery collection), see above, pp. 107, 151 ; "Modern Italy" is in the Corporation Galleries, Glasgow : see Vol. III. p. 243 ; for "The Slave Ship," see Vol. III. p. 572, and plate opposite ; and for the "Téméraire" (National Gallery, No. 524), see above, p. 167.]

[2] [Compare above, p. 167.]

[3] [For the "Campo Santo" (now in the collection of Mrs. Keiller), see Vol. III. p. 251 ; for the "Approach to Venice" (in that of Mrs. Moir), *ibid.*, p. 251, and above, p. 164 *n.*]

and the level mists, motionless, and grey beneath the rose of the moorlands, veil the lower woods, and the sleeping village, and the long lawns by the lake-shore.

Oh, that some one had but told me, in my youth, when all my heart seemed to be set on these colours and clouds, that appear for a little while and then vanish away, how little my love of them would serve me, when the silence of lawn and wood in the dews of morning should be completed; and all my thoughts should be of those whom, by neither, I was to meet more!

BRANTWOOD, 12th February 1878.

on remarkable fells, and the level mists

were beneath the nose of the overlands, rail

the future by the lecture then

the lunar wrapt

and the sleeps villenys, and the long lawn

by the lake show

the children now have helped me

their little feannes in youth, when all my

hearts seemed to be tak in these to eleven

chents appears for a little tired, and the wind

errs. how little my love the

me. when, to add the appearance

wrned in the door of down shudder to

and all my things his, howled & of them when

by neither. I should meet them.

Brantwood. 12th February 1878

and the land mists/melancholy, and grow beneath
the ... of the meadows, void the lower weary,
and the sleeping villages, and the long leaves
by the lake-shore.

Oh, that none me had, told me, in my youth.
when all my heart seemed ... to ... on then
colour and cloudy, that ... for a little while
and then vanish away, how little my love I then
would seem me, when the silence of ... word
in the dawn of morning should be employed;
and all my thoughts should be of them when
by written, I was to ...

PREFATORY NOTE

THE drawings here shown are divided into groups, not chronological merely, but referred to the special circumstances or temper of mind in which they were produced. Their relation to the five periods of Turner's life, which are defined in the Introduction, is, therefore, a subdivided one, and there are ten groups of drawings illustrating the six periods, in the manner shown in this table.[1]

Divisions in the Introductions.	*Divisions in the Catalogue.*
SCHOOL DAYS, 1775–1800 . .	GROUP I. 1775–1800.
1st PERIOD, 1800–1810 . .	GROUP II. 1800–1810.
2nd PERIOD, 1810–1820 . .	GROUP III. 1810–1820.
3rd PERIOD, ⌠Before change . .	GROUP IV. 1820–1825.
1820–1830 ⌡During change .	GROUP V. 1825–1830.
4th PERIOD, ⌠Best England drawings . . .	GROUP VI. 1830–1840.
1830–1840 ⌡Most highly finished vignettes, etc. .	GROUP VII. 1830–1840.
5th PERIOD, ⌠Best France drawings . . .	GROUP VIII. 1830–1840.
	Best Alpine sketches GROUP IX. 1840–1845.
1840–1845 ⌡Finished drawings in realization of them for friends . .	GROUP X. 1840–1845.

[1] [In eds. 1–6 this table was differently arranged. There were only nine groups, and Periods 4 and 5 were differently arranged as follow :—

"4th PERIOD, ⌠Work for engravers. Group VI. 1830–1840.
1830–1840 ⌡Work both for engravers and for himself.* Group VII. 1830–1840.
⌡Work for himself. Group VIII. 1830–1840.

"5th PERIOD, ⌠Work for friends. Group IX. 1840–1845."
1840–1850 ⌡

* "By 'work for himself' I mean that done wholly to please and satisfy his own mind, without any reference to facilities of engraving or limitation in size or price. The 'work for friends' implies reference to their wishes, so far as possible, as will be seen."

DRAWINGS

FIRST GROUP. SCHOOL DAYS, 1775–1800

1. The Dover Mail.[1]

A drawing of his earliest boyhood, deeply interesting in the number of the elements of his character already shown to be determined.

First, *A*. his interest in sailors, and in such conditions of lower English life as were connected with them; not jesting with it, like Marryat or Dickens, but giving, so far as he could, the mere facts of it, I do not know with what personal feeling about them, how far, that is to say, the interest was joyful, how far regretful, and how far morbid. I shall return presently to this question. See No. 36.

B. The perfect power already attained over the means at his disposal. It is impossible to lay a flat wash of water-colour better than this sky is laid.

C. Perception of qualities of size, and aerial distance, the castle being already treated with almost as much sense of its vastness, and pale hue in distance, as ever was shown in his central work.

D. Love of mist, and gradations of vanishing form: see the way he dwells on the effect of the dust from the coach-wheels.

E. Perfectly decisive drawing of whatever is seen, no slurring of outline, and the effect of the dust itself got, not by rubbing out, but by pure painting.*

* I am advised by a friend and good judge that this is not so. It does not matter, however—all his beautiful mist effects in the fine drawings are unquestionably got by pure painting.

[1] [For another note on this drawing, see *Lectures on Landscape*, § 29.]

F. Conventional touch for trees; taught to the boy by his masters: conquered gradually as we shall see, by his own intense veracity, but never wholly, even to the end of life. No bad habit of youth ever can be, and I give this drawing so much importance, in description, because it shows a quite unthought-of fact in human nature, that all a *man* is (as with a crow or a duckling), *was* in the shell of him, mental vulgarity and all![1] The moral question of his life is, what of this good in him you can, *get at* and nourish; what of the bad, chain down.

2. TUNBRIDGE CASTLE. (Oxford Rudimentary Series.[2])

An example of the constant method of Turner's study, in early youth. He soon found that the yellow and blue he had been taught to use were false, and worse than useless: he cast all colour aside for a while, and worked only for form and light; not light *and shade* observe; but only gradated *light*, showing everything in the clearest and loveliest way he could. Shade proper, with its hiding and terror, was at present ignored by him altogether. Amateurs and artists of lower power are constantly betrayed into it by their inability to draw, and their love of strong and cheaply-got sensation. The little bit of reflected light under the bridge, and half tone over the boats in this drawing, is worth any quantity of sensational etchings.

The material is, I believe, Prussian blue with British ink. See illustrative sketch, No. 80.

3. PONT ABERGLASLYN.

A drawing of the same period, showing his incipient notions of mountain form. Again note (as showing his

[1] [On this subject compare *Modern Painters*, vol. iii. (Vol. V. p. 68).]

[2] [The drawing, however, was not included in Ruskin's gift to Oxford; nor was it included in the exhibition of 1900. Ruskin at various times placed drawings on loan in his Drawing School, which he afterwards removed.]

early love of mystery, carrying it right up into his fore-ground), the smoke on the left hand, painted, or rather, left *un*painted, with deliberate skill, not rubbed or washed out.

4. BERGAMO. (Oxford Rudimentary Series.[1])

This wonderful little drawing is the earliest example I can give of the great distinctive passion of Turner's nature; the one which separates him from all other modern land-scapists,—his sympathy with sorrow, deepened by continual sense of the power of death. All other recent work is done either in happy perception of natural beauty, or in morbid enjoyment of the sensation of grief; Turner alone works in a grief he would escape from, but cannot.

It is this inner feeling which, added to his perception of what was wise in practice, kept his colour dark and grave so long. This little drawing was evidently made before he had ever been abroad. It is an endeavour to realize his impressions of Italy, from some other person's sketch: the Alps, with the outline of Sussex downs, and the small square-built Bergamo, enough show this; but the solemnity of feeling in the colour and simple design of it, as in the prominence of the shrine on the hill against the sky, are unfound in any of his later works.

The touch is singularly broad: it was already becoming his practice to exercise himself, if usually in the minutest, often in the boldest execution; the latter being his ideal of method in heroic work.

5. RUINED ABBEY (unfinished). (Oxford Educational Series.)[2]

There are many drawings of this class in the National Gallery; few out of it; and of those few, it would be

[1] [In the Ruskin Drawing School; No. 127 in the Catalogue of the Rudimentary Series, reprinted in a later volume of this edition.]

[2] [No. 102 in the Catalogue of the Educational Series, reprinted in a later volume of this edition.]

difficult to find one more perfectly demonstrative of the method of Turner's work. I can never get the public to believe, nor, until they believe it, can they ever understand, the grasp of a great master's mind, that, as in fresco, so in water-colour, there can be no retouching after your day's work is done; if you know what you want, you can do it at once, *then*;[1] and if you don't, you cannot do it at all. There is absolute demonstration in this and at least fifty other such unfinished pieces in the National Gallery, that Turner did his work bit by bit, finishing at once, and sure of his final harmony.[2] When a given colour was needed over the whole picture, he would, of course, lay it over all at once and then go on with detail, over that, as he does here over white paper. I gave the drawing to the Oxford Schools to be used in examination, a copy of it being required as a test of skill.

6. Boat-Building.

By patient labour, like that in No. 5, the youth at last attains such power as we see here. Utmost delicacy, with utmost decision. Take a lens to it, you will find the teeth of the saw in the carpenter's hand, and the blocks of the shrouds, in the distant vessels. Yet the gradation of the interior of the boat is given with one dash of colour, carefully managed while wet, and the harmony of the whole is perfect. The sky is singularly tender and lovely.

Nothing more to be learned now in ways of doing: it is time for us to see what we have to do.[3]

[1] [Compare Mulready's remark cited in *Seven Lamps* (Vol. VIII. p. 19).]

[2] [See, for instance, No. 333 (for which drawing see *Modern Painters*, vol. v. pt. viii. ch. iv. § 19; and No. 409 (for which see above, p. 259).]

[3] [See additional note by Mr. Kingsley, p. 533. In the catalogue of the Exhibition of 1900, four drawings here follow which were not in the Exhibition of 1878. They were :—

Turner's First Sketch of Coniston "Old Man."

On the reverse the lions on a coat-of-arms drawn in his father's shop. Painted 1797. On the back of the frame is the following :—

"This sketch was discovered among several I was going to return to Dr. Pocock, of whom I begged it when I saw what it was. I now make

SECOND GROUP. THE ROCK FOUNDATIONS, SWITZERLAND, 1800–1810

7· LAKE OF THUN FROM NEUHAUS.[1]

The Niesen dark in centre; the group of the Stockhorn in light, in the distance.

This drawing begins the series which I hold myself greatly fortuñate in possessing, of studies illustrative of the first impression made on Turner's mind by the Alps.

To most men of the age (he was at this time five-and-twenty) they are entirely delightful and exhilarating; to *him* they are an unbroken influence of gloomy majesty, making him thenceforth of entirely solemn heart in all his work, and giving him conceptions of the vastness and rock-frame of the earth's mass, which afterwards regulated his design, even down to a roadside bank.

Six out of the nine drawings in this group are studies, not made on the spot, but records, for future use, of the actual impression received on the spot; to be afterwards completed into a drawing, if required.

And observe generally, Turner never, after this time, drew from nature without *composing*. His lightest pencil sketch was the plan of a picture, his completest study on the spot, a part of one. But he rarely painted on the spot; —he looked, gathered, considered;—then painted the sum of what he had gained, up to the point necessary, for due

it No. 1 of the Brantwood Series of Turner Drawings. John Ruskin, 22nd March 1889."
 See also " Introduction," [page 406 of this volume], regarding picture founded on this drawing. *Not in the* 1878 *Exhibition.*

KILGARREN CASTLE.
Acquired by Mr. Ruskin since the 1878 *Exhibition.*

EARLY DRAWING OF AN OLD MAN WITH MULE.
Not previously exhibited.

ST. AGATHA'S ABBEY.
Acquired by Mr. Ruskin since the 1878 *Exhibition.*

The late Dr. Crawfurd Pocock of Brighton was a collector of the works of Turner and Ruskin. The "Kilgarren Castle" was an early drawing of a subject often painted by Turner.
[1] [For another description of this drawing, see *Deucalion*, i. ch. i. § 17.]

note of it—and, much more of the impression, since that would pass, than of the scene, which would remain.

The Niesen and Stockhorn might be completely drawn at any time; but his vision of them amidst their thunder-clouds, and his impression of the stormy lake, with the busy people at its shore, careless of storm or calm, was to be kept. And kept it was, to his latest day, realized first completely in the "Lake of Thun," of the Liber Studiorum.[1]

The study itself, however, is far inferior to most of his work; the mountain is curiously heavy and overcharged in darkness; there is, perhaps, scarcely another of his drawings showing this fault to such a degree; but he was not yet well on his guard against it, and was working chiefly with a view to gain power. Hence the blackness of the Calais Pier, and other oil-paintings of this time.

8. VEVAY.

A few of the backs of the houses of the lovely old village, as they used to rise out of the lake,—the sun setting over Jura in the distance. Inestimable in its quiet tone, and grandeur of form perceived in simple things; already he shows the full passion for the mystery of light, which was to be the characteristic influence of his future art.

The drawing is otherwise interesting as a very clear example of his practice at this time in dark drawings, manufacturing his own tinted paper with a wash of grey, and taking out the lights.[2]

9. GENEVA.

This is a finished drawing, yet made more or less experimentally, in preparation for the large one, No. 70,[3] under which I shall give account of both.

[1] [The drawing for this plate is No. 474 in the National Gallery.]
[2] [This drawing was afterwards in the collection of Sir T. Gibson Carmichael, Bart.]
[3] [An error for 69. Ruskin, as already explained, was taken ill before he had completed the Notes, and he did not further refer to this drawing.]

10. BONNEVILLE, SAVOY.

A quite stupendous study, recording, probably, Turner's first impression as he drew near the great Alps. He painted it again and again, but none of the more finished realizations approach the majesty of this sketch, which adds to all its other merits that of being literally true. The grand old keep on the right with round towers at the angles, stood till within the last ten years, and was then pulled down for such use as its stones and ground would serve for; the more extensive ruins on the farther crag were about the same time bought by an "avocat" of the place, and cleared away, he building for himself a villa with a roof in the style of a Chinese pagoda, where the main tower had been. It does not in the least matter to the British public, who rarely stop now at Bonneville even for lunch; and never look at anything on the road to it, being told there is nothing to be seen till they get to Chamouni.

To me it once mattered not a little, for I used to pass months and months at Bonneville climbing among the ravines of the Mont Vergi;[1] but shall, probably, never be there again: so now *I* need not mind, neither.

In all points of composition and execution, this drawing is insuperable, as an example of Turner's grandest manner, nor has any painter in the world ever rivalled it in calm reserve of resource, and measured putting forth of strength. Mountains, properly speaking, never had been drawn before at all, and will, probably, never be drawn so well again.[2]

11. THE AIGUILLETTE (first study).

The peak forming the central subject in this drawing is the termination of a range of limestone crags, joining the Aiguille de Varens on the north, and forming a seeming pinnacle above this ravine, which descends into the valley

[1] [In the years 1860–1863, when Ruskin was living for much of the time in Savoy.]
[2] [This drawing (now in the possession of the Rev. W. MacGregor) was reproduced in *Turner and Ruskin*, vol. ii. p. 302, and in *Ruskin on Pictures*, vol. i. p. 308.]

of the Arve between the Nant d'Arpenaz and village of Maglans.

The little bridge and cottage stood exactly as Turner has drawn them, in my young days. The sketch has been quite literal; only afterwards Turner was vexed with the formality of the gable, and rubbed out a minor one in white —only its place suggested—the other still showing through. The cottage is now gone; the bridge would scarcely be noticed, the diligence road goes over so many like it. Note especially that Turner at *this* time of his work does not make things more picturesque than they are, in first sketching them; there is no coaxing or breaking the simple masonry of the commonplace arch.

12. THE AIGUILLETTE (finished drawing).

But here, when he completes the composition for a perfect rendering of his impression of the Valley of Cluse, he bends and breaks it a little, making it, so, really more true to the spirit of the place; for the bridges generally *are* curved or broken in and out a little, and this one is rare in its formality.

This drawing has been made at least five years later than the sketch; the power of drawing animals having been perfected in the meanwhile (of which presently).[1] It is unique, to my present knowledge, in grave purity and majestic delicacy among the drawings of this period. His memory fastens intensely on the first impression of the pastoral mountains, and the change, under the power of Hermes, of the white cloud on the hill into the white flocks in the valley.

He was always fond of the junction of streams; at the right hand, in the lower corner of the drawing, the strong eddies of the Arve itself mingle with the calm of the waters of the little brook ending their course. The stones through which these eddies flow indicate, by their sloping cleavage,

[1] [See below, No. 31, p. 435.]

that they are a part of the great rock system over which the cascade falls in the middle distance.

The harmony of blue and warm brown, constant in his finest early work, is here perfected. The blue of the shadowy cloud cannot be lovelier, the warm colour is concentrated by the little pitcher and horse saddle (see how little is enough!), and all thrown into light and air by the black dog.

Look carefully, and with magnifying glass, at the crowded sheep.[1]

13. THE GLACIER DES BOSSONS.

Fierce, fresh sketch, colossal in power. Directed chiefly to show the looseness of the huge tumbled blocks of moraine, and the distortion of the bent trees. The leaving the outline of the ice clear with one wash is especially characteristic of him.

This drawing has been touched with chalky white, not easily seen, except in side light; but the ice-drawing is much dependent on it.

Observe in this and the Bonneville (No. 10), that Turner is no slave to method, but unhesitatingly uses two methods when there are two textures. In both, he takes the rough near lights out roughly, and lays the light on the snow and ice smoothly. But he would only allow himself this licence when sketching. His finished work is always consistent in method, either all transparent (as No. 12) or all opaque (as No. 29). The two white parasols in No. 33 are literally the only instance known to me of his using body-white in a transparent drawing, and, I doubt not, then only because he had scratched the paper too thin to trust it.[2]

e (
wh　　　　　g is reproduced. It was also reproduced in *Turner and Ruskin*, vol. ii. p. 304. See also ii. 65 of the privately-printed *Letters to William Ward*, reprinted in a later volume of this edition.]

[2] [This sketch is now in the possession of Sir Hickman Bacon, Bart.]

14. FORTIFIED PASS IN THE VAL D'AOSTA.

Perfectly true to the place, about ten miles below Courmayeur, and a quite stupendous piece of drawing power. Note the way the outline of the foreground bush is left by the black blot of shadow, and then the whole bush created by two scratches for stems.

This scene impressed him greatly. He amplified it first into a drawing for Mr. Fawkes, and then for exhibition (alas) into the large water-colour (the "Battle of Fort Rock") now in the National Gallery, which, however, is an inferior work, terribly forced and conventionalized.[1]

15. IN THE VAL D'AOSTA.

I am not quite sure if I am right in the name of this village; its remnant of (Roman?) bridge is, I think, some eight or ten miles above Ivrea. It has been erroneously sometimes called Narni. See No. 19.

This drawing is one of the first efforts which Turner made to give Italian classical character to the landscape of the South Alps, and to impose his former refinement on his recent impressions of mountain power. It fails in many respects, especially in the ludicrous figure; he was not yet able to draw either the figure, or even animals with skill; and nearly all his power vanishes in the effort to discipline and conventionalize it: the drawing is entirely transitional—an example of the effort by which he fought up to the power of doing work like that of No. 13, a much later drawing, though I am obliged, for its relation to No. 12, to put the last first.

In both, however, the trees are still very rudely drawn, and it took some four or five years more to develop his strength into the serene splendour in which he produced the great series of Italian designs which we have next to examine.

[1] [No. 555 in the water-colour collection; see p. 268 of this volume. See also Mr. Kingsley's note, p. 534. The "fortified pass" is Fort Bard.]

THIRD GROUP. DREAMLAND, ITALY.
[1810–1820]

16. ISOLA BELLA, LAGO MAGGIORE.

Here begins a series which expresses the mind of Turner in its consummate power, but not yet in its widest range. Ordering to himself still the same limits in method and aim, he reaches, under these conditions, the summit of excellence, and of all these drawings there is but one criticism possible—they " cannot be better done."[1] Standards of exquisitest landscape art, the first of such existent among men, and unsurpassable.

We begin with the simplest, apparently; perhaps, if we had time to analyze it, the most wonderful in reality; its charm of harmony being reached through such confusion of form, and its charm of poetry through such poverty of material. Flower-pots, pedestals of statues and gravel walks, chiefly; for the statues themselves are, in the reality, commonest garden ornaments, nor otherwise here represented. But the sense of calm sunshine, of peace and purity in the distant hills, and of orderly human affection at rest in playful artifice among them, render the drawing, to myself, a very chiefly valued possession.[2]

17. TURIN, FROM THE CHURCH OF THE SUPERGA.

One of the most interesting compositions here, in its demonstration of Turner's first principle of carrying his masses by other masses.* (Compare 33.) He learned it,

* Putting the figures here as definitely for the foundation of the pillars as a Lombard would put his dragon sculptures.

[1] [For this saying of Dürer's, see also Vol. V. p. 331; Vol. VI. p. 159 n.; Vol. XI. p. 14 n.]
[2] [See Ruskin's references to it and the next drawing in *Modern Painters*, vol. iii. (Vol. V. p. 170). The drawing was engraved in Hakewill's *Picturesque Tour of Italy* (1820), and a reproduction of the plate was given in the illustrated edition of the Notes.]

without doubt, from Titian and Veronese; adopting their architecture as his ideal; but for *his* foundations, such figures as he saw, here on one side, beggars, attendant now always in the portico of palace or church. Beyond the city, the straight road through the plain was a principal object in Turner's mind, the first fifteen miles of approach to the pass of the Cenis.

The inlaid diamond-shaped mosaics in the pavement, which complete the perspective of the distance, are his own invention. The portico is in reality paved with square, slabs of marble only.[1]

18. FLORENCE, FROM FIESOLE.

Showing the enormous advance made in his tree drawing, since the thorny branches of No. 12 and No. 15. But chiefly, this piece is notable for the tenderness of its distant undulating hills; carried out with subtlety of tint and perfectness of form, quite undreamt of before Turner saw it.

He had great sympathy at this time with monks; and always drew them reverently and well. The little bend of wall within which they are placed is not really a part of the Franciscans' garden, but one of the turns of the road in the ascent to Fiesole.[2]

19. THE BRIDGE OF NARNI.

The railroad between Perugia and Rome now passes along the opposite bank of the river, the station being just outside the picture, to the right; few travellers, as they

[1] [This drawing was also engraved in Hakewill, and the plate reproduced in the illustrated edition of the Notes. For another reference to the placing of the figures in the drawing, see *Elements of Drawing*, § 220. The drawing is now in possession of Mr. C. Morland Agnew. A copy of it, made for Ruskin by Mr. W. Hackstoun, is in the Ruskin Museum at Sheffield: see in a later volume, *Report of the St. George's Guild* (1879–1881).]

[2] [Another of the Hakewill series; the plate was reproduced in the illustrated edition of the Notes, and the drawing in *Turner and Ruskin* (vol. ii. p. 310). The drawing is now in the collection of Mr. A. T. Hollingsworth.]

pass, getting even a glimpse of the grand ruin of the Roman bridge, still less of the mediæval one just above.

Turner's mind, at this time, was in such quiet joy of power, that he not so much wilfully as inevitably, ignored all but the loveliness in every scene he drew. This river is, in truth, here neither calm nor pure; it is the white and sulphurous Nar of which Virgil uses the name and the image, in the great line which, with its deep, redoubled full vowels, imitates the trumpet call of the Fury.

> "Audiit et Triviæ longé lacus, audiit amnis,
> Sulfureâ Nar albus aquâ, fontesque Velini." [1]

(Compare, by the way, for the Virgilian art—

> " —longa canoros
> Dant per colla modos ; sonat amnis, et Asia longé
> Pulsa palus.") [2]

Assuming, however, that the stream is to be calm and clear, a more lovely study of water-surface does not exist. Note again Turner's sympathy with monastic life, in the way he leads the eye by the bright trees to the convent on the hill, seen through the ruined Roman arch.[3]

20. The Falls of Terni.

"Fontesque Velini," themselves. Probably the most perfect piece of waterfall drawing in existence. The Reicheubach at Farnley and the High Fall of Tees run it hard; but they both break more into foam, which is comparatively easy; while the subtlety of the drawing of the massy veil of water here shadowing the cliff is beyond all other conquest of difficulty supreme. For pure painting of light and mist also I know nothing like it, the rock drawing through the spray showing that the work is all straightforward, there is no sponging.[4]

[1] [Æneid, vii. 517.]
[2] [Ibid., 701.]
[3] [The plate from Hakewill was reproduced in the illustrated edition of the Notes. The drawing is now in possession of Mr. George W. Agnew.]
[4] [Compare Aratra Pentelici, § 126.]

The public seem to agree with me in their estimate of this drawing. I had to give 500 guineas* for it at Christie's.

21. ROME, FROM THE MONTE MARIO.

The Turner drawings of Rome, and Tivoli, made in the first enthusiasm of his art, and with a devotion to his subject, which arose from a faith in classic tradition and classic design quite inconceivable to the dilettante temper of the modern connoisseur, will in future be held precious among European treasures of art, not only because they are the subtlest pieces of point-work executed since the best days of the Florentines, but the most accurate pieces of topography extant, either among architects or engineers, of the central city of the world.

This little drawing represents, within its compass of $8\frac{1}{2}$ inches by $5\frac{1}{2}$, every principal building in Rome, in Turner's time, so far as they could be seen from this point; and that with such earnestness and accuracy that if you take a lens of good power to it, you will find even the ruinous masonry of the arches of the Coliseum distinctly felt and indicated.

The most accomplished gem engraving shows no finer work, and, in landscape drawing, not the slightest attempt has ever been made to match it.[1]

22. NEMI.

No less true, this, than the Rome; but with clearer and lovelier light, and with a sense of whatever is most beautiful

* And more, but I forget exactly how much.[2]

[1] [For other drawings of this class, see Nos. 253–269, 590–600 in the National Gallery. A copy of this drawing made for Ruskin by Mr. W. Hackstoun is in the Ruskin Museum at Sheffield. The plate in Hakewill was reproduced in the illustrated edition of the Notes.]

[2] [Ruskin remarked in *Fors Clavigera*, Letter 76, that he had to buy in the dearest and sell in the cheapest market, "the dealers always assuring me that the public would not look at any picture which I had seen reason to part with; and that I had only my own eloquence to thank for the prices of those I wished to buy." The price paid for this drawing at the Dillon sale in 1869 was £593, 5s. The plate in Hakewill was reproduced in the illustrated edition of the Notes.]

and awful in the repose of volcanic Italy, which stayed in his mind for ever, forming all his thoughts of Fate and life. The skipping goats are meant for opposition to this key-note of beautiful terror.

Consummate in all ways. I have never seen, and would give much to see, the Hakewill drawing of La Riccia;[1] but, unless that beats it, this is the loveliest of the series.

For example of Turner's execution, see how the light tree is left, as he finishes the distant lake and crag; and note, with lens, that the houses of the village on the right are painted *before* the sea horizon, which is laid in afterwards with a wash that stops short before touching the houses.[2]

23. VESUVIUS CALM.

With the Nemi, my Hakewill possessions[3] end (to my extreme discontent), but this drawing is of the same time, and no less exquisite in work, perhaps surpassing all in qualities of delicate mist.[4]

As a composition, it is interesting in bringing us first clearly acquainted with a principle of Turner's, of which as we go on we shall see numerous instances, always to repeat a form which had become too conspicuous, and to divert the eye from it. The duplicate sails, made here so conspicuous on both sides, are thus introduced entirely to divert the eye from the too distinct duplicity of the mountain cone.[5] Compare notes on No. 33, p. 436; No. 39, p. 442; and No. 50, pp. 447–448.[6]

[1] [The "La Riccia" is in the collection of Mr. E. Steinkopff.]

[2] [The plate in Hakewill was reproduced in the illustrated edition of the Notes. The drawing is now in possession of Mr. C. Morland Agnew. For another reference to it, see p. 521.]

[3] [*A Picturesque Tour of Italy, from Drawings made by James Hakewill.* John Murray, 1820. Turner's draw from sketches by Hakewill, who was an architect. Nos. 16–22 in Ruskin's collection were all drawings of this kind.]

[4] [Eds. 1–6 add here, "and light effect, except only the distance of the Florence." The references to notes 33, 39, and 50 were first added in ed. 7.]

[5] [Compare on this point *The Harbours of England,* p. 52 above, and 63 R. below, p. 530 ; see also *Notes on Prout and Hunt,* No. 10 (Vol. XIV.).]

[6] [This drawing, No. 23, seems to have been sold by Turner to W. B. Cooke, the engraver (see Thornbury, p. 633), but it was not engraved.]

24.. VESUVIUS ANGRY.

I am very thankful to possess these companion drawings, but chiefly this one, because the engraving from it was the first piece of Turner I ever saw. It was published by Smith and Elder in their annual, *Friendship's Offering*, when I was a mere boy ;[1] and what between my love of volcanoes, and geology,—my delight in Miss Edgeworth's story of " The Little Merchants,"—and my unconscious sense of real art, I used to feast on that engraving every evening for months, and return to it again and again for years, before I knew anything either about drawing, or Turner, or myself. It is a most valued possession to me now, also, because it proves irrefragably that Turner was *reserving* his power, while he made all these tender and beautiful drawings ; that he had already within himself the volcano of fiercer fire : and that it was no change of principle or temper, but the progressive expression of his entire mind, which led him, as life wore on, to his so-called " extravagant" work, of which more presently :[2] in the meantime observe that the execution of this terrific subject is just as pure and quiet as that of the lake of Nemi, and the complex drawing of the volcanic cloud finished with the precision of a miniature.*

A good objection was made to the design by my keenly thoughtful friend, W. Kingsley.[3] He said that he believed Turner had never seen an eruption ; if he had, he would have made the falling ashes obscure the flame. I think we may receive the scene, however, as one of instantaneous

* For this drawing, and its companion, Turner had fifteen guineas each. I was obliged, at Christie's, to give three hundred and odd for " The Calm," and two hundred and fifty for " The Anger."[4]

[1.] [See *Præterita*, i. chs. v. and viii. The " Vesuvius Angry " was the third "embellishment" in " *Friendship's Offering* : A Literary Album and Christmas and New Year's Present for 1830!"]
[2] [See below, pp. 434–435.]
[3] [See above, pp. 162, 335, 370 n., and below, pp. 533–536.]
[4] [The prices paid at the Dillon sale in 1869 were £404, 5s., and £241, 10s.]

renewed eruption. The ashes will be down on us in half a
minute more, but, till that curtain falls, we can see clearly.[1]

FOURTH GROUP. REALITY. ENGLAND
AT REST. [1820–1825]

25. Heysham (Village of), Lancaster Bay and Cumberland Hills in the Distance.

This lovely drawing, with the group it introduces, shows
the state of Turner's mind in its first perfect grasp of
English scenery, entering into all its humblest details with
intense affection, and shrinking from no labour in the ex-
pression of this delight, not only in the landscape but the
sky, which is always more lovely in his English drawings
than in any other.

I cannot strictly date the Yorkshire series,[2] but in
general temper and power they are slightly in advance of
the Hakewill: the foliage more free, rich and marvellous
in composition; the effects of mist more varied and true,
the rock and hill drawing insuperable; the skies exquisite
in complex form, his first and most intense cloud painting.
(In this Heysham there is more design, and more work,
in the sky alone than would make a dozen of common
water-colour drawings; compare No. 32, p. 435, and all
this done without losing for a moment the sincere sim-
plicity of the wild country and homely people, in any
morbid or strained idealization.)[3]

[1] [For another reference to the two Vesuvius drawings, see (in a later volume) *Lectures on Landscape*, § 4, where reproductions of both are given.]

[2] [They first appeared in Dr. T. D. Whitaker's *History of Richmondshire* (1823). Nos. 25, 26, and 27 belong to this series.]

[3] [This drawing was lent in 1880 by Ruskin to an Exhibition at Douglas, Isle of ith the following note in the catalogue, p. 10 (see p. lvi.) :—

"75. Heysham *J. M. W. Turner, R.A.*

"*Note by Professor Ruskin.*—Turner's Drawing of Heysham. Made for the Yorkshire Series. 'I do not know if the village is indeed an outlying Yorkshire one. Described at length in my *Element of Drawing*, p. 325, as follows :—'The subject is a simple . . . days of toil and nights of innocence.'"

See *Elements of Drawing,* § 244. The plate was reproduced in the illustrated edition of the Notes; the drawing in *Turner and Ruskin*, vol. ii. p. 316 and *Ruskin on Pictures*, i. 318.]

26. EGGLESTONE ABBEY.

One of the finest of the series in its foliage: notable also for intense truth to the spot: the little brooklet and dingle joining the Tees on the right being not even the least displaced to bring them within the picture.

I fear the drawing is much faded;[1] I never saw it in its freshness, but suppose the distant foliated arches of the abbey were once far more distinct. The effect was always, however, one of misty diffused sunshine: and the simple colours have changed so harmoniously that I find in their faintness more to discover through mystery than to surrender as lost.

The cluster of foliage in the foreground will be seen to have been much altered before he got it to his mind, and will serve to show how easily his alterations may be detected; the tall trees on the left in their perfect freshness of straightforward execution serve for ready means of comparison.[2]

27. RICHMOND, YORKSHIRE.

A favourite subject with him: painted twice also in the England series.[3] The most beautiful of the three drawings, after engraving its outline carefully for *Modern Painters* [plate 61 in vol. v.], I gave to Cambridge, where it now leads the series of Turners in the Fitzwilliam Museum.[4] The second subject, though a lovely drawing, I got provoked

[1] [For other references to the fading of this drawing, see above, p. 343, and below, pp. 590, 592.]

[2] [This drawing is also described in *Lectures on Landscape*, § 8, where a reproduction of it is given. The plate was reproduced in the illustrated edition of the Notes. Here in the catalogue of the Exhibition of 1900 follows:—

"SCARBOROUGH.—*This drawing was acquired by Mr. Ruskin subsequent to the Exhibition in 1878.*"]

[3] [*Picturesque Views in England and Wales, from drawings by J. M. W. Turner, Esq., R.A., engraved under the superintendence of Mr. Charles Heath. With descriptive and historical illustrations* by H. E. Lloyd: 2 vols., 1838. For the other "Richmonds," see Index, p. 603, below. The engraving of this drawing was reproduced in the illustrated edition of the Notes; the drawing in *Turner and Ruskin*, vol. ii. p. 320.]

[4] [The reference is to the collection of twenty-five drawings by Turner, presented by Ruskin to the University of Cambridge in 1861: see below, pp. 557–558.]

with for having a manufactory in it; (alas, the entire scene
is now destroyed by a complete inferno of manufactory
at the base of the Castle!) and allowed Mr. Gambart to
get it from me; this last one, I don't think anybody
is likely to get, while I live. There is no more lovely
rendering of old English life; the scarcely altered sweet-
ness of hill and stream, the baronial ruin on their crag,
the old-fashioned town with the little gardens behind each
house, the winding walks for pleasure along the river shore
—all now, in their reality, devastated by the hell-blasts of
avarice and luxury.

28. Farnley.

I have no more drawings (I wish I had!) belonging to
the published Yorkshire series. My best of all, the junction
of the Greta and Tees, I gave to Oxford;[1] and these
which now follow are drawings belonging to the same
period, showing the kind of work he did for the pleasure of
English gentlemen, in the representation of their houses.

He visited much at this time: was of course always
kindly treated, and did his utmost to please his hosts by
faithful and lovely drawings of their houses.[2]

There are no drawings by his hand finished with so
great care as the good examples of this most accurately
"domestic" landscape.

This drawing of Farnley Hall is an entirely character-
istic one. The subject itself is by no means interesting;
and would not have stayed Turner for a moment in itself,
the blank broad hillside being extremely difficult to treat,[3]
and its scattered piece of wood, apparently intractable into
any grace of composition. But not a space of the park is

[1] [No. 2 in the Standard Series in the Ruskin Drawing School: see below, p. 559.]

[2] [Eds. 1–6 add here:—
 "That in after life he became 'unsociable' was in no small degree
 owing to the tenderness of feeling which rendered it impossible for him
 even to go back to a house where his first host had died."]

[3] [In eds. 1–6 "to render interesting."]

modified: just as the trees really were set, he sets them; marks carefully the line of the drive up to the house, and then applies his whole skill to lead the eye delightedly into the finitudes of distance across the moorlands; and to find minute decoration of herbage and heath among the sandstone blocks of the foreground. There is nothing more lovely, or more true, existent by his hand.[1]

29. The "Peasant's Nest," Farnley.

The drawing, kindly identified by Major Fawkes,[2] came to me with No. 9, and No. 30, from a collection in the West of England, sold in the year 1868.

It is the first example we have seen of Turner's body-colour work on grey paper, being, as before observed, totally in this manner; and not at all allowing the mixture of transparent with opaque pigment.

It will, I hope (with No. 28), put an end to the ordinary notion that Turner "could not *draw* trees." But it may very well encourage the also very ordinary, and much better founded notion, that he could not *colour* them. His dislike of fresh green is a curious idiosyncrasy in him; no drawing exists, that I know of, founded frankly on that key of colour, nor is there any evidence of his having taken any pleasure in the colours of flowers. Here, the upper foliage is grey or black, and the foreground weedy, while the real delights of such a place would have been altogether in spring-time, when all the grey trunks would have been fresh in leaf, and the primroses bright among the rocks. That the figures should be dressed only in black

[1] [See another reference to the drawing on p. 513 below, and the additional note by Mr. Kingsley, p.534. The drawing was reproduced in *Turner and Ruskin*, vol. ii. p. 320.]

[2] [In eds. 1–6 the drawing was entitled "The Summer House," and the Note began, "I am not sure if this wood walk is at Farnley or at some house in the South; the drawing came . . ." In Ruskin's copy now in the Ambleside Library (see above, p. 397) he notes: "Pheasant's, I suppose. Pet name for an old summer-house."]

and white became necessary, in this subdued key of general tones: but may perhaps also suggest some reason for it, which we cannot know.[1]

30. THE AVENUE, FARNLEY.[2]

Nearly the same tones of colour, however, are adopted here, but a gleam of blue on the white figure completes what was always Turner's ideal of a lady's dress.

A quite magnificent sketch, but grievously injured by damp and various ill-treatment. I have no idea what the original effect was in the distance—now hopelessly darkened.

FIFTH GROUP. REALITY. ENGLAND DISQUIETED. [1825–1830.]

31. SUNSHINE. ON THE TAMAR.[3]

The drawings we have hitherto examined have, without exception, expressed one consistent impression on the young painter's mind, that the world, however grave or sublime in some of its moods or passions, was nevertheless constructed entirely as it ought to be; and was a fair and noble world to live in, and to draw. Waterfalls, he thought, at Terni, did entirely right to fall; mountains, at Bonneville, did entirely right to rise; monks, at Fiesole, did well to measure their hours; lovers, at Farnley, to forget them; and the calm of Vesuvius was made more lovely, as its cone more lofty, by the intermittent blaze of its volcanic fire.

But a time has now come when he recognizes that all is not right with the world—a discovery contemporary, probably, with the more grave one that all was not right within

[1] [See additional note by Mr. Kingsley, p. 534. The drawing was reproduced in *Turner and Ruskin*, vol. ii. p. 322.]

[2] [In eds. 1–6 "The Long Walk."]

[3] [This drawing is in the Educational Series in the Ruskin Drawing School at Oxford. In one of the catalogues of that series Ruskin described it as "Pigs in Sunshine. Scene on the Tavy, Devonshire." A chromo-lithograph of the drawing is in the British Museum. The date is about 1813.]

himself. Howsoever it came to pass, a strange, and in many
respects grievous metamorphosis takes place upon him, about
the year 1825. Thenceforward he shows clearly the sense of
a terrific wrongness and sadness, mingled in the beautiful
order of the earth; his work becomes partly satirical, partly
reckless, partly—and in its greatest and noblest features—
tragic.

This new phase of temper shows itself first in a resolute
portraiture of whatever is commonplace and matter-of-fact
in life, to take its full place in opposition to the beautiful
and heroic. We may trace this intent unmistakably in the
Liber Studiorum, where indeed the commonplace prevails to
an extent greatly destructive of the value of the series, con-
sidered as a whole; the "Hedging and Ditching," "Water-
cress Gatherers," "Young Anglers," and other such plates,
introducing rather discord than true opponent emotion
among the grander designs of pastoral and mountain scenery.[1]
With this change of feeling came a twofold change of
technical method. He had no patience with his vulgar
subjects, and dashed them in with violent pencilling and
often crude and coarse colour, to the general hurting of his
sensitiveness in many ways; and, perhaps, the slight loss
of defining power in the hand. For his beautiful subjects,
he sought now the complete truth of their colour but as a
part of their melancholy sentiment; and thus it came to
pass that the loveliest hues, which in the hands of every
other great painter express nothing but delight and purity,
are with Turner wrought most richly when they are pen-
sive:[2] and wear with their dearest beauty the shadows of
death. How far he was himself responsible for this change,
and how far it was under the conditions of his London
life inevitable—and what modern philosophers would call
the development of natural law—I have no means of decid-
ing; but, assuredly, whether faultful or fated, real conditions

[1] [Compare *Modern Painters*, vol. v. pt. ix. ch. xi. The passage was quoted in
the original edition of this pamphlet : see below, p. 497.]
[2] [Eds. 1–6 add here, "verge from their quiet continually towards luxury, and
wear," etc.]

of error affect his work from this time forward, in conse-
quence of which it in many respects greatly lost its influence
with the public. When they see, gathered now together in
one group, examples of the drawings in which the calamitous
change is expressed most clearly, the public may perhaps
see how in the deepest sense their own follies were the cause
of all that they blamed, and of the infinitely greater all
that they lost.

This first drawing, however, No. 31, does not accurately
belong to the group, yet it shows already one of Turner's
specially English (in the humiliating sense) points of char-
acter—that, like Bewick, he could draw *pigs* better than
any other animal. There is also some trace already of
Turner's constant feeling afterwards. Sunshine, and rivers,
and sweet hills; yes, and who is there to see or care for
them ?—Only the pigs.

The drawing is in his finest manner, earlier perhaps than
some of the Yorkshires.

32. Work. Dudley Castle.

One of Turner's first expressions of his full understand-
ing of what England was to become. Compare the ruined
castle on the hill, and the church spire scarcely discernible
among the moon-lighted clouds, as emblems of the passing
away of the baron and the monk, with the vignette on
the title-page of Bewick's Birds.*

The hasty execution of the sky, almost with a few radiat-
ing sweeps of the brush, is most notable when compared
with the tender work in Nos. 25 or 27. I have no doubt
that at least *twice the time given to this whole drawing* of
Dudley was spent on the *sky* of the Heysham alone.

* Laid open on the table.[1]

[1] [A favourite book with Ruskin : see, for instance, *Elements of Drawing*, § 257,
Queen of the Air, § 138, *Ariadne Florentina*, § 226, and his *Notes* on it in a later volume
of this edition. The vignette on the title-page shows a tombstone, with a river covered
with boats in the foreground, and a chimney in the distance. In his copy Ruskin
wrote on one side, "The gravestone of aristocracy" ; and on the other, "Vita Nuova :
the new life of Commerce and Manufacture."]

As an example of rapid execution, however, the draw-
ing is greatly admirable; and quite faultless, to the point it
intends.[1]

33. PLAY. RICHMOND BRIDGE, SURREY.

Not so this, though in many respects a very precious
drawing to me; among other reasons, because it was the
first I ever possessed; my father buying it for me, thinking
I should not ask for another,—we both then agreeing that
it had nearly everything *characteristic* of Turner in it, and
more especially the gay figures![2]

A more wonderful or instructive piece of composition I
could not have had by me; nor was I ever weary of trying
to analyze it. After thirty years' endeavour, I finally sur-
render that hope—with all similar hopes of ever analyzing
true inventive or creative work.

One or two quite evident conditions of his artistic method
may be specified, however. Among the first, the carrying
his mass of foliage by the mass of figures (compare No. 17),
and his resolution that, in a work meant especially for a
piece of colour, there should be no *black* that did not pro-
claim itself as such. The parasols are put in the foreground
so conspicuously, to repeat and reverse the arches of the
bridge (compare notes on No. 23), and the plumy tossing
of the foliage, to repeat the feather head-dresses of the
figures.

Nothing can be more exquisite than the aërial foliage
beyond the bridge: but the sunshine throughout is partly
sacrificed to play of colour, chiefly by the extreme yellow-
ness of the grass, with blue shadows, while the lights on
the other colours are kept cool, and the shades warm, those
of the crimson shawl by the parasols being pale crimson,
with the lights white.

[1] [This drawing is referred to in *Lectures on Landscape*, § 91 ; see a later volume
of this edition, where a reproduction of it in colours will be found ; it was also re-
produced by photogravure in *Turner and Ruskin*, vol. ii. p. 324. The plate in *England
and Wales* was reproduced in the illustrated edition of the *Notes.*]

[2] [See *Præterita*, ii. ch. i. § 12.]

Note again the intensely facile, though therefore most wonderful, laying in of the sky—a few sweeps of broken cobalt blue made into cumulus clouds in a moment by two or three clusters of outline-touches. In the left-hand upper corner, however, the colouring is morbid and impossible, and the whole drawing much reprehensible in its wanton power. Compare, in relation to it, Turner's rough map of the road over the bridge to Sandycombe Lodge (Illustrative Sketches, No. 101).[1]

34. ON THE MARCH—WINCHELSEA.

Turner was always greatly interested, I never could make out why, in the low hill and humble antiquities of Winchelsea.[2] The tower and East gate, though little more, either of them, than heaps of old stone, are yet made each a separate subject in the Liber Studiorum,[3] and this regiment on the march was introduced before, in an elaborate though smaller drawing of the town from a distance, made for the Southern coast.[4] Here, the piece of thundrous light and wild hailstorm among the houses on the hill to the left is entirely grand, and so also the mingling of the shaken trees (all the grace of their foliage torn out of them by the wind) with the wild rain as they melt back into it. But he has missed his mark in the vermilions of the foreground, which fail in distinction of hues between sunlight and shade: the violently forced shadows on the field (false in form also) not redeeming the want of tone, but rather exhibiting it. He is, throughout, ill at ease, both in himself, and about the men and the camp-followers;

[1] [See below, p. 468. The "Richmond Bridge" was reproduced in *Turner and Ruskin*, vol. ii. p. 326; and the plate, from *England and Wales*, in the illustrated edition of the *Notes*. The drawing is now in the collection of Mr. G. P. Dewhurst.]
[2] [On Turner's various drawings of Winchelsea, see also *Pre-Raphaelitism*, § 52 (Vol. XII. p. 384).]
[3] [Nos. 487 and 488 in the National Gallery.]
[4] [*Picturesque Views on the Southern Coast of England*, from drawings made principally by J. M. W. Turner, and engraved by W. B. Cooke, Geo. Cooke, and other eminent engravers: J. and A. Arch. First published in 16 parts between 1814 and 1827, in 2 vols. 4to, 1826.]

partly laughing the strange half-cruel, half-sorrowful laugh
that we wonder at, also, so often, in Bewick; thinking of
the trouble the poor fellows are getting into, drenched
utterly, just as they stagger up the hill to their quarters,
half dead with heat and thirst, and white with dust.

My father gave me the drawing for a birthday present,
in 1840, and it used to hang in my rooms at Oxford; no
mortal would believe, and now I can scarcely understand
myself, the quantity of pleasure it gave me.[1] At that
time, I loved storm, and dark weather, and soldiers. *Now*,
I want blue sky, pure air, and peace.

35. LOUTH—THE HORSE FAIR.

Another drawing of what he clearly felt to be objec-
tionable, and painted, first, as a part, and a very principal
part of the English scenery he had undertaken to illus-
trate; and yet more, I fear, to please the publisher, and
get circulation for the book in quarters where the mere
picturesque was no recommendation. He dwells (I think,
ironically) on the elaborate carving of the church spire,
with which the foreground interests are so distantly and
vaguely connected.[2]

36. DEVONPORT.

By comparing the groups of figures in this drawing with
those in the other four which I have arranged with it
(Nos. 33 to 37), and the boy's drawing, No 1, I think
it will be seen that much of what the public were most
pained by in Turner's figure drawing[3] arose from what
Turner himself had been chiefly pained by in the public.
He saw, and more clearly than he knew himself, the
especial forte of England in "vulgarity." I cannot better

[1] [See *Præterita*, ii. ch. i. § 13, and compare the letter to Liddell, given in Vol.
III. p. 673.]
[2] [The engraving of this drawing was reproduced (from *England and Wales*) in the
illustrated edition of the *Notes*.]
[3] [On the subject of Turner's figure-drawing, see above, pp. 151–155.]

explain the word than by pointing to those groups of Turner's figures exaggerating this special quality as it manifested itself to him, either in Richmond picnics, barrack domestic life, jockey commerce, or here, finally, in the general relationships of Jack ashore. With all this, nevertheless, he had in himself no small sympathy; he liked it at once and was disgusted by it; and while he lived, in imagination, in ancient Carthage, lived, practically, in modern Margate. I cannot understand these ways of his; only be assured that what offends us in these figures was also, in a high degree, offensive to him, though he chose to paint it as a peculiarly English phenomenon, and though he took in the midst of it, ignobly, an animal English enjoyment, acknowledging it all the while to be ugly and wrong.

His sympathy with the sailor's part of it, however, is deeper than any other, and a most intimate element in his whole life and genius. No more *wonderful* drawing, take it all in all, exists, by his hand, than this one, and the sky is the most exquisite in my own entire collection of his drawings. It is quite consummately true, as all things are when they are consummately lovely. It is of course the breaking up of the warm rain-clouds of summer, thunder passing away in the west, the golden light and melting blue mingled with yet falling rain, which troubles the water surface, making it misty altogether, in the shade to the left, but gradually leaving the reflection clearer under the warm opening light. For subtle, and yet easily vigorous drawing of the hulls of our old ships of war, study the group in the rain, no less than the rougher one on the right.[1]

37. Gosport.

A delightful piece of fast sailing, whether of boats or clouds; and another of the wonderful pieces of Turner composition which are delicious in no explicable manner. It

[1] [For a further reference to this drawing, see p. 593, below. It was reproduced in *Turner and Ruskin*, vol. i. p. 122, and is now in the collection of Mr. Fairfax Murray.]

was the second drawing of his I ever possessed, and would be among the last I should willingly part with. The blue sky, exquisitely beautiful in grace of indicated motion through fast-flying white clouds, seems revealed there in pure irony; the rude figures in the boat being very definitely terrestrial and marine, but not heavenly. But with them we close our study of the Disquietudes.[1]

SIXTH GROUP. MEDITATION. ENGLAND
PASSING AWAY. [1830–1840]

38. SALISBURY.

The seven drawings placed in this next following group are entirely fine examples of the series known as Turner's "England and Wales,"[2] representing his central power and dominant feelings in middle life, towards his native country.

If the reader will cast his eye down the column of their titles in the introductory table, I think he ought to be struck by the sequence of these seven words, expressing their essential subjects:—

> CATHEDRAL.
> CASTLE.
> CASTLE.
> CASTLE.
> CASTLE.
> ABBEY.
> ABBEY.

He may suppose at first that I myself chose these subjects owing to my love of architecture. But that is not so. They have come to me as Fate appointed, two of them,

[1] [For another reference to this drawing, "our second Turner," see *Præterita,* ii. ch. i. § 12. It was reproduced in *Turner and Ruskin,* vol. i. p. 110; and the engraving of it, from *England and Wales,* in the illustrated edition of the *Notes.*]
[2] [See note on p. 430 above.]

long coveted, only last year;[1] all of them bought simply as beautiful Turner work, and not at all as representations of architecture. But so it is, that every one of the seven was composed by Turner to do honour to some of those buildings of which it is England's present boast that she needs no more. And, instead of Cathedrals, Castles, or Abbeys, the Hotel, the Restaurant, the Station, and the Manufactory must, in days to come, be the objects of her artists' worship. In the future England and Wales series, the Salisbury Terminus, the Carnarvon Buffet, the Grand Okehampton Hotel, and the United Bolton Mills will be the only objects thought deserving of portraiture. But the future England and Wales will never be painted by a Turner.[2]

This drawing is of unsurpassable beauty in its sky, and effect of fast-flying storm and following sunbeams: it is one which also I think every lover of art should enjoy, because it represents in the sweetest way what all have seen, and what it is well within the power of painting to imitate. Few of the public now ever see a sunrise, nor can the colours of sunrise be ever represented but feebly and in many respects inharmoniously, by art; but we all of us are sometimes out in April weather; and its soft clouds and gentle beams are entirely within the scope of Turner's enchantment and arrest. No more lovely or skilful work in water-colour exists than the execution of the distance in this drawing.[3]

39. LANGHARNE CASTLE, COAST OF SOUTH WALES.

Described at length in *Modern Painters*.[4] Its sweeping sea is very grand; but the chief wonder of the drawing to

[1] [Namely, the "Carnarvon" and the "Leicester"; bought at the sale of the former collection of Munro of Novar (see *Fors Clavigera*, Letter 85), in 1877, for £798 and £651 respectively. At the same sale Ruskin bought the "Narni" (No. 19 here) for £619, 10s.; and "Louth" (No. 35) for £430.]

[2] [In Ruskin's copy now in the Ambleside Library (see above, p. 397) he emphasises this passage by double lines.]

[3] [For a further reference to this drawing, see p. 593, below. It was reproduced in *Turner and Ruskin*, vol. ii. p. 330, and is now in the collection of Mr. George Coats.]

[4] [See, in this edition, Vol. III. pp. 564–566.]

my present mind is in the exquisite stone and ivy drawing of the grey ruin.

Among the artifices of repetition, before noticed as frequent in Turner's design,[1] those used in this case are very notable. The castle was too simply four-square in its mass to be entirely satisfactory to him; so he shows the much more cubic packages of the wreckage, repeating the quality of masonry in them, by their cross cords and divisions; compare the oar in No. 50; and the narrow turret and broader tower of the castle being repeated so as to catch the eye too distinctly, he *triples* them with the piece of floating mast and foretop,—and thus diffuses their form over the drawing, as he diffused the arches of Richmond Bridge with the parasols.[2]

40. CARNARVON CASTLE.

Quite one of the most exquisite pieces of Turner's twilight mist. Its primrose-coloured sky has been often objected to, but this is only because Turner is resolved to have the true colour in opposition to his violets, and as he cannot give the relative light, persons who look for effects of light only are always offended. But any one with real eyes for colour, who will look well into the drawing of the rosy towers, and purple mountains and clouds beyond the Menai, will be thankful for them in their perfectness, and very glad that Turner did not what a common painter would, darken them all down to throw out his twilight.[3]

41. FLINT CASTLE.

This is the loveliest piece of pure water-colour painting in my whole collection; nor do I know anything elsewhere that can compare, and little that can rival, the play of light

[1] [See above, p. 427.]

[2] [See above, p. 436. For a further reference to this drawing, see p. 343, above. The engraving, from *England and Wales*, was reproduced in the illustrated edition of the *Notes*. The drawing is now in the collection of Mr. F. Stevenson.]

[3] [See additional note by Mr. Kingsley, p. 534. The engraving is reproduced from *England and Wales* in the illustrated edition of the *Notes*. The drawing is now in the collection of Mr. R. E. Tatham.]

on the sea surface and the infinite purity of colour in the ripples of it as they near the sand.

The violent green and orange in the near figures are in themselves painful; but they are of invaluable use in throwing all the green in the water, and warm colours of the castle and sky, into aërial distance; and the effect of the light would have been impossible without them.[1]

42. OKEHAMPTON CASTLE.

I have arranged these drawings to illustrate Turner's versatility. The contrast between the iridescent sea and misty morning woods must, it seems to me, be felt with pleasant surprise. Remember what division of subject there used to be among old painters, how Hobbima and Both were always in thickets, Cuyp in calm fields, Vandevelde on grey sea,—and then think how this man is woodman, or seaman, or cragsman, or eagle in cloud, at his will.

Here we have another pretty instance of the conquest by iteration. The pyramidal form of the castle mound, too conspicuous, is repeated twice over by the angular blocks of sandstone in the foreground; and we are not compelled any more to climb it, whenever we look. The smoke of the sportsman's shot repeats the mist on the far away hills. (I wish Turner had fallen on some gentler expedient.) The winding valley in the left-hand distance, painted with little more than a single wash, and a scratch of light through it, may be taken for example of the painter's loveliest work at speed; but the sky is unusually careless.[2]

[1] [This drawing is also referred to in § 91 of *Lectures on Landscape*; see a later volume of this edition, where a reproduction of it in colours will be found. The engraving, from *England and Wales*, was reproduced in the illustrated edition of the *Notes*. The drawing is now in the collection of Mr. George Coats. The point about the green is noticed again in a letter to E. S. Dallas, of July 8, 1878, reprinted in a later volume of this edition, from *Letters from John Ruskin to Various Correspondents*, 1892, p. 71.]

[2] [The words "but . . . careless" were first added in ed. 7. The drawing is reproduced in Vol. III. of this edition, p. 410; also in *Turner and Ruskin*, vol. i. p. 86. The engraving, from *England and Wales*, is reproduced in the illustrated edition of the *Notes*. The drawing passed from Ruskin's collection into that of Mr. James Orrock, at whose sale in 1904 it was bought by Messrs. Agnew for 950 guineas.]

43. LEICESTER ABBEY.

Every way consummate, but chiefly in the beautiful drawing of the towered wall of the moat, of the willow branches, and the stepping-stones.

The sunset and moonrise thus associated are not meant to be actually contemporaneous. Strictly, this is two pictures in one; and we are expected to think of the whole as a moving diorama.[1]

44. BOLTON ABBEY.

A deservedly celebrated drawing, analyzed at length in *Modern Painters*. A proof of my own etching from the rocks, in first state, is among the other engravings.[2]

Glorious as the rock drawing is, and beautiful as the flow of the dark stream, I regret the exaggeration of mountain scale which he admitted to fulfil the strength of his mental impression. This habit gained on him in later years injuriously; and though this Bolton is unrivalled as a piece of lovely art, I denied myself more in giving to Oxford the quiet sincerity of transcript with which his younger spirit reverenced the streams of Greta and Tees.[3]

SEVENTH GROUP. MINSTRELSY. THE PASSIONATE PILGRIM. [1830–1840]

45. STAFFA. VIGNETTE TITLE-PAGE TO THE "LORD OF THE ISLES."

All the designs of Turner until middle life had been made, it must be remembered, either in his own natural

[1] [The engraving, by W. R. Smith (1834), is reproduced in the illustrated edition of the *Notes*.]

[2] [*i.e.*, a collection of engravings on view at the same time in the Fine Art Society's rooms. The principal reference in *Modern Painters* to the drawing is in vol. iv. (Vol. VI. pp. 303–308). There are many other references. Ruskin's etching from the rocks is reproduced as Plate 12 in vol. iii.; a reproduction of Lupton's engraving is Plate 12A in vol. iv. The engraving of the drawing in *England and Wales* was reproduced in the illustrated edition of the *Notes*; the drawing in *Turner and Ruskin*, vol. i. p. 82. It passed from Ruskin's collection into that of Mr. James Orrock, at whose sale in 1904 it was bought by Messrs. Agnew for 980 guineas.]

[3] [For a description of the drawing referred to, see, in a later volume of this edition, *Catalogue of the Standard Series*, No. 2.]

feeling, or under the influence of classic writers only. In Italy he was guided by Virgil and Ovid, in England by Thomson and Pope. But his work under Mr. Rogers brought him into closer relation with modern thought; and now for some seven or eight years he works chiefly under the influence of Scott and Byron, this phase of his mind being typically represented by the "Childe Harold."[1]

The vignettes to Rogers' *Italy* (all but one, in the National Gallery: Nos. 201–230) were simply his own reminiscences of the Alps and the Campagna, rapidly and concisely given in right sympathy with the meditative poem they illustrate. They are entirely exquisite; poetical in the highest and purest sense; exemplary and delightful beyond all praise.

The illustrations to Scott and Byron[2] were much more laboured, and are more or less artificial and unequal. I have never been able to possess myself of any of the finest; the best I had, Ashestiel, was given to Cambridge.[3] The group shown in the following series represents them very feebly, one only, the Plains of Troy, being of their highest class, and even that not well representing its order.

This vignette of Staffa (Fingal's Cave) I bought only the other day[4] for its geology, there being no other such accurate drawing of basaltic rock (note the hexagonal outline of the column used in the decoration). But it is interesting also in its effect of light (looking out of the cave to the sea), and in the wonderful outline drawing of the rich decoration.[5]

[1] [No. 516 in the National Gallery, p. 140 of this volume.]

[2] [Turner provided a series of sixty-five vignettes for Cadell's edition of Scott's prose and poetical works in 1834. The illustrations to Byron appeared in Murray's octavo edition in eleven vols. (1825); in Finden's *Illustrations to Byron* (1833); and in the edition of Byron in seventeen vols. (1834).]

[3] [See below, p. 558.]

[4] [The drawing was bought at the Munro sale in 1877 for £115, 10s.]

[5] [This drawing was lent to the Douglas Exhibition of 1880. In the catalogue appeared the following "Note by Professor Ruskin":—

"Fine work of his middle period, the bit of wild sailing sketched on the right in the ornamentation showing his perfect power of outline drawing."

The engravings of this drawing, and of Nos. 46–51, were reproduced in the illustrated edition of the *Notes*.]

46. LOCHMABEN.[1]

Average vignette work, the subject not greatly interest-ing him. I have never seen it, but suppose the masses of ruin to be nearly shapeless and unmanageable, except in the distance. I am glad to have it, nevertheless, for the sake of the Bruce.[2]

47. ROUEN.

One of the most exquisitely finished of the Scott series, but forced in effect to suit the purposes of engraving. Compare notes on No. 56.[3]

48. FOUNTAIN, CONSTANTINOPLE. ·

One of the Byron vignettes. These are all finished with extraordinary labour; there is as much drawing in the left-hand distance of this, alone, as in some of the Rogers *Italy* vignettes altogether. But it is like cameo-work, and takes more trouble to look at it than it is worth.

The painting of the little china vase in front, in its complete expression of porcelain with so few touches, is executively very admirable.

49. THE PLAINS OF TROY.[4]

One of the most elaborate of the Byron vignettes, and full of beauty. I need not hope to make the public believe that the meaning of the sunset contending with the storm is the contest of the powers of Apollo and Athene; but there is nevertheless no question as to the fact. For Turner's grasp of Homeric sentiment was complete from the day he painted Chryses praying to the sun as it lightened in going down, over the surf of the beach,[5] through the

[1] [The drawing of Lochmaben is now in the collection of Sir Donald Currie, G.C.M.G. The vignette appeared in vol. iii. of Scott's *Poetical Works* (1834): the castle was the home of the Bruces; it was rebuilt by Robert Bruce.]

[2] [Here in the catalogue of the Exhibition of 1900 follows :—
"THE AVALANCHE; UNPUBLISHED DRAWING FOR ROGERS' 'ITALY.'"]

[3] [This "Rouen" is now in the collection of Mr. F. Stevenson.]

[4] [For a reference to the fading of this drawing, see p. 343, above, and p. 592, below.]

[5] [Turner's drawing of Chryses, priest of Apollo, was exhibited in 1811. It is now in the collection of Mr. Thomas Ashton.]

crimson sunrise of the Polyphemus, with the horses of
Apollo *drawn* in the orb,[1] down to this piece of passionate
pilgrimage, the Childe always leading him, whose true love
was at last known "from another one"[2] at Missolonghi.

I hope Dr. Schliemann may like it a little; let me at
least thank *him* with reverent heart for all his life's work,
and *its* passionate pilgrimages.[3]

50. CORINTH.

This and the next following belong to the series of
illustrations of Palestine,[4] to which Turner gave his utmost
strength, as far as he knew himself at this time in what his
strength lay. He had never been in Palestine—(his time
for *that* pilgrimage is perhaps to come)—and the drawings
have grave faults, but are quite unrivalled examples of his
richest executive power on a small scale. My three best
("Solomon's Pool," "Lebanon," and "Jericho") were given
to Cambridge and Oxford,[5] but these that I have left are
not unworthy. The crowded figures of the foreground here
are meant in illustration of St. Paul's trade: "By their
occupation they were tent makers."[6] You will dislike them
at first, but if they were not there, you would have felt
the white houses a painful interruption to the Acropolis—
as it is they are a reposeful space of light. The square oar

[1] [No. 508 in the National Gallery, p. 136 of this volume.]

[2] [*Hamlet*, Act iv. sc. 5. As in Ophelia's song, the "true love" is known "From another one" by the cockle-hat and staff, so, at Missolonghi, Byron's true love was known to be, not the Guiccioli or any other lady, but "Glory and Greece": see the poem entitled "On this Day I complete my Thirty-Sixth Year."]

[3] [Dr. Schliemann's *Troy and its Remains* had been published in 1875; his *Mycenæ* in 1878. That Ruskin was much interested in Schliemann's work appears also in a letter to Mr. F. S. Ellis, dated June 30, 1875: "I have just seen an article in the *Telegraph* on Dr. Schliemann—the excavator in the Troad—which refers to his 'autobiography.' I am intensely desirous to see this, but fear there may be no translation. Can you refer me to any completer account of the grand fellow than this absurd *Telegraph* one?"—*Letters to F. S. Ellis*, p. 32, reprinted in a later volume of this edition.]

[4] [These appeared in the following work: *Illustrations of the Bible from Original Sketches taken on the Spot*, engraved by W. and E. Finden, with descriptions by the Rev. T. H. Horne, B.D., 2 vols., 1836. The drawings were made by Turner, Callcott, and Stanfield, from sketches by various travellers: see additional note by Mr. Kingsley, p. 534.]

[5] [See below, pp. 558, 560.]

[6] [Acts xviii. 3.]

in front is to repeat and conquer their squareness; the little
triangular flag, to join them with the Acropolis slope; and
their divided masses to echo its duplicity.[1]

51. JERUSALEM—THE POOL OF BETHESDA.

From the engraving of this drawing, lent me by one of
my girl companions when I was a youth of fourteen,[2] I
first learned what real architectural drawing was. I believe
it to have been one of the subjects which Turner accepted,
when other artists had refused it as intractable, the mere
square angle of blank walls seeming a hopeless difficulty.
But the artifices of shadow or mist and transparent ray, by
which he has dealt with it, are too laborious, and by no
means wholly true or defensible.; to be reverenced only as
his effort to do all his best in a sacred service. I hope
that the infinite care and finish thus given, in his advanc-
ing age, to subjects not in themselves pleasing to him,
will be a practical lesson to the careless egotism in which
the rising race of young painters too often waste their
narrower power.[3]

EIGHTH GROUP. MORNING. BY THE
RIVERSIDES. [1830–1840]

52. PONT DE BUSEL?[4]

From the more or less conscientious, but mistaken tem-
per, in which Turner worked for the illustration of the
thoughts of others, and of scenes in which he had little

[1] [The drawing was reproduced in *Turner and Ruskin,* vol. ii. p. 334.]
[2] [The sister of his friend Richard Fall; see *Præterita,* i. ch. viii. § 176.]
[3] [This drawing was lent by Ruskin to the Douglas Exhibition of 1880. In the
catalogue appeared the following "Note by Professor Ruskin":—
 "Best work in his latest manner, drawn for Finden's Bible Series (not
 from his own sketch)."
See also additional note by Mr. Kingsley, p. 534.]
[4] [In eds. 1–6 "Pont de Basel"; on the title, see below, p. 598.]

personal interest, he was continually recalled by the impressions on his own mind, in his later Continental journeys. These he got into the habit of recording, chiefly for his own pleasure, in the masses of studies which between 1803 and 1845 accumulated in bundles and rolls, seen by none, until my work upon them in the National Gallery after his death.[1] Of these "personal" subjects, he realized two connected series on the French Rivers; of which the subjects on the Seine are on the whole the most *wonderful* work he ever did, and the most admirable in artistic qualities. Those on the Loire, less elaborate, are more majestic and pensive. Fortune enabled me to possess myself of this complete series, and to place it, for the foundation of our future art schooling, in the Galleries of Oxford.[2] Of Seine subjects, fortune gave me one, the Rouen, No. 56, on the whole the mightiest piece of work in these rooms next to the Goldau (No. 65). Of the unpublished drawings I obtained, belonging to the same period, one on the Loire, quite inestimable, was given to Oxford (Standard Series No. 3); five others are here, variously characteristic, but it is in the National Gallery that his work of this class can alone be adequately studied. It is notable always for its pensiveness—the chief feeling on his mind being now the sorrow of declining life—with an eternity of beauty in his thoughts.

I do not know where the scene of this little mountain study is; there are thousands of such among the southern hills of France; and the name I have given, Busel, is a conjecture only from the indecipherable inscription. Perhaps I love the little drawing more for remembering many a drive down hill to such bright and sunny bridges, in the old days when one saw rivers sometimes as one crossed them, and went up and down hills instead of underneath them.[3]

[1] [See above, pp. 81–83, 189–190, 319–322, and Introduction, p. xxxvi.]
[2] [See below, p. 559.]
[3] [This drawing is now in the collection of Mr. G. Harland Peck.]

53. Dinant, on the Meuse.

It will be seen both in the last drawing and this how absolutely determined Turner's execution was, leaving the grey or warm tinted paper entirely untouched for part of his ground colour. This Dinant is a study of the highest quality, the rock drawing under the fort insuperable.

54. On the Rhine.

The place must be recognizable enough; but almost any reach of the *old* Rhine, with village below, and towers above, served Turner for such a drawing. I say the *old* Rhine, for I suppose these villages, with their little remnant of walls, tree-planted, and clustered gables, and arched bridges over the mountain brooks, are all gone now, and nothing but the rail-station and steamer quay any more visible.

This drawing is one of the most precious I have; to me quite inestimable in expression of pure white in warm sunlight. It is so difficult to keep warm in so bright and unsubdued a tone. The basalt rock drawing is also entirely grand.

55. Twilight.

An example of the extremely simple things which Turner would often set down note of, as if he was afraid of forgetting these, while more splendid effects of sky or scene might often be trusted to memory: there is no record whatever, for instance, of the effect of the sunset for the next following drawing; only a pencil outline, one of three on the same leaf, now in the National Gallery.[1] This little study of twilight is very lovely in tone, and characteristic of the pensive temper in which he was now working.[2]

[1] [No. 566 : see above, p. 273.]
[2] [Referred to at p. 463, below, as " Rolandseck."]

56. ROUEN, FROM ST. CATHERINE'S HILL.

No drawing in the great series of the "Rivers of France" surpasses this, and few equal it. It is beyond all wonder for ease, minuteness, and harmony of power; perfectly true and like the place; also inestimable as a type of Turner's consummate work.

If any foreign master of landscape painting, hitherto unacquainted with Turner, wishes to know his essential strength, let him study this single drawing, and try to do anything like it.

I have never been certain of the material used by Turner in his drawings on grey paper. It is often common white chalk washed up, and I believe in all cases some preparation of chalk, the difficulty of working with which is trebled by its effect being unseen till dry.[1]

It has before been noticed that Turner always signs a locality with some given incident; the diligence coming up the hill and passengers walking therefore occur in both the views of Rouen, Nos. 47 and 56. There is no comparison, however, between the two drawings in general quality: the smaller of them was conventionalized and much spoiled by direct reference to engraving; No. 56 is the record of a real impression, carried out for its own sake.[2]

NINTH GROUP. AGAIN THE ALPS. [1840–1845]

57. TELL'S CHAPEL, LAKE LUCERNE.

Between the years 1840 and 1845, Turner went every summer to Switzerland, finding, it seemed, new strength

[1] [See additional note by Mr. Kingsley, p. 534. Mr. William Ward wrote for Ruskin an account of a description of Turner's methods in his body-colour drawings on grey; see *Letters to Ward*, 1893, ii. 71 (reprinted in a later volume of this edition). The account itself is given below, p. 615. This was one of the drawings most prized by Ruskin: see *ibid.*, ii. 57.]

[2] [This drawing is now in the collection of Mr. Henry Yates Thompson, in London. For another reference to it, see above, p. 273; and *Modern Painters*, vol. i. (Vol. III. p. 388). It is reproduced in *Turner and Ruskin*, vol. ii. p. 200; and the engraving in the illustrated edition of the *Notes.*]

and pleasure among the scenes which had first formed his power. Every day, on these excursions, furnished him with many more subjects for complete pictures than he could at all sufficiently express, and he could not bear to let any of these escape him. His way was, therefore, to make rapid pencil note of his subject on the spot; and it seems, at his inn in the evening, to put so much colour on his outline as would recall the effect to his mind.[1] The five examples of such sketches here given, Nos. 57 to 61, give good idea of their general manner, but all the finest of this kind are in the National Gallery.[2]

This first, No. 57, is very slight, but a lovely record of his retained impression of the Chapel, first drawn by him in the exquisite vignette for Rogers.[3] The traveller now passes, at his choice, by the rail behind the chapel, or steamer in front of it. Its legend is no more—and its lake —will doubtless be made a reservoir in due time.[4] Compare No. 70.

58. Dazio Grande.

On the Italian side of the St. Gothard, two miles above Faido. Magnificent. See notes in Epilogue.[5]

[1] [Eds. 1, 2 insert here:—
　　"Favourite subjects he would carry forward further; with some, he seems scarcely to have been able to stop till he had made finished drawings of them, and in some cases the sketch arrested at this point was better than the drawing afterwards completed from it. (See notes on No. 64.)"
Eds. 3–6 repeat the passage, but omit the words "See notes on No. 64." When Ruskin came to write the note on No. 64, this point was not made, and the passage was in ed. 7 and later omitted.]

[2] [See above, pp. 189 *seq.* See also p. 477, below.]

[3] [No. 213 in the National Gallery. Eds. 1–6 read, instead of this reference to the Rogers vignette, "impression of the 'Sacred lake, withdrawn among the hills.'" This line from the *Italy* was afterwards used in the note to No. 70. So also the words "for the town of Basle," which in eds. 1–6 followed "reservoir." The words "Compare No. 70" were also added in ed. 7. The drawing No. 57 is now in the collection of Sir Hickman Bacon, Bart.]

[4] [An allusion to the Manchester waterworks at Thirlmere: see below, p. 517 and *n.*]

[5] [Ruskin did not carry out his intention of referring to this drawing in the Epilogue. The drawing No. 58 is now in the collection of Mr. R. C. Edwards.]

59. BELLINZONA.

Or at least, the Ticino, two miles below Bellinzona, the
opening valley to the pass of the Bernardino in distance.
This drawing shows the pencil outline made on the spot
more clearly than the others; the more that it has not been
followed in the mountain masses on the right, but modified
into quite new forms. The fury of the rushing white water
modelled into masses with a few sweeps of the brush, and
the lovely infinitude of aërial peaks beyond, are in his finest
manner.

60–61. THE BRIDGE.

I am always in hopes of being told by some traveller
where this bridge is; a very notable one over a wide river,
by evidently an important city.[1]

TENTH GROUP. SUNSET.[2] [1840–1845]

See Epilogue for notes, on these, the noblest drawings
ever made by him for passion and fully developed power.
Failing only in some qualities of execution, never attainable
but by the scrupulous patience of youth; and in some of
delineation incompatible with their effects of light, and of
magnitude.

Only six of the nine drawings in this group, however,
belong to it properly; the other three (67, 68, and 69) are
placed with it for illustration, belonging themselves to much
earlier dates.

[1] [Here, in ed. 1, this part of the catalogue ends; in eds. 2–6 the Notes end, Nos.
62–70 being enumerated without comment, and the Illustrative Studies (with notes)
at once following. The Notes on Nos. 62–70 and the arrangement of a tenth group
first appeared in ed. 7.]

[2] [For another reference to these "Sunset" drawings, see p. 556 below.]

62. Coblentz.

The old bridge over the Moselle, Ehrenbreitstein in the distance on the left. Last minutes of sunset, the river mists rising.[1]

Painted for me by Turner in 1842, and now literally the only existent drawing which gives a complete idea of the ideal of purple and golden colour in which his later work for the Academy was done, or of its exquisite execution. The "Sun of Venice," the San Benedetto looking towards Fusina, the "Approach to Venice,"[2] the "Cemetery at Murano," and such others, were all as exquisite as this; but they rotted, rent, faded, and mouldered away in miserable patches of variously deforming changes, *darkening* in spots; but to the rich colours bringing pallor, and to the subtle ones, absolute effacement. Cleaning, and retouching over cracks, followed, and the ruin is now total. This drawing alone remains to show what they once were, and how they were painted. There is nothing in painters' work of any time more exquisite, as any painter may quickly find out, who will try to copy the right-hand side of it, with the gliding boat, struck with a few lines of brown and vermilion over the exquisitely laid ground of blue and purple; or who will similarly work out a square inch of the reflections on the left under the bridge.[3]

63. Constance.

Another drawing of the year 1842, and a greater and better one than the last, but not so entirely illustrating his

[1] [For another note on this picture, see on p. 475 n. the first version of the Epilogue, written before any note had been supplied in the catalogue. Mr. Arthur Severn made two copies of this drawing; one is at the Ruskin Museum, Sheffield (see, in a later volume, *Report of the St. George's Guild*, 1879–1881); the other, touched by Ruskin, belongs to Mr. Wedderburn, who once asked Ruskin if the colour of the

to

[2] [Compare notes on the National Gallery Turners, pp. 163–164.]
[3] [The original sketch for this drawing is No. 280 in the National Gallery, p. 194 of this volume. The drawing itself is discussed in the *Elements of Drawing*, §§ 196, 218, where a rough sketch of it is given. The drawing, here reproduced, was also given in *Turner and Ruskin*, vol. ii. p. 338. It is now in the collection of Mr. J. F. Haworth.]

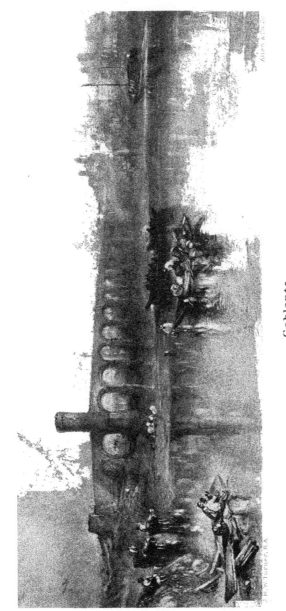

Coblentz

From the drawing in the possession of J.F. Haworth. Esq.

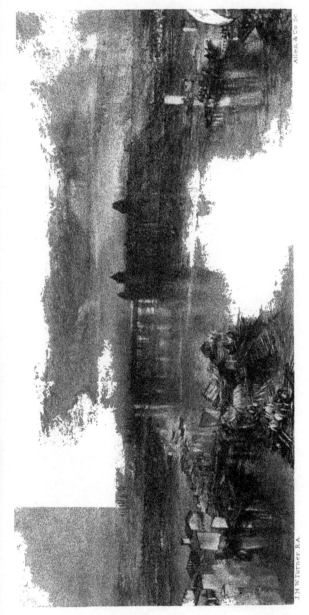

Constance

From the drawing in the possession of R.E.Tatham, Esq

J.M.W.Turner, R.A.

Allen & Co sc

Academy pictures, because the sky here is laid in with a magnificently bold first wash, and the green reflections on the left with the same audacity, while his Academy pictures at this time were laboured throughout like No. 62.

Part of the Lake of Constance is seen, pale behind the city, retiring under the far-away blue clouds, from behind which the sun is just going to rise. There are many points of resemblance here to the composition of the "Leicester Abbey,"[1] and both drawings are consummate work of their time, but the "Constance" is unique in its luxury of colour.[2]

64. LAKE OF ZUG—EARLY MORNING.

The town of Arth seen yet in shadow over the inner bay of the lake; the first rays of rosy light falling on the nearer shore. The sunrise is breaking through the blue mist, just above the battle-field of Morgarten. The two Mythens which protect the central and name-giving metropolis of Switzerland, Schwytz, are bathed in his full light.

Painted a year later, for Mr. Munro of Novar, with less care for the painting, and more for the facts. (See Mr. Kingsley's note, p. 534.) An inestimable drawing, but with bad faults, of which I need not point out more than the coarse figure drawing, and falsely oblique reflection of the sun.[3]

65. GOLDAU.

Lake of Zug in distance, seen like a lake of lava under the fiery sunset. Under the dark masses of rock in the foreground lies buried the ancient village of Goldau. The

[1] [See above, p. 444.]

[2] [The original sketch for this drawing is No. 286 in the National Gallery, p. 199 of this volume. For some remarks on the drawing, see the first version of the Epilogue, written before any note had been supplied to this drawing, p. 475 n. The drawing, here reproduced, was also given in *Turner and Ruskin*, vol. ii. p. 340. It is now in the collection of Mr. R. E. Tatham.]

[3] [The drawing was engraved in *Modern Painters*, vol. v., Plate 87, and the plate was reproduced in the illustrated edition of the *Notes*. For the original sketch, see National Gallery, No. 97, p. 202, above, where further particulars are given.]

spire of the village of Arth, the same which glitters through
the morning mist in No. 64, is here seen as a point of fire
at the edge of the distant lake.

Painted for me in 1843 (with No. 64 for Mr. Munro).
Engraved in *Modern Painters*, being on the whole the
mightiest drawing of his final time.[1]

66. PASS OF ST. GOTHARD.

Just above Faido. Painted for me, with No. 65, in
1843: etched by myself, and described at length in *Modern
Painters*, to which I must refer the reader: some notes on
the selection of the subject are however added here in the
Epilogue.[2]

67. ARONA, LAGO MAGGIORE.

I have placed this drawing next to the one representing
the fury of the Ticino on its Alpine bed, that the reader
may compare the calm of the lake with the passion of the
river; and feel the infinite sympathy of the painter with
them both. Vesuvius in his two moods, not more marvel-
lously opposed. The Arona is far the earlier drawing, made
originally for the *Keepsake* Annual.[3] The towers defending

[1] [The original sketch from which this drawing was made is No. 98 in the National
Gallery: see p. 202 of this volume. In the catalogue of the Exhibition in 1900
here follows another drawing :—
 "LINLITHGOW CASTLE."]

[2] [See p. 485. The original sketch for this drawing (now in the collection of Mr.
George Coats) is in the Ruskin Drawing School at Oxford, on loan from the National
Gallery: see above, p. 206. The reference to *Modern Painters* is to vol. iv. (Vol. VI.
pp. 34 *seq.*) and Plate 21. For further particulars see the Introduction to that volume
in this edition (Vol. VI. p. xxv.). The drawing is reproduced in *Turner and Ruskin*,
vol. ii. p. 168. It passed from the Ruskin into the Kennedy collection, and was again
sold in 1895.]

[3] [It appeared in the *Keepsake* for 1829; the plate was introduced in the illustrated
edition of the *Notes*. For a comparison of it with a drawing by Stanfield, see *Modern
Painters*, vol. i. (Vol. III. p. 441); and for another reference, see below, p. 521.
Ruskin made some remarks on it, in connexion with "Turnerian Topography"
(*Modern Painters*, vol. iv. ch. ii.), in a letter to his father :—
 "ARONA, July 14, 1858.— . . . I had made up my mind before arriving
 here to find Mr. Turner's port a thing of the past, and a beautiful new quay
 for the steamers, with an 'embarcadère' opposite for the railroad, in its place.

the little port were quite among the most precious historical monuments in Italy, dating from the time of the military power of the lake districts of the North, centred in that of the Comaschi, who were, among the "mountain-flint" races of Italy, in the history of Lombardic war and architecture, what the race of Fesolé was to the Val d'Arno. But since I first began studying Italian history, the only remaining gate of Fesolé (old Etruscan) has been pulled down for the materials; and this entirely unique part of Arona destroyed by the modern progressists, and a "promenade" built over the filled-up space of it, on which they may lounge, smoke, and read newspapers.

68. ITALY OF THE OLDEN TIME.—(Sixty years since, I mean.)

An unique drawing of Turner's early period, curiously broad in execution, majestic in tone, with extremest subtlety of subdued colour :—inimitable modelling of hill masses, and superb composition throughout : but foliage treatment as yet not fully developed, and bough drawing still grossly imperfect.

Placed here after the Arona, to complete, for my readers, the old-fashioned journey from Coblentz by Constance, Zug, and the St. Gothard, into deep Italy, as Turner knew it,

I thought myself therefore more fortunate to find the two towers still left— though the whole further side of the port, with its arches, has, just as I expected, been turned into a grand quay for the steamers. The near side of the port with the garden and trees must from the first have been drawn out of Turner's head, as there are large houses on that side (of the towers) which clearly date from the beginning of the last century. But the terrible roguery is in the hills. No such hills are, or ever were, in sight from Arona. They are gathered together, hill by hill, partly from the Battes of Oleggio, partly from above the town here, partly from half way up the lake near Baveno, and then all thrown together in one grand imaginary chain. I have roughly sketched the real view from here, with some boats in the port, and I have daguerreotyped the towers; but I cannot quite apologise for Mr. Turner this time. Usually, his work is only inaccurate in detail in order to give a more complete impression of the place; but the 'Arona' is far more beautiful than anything that can anywhere be seen or fancied by plain people on all Lago Maggiore. It has made all the real lake look mean and blank, and its mountains low, to me, in spite of the sweet pensive character which I enjoy in them, as I told you, more than ever."]

and as we old travellers knew it,—doing thirty or forty miles a day, chatting in every village, walking up every hill, staying in every lovely place; and seeing, what none of you, my poor readers, can ever see more—human life in its peace, and its homes.[1]

69. GENEVA.

This magnificent drawing (I owe the possession of it to the kindness of my always helpful friend, Mr. F. S. Ellis,[2] —see further No. 87) is a little earlier than No. 68, but should be carefully compared with it, the mountain drawing being, in like manner, ineffably subtle; while the foliage is conventional, and even feeble: the composition masterly in the extreme, especially the placing of the cattle.

There are very few water-colour drawings by Turner of this size, except those at Farnley; of which the chief, Lake Lucerne from Fluelen, is the grandest work of Turner's early time, and first expresses his full perception of the tenderness of the great Alps, and of their waters; being to his Swiss work, what the "Coniston Fells" study was to his English work.

[1] [This drawing was lent by Ruskin to an exhibition held at Douglas in 1880. In the catalogue, p. 8, the drawing was called "Scene in Savoy," and the following note d by Ruskin:—

"Turner's drawing of a scene in Savoy, of which the pencil sketch is in a group of early ones lent by the National Gallery Trustees to Oxford. I found the sketch in arranging the series for Oxford, having before mistakenly described the scene as in Italy in my notes on my Turner exhibition. The drawing is one of much earlier date than the Heysham, and in Turner's grandest classical manner; the trees, however, not yet rightly drawn, but more or less copied from Poussin. (In the Heysham all the tree drawing is perfect.) Having no drawing of like quality, I gave unlimited commission for this one at Mr. Dillon's sale [1869]. I did not expect it to be hard fought for; but it went up to £1260, to my great indignation and disgust."

The sketch referred to is No. 111 in the Oxford Series (see below, p. 565). For the Heysham, see above, p. 429; for a further reference to the present drawing, see p. 593 below. It was reproduced in *Turner and Ruskin*, vol. i. p. 92.]

[2] [See Ruskin's letters to him in a later volume of this edition. This large drawing at one time hung over the mantelpiece of Ruskin's study at Brantwood; when he sold it, a Madonna in Luca della Robbia ware took its place. The drawing is now in the collection of Mr. J. Budgett. The size is 28½ × 44½, and it is signed by the artist. For another reference to it, see below, p. 519.]

Fluelen

From an etching after the drawing formerly in Ruskin's collection

W. Turner. R.A.

J. Ruskin
Allen & Co. Sc

70. FLUELEN.

And now note how constant his life is to these first impressions. No. 70, placed as the last drawing in this collection, is in fact the last Alpine drawing Turner ever made with loving power;—not unabated power,—for it was painted in 1845, the year of his failure; and it shows, in the foreground work, incipient conditions of fatal decline. But his love for the scene remains unabated—for it is the old place, Fluelen, the scene of that great Farnley drawing, now fading away into a mere dream of departing light.

I have asked that it may be placed under his portrait;[1] and have a few words yet to say of this and the great Geneva; but I should like the reader first to glance over the Epilogue, that he may clearly know the way in which these later drawings were produced; noting only for the present that, in some respects, the execution of this one is in freshness and clearness unrivalled, the sky being laid in with one dash, like that of the "Okehampton" [42]. Also the subtle modelling of the great limestone cliff on the right, though different in manner, is not less wonderful than that of the hill under the castle in 68. Turner never attempted at any period of his life to draw the higher snows, knowing their beauty to be impossible;[2] their presence is only suggested among the clouds by the broken fragments of white for the Rothstock, on the left; and the domed masses on the right, which are imaginary altogether, and put there only to give solidity to the nearer cliff, there being in reality no snowy heights above that promontory.

Tell's chapel is on the other side of it; but the whole cliff tunnelled now for the railway,—and so ends the story of the "Sacred Lake, withdrawn among the hills." Doubtless it will soon be embanked at Lucerne and drunk up by the Basle people, in emulation of our British thirsting

[1] [Reproduced as frontispiece to this volume : see below, p. 473.]
[2] [On this subject see also pp. 509-510, below, and compare *Modern Painters*, vol. iv. (Vol. VI. p. 293).]

" as the hart after the waterbrooks," [1]—their own waterbrook of the Rhine being used only as a Cloaca Maxima, practically, for all the fighting and singing about it that has been, or is to be, on either shore, between the wise and poetical nations it cannot separate. [2]

[1] [Psalms xlii. 1.]

[2] [The original sketch from which this drawing was made is No. 99 in the National Gallery: see p. 205 of this volume. The drawing was offered for sale at Christie's in 1882 (see below, p. 573). This was one of the drawings which Ruskin proposed to include in his series of representations of Turner's work in the actual size. He made an etching of it, and this is here reduced by photogravure (see above, p. lix.) In his diary for 1852 (when Ruskin went to Fluelen on his way back from Venice, see Vol. X. p. xlii.), he makes these notes on "Turnerian Topography" :—

"FLUELEN.—Observe the tower of which Turner has made so much is nothing but a square white house arranged as opposite [reference to a sketch], with a little turret in the middle, and nice green shutters to all its windows. The irregular streams and flat land are there, and small stone bridges; or wooden ones, if need be, for the water was across one of the paths; and chalets, just as he has placed them, but there is no point from which he could have got his view. He supposes himself in the air. As the scene is in reality seen, the tower is half as high as the cliff on the right, owing to the lowness of the point of sight. The church tower is all right—but there are fewer houses and more trees—large walnuts, and the grass is green to the lake's edge: there is no sandy shore."]

ILLUSTRATIVE STUDIES AND
SUPPLEMENTARY SKETCHES[1]

I PLACE first among these, six of the great plates of the Liber Studiorum, engraved by Turner himself, with his own hand; namely:—

71. RAGLAN.

An inestimable and unique early proof.[2]

72. THE LOST SAILOR.

Of which only two proofs exist that I know of, besides.[3]

73. THE DEVIL'S BRIDGE, ST. GOTHARD.

Also only two other proofs, I believe.[4]

74. GLACIER DES BOIS, AND SOURCE OF THE ARVERON, CHAMOUNI.

Fine early impression.[5]

[1] [In eds. 1–6 these Illustrative Sketches were described and arranged in the text under Five Groups. Group I. contained *Liber Studiorum* plates (comprising Nos. 71–76 above). Group II., "Early Pencil Drawings; Various" (77–80). Group III., "Pencil Sketches on the First Tour into Yorkshire cotland" (81–100). Group IV., "His own studies or sketches, either for practice, or play, or pleasure" (101-109). Group V. [no description] (110–120).]

[2] [Compare No. 865 in the National Gallery.]

[3] [Described in *Modern Painters*, vol. v. pt. ix. ch. xi. § 31 *n*.]

[4] [This is the plate otherwise called "Swiss Bridge" or (incorrectly) "Via Mala"; see *Modern Painters*, vol. iv. (Vol. VI. p. 40).]

[5] [In eds. 1–6 the words "Fine early impression" are omitted, and the note is:— "Here the thing itself has ceased to exist, the Glacier des Bois is gone"— the reference being to the retreat of the glacier, which had deprived the Source of the Arveron (from an ice cavern) of its former interest. The original drawing for this plate is No. 879 in the National Gallery.]

75. ÆSACUS AND HESPERIE.

Fine impression; and the greatest piece of tree-drawing in the Liber.[1]

76. MILL NEAR THE GRANDE CHARTREUSE.[2]

The five first were all *engraved* by Turner himself, but only the Devil's Bridge and Æsacus also *etched* by him under the mezzotint. The Grande Chartreuse is only in part engraved by him. My dear old friend and master in etching, Thomas Lupton, told me he was sure there was a great deal of Turner's own work in it; and of his mind, more.

The first two of these belong to Oxford.[3] I gave them with the Loire series—to be companions to it and to each other, as perpetual types of the two modes of Turner's sorrow for the passing away of human souls.

Next come four early sketches, namely:—

77. THE TOWER OF OXFORD CATHEDRAL, FROM THE GARDEN OF CORPUS CHRISTI COLLEGE.

Inscribed, "Christ Church Cathedral from Corpus Gardens," but not, I think, in his own hand. The drawing was given me by my friend, since dead, Mrs. Cooper of St. Paul's, from whom also I bought[4]—she sorrowfully parting with them, because she had duties for which the money was needed—the Loire series, which I gave to

[1] [Reproduced and referred to in *Lectures on Landscape*, § 73; see also *Modern Painters*, vol. i. (Vol. III. pp. 586, 595 *n*.).]

[2] [Compare No. 866 in the National Gallery. This plate is frequently referred to by Ruskin as among the finest in the *Liber* ; see *Modern Painters*, vol. i. (Vol. III. pp. 586, 595 *n*.); vol. ii. (Vol. IV. p. 351); vol. iii. (Vol. V. p. 399); vol. iv. (Vol. VI. p. 316).]

[3] ["Raglan" is in the Ruskin Drawing School (Rudimentary Series, No. 172). "The Lost Sailor" was for some years exhibited by Ruskin in the University Galleries, but he afterwards removed it.]

[4] [Wife of the late Rev. J. Cooper, for many years an assistant-master at St. Paul's School. The Rev. Canon Cooper informs the editors that his mother sold seventeen drawings of the Loire to Ruskin in February 1858 for 1000 guineas, to purchase a commission in the army for another son.]

Oxford,[1] and the Rouen, Rolandseck, and Dinant, Nos. 56, 55, 53.

It is an extremely early sketch, about the time of the Dover Castle.[2]

78. AT CHESTER.

Old shops, belonging to Messrs. " Clarke, (shoe) ? " maker ? " Robarts " Upholsterer ? the substantial " sign " of two chairs of the oldest and newest fashion—St. Jerome's style[3] (easy), and modern cheap-made, uncomfortable to a degree, and not strong. Finally " Drugs and colours," no name.[4]

79. IN THE MAIN STREET, CHESTER.

Old style. Cathedral seen over the gables.

Both these, Nos. 79 and 80, are very early, not much more than a year's difference between them and the Oxford.

80. PEN AND BRITISH INK SKETCH.

Made on the back of a letter in which a friend had asked for some advice about drawing. He just turned the paper, drew, wrote, and sent back folded the other way.

A most precious example of the advancing method of study.

Hence to No. 100, inclusive, are placed various pencil sketches made on the first tour into Yorkshire and Scotland, some more or less touched with colour.

81. SCARBOROUGH.

Observe the perfect, quiet, fearless decision, with no hurry, and no showing off, perspective watched in every

[1] [See below, p. 559; and for an anecdote in regard to this series, see above, Introduction, p. li.]

[2] [See above, p. 413.]

[3] [The reference is to the arm-chair in Carpaccio's picture at Venice of St. Jerome's study : see *St. Mark's Rest*, § 185.]

[4] [Eds. 1–6 add : " Shopman conceivable."]

line, then the perfect setting of the beds of the rock up the angle of it, when they are vital to it, up to the highest piece of Castle. And see the love of walls and rocks, and many forms of them gathered well together, as fixed in him already as it was to his death. Compare Nos. 54, Rock and wall; 55, Rock and *current* wall, zigzag like forked lightning up the hill; 62, Rock and broad mass of fortress; 63, Walls, more his object than the town.

82. SCARBOROUGH.

First dash of colour on pencil, same day as 81. Foam of sea deliberately left. Broad wash, stopping short of outline, for future work on the all-important edges; never going *over* the outline, you observe.

83. SKETCH ON THE SPOT. BRINKBURN PRIORY.

The England subject.[1] This was all he wanted for a subject of picture, if he saw no details on the spot of any particular beauty and importance. If he did he went on, as we shall see; if not, he put in out of his own head what would serve. Neither the trees nor stones here pleased him, only the bit of Priory, nor *that* much. He did it when it was wanted in the England series, but not to please himself.

84. JEDBURGH?

I used to be quite sure it was, but am a little confused now by the modern improvements.[2] An exquisite Scottish scene of the olden time, at all events. Distant hills most carefully outlined, abbey the same; the rest at speed, noting only well the steps in gable of cottage.

[1] [*i.e.*, the subject of the drawing in *England and Wales* (No. 15).]
[2] [Eds. 1-6 insert here: "(See Oxford Lecture in *Nineteenth Century*.)" The lecture was published in that magazine, January 1878, and is reprinted in a later volume of this edition. The reference is to a passage where Ruskin describes "modern improvements" at Jedburgh.]

85. EDINBURGH, FROM ST. ANTHONY'S CHAPEL.

This is the scene in the *Heart of Midlothian*—(scene in the moonlight, where Jeanie goes alone).[1] Look, how he dwells on the points of. the place—the winding paths to the town—shepherd driving the *cows* down it (*sheep*, those round things in the middle, hieroglyphic) ;—they were to be *there* and not elsewhere—wanted to centralize the whole picture in pastoral character. Then—look at Holyrood down on the right—and up the Canongate, and up! the *Heart* I think behind St. Anthony.[2] North Bridge clear enough; brow of Calton, note the zigzag rock edge, the edge that is painted afterwards for the entire main subject in the great National Gallery North Bridge drawing.[3] There's a spire, too!—not Scott's monument that—but St. Anthony's chapel and Holyrood, and the fields where Jeanie's cows fed—*they* are his monument.[4]

86. THE CASTLE.

Bit of North Loch yet left on the right. Mound building? First of the deadly innovations.

A quite glorious sketch,[5] of humiliating unerringness. Never a line hesitating, never one changed. You can scarcely see a finer example of *early* Turner sketching. His greatest was about the 1820 time, but this was the way he got to it.

[1] [See ch. iii. of vol. ii. of the novel; ch. xv. in the one-volume editions.]
[2] [The old Tolbooth, better known as the "Heart of Midlothian," was pulled down in 1817 ; a rude "heart" of paving stones let into the causeway, in the open space in front of the County Hall, now marks the site.]
[3] [No. 549 : see above, p. 267.]
[4] [Ruskin, it will be remembered, was specially interested in the Scott monument, about which he had, when a youth, been asked to give his opinion (Vol. I. pp. 247-264). The actual monument, subsequently erected, he detested (see *Fors.Clavigera*, Letter 31); for another remark on the true monument to the genius of Scott, see *Fors*, Letters 92 and 95. The ruins of St. Anthony's Chapel on the northern slope of Arthur's Seat are shown in Fig. 40 of Vol. I. (p. 260).]
[5] [Eds. 1-6 read : "Note its quite terrific and humiliating," etc.]

87. VIEW FROM FOOT OF CALTON, BEHIND LADY GLEN-
ORCHY'S CHAPEL.[1]

'Only the Ghost of Castle 'and Ghost of North Bridge—
these being drawn before: Houses on left, accurately—but
St. Giles's—yes—we have not drawn *that* before, we must go
in at it, and, is that the Heart then, low down on the left?

The little scrawled sketch in the book laid open on the
table under the glass.—It is Sir Walter's own sketch of the
niche of the Tolbooth, which he had a mind to take to
Abbotsford, and his directions to the architect of Abbots-
ford for transference of the same.

Beside it lie the MSS. of the *Black Dwarf, Peveril of
the Peak, Woodstock*, and the *Fortunes of Nigel*. I name
this last because I got it first—and it is the most important
MS. in many ways; but note in the *Woodstock* the inter-
polation on the left-hand page. *It* is significant, in a way
which I may tell you in the Epilogue.[2]

The *Fortunes of Nigel* MS. was bought long ago by
my Father, the rest lately by me, when I could: my friend
Mr. F. S. Ellis giving me warning when he could get them
for me.[3]

[1] [One of the chapels founded for her religious followers by Willielma, Vis-
countess Glenorchy (1741–1786).; it was pulled down in 1845 in the course of
building operations by the North British Railway; it stood on the low ground
between the Orphan Hospital and the Trinity College Church (see J.'Grant's *Cassell's
Old and New Edinburgh*, i. pp. 359–362).]

[2] [This was not done; but in a conversation with Mr. M. H. Spielmann, reported
in the *Pall Mall Gazette* (April 21, 1884), and reprinted in a later volume of this
edition, Ruskin made some remarks on the MS. of *Woodstock* as being of par-
ticular interest, because it was the book which Scott was writing when the news of
his ruin came upon him.]

[3] [Ruskin continued to buy Scott MSS. In a letter to Mr. F. S. Ellis, of
February 1881, he wrote :—

"What on earth do you go missing chance after chance like that for!
I'd rather have lost a catch at cricket than that *St. Ronan's*. . . . Seriously,
my dear Ellis, I do want you to secure every Scott manuscript that comes
into the market. *Carte blanche* as to price—*I* can trust *your* honour ; and
you may trust, believe me, *my* solvency."

On March 24th, 1881, he wrote :—

"I am buying Scott's and other manuscripts, observe now, for my future
Museum ; and shall without hesitation add to the Scott series when any
addition is possible."

Letters to Ellis (privately printed 1892, and reprinted in a later volume of this
edition), pp. 51, 54.]

88. STIRLING.

Look at the intense accuracy of the town along the ridge that King James rode up in the *Lady of the Lake*, after the Douglas "had endured that day," all but *one* thing,

"But LUFRA had been fondly bred." [1]

89. STIRLING, FROM THE CASTLE FOOT.

Scene of the Laird of Balmawhapple's pistol shot. Highlands in the distance, outlined carefully, Ben Lomond (I think). Bailie Nicol Jarvie could tell us if he would, perhaps—but won't, only that—"They're the Hieland Hills—the Hieland Hills." [2]

90. BENVENUE.

At least, I think so. I could have told, once, but I don't know the outline now, so well as some "in foreign land."

91. HAWTHORNDEN?

92. BORTHWICK?

Very fine; a wonderful bit of stone and stream.

93. DUNFERMLINE?

94. WARKWORTH?

Most important in showing his way of *outlining* reflections in water, that he might be sure about them.

95. THE STRID?

Rapid above, I think; the stream eddies deep where one can leap it. [3]

Most instructive in his way of drawing the forms of water.

[1] [*Lady of the Lake*, canto v. stanza 25.]

[2] [The words "Bailie . . . Hills," in eds. 1 and 2, were omitted in eds. 3-6, but restored in ed. 7 and later. See *Rob Roy*, vol. ii. ch. xiii. ; and for the Laird's pistol-shot, *Waverley*, vol. ii. ch. x. ; ch. xxxix. of the one-volume editions.]

[3] [Eds. 1-6 read : "Rapid above, I think, or it may be on the Greta."]

96. BRIDGE AND WATERFALLS.

So also this, in drawing of rock. Some traveller will, I hope, recognize it.

97. SOLWAY?

With Skiddaw beyond. Precious in simplicity of washed tint; the group of figures, seen on this spot, the original hint for those in the Salisbury.[1]

98. FAST STUDY OF CLOUDS.

99. FAST STUDY OF CLOUDS.

100. FALL OF TEES?

Tinting begun for a really careful drawing.

The remaining twenty examples are of mixed character; consisting of his own private studies or sketches, either for practice, or play, or pleasure. The first is only the back of a letter, written from his Surrey hermitage.

101. INVITATION TO DINE AT HIS HOUSE, SANDYCOMBE.[2]

With scratched Guide Map, and hieroglyph of Richmond Bridge (in the manner of Drayton's *Polyolbion*);[3] compare No. 33, "Play."[4] He never called it so to me, but it is vulgar English play, as opposed to vulgar English work.

102. DOG.

What kind?—sketched—but see inscription, certifying the same.

[1] [See above, p. 440.]

[2] [Sandycombe Lodge, on the road from Twickenham to Isleworth, was for many years (about 1810–1826) Turner's country house.]

[3] [*i.e.*, in the manner of the maps with figures and other graphic hieroglyphics which illustrated the original edition (1613) of Drayton's poem.]

[4] [Eds. 1–6 add here: "the first drawing I ever had of his." See above, p. 436.]

103. GROUSE.

Hard study, too laboured.

104. PHEASANTS.

Rapid note of colour for a bit in foreground; splendid.

105. JAY.

The most wonderful piece of water-colour work at speed I have. It was given me by Mr. W. Kingsley, of Kilverton, with many and many a precious thing besides. See his terminal notes (p. 535).[1]

106. MACKEREL.

Study on his kitchen dresser at Margate, splendid.[2]

107. MACKEREL.

Just a dash for three more. Cook impatient.

108. STUDY FOR FISH.

Coming on at speed, in the Slaver (modern trade?).

109. STUDY FOR FISH.[3]

Looking up to the sky, in the Slaver[4] (modern philosophy?).

110. NAMUR?

There are many such scenes; this is only given as an example of work done deliberately, but stopping when the future drawing is but just suggested.

[1] [And compare p. 370 of this volume.]
[2] [Instead of "splendid," eds. 1–6 read : "before the cook wanted it."]
[3] [Eds. 1–6 read :—

 " 109. STUDY FOR THE SLAVER.
 Fish looking up to the sky (modern philosophy)."]
[4] [The picture once in Ruskin's possession : see Vol. III., Plate 12.]

111. WRECK ON SANDS.

Memorandum in chalk on grey.

112. THE SAME SUBJECT.

Later, tide further out, ship fallen over.[1]

113. RAINBOW.

Effect dashed down on the inside of the cover of
sketch-book, all the paper being gone, his point being the
gradation of light in the bow to the darkness of cloud;
rare, therefore noted eagerly and energetically. Wild sea,
chalk cliffs with faint rosy light from rosy distant clouds,
opening of blue sky beyond the rain, the veil being with-
drawn gradually.

I bought the whole book from his good Margate house-
keeper, in whose house, at Chelsea, he died.[2]

114. HEAPED THUNDERCLOUD, over sea and land. Light
 breaking over far horizon.

Mighty work. A leaf out of the same book.

115. FLYING SCUD, of thundercloud, heavy central storm,
 eddies of advancing tide meeting over tongue of
 sand.

Noble. (Out of same book.)

116. STUDIES FOR THREE SUBJECTS.

One under another, the highest sunset on beach,[3] nearly
a perfect drawing.

[1] [Eds. 1–6 add : " touched with brown."]
[2] [Mrs. Booth. See *Fors Clavigera*, Letter 9, for some remarks on Turner's fondnes
for the Margate skies.]
[3] [Eds. 1–6 insert here : " Boat lovely, . . ."]

117. STUDIES FOR THREE SUBJECTS.

Moonrise (at top) wonderful.

One of these two has its study of green and white sea upside down.

118. ALPINE STREAM.

Pretty bridge and torrent subject; slightest possible indication of a perfectly intended picture, over the pencil sketch from nature.

119. SALLENCHES.

Seen from St. Martin's, pencil sketch of the grandest time.

120. MONT BLANC.

Over the bridge of St. Martin's. The old Hôtel du Mont Blanc on the left.[1]

St. Martin's Bridge with the cross on its keystone has been principal in Turner's mind in both these last two sketches. There will doubtless soon be an iron one instead —with no such useless decoration; but probably a bill pasted on it of the Sunday trains to Chamouni at reduced fares.[2]

J. RUSKIN.

BRANTWOOD,
 February 21, 1878.

[1] [See *Præterita*, ii. ch. xi.]

[2] [This prediction has been partly fulfilled. The railway to Chamouni now passes through St. Martin's. In eds. 1–6 the final paragraph was as follows:—

"I have the deepest affection for these last two sketches, for personal reasons which I will state in the Epilogue, but I also close the entire series of Turner's works remaining in my possession with these two studies, because St. Martin's Bridge with the cross on its keystone has been principal in Turner's mind in both, and his thoughts are connected as he drew with the melting of the cloud on the Aiguille de Varens, that the streams may water the sheep."

Compare the notes on Nos. 11 and 12 above. When the Epilogue was written, however, Ruskin did not introduce any reference to the drawings of Sallenches and St. Martin's; for his affection for the places, see the chapter in *Præterita* (ii. ch. xi.) entitled "L'Hôtel du Mont Blanc." Here in eds. 1 and 2 Ruskin's portion of the pamphlet ended, the rest consisting of Mr. Huish's list of Turner engravings.]

ADDENDA[1]

121. PORTRAIT OF TURNER AT ABOUT THE AGE OF 17, by himself.

I have placed in this group, with the pencil sketches above referred to, a few studies in colour, letters, and the like, of various interest, but which could not be properly examined in any consecutive way with the larger drawings. Of these, the principal is the "Study" of Turner, by himself, No. 121, given by him to his housekeeper, and by her (Mrs. Danby) bequeathed to me.[2] It in the first place shows the broad and somewhat clumsy manner of his painting in the "school days"; in the second, it is to me who knew him in his age, entirely the germ and virtually

[1] [These Addenda, with a second heading (discarded in ed. 7 and later), "Further Illustrative Studies," first appeared in ed. 3.]

[2] [This was in 1854. For another reference to the portrait (reproduced as the frontispiece to this volume) see above, p. 156; it is in oils. It appears from papers at Brantwood that Ruskin bought another portrait of Turner by himself as well as the sketch-book (122) in 1860 from Ann Dart of Bristol. From letters of this lady to Ruskin it appears that her uncle, the late John Narraway, a fell-monger in Bristol, was a friend of Turner's father. The young artist often visited Mr. Narraway, and was in the habit of leaving pictures or sketches behind him as presents. "During one of those visits," writes Ann Dart, "Turner took the likeness of my aunt and two of my cousins, after which my uncle said to him, 'Before you go away you must take a portrait of yourself and leave it as a remembrance.' He had some difficulty in persuading him to do so, but eventually prevailed. This is the oval portrait which you have purchased. The Sketch Book was one in which Turner made drawings when at home, and when on visits to Bristol; he left it after him on one of these visits to my uncle's house." Ann Dart puts the date of the portrait at 1791 or 1792, when Turner was 16 or 17. A portrait of Turner by himself a year later is in the National Gallery, No. 458. This oval portrait (which is painted on ivory) was given by Ruskin to Mrs. Booth, and it was bought by Mr. Cosmo Monkhouse from her son (by a former marriage), Mr. Pound, who had been educated at Turner's expense. At Mr. Monkhouse's death, the portrait was bought by some of his friends, and by them presented to the National Portrait Gallery (1902), where it now hangs (No. 1314). Many of the books and articles about Turner, misled by Thornbury, apply to the portrait which Ruskin retained at Brantwood, the particulars above given which really apply to the earlier Monkhouse portrait. See on the whole subject an article by Cosmo Monkhouse on "Some Portraits by Turner" in *Scribner's Magazine*, July 1896, vol. 20, pp. 89–98, where at p. 89 the oval miniature is reproduced.]

capable contents of the man I knew. But more—of it, or
of him,—I am not able to say here or now.

122. His first (known) Sketch-Book ; open at his
 first sketch of Malmesbury.*

123. His last Sketch-Book in Colour. It is full of
 such memoranda of skies.

124. His actually last Sketch-Book.

125. His Working Colour-Box (for travelling).

126. His last Palette, as it was left.

<div align="right">J. R.[1]</div>

* Bought by me at Bristol, where it had been left. Nos. 123–126
given me by Mrs. Booth. The little water-colour palette, it will be ob-
served—sent out for in his last illness—has the colours on the wrong side,
his hand never having *lifted* it.[2]

[1] [In the catalogue of the Exhibition of 1900, the following items were added :—

His List of Colours for his Paint-Box.

Two Letters from Turner to Mr. Ruskin's Father.

Mr. Ruskin marked on the second letter : "The date of this letter (returning
thanks to my mother for a present of pork) may be found by reference to the last
wars of the Swiss Cantons,—Catholics against Protestants." [1]

Letter from him to Mr. Ruskin.

Endorsed as follows :—"This letter refers to the last drawings executed for me
by Turner ('The Brunig,' 'The Descent of Mount St. Gothard,' and 'Airolo'), and
to the last call made by my mother at Queen Anne's Street."

Letter from him to Mr. Ruskin.

Letter from Mr. Turner to Mr. Ruskin accepting an invitation to dine with
 him and his mother on New Year's Day.

Copy of Letter (by Mr. Ruskin) from Turner to the father of Mr. Hammersley,
 School of Art, Manchester—his father having asked Turner's advice as to
 making him an artist.

Turner's Ring, which he always wore.

Turner's Umbrella, with sword-stick handle, which he always carried with him
 upon his Swiss and Italian journeys as a defence against brigands.

Portrait of Mr. Ruskin, painted by Mr. Arthur Severn in 1898.[2]

Water-Colour of Mr. Ruskin's Bedroom, in which he died, by Mr. Arthur
 Severn, 1900.][3]

[2] [See additional note by Mr. Kingsley, p. 535.]

[1] [The text of this letter is given in *Præterita*, ii. ch. viii. ; the date is 1845.]
[2] [Published in vol. ii. of *Turner and Ruskin*.]
[3] [Showing the walls lined with many of the Turner drawings described in these Notes.]

EPILOGUE[1]

BETWEEN the years 1840 and 1845, Turner executed a series of drawings under quite other conditions than those.

[1] [In eds. 3–6 the Epilogue was printed in an incomplete state. For the later editions it was rewritten, and, although the general purport remained the same, the wording and arrangement were much altered. The following was the version in eds. 3–6, minor differences being supplied in later footnotes or in the "Variæ Lectiones," above, pp. 401–402 :—

"EPILOGUE

" Left by Mr. Ruskin in an incomplete state at the time when he was taken ill.

"This is the story, so far as I know its position, of the ten drawings which Turner did for love in 1842.

"CONSTANCE (62).

" Looking out towards the lake up the Rhine from below the old wooden bridge. The walls were not so high, and the towers, therefore, more square set in reality. I suppose every thing is gone now—bridge, towers, and town.

"Turner had never made . . . [as on p. 484 here]. Munro thought the Zug too blue, and let me have it. The three are here :—

"(*a*) Lake of Zug, sunrise, above the descent from Morgarten.
"(*b*) Goldau ; lake of Zug in the distance, sunset.
"(*c*) Pass of St. Gothard.

"COBLENTZ (63).

" With the Broad Stone of Honour seen over the old bridge across the Moselle. Painted for me, by Turner, in the spring of 1842.

"He never told me, and I never understood till this moment, as I write correcting the just-written 'Ehrenbreitstein' into English, why he had fused all the fortress and its opposite hill into that calm of light, and put the misty blue above and purple below.

"I told you that in 1840 began the sunset time. He then quitted himself of engraver work and went back to the Alps, bringing home (*literally*) thousands of sketches, pencil and colour, which have been lying this twenty years in the cellars of your National Gallery, packed close in tin boxes, in consequence of the great value which the British public sets upon the works of Turner.

"Out of these sketches, when he came home in the winter of 1841, he chose ten, which he liked himself, and felt he should like to make drawings from. Why should he *not* have made drawings from these, then, to his mind?

"Well, because he was not Fra Angelico, or because *he* did not belong
475

which he had previously accepted, or insisted on.[1] The
history of these drawings, known to me, down to somewhat
minute particulars, will, I think, be at least in several of
these, interesting to the reader, after the thirty years' in-
terval; and at all events, illustrative of some of the changes
which have taken place during that interval, in our esti-
mate of the monetary value of a painter's toil (or genius?
—see Turner's own words to Mr. Kingsley, at the close of
his added notes).[2] In the years 1840 and 1841, Turner had
been, I believe, for the greater part of their summers in

to your Idealists, and that sort of person evolutionists consign to ridicule,
altogether.
 "Some little English sense and practical understanding he had retained
even so late in life as this.
 "So he went to Mr. Griffith . . . [substantia y as here, pp. 478–484, down
to—] No. 10 was sold at Mr. Bicknell's sale, and went I know not where.

 "In 1844 he did no drawings.

 "In 1845 eight :—

 1. Schaffhausen. Munro.
 2. Fluelen. Munro.
 3. Lake Lucerne. Mrs. [Newall].
 4. My Lake Lucerne.
 5. My Town Lucerne. Griffiths.
 6. My yellow one. Brunnen.
 7. Altdorf.
 8. Lucerne. Windus.

 "The best of these, a Schaffhausen, I parted with afterwards, because
the Rhine was falsely calm instead of rapid. The second best, Lucerne
Town from the Lake, I parted with because it was too sorrowful to me—
after Lucerne itself was finally destroyed. Mr. Windus had a Zurich,
with crowded figures on the bridge—and a Lake Lucerne from Brunnen—
both engraved. I had three—a faint Lucerne with floating vapours, they
and the mountains passing away. I had two more, Altdorf and Brunnen.
 "But Munro had Fluelen—Morning—on—not now—Coniston Fells—
and the mists higher—passing away.
 "I gave Munro of Novar my two, Altdorf and Brunnen, for it. It is
No. 70 here."

With regard to the 1845 drawings here mentioned, for the "Schaffhausen," see Index,
p. 604; for the "Fluelen," see above, p. 453; for "Lucerne Town from the Lake,"
see above, p. 201 (No. 24); for Mr. Windus' "Zurich," p. 199 (No. 21); for his
"Lucerne from Brunnen," p. 204 (No. 34); for Ruskin's "faint Lucerne," see Index,
p. 602, and compare p. 316. For the "Altdorf," see p. 205 (No. 39); and for the
"Brunnen," p. 203 (No. 32). No. 5 in the list above seems to be a mistake, the
drawing referred to must be that of 1842–1843 ; see below, p. 482.]
 [1] [For other references to the Swiss drawings of these years, see Modern Painters,
vol. i. (Vol. III. p. 250), and above, p. 194 (No. 8).]
 [2] [Below, p. 536.]

Switzerland; and, as aforesaid, had filled, for his own plea-
sure, many note-books with sketches such as those num-
bered here from 57 to 61. My statement in p. 452 that
"all the finest are in the National Gallery" is a little too
general, for a grander one than 58 exists nowhere.

That sketch, with fourteen others, was placed by Turner
in the hands of Mr. Griffith of Norwood, in the winter
of 1841–1842, as giving some clue to, or idea of, drawings
which he proposed to make from them, if any buyers of
such productions could by Mr. Griffith's zeal be found.

There were, therefore, in all, fifteen sketches, of which
Turner offered the choice to his public; but, he proposed
only to make *ten* drawings. And of these ten, he made
anticipatorily four, to manifest what their quality would be,
and honestly "show his hand" (as Raphael to Dürer)[1] at
his sixty-five years of age,—whether it shook or not, or had
otherwise lost its cunning.

Four thus exemplary drawings I say he made for speci-
mens, or *signs*, as it were, for his re-opened shop, namely:—

1. THE PASS OF THE SPLÜGEN.

2. MONT RIGHI, seen from Lucerne, in the morning,
dark against dawn.

3. MONT RIGHI, seen from Lucerne at evening, red
with the last rays of sunset.

4. LAKE LUCERNE (the Bay of Uri) from above Brunnen,
with exquisite blue and rose mists and "mackerel" sky on
the right.

And why he should not have made all the ten, to his
own mind, at once, who shall say? His oil-pictures, he
never asked the public to choose the subjects of!—nay, at
this time of his life, he made his selections for the Exhibi-
tion with some definite *adversity* to the public's advice, as

[1] [See *Lectures on Art*, § 74; and compare Sir Martin Conway's *Literary Remains
of Albrecht Dürer*, p. 33.]

conveyed to him by his critics! Why, therefore, of these direct impressions from the nature which he had so long loved, should he have asked anybody to choose which he should realize? So it was, however; partly, it seems, in uncertainty whether anybody would care to have them at all.

So he went to Mr. Griffith of Norwood. I loved—yes, loved—Mr. Griffith;[1] and the happy hours he got for me![2] (I was introduced to Turner on Mr. Griffith's garden-lawn.) He was the only person whom Turner minded at that time: but my father could not bear him. So there were times, and times.

One day, then, early in 1842, Turner brought the four drawings above-named, and the fifteen sketches in a roll in his pocket, to Mr. Griffith (in Waterloo Place, where the sale-room was).

I have no reason to doubt the substantial accuracy of Mr. Griffith's report of the first conversation. Says Mr. Turner to Mr. Griffith, "What do you think you can get for such things as these?"

[1] [In a letter to his father from Venice in 1852, Ruskin writes :—
"*4th January.*— . . . I was sorry to hear your account of poor Griffith ; he was sadly thin when he left his London rooms. I have an affection for him —having passed many happy hours in his Norwood house, and having got, through him, all that I most value in the world. Other picture-dealers, while they were quite as far from the rigid line of plain dealing, were always acting not only for their own interest, but for other people's rather than mine, and showing what they had to Munro, Stokes, Windus, or anybody else *before* me. But Griffith always gave me first sight, first offer, first choice. Many a golden offer he put in my way, such as I shall never have more, and you know we always had the first choice in the Turner sketches. Give him my best regards."
Mr. Stokes, of Gray's Inn, was an old friend of Turner and a collector of his works. The catalogue of Turner's engraved work, at the end of Thornbury's Life, was mainly compiled by him. Ruskin exchanged some drawings with him (see below, p. 558).]
[2] [The first version of the Epilogue reads here :—
". . . got for me ! being the only person whom Turner minded at that time: and my father could not bear him. So there were times and times. Honour thy father, yes, but not with falsehood, nor even always with reticence of fact. Turner did actually make four drawings, to show what drawings he could do yet, at sixty-five years old—observe your dates now. Four drawings : the Pass of the Splügen, a red Righi and a blue Righi, and a blue Lake Lucerne. 'And,' says Mr. Turner to Mr. Griffith, 'what do you think . . .'"
For further reference to Mr. Griffith, see *Præterita*, ii. chs. i. and iv. §§ 14, 66, 71.]

Says Mr. Griffith to Mr. Turner: "Well, perhaps, commission included, eighty guineas each."

Says Mr. Turner to Mr. Griffith: "Ain't they worth more?"

Says Mr. Griffith to Mr. Turner (after looking curiously into the execution, which, you will please note, is rather what some people might call hazy): "They're a little different from your usual style"—(Turner silent, Griffith does not push the point)—"but—but—yes, they are *worth* more, but I could not *get* more."

(Question of intrinsic value, and political economy in Art, you see, early forced on my attention.)

So the bargain was made that if Mr. Griffith could sell ten drawings—the four signs, to wit, and six others—for eighty guineas each, Turner would make six others from such of the fifteen sketches as the purchasers chose, and Griffith should have ten per cent. *out* of the eight hundred total (Turner had expected a thousand, I believe).

So then Mr. Griffith thinks over the likely persons to get commissions from, out of all England, for ten drawings by Turner! and these not quite in his usual style, too, and he sixty-five years old;—reputation also pretty nearly overthrown finally, by *Blackwood's Magazine;* a hard thing enough; but the old man must be pleased if possible! So Griffith did his best.

He sent to Mr. Munro of Novar, Turner's old companion in travel;[1] he sent to Mr. Windus of Tottenham; he sent to Mr. Bicknell of Herne Hill; he sent to my father and me.

Mr. Windus of Tottenham came first, and at once said "the style was changed, he did not quite like it." (He was right, mind you, he knew his Turner, in style.) "He

[1] [Mr. H. A. J. Munro, of Novar and of Hamilton Place, London, one of the greatest of Turner's contemporary admirers and collectors of his works (a list of his collection is given by Thornbury, p. 593; it was dispersed in 1877 and 1878). Munro went abroad with the artist to Switzerland and Italy in 1836: for an anecdote of this tour, see *Modern Painters*, vol. v. pt. ix. ch. xii. § 4 *n.* For Mr. Windus and Mr. Bicknell, see Vol. III. pp. 234–235 *n.*, 244 *n.*).]

would not have any of these drawings." I, as *Fors* would have it, came next; but my father was travelling for orders, and I had no authority to do anything. The Splügen Pass I saw in an instant to be the noblest Alpine drawing Turner had ever till then made; and the red Righi, such a piece of colour as had never come *my* way before. I wrote to my father, saying I would fain have that Splügen Pass, if he were home in time to see it, and give me leave. Of more than one drawing I had no hope, for my father knew the worth of eighty guineas; we had never before paid more than from fifty to seventy, and my father said it was "all Mr. Griffith's fault they had got up to eighty."

Mr. Bicknell of Herne Hill bought the blue Righi, No. 2. It used to hang in his drawing-room, next the window, opposite another drawing, next the door, of which presently.[1]

Then Mr. Munro of Novar, and bought the Lucerne Lake, No. 4 (and the red Righi?*), and both Mr. Munro and Mr. Bicknell chose a sketch to be "realized"—Mr. Bicknell, another Lucerne Lake; and Mr. Munro, a Zurich, with white sunshine in distance.

So, you see, when Turner came to hear how things were going on, two of the sketches were provided for, which was pretty well, considering the change of style. Three out of the four pattern drawings he had shown were really bought—"And not *that*," said Turner, shaking his fist at the Pass of the Splügen;—but said no more!

I came and saw the Pass of the Splügen again, and heard how things were going on, and I knew well why Turner had said "And not THAT."

And next day Munro of Novar came again; and *he*

* I am not absolutely sure about *this* drawing, whether Mr. Bicknell or Mr. Munro bought it.

[1] [The first version of the Epilogue reads simply :—
"Then came Mr. Bicknell of Herne Hill. He bought the blue Righi."]

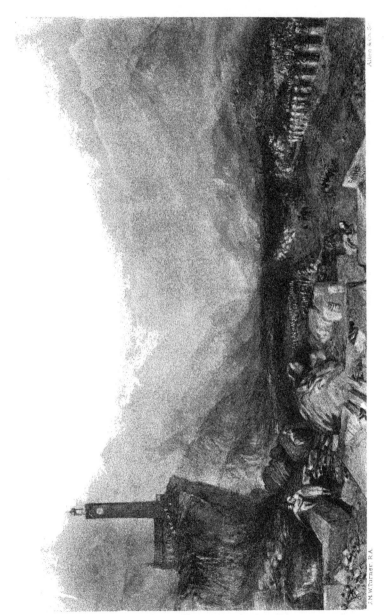

J.M.W.Turner R.A.

Alken &Co. Sᶜ

The Pass of the Splügen.

also knew why Turner had said "not that," and made up his mind; and bought the Pass of the Splügen.[1]

At last my father came home. I had not the way of explaining my feelings to him somehow, any more than Cordelia to *her* father; nevertheless, he knew them enough to say I might have *one* of the sketches realized. He went with me, and chose with me, to such end, the original of the Ehrenbreitstein, No. 62, here. The *sketch* we saw is now in the National Gallery.[2] That made seven, in all, bought and ordered. Three others had to be placed yet, before Turner would begin to work.

Mr. Munro was got to order one more, a Righi dark in twilight. By hard coaxing, and petitioning, I got my father's leave to promise to take a Lucerne Town, if it turned out well! The other sketches no one liked, no one would have them at any price; only nine drawings could be got orders for, and there poor Mr. Griffith was. Turner growled; but said at last he would do the nine, *i.e.*, the five more to be realized.

He set to work in the spring of 1842; after three or four weeks, he came to Mr. Griffith, and said, in growls, at intervals, "The drawings were well forward, and he had after all put the tenth in hand, out of those that no one would have: he thought it would turn out as well as any of them; if Griffith liked to have it for his commission, he might." Griffith agreed, and Turner went home content, and finished his ten drawings for seven hundred and twenty guineas, cash clear. Griffith's commission drawing, the one that no one would have, is No. 63, and we'll talk of its

[1] [The first version of the Epilogue adds here :—

"And so, you see, everything went right, and according to Miss Edgeworth's notions of the way in which beautiful behaviour and filial piety is rewarded.

"(I correct with Sir Walter Scott's pen, given to her August 14th, 1825, lent me by the Master of Harrow, Mr. Butler. It is a little matter, you think, nevertheless worth your notice. But at last . . .")

With this passage, compare *Præterita*, ii. ch. iv. §§ 71, 72, where Ruskin gives another account of his disappointment at missing the Splügen; and for Scott's pen, see above, p. 400.]

[2] [No. 280: see above, p. 194.]

quality a little, presently, oh, recusant British˙ Public! but
first I'll finish my story, please.

My conditional drawing, also, turned out well, and I
was allowed to take it, but with comment. "I was sure
you would be saddled with that drawing," said my father.[1]

Four or five years ago—Mr. Vokins knows when, I
haven't the date handy here—he came out to me, say-
ing he wanted a first-rate Turner drawing, had I one to
spare?

"Well," I said, "I have none to *spare*, yet I have a
reason for letting *one* first-rate one go, if you give me a
price."

"What will you take?"

"A thousand pounds."

Mr. Vokins wrote me the cheque in Denmark Hill
drawing-room (my old servant, Lucy Tovey,[2] bringing pen
and ink), and took the Lucerne.[3] Lucy, amazed and
sorrowful, put the drawing into his carriage.

I wished to get *dead* Turner, for one drawing, his own
original price for the whole ten, and thus did.[4] Of the re-
maining eight drawings, this is the brief history.

Mr. Munro some years afterwards would have allowed
me to have the Splügen Pass, for four hundred pounds,
through White of Maddox Street; my father would then
have let me take it for that, but I myself thought it hard
on him and me, and would not, thinking it would too much
pain my father. It remained long in the possession of Mr.
Munro's nephew; so also the Novar Lucerne Lake, and

[1] [The first version of the Epilogue adds: "Honour best here."]

[2] [For references to Lucy Tovey, "our perennial parlour-maid," see *Præterita,* ii.
ch. vi. § 108, and iii. ch. ii. § 45. Lucy sometimes accompanied Ruskin and his parents
on their foreign tours, "that she might see the places we were always talking of."
The first version reads here:—
"... Lucy Tovey bringing me pen and ink ... Lucy put ... into his
carriage, I think."]

[3] [This drawing is now in the collection of Mr. E. Nettlefold. It is reproduced in
Turner and Ruskin, vol. i. p. 126; the original sketch for it is No. 288 in the National
Gallery: see above, p. 200.]

[4] [The first version of the Epilogue reads:—
"... and did, for Mr. Vokins necessarily makes fifty guineas by coming
out in a cab to Denmark Hill, Turner's own exact price to a buyer."]

Zurich. But of that, and of the red Righi, there were at first vicissitudes that are too long to tell ; only, when the ten drawings were finished, and at Waterloo Place, their possession was distributed thus :—

1. SPLÜGEN	. .	Munro of Novar.
2. BLUE RIGHI	. .	Mr. Bicknell.
3. RED RIGHI	. .	Munro of Novar.
4. LUCERNE LAKE	. .	Munro of Novar.
5. LUCERNE LAKE	. .	Mr. Bicknell.
6. LUCERNE TOWN	. .	J. R.
7. COBLENTZ	. .	J. R.
8. CONSTANCE	. .	Mr. Griffith.
9. DARK RIGHI	. .	Munro of Novar.
10. ZURICH	. .	Munro of Novar.[1]

Mr. Griffith soon afterwards let me have the Constance for eighty guineas, and the day I brought that drawing home to Denmark Hill was one of the happiest in my life.

Nos. 1, 4, and 10 were, I believe, lately sold at Christie's.

No. 5 was bought at Mr. Bicknell's sale long ago, far over my head, and went to Edinburgh ; there was a pretty story connected with it, which I think is known to Dr. John Brown.

No. 6 is—I know not where ; very sorrowful am I that it is not here—for all my thousand pounds.

Nos. 7 and 8 are here, side by side, Nos. 62 and 63.

[1] [Of these drawings, No. 1 remains at Brantwood ; Nos. 2 and 3 are in the collection of Mr. J. E. Taylor ; No. 4 was bought by Mr. Newall, of Ferndene, Gateshead (see below, p. 535) ; No. 5 is in the collection of Mr. J. Irvine Smith: it is a view from above Brunnen looking up the bay of Uri (a steamer on the lake) ; No. 6 (Mr. E. Nettlefold): see above, p. 482 ; No. 7 is in the collection of Mr. J. F. Haworth ; No. 8 in that of Mr. R. E. Tatham ; No. 9 was in the collection of the late Mr. C. A. Swinburne : see above, p. 203 n. ; No. 10 is in that of Mr. J. Irvine Smith. The original sketches for most of the ten are in the National Gallery : No. 1 is (N. G.) 75 ; No. 3 is No. 45 ; No. 6 is No. 288 ; No. 7 is No. 280 ; No. 8 is No. 286 ; No. 9 is No. 96 ; No. 10 is No. 289. It should be noticed that in his Catalogue of Turner Sketches, written in 1857, Ruskin mentions a drawing belonging to this group which he does not here include—namely, a Bellinzona "realised for Mr. Munro" : see above, p. 209 (No. 48).]

No. 3 was once mine also. It had a correction in it, which I regretted; and I let it go, which I regret more. Mr. Mackay of Colnaghi's had it of me, I don't know who has it now.

No. 9 was sold at Christie's while I was last at Venice.

No. 2 was sold with No. 5 at Mr. Bicknell's sale, and went I know not where.

Turner had never made any drawings like these before, and never made any like them again. But he offered, in the next year (1843), to do ten more on the same terms. But now—only five commissions could be got. My father allowed me to give two: Munro of Novar took three. Nobody would take any more. Turner was angry; and, partly ill, drawing near the end, you perceive. He did the five, but said it was lucky there were no more to do.

The five were:—

1. KUSSNACHT. Munro of Novar.

2. ZUG. (No. 64.) Munro of Novar.

3. (I forget at this moment Munro's third.) I think it was the Zurich by moonlight, level over the rippling Limmat; a noble drawing, but not up to the mark of the rest.

4. GOLDAU. (No. 65.) J. R.

5. ST. GOTHARD. (No. 66.) J. R.[1]

Mr. Munro thought the Zug too blue, and let me have it. So three are here.

64, 65, and 66. Done passionately; and somewhat hastily, as drawing near the end. Nevertheless, I would not take all the rest of the collection put together for them.

[1] [Of these five drawings, No. 1 was in the collection of the late Mr. C. A. Swinburne (see above, p. 202 n.); for No. 2, see above, p. 455; No. 3 is perhaps the drawing elsewhere mentioned (p. 200, above) as having been done in 1845 for Mr. Windus; for Nos. 4 and 5, see above, p. 456. The original sketches for these five drawings also are in the National Collection. No. 1 is lent to Oxford (see below, p. 562); No. 2 is (N. G.) No. 97; No. 3 (if to be identified as suggested above) is No. 287; No. 4 is (N. G.) No. 98; and No. 5 is lent to Oxford (see below, p. 562).]

For the end had *not* come, though it was near. His full, final, unshortened strength is in these; but put forth, as for the last time—in the presence of the waiting Fate. Summing his thoughts of many things,—nay, in a sort, of all things. He is not showing his hand, in these; but his heart. The Constance and Coblentz here (with the Splügen (1), Bay of Uri (4), and Zurich (10)), of the year 1842, are the most finished and faultless works of his last period; but these of 1843 are the truest and mightiest. There is no conventionalism,—no exhibition of art in them ;—absolute truth of passion, and truth of memory, and sincerity of endeavour. " That litter of stones which I *endeavoured* to represent," he said to me himself of the St. Gothard,[1] which recalled to him so many earlier visions of the fierce Reuss and Ticino ; and of the Power that poured them from the clouds, and clove the earth with rivers.

I can't write any more of them just now. Perhaps during the last fortnight of this exhibition I may get a few further notes and illustrative studies together : but none· will be of real use, unless the spectator both knows and *loves* the Alps, in some measure, as Turner knew and loved them, which—for aught I know—there may yet be some who do :—but one cannot say. For assuredly none who love them, ever peril on them either their Love, or Life.

BRANTWOOD, 10*th May* 1878.
*Being my Father's birthday,—who—though as afore-
said, he sometimes would not give me this, or
that,—yet gave me not only all these drawings,
but Brantwood—and all else.*

[1] [See *Modern Painters*, vol. iii. (Vol. V. p. 122), and compare Vol. XII. p. 500.]

PART II[1]

NOTES ON
MR. RUSKIN'S OWN HANDIWORK
ILLUSTRATIVE OF TURNER

PREFACE

THE presentation to me by friends' kindness, of the long-coveted drawing of the Splügen, has given me much to think of,[2] if, just now, I were able to think;—and would urge me to say much,—if I were able to speak. But I am shaken and stunned by this recent illness,—it has left me not a little frightened, and extremely dull.

I cannot write a circular letter of thanks, of so wide a radius as to include all I feel, or ought to feel — on the matter; and besides, I do not usually find that any one worth pleasing is pleased by a circular letter. The recipients always, I think, "speak disrespectfully of the Equator."[3] A parabolic letter, or even hyperbolic, might be more to the purpose, if it were possible to me; but on the whole I think it will be the best I can do in this surprised moment to show the importance of this Splügen drawing, in connection with the others in my collection, belonging to its series; by trusting in public indulgence

[1] [This Part II. appeared for the first time in ed. 9. In eds. 1-6 there was instead an Appendix, "containing a list of the engraved works of the late J. M. W. Turner, R.A., exhibited at the Fine Art Society's Galleries, with Mr. Ruskin's drawings by the same master." This Appendix, with a preface, was the work of Mr. Marcus B. Huish, and therefore is not reprinted here. It was withdrawn in order to make room for Ruskin's Notes on the Collection of his own Drawings, etc., which he arranged on recovering from his illness : see p. 395.]

[2] [The drawing of the Splügen was presented to Ruskin during the progress of the Exhibition. The price paid was 1000 guineas; it was raised by subscription among his friends and admirers.]

[3] [Sydney Smith's saying of Jeffrey, cited in Lady Holland's *Memoir of Sydney Smith*, vol. i. p. 23.]

for the exposition also of so much of my own handiwork in illustration of Turner, as may explain the somewhat secluded, and apparently ungrateful, life which I have always been forced to lead in the midst of a group—or as I now thankfully find, a crowd—of most faithful and affectionate friends.

I have accordingly amused, and humiliated myself, by arranging a little autobiography of drawings, from childhood until now; out of which it appeared to me that some useful points might be made evident respecting the service of particular methods, or the danger of particular errors. What consistency of effort they show, has been noted, as briefly as I could, and the grounds on which I felt it necessary to pursue some lines of study which cost me much labour, and gave little reward, except in enabling me to understand the virtue of better work.

Of the Splügen drawing, and of the collection which it in a manner consecrates finally to public service, I hope yet to make some practical uses, such as my friends will be glad to have strengthened me in: but recovery from such illness as struck me down last February, must be very slow at the best: and cannot be complete, at the completest. Without abandoning any of my former aims, I must not for many a day—if ever—resume my former activities; and though I have now gone so long in literary harness that the pole and collar rather support, than encumber me, I shall venture to write in future, only what costs me little pains.

As all that I have written hitherto has cost me much, my readers will I hope credit me with indolence when they weary of me; and acquit me, yet for a few years more, of apoplexy, even though they cannot in conscience assure me that I have "jamais composé de meilleure homélie."[1]

BRANTWOOD, *June 5*, 1878.

[1] [A reference to *Gil Blas* (book vii. ch. iv.), where the Archbishop of Grenada, having astonished his hearers by a discourse bearing evident signs of his stroke of apoplexy, assures them that on the contrary, "je n'ai jamais composé de meilleure homélie." Hence the proverbial phrase "homélies de l'archevêque de Grenade" for the writings of an author's decadence.]

NOTES ON MY OWN DRAWINGS
AND ENGRAVINGS

1. R. CONWAY CASTLE.

Drawing by my father, made in the Edinburgh drawing class under Nasmyth the elder, and showing the way in which young people were in those days taught: the first tints being laid in grey; then the warm colour laid on the lights, and no "effects" of light, or of *local* colours ever thought of.

The great Hakewill drawings by Turner are nothing more than the perfect development of this method.

For the influence of this drawing on my own infant mind, by help of my father's patience at his dressing time, see *Fors Clavigera*, June 1875, p. 161.[1]

2. R. DESCENT FROM THE SPLÜGEN ON THE ITALIAN SIDE. Old Swiss print, coloured by hand.*

Showing the adaptation of this cool shadow and warm light system to popular engraving.

A most lovely piece of quiet work, full of honourable and right feeling.

All the prints for sale in the shops of the Swiss towns, at the time of Turner's early travels, were done in this manner: and he, in his studies on the spot, would definitely set himself to beat one of these old prints by

* I believe so, but cannot be certain the Swiss had not already fallen on some mechanical help,—encouraged with conscientiousness and skill.

1 [*i.e.*, of the original edition; Letter 54. See also now *Præterita*, i. ch. ii. § 42.]

supplying the fire, or force, that it wanted. The post-chaise, or diligence, as the means of communication between Northern and Southern Europe over this great wall of eternal ordinance, was profoundly interesting to him :—(the Apotheosis of the Dover mail![1]) We will look at one or two more of the Swiss prints,—his "old masters,"—and then see what he made of the Dover mail at last.[2]

3. R. THE "LOST DUNGEON": on the Pass of the Splügen.

The French translation of "Trou-Perdu," entirely loses the grand meaning of the German "Verlohren Loch," a place in which one is both *locked up*, and *lost*:—wilderness and dungeon in one!—and an abyss besides. It is the most terrific chasm, on a large scale, in the Alps,—the Latins and early Grisons calling it the "Via Mala."*

Turner was continually combining impressions from this gorge, and that of the Devil's Bridge on the St. Gothard. There is a study of crag and pine among the framed examples in my sliding cabinets at the National Gallery, which I think is done in challenge of this very plate.[3]

* "The language of the Grisons is divided into two principal dialects, the Rumonsch and the Ladin; the latter is the dialect of the Engadin. These dialects are each subdivided into upper and lower. The origin of these dialects is certainly Italian, and they are quite distinct from the Teutonic dialects of the surrounding cantons of Switzerland. They are believed to be the remains of the ancient Etruscan language, more ancient than the written Latin, or Roman language, but having probably great affinity to the spoken languages of Latium, Umbria, and other parts of Central Italy, before the period of Roman greatness. The Etruscans were at one time in possession of a great part of the plain of the Po, from whence they were expelled by the Gauls in the second century of Rome, or about 600 years before Christ. They then took refuge in the mountains of Rhætia, where names still remain which remind us of Etruria and Latium, such as the river Albula, the towns of Lavin, Ardez, Thusis, Rhœzuns," etc.—Vieusseux's *History of Switzerland.*[4]

[1] [No. 1 in the Notes on Turner : see above, p. 413.]
[2] [See below, p. 495.]
[3] [Probably No. 71 or 73.]
[4] [*The History of Switzerland, from the Irruption of the Barbarians to the Present Time*, published by the Society for the Diffusion of Useful Knowledge, 1840 (by A. Vieusseux), p. 305.]

4. R. STURZ (literally, "*Overthrow*" or "*Ruinous* Fall")
OF THE RHINE and Avers-torrent.[1]

Another quite admirable study of pines, and true effort
to give the forms of water in violent and ponderous fall.
Also one of the "Junctions" of less with greater rivers, in
which Turner took such delight: the personality of rivers
being to him almost as vivid as to a classic poet, or a true
German one. By railway, I wonder how many travellers
would know whether this was a Rhein-fall, Reuss-fall, or
Rhone-fall; or would lift their eyes from their newspapers
to see it, though it were a fall of all three!

5. R. SWISS LIFE IN THE OLDEN TIME.

Not idealized in the least; but a quite true picture of
a well-to-do farmer's house in Canton Berne. I used to go
to Switzerland quite as much to see this life, and the re-
mains of the mediæval strength that had won it, as to see
the Alps themselves.

The reader will have patience, perhaps,—it may be, also
pleasure, in comparing with the old-fashioned picture, the
greatest of Swiss authors' description of such a scene.[2] I
have an especial reason for asking him now to dwell upon
it a little:—and will even hope that my own friends will
read the passage introducing it, the opening paragraph of
Gotthelf's[3] *L'Ame et l'argent*, A to B of the following
extract; the actual description to be compared with the
picture is between B and c. The sequel contains some
matters of farther interest, readable perhaps at home.

A. "Le vrai bonheur est une fleur délicate, autour de laquelle bour-
donnent des milliers d'insectes malfaisants, et que tue le moindre
souffle impur. L'homme est le jardinier chargé de la cultiver; la
béatitude est sa récompense; mais combien peu savent leur métier;

[1] [The junction of the Hinter Rhein and the Averser Rhein, a mile and a half above
Andeer.]
[2] [For Ruskin's own description of a typical Swiss cottage, see *Poetry of Architec-
ture*, § 41 (Vol. I. p. 33).]
[3] [For this author, see *Modern Painters*, vol. iv. (Vol. VI. p. 172 n.). *L'Ame et
l'argent* is the title of the French translation of the German original, *Geld und Geist,
oder die Versöhnung*.]

combien regardent indifférents comme les insectes s'y posent; combien s'amusent à voir comme ils la dévorent et comme la fleur s'étiole! Heureux celui qui ouvre à temps les yeux, qui, d'une main habile, préserve la fleur et tue son ennemi; car celui-là préserve en même temps la paix de son cœur, et assure le salut de son âme; deux choses qui tiennent l'une à l'autre, comme le corps et l'âme, comme ce monde terrestre et l'autre monde.

"Il y a dans le pays de Berne beaucoup de jolies fermes, de riches villages habités par une quantité de dignes couples, réputés pour leur crainte de Dieu et la sagesse avec laquelle ils élèvent leurs enfants; beaucoup de riches villages où chambres et greniers sont remplis de richesses, que ne soupçonne guère le petit monde à la nouvelle mode, lequel convertit tout en argent, parce que, dans le fait, il dépense beaucoup d'argent. Toutes ces provisions entassées représentent, pour les besoins personnels et étrangers, des sommes telles qu'on n'en trouverait certes pas, bon an mal an, chez beaucoup de messieurs. Ces sommes n'ont, à l'ordinaire, aucune place stable. Pareilles à des esprits familiers, mais à de bons esprits, elles courent par le maison, et se trouvent tantôt ici, tantôt là, tantôt partout à la fois, à la cave, au grenier, au cabinet, dans la caisse aux quartiers de pommes sèches, dans ces quatre lieux à la fois, sans compter une demi-douzaine d'autres encore. Dès qu'un morceau de terre est à vendre qui convient à la ferme, on l'achète, argent comptant. Là, jamais le père ni le grand-père n'ont rien dû à personne; tout ce qu'ils achetaient, ils le payaient, argent sur table, et de leurs propres deniers. Quand, dans la parenté parmi les amis ou dans la commune, un brave homme était en besoin d'argent, ou voulait faire quelque bon marché, cet argent était toujours à sa disposition, non comme placement, mais comme assistance temporaire, pour un temps déterminé, sans billet ni intérêts, tout bonnement sur la garantie de sa bravoure, et sous la garde du Ciel; et on agissait ainsi par le motif tout simple que l'on croyait encore au Ciel, comme de juste et de raison.

"Là, le mari va à l'église et à la foire en respectable habit de droguet; la femme est toujours, le matin, la première à éplucher quelque chose, et le soir, la dernière à éplucher de même. Pas un mets n'arrive sur la table, qu'il n'ait été cuit par elle, *et pas une seille n'est versée dans l'auge des cochons, qu'elle ne l'ait au préalable bien remuée jusqu'au fond, avec son bras nu.**

B. "*Pour trouver un échantillon de cette honorabilité aristocratique,* on n'a qu'à aller à Liebiwyl (nous le parlons pas de celui qui est près de Kœnitz, ne sachant pas si on s'y comporte ainsi). Là, unè superbe ferme resplendit au soleil, avec des fenêtres qui scintillent au loin; une superbe ferme, que tous les ans on lave avec la pompe à incendie; aussi paraît-elle toujours neuve, bien qu'elle ait déjà quarante ans; et quelle bonne chose c'est que le lavage, même pour les maisons; on en a là la preuve journalière.

* This is a little farther than St. George wishes his "aristocracy" of the cottage to follow!

"Une galerie commode et joliment sculptée,* fait saillie sous les ailes
de la toiture; une terrasse fait ceinture autour de la maison, pavée
de petits cailloux serrés devant les étables et de larges dalles devant
les pièces d'habitation. De magnifiques arbres à fruit entourent les
bâtiments de leur verdure touffue; une colline la défend des vents
du nord, tandis que, des fenêtres, on aperçoit les Alpes qui opposent
une résistance si fière et si majestueuse à la marche du temps et à
la marche des hommes.

"Le soir, on voit, près de la porte, un homme assis sur un banc, en
train de fumer sa pipe, et qu'on ne croirait guère âgé de plus de
soixante ans. De temps en temps, apparaît sur la porte une créa-
ture à mine avenante et proprette, qui a quelque chose à dire ou
à demander à cet homme. C'est sa femme. Dans la remise, un
beau garçon, svelte et vigoureux, fait boire deux beaux chevaux
bruns, pendant que son frère aîné porte de la paille dans l'étable.
Par moments, on voit dans le jardin, sortir du milieu des fleurs et
des herbages, une joviale figure de jeune fille, qui demande à sa
mère si elle veut aller lui donner un coup de main, ou qui peste
contre les chats qui courent dans la salade, et demande à son père
ce qu'il faudrait faire contre la maladie qui attaque ses roses. Les
domestiques et les journaliers rentrent lentement des champs; les
poules regagnent l'une après l'autre leur poulailler, tandis que le
pigeon fait encore très chaudement la cour à sa colombe."

c. "Tel est le tableau qu'on aurait eu presque tous les soirs sous les
yeux, si on s'était arrêté devant cette maison de Liebiwyl, il y a
cinq ou six ans; et si on avait interrogé les voisins ou telle vieille
femme emportant quelque chose sous son tablier, sur le compte
de ceux qui l'habitaient, on n'eût pas manqué de vous répondre
brièvement:

"—Ce sont des gens extrêmement bons et terriblement riches.

"A l'époque de leur mariage, il y a une trentaine d'années, ils formaient
le plus beau couple qu'on eût vu entrer depuis bien longtemps à
l'église. Plus de cent voitures leur faisaient cortége, sans compter
tous ceux qui étaient arrivés à cheval, ce qui alors était beaucoup
plus à la mode qu'à présent; car alors les femmes elles-mêmes
montaient à cheval, surtout quand il s'agissait d'aller à la noce.
Pour ce qui est de la leur, elle avait duré trois jours; en fait de
boire et manger, on n'y avait rien épargné, aussi en avait on beau-
coup parlé dans tout le pays. Mais alors aussi les cadeaux de noce
avaient-ils abondé d'une telle façon, qu'ils en avaient eux-mêmes
été effrayés. Deux journées entières ne leur avaient pas suffi pour
les recevoir tous, et force leur avait été de se faire aider par des
étrangers. Il est vrai qu'on n'eût pas été dans le cas de trouver,
ni en amont ni en aval, une ferme plus réputée que celle-ci.

"Le fait est qu'une belle ferme pareille, complètement payée, sans
compter une masse de mille livres, ne se trouve pas partout. Mais

* It might be thought that Gotthelf had made his description from the
print itself! But it is from the vivid fact of his own village, "Herzogen-
buch-see."

ils ne possédaient pas cela pour eux seuls; ils savaient encore que
les riches ne sont que les mandataires de Dieu, et qu'ils auraient
à rendre compte de chacun de leurs écus. Quand on les demandait
pour parrain ou marraine, il n'y avait jamais de non, et ils ne se
figuraient nullement que depuis que le bois est devenu si cher,
les pauvres n'en avaient plus besoin. Les domestiques étaient
traités là comme il ne le sont pas souvent; on n'y prétendait pas
que la besogne dût être achevée d'un seul jour, et que le lait qu'on
y servait fût toujours trop bon pour eux."

I said that I had an especial reason for asking the
reader to look at this image of old Swiss life. To me
personally it was the soul of the Alps, just as much as the
life of Giotto and Farinata[1] was the soul of Fésole and
Florence. But from the first, Turner was awe-struck by
the "mountain-gloom" of the great passes, and by the
distress, and the heroism, of the dwellers in their deeper
recesses of Uri and Unterwalden,—not without acknowledg-
ing the charm of what remained of their old life, after the
great ruin of 1798;* see therefore:—

6. R. THE BAY OF URI, FROM FLUELEN:—

Photograph (I fear much faded) from the great drawing
at Farnley, in which his main purpose has been to give the
place of incoming, and the happy animation of the shore,
when the boats were embarking for the Lucerne market.
I remember a bit of an early rhyming letter to one of my
then brightest girl-friends (the niece of my father's partner,
Mr. Telford) describing one of these boats at Lucerne quay,
laden with its

"Mealy potatoes and marrowfat pease,
And honey, and butter, and Simmenthal cheese;
And a poor little calf, not at all at its ease,
Tied by the neck to a box at its knees;
Don't you agree with me, dear Louise,
It was unjustifiably cruel in
Them, to have brought it in all that squeeze
Over the lake from Fluelen?"[2]

* See note farther on, to No. 29. R. [p. 511.]

[1] [See *Val d'Arno*, § 97.]
[2] [See *Præterita*, ii. ch. x. § 191, where the rhymes are again given, and "Louise"
is explained.]

Not incognizant of this joyful industry, Turner was yet, as I said, from the first, appalled by the sense of the mountain pestilence and mortal war, that oppressed it, in the close valleys; and held in constant admiration by the physical terrors of the greater Alps, in the rock masses which impended over human habitation or journeying. The fall of the rocks themselves,—the "Snowstorm, avalanche, and inundation,"[1]—became at once chief subjects of his effort in explaining the relations of this vast, and so often cruel, Nature to its children; to himself, penetrating and contending with it as a traveller, the roads, and the diligence, were of constantly increasing interest; and as the idea of the "Dover Mail" (No. 1 in my first group, Schooldays) rises gradually into the two studies of the stage-coach crossing Lancaster Sands, not always without peril,—so the postchaise on the Splügen Pass, in the old Swiss print, remains to his last years the principal object of vital interest, in the Dazio Grande, No. 58, as in the Pass of Faido, 66; while, long before, it had risen into the imperilled diligence on the Cenis, of the Farnley drawing. I place now in succession,

7. R. PHOTOGRAPH FROM THE FARNLEY DRAWING OF LANCASTER SANDS.[2]

A simple rendering of the daily facts, as he had seen them.

8. R. THE ENGRAVING FROM THE "ENGLAND" LANCASTER SANDS.

The full development of his central conception, quite one of the noblest of the England series, and admirably engraved by Mr. Brandard;[3] and, lastly,

[1] [The title of one of his Academy pictures of 1837, formerly in the Munro collection: see Vol. III. pp. 239, 463.]
[2] [For a description of the "Lancaster Sands," see *Elements of Drawing*, § 243. The drawing is reproduced in *Turner and Ruskin*, vol. ii. p. 268.]
[3] [Robert Brandard (1805-1862), engraver and painter, engraved several subjects in Turner's *England and Wales* and *Rivers of England*, and also some of the master's large pictures.]

9. R. PHOTOGRAPH FROM THE FARNLEY PASS OF THE CENIS.[1]

A quite magnificent drawing, though it always fretted me by its confusion in the foreground of the forms of rock with those of ice. But nothing can be finer than its rendering of the effect of a sudden whirlwind, entering with drift of the dry snow, like fire, over the low refuge on the left, and turning the diligence horses at once back in frantic terror, while those of the baggage cart refuse to stir, helpless to extricate it from its danger on the precipice side when the snow has given way.

Finally,

10. R. SOURCE OF THE ARVERON (Farnley Drawing),[2]

Is his record of a similar storm coming down the Mer de Glace upon the valley of Chamouni, the shepherd and flock rushing to find shelter beneath the rocks which the pines, their branches torn half away, can give no longer.

These drawings of the violence of the Alps, concentrated at last in the picture, now in the National Gallery, of the rock with a couple of pines upon it, falling sheer through the air on a châlet roof, were seldom carried out with his best work.[3] It was only when calm had succeeded the tempest, and its desolation was being hidden by new, though sorrowful life, that his entire thought and power was brought to bear on his work.

And now I must ask the reader's patience again—but more timidly—in reprinting here the passages in the last volume of *Modern Painters*, which gives the meaning of the Liber Studiorum, and of those now exhibited Swiss drawings, with the introductory passages (which I am particularly desirous should be re-read at this time) and their sequel in the close of the chapter; showing as they do,

[1] [This drawing is described in *Pre-Raphaelitism*, §§ 38, 39, Vol. XII. p. 374, where a reproduction of it is given (Plate 18).]
[2] [See *Pre-Raphaelitism*, § 59, Vol. XII. p. 390.]
[3] [The "Cottage destroyed by an Avalanche," No. 489 : see above, p. 122.]

that the truths I have been endeavouring to teach during these last seven years in *Fors Clavigera* were as clearly established in my mind, and as strongly expressed, in the close of my first work, as they will be, with God's help, in whatever He appoints to be my last.[1]

.

Thus far the last chapter but one of *Modern Painters*. It was written early in 1860; the entire volume being sent out to me in June to St. Martin's, where I was then resting, chiefly for the sake of the gentians, lilies, and wild roses of the Aiguille de Varens (see first chapter of *Proserpina*). I went up thence to Chamouni, and there wrote ·*Unto this Last*, reading it, as it was finished, to the friend staying at the Old Union Inn with me, Mr. Stillman.[2]

And so my St. George's work began, and Turner's birthday took another significance to me; and his "Venice" also. I call it *his* "Venice," for she was the joy of his heart, no less than his great teacher. The Alps brought him always sadness, but Venice delight. (He died, happily, before he saw what modern Venetians and English would make of her.)

It is a woful fault in this collection of mine, considered as illustrative of his life, that there are no Venetian sketches in it. I gave all I had to Cambridge and Oxford,[3] not generously, but because to think of Venice now is mere misery to me. The sorrow of my work there, last year,[4]

[1] [Here in the catalogue came several passages from ch. xi. of the fifth volume of *Modern Painters*—namely, from § 18 (beginning at "Looking broadly, not at the destiny of England . . .") to the end of the chapter, the three long footnotes to § 22 "I cannot repeat too often," etc.), to § 30 ("I limit myself in this book," etc.), and to § 31 ("I have not followed out, as I ought," etc.) being incorporated in the text. Ruskin added a few notes, which are now given in that volume.]

[2] [The late W. J. Stillman, the well-known correspondent of the *Times*. He has left some record of this summer spent in sketching with Ruskin in his *Autobiography of a Journalist*, 1901, vol. i. ch. xvii. : see also an article by him in the *Century Magazine*, January 1888, where a letter from Ruskin (reprinted in a later volume of this edition) is given. Ruskin alludes to this companionship in *Time and Tide*, Letter 22 of the original letters as published in the *Manchester Examiner and Times*.]

[3] [See below, pp. 558, 560.]

[4] [Ruskin was at Venice from September 12, 1876, till May 23, 1877, studying Carpaccio, writing the *Guide to the Academy*, planning *St. Mark's Rest*, and much exercised with the restorations of St. Mark's : see also *Fors Clavigera*, Letters 71–78.]

was in great part the beginning of the illness which in its culmination has been the cause of too much anxiety to my friends, as of their not easily to be acknowledged kindness.

The best representation, therefore, that I can here give them of Turner's Venetian work is (11. R.) the beautiful engraving by Mr. Miller [1] of his picture of the

11. R. (a). GRAND CANAL.

A picture which was itself a challenge to Canaletto, being nothing else than Turner's adaptation of the great Louvre picture of the "Church of the Salute," taken with entirely false and absurd perspective by Canaletto from its own steps. Turner changed the point of sight to the middle of the canal, corrected the perspective—showing that even at this greater distance the Dome could not possibly be represented on a vertical plane; and then threw his whole strength into the boats and water, which Canaletto could not paint at all.

There is no better representation of Turner's work by line engraving; the sky especially is exquisite, and was, when Mr. Miller left it, nearly a facsimile of Turner's. The publisher of the plate, thinking he knew better than either Turner or Mr. Miller what a sky should be, had it all burnished down to make it "soft" and popular. This proof, though early, is yet only an intermediate state between the first perfect one and the final inanity. I have never seen but one proof of the plate in its original beauty.

11. R. (b). The best facsimile of Turner's work in skies, laid often with the palette-knife and then broken or gradated

[1] [For William Miller (1796–1882), "the best engraver of Turner," see *Modern Painters*, vol. iii. (Vol. V. p. 157 *n*.). The picture here referred to is "Venice from the Porch of Madonna della Salute" (R. A., 1835); it is now in the Metropolitan Museum, New York; see above, p. 213. To Miller's engraving of it (published June 1, 1838) and to the alterations in the sky, Ruskin refers in *Modern Painters*, vol. v. pt vii. ch. ii. § 6 *n*. For the Canaletto (No. 1203 in the Louvre), see Vol. XII. p. 468.]

with the brush, is this plate, executed by Mr. Armytage with consummate skill and patience,[1] from the upper cluster of white clouds in the "Cemetery at Murano," lent me by its then possessor, Mr. Bicknell, of Herne Hill, my always kind neighbour. It was the most perfect of all the late Venices.

I have noticed elsewhere that Turner's later Venices, when introducing much architecture, were often spoiled by his leaving the buildings too white.[2] This was a morbid result of his feeling that he never could get them bright enough in their relation to the blue or green of the sea, and black of the gondolas.

12. R. THE DUCAL PALACE.

My own study, made in 1874, of the colour of the Ducal Palace in morning sunlight, comes as near, I believe, to the actual facts of the relation between dark and light in the *architecture alone,* as attentive care can reach; and it is wholly impossible to get the drawing of the finer details, unless in this delicate and literally true tone, for all the local darks, such as those of the nearer prison-pillars in this sketch, lose their relative power if the lights are put in deeper tone. But the moment sky is added to such a study as this, all its detail becomes ghostly and useless; the eye then requires the relation between the nearer buildings and the light at the horizon, or between their shadows and the light of the blue above; and all one's delicate work is lost.

But, besides, Turner had been grievously injured by his education in the principles of Eighteenth-century Classicism,[3] and never had drawn Gothic architecture since his youth; hence while the detail of the Salute porch is given with perfect intelligence, he does not represent the Gothic palaces

[1] [Plate 67 in *Modern Painters*, vol. v. For the picture, see *Modern Painters,* vol. i. (Vol. III. p. 251 n.]
[2] [See above, pp. 159, 213.]
[3] [Compare above, p. 159.]

on the left with the least accuracy.[1] To represent them
with completion would have been impossible, unless he had
taken a year to the picture instead of a fortnight, which
was, I doubt not, all he gave to it.

13. R. CASA CONTARINI FASAN (Oxford*).[2]

A sketch of my own in 1841, shows the main detail
of a little piece in this group of houses in some complete-
ness; but it would take a month to draw even this small
group rightly, and it is totally beyond any man's power,
unless on terms of work like Albert Dürer's, to express
adequately the mere "contents" of architectural beauty in
any general view on the Grand Canal.

14. R. VIEW FROM THE FISH MARKET TO THE CA'
 FOSCARI. (1872.) (Oxford.[3])

15. R. VIEW FROM CA' BERNARDO TO CA' GRIMANI.
 (1876.) (Oxford.[3])

16. R. VIEW OF THE UPPER REACH OF THE GRAND
 CANAL, looking north and,—(given up in de-
 spair). (Oxford.[4])

17. R., 18. R., and 19 R.,

Various beginnings on distant views of the city, may
serve to give the reader some idea of the mere *quantity*
which must be put into any faithful view of Venice.

* Whenever the word "Oxford" is appended, it signifies that the
exhibit has been given by me to the University schools at Oxford.

[1] [On this subject see above, pp. 46, 159, 285.]
[2] [Reference Series, No. 65. This drawing is Plate 2 in this edition of the first
volume of *Modern Painters* : see Vol. III. pp. liv., 212. The drawing was exhibited at
Manchester in 1904 (No. 260).]
[3] [14 R. and 15 R. are not now in the Ruskin Drawing School at Oxford : see note
on p. 414 above.]
[4] [Reference Series, No. 66. An autotype of this drawing is Plate vii. in the quarto
edition of E. T. Cook's *Studies in Ruskin*; it is reproduced in a later volume of this
edition. The drawing was exhibited at the Royal Society of Painters in Water-Colours
in 1901 (No. 35), and at Manchester in 1904 (No. 372).]

And here I will venture to say a few words respecting
the labour I have had to go through in order to make sure
of my facts, in any statements I have made respecting either
Architecture or Painting.

No judgment of art is possible to any person who does
not love it, and only great and good art can be truly loved;
nor that, without time and the most devoted attention.

Foolish and ambitious persons think they can form their
judgment by seeing much art of all kinds.[1] They see all
the pictures in Italy;—all the architecture in the world—
and merely make themselves as incapable of judgment as a
worn-out Dictionary.

But from my youth, I was protected against this fatal
error by intense love for particular places; returning to them
again and again, until I had exhausted what was exhaust-
ible (and therefore bad) and thoroughly fastened on the in-
exhaustible good. To have well studied one picture by
Tintoret, one by Luini, one by Angelico, and a couple of
Turner's drawings, will teach a man more than to have
catalogued all the galleries of Europe; while to have drawn
with attention a porch of Amiens, an arch at Verona, and
a vault at Venice, will teach him more of architecture than
to have made plans and sections of every big heap of brick
or stone between St. Paul's and the Pyramids. Farther, it
is absolutely necessary that fine architecture should be drawn
separately both in colour and in light and shade;—with
occasional efforts to combine the two, but always with
utmost possible delicacy;—the best work depending always
on the subtlest lines. For instance in

20. R. STUDIES OF INLAID MARBLE WORK AT LUCCA.

The sketch on the left is the spring of two arches of an
early thirteenth-century palace. The refinement of the little
rose-moulding in the inlaid brickwork (compare rose-mould-
ing in 58 R., porch of Amiens) and of the gradated spaces

[1] [On this subject compare *Elements of Drawing*, § 86.]

of radiation in the stones and curves of the Saracenic arch, require as much care in delineation as the petals of a living flower; the border of the shield above (porphyry and black marble, inlaid in white), was too fine to be drawn at all, in the time I had; and the curves of the hair and veil-border in the bas-relief below (from Santa Maria della Spina at Pisa) are as subtle as is an Etruscan statue. Now these qualities of a building can only be known by drawing it; and it has become time for me now seriously to represent to my friends who suppose overwork to have been the cause of my recent illness, that it is not the work, but the sorrowful interruptions of it, that overthrow me;—and that they will now do me more grace by leaving me in quiet, to use in some consummation of purpose the materials collected during these last forty years, than by the most affectionate solicitude which requires me to answer letters, and divert my mind from the things it has hold of. With me, it is not grasping a thing, but letting it go, that does my brains mischief, and above all, I find it needful that henceforward I should decline endeavours to teach or advise, except through my books. The sense of responsibility involved in giving personal advice, and the time required to give it rightly, are entirely incompatible with any possibility for me of prolonged future work and life.

But having been compelled to speak thus much concerning myself, I think it may be well, in relation to the principal work I have now in hand, the founding of a school of drawing in Oxford, to show concisely the methods of work I have tried in vain, or used, with more or less advantage, from the time when I first began to care for colours and lines, up to the date when I painted the study of Amiens,[1]—at which time I had made myself, so far as I can judge, up to a sufficient point, master both of the theory and practice of my business.

I began to learn drawing by carefully copying the maps in a small quarto Atlas, of excellent old-fashioned type, the

[1] [See below, p. 527.]

mountains well marked (but not blackened all over like those in the modern Geological Survey), the names clear, not crowded—above all, not run across each other, nor to be gleaned, a letter at a time, when one can pick them up.

21. R. MAP OF FRANCE,[1] and,

22. R. MAP OF AFRICA,

Are examples of many done by the time I was ten years old. These maps were a great delight to me; the colouring round the edges being a reward for all the tediousness of the printed names; the painting, an excellent discipline of hand and eye; and the lines drawn for the mountains and sea a most wholesome imitation of steady engraver's work. And it will be found that in the forthcoming number of Fésole,[2] I place map-making first among the elementary exercises which include subsequent colour; with certain geographical modifications in their construction, of which I may say in forestalment now, that every chief exercise map is to be a square of ten, fifteen, or thirty degrees—European countries mostly coming in squares of ten degrees, India and Arabia in squares of thirty—and the degree is to be divided always into sixty (so-called) miles, of which great measure of longitude and latitude I hope my young students will form a sure practical estimate by often walking it.

23. R. (a). Copies in pen and ink (common, both, not crow-quill nor Indian), from Cruikshank's vignettes to Grimm's German stories. Done to amuse myself.[3] About the date of the map of France. They show curious accuracy of eye, and self-confidence, not having the slightest fear of being unable to carry out my full complement of

[1] [This map was No. 4 in the Ruskin Exhibition at Coniston in 1900, and No. 1 in the Ruskin Exhibition at Manchester, 1904. He refers to his boyish exercises in map-drawing in *Præterita*, i. ch. iv. § 82.]

[2] [Now chapter ix. of *The Laws of Fésole* (Vol. XV.).]

[3] [See again *Præterita*, i. ch. iv. § 82. These copies were No. 5 in the Coniston Exhibition, and No. 2 in the Ruskin Exhibition at Manchester, 1904.]

subjects without making a mess. I place two proofs of the etchings themselves by them for comparison. I could not have had better teachers of line work.

23. R. (b). CRUIKSHANK'S ETCHINGS.

Nothing in modern line work approaches these in pure, straightforward, unaffected rightness of method, utterly disclaiming all accident, burr, scrawl, or tricks of biting.[1]

23. R. (c). OLD-FASHIONED ENGRAVING.

From drawing by Richard Gastineau[2] of the Old Water-Colour [Society]; and beneath it,

My first attempt at "composition from Nature," Mr. Gastineau's sky with my own "Dover Castle!" the latter done out of my head! All dark side and no shadow.

This was literally my first attempt at picture-making, at twelve years old. Infinitely stupid, but showing steady power and will to work.[3]

23. R. (d). BATTLE ABBEY. (Same date.)

My first study of Architecture from Nature, after much examination of what engravers call "texture."

23. R. (e). ETON.

Some feeling began to show itself in the ignorant work, when I was between thirteen and fourteen.

23. R. (f). CHURCH AT DIJON. (Foundation poetically omitted!)

Example of architectural sketching on my first Continental journey, when I was fourteen.[4]

[1] [Cruikshank's etchings for Grimm are among the "Things to be Studied" recommended in *The Elements of Drawing*. See ch. iii. §§ 91, 239, 257 of that book; and for other references, the note in Vol. VI. p. 471.]

[2] [A slip for Henry Gastineau (for whom see *Academy Notes*, 1857, "Old Water-Colour Society," No 57). He lived close to Ruskin at Camberwell.]

[3] [Rus in refers to his "Dover Castle" and "Battle Abbey" in *Præterita*, i. ch. iv. § 85.]

[4] [In 1833: see Vol. I. p. xxix. The drawing was in the Ruskin Exhibition at the Royal Society of Painters in Water-Colours, No. 420; and at Manchester, No. 83.]

Always supremely stupid, but no shirking of work, till
I got near the bottom; of the sorrowful absence of figures
I will explain the reason presently.

23. R. (*g*). A day's sketching, finished out of my head;
between Arona and Domo d'Ossola on the same journey.
Interesting to me now, in their proper economy of paper,
their weak enthusiasm, and the fastening so early on the
"rock at Arona," afterwards drawn for *Modern Painters*.[1]

23. R. (*h*). Hôtel de Ville, Brussels. (Oxford.[2])

Copy from Prout's wonderful drawing, in his sketches
in Flanders and Germany. Made at home (Herne Hill),
with other such, to "illustrate" my diary of that first Con-
tinental Travel.[3] Most wholesome discipline;—the grey
wash being now introduced when the pencil shade was im-
possible, but not carelessly or licentiously.

And better things should have come of such practice,
but I got overpraised for the mechanical industry, and led
away besides into other work, not fit for me. Had I been
permitted at this time to put my whole strength into draw-
ing and geology, my life, so far as I can judge, would have
been an entirely harmonious and serviceable one. But I
was too foolish and sapless myself to persist in the healthy
bent; and my friends mistook me for a "genius," and were
minded to make me a poet—or a Bishop, or a member of
Parliament. Had I done heartily and honestly what *they*
wished, it had also been well. But I sulked, or idled,
between their way and my own, and went all to pieces,
just in the years when I ought to have been nailing myself
well together. And the drawing especially came nearly to
nothing : farther on in the series will be found an example
of it when I was sixteen :—the Oxford vacation sketches,

[1] [Plate 41 in vol. iv. (Vol. VI. p. 311).]
[2] [Not now at Oxford : see above, p. 414 *n*. The drawing was No. 9 in the Ruskin
Exhibition at Manchester, 1904.]
[3] [See *Præterita*, i. ch. iv. § 90.]

made two years later, among the Yorkshire and Scottish
Abbeys, contain some details which are even now of in-
terest in illustrating the Turner outlines of the same sub-
jects. I put them all together, under the head of 24. R.,
distinguishing them by letters only.

24. R. (*a*). PETERBOROUGH (1837).[1]

24. R. (*b*). LICHFIELD (1837).

Both these are accurate in the angles of the pinnacles
and spires; and express at least wholesome enjoyment in
the richness of decorated English Gothic.

24. R. (*c*). BOLTON (1837).

24. R. (*d*). NEWARK (1838).

The year's progress is very clearly manifest; some sense
of light and shade now coming into the line work, and
the masonry markings very good.

24. R. (*e*). ROSLYN. Entrance porch (1838).

Trying to be very fine, and failing, of course; but the
shadows creditably even for point work.

24. R. (*f*). ROSLYN. Interior — The Prentice Pillar—
(1838).

Very much out of drawing, but I imagine the roof
itself may have been warped a little. It is a rude provin-
cial building, and has had many a rough wind to stand
since those that sang the dirge for Rosabelle.[2]

24. R. (*g*). EDINBURGH. Lady Glenorchy's Chapel, look-
. ing to the Old Town and the Craigs (1838).

[1] [" Peterborough" was in the Ruskin Exhibition at the Royal Society of Painters
in Water-Colours, No. 67; "Lichfield," No. 254; "Newark," No. 99; "Roslyn,"
No. 266; "Edinburgh," No. 340 (also Manchester, No. 43); and "Stirling," Man-
chester, No. 45.]

[2] [*The Lay of the Last Minstrel*, Canto vi.]

24. R. (*h*). STIRLING (1838).

24. R. (*i*). STIRLING (1838).

It might easily be thought that I was partly imitating Turner's sketches in the foregoing series. But I never saw a Turner sketch till 1842:[1] and what correspondence there is in manner, results from what really was common to us both,—intense love of form, as the basis of all subject. I have never been able in the least to make either artists, or *a fortiori* the public, understand this in Turner:[2]—and the engravings from him only increased the difficulty, for they continually gave reduced representations of his work, in which the drawing was necessarily missed. For instant example, look at the narrow dark side of the church tower in this Splügen drawing[3] with a magnifying glass. You will find the flanking pilasters of the Lombardic tower indicated all the way down, with a subtlety of drawing which explains at once its age and its style. But suppose the whole drawing reduced to the size of an octavo page, or less; and where would these markings be? The wonderful facsimile by Mr. Ward of one of Turner's average sketches in his central time (32. R.), will show still better what I mean:—at present I pursue the course of my own—at this time very slow and broken—progress.

The exhibition of David Roberts' Syrian sketches[4] put me into a phase of grey washed work with lights of lemon yellow, which lasted till the winter of 1841; enabling me from the clear and simple system of it to get some useful sketches in Italy in the winter of that year.

24. R. (*k*). MARKET PLACE AT VERONA (Oxford[5]), and 13. R., already given, are examples of satisfactory memoranda made at this time, and finally,

[1] [In which year Turner showed some of his foreign sketches : see above, pp. 477, 480.]

[2] [Compare, above, pp. 241 *seq.*]

[3] [See Plate xxv., p. 480. On the impossibility of doing full justice to Turner's work on a reduced scale, see *Modern Painters*, vol. iv. (Vol. VI. p. 4).]

[4] [Ruskin explains more fully what he owed to Roberts in *Præterita*, ii. ch. ii.]

[5] [Reference Series, No. 62.]

**24. R. (*l*). CALAIS TOWN-HALL, BELFRY, AND LIGHT-
HOUSE (1842),[1]**

Shows the point I had got to when the first volume
of *Modern Painters* was taken in hand; a creditable know-
ledge, namely, of what drawing and chiaroscuro meant; and
a resolute determination to have ever so small a bit of my
work right, rather than any quantity wrong.

Serious botanical work began that same year in the Valley
of Chamouni, and a few careful studies of grass blades and
Alpine-rose bells ended my Proutism and my trust in draw-
ing things out of my head, for ever.

But the power of *delineation* natural to me only became
more accurate, and I carried on at the same time separate
outline and chiaroscuro studies, which few persons, I believe,
would imagine were by the same hand;—and still less, that
they were done contemporaneously.

**25. R. (*a*). OUTLINE FROM THE FRESCO OF THE SACRI-
FICE OF JOB, in the Campo Santo of Pisa;[2]
and,**

**25. R. (*b*). STUDY OUTSIDE THE SOUTH GATE OF FLOR-
ENCE,**

Done within ten days of each other, show these two
directions of study with definiteness—and, had I but been
able to keep myself clear of literature, and gone on doing
what I then saw my way to,—well, perhaps I should have
died of fever in an old cloister—or of sorrow for the loss
cf one before now:—and must make the best of what I
am, crazy or *compos mentis*, as it may be.

But from this time forward, my drawing was all done
that I might learn the qualities of things, and my sketches
were left miserably unfinished, not in idleness,—but because

[1] [Exhibited also at the Prout and Hunt Exhibition in the following year: see
under "Notes on Prout," No. 1, in Vol. XIV.]
[2] [See the Epilogue to vol. ii. of *Modern Painters*, Vol. IV. p. 350.]

I had to learn something else. The Venetian ones, for instance (14. R., etc.), ought all to have been full of boats. But to draw a Venetian boat! (whether the "Sun of Venice" is going to sea,[1] or occupying its place in a solar system, or fixed stellar-system, in the Canal) is to begin another picture, and if of a market boat, generally with an elaborate fruit-piece on her deck besides—*e.g.*,

26. R. (*a*).

Upper subject, melons; lower, mats and fish-baskets. Notes of colour merely (1845), to be corrected always by notes of curvature, such as,

26. R. (*b*).

More hurried than the two last, but attending to quite other matters,—the angles of mast and rudder, and infinitely subtle curve of oar. If once one got into boat study, in fact, it was all over with the architecture; and Turner loving the sea and ships of Venice more than her buildings—and wisely (for she, like Athens, had true wall and weapon, both, of wood) could not get time to draw his palaces. But he is the only painter who ever drew a gondola, or a sail, of Venice, with their *motion* in them.[2]

It is curious (and what our modern school of gym-nastic tourists will think of it I know not), that among the Alps he shunned the upper snows, as. at Venice the bright palace-walls; and drew only the great troubled and surging sea of the pastoral rocky mountains. But he felt always that every power of art was vain among the upper snows. He might as well have set himself to paint opals, or rubies. The Alps are meant to be seen, as the stars and lightnings are, not painted. All proper subjects for a painter are easily paintable; *if* only you can paint![3] Carpaccio and Sir Joshua can paint a lovely lady's cheek with no expense

[1] [See above, p. 163.]
[2] [See above, p. 45.]
[3] [On this subject, compare *Modern Painters,* vol. iv. (Vol. VI. pp. 350 *n.,* 351-352).]

in strange colours; but none can paint the Snows of the Rosa at dawn.[1]

But, besides, even the lower Swiss hills were a good deal more than his match, and that he well knew. Elsewhere, I have noticed his prudence in "counting their pines,"* or at least estimating their uncountableness! I did not understand his warning, and went insanely at them at first, thinking to give some notion of them by sheer labour.

27. R. PASS OF THE CENIS, above St. Michel (1854 or 1856), was one trial of the matter. (Oxford.[2])

The place itself, a glorious piece of Alpine wilderness, radiant with cascades and flowers among the forest glades —the modern traveller passes beneath it after some eighteen hours' night and morning travel, in wearied looking out for the custom-house at Modane, and derives much benefit, doubtless, from the dews of morning on those wild-wood glens. But one couldn't draw them with pen and sepia, I found; nor even with one's best pains in softer grey.

28. R. A PIECE OF THE MOUNTAIN-SIDE OF CHAMOUNI;[3]
 and,

29. R. CLIFF OF THE BAY OF URI,

Are examples of the best I could do, but still useless to express the pine beauty; this last, however, is of some value as a study of what one used to see in the old boating days, when one could dabble about like a wild duck at the lake shores. These cliffs are passed by the beatified and steam-borne modern tourist, about half a mile off, the whole range in some three minutes, and long before he has

* See *Mornings in Florence*, the Strait Gate, p. 141.[4]

[1] [On the unpaintableness of the upper snows, compare p. 459, above.]

[2] [Educational Series, No. 275. An autotype of this drawing is Plate ii. in E. T. Cook's *Studies in Ruskin*, large paper edition; it is reproduced in a latv. volume of this edition.]

[3] [This drawing was exhibited at the Royal Society of Painters in Water-Colours, No. 142; it is in the collection of Mrs. Cunliffe.]

[4] [Now § 108.]

got his trunks seen after, and that important one found which he thought he had left at Fluelen.

I have endeavoured partly to describe the Bay of Uri, seen from this spot, in the chapter on the Pine in the last volume of *Modern Painters* [pt. vi. ch. ix. sec. 16]. What recent Historical associations are connected with the range of rocks themselves, the reader may see in the following passages,—alas! not fabulous these (whatever modern sagacity may have made of the legend of Tell and of Grütli).[1] (29. R. (*b*) is a rapid note of the field of Grütli, seen under the Rothstok.)

"In the month of July [1798] the French commissioners and general ordered that the people should assemble in every canton in order to take the oath to the new constitution of the Helvetic republic one and indivisible, which had been proclaimed at Aarau. The small mountain cantons refused: they had sent deputies to Aarau, and had submitted to the new constitution by force, after the capitulation of Schwyz, but they would not perjure themselves by swearing perpetual fidelity to an institution which they disliked. Schauenburg threatened to treat them as rebels. The forest cantons replied that 'they would willingly promise never to take up arms against the French republic, nor join its enemies. But our liberty is our only blessing, and the only thing for which we can ever be induced to grasp our arms.' Schauenburg repaired to Luzern with 15,000 men ready to invade the forest cantons. Schwyz and Uri wavered in their resolution, and the small canton of Unterwalden was left alone in the struggle. But even in Unterwalden (which is divided into two diminutive republics) the Oberwalden, or upper one, taken by surprise by the entrance of a French column, did not oppose any resistance, *and the Nidwalden alone, or lower division of the canton, which stretches along the banks of the Waldstätten lake*, stood in arms to repel the aggressors. The whole population of Nidwalden did not much exceed 10,000, of whom about 2000 were able to bear arms. That such a district should attempt to resist the might of France appears madness: it was, however, a determination produced by a feeling of right and justice among men secluded from the rest of the world, who knew nothing of politics and its overbearing dictates. They had not injured any one, why should others come to injure them? On the 9th September 1798 the attack took place. Schauenburg had sent a column round by the Obwalden to attack the Nidwalders in the rear, while he embarked with another division at

[1] [For other references to the legend of Tell, see *Arrows of the Chace*, 1880, ii. 4 (letter of June 6, 1859), reprinted in a later volume of this edition; *Eagle's Nest*, § 215; *Præterita*, i. ch. vi. § 131. The meadow—or, rather, clearing in the forest (Grütli or Rütli)—where the three legendary founders of Swiss freedom had their rendezvous, is on the lake-side, nearly opposite "Tell's chapel."]

Luzern and landed at Stanzstadt. The dispatch of Schauenburg, written on the evening of that day, furnishes a pithy account of the catastrophe. ' After a combat which has lasted from five of the morning till now, we have taken possession of the district of Stanz. I grieve at the consequences of so severe a conflict : it has cost much bloodshed. But they were rebels, whom we must subdue.' And the following day, 10th September, he wrote again : ' I could succeed only by sending a column round by the Oberwald, while I attacked them at the same time by the lake. At six in the evening we were masters of this unhappy country, which has been pillaged. The fury of the soldiers could not be restrained; all that bore arms, including priests, and unfortunately many women also, were put to the sword. Our enemies fought desperately; it was the warmest engagement I ever was in. We have had about 350 wounded; we have lost several officers; but victory has remained with the *republicans.* All Unterwalden is now subdued.' The unfortunate Nidwalders who perished on that day were reckoned at 1500, the rest took refuge in the recesses of the higher Alps. All the cattle were carried off by the French—the houses and cottages were set on fire—fruit trees cut down; the pretty town of Stanz was burnt, Stanzstadt and Buochs shared the same fate. That district, a few days before so peaceful and happy, now exhibited a scene of horrible desolation. In the churchyard of Stanz a chapel has been built, consecrated to the memory of 414 inhabitants of that town, including 102 women and twenty-five children, murdered on the dreadful 9th September. The priest was saying mass in the church when the French rushed in : a shot struck him dead, and fixed itself in the altar, where the mark is still seen. On the road from Stanz to Sarnen is the chapel of St. Jacob, outside of which eighteen women, armed with scythes, leaning against the walls, defended themselves against a party of French soldiers until they were all killed."

Followed, as students of Christian war may remember, by the campaigns of Massena, the Archduke Charles, and Suwarrow.

"The details of this mountain warfare among the high Alps, in which Generals Lecourbe, Soult, and Molitor among the French, and Suwarrow and Hotze among the Russians and Austrians, distinguished themselves, are full of strategic interest. But the unfortunate mountain cantons were utterly ruined by this strange immigration of numerous armies of Russians, Austrians, and French, all living at free quarters upon the inhabitants, and committing many acts of violence. At the end of that campaign, one-fourth of the population of the canton of Schwyz was depending on public charity for support. In the valley of Muotta alone between 600 and 700 persons were reduced to a state of utter destitution. In the still poorer canton of Uri the same distress prevailed, in addition to which a fire broke out at Altorf, which destroyed the greater part

of that, the chief town of the canton. The canton of Unterwalden had been already devastated the year before. In the valleys of the Grisons similar scenes took place; in that of the Vorder Rhein the inhabitants rose against the French on the 1st of May 1799, killed a great many of them, and drove the rest as far as Coire. But the French soon received reinforcements, and overpowered that handful of mountaineers, upon whom they broke their vengeance, killing above 3000 of them, and setting on fire the venerable abbey of Disentis. The inhabitants of the remote valley of Tavetsch, at the foot of the great Alps, were all butchered; the women were hunted down by the soldiers; four of them, being overtaken, threw themselves into the half-frozen lake of Toma, with their infants in their arms, and were shot at in that situation. This was on the 20th of May. The spot where the bodies were buried is still pointed out by the guides.* During the winter of 1799–1800, the two hostile armies in Switzerland remained inactive; the Austrians occupying the Grisons and the banks of the lake of Constance, and the French, under Lecourbe, having their headquarters at Zurich, and being in possession of almost the whole of Switzerland." [1]

With detail of this kind Turner saw at once it was hopeless to contend, in complete pictures. His drawing of Farnley [2] shows what he *saw* in *one* pine;—the etching of the Valley of Chamouni shows also that he had no hope of ever representing their multitudes. He did not even etch this subject himself; the pines are mere conventional zig-zags. Turner left them all veiled under the mezzotint, and put his strength into the stones, upper crags, and clouds.

In the Pass of the Splügen, just presented to me, the spectator must at once understand these two great and unconditional *surrenders* of his power in the Alpine presence. Upper snows, hopeless—pines, hopeless. What is there yet left to be done? or shown?

Well, one thing had to be shown, in which the majesty of the Alps was more concerned than in their pines or snows. That they had in some sort purified such human soul as had chanced to be shed from heaven upon them

* Dandolo, *Lettere sulla Svizzera, Cantone du Grigioni*, Milan, 1829.

[1] [The extracts on pp. 511–513 are from Vieusseux (see above, p. 490 *n.*), pp. 242–243, 245–246.]
[2] [In Ruskin's collection: see above, p. 431. The etching of the Valley of Chamouni is the plate in *Liber Studiorum*.]

and strengthened such human will as had grown up among them from the ground.

And here I must leave my Splügen Pass again for a minute or two, and go back to his earlier Alpine work.

30. R. (*a*). Is my FACSIMILE OF THE VIGNETTE OF THE DEAD-HOUSE OF ST. BERNARD (now in America), for Rogers' *Italy*. (Oxford.[1])

30. R. (*b*). A traced outline from the original vignette, with the dogs added by Landseer. (Oxford.)

30. R. (*c*). Mr. Ward's facsimile of the vignette of the Monastery of the great St. Bernard, now in the National Gallery.

I am very glad to be able to show these studies, in order to correct the impression which has gone abroad that the figures in this vignette [30. R. (*a*)] were not Turner's. Some one had found fault with the dogs, and Landseer sketched his "improvement" on the margin. But Mr. Rogers had the good sense to refuse the improvement. For Landseer had forgotten—what it was not in Turner's nature to forget—that the dogs, after they had dug down to the body and run back to the convent for help, would be *tired*, and would lie down as flat and close to the snow as possible. Look at the utter exhaustion of the couchant one by Turner, and the complacent, drawing-room-rug, pose of Landseer's.

This vignette of Mr. Ward's, by the way, 30. R. (*c*), is a quite marvellous achievement in representing Turner's dashed blots of water-colour, in facsimile, by sheer labour. In my own copy, 30. R. (*a*), the stippling by which the forms are got is visible enough, but I think few eyes would be keen enough to know this of Mr. Ward's from the real drawing.[2] And no lessons in water-colour whatsoever, now

[1] [Educational Series, No. 110; (*b*) is No. 150 in the Reference Series; the original of (*c*) is No. 211 in the National Gallery: see above, p. 376 and *n*. Landseer's suggested substitutes for Turner's dogs were drawn, one in the margin on the right, and the other underneath Turner's group.]

[2] [For further remarks on Mr. Ward's copies, see below, pp. 575–577.]

attainable by the British public for love or money, are comparable to one of these copies of the *Italy* vignettes—the pupil, of course, practising from them in the way they were originally done—outlining first with extreme care, and then, with brown and grey wash, coming as near Turner's total result as he can in half an hour;—for assuredly, from twenty minutes to half an hour was all the time that Turner gave to this drawing;—

But, mind you,—the twenty minutes to half an hour, by such a master, are better in result than ten years' labour would be—only *after the ten years' labour* has been given first: and while the pupil should copy these vignettes, that he may know what entirely first-rate work in water-colour *is*, he can only obtain a similar power in the proportion attainable by his own natural genius, if he rises towards it by Turner's own path—pure pencil drawing, of which more presently;[1] meantime I must get back to the meaning of these two St. Bernard subjects.

You see how Turner leans in both of them on the Disconsolateness — loneliness — tragic horror of the place. I don't know if he ever passed it in winter himself:—whenever I have myself passed it the delight of spring or summer has been on the mountain ridge, and bossy tufts of *Silene acaulis* or dazzling blue of *Gentiana verna* shone round the sable and silver of the lake and its snows.[2]

But Turner saw only the *Monastery*, in his heart, if not with his bodily eyes; the fact being that,—landscape painter though he was, exclusively, and "ridiculous as Turner's figures always are," if you please,[3]—he nevertheless did care for his landscape only for its inhabitants' sake;—living or dead. And the main emotion with him through all his life, is sympathy with the heroism and the sorrow of the living, and wonder and pity concerning the dead. Of which passion in him this Splügen Pass, with its

[1] [See below, p. 521.]
[2] [For Ruskin's earliest impressions of the St. Bernard, see Vol. I. p. 505 ; for a later visit, Vol. X. p. xxiv.]
[3] [On this subject see above, pp. 151–157.]

solitary tower on the rock, is a most notable, and in a sort conclusive expression, the chief of the four in which he "showed his hand," [1] and, if people could read it, his heart, about the Alps, when he went back to them in his old age. Look back to the list of the four, page 477 in the Epilogue to my first notes. Three, you see, on Lake Lucerne; Dawn on the Righi; Morning on the bay of Uri; Sunset on the Righi (*Regina* Montium in old times) —and this! the one nobody would buy, at first,—too grey and colourless to please, I suppose,—being indeed the expression not of Swiss Alps, but of the Grey Kingdom, "GRISONS," where, in May time, 1424,

> "the abbot and all the lords of Upper Rhætia joined the deputies of the various valleys, and of the towns of Ilantz and Tusis, in an open field outside of the village of Trons, and there forming a circle round a gigantic maple tree, all of them standing, nobles, magistrates, deputies, and elders, swore, in the name of the holy Trinity, a perpetual alliance for the maintenance of justice, and the security of every one, without, however, infringing on the rights of any. The articles of the league which, to this day, rules that country, were then stipulated. This was called the *Grey league,* from the colour of the smocks which the deputies wore. By degrees it gave its name to the whole country, which was called Grisons, *Graubundten,* and that of Rhætia became obliterated. Such was the glorious covenant of Trons, one of the few events of its kind which can be recorded with unmixed satisfaction." *

And that is the meaning of the tall church tower upon the Rock of the valley, and of the fading light on the solitary Baron's tower on the far-off crag; just as in the Dudley, and Raglan (32 and 71), his mind is set on the passing away of the baronial power in England.

Not *quite* fallen yet, though; thank Heaven!—I look upon the arrest of the Manchester Thirlmere plan by the House of Lords as the most hopeful political sign of the

the last century; the diet of the Grey league was held every year under its shading branches until the epoch of the French invasion, when it was cut down and burnt amidst the general devastation of the country.[2]

[1] [See above, p. 477.]

[2] [This note is from the same source as the quotation above, which is from Vieusseux (see above, p. 490 *n.*), p. 88.]

last ten years,—showing at last some perception by the English Lords of the Land and its Water, what their power is, and their duty.[1] On their full perception of which, and an iron-hearted (not iron-*clad*, still less iron-selling) maintenance and fulfilment of both, against the commercial mob, the country's safety at this crisis utterly depends; as Carlyle told them, foreseeing it ten years ago *—"This is the question of questions, on which all turns,—how many of our titular aristocracy will prove real gold, when thrown into the crucible."

I must get back to my Splügen Pass;—in which, you see, this question of direct water-supply from the Rock is also considered: not less a water-supply from heaven, whether with gentle rain or condemning storm, in the Salisbury, 38 of first series, and two PÆSTUMS, 31. R. (*a*), and 31. R. (*b*) (Oxford[2]) of this series. (See note on 64. R.[3]) But chiefly, Turner's mind was set, in this drawing, on the sympathy even of the Rocks themselves with the decline of all human power, in their own dissolution; the fragments at the foot of this strong rock being only cloven pieces of its ancient mass, fallen, and for the most part, swept away, —and the dark plain being itself only the diffused wreck of the purple mountains that rise from it, rounded like thunder-clouds.

For the snowy-range in the distance, I can say little. The real contrast between rock and snow is given approximately in my sketch 32. R. (*a*), Mont Blanc from St. Martin's;

* "Shooting Niagara," p. 25 of first edition, of 1867.

[1] [The Bill promoted by the Corporation of Manchester for supplying the city with water from Thirlmere had been temporarily checked by the action of a Committee of the House of Lords. The Examiner reported that the Standing Orders of the House had not been complied with, and the Committee refused an application to allow the Standing Orders to be dispensed with (*Times*, June 3, 1878). The arrest of the scheme for converting Thirlmere into a reservoir was only temporary. The Bill became law in the following year, and the works at Thirlmere have since been completed. Ruskin had been closely associated with the "Thirlmere Defence Association" (see *Fors Clavigera, passim*).]

[2] [Rudimentary Series, No. 171.]

[3] [Below, p. 531, where the reference is to engravings of the "Pæstum."]

but this contrast would have entirely destroyed all his power of expressing the middle distances. This following[1] note on the deficiencies of all Turner's Alpine work, written yesterday in deprecation not merely of criticism by the Alpine Club, but by the less ambitious lovers of Switzerland, who care for her meadows more than for her glaciers, had like to have led me on into subjects of which I must keep clear for the present.

BRANTWOOD, *30th May.*

Neither snows,—nor pines,—in Turner's Switzerland! No—nor are these all that he refuses us. I have heard of other artists who avoided pines, and have known few who drew them affectionately. But there are no other trees, here on our Splügen Pass, of any kind. Not even an avalanche-torn trunk. Of wild chestnut glade among the rocks, of domestic walnut and cherry by the cottage,— nothing. The felicity of their abiding shade at its door, —the wealth of the wandering vine about its balconies,— unheeded by him; only these scratches in the shadow, scarcely intelligible, stand for the trimmed vineyard—necessary absolutely for indication of heat in the plains, and its lowest hills; see, however, foreground in photograph

32. R. (COIRE), showing how true his scratchy symbolism is.

No trees!—well, with our English prejudice, that there *are* none but in England, we might forgive him these; and the rather, considering what we are now making of our own greenwood, only a little north of Robin Hood's country.

[1] [Ed. 9 omits the words: "For the snowy-range . . . following," in place of which was this passage :—

"And here open before me questions on which again I have been at work all my life, tacitly, for the most part, but of which I hope yet to give some solution in *Deucalion,* to which work, and what may be connected with it in the *Laws of Fésole,* I must now wholly set myself, while yet I have some strength and time. Of neither have I enough at present to analyze this Splugen drawing further in any deliberate way; but the studies I have looked over for its illustration may as well be shown, and shall be catalogued; this note on the," etc.]

33. R. Photograph of the vegetable types of modern
English piety and prosperity—by Tyne-side. "His leaf also
shall not wither, and look,—whatsoever he doeth it shall
prosper."[1] But if we ask no trees of him, are our conces-
sions ended?

Alas,—no. Switzerland without snows, and without trees,
is not yet desolate enough. She must even lose her flowers.

In the left-hand lowest corner of this Splügen drawing,
there is a little blue circle, and a blue spot beside it, con-
struable into the indication of two convolvulus blossoms.

Over the pedestal on the right, in the Isola Bella (16),
is thrown a tendril of the same flower.

In the great Geneva (69), a few whitish spots may stand
for hemlock, or the like. In the Arona, and the Italy, no
vestige of flowers—and the trees black or brown against
the sky!

Had he never seen Alpine roses—nor pinks, nor gentians,
nor crocuses, nor primulas? Had he never seen oleander,
pomegranates, or orange? Instead of white orange blossom,
he gives us black foliage, blossomless and fruitless, and a
white—Bridge of Sighs! Instead of Alpine rose in morning
light—only the purple of sunset on river mist, or its scarlet
on clouds of storm.

Whose fault is it, I wonder,—his or ours, good British
public?

It can't possibly be ours, you think. "Don't we love
flowers to that degree, that we can't so much as eat our
mutton, but we must mix up the smell of roses with the
smell of gravy and fat? And what sums do not we spend
on our hot-houses! and has not the Horticultural Society
built itself beautiful arcades;[2] and has it not always the
Guards and the Rifles to play beautiful tunes in honour
of Horticulture? And don't we always see the dew of
May in the morning, after dancing in time all night?"

[1] [Psalms i. 4 (Prayer-Book version).]
[2] [The reference is to the gardens and arcades on the Kensington Gore site,
formerly occupied by the Horticultural Society, and used for exhibitions; now covered
by the Imperial Institute and other buildings.]

Well, if it be not our fault, is it poor Peggy's fault, who hates the smell of roses! or is it—you will think I am going crazy again, if I tell you it is—in any wise the fault of Mephistopheles and his company, who detest it more than Peggy, and have introduced the preferable perfumes of tobacco, sulphur, and gunpowder, for European delectation.*

The truth of the matter lies deep and long ago. For this essential dislike of trees and flowers began precisely when Art was culminating, and Titian, and Veronese, and Vandyck, and Velasquez, care as little for flowers as Turner. My own impression is that the English Wars of the Roses did indeed end the power of the Rose, for *us;* that the wars of the Red and White Lilies ended the power of the Lily, for Italy;—and the death, this day, 30th May, four hundred and forty-seven years ago, of her own wildwood-flower of Domrémy,—that of the Fleur-de-Lys for France. And since, you have had your artists—Italian, French, and English, studious of anatomies, and putrescent substances of all kinds—but of leaves or flowers—no more.

But as for Turner—I can positively tell you, there was no possibility of his drawing flowers or trees, rightly, after he had once left Yorkshire for Rome. Michael Angelo's sprawling prophets, and Bernini's[1] labyrinthine arcades wholly

* Compare the stanza of "Miss Kilmansegg," with the close of the second part of *Faust,* and Palgrave's *Arabia.*[2]

[1] [Giovanni Lorenzo Bernini (1598–1680) designed the colonnades of the Piazza di S. Pietro; for Turner's studies of them, see above, p. 256. See *Ariadne Florentina,* § 184, for "the fluent efflorescence of Bernini."]

[2] [The first reference is to stanza 18 of Hood's "Miss Kilmansegg and her Precious Leg: a Golden Legend':—

"Poor Peggy hawks nosegays from street to street
Till—think of that, who find life so sweet!—
She hates the smell of roses!"

The next reference is to the last scene but one of the Second Part of *Faust,* where Mephistopheles in his contest with the angels blasts the roses which they scatter. W. G. Palgrave in his *Narrative of a Year's Journey through Central and Eastern Arabia* (1865) explains that one of the objects of his travel was "to bring the stagnant waters of Eastern life into contact with the quickening stream of European progress." Ruskin (who detested tobacco) perhaps refers to Palgrave's account of his attempts to persuade the Arabs to become votaries of the weed (vol. ii. pp. 12, 13).]

bewildered him, and dragged him into their false and fantastic world; out of which he broke at last, only in the strength of sympathy with human suffering; not again capable of understanding human simplicity and peace.

There was some indolence of age telling in the matter also, and whatever of disease or evil was in him, bodily or mental. All his failures and errors are chronicled, no less than his advanced knowledge and passion, in the Swiss drawings, and whatever the powers of this evil world had done upon him, is enough shown in the transitions from the beautiful flock of goats with their skipping kids in the Nemi, to the black and white spots which do service for goats and sheep on this dusty road. The piece of foliage on the right hand in the "ARONA"[1] is almost the last he ever did with care, but even the conventional crumbling work of the tree stems in that drawing is infinitely beautiful. I tried to translate it into pencil in the study 34. R., hoping thus to make it publishable in photograph for my pupils; but in vain, this and other such efforts manifold; for I find the photograph refuses to translate pencil drawing, and I cannot work in chalk or sepia up to the required fineness.

And now once more—and for the last time, as the most important thing for the reader to notice—I beg him to convince himself of this quality of fineness in Turner's work. Unless his own eyes are fine indeed, he simply cannot see a Turner drawing at all; my own are already too much injured by age and sickness to see the effect of the lines in the dark side of the tower (above-mentioned), or of the dark stippling in the distant plain; nor can I see now without a lens even the detail of the drawings I made from the year 1854 onwards, to illustrate the towns of Switzerland.[2] I spent the summers of some half-dozen years in collecting materials for etchings of Fribourg, Lucerne,

[1] [For "Nemi," see above, p. 426; and for "Arona," p. 456.]
[2] [See Introduction to Vol. V. p. xxxii., and *Prœterita*, iii. ch. i. §§ 10, 12; an elaborate drawing of Thun done for this intended series was exhibited (from Mrs. Cunliffe's collection) at Manchester in 1904 (No. 101), with two studies for it (No. 102).]

and Geneva, but had to give all up,—the modern mob's madness destroying all these towns before I could get them drawn, by the insertion of hotels and gambling-houses exactly in the places where they would kill the effect of the whole.[1]

Look at the photograph of Coire, for instance. You can scarcely see its tall Grison tower though white against the plain; it is a mere appendage now of the hotel ("Steinbock"—is it?—I can't quite make out the letters on the right of its balcony)—haggard yet in newness of erection; and of what avail is the glittering of the feeble snow among those upper pines, against the glare of the new lodging-house?—I can't make drawings of towns thus disfigured, any more than I could of a beautiful face with a false carnival nose: and my six years' work has gone pretty nearly for nothing.

It may amuse the reader, I hope it will also make him a little sorrowful for me, to compare my boy's drawing of the SWISS BADEN, 35. R., made when I was sixteen, with the hard effort to get it right, in 36. R.—coloured only in a quarter of it before the autumn leaves fell—then given up—cut into four—now pasted together again to show how it was meant to be;—or my boy's drawing of FRIBOURG, 37. R., with my pen and ink beginning on the hill chapel in its distance, thirty years afterwards, 38. R. (Oxford[2]). The old-fashioned engraving beneath, of the same place, is not without its lesson.

39. R. (a). SPIRE AND ANGLE WINDOW AT ZUG is an exemplary little bit of pencil study (1854 or 1856), with careful note of the foliation and bottom of the bracket of the window. It will bear a lens, though the coronet over the two shields in the front panel should have been clearer.

[1] [Compare *Modern Painters*, vol. iv. (Vol. VI. pp. 455–456).]

[2] [The "boy's drawing of Fribourg" (1835) is reproduced in Vol. II. of this edition, Plate 24, p. 438. It was exhibited at Manchester in 1904, No. 15. The "pen and ink beginning" is reproduced in Vol. V. Plate F, p. xxxiv.; it is in the Educational Series at Oxford, No. 114.]

39. R. (*b*). Upper subject, TWISTED SPIRE, VILLAGE NEAR BRIEG (Valais), 1876; middle, TOWERS AT BADEN—1863; lower, at VERONA, 1876, show what I have finally adopted in manner of pencil drawing; and I believe my pupils will find it a satisfactory one, for rendering the essential qualities of form.

40. R. LUCERNE, is one of the outlines of general view, such as I meant to join these studies into. All little better than waste paper now. Compare 44. R. for method of outline.

41. R. FRA GIOCONDO'S BRIDGE AT VERONA, with Albert della Scala's tower at the end of it,—enlarged studies of the weeds on the nearer buttress, and the water under the nearer arch, below.[1]

42. R. COLOUR STUDY of the other side of the same bridge (beginning only). The two together may perhaps give some idea of what bridges used to be before they were changed by modern art into brittle gridirons, with blinkers at the sides to keep you from seeing the river, unless you are dropped into it and burnt to prevent you being drowned.

43. R. NARNI, with its *two* bridges, the fragment of the Roman one, Turner's subject,[2] seen between the tree stems on the right. The nearer, fourteenth century, carried away partly by a flood of the Nar, and repaired, but long ago, with wholesome and safe woodwork.

44. R. BRIDGE OF LAUFFENBOURG. Woodwork here original,—grand old Swiss carpentry. I got into a great mess with my rocks in this drawing; but it is a valuable

1 [Exhibited at the Society of Painters in Water-Colours, 1901, No. 219.]
2 [See above, p. 424.]

one in bare detail. For the gneiss, and its curious weeds, they were hopeless, unless I had gone at them as in the next subject.[1]

45. R. (*a*). GNEISS, with its weeds, above the stream of Glen-Finlas (Oxford[2]). Old drawing of *Modern Painters'* time (1853), which really had a chance of being finished, but the weather broke; and the stems in the upper right-hand corner had to be rudely struck in with body-colour. But all the mass of this rock is carefully studied with good method.

45. R. (*b*). WILD STRAWBERRY BLOSSOM;—*one* of the weeds of such a rock, painted as it grew. (Recent lesson for my Oxford schools.[3])

46. R. OLD SKETCH OF GNEISS with its weeds, in colour. (Chamouni.) I have been promising myself these last thirty years to do one bit of rock foreground completely, with its moss and lichen inlaying; but the golden brown of the moss always beat me. I may yet do it, I think, in a measure, if I can only get some peace.

47. R. GNEISS CLEAVAGES. Study at the Montanvert.

48. R. GRANITE CLEAVAGES. Aiguille Blaitière. The centre of this drawing was engraved for *Modern Painters;*[4] and I was led at that time into a quantity of anatomical work on mountains, of which the service, if any, is yet to come, for I don't think the public ever read the geological chapters in *Modern Painters.* But now, with the three drawings before them, 58, 66, and the Splügen, they may

[1] [Exhibited at the Society of Painters in Water-Colours, 1901, No. 41; at Manchester, 1904, No. 103. The drawing, made in 1863, is in Mrs. Cunliffe's collection.]
[2] [Reference Series, No. 89. Reproduced in Vol. XII., Plate i. p. xxvi.]
[3] [Educational Series, No. 11.]
[4] [Plate 31 in vol. iv. (in this edition, Vol. VI. p. 230). The drawing was in the Ruskin Exhibition at Coniston, 1900, No. 72; at the Royal Society of Painters in Water-Colours, 1901, No. 228; at Manchester, 1904, No. 323.]

be interested a little in seeing how important the lines of diagonal cleavage had become in Turner's mind, as the origin of the most noble precipice forms.[1] See the parallel lines in the foreground of 58; the sloping chasm in the distance of 66; and the precipice under the church in the Splügen, with its lines carried forward by the rocks in dissolution below.

But I lost much artistic power through the necessity of making these geological studies wholly accurate, without allowing aërial or colour effect to disturb them; and indeed it was not until the year 1858 that hard work under Veronese and Titian forced me to observe the true relations between line and colour. But, to my amazement, the conclusive lessons on these matters were given me, not by Venetians, but by the three Florentines, Botticelli, Giotto, and—name despised of Artists!—Angelico. So that I have been forced to call the lesson-book on which I am now working The Laws of Fésole. The genius of Carpaccio in Venice was a distinct one, and never formed a school. But the studies I made last year from his pictures of the life of St. Ursula, and two fragments from Assisi, will serve to show the final manner of work in which I am endeavouring to lead my Oxford pupils.[2]

49. R. STUDY OF FURNITURE AND GENERAL EFFECT IN CARPACCIO'S PICTURE OF ST. URSULA'S DREAM.[3]

The original picture is, I think, a quite faultless example of the unison of right delineation with right colour. On this small scale I could not attempt more than the indication of the details, but good photographs of the picture

[1] [Compare Modern Painters, vol. iv. (Vol. VI. pp. 300 seq.).]

[2] [For the development of Ruskin's views on these matters in 1858, see the preface to Modern Painters, vol. v. § 4; and Fors Clavigera, Letter 76. For his discovery of Carpaccio, see Vol. IV. p. 356 n. For the title "The Laws of Fésole," see the preface to that work (Vol. XV.).]

[3] [Several of the following studies were made for the Ruskin Museum at Sheffield. For Ruskin's notes on the pictures by Carpaccio here mentioned, see Guide to the Academy at Venice, part ii.; St. Mark's Rest ("The Shrine of the Slaves"); and for "St. Ursula's Dream," Fors Clavigera, Letter 20.]

itself are now published by Messrs. Naya at Venice, and I think these coloured here at Coniston, by my patient friend Mr. Gould,[1] from this drawing, very desirable possessions at their moderate price.

50. R. FRAGMENT STUDIED FROM CARPACCIO'S PICTURE OF THE FUNERAL PROCESSION OF ST. URSULA.

I broke down here over the canopy and Bishop's robes, quite inimitable pieces of decorative work. What Carpaccio puts into his decoration may be seen in Mr. Murray's drawing, next following.

51. R. LOWEST COMPARTMENT OF THE BORDER OF THE HIGH-PRIEST'S ROBE, IN CARPACCIO'S PICTURE OF THE PRESENTATION.

Size of original. Study by Mr. Fairfax Murray.[2]

52. R. MARTYRDOM OF ST. URSULA.

Old engraving from Carpaccio's picture. Good and legitimate old-fashioned work as engraving ; without the slightest power of expression, or endeavour to represent chiaroscuro. (On which point, see my *Ariadne Florentina* (§§ 82, 83, and 107.)

53. R. MARTYRDOM OF ST. URSULA.

Study from the central portion of this picture, and a most admirable one ; by Mr. Fairfax Murray. I hold this drawing among the most valuable I have been enabled to present to my Oxford School.[3]

[1] [See above, p. 400.]

[2] [The artist and connoisseur, who did much work at this time for Ruskin : see *Mornings in Florence*, § 118 ; *St. Mark's Rest*, § 176.]

[3] [This was a slip. Mr. Murray's drawing was for a time shown at Oxford, but it was presented to the St. George's Museum at Sheffield, where it may now be seen. Ruskin describes it in detail in *An Oxford Lecture* (1877), § 13 (*Nineteenth Century*, Jan. 1878 ; *On the Old Road*, 1899, ii. § 290 ; and reprinted in a later volume of this edition).]

54. R. OLD ENGRAVING from Carpaccio's picture of St. Ursula and her Bridegroom before the Pope.

55. R. PART OF THE DISTANT PROCESSION, in this picture, sketched by Mr. F. Murray.

Showing its true harmonies of chiaroscuro and colour. (For some description of the picture itself, see my first supplement to *St. Mark's Rest.*[1])

56. R. BLIND LOVE, DEATH, AND ANGER, driven from the presence of Chastity.

Lowest corner of the northern fresco by Giotto, over the tomb of St. Francis at Assisi.[2] Sketch by myself, in 1874, to show Giotto's power in colour; unrivalled when he chooses to use it.

57. R. PART OF THE CLUSTER OF ROSES ROUND THE HEAD OF GIOTTO'S POVERTY.

Real size from the eastern fresco of the same quadripartite vault. Study by myself in 1874.

58. R. PORCH OF AMIENS, sketched in 1856.

Showing the original rose-moulding, replaced now by a modern one, improved according to modern French notions of what thirteenth-century design ought to have been: as also the paintings in the Sainte Chapelle. (Oxford.[3])

59. R. PART OF THE FRONT OF THE CATHEDRAL, LUCCA (1874). (Oxford.[4])

[1] [Now §§ 203–206. This and the other pictures of the St. Ursula series are in the Academy at Venice.]

[2] [In the vault over the High Altar in the lower church. See *Fors Clavigera*, Letters 45 and 76, where Ruskin refers to his drawing at Assisi in 1874, and to the influence of his studies on his view of the relations of the great masters. For Giotto's gift of colour, see also *Stones of Venice*, vol. i. (Vol. IX. p. 449).]

[3] [Educational Series, No. 51.]

[4] [Not now there : see note on p. 414, above.]

THE RUSKIN COLLECTION, 1878

60. R. PART OF THE APSE OF CATHEDRAL OF PISA
(1872). (Oxford.[1])

This sketch has been before exhibited; but without my
having directed attention to the subtlety of the arch curves,
intersections of the horizontal curve of the circular apse
with stilted Saracenic curves widening the voussoirs as they
spring; compare the spring of the arch in 20. R.

These drawings will be enough to give my friends,
known and unknown, a clear idea of the various efforts
which, especially of late, have been necessary to form the
foundations of my literary work. I do not find that my
recent illness has seriously impaired my powers of quietly
using these materials as I intended: but it has made me,
at all events, incapable of turning my mind to any matters
involving difficulty of deliberation, or painful excitement.
Unable therefore now to carry forward my political work,
I yet pray my friends to understand that I do not quit it
as doubting anything that I have said, or willingly ceasing
from anything that I proposed: but because the warning
I have received amounts to a direct message from the Fates
that the time has come for me to think no more of any
Masterhood; but only of the Second Childhood which has
to learn its way towards the other world.

[1] [In the Reference Series in the Ruskin Drawing School. The drawing was
probably placed in the rooms of the Old Water-Colour Society, where, after his
election as an honorary member of the Society in 1873, Ruskin occasionally sent
drawings.]

NOTES RESPECTING FUTURE USES
OF ENGRAVINGS

THIS catalogue has already reached length far more cumbrous than I intended; but I must yet find room for a few paragraphs in small print, taken from the Appendix to *Ariadne Florentina* [§ 231], respecting the possible future uses of engraving.

"I will not lose more time in asserting or lamenting the mischief arising out of the existing system: but will rapidly state what the public should now ask for.

"1. Exquisitely careful engraved outlines of all remaining frescoes of the thirteenth, fourteenth, and fifteenth centuries in Italy, with so much pale tinting as may be explanatory of their main masses, and with the local darks and local lights brilliantly relieved. The Arundel Society have published some meritorious plates of this kind from Angelico—not, however, paying respect enough to the local colours, but conventionalizing the whole too much into outline.

"2. Finished small plates for book illustration. The cheap wood-cutting and etching of popular illustrated books have been endlessly mischievous to public taste: they first obtained their power in a general reaction of the public mind from the insipidity of the lower school of line engraving, brought on it by servile persistence in hack work for ignorant publishers. The last dregs of it may still be seen in the sentimental landscapes engraved for cheap ladies' pocket-books. But the woodcut can never, educationally, take the place of serene and accomplished line engraving; and the training of young artists in whom the gift of delineation prevails over their sense of colour, to the production of scholarly, but small plates, with their utmost honour of skill, would give a hitherto unconceived dignity to the character and range of our popular literature.

"3. Vigorous mezzotints from pictures of the great masters, which originally present noble contrasts of light and shade. Many Venetian works are magnificent in this character.

"4. Original design by painters themselves, decisively engraved in few lines— (not etched); and with such insistence by dotted work on the main contours as we have seen in the examples given from Italian engraving.

"5. On the other hand, the men whose quiet patience and exquisite manual dexterity are at present employed in producing large and costly plates, should be entirely released from their servile toil, and employed exclusively in producing coloured copies, or light drawings, from the original work. The same number of hours of labour, applied with the like conscientious skill, would multiply precious likenesses of the real picture, full of subtle veracities which no steel line could approach, and conveying to thousands true knowledge and unaffected enjoyment of painting; while the finished plate lies uncared for in the portfolio of the virtuoso, serving only, so far as it is seen in the print-seller's window by the people, to make them think that sacred painting must always be dull, and unnatural."

Under the second head, in the above statement, I ought more specially to have mentioned flower and animal engraving in perfection. The two plates, 61. R. and 62. R., from the *Flora Danica*,[1] published a hundred years ago, will show at once what loving and tender engraving can do in plant-illustration. But that of birds and animals has yet to begin; and I hope that a public demand for careful picture of them, will arise out of the increasing public desire for their more kindly treatment.

And under the first head, of engraved outlines, I ought to have expressed my strong conviction that for educational purposes (and not less for the most refined pleasure to advanced students), engraving, from Turner outlines, with pale tints for his greys, and afterwards coloured by hand, would be worth far more to the purchaser than the most finished plates.

63. R. and 64. R. 'will sufficiently show what I mean. I do not remember if these are Mr. Ward's copies or Miss Jay's (both have executed work for me which has been a delightful possession):[2] but see how much may be learned from each of these, of essential Turner composition.

63. R. is the market-place at Louviers; and has of course interested Turner chiefly for the elephantine mass of Gothic rising above it. This, however, was painful and defective by the meagreness of its square tower, —so Turner hangs out the signboard on the left to outsquare it; and a wriggling bit, of iron above to contrast with it. He trebles this sign, downwards, in harmony with the horizontal divisions of the church: then he puts his black vertical figures to carry down the richness of its apse— hide them, and see how the apse also seems to disappear! Then with his pair of horses and postillion, he repeats the too isolated form of the whole church and its spire, and with his scattered black dots on the right overpowers the formalism of the shop doors and windows beyond.[8]

Carefully engraved from the original, printed on grey paper, and touched with white by hand, this entire sketch might be, to all intents and purposes, multiplied indefinitely.

64. R. (Study for the large drawing of Saumur, copied, I think, by Miss Jay.[4]) ·Infinitely more instructive to *me* than the large drawing itself. The grand masses of the buildings given in fearless simplicity : their formalism taken up, reflected, and conquered by the flat top of the huge pier in front : the massy stones of the near wall on the right by their perspective lines

<hr>

[1] [Properly *Icones Floræ Danicæ* (see *Proserpina*, ch. i.), "a beautiful series of engravings of the flowers of Denmark, Norway, and Sweden, which was begun in 1761, and is still continuing" (*Instructions in the Preliminary Exercises arranged for the Lower Drawing School, Oxford*, 1872). The work (begun in 1764) is still in progress. For another reference to it, see *Laws of Fésole*, ch. x. § 37. Ruskin took several plates out of his copy and placed them as examples in his Oxford School.]

[2] [See on this subject, Appendix iv., pp. 575–578.]

[3] [For the principle of composition here noted, compare p. 427, above. The drawing is No. 422 (*b*) in the National Gallery : see p. 285 of this volume.]

[4] [The "large drawing" was engraved in the *Keepsake* for 1831, and is said to have been once in Ruskin's collection (see below, p. 604); it was reproduced in *Turner and Ruskin*, vol. i. p. 88. The study, copied by Miss Jay, is No. 619 (*a*) in the National Gallery.]

completing the distance of all; and the stripes of the boat in the centre taking up and conquering their formality.

Of course, neither these, nor, *a fortiori*, the more delicate pencil outlines which are still more valuable as elementary lessons, could be rendered without the recovery of the old Italian method of work, of which I myself possess only one example—and that a singularly unattractive one, 65. R. But it shows sufficiently how the most delicate pencilling may be rendered on metal.

On the other hand, Turner's finished coloured work can only be represented by coloured copies, faithfully executed by hand. All the aid which it has been thought he gave to the engraver in translating colour was merely changing his own picture into a chiaroscuro study instead; and too often, scratching it all into white spots to make it "sparkling."[1] The best engravings are those which pretend least to effect, and dwell on what they can efficiently render, delineation. The four I have chosen,— 66. R. to 69. R., this last an exquisite proof with Turner's added brambleleaves in the foreground, in his own lovely pencil-touching,—show what has been nobly and beautifully done by modern engraving of this kind.[2] For light and shade, mezzotint only should be used. The two states of Turner's unpublished plate of Pæstum, 31. R. (*a*) and (*b*), show better than the finished plates of the Liber, how much artists themselves might accomplish, by the use of this certain method instead of the laborious accidents of etching.

[1] [See above, p. 64.]

[2] [Instead of the following sentences to end of the *Notes*, ed. 9 reads: " ;—the Splügen Pass itself, No. 70. R., uniting all that's best of dark and light, with colour for ever inimitable."]

APPENDIX[1]

NOTES BY THE REV. W. KINGSLEY ON THE
TURNER DRAWINGS

HAVING for very many years enjoyed the intimate friendship of Mr. Ruskin, and being familiar with the collection of drawings exhibited, I venture to add a few words to his descriptions which have been so sadly cut short by his illness. I know how much good this exhibition of Turner's drawings with Mr. Ruskin's notes in the hands of those who look at them may do, and therefore I consider it a duty to add what I feel assured Mr. Ruskin himself would have accepted as materials for further notes, and the mention of my name by him in what he has written tends to remove the scruples that naturally arise in adding to his work at a time when his permission cannot be asked.

Magnificent as this collection is, it is far from what it would have been had Mr. Ruskin not been magnificently generous. His gifts to Oxford and Cambridge contain some of the very best drawings he ever possessed, and the generosity must be measured not by the money value, which is in itself very large, but by the admiration and love in which he held them.*

NOTES ADDED[2]

No. 6 [p. 416]. BOAT BUILDING. I copied this drawing carefully nineteen times, and by that labour learned it well. Examine the rings round the inside of the boat and the cleats for the oars, each is a separate study. The tools in the carpenter's hands and on the bench are portraits. See also the footprints the men have left on their way from the boat. In the vessel on the right the block on the yard has the halyard through it. The colours used are only Prussian blue, light red, raw umber, and black. Turner took care to learn how much could be got out of such simple colours before he

* *Able now to thank, and very earnestly, my old friend for these added notes, of extreme value to myself no less than to the present students of Turner, I should yet scarcely have passed this paragraph, unless it had given me pleasant occasion to note that the "Mossdale Fall" at Cambridge,[3] and the Lowther sketches at Oxford were originally Mr. Kingsley's own gifts to me, parted with as, indeed, the best educational drawings in my collection.*

[1] [This appendix, with Mr. Kingsley's Notes, first appeared in ed. 7. For Mr. Kingsley, see above, p. 162 n.]
[2] [References to the pages (to which Mr. Kingsley's Notes refer) are here inserted.]
[3] [Cambridge, No. 5 : see below, p. 558. The "Lowther sketches" are in the Ruskin Drawing School, Nos. 127 and 128 in the Educational Series ("Park Scenes"), and No. 131 in the Rudimentary Series (see below, p. 559). Two are pencil drawings, the other is partly in colour.]

ventured on using more; and in his most brilliant effects there is no diffi-
culty in matching the colours used: the colour-box exhibited contains only
the old-fashioned paints manufactured by Sherborn.

No. 14 [p. 422]. The National Gallery Fort Rock was found after
Turner's death, blocking up a window in an out-house, placed there no
doubt to save window tax.

No. 25 [p. 429]. See *Elements of Drawing*, § 244.

No. 28 [p. 432]. This drawing was one of two given to a nephew of
Mr. Fawkes to take with him to Eton; one he cut in two, and this, having
got dirty, he washed, which accounts for the stains and want of light in the
distance and sky. Miss Charlotte Fawkes copied the drawing when fresh,
and her copy now proves how serious is the damage done.

No. 29 [p. 432]. Yes, it is at Farnley, as is also the No. 30. Mr. Fawkes
lost his wife about this time, and the black dress is probably due to this
cause, the tone of the drawing being due to this rather than the colour
of the dress being suited to that of the drawing.

No. 40 [p. 442]. Yellow comes forward,[1] and I believe it is not possible
to get the colour of such a sky true and at the same time preserve the trans-
parency and distance. But in the series of the England and Wales Turner
painted many skies with thorough transparency, and he could afford to sacri-
fice an effect in any individual drawing, realizing that effect in another.

No. 50 [p. 447]. Turner told me that he and Callcott had a certain
number of the Bible sketches to realize between them: they agreed to
pick them alternately, drawing lots for first choice. Callcott won the choice
and selected at once a sketch of Ararat; the sketch of the Pools of Solomon[2]
was left to the last, and Turner said he kept it on his breakfast table for
a month before he could make up his mind how to treat it.
Look at the pennon wrapped round the mast of the boat, at the top
you see the inside of the whorl and the sunlight coming through the cloth;
such little bits of truth prove both the amount of study and his intense
memory and imagination in making use of such details.

No. 51 [p. 448]. The depth, transparency, and luminousness of the sky
against sunlighted buildings are wonderful.

No. 56 [p. 451]. I have no doubt of chalk being the base of the body-
colour of this drawing.

No. 62 [p. 454]. See *Elements of Drawing* [§§ 196 *seqq*., 218 *seqq*.].

No. 64 [p. 455]. Look quietly at this drawing for a little time and
I think you will feel that it is not too blue, but does most truly give the

[1] [On this subject, see above, p. 218.]
[2] [For a reference to this drawing, see *Modern Painters*, vol. i. (Vol. III. p. 383).] .

effect of the instant before the sun appears over a mountain. Before you venture to criticize it be sure that you have watched one hundredth of the sunrises Turner studied.*

No. 105 [p. 469]. Look at the execution of the edges of the feathers, the filaments are expressed by the same stroke of the brush that defines the form, and gives the gradation. This is easily seen on the tail, but the same thing is done over and over again throughout the drawing, with absolute certainty of touch.

No. 122 [p. 474]. Compare the engraving of the England drawing of the Malmesbury; he must have remembered this early sketch through all the intervening years.

Page 483, No. 4. The Lucerne is now in the possession of Mr. Newall of Ferndene, Gateshead-on-Tyne.

Turner's work may be broadly divided into three periods; the first that of wonder and delight in the beauty of natural scenery as first seen; the second that of looking at nature for the purpose of making pictures; and the last the "recording" as far as he could what he saw after nearly fifty years of observation. His worst work is to be found in the second period; he tried to please the public, and false and cruel criticism made him at times low-spirited and at others defiant, and it was only very late in his life that he put forth his full strength to depict nature as he saw it with all his knowledge and experience. He himself told me that he did not like looking at his own work "because the realization was always immeasurably below the conception," and again to use his own words "he considered it his duty to record"[1] certain things he had seen; and so in these late Swiss drawings he felt that he could only "record" imperfectly the effects of nature, but he did his best with all his acquired knowledge and power to tell what he had seen. There is so much in these drawings that each requires many pages to describe the ideas expressed. One quality, that of colour, must surely be felt by every one whose colour-sense is not dead; for purity, intensity, and harmony they cannot be surpassed; nothing short of opal can go beyond the Fluelen. But for the rendering of natural facts and for the poetry it is hopeless for any one to criticize them who has not in some degree the mental penetration and grasp of Turner, and an imagination almost as vivid. No greater nonsense can be uttered than the story of Turner's saying that Mr. Ruskin saw things in his pictures that he himself had not thought of.† By anything like a full rendering of a natural scene ideas will be caused in the spectator like those the actual scene would have excited,

* (*Quite right, my dear old friend;—just what I wanted to say of it, but hadn't time.—J. R.*)

† *I'm so glad of this bit. Nothing ever puts me more "beside myself"—though a good many things have produced that effect lately—than this vulgar assertion.*[2]

[1] [See above, p. 162.]
[2] [See also *Modern Painters*, vol. iv. (Vol. VI. pp. 274–275 n.).]

and so thoughts may arise in the mind of any one in looking at a good picture which really belong to the picture but which had not been dwelt on definitely by the painter. Had anything like this been the burden of the story it might have been credible; but it must have been invented for the purpose of disparaging both Turner and Ruskin by some one who knew neither.

Now Turner's work differs from that of all other landscape painters especially in this:—that his knowledge and imagination enabled him to grasp at once with the leading subject a vast amount of details all in keeping and all perfectly clear and defined in his own mind; the apparent vagueness of his late work is due to his effort to represent as far as possible the infinite delicacy of gradation and endless detail of nature, and not to any want of clearness in idea or want of power. The Landscape painters of the present school are quite right in painting only what they see, and with definite purpose of detail, but they fail through representing nature as if it contained no more detail or gradation than they express; the very clearness of the work showing at once the want of keen observation and of real imagination; and although Turner did not sacrifice truth to mere beauty, he always saw beauty in nature; terrible his works may be at times, but never ugly. It is well also to observe that Turner in his figures takes care to express clearly their action, but is well aware of the danger of allowing a figure to draw away the attention from the subject of the Landscape.

These late Swiss Drawings bear about the same relation to his early work that Beethoven's Choral Symphony does to one of the simple movements of his early Piano Forte Sonatas, and should be looked at with the respect and reverence due to one who was doing his best to tell what he had seen and loved, at the end of a long life spent in the most industrious study of nature: the early drawings in this collection are enough to prove the power and refinement of hand and eye, and the nineteen thousand and odd sheets of paper covered with studies in the National Gallery speak for his industry.[1]

I will end what I have added to these notes by repeating what he once said to me, because I have found his words to be amongst the soundest and truest I have ever heard, and also because they apply but too sadly at the present moment to one to whom we all owe much. I had made the remark that the want of power in a certain painter to depict what was not before him showed a want of genius; Turner said vehemently, "I know of no genius but the genius of hard work."

<div align="right">W. KINGSLEY.</div>

South Kilverton.

[1] [A passage in Mr. Kingsley's Notes which Ruskin here struck out is of considerable interest in Turner's biography: "His powers failed suddenly, as Mr. Ruskin states; the cause was the loss of his teeth; Cartwright did his best to make him a set of false ones, but the tenderness of the gums did not allow him to make use of them; so his digestion gave way and he suffered much from this to the end of his life." What Mr. Kingsley says is confirmed in statements (among Ruskin's papers) by other friends of the painter.]

APPENDIX

PICTURE GALLERIES—THEIR
FUNCTIONS AND FORMATION

THE NATIONAL GALLERY SITE COMMISSION[1]

Evidence of John Ruskin, Monday, April 6, 1857

1. *Chairman.* Has your attention been turned to the desirableness of uniting sculpture with painting under the same roof?—Yes.

2. What is your opinion on the subject?—I think it almost essential that they should be united, if a National Gallery is to be of service in teaching the course of art.

3. Sculpture of all kinds, or only ancient sculpture?—Of all kinds.

4. Do you think that the sculpture in the British Museum should be in the same building with the pictures in the National Gallery, that is to say, making an application of your principle to that particular case?—Yes,

[1] [This evidence was first printed in the *Report of the National Gallery Site Commission*, 1857, pp. 92–97. Questions 2392–2504. The Commission was appointed "to determine the site of the New National Gallery, and to report on the desirableness of combining with it the Fine Art and Archæological Collections of the British Museum." It reported against the latter proposal, and on the former point decided in favour of the site of the then and now National Gallery; the idea of the Government of the day was to build a new gallery on the Kensington Gore site. The Commission consisted of Lord Broughton (Chairman), Dean Milman, Professor Faraday, Mr. Cockerell, R.A., and Mr. George Richmond, all of whom were present on the occasion of Ruskin giving his evidence. It was reprinted in *The Literary Gazette*, August 22, 1857, and in *On the Old Road*, 1885, vol. i. pt. ii. pp. 549–573, §§ 405–429; and again in the second edition of that work, 1899, vol. i. pp. 153–182, §§ 114–138. The questions are here renumbered (1–114). In 105 "Crevelli" is here corrected to "Crivelli."

The following analysis of the evidence was given in the Index to the Report (p. 184), and reprinted in *On the Old Road* (1st ed., pp. 572–573; 2nd ed., pp. 181–182); the numbering of the questions is here altered to correspond with the text:—

1–18. Sculpture and painting should be combined under same roof, not in same room.—Sculpture disciplines the eye to appreciate painting.—But, if in same room, disturbs the mind.—Tribune at Florence arranged too much for show.—Sculpture not to be regarded as *decorative* of a room.—National Gallery should include works of all kinds of art *of all ages*, arranged chronologically (*cf.* 84).—Mediæval sculpture should go with painting, if it is found impossible to combine art of all ages.

19–30. Pictures should be protected by glass in every case. It makes them

539

certainly; I think so for several reasons—chiefly because I think the taste of the nation can only be rightly directed by having always sculpture and painting visible together. Many of the highest and best points of painting, I think, can only be discerned after some discipline of the eye by sculpture. That is one very essential reason. I think that after looking at sculpture one feels the grace of composition infinitely more, and one also feels how that grace of composition was reached by the painter.

5. Do you consider that if works of sculpture and works of painting were placed in the same gallery, the same light would be useful for both of them?—I understood your question only to refer to their collection under the same roof. I should be sorry to see them in the same room.

6. You would not mix them up in the way in which they are mixed up in the Florentine Gallery, for instance?—Not at all. I think, on the contrary, that the one diverts the mind from the other, and that, although the one is an admirable discipline, you should take some time for the examination of sculpture, and pass afterwards into the painting room, and so on. You should not be disturbed while looking at paintings by the whiteness of the sculpture.

7. You do not then approve, for example, of the way in which the famous room, the Tribune, at Florence, is arranged?—No; I think it is

more beautiful, independently of the preservation.—Glass is not merely expedient, but essential.—Pictures are permanently injured by dirt.

31–43. First-rate large pictures should have a room to themselves, and a gallery round them.—Pictures must be hung on a line with the eye.—In one, or at most two, lines.—In the Salon Carré at the Louvre the effect is magnificent, but details of pictures cannot be seen.

44, 45. Galleries should be decorated not splendidly, but pleasantly.

46. Great importance of chronological arrangement. Art the truest history (*cf.* 59 and 84).

47–56. Best works of inferior artists to be secured.

57–59. All the works of a painter, however incongruous their subjects, to be exhibited in juxtaposition.

60, 61. Love of detail in pictures among workmen.—Great refinement of their perceptions.

62–64. Accessibility of new National Gallery.

65–69. There should be two galleries—one containing gems, placed in as *safe* a position as possible; the other containing works good, but inferior to the highest, and located solely with a view to accessibility.

70. Impossible to protect *sculpture* from London atmosphere.

71–76. Inferior gallery would be useful as an instructor.—In this respect superior to the great gallery.

77–85. *Copies* of paintings much to be deprecated.

86–93. Good collection of casts a valuable addition to a national gallery.—Also architectural fragments and illustrations.—And everything which involves art.

94–103. If it is impossible to combine works of art of all ages, the Pagan and Christian division is the best. — " Christian " art including *all* art subsequent to the birth of Christ.

104. Great importance of arranging and setting off sculpture.

108. Recent purchase by Government of the great Paul Veronese.

112. " Restoring " abroad.

113, 114. Witness is Master of the Elementary and Landscape School of Drawing at the Working Men's College in Great Ormond Street.—Progress made by students highly satisfactory.]

merely arranged for show—for showing how many rich things can be got together.

8. *Mr. Cockerell.* Then you do not regard sculpture as a proper decorative portion of the National Gallery of Pictures—you do not admit the term decoration?—No; I should not use that term of the sculpture which it was the object of the gallery to exhibit. It might be added, of course, supposing it became a part of the architecture, but not as independent—not as a thing to be contemplated separately in the room, and not as a part of the room. As a part of the room, of course, modern sculpture might be added; but I have never thought that it would be necessary.

9. You do not consider that sculpture would be a repose after contemplating painting for some time?—I should not feel it so myself.

10. *Dean of St. Paul's.* When you speak of removing the sculpture of the British Museum, and of uniting it with the pictures of the National Gallery, do you comprehend the whole range of the sculpture in the British Museum, commencing with the Egyptian, and going down through its regular series of gradation to the decline of the art?—Yes, because my great hope respecting the National Gallery is, that it may become a perfectly consecutive chronological arrangement, and it seems to me that it is one of the chief characteristics of a National Gallery that it should be so.

11. Then you consider that one great excellence of the collection at the British Museum is, that it does present that sort of history of the art of sculpture?—I consider it rather its weakness that it does not.

12. Then you would go down further?—I would.

13. You are perhaps acquainted with the ivories which have been recently purchased there?—I am not.

14. Supposing there were a fine collection of Byzantine ivories, you would consider that they were an important link in the general history?—Certainly.

15. Would you unite the whole of that Pagan sculpture with what you call the later Christian art of Painting?—I should be glad to see it done —that is to say, I should be glad to see the galleries of painting and sculpture collaterally placed, and the gallery of sculpture beginning with the Pagan art, and proceeding to the Christian art, but not necessarily associating the painting with the sculpture of each epoch; because the painting is so deficient in many of the periods where the sculpture is rich, that you could not carry them on collaterally—you must have your painting gallery and your sculpture gallery.

16. You would be sorry to take any portion of the sculpture from the collection in the British Museum, and to associate it with any collection of painting?—Yes, I should think it highly inexpedient. My whole object would be that it might be associated with a larger collection, a collection from other periods, and not be subdivided. And it seems to be one of the chief reasons advanced in order to justify removing that collection, that it cannot be much more enlarged—that you cannot at present put other sculpture with it.

17. Supposing that the collection of ancient Pagan art could not be united with the National Gallery of pictures, with which would you associate the mediæval sculpture, supposing we were to retain any considerable amount of sculpture?—With the painting.

18. The mediæval art you would associate with the painting, supposing you could not put the whole together?—Yes.

19. *Chairman.* Do you approve of protecting pictures by glass?—Yes, in every case.[1] I do not know of what size a pane of glass can be manufactured, but I have never seen a picture so large but that I should be glad to see it under glass. Even supposing it were possible, which I suppose it is not, the great Paul Veronese, in the gallery of the Louvre, I think would be more beautiful under glass.

20. Independently of the preservation?—Independently of the preservation, I think it would be more beautiful. It gives an especial delicacy to light colours, and does little harm to dark colours—that is, it benefits delicate pictures most, and its injury is only to very dark pictures.

21. Have you ever considered the propriety of covering the sculpture with glass?—I have never considered it. I did not know until a very few days ago that sculpture was injured by exposure to our climate and our smoke.

22. *Professor Faraday.* But you would cover the pictures, independently of the preservation, you would cover them absolutely for the artistic effect, the improvement of the picture?—Not necessarily so, because to some persons there might be an objectionable character in having to avoid the reflection more scrupulously than otherwise. I should not press for it on that head only. The advantage gained is not a great one; it is only felt by very delicate eyes. As far as I know, many persons would not perceive that there was a difference, and that is caused by the very slight colour in the glass, which, perhaps, some persons might think it expedient to avoid altogether.

23. Do you put it down to the absolute tint in the glass like a glazing, or do you put it down to a sort of reflection? Is the effect referable to the colour in the glass, or to some kind of optic action, which the most transparent glass might produce?—I do not know; but I suppose it to be referable to the very slight tint in the glass.

24. *Dean of St. Paul's.* Is it not the case when ladies with very brilliant dresses look at pictures through glass, that the reflection of the colour of their dresses is so strong as greatly to disturb the enjoyment and the appreciation of the pictures?—Certainly; but I should ask the ladies to stand a little aside, and look at the pictures one by one. There is that disadvantage.

25. I am supposing a crowded room—of course the object of a National Gallery is that it should be crowded—that as large a number of the public should have access to it as possible—there would of course be certain limited hours, and the gallery would be liable to get filled with the public in great numbers?—It would be disadvantageous certainly, but not so disadvantageous as to balance the much greater advantage of preservation. I imagine that, in fact, glass is essential; it is not merely an expedient thing, but an essential thing to the safety of the pictures for twenty or thirty years.

26. Do you consider it essential as regards the atmosphere of London, or of this country generally?—I speak of London only. I have no experience

[1] [See above, pp. 173-175.]

of other parts. But I have this experience in my own collection. I kept my pictures for some time without glass, and I found the deterioration definite within a very short period—a period of a couple of years.

27. You mean at Denmark Hill?—Yes; that deterioration on pictures of the class I refer to is not to be afterwards remedied—the thing suffers for ever—you cannot get into the interstices.

28. *Professor Faraday.* You consider that the picture is permanently injured by the dirt?—Yes.

29. That no cleaning can restore it to what it was?—Nothing can restore it to what it was, I think, because the operation of cleaning must scrape away some of the grains of paint.[1]

30. Therefore, if you have two pictures, one in a dirtier place, and one in a cleaner place, no attention will put the one in the dirtier place on a level with that in the cleaner place?—I think nevermore.

31. *Chairman.* I see that in your *Notes on the Turner Collection,* you recommended that the large upright pictures would have great advantage in having a room to themselves.[2] Do you mean each of the large pictures or a whole collection of large pictures?—Supposing very beautiful pictures of a large size (it would depend entirely on the value and size of the picture), supposing we ever acquired such large pictures as Titian's Assumption, or Raphael's Transfiguration, those pictures ought to have a room to themselves, and to have a gallery round them.

32. Do you mean that each of them should have a room?—Yes.

33. *Dean of St. Paul's.* Have you been recently at Dresden?—No, I have never been at Dresden.

34. Then you do not know the position of the Great Holbein and of the Madonna de S. Sisto there, which have separate rooms?—No.

35. *Mr. Cockerell.* Are you acquainted with the Munich Gallery?—No.

36. Do you know the plans of it?—No.

37. Then you have not seen, perhaps, the most recent arrangements adopted by that learned people, the Germans, with regard to the exhibition of pictures?—I have not been into Germany for twenty years.[3]

38. That subject has been handled by them in an original manner, and they have constructed galleries at Munich, at Dresden, and I believe at St. Petersburgh upon a new principle, and a very judicious principle.[4] You have not had opportunities of considering that?—No, I have never considered that; because I always supposed that there was no difficulty in producing a beautiful gallery, or an efficient one. I never thought that there could be any question about the form which such a gallery should take, or that it was a matter of consideration. The only difficulty with me was this—the persuading, or hoping to persuade, a nation that if it had pictures at all, it should have those pictures on the line of the eye; that it was not well to have a noble picture many feet above the eye,

[1] [See on this subject, Vol. XII. pp. 397–403.]
[2] [See above, pp. 176–177.]
[3] [These questions and other reasons led Ruskin to visit the German galleries in 1859; see *Præterita,* iii. ch. i. § 12, and the Introduction to Vol. VII.]
[4] [The principle here referred to is that of large central galleries with side "cabinets" for small pictures of corresponding schools. The arrangement is well seen in the Munich Gallery, built after the design of Klenze, 1826–1836.]

merely for the glory of the room. Then I think that as soon as you decide that a picture is to be seen, it is easy to find out the way of showing it; to say that it should have such and such a room, with such and such a light; not a raking light, as I heard Sir Charles Eastlake express it the other day, but rather an oblique and soft light, and not so near the picture as to catch the eye painfully. That may be easily obtained, and I think that all other questions after that are subordinate.

39. *Dean of St. Paul's.* Your proposition would require a great extent of wall?—An immense extent of wall.

40. *Chairman.* I see you state in the pamphlet to which I have before alluded, that it is of the highest importance that the works of each master should be kept together.[1] Would not such an arrangement increase very much the size of the National Gallery?—I think not, because I have only supposed in my plan that, at the utmost, two lines of pictures should be admitted on the walls of the room; that being so, you would be always able to put all the works of any master together without any inconvenience or difficulty in fitting them to the size of the room. Supposing that you put the large pictures high on the walls, then it might be a question, of course, whether such and such a room or compartment of the Gallery would hold the works of a particular master; but supposing the pictures were all on a continuous line, you would only stop with A and begin with B.

41. Then you would only have them on one level and one line?—In general; that seems to me the common-sense principle.

42. *Mr. Richmond.* Then you disapprove of the whole of the European hanging of pictures in galleries?—I think it very beautiful sometimes, but not to be imitated. It produces most noble rooms. No one can but be impressed with the first room at the Louvre, where you have the most noble Venetian pictures one mass of fire on the four walls; but then none of the details of those pictures can be seen.

43. *Dean of St. Paul's.* There you have a very fine general effect, but you lose the effect of the beauties of each individual picture?—You lose all the beauties, all the higher merits; you get merely your general idea. It is a perfectly splendid room, of which a great part of the impression depends upon the consciousness of the spectator that it is so costly.

44. Would you have those galleries in themselves richly decorated?— Not richly, but pleasantly.

45. Brilliantly, but not too brightly?—Not too brightly. I have not gone into that question, it being out of my way; but I think, generally, that great care should be taken to give a certain splendour— a certain gorgeous effect—so that the spectator may feel himself among splendid things; so that there shall be no discomfort or meagreness, or want of respect for the things which are being shown.

46. *Mr. Richmond.* Then do you think that Art would be more worthily treated, and the public taste and artists better served, by having even a smaller collection of works so arranged, than by a much larger one merely housed and hung four or five deep, as in an auction room?— Yes. But you put a difficult choice before me, because I do think it a

[1] [See above, p. 177.]

very important thing that we should have many pictures. Totally new results might be obtained from a large gallery in which the chronological perfect, and whose curators prepared for that chronological leaving gaps to be filled by future acquisition; taking the greatest pains in the selection of the examples, that they should be thoroughly characteristic; giving a greater price for a picture which was thoroughly characteristic and expressive of the habits of a nation; because it appears to me that one of the main uses of Art at present is not so much as Art, but as teaching us the feelings of nations.[1] History only tells us what they did; Art tells us their feelings, and why they did it: whether they were energetic whether they were, as in the case of the Dutch, imitating , quiet and cold. All those expressions of feeling cannot History. Even the contemporary historian does not feel them; he does not feel what his nation is; but get the works of the same master together, the works of the same nation together, and the works of the same century together, and see how the thing will force itself upon every one's observation.

47. Then you would not exclude the genuine work of inferior masters? —Not by any means.

48. You would have the whole as far as you could obtain it?—Yes, as far as it was characteristi I think you can hardly call an inferior master one who does in the to do; and I would not take any ot in some way excel. For instance, I would not take a mere imitator of Cuyp among the Dutch; but Cuyp himself has done insuperable things in certain expressions of sunlight and repose.[2] Van der Heyden and others may also be mentioned as first-rate in inferior lines.

49. Taking from the rise of art to the time of Raphael, would you in the National Gallery include examples of all those masters whose names have come down to the most learned of us?—No.

50. Where would you draw the line, and where would you begin to leave out?—I would only draw the line when I was purchasing a picture. I think that a person might always spend his money better by making an effort to get one noble picture than five or six second or third-rate pictures, provided only, that you had examples of the best kind of work produced at that time. I would not have second-rate pictures. Multitudes of masters among the disciples of Giotto might be named; you might have one pictures of Giotto, and one or two pictures of the disciples of Giotto.

51. Then you would rather depend upon the beauty of the work itself; if the work were beautiful, you would admit it?—Certainly.

52. But if it were only historically interesting, would you then reject it?—Not in the least. I want it historically interesting, but I want as good an example as I can have of that particular manner.

53. Would it not be historically interesting if it were the only picture known of that particular master, who was a follower of Giotto? For instance, supposing a work of Cennino Cennini[3] were brought to light, and

[1] [Compare the preface to *St. Mark's Rest*.]
[2] [See *Modern Painters*, vol. i. (Vol. III. p. 271). Of the architectural pictures by Jan van der Heyden (1637–1712); there are several examples in the National Gallery.]
[3] [See Vol. XII. p. 269 n.]

had no real merit in it as a work of art, would it not be the duty of the authorities of a National Gallery to seize upon that picture, and pay perhaps rather a large price for it?—Certainly; all documentary art I should include.

54. Then what would you exclude?—Merely that which is inferior, and not documentary; merely another example of the same kind of thing.

55. Then you would not multiply examples of the same masters' if inferior men, but you would have one of each. There is no man, I suppose, whose memory has come down to us after three or four centuries; but has something worth preserving in himself, which perhaps no other person retain one example of such, would you not?—I would, if it was in my power, but I would rather with given funds make an effort to get perfect examples.

56. Then you think that the artistic element should govern the archæo-

one master consecutively, would you pay any regard or not to the subjects? You must be well aware that many painters, for instance, Correggio, and others, painted very incongruous subjects; would you rather keep them together than disperse the works of those painters to a certain degree according to their subjects?—I would most certainly keep them together. I think it an important feature of the master that he did paint incongruously, and very possibly the character of each picture would be better understood by seeing them together; the relations of each are sometimes essential to be seen.

58. *Mr. Richmond.* Do you think that the preservation of these works is one of the first and most important things to be provided for?—It would be so with me in purchasing a picture. I would pay double the price for it if I thought it was likely to be destroyed where it was.

59. In a note you wrote to me the other day, I find this passage: "The Art of a nation I think one of the most important points of its history, and a part which, if once destroyed, no history will ever supply the place of— and the first idea of a National Gallery is, that it should be a Library of Art, in which the rudest efforts are, in some cases, hardly less important than the noblest." Is that your opinion?—Perfectly. That seems somewhat inconsistent with what I have been saying, but I mean there, the noblest efforts of the time at which they are produced. I would take the greatest pains to get an example of eleventh-century work, though the painting is perfectly barbarous at that time.

60. You have much to do with the education of the working classes in Art. As far as you are able to tell us, what is your experience with regard to their liking and disliking in Art—do comparatively uneducated persons prefer the Art up to the time of Raphael, or down from the time of Raphael?—we will take the Bolognese School, or the School—which do you think a working man would feel the greatest interest in looking at?—I cannot tell you, because my working men would not be allowed to look at a Bolognese picture; I teach them so much love of detail, that the moment they see a detail carefully drawn, they are caught by it. The main thing which has surprised me in dealing with these men

is the exceeding refinement of their minds—so that in a moment I can get carpenters, and smiths, and ordinary workmen, and various classes to give me a refinement which I cannot get a young lady to give me when I give her a lesson for the first time. Whether it is the habit of work which makes them go at it more intensely, or whether it is (as I rather think) that, as the feminine mind looks for strength, the masculine mind looks for delicacy, and when you take it simply, and give it its choice, it will go to the most refined thing, I do not know.

61. *Dean of St. Paul's.* Can you see any perceptible improvement in the state of the public mind and taste in that respect since these measures have been adopted?—There has not been time to judge of that.

62. Do these persons who are taking an interest in Art come from different parts of London?—Yes.

63. Of course the distance which they would have to come would be of very great importance?—Yes.

64. Therefore one of the great recommendations of a Gallery, if you wish it to have an effect upon the public mind in that respect, would be its accessibility, both with regard to the time consumed in going there, and to the cheapness, as I may call it, of access?—Most certainly.

65. You would therefore consider that the more central the situation, putting all other points out of consideration, the greater advantage it would be to the public?—Yes; there is this, however, to be said, that a central situation involves the crowding of the room with parties wholly uninterested in the matter—a situation more retired will generally be serviceable enough for the real student.

66. Would not that very much depend upon its being in a thoroughfare? There might be a central situation which would not be so complete a thoroughfare as to tempt persons to go in who were not likely to derive advantage from it?—I think that if this gallery were made so large and so beautiful as we are proposing, it would be rather a resort, rather a lounge every day, and all day long, provided it were accessible.

67. Would not that a good deal depend upon its being in a public thoroughfare? If it were in a thoroughfare, a great many persons might pass in who would be driven in by accident, or driven in by caprice, if they passed it; but if it were at a little distance from a thoroughfare, it would be less crowded with those persons who are not likely to derive much advantage from it?—Quite so; but there would always be an advantage in attracting a crowd; it would always extend its educational ability in its being crowded. But it would seem to me that all that is necessary for a noble Museum of the best art should be more or less removed, and that a collection, solely for the purpose of education, and for the purpose of interesting people who do not care much about art, should be provided in the very heart of the population, if possible, that pictures not of great value, but of sufficient value to interest the public, and of merit enough to form the basis of early education, and to give examples of all art, should be collected in the popular Gallery, but that all the precious things should be removed and put into the great Gallery, where they would be safest, irrespectively altogether of accessibility.

68. *Chairman.* Then you would, in fact, have not one but two Galleries? —Two only.

69. *Professor Faraday.* And you would seem to desire purposely the removal of the true and head Gallery to some distance, so as to prevent the great access of persons?—Yes.

70. Thinking that all those who could make a real use of a Gallery would go to that one?—Yes. My opinion in that respect has been altered within these few days from the fact having been brought to my knowledge of sculpture being much deteriorated by the atmosphere and the total impossibility of protecting sculpture. Pictures I do not care about, for I can protect them, but not sculpture.

71. *Dean of St. Paul's.* Whence did you derive that knowledge?—I forget who told me; it was some authority I thought conclusive, and therefore took no special note of.

72. *Chairman.* Do you not consider that it is rather prejudicial to art that there should be a Gallery notoriously containing no first-rate works of art, but second-rate or third-rate works?—No; I think it rather valuable as an expression of the means of education, that there should be early lessons in art—that there should be this sort of art selected especially for first studies, and also that there should be a recognition of the exceeding preciousness of some other art. I think that portions of it should be set aside as interesting, but not unreplaceable; but that other portions should be set aside as being things as to which the function of the nation was, chiefly, to take care of those things, not for itself merely, but for all its descendants, and setting the example of taking care of them for ever.

73. You do not think, then, that there would be any danger in the studying or the copying of works which notoriously were not the best works?—On the contrary, I think it would be better that works not altogether the best should be first submitted. I never should think of giving the best work myself to a student to copy—it is hopeless; he would not feel its beauties—he would merely blunder over it. I am perfectly certain that that cannot be serviceable in the particular branch of art which I profess, namely, landscape-painting; I know that I must give more or less of bad examples.

74. *Mr. Richmond.* But you would admit nothing into this second gallery which was not good or true of its kind?—Nothing which was not good or true of its kind, but only inferior in value to the others.

75. And if there were any other works which might be deposited there with perfect safety, say precious drawings, which might be protected by glass, you would not object to exhibit those to the unselected multitude?—Not in the least; I should be very glad to do so, provided I could spare them from the grand chronological arrangement.

76. Do you think that a very interesting supplementary exhibition might be got up, say at Trafalgar Square, and retained there?—Yes, and all the more useful because you would put few works, and you could make it complete in series—and because, on a small scale, you would have the entire series. By selecting a few works, you would have an epitome of the Grand Gallery, the divisions of the chronology being all within the compartment of a wall, which in the great Gallery would be in a separate division of the building.

77. *Mr. Cockerell.* Do you contemplate the possibility of excellent copies being exhibited of the most excellent works both of sculpture and

of painting?—I have not contemplated that possibility. I have a great horror of copies of any kind, except only of sculpture. I have great fear of copies of painting; I think people generally catch the worst parts of the painting and leave the best.

78. But you would select the artist who should make the copy. There are persons whose whole talent is concentrated in the power of imitation of a given picture, and a great talent it is.—I have never in my life seen a good copy of a good picture.[1]

79. Have you not seen any of the German copies of some of the great Italian masters, which are generally esteemed very admirable works? —I have not much studied the works of the copyists; I have not observed them much, never having yet found an exception to that rule which I have mentioned. When I came across a copyist in the Gallery of the Vatican, or in the Gallery at Florence, I had a horror of the mischief, and the scandal and the libel upon the master, from the supposition that such a thing as that in any way resembled his work, and the harm that it would do to the populace among whom it was shown.

80. *Mr. Richmond.* You look upon it as you would upon coining bad money and circulating it, doing mischief?—Yes, it is mischievous.

81. *Mr. Cockerell.* But you admit engravings—you admit photographs of these works, which are imitations in another language? — Yes; in abstract terms, they are rather descriptions of the paintings than copies —they are rather measures and definitions of them—they are hints and tables of the pictures, rather than copies of them; they do not pretend to the same excellence in any way.

82. You speak as a connoisseur; how would the common eye of the public agree with you in that opinion?—I think it would not agree with me. Nevertheless, if I were taking some of my workmen into the National Gallery, I should soon have some hope of making them understand in what excellence consisted, if I could point to a genuine work; but I should have no such hope if I had only copies of these pictures.

83. Do you hold much to the archæological, chronological, and historical series and teaching of pictures?—Yes.

84. Are you of opinion that that is essential to the creative teaching, with reference to our future schools?—No. I should think not essential at all. The teaching of the future artist, I should think, might be accomplished by very few pictures of the class which that particular artist wished to study. I think that the chronological arrangement is in nowise connected with the general efficiency of the gallery as a matter of study for the artist, but very much so as a means of study, not for persons interested in painting merely, but for those who wish to examine the general history of nations; and I think that painting should be considered by that class of persons as containing precious evidence. It would be part of the philosopher's work to examine the art of a nation as well as its poetry.

85. You consider that art speaks a language and tells a tale which no written document can effect?—Yes, and far more precious; the whole soul of a nation generally goes with its art. It may be urged by an ambitious king to become a warrior nation. It may be trained by a single leader to

[1] [Compare *A Joy for Ever,* § 90 (a passage in a lecture of 1857); in later years Ruskin was at pains to train and encourage copyists in the right way: see Appendix iv., below, and pp. 530–531, above.]

become a *great* warrior nation, and its character at that time may materially depend upon that one man, but in its art all the mind of the nation is more or less expressed: it can be said, that was what the peasant sought to when he went into the city to the cathedral in the morning—that was the sort of book the poor person read or learned in—the sort of picture he prayed to. All which involves infinitely more important considerations than common history.

86. *Dean of St. Paul's.* When you speak of your objections to copies of pictures, do you carry that objection to casts of sculpture?—Not at all.

87. Supposing there could be no complete union of the great works of sculpture in a country with the great works of painting in that country, would you consider that a good selection of casts comprising the great remains of sculpture of all ages would be an important addition to a public gallery?—I should be very glad to see it.

88. If you could not have it of originals, you would wish very much to have a complete collection of casts, of course selected from all the finest sculptures in the world?—Certainly.

89. *Mr. Richmond.* Would you do the same with architecture—would you collect the remains of architecture, as far as they are to be collected, and unite them with sculpture and painting?—I should think that architecture consisted, as far as it was portable, very much in sculpture. In saying that, I mean, that in the different branches of sculpture architecture is involved—that is to say, you would have the statues belonging to such and such a division of a building. Then if you had casts of those statues, you would necessarily have those casts placed exactly in the same position as the original statues—it involves the building surrounding them and the elevation—it involves the whole architecture.

90. In addition to that, would you have original drawings of architecture, and models of great buildings, and photographs, if they could be made permanent, of the great buildings as well as the mouldings and casts of the mouldings, and the members as far as you could obtain them?—Quite so.

91. Would you also include, in the National Gallery, what may be called the handicraft of a nation—works for domestic use or ornament? For instance, we know that there were some salt-cellars designed for one of the Popes; would you have those if they came to us?—Everything, pots and pans, and salt-cellars, and knives.

92. You would have everything that had an interesting art element in it?—Yes.

93. *Dean of St. Paul's.* In short, a modern Pompeian Gallery?—Yes; I know how much greater extent that involves, but I think that you should include all the iron work, and china, and pottery, and so on. I think that all works in metal, all works in clay, all works in carved wood, should be included. Of course, that involves much. It involves all the coins—it involves an immense extent.

94. Supposing it were impossible to concentre in one great museum the whole of these things, where should you prefer to draw the line? Would you draw the line between what I may call the ancient Pagan world and the modern Christian world, and so leave, to what may be called the ancient world, all the ancient sculpture, and any fragments of ancient painting which there might be—all the vases, all the ancient bronzes, and,

in short, everything which comes down to a certain period? Do you think
that that would be the best division, or should you prefer any division
which takes special arts, and keeps those arts together?—I should like the
Pagan and Christian division. I think it very essential that wherever its
sculpture of a nation was, there its iron work should be—that wherever its
iron work was, there its pottery should be, and so on.

95. And you would keep the mediæval works together, in whatever
form those mediæval works existed?—Yes; I should not at all feel injured
by having to take a cab-drive from one century to another century.

96. Or from the ancient to the modern world?—No.

97. *Mr. Richmond.* If it were found convenient to keep separate the
Pagan and the Christian art, with which would you associate the mediæval?
—By "Christian and Pagan Art" I mean, before Christ and after Christ.

98. Then the mediæval would come with the paintings?—Yes; and
also the Mahomedan, and all the Pagan art which was after Christ, I should
associate as part, and a most essential part, because it seems to me that
the history of Christianity is complicated perpetually with that which
Christianity was affecting. Therefore, it is a matter of date, not of Chris-
tianity. Everything before Christ I should be glad to see separated, or you
may take any other date that you like.

99. But the inspiration of the two schools—the Pagan and the Christian—
seems so different, that there would be no great violence done to the true
theory of a National Gallery in dividing these two, would there, if each
were made complete in itself?—That is to say, taking the spirit of the
world after Christianity was in it, and the spirit of the world before Chris-
tianity was in it.

100. *Dean of St. Paul's.* The birth of Christ, you say, is the com-
mencement of Christian art?—Yes.

101. Then Christian influence began, and, of course, that would leave
a small debateable ground, particularly among the ivories for instance, which
we must settle according to circumstances?—Wide of any debateable
ground, all the art of a nation which had never heard of Christianity, the
Hindoo art and so on, would, I suppose, if of the Christian era, go into
the Christian gallery.

102. I was speaking rather of the transition period, which, of course,
there must be?—Yes.

103. *Mr. Cockerell.* There must be a distinction between the terms
"museum" and "gallery." What are the distinctions which you would
draw in the present case?—I should think "museum" was the right
name of the whole building. A "gallery" is, I think, merely a room in
a museum adapted for the exhibition of works in a series, whose effect
depends upon their collateral showing forth.

104. There are certainly persons who would derive their chief advantage
from the historical and chronological arrangement which you propose, but
there are others who look alone for the beautiful, and who say, "I have
nothing to do with your pedantry. I desire to have the beautiful before
me. Show me those complete and perfect works which are received and
known as the works of Phidias and the great Greek masters as far as we
possess them, and the works of the great Italian painters. I have not
time, nor does my genius permit that I should trouble myself with those

details." There is a large class who are guided by those feelings?—And I hope who always will be guided by them; but I should consult their feelings enough in the setting before them of the most beautiful works of art. All that I should beg of them to yield to me would be that they should look at Titian only, or at Raphael only, and not wish to have Titian and Raphael side by side; and I think I should be able to teach them, as a matter of beauty, that they did enjoy Titian and Raphael alone better than mingled. Then I would provide them beautiful galleries full of the most noble sculpture. Whenever we come as a country and a nation to provide beautiful sculpture, it seems to me that the greatest pains should be taken to set it off beautifully. You should have beautiful sculpture in the middle of the room, with dark walls round it to throw out its profile, and you should have all the arrangements made there so as to harmonize with it, and to set forth every line of it. So the painting gallery, I think, might be made a glorious thing, if the pictures were level, and the architecture above produced unity of impression from the beauty and glow of colour and the purity of form.

105. *Mr. Richmond.* And you would not exclude a Crivelli because it was quaint, or an early master of any school—you would have the infancy, the youth, and the age, of each school, would you not?—Certainly.

106. *Dean of St. Paul's.* Of the German as well as the Italian?—Yes.

107. *Mr. Richmond.* Spanish, and all the schools?—Certainly.

108. *Mr. Cockerell.* You are quite aware of the great liberality of the Government, as we learn from the papers, in a recent instance, namely, the purchase of a great Paul Veronese?—I am rejoiced to hear it. If it is confirmed, nothing will have given me such pleasure for a long time. I think it is the most precious Paul Veronese in the world, as far as the completion of the picture goes, and quite a priceless picture.[1]

109. Can you conceive a Government, or a people, who would countenance so expensive a purchase, condescending to take up with the occupation of the upper story of some public building, or with an expedient which should not be entirely worthy of such a noble Gallery of Pictures? —I do not think that they ought to do so; but I do not know how far they will be consistent. I certainly think they ought not to put up with any such expedient. I am not prepared to say what limits there are to consistency or inconsistency.

110. *Mr. Richmond.* I understand you to have given in evidence that you think a National Collection should be illustrative of the whole art in all its branches?—Certainly.

111. Not a cabinet of paintings, not a collection of sculptured works, but illustrative of the whole art?—Yes.

112. Have you any further remark to offer to the Commissioners?— I wish to say one word respecting the question of the restoration of statuary. It seems to me a very simple question. Much harm is being at present done in Europe by restoration, more harm than was ever done, as far as I know, by revolutions or by wars. The French are now doing great harm to their cathedrals, under the idea that they are doing good; destroying more than all the good they are doing. And all this proceeds

<hr>

[1] [See above, pp. 88, 244, 287.]

from the one great mistake of supposing that sculpture can be restored
when it is injured. I am very much interested by the question which
one of the Commissioners asked me in that respect;[1] and I would suggest
whether it does not seem easy to avoid all questions of that kind. If the
statue is injured; leave it so, but provide a perfect copy of the statue in
its restored form; offer, if you like, prizes to sculptors for conjectural re-
storations, and choose the most beautiful, but do not touch the original
work.

113. *Professor Faraday.* You said some time ago[2] that in your own
attempts to instruct the public there had not been time yet to see
whether the course taken had produced improvement or not. You see
no signs at all which lead you to suppose that it will not produce the
improvement which you desire?—Far from it—I understood the Dean of
St. Paul's to ask me whether any general effect had been produced upon
the minds of the public. I have only been teaching a class of about forty
workmen for a couple of years, after their work—they not always attend-
ing—and that forty being composed of people passing away and coming
again; and I do not know what they are now doing; I only see a gradual
succession of men in my own class. I rather take them in an elementary
class, and pass them to a master in a higher class. But I have the greatest
delight in the progress which these men have made, so far as I have seen
it; and I have not the least doubt that great things will be done with
respect to them.

114. *Chairman.* Will you state precisely what position you hold?—I am
master of the Elementary and Landscape School of Drawing at the Working
Men's College in Great Ormond Street. My efforts are directed not to
making a carpenter an artist, but to making him happier as a carpenter.

[1] [See above, Question 89, p. 550. On the subject in question, compare the letter
on Ribbesford Church, *Arrows of the Chace*, 1880, i. 235 (reprinted in a later volume
of this edition, and already referred to in Vol. XII. p. 423 *n.*).]
[2] [See above, Question 61, p. 547.]

II

THE CHARACTER OF TURNER

1. FROM THORNBURY'S "LIFE" (1862)

[THE following words are from the Preface to *The Life of J. M. W. Turner, R.A.* . . . By Walter Thornbury, 2 vols., 1862; vol. i. pp. v.-vi.: "Some four years ago, when the desire to write a life of·Turner first entered my mind, I determined to take no steps in such a scheme till I had ascertained whether Mr. Ruskin might not himself have some intention of one day becoming the biographer of that great painter whose genius he had done so much to illustrate. In answer to my letter of inquiry, Mr. Ruskin replied that he had no intention of writing a life of Turner, but that he should much rejoice in my doing so, and would give me all the help he could. His words were :—"]

Fix at the beginning the following main characteristics of Turner in your mind, as the keys to the secret of all he said and did :—

Uprightness.	*Obstinacy* (extreme).
Generosity.	*Irritability.*
Tenderness of heart (extreme).	*Infidelity.*
Sensuality.	

And be sure that he knew his own power, and felt himself utterly alone in the world from its not being understood. Don't try to mask the dark side. . . .

Yours most truly,

J. RUSKIN.[1]

[1] [Ruskin's letter was written in 1857. It contained also the admonition, "there is no time to be lost, for those who knew him when young are dying daily" (Thornbury, 1862, vol. i. p. viii.). See also *Modern Painters*, vol. v. pp. 345-347, and *Lectures on Architecture and Painting*, pp. 181-188, where the character of Turner is further explained, and various anecdotes given in special illustration of his truth, generosity, and kindness of heart. Mr. Thornbury's book was also referred to in *Modern Painters*, vol. v. p. 344, where Ruskin speaks of this "Life of Turner," then still unpublished, as being written "by a biographer, who will, I believe, spare no pains in collecting the few scattered records which exist of a career so uneventful and secluded." In the second edition, one vol., 1877, p. v., the following letter was also given :—

"LUCERNE, *Dec.* 2, 1861.—I have just received and am reading your book with deep interest. I am much gratified by the view you have taken and give of Turner. It is quite what I hoped. What beautiful things you have discovered about him! Thank you for your courteous and far too flattering references to me."

The two extracts were reprinted in *Arrows of the Chace*, 1880, vol. i. pp. 157-158. A letter from Ruskin to his father shows that he was not blind to the defects of Thornbury's work :—

"LUCERNE, *Dec.* 2, 1861.— . . . That is a dreadful book of Thornbury's—in every sense—utterly bad in taste and writing; but the *facts* are the sorrowful things. Hamlet is light comedy to it. What beautiful things there are in it, of Turner's doing! In this respect, and in Thornbury's view of the man, the book is better than I expected."]

2. FROM WILLIS'S *CURRENT NOTES* (MARCH 1855)

In *Current Notes* for January 1852 there are some interesting particulars respecting the late J. M. W. Turner. I take the liberty of writing to you in the hope that at some leisure moment the writer might be disposed to set down on paper any further particulars which he remembers about him, and to beg that I might be favoured by the perusal of any such notes.

Might I also ask for the privilege of a glance at the original sketch, if still existing, from which the woodcut in the *Current Notes* was executed. I know that in transference to wood many points of character are likely to be lost.[1]

J. RUSKIN.

DENMARK HILL.

[1] [The article in Willis's *Current Notes* for January 1852 (No. 13, vol. 2, p. 1) contained some slight reminiscences by " T. J. A." of Turner at Farnley in 1805 or 1806—recording how he went out grouse-shooting, and how on another occasion the party accompanied the artist on a sketching expedition to Gordale. The writer had made a surreptitious sketch of Turner, which was reproduced in the *Current Notes*. It much resembles the better known sketch by Mr. Hawksworth Fawkes. In response to Ruskin's letter in the *Notes* of March 1855 (No. 51, vol. 5, p. 18), "T. J. A." wrote in the May number regretting that his "treacherous memory retained no further traces" of the artist, but adding at second-hand a story about Turner putting some of his canvases under the pump. Ruskin's letter in *Current Notes* was reprinted in *Igdrasil* for June 1890 (vol. i. p. 209), and thence again reprinted in the privately issued volume of *Ruskiniana*, 1890, part i. p. 27. On the subject of Ruskin's own intention at various times to write a life of Turner, see above, Introduction, p. lvi. An interesting note on the character of Turner, in connexion with sketches and drawings discussed in this volume, occurs in a letter from Ruskin to his father in 1858 :—

"BELLINZONA, *June* 20.— . . . You are quite right in your feeling about the later drawings in this respect, that the power of sight is in a considerable degree diminished, and that a certain impatience, leading sometimes to magnificence, sometimes to mistake, indicates the approach of disease ; but at the same time, all the experience of the whole life's practice at art is brought to bear occasionally on them, with results for wonderment and instructiveness quite unapproached in the earlier drawings. There is, however, one fault about them which I have only ascertained since my examination of the Turner sketches. There is evidence in those sketches of a gradual moral decline in the painter's mind from the beginning of life to its end—at first patient, tender, self-controlling, exquisitely perceptive, hopeful, and calm, he becomes gradually stern, wilful, more and more impetuous, then gradually more sensual, capricious—sometimes in mode of work even indolent and slovenly—the powers of art and knowledge of nature increasing all the while, but not now employed with the same calm or great purpose—his kindness of heart never deserting him, but encumbered with sensuality, suspicion, pride, vain regrets, hopelessness, languor, and all kinds of darkness and oppression of heart. What I call the ' sunset drawings'—such as our Coblentz, Constance, Red Rigi, etc.,—marks the efforts of the soul to recover itself, a peculiar calm and return of the repose or youthful spirit, preceding the approach of death.

"The great value I attach to the Heysham ;—the old Richmond and the Yorkshire series generally, as well as to the Isola Bella and Superga, depends much on their being the exponents of Turner's mind at its highest and purest period of aspiration and self-control."]

III

MINOR CATALOGUES OF TURNER DRAWINGS

1. TURNER'S DRAWINGS IN THE COLLECTION OF J. RUSKIN, ESQ.[1]

[About 1860]

PAINTINGS

1. "Shylock." The Rialto at Venice. | 2. Slaver Throwing Overboard the Dead.

DRAWINGS

, rksh
Castle, from the Ba River. E.
2. Richmond, Yorkshire, from the Moors. E.
3. Richmond, Yorkshire. The Town and Castle, from footpath above River. E.
4. Warwick. E.
5. Constance. S.
6. Salisbury. E.
7. Lucerne Town, from above. S.
8. ,, ,, from Lake. S.
9. ,, Lake, from Brunnen. S.
10. ,, ,, from Fluelen. S.
11. ,, ,, with Rigi. S.
12. Pass of St. Gothard, near Faido. S.

13. Lake of Zug, from Goldau.
14. Lake of Zug, near Aart. S.
15. Coblentz. S.
16. Winchelsea. E.
17. Gosport. E.
18. Richmond, Surrey. E.
19. Dudley. E.
20. Devonport. E.
21. Schaffhausen Town. S.
22. ,, Falls. K.
23. Arona. Lago Maggiore. K.
24. Château de la Belle Gabrielle. K.
25. Llanthony Abbey. E.
26. Derwent Water. E.
27. Okehampton. E.
28. Rochester. E.
29. Buckfastleigh Abbey. E.

[1] [This catalogue is reprinted from Thornbury's *Life of Turner;* where it was given, in the first edition, 1862, at vol. ii. pp. 395–396; in the second, 1877, at pp. 592–593. It must have been drawn up by Ruskin before 1861, for it includes the drawings which he presented in that year to Oxford and Cambridge. The numbers are added here for convenience of reference; but Nos. 20 and 33 are apparently a double entry of the same drawing. Various misprints which occurred in both editions of Mr. Thornbury's book are corrected; such as "Zug" for "Lug." For particulars of the drawings in this list, see Index I.]

30. Bolton Abbey. E.
31. Nottingham. E.
32. Harlech. E.
33. Devonport. E.
34. Carisbrook Castle. E.
35. St. Catherine's Hill. E.
36. Flint Castle. E.
37. Scarborough. (Once at Farnley.)
38. Farnley Hall. (Once at Farnley.)
39. Grandville. (Unpublished Drawing on Coast of France.)
40. Isola Bella. (Hakewill's *Italy*.)
41. Turin, from Superga. (Hakewill.)
42. Yarmouth. (Unpublished. A Body-Colour Drawing. Sailors Illustrating Trafalgar by Models of the Ships.)
43. Lebanon. (For Finden's *Bible*.)
44. Pool of Solomon. (For Finden's *Bible*.)
45. Pool of Bethesda. ,, ,,
46. Jericho. ,, ,,
47. Corinth. ,, ,,

48. Rhodes. (For Finden's *Bible*.)
49. Combe Martin. (*Southern Coast*.)
50. Boscastle ,,
51. Wolfe's Hope. (Small.) ,,
52. St. Cloud. ,,
53. Pisa. (Byron Vignette.)
54. School of Homer. (Byron Vignette.)
55. Gate of Theseus. ,, ,,
56. Ashestiel. (Vignette to Scott's *Poems*.)
57. Linlithgow. ,, ,,
58. Margate. (*Harbours of England*.)
59. Malta. (*Life of Byron*.)
60. Rouen, from St. Catherine's Hill. (*Rivers of France*.)
61–77. Seventeen Drawings of the Loire Series. (*Rivers of France*.)
78. Namur, on the Meuse.
79. Dinant, on the Meuse.
80. On the Meuse.
81, ,, ,,
82. Sketches of Venice.
83. Early Sketches. (Various.)

The letter E. in above list means England series; S., Swiss series, meaning a series executed for various private persons by Turner after the year 1842, of which two only, belonging to Mr. Windus of Tottenham, have been engraved.[1] None of mine have. K. means made for the *Keepsake.*—J. RUSKIN.

2. CATALOGUE OF DRAWINGS

BY THE LATE

J. M. W. TURNER,

PRESENTED TO THE FITZWILLIAM MUSEUM,

BY

JOHN RUSKIN, Esq., DENMARK HILL, CAMBERWELL, LONDON.[2]

[1861]

1. Flag of England, title vignette for *Harbours of England*, 1825; highest possible quality of work in neutral tint.[3]
2. Old Gate, Canterbury. An early drawing characteristic of his first architectural studies.

[1] [Namely, "Zurich" : see above, p. 200 (No. 21), and "Lucerne," p. 204 (No. 34).]
[2] [This catalogue is reprinted from a single folio sheet, printed on one side only, and with the title as given above at the top. There is no imprint. Some obvious misprints have here been corrected—"Bremen" for "Brunnen," and "Fluellen" for "Fluelen," and "Hospital, Pass of St. Gothard" for "Hospital from off St. Gothard."]
[3] [Reproduced on p. 6 above.]

3. Seals drawn for an illustration to a work on antiquities of Whalley
Abbey; showing what simple work he would undertake.[1]
4. First sketch, showing his pure mode of using water-colours. Some-
what early.
5. Mossdale Fell, Yorkshire; one of the Yorkshire series. First-rate
work of the early period.
6. Richmond, Yorkshire; drawing for the England series. First-rate
work of the second period.
7. Ashestiel. Vignette engraved for Scott's works. Average work of
middle time.
8. St. Cloud. Engraved for Scott's Works. Very fine work of the
middle time.
9. Pool of Solomon. Engraved for Finden's *Bible.* Consummate work;
rather characteristic of later period.[2]
10. Yarmouth Sands. Drawing of the middle time in body-colour.
Highest possible quality. (Sailors explaining the position of the
Victory and *Redoubtable* at Trafalgar by the help of models.)
11. Namur, on the Meuse. Body-colour of the third period. Very
fine.
12. Huy, on the Meuse. Body-colour; companion to the foregoing.
Real first-rate.
13. Orleans (Twilight). Unpublished drawing for *Rivers of France.*
First-rate.
14. Amboise. Unpublished drawing for *Rivers of France;* interesting
as an example of his use of the pen.
15. Bacharach. Finished body-colour sketch of the third period.
16. Scene in the Tyrol. Water-colour sketch. Third period. High in
quality.
17. Schaffhausen. Sketched from nature, worked with colour, and re-
newed with the pen.
18. Brunnen; Lake Lucerne in the distance. First sketch.
19. Fluelen, from the Lake. Cliff above Altorf in the distance. Fine.
20. The Devil's Bridge, St. Gothard.
21. Hospital from off St. Gothard (Sunset). Fine.
22. Hospital from off St. Gothard (Morning).
23. Venice. First sketch, showing his mode of using pencil with colour.
24. Venice. Storm at Sunset. Consummate work of the third period.
Unique; among his last sketches.
25. Venice. Calm at Sunset. First-rate companion to the foregoing.

J. RUSKIN, ESQ.
May 28, 1861.

[1] [See *Pre-Raphaelitism,* § 95 (Vol. XII. p. 124), where this point is referred to.
Ruskin acquired the Whalley drawings in 1852, in exchange for a *Liber* proof, from
Mr. C. Stokes, for whom see above, p. 478 *n.*]
[2] [See p. 447, above.]

3. WATER-COLOUR DRAWINGS BY J. M. W. TURNER

Presented by MR. JOHN RUSKIN, M.A., *First Slade Professor of Fine Art, and Founder of the Ruskin School of Drawing*[1]

[1861, 1870]

1. St. Julien, Tours For *The Rivers of France.*
2. Tours For *The Rivers of France.*
3. Tancarville. .
4. Calm on the Loire, near 'Nantes.
5. Yarmouth (?). .
6. Margate For *The Harbours of England.*
7. Coast of Genoa.
8. Mont Jean For *The Rivers of France.*
9. Blois For *The Rivers of France.*
10. Canal of Loire and Cher at Tours . For *The Rivers of France.*
11. Rietz, near Saumur For *The Rivers of France.*
12. Orleans For *The Rivers of France.*
13. Beaugency For *The Rivers of France.*
14. Near the Coteaux de Mauves . . For *The Rivers of France.*
15. Coteaux de Mauves For *The Rivers of France.*
16. Amboise For *The Rivers of France.*
17. Nantes For *The Rivers of France.*
18. Between Clairmont and Mauves . For *The Rivers of France.*
19. Angers.

[1] [This catalogue is reprinted from pp. 59–61 of *A Provisional Catalogue of The Paintings in The University Galleries, Oxford:* Clarendon Press, 1891. It also appeared, differently arranged, in the following catalogue:—*The University Galleries, Oxford. A Catalogue of the Works of Art in Sculpture and Painting. With Illustrations. Oxford: Printed for J. Fisher. 1878.* This earlier list included four numbers 37–40 which were omitted from the later; they are added here. The drawings here enumerated hang in a compartment of the University Galleries; for Ruskin's reasons for presenting them, see *Lectures on Landscape,* § 67. At a later date Ruskin presented a further series of drawings by Turner to the University—but to the Ruskin Drawing School, not to the University Galleries. drawings are described in the later volume of this edition, containing Ruskin's Oxford Catalogues. For the sake of completeness here, a summary list of the later gift is subjoined:—

Educational Series.	*Standard Series.*
No.	No.
102. Ruined Abbey.	2. Greta and Tees.
126. Durham.	3. Loire.
127. Park Scene (Lowther).	
128. „ „ „	*Reference Series.*
131. Old Houses, Chester.	An early drawing in neutral tint and
132. „ „ „	blue; hills, stream, and bridge.
140. Pigs in Sunshine (see p. 433).	
141. Coast of Yorkshire.	*Rudimentary Series.*
143. Solway Moss.	
145. Dunblane Abbey.	14. Armour.
181. Study of Fish.	126. Boats.
182. Mackerel.	127. Bergamo.
183. Pheasant.	131. Lowther.
185. Cattle.	300. Pen and sepia sketch for unpub-
300. Evening, Zug.	lished plate of *Liber Studiorum.*]

20. Château de Blois For *The Rivers of France.*
21. Harfleur.
22. Amboise Bridge For *The Rivers of France.*
23. Amboise (the first thought of No. 22).
24. The Bridge of Blois. Fog clearing.
25. Scene on the Meuse.
26. Château Hamelin For *The Rivers of France.*
27. Château de Nantes For *The Rivers of France.*
28. Pisa. The Spina Chapel . . . For Finden's *Byron.*
29. Venice. Riva dei Schiavoni . . *Sketch on the Spot.*
30. Venice. The Academy[1] . . . *Sketch on the Spot.*
31. Venice. The Grand Canal . . . *Sketch on the Spot.*
32. The School of Homer . . . For Finden's *Byron.*
33. Jericho For Finden's *Bible.*
34. Mount Lebanon[2] For.Finden's *Bible.*
35. Combe Martin For. *The Southern Coast.*
36. Boscastle For *The Southern Coast.*
37–40. Sketches, in black and white chalk, on grey paper.[3]

4. CATALOGUE OF SKETCHES BY TURNER

Lent by the Trustees of the National Gallery to the Ruskin Drawing School, Oxford [4]

[1878]

1. Lower end of Coniston Water.
2. Coniston Hall.
3. Ambleside Mill.

[1] [For a reference to this sketch, see *Guide to the Academy at Venice*.]
[2] [For Nos. 33 and 34, see above, p. 447.]
[3] [Very rough, slight sketches; kept in one of the Turner Cabinets in the University Galleries in which the whole series was contained when Ruskin presented it (see below, p. 592.)]
[4] [Of this catalogue, which was drawn up by Ruskin, there are two issues. The earlier is an octavo pamphlet of 12 pages (without wrappers), with the following title on p. 1 :—

Catalogue | of | Sketches by Turner | Lent by the | Trustees of the National Gallery | to the | University of Oxford.

Page 2 is blank. On p. 3 the "Catalogue" begins; p. 12 is blank. There is no imprint. This issue enumerates 250 pieces, divided as follows: " I. Oxford and Basle Series" (1–8); " II. Early Beginnings" (9–18); " III. Lake Series" (19–25); " IV. Durham Series" (26–31); " V. Savoy Series" (32–41); " VI. Mont Blanc Series" (42–50); " VII. Schaffhausen Series" (51–56); " VIII. Early English Series" (57–66); " IX. Lichfield Series" (67–75); " X. Bolton Series" (76–83); " XI. Yorkshire Series" (84–95); " XII. Animal and Liber Series" (96–100); " XIII. Great Roman Series" (101–107); " XIV. Tivoli Series" (108–122); " XV. oge s' Vignette Series" (123–137); " XVI. Later Beginnings Series" (138–148); " XVII. Marine Series" (149–162); " XVIII. Continental Series, Mixed" (163–175); " XIX. Black French Series" (176–181); " XX. [numeral omitted by mistake] Loire Series" (182–193); " XXI. Colour on Grey Series" (194–217); " XXII. Geneva Series" (218–223); " XXIII. Fribourg Series" (224–229); " XXIV. Lucerne Series" (230–238); " XXV. Faido Series" (239–250). Also " Extra Pieces," as given below, p. 568.
This earlier catalogue seems to have been made by Ruskin at the time (1878) of

4. Goldrill Bridge.[1]
5. Rydal Water.
6. Rydal Water.
7. Grasmere.
8. Ouse Bridge, York.
9. Richmond Castle.
10. Durham from the Low Bridge.
11. Durham from the Weir.
12. Melrose.
13. Melrose.[2]

14. Mill and Stream: compare No. 87. Reflections in procession.
15. Mountain Torrent.
16. Chepstow. Unfinished. His chosen method fully applied.
17. Trees and Brook. Bridge used afterwards in Raglan.[3]
18. Study for drawing of Folkestone.
19. Eu.
20. Blue Lake.[4]

his selecting the pieces from the tin boxes at the National Gallery (see above, Introduction, p. liii.).

When he proceeded to arrange and frame the sketches, and place them in cabinets, in his Drawing School at Oxford, he recast his arrangement entirely. Among other reasons for this rearrangement were (1) considerations of size, it being necessary to keep the larger and smaller pieces together respectively; thus Nos. 1–56 in the catalogue as here printed are in larger cabinets than the others. And (2) the fact that in some cases the drawings were on the two sides of the same piece of paper. In these cases, and in some others, Ruskin used reversible frames, glazed on both sides; this is the meaning of the bracketed drawings in the catalogue as printed here: see Nos. 57, etc., etc. The 250 (really, on recounting and rearrangement, 251) pieces filled 195 frames (196 numbers, but 163 is blank).

In accordance with this rearrangement Ruskin wrote a new catalogue—an octavo pamphlet (on thicker paper, without wrappers) of 16 pages. The title (as before) is on p. 1; the catalogue, pp. 3–14; pp. 15, 16 are blank.

It is this second issue which is followed in the text here, because its arrangement corresponds with that which subsists in the Ruskin Drawing School. But the following modifications are made: (1) in the second issue of the catalogue there was a double system of enumeration, owing to the fact that the first issue was still current. On the left-hand side of the page the numbers 1–196 correspond to those on the frames, two sketches being often included in one frame. On the right-hand side of the page there is a different series of numbers, which refer to those in the earlier issue. As, however, that is no longer current, it has not been thought desirable to cumber, and perhaps confuse, the page by adding the references to the obsolete enumeration. (2) The earlier issue sometimes contained fuller notes than the later; in such cases, the additional notes are here incorporated in the text. Other variations are mentioned in footnotes; while some obvious misprints (numerous in the Oxford, as in the Cambridge, catalogue), such as " Recess Bridge" for "Reuss Bridge" and "Farnby" for "Farnley," have been corrected. (3) The list of Extra Pieces was omitted in the second issue; it is here included, as the pieces in question are on view in the Ruskin Drawing School. Both issues are now out of print and seldom met with; neither is included in the *Bibliography* by Wise and Smart.]

[1] [In Patterdale.]
[2] [These are all pencil sketches. In the earlier catalogue " III. Lake Series"; and Nos. 8–13, "IV. Durham Series."]
[3] [In *Liber Studiorum*: see below, p. 644.]
[4] [Nos. 14–20 are beginnings of colour-drawings.]

21. Pæstum in Storm. Study for engraving.[1]
22. Naples from the Sea.
23. Naples. Queen Joanna's Palace.
24. Rome. The City from the Vatican.
25. Rome. The Palatine and Alban Mount.
26. Rome. The Arch of Titus. (Coliseum on back.)
27. Rome. The Temple of Peace.
28. Rome. The Forum.[2]

29. Pass of Faido. St. Gothard. Sketch for picture belonging to Mr. Ruskin.[3]
30. The Alpine Valley. (Near Bellinzona.)
31. The Square Fort.
32. Sunset in Storm.[4]
33. Heidelberg.
34. The Castle, Schaffhausen.
35. Baden. (Switzerland.)
36. Fribourg (Switzerland). The descent from Hôtel de Ville.[5]
37. Fribourg. The Red Tower.
38. Fribourg. The Golden Tower.
39. Fribourg. The Lower Bridge.
40. Fribourg. The Convent Vale.
41. Fribourg. The Convent.
42. Lucerne. Lake, with Mont Righi.
43. Lucerne. Reuss Bridge and Mont Pilate.
44. Lucerne. Mont Pilate, nearer.
45. Lucerne. Mont Pilate, from Bay of Stanz.
46. Lucerne. The Stanzstadt Mountains.
47. Kussnacht.[6]
48. Lucerne. Mont Righi and Cathedral. Moonrise.
49. Lucerne. Mont Righi. Evening.
50. Lucerne. Mont Righi. Last rays of sunset.
51. Geneva. Sails in port.
52. Geneva. The Mole and Savoy hills.
53. Geneva. Sunset on Jura.
54. Village near Lausanne.
55. Vevay.
56. Funeral at Lausanne.[7]

[1] [See No. 206 in the National Gallery, p. 617. Nos. 22 and 23 are in pencil.]
[2] [Nos. 22–28 were headed in the earlier catalogue "XIII. Great Roman Series." No. 25 was called "Aqueducts and St. John Lateran," and No. 24, "From Monte Mario."]
[3] [This is the sketch described by Ruskin as No. 40 in his first catalogue of the sketches at the National Gallery : see above, p. 206.]
[4] [In the earlier catalogue, "Red Cliff."]
[5] [In the earlier catalogue, "The great descent by the steps."]
[6] [This is the sketch described by Ruskin as No. 29 in his first catalogue of the sketches at the National Gallery : see above, p. 202.]
[7] [In the earlier catalogue Nos. 51–56 were headed "XXII. Geneva Series"; Nos. 36–40, "XXIII. Fribourg Series"; Nos. 42–50, "XXIV. Lucerne Series"; Nos. 29–35 (together with Nos. 19, 20, 173–175), "XXV. Faido Series." The whole series,

57. {Oxford. General View. Pencil.
{Oxford from Magdalen Bridge. Pencil.
58. Cathedral of Wells.
59. Lichfield. General View.
60. Lichfield. South-west Tower.
61. Tintern.
62. Sedburgh (?) Abbey.
63. Langharne Castle.
64. {Carlisle.
{Castle in "Rivers of England."
65. Raby.
66. {Launceston. England drawing,
{Okehampton. England drawing. Picture belónging to Mr. Ruskin.[1]
67. {Bolton Abbey from up stream.
{Bolton Abbey from down stream.
68. {Bolton Abbey from across the river.
{Bolton Abbey from the knoll, with oaks.
69. Burden Tower (partly coloured).
70. {Richmond, Yorkshire (Yorkshire Series).
{Raby. Distance to left of castle.[2]

71. {Basle.
{Lucerne.
72. {Rhine.
{Rhine.
73. {Rhine.
{Waterfall.
74. {Dinant.
{Dinant.
75. {Dinant.
{Schaffhausen Castle.
76. {Dinant.
{Dinant.[3]

77. {Tivoli. The Falls.
{Study for trees in "Crossing the Brook."
78. {Tivoli. Villa of Mæcenas.
{Tivoli. Arcades and waters.
79. {Tivoli. Temple and shepherds.
{Tivoli. Temple under tower.
80. {Tivoli. The Grottoes.
{Tivoli. The Dark Arches.
81. {Tivoli. The Falls and the Campagna.
{Tivoli. Villa of Mæcenas and Campagna.

Nos. 29–56, are Continental sketches in pen, pencil, and water-colour, of a late period, similar to the "First Hundred," pp. 191–226 ; many of them carried towards completion and very beautiful.]
[1] [See below, p. 603.]
[2] [Nos. 57–70 are labelled by Ruskin on the Cabinet "English Outlines, smaller size."]
[3] [Nos. 71–76 are also in pencil.]

82. { Tivoli. Olives among the spray.[1]
 { Tivoli. Olives on the hillside.

83. { Tivoli. Villa d'Este.
 { Tivoli. Temple and plain.

84. { Tivoli. The City and her Streams.
 { Tivoli. The Groves of the Sybil.[2]

85. Oxford. Oriel Lane.
86. Oxford. Christ Church. Unfinished.
87. Mill and Stream. Rough water. Early study.
88. Sea surf on Rocks. Early study.[3]
89. High Fall of Tees. Unfinished. Lovely.[4]
90. Maidstone Bridge. Example of his chosen method in first development.
91. View from Richmond Hill.

92. { Raby. Autumnal colouring.
 { Raby. Part of the same drawing.

93. { Stags.
 { Stags.

94. (Italy). St. Maurice.
95. (Italy). The Simplon.[5]

96. (Italy) { Venice, not engraved.
 { Florence, not engraved.

97. (Italy) { Galileo's Villa.[6]
 { Tivoli.

98. (Italy) Pæstum.

99. (Poems) { Pencil sketch for the Lawn.
 { Pencil sketch for the Arbour.

100. (Poems) { Greenwich.
 { The Tower.

101. (Poems) { Lodore.
 { Colour-study at Sea.[7]

[1] [In the earlier catalogue "Olives among the spray"; and "Olives on the steep."]

[2] [Nos. 77-84 were headed in the earlier catalogue "XIV. Tivoli Series." They are for the most part in pencil on paper prepared with black lead, the lights being obtained by rubbing out. The next group is in colour.]

[3] [In the earlier catalogue "Earliest try at it."]

[4] [In the earlier catalogue "Mystery drawn at once."]

[5] [In the earlier catalogue "Passing the Alps"—a study for vignette No. 207 in the National Gallery.]

[6] [The earlier catalogue adds "(changed to twilight)"—i.e., in the finished vignette; similarly to the other sketch in this frame, the earlier catalogue adds "(changed to front view)"; and to 98, "(changed to thunder)"; and to 102, "(much changed)." Nos. 94-103 were in that catalogue headed "XV. Rogers' Vignette Series"; the sketches are beginnings of water-colour studies. For the finished drawings, see in the National Gallery, Nos. 205, 221, 224, 206, 228, 229, 234, 235, 239, 397, 230.]

[7] [In the earlier catalogue "Lugger going out."]

102. (Poems) Datur Horæ Quieti.

103. (Poems) { The Shepherd on Tornaro. First Study.
{ The Shepherd on Tornaro. Second Study.

104. Storm on the sands.[1]
105. Sail in golden light.
106. Dutch boats.
107. Fast sailing. Colour on grey.

108. { Cottage outline used in Aiguillette.[2]
{ Hospice of Great St. Bernard.
109. { Martigny.
{ Crag and Village.
110. { Village with peaked Alps.
{ Village with clouds.
111. { Tower on hill. Original of dark pastoral.[3]
{ Distant Alps.
112. { Gorge of Trient.
{ Crag and Village.

113. Street with Diligence and Postillion.[4]
114. Shed in Street. Tours (?).
115. Calais.
116. { Rouen. Pencil and ink on grey.
{ St. Germain.
117. Cathedral Apse.

118. French Series. Colour begins. Sheep in the trench.
119. Savoyard city.
120. Jumièges.
121. Quillebœuf.
122. Quai du Louvre.
123. French Château, with dark trees and river. Cool weather.
124. St. Laurent.
125. Country town on stream.
126. Dijon.
127. Aux Invalides.
128. Porte St. Martin.

[1] [In the earlier catalogue "Trial piece. Squall on sand." These four pieces, 104–107, are in water-colour, and more finished than the foregoing studies.]

[2] [i.e., the drawing in Ruskin's collection: see pp. 419–420. To the first sketch in Frame 111 the earlier catalogue has "Mine," instead of "Original of dark pastoral." The group 108–112 was in the earlier catalogue headed "V. Savoy Series." The sketches are mostly in pencil and white.]

[3] [This is the original sketch for the drawing No. 68 in the Ruskin Collection, 1878 : see above, pp. 457–458. In the sketch, the hill and tower are put in in white; in the drawing, in dark ; this is perhaps why he speaks of the "dark pastoral," by way of noting the change made in the drawing.]

[4] [This series, 113–117, is headed in the earlier catalogue "XIX. Black French Series"—i.e., sketches in pencil and ink on grey paper.]

129. Place du Carrousel.
130. French Château in sunny afternoon. Warm weather.
131. Luxembourg.
132. Ehrenbreitstein.
133. Tower in Sunbeam.
134. Crag and Tower.
135. Crag farther away.
136. Bacharach. Winding walls.
137. The Ruby Fortress.
138. Entrance gate between bastions.
139. Coast of Genoa.
140. Honfleur. Unengraved drawing of Seine Series.[1]

141. { Fast sailing. (Pen only.)
 { Brig in fresh breeze. (Pen only.)
142. { First sketch for Flint Castle. (Pen only.)
 { Ship's boat and Fish boat. (Pencil.)
143. { Sailing-boats and ship of line.
 { Ships of line at stated distances. (Pen only.)
144. { Boats, various.[2] (Pencil.)
 { Mainsail against rope.
145. { Sea-wave on beach. (Pencil.)
 { Sea-wave on beach. (Pencil.)
146. { Shipwreck.[3]
 { Beach-piece.

147. { Château de Blois.
 { Château de Blois.
148. { Château de Blois.
 { Château de Blois.
149. { Beaugency.
 { Beaugency.
150. { Orleans.
 { Orleans.
151. On the Rhine. Sketch for drawing, once called Baden.
152. { Small English pencil series begins. Warwick.
 { Warwick.
153. { Warwick. For England Drawing.
 { Leicester Abbey.
154. { Distance for "Crossing the Brook."
 { At the same spot.
155. { On the Thames.
 { Study of Sky. "Sun like egg's *yoke*."[4]
156. { Carnarvon Castle.
 { Carnarvon Castle.

[1] [This series, 118–140, is headed in the earlier catalogue, "XXI. Colour on Grey Series."]
[2] [In the earlier catalogue, "Mediterranean Boats."]
[3] [In the earlier catalogue, "The *Inscrutable!*" and "Dutch boats in breeze." The series 141–146 is there headed "XVII. Marine Series."]
[4] [*Sic*; the spelling is Turner's.]

157. { Okehampton ("Rivers of England").
{ Okehampton. View opposite to.

158. { Richmond, Yorkshire. The drawing at Cambridge.
{ Study for the Church in Yorkshire drawing.

159. { Hôtel de Ville, Cologne.
{ Cathedral, Cologne.

160. { Avignon.
{ Bacharach.

161. { Park Scene. Distance. }
{ Park Scene. Foreground. } One long drawing.

162. { Bridge and Village.
{ Bridge with figures.

163.[1]

164. { Fluelen.
{ Donkeys.

165. Coast of Naples.
166. Lago Maggiore.
167. Corfe Castle, Dorset.
168. Junction of Greta and Tees, Mortham Tower. Sepia.
169. Sheep-washing at Eton.
170. Æsacus. Drawing on Etching.[2]

171. His first Tivoli.
172. Thames. Old colour. Q. out of Hesperides Book?
173. Venice. The Redentore.
174. Venice. The Fruit Market.
175. Venice. The Rialto.
176. Sunset. Sketched with turned edge.[3]

177. The first view of Oxford.
178. Canterbury Gate.
179. Wharfedale (?).
180. Farnley.
181. On the Greta. Mortham Tower.
182. Basle.
183. Lauffenbourg.

[1] [This frame is blank. The series 147–164 was scattered among various other series in the earlier catalogue. It consists of pencil sketches from the artist's notebooks.]
[2] [This series again, 165–170, was scattered among others in the earlier catalogue. The pieces are all in water-colour or sepia. No. 169 is a study for the *Liber*, similar to one in the National Gallery (from the Vaughan bequest), No. 880 : see p. 645. No. 170 is another *Liber* plate : see p. 462.]
[3] [These sketches also, 171–176, were scattered in various series in the earlier catalogue. No. 171 is in the artist's earliest tinted manner; No. 172 is an early water-colour. For "Hesperides Book" see "Extra Pieces," No. 6, on the next page. Nos. 173–176 are later water-colour sketches.]

184. Lauffenbourg. Original of Liber.
185. Lauffenbourg. The Bridge.
186. Schaffhausen, Castle of Laufen.
187. Schaffhausen from above the Fall.
188. High St. Gothard.
189. Little Devil's Bridge, St. Gothard.
190. Thun.
191. Lauterbrunnen and Staubbach.
192. Mont Blanc from St. Martin's.
193. Mont Blanc from St. Martin's Bridge.
194. Sallenches.
195. Cascade de Chêde.[1]
196. Old Village of Prieuré, Chamouni.[2]

EXTRA PIECES

1. Aosta book.
2. Geneva book.
3. Roman book.
4. Roman detail book.
5. Tivoli book.
6. Hesperides book.[3]
7. Early English book.[4]
8. Red marine book.[5]

[1] [For this scene, now destroyed, see Vol. II. p. 425 and n.]
[2] [Of this group (put together, owing to their extra large size), Nos. 177 and 178 are very early water-colours; the rest are pencil sketches. Nos. 182-184 are particularly beautiful. In the earlier catalogue Nos. 182-187 were headed "VII. Schaffhausen Series," and Nos. 188-196, "VI. Mont Blanc Series." The other pieces were scattered in other series.]
[3] [i.e., the sketch-book containing the first studies for the picture of the Dragon in the Garden of the Hesperides; No. 477 in the National Gallery : see above, p. 113.]
[4] [Twenty-five drawings from this book, mostly in pencil, Ruskin afterwards framed as examples, as he wrote on the case, of "drawing from the shoulder."]
[5] [This is a late sketch-book, with wonderful sunsets and other effects in' water-colour made at Margate and Ambleteuse. Several are dated May 12, 1845.]

5. CATALOGUE

OF

PICTURES,
DRAWINGS AND SKETCHES,

CHIEFLY BY

J. M. W. TURNER, R.A.,

THE PROPERTY OF

JOHN RUSKIN, ESQ.[1]

[1869]

N.B.—The following Sketches, Drawings, and Pictures are the Property of John Ruskin, Esq., by whom the Catalogue is compiled:—

SKETCHES AND DRAWINGS

BY

J. M. W. TURNER, R.A.

1. SCARBOROUGH : study from nature. Very characteristic of Turner's method of completing some portions of his intended drawing without touching the paper in others. Of the early period. Fine. [19 gs., Vokins.]

2. CROSSES, SEDILIA, etc. : drawing for a work on the antiquities of Whalley Abbey. Few drawings by Turner of this class exist.[2] Of the early period. [18½ gs., Agnew.]

3. BATTLE ABBEY. A very beautiful drawing of the second period, showing the mastery of architectural detail obtained by studies such as No. 2. [97 gs., Gambart.]

4. COAST SCENE: unfinished drawing of the early time. The lights are taken out, in the smoke, shore, and boats, a very unusual process in Turner's work. [51 gs.]

5. RIVER SCENE: an exquisite fragment. Unfinished, of earliest time. All the lights left, not taken out; and part of the paper untouched. An admirable example of Turner's method of work in his finest drawings. [10 gs., Agnew.]

[1] [This catalogue is reprinted from an Auction Catalogue, headed on the title-page as above. The sale by Messrs. Christie, Manson, and Woods took place on Thursday, April 15, 1869. The purchasers, and the prices given, are here added.]

[2] [Compare p. 558 above.]

6. The Pencil Sketch from Nature for the Liber Studiorum. Subject of Rivaulx Abbey. [10 gs.]

7. Sketch for a Marine Picture, of the middle period. Containing only about three minutes' work, but as fine as three minutes' work can be. [5½ gs.]

8. Sketch for, or more probably, Commencement of Drawing of the Bass Rock. Most characteristic of Turner's execution in the middle time, impetuously deliberate. [84 gs.]

9. The Marsh Mist. Chalk sketch, advanced with brown and grey, of the early time; fine, but much injured by ill-treatment. [24 gs., Vokins.]

10. Dead Pheasant. Slight, but a beautiful example of Turner's most rapid work in the middle period. [19 gs., Vokins.]

11. Dead Pheasant. Finished study. Superb. [48 gs., Vokins.]

12. Sketch of Alpine Valley, with Châlets, on white paper, tinted with warm grey; then the lights taken out. Carried far in the middle distance, but showing general signs of carelessness and fatigue. [14½ gs.]

13. Margate Pier. Unfinished drawing of the finest period. Exquisite in every respect as far as it is carried. I have seen no other example of a drawing by Turner arrested so near completion. [70 gs., Colnaghi.]

14. Margate Pier: study of storm and sunshine. Sketch on tinted (brown) paper, the leaf of a sketch-book of the late period. Entirely magnificent. [64 gs.]

15. Storm on Margate Sands. Another leaf of the same sketch-book. Very fine. [22½ gs., White.]

16. Steamers off Margate. Another of the same series. Superb. [19 gs.]

17. Sunrise off Margate. Another of the same series. [19 gs.]

18. Sunset off Margate, with Mackerel Shoals. A sketch of the latest time, careless and bad. [39 gs., Colnaghi.]

19. Moonrise off Margate. Late sketch, hasty and of inferior quality. [42 gs., Agnew.]

20. Two Sunsets and a Grey Storm, off Margate. The sunsets are of the finest time, though extremely slight. The marine is late and inferior. [39 gs.]

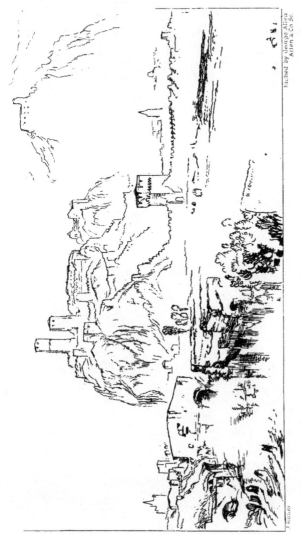

Etched by George Allen
Allen & Co Sc.

J. Ruskin

Bellinzona

21. SURF ON THE BEACH, MARGATE. Late, but exceedingly interesting, as showing the retention to the last of the deliberate method of execution which sets or leaves everything in its right place at once. [9½ gs., Colnaghi.]

22. SUNSET ON THE BEACH, MARGATE. An exquisite sketch of the late time, far carried. [20 gs., White.]

23. LUXEMBOURG. A fine sketch, a little after the time of the *Rivers of France* series—body-colour. [58 gs., Vokins.]

24. ON THE RHINE. A grand glowing sketch, very characteristic of Turner's method of getting gold out of a grey ground. [55 gs.]

25. ON THE RHINE: Evening. A water-colour sketch unfinished, containing some passages of great beauty. [51 gs., Agnew.]

26. ON THE RHINE. A white paper sketch, tinted and with scratched lights. Careless; but fine in subject. [15 gs.]

27–32. SIX SKETCHES ON THE RHINE. Some drawn on the back of the paper as well; all of late time. 32 is of the CASTLE OF RHEINFELS. [27, 17 gs.; 28, 12 gs.; 29, 16 gs.; 30, 18 gs.; 31, 10 gs.; 32, 15 gs., Vokins.]

33. THE NIESEN: from the upper end of the Lake of Thun. Always a favourite subject of ¡Turner's.[1] ¡A fine sketch of the late time. i.]

34. MOUNTAINS AT THE HEAD OF THE LAKE OF THUN, on the South Shore. A highly finished sketch of the late time. [130 gs.]

35. BELLINZONA. One of a grand series of sketches made by Turner for complete pictures, but never realized.[2] [102 gs.]

36. THE DESOLATE BED OF AN ALPINE STREAM, with mist rising at sunset. Another sketch of the same series of the highest quality. [101 gs.]

37. ALPINE TORRENT AND PASS. An exquisite sketch. One of the most beautiful existing of the late time. [119 gs., Agnew.]

38. SCENE IN THE TYROL. Unrivalled in its kind. [154 gs., Agnew.]

[1] [See above, pp. 417–418.]
[2] [This was one of the drawings which Ruskin intended to include in his proposed series of representations of Turner's drawings in the actual size. Ruskin traced it in outline, and Mr. George Allen then engraved the outline, at Mornex in 1863. The engraving is here reproduced by photogravure, the reduction being from 11 × 9 to 6 × 4¾.]

39. The Glacier des Bossons : looking up to the Aiguille du Midi. A grand sketch at the time of Turner's first visit to Chamouni. [61 gs., Agnew.]

40. The Lake of Brientz : looking towards Interlachen, with the entrance to the valley of Lauterbrunnen on the left. A beautiful drawing of the early time. [312 gs., Agnew.]

W. Hunt.

41. Head of Negro. Painted for Mr. · Ruskin, and very fine. [61 gs., Vokins.]

W. Hunt.

42. Head of Country Girl. Painted for Mr. Ruskin, and consummate in beauty of execution. [52 gs., Vokins.]

W. Hunt.

43. Dead Game. An early drawing. Highly finished. [29 gs., Vokins.]

W. Hunt.

44. Grapes and Medlars. Exquisite in purity of light and colour. [93 gs., Agnew.]

David Cox.

45. Watermill in Wales. [76 gs., Agnew.]

Duverger.

46. Interior of French Village School. [145 gs., Vokins.]

J. Brett.

47. Val d'Aosta.[1] [245 gs. Bought in.]

Copley Fielding.

48. Scene between King's House and Inverary. Bought by Mr. Ruskin out of the Old Water-Colour Exhibition. [440 gs.]

Copley Fielding.

49. Sea-Piece : off Portsmouth. Painted for Mr. Ruskin, and superb of its class. [460 gs.]

J. M. W. Turner, R.A.

50. The Slave Ship. Exhibited in 1840. Bought by Mr. Ruskin out of Turner's gallery, and still in perfect state, having been always protected both from damp and dust, and never cleaned. An unengraved picture, carrying copyright.[2] [1945 gs. Bought in.]

5648½ gs., Total.

[1] [For this picture, see *Academy Notes*, 1859, Vol. XIV.]
[2] [For this picture, see Vol. III. p. 571 n., and Plate 12.]

6. CATALOGUE

OF

.
ELEVEN WATER-COLOUR DRAWINGS,

BY J. M. W. TURNER, R.A.,

THE PROPERTY OF

JOHN RUSKIN, ESQ.[1]

. [1882]

WATER-COLOUR DRAWINGS

J. M. W. TURNER, R.A.

51. FLUELEN: Lake Lucerne.
> Painted for Mr. Munro, of Novar, from the sketch now in the
> National Gallery.[2] [£1491.]

J. M. W. TURNER, R.A.

52. A SCENE IN SAVOY, with castle in the distance, and cattle and figures
in the foreground.
> Painted about 1804–1805, from pencil sketch in the National
> Gallery; lent to Oxford. From the Dillon Collection.[3]
> [£1207, 10s.]

J. M. W. TURNER, R.A., 1818.

53. HEYSHAM (Village of): Lancaster Bay and Cumberland Hills in the
distance.
> Engraved by W. R. Smith, in Whitaker's *History of Richmondshire.*
> Described in Mr. Ruskin's *Notes on his Drawings, by J. M. W.
> Turner, R.A.* [p. 429]. [£787, 10s.]

J. M. W. TURNER, R.A.

54. EGGLESTONE ABBEY.
> Engraved by T. Higham, in Whitaker's *History of Richmondshire.*
> Described in Mr. Ruskin's *Notes on his Drawings, by J. M. W.
> Turner, R.A.* [p. 430]. [£787, 10s.]

[1] [This is part of an Auction Catalogue issued by Messrs. Christie, Manson,
and Woods for a sale on Saturday, July 22, 1882. Only the drawings, numbered
59 and 60, were, however, sold; see above, Introduction, p. liv.]
[2] [This drawing was afterwards sold to the late Mr. T. S. Kennedy, of Leeds.
For the drawing, see above, p. 458; for the sketch, p. 205.]
[3] [For this drawing, see above, p. 457 (No. 68).]

J. M. W. TURNER, R.A.

55. FARNLEY, the seat of Walter Fawkes, Esq.
 Engraved in Whitaker's *Parish of Whalley*. [£682, 10s.]

56. FARNLEY STREAM, and summer-house. [£472, 10s.]

57. FARNLEY AVENUE.
 Described in Mr. Ruskin's '*Notes on his Drawings, by J. M. W. Turner, R.A.* [pp. 431–433]. [£199, 10s.]

J. M. W. TURNER, R.A.
58. BELLINZONA. [£57, 15s.]

J. M. W. TURNER, R.A.
59. THE BRIDGE.

J. M. W. TURNER, R.A.
60. THE BRIDGE : Evening. [£126, apparently for 59 and 60.]

J. M. W. TURNER, R.A.
61. PONT DE BUSEL. [£60, 18s.]

The four preceding drawings are described in Mr. Ruskin's *Notes on his Drawings, by J. M. W. Turner, R.A.* [pp. 453, 448].

IV

LETTERS ON COPIES OF TURNER'S DRAWINGS

[1867–1882]

[IT will have been seen above (pp. 530–531) that Ruskin attached great educational importance to the circulation of good copies of Turner's Drawings. The trouble he took in training copyists appears in the *Letters to William Ward* (2 vols., 1893), reprinted in a later volume of this edition. A collection of Mr. Ward's copies was on view at the Fine Art Society's Gallery at the same time as Ruskin's Collection of Turners in 1878. On p. 4 of the wrapper of Ruskin's *Notes* the following announcement was printed :— ᵔᵗ.

MR. RUSKIN having also placed at the disposal of the FINE ART SOCIETY a Series of facsimiles of a portion of the Turner Drawings in the National Gallery executed for him by Mr. Ward, the Collection is now on view at the Galleries of the Society, 148, New Bond Street. The Series represented are as follows :—

FROM ROGERS' *ITALY* AND *POEMS*

1. Amalfi.	7. Tell's Chapel.
2. Composition, Moonlight.	8. Tivoli.
3. Rome.	9. The Forum.
4. Aosta.	10. Bolton.
5. Pæstum.	11. The Native Village.
6. Lake of Geneva.	12. Farewell.

FROM THE UNPUBLISHED *RIVERS OF FRANCE*

13. Beaugency.	21. Building a Bridge.
14. St. Cloud.	22. Boats, Sun, and Rain.
15. Havre.	23. On the Seine.
16. Honfleur.	24. Light Towers of the Hêve.
17. Shoal on the Seine.	25. Luxembourg.
18. Dinant.	26. Château de Blois.
19. Rouen.	27. Nantes.
20. Town on River.	28. Honfleur.

MR. RUSKIN describes them as follows :—" Most precious drawings, which can only be represented at all in engraving by entire alteration of

their treatment, and abandonment of their finest purposes. I feel this so strongly that I have given my best attention, during upwards of ten years, to train a copyist to perfect fidelity in rendering the work of Turner; and have now succeeded in enabling him to produce facsimiles so close as to look like replicas—facsimiles which I must sign with my own name and his, in the very work of them, to prevent their being sold for real Turner vignettes."

Of the drawings which are not for sale, copies of the originals, certified and signed by MR. RUSKIN, can be obtained of the Society.

The following letters refer to copies (1) by Mr. William Ward, (2) to Miss Isabella Jay.]

1. ON MR. WILLIAM WARD'S COPIES

(1) Extract from a Letter by Ruskin to Professor Charles Eliot Norton 1867 : [1]—

"They· are executed with extreme care under my own eye by the draughtsman trained by me for the purpose, Mr. Ward. Everything that can be learned from the smaller works of Turner may be as securely learned from these drawings. I have been more than once in doubt, seeing original and copy together, which was which; and I think them about the best works that can now be obtained for a moderate price, representing the authoritative forms of art in landscape."

(2) A letter to the *Times* (April 25, 1876) on "Copies of Turner's Drawings" by Mr. Ward, exhibited for sale in the rooms of the Fine Art Society :—

" To the Editor of the ' Times.'

"SIR,—You will oblige me by correcting the misstatement in your columns of the 22nd,[2] that 'only copies of the copies' of Turner exhibited at 148, New Bond Street, are for sale. The drawings offered for sale by the company will, of course, be always made by Mr. Ward from the originals, just as much as those now exhibited as specimens.

[1] [This extract is reprinted from a fly sheet where it is given as from the *Catalogue of the Fine Art Department, Harvard University;* the sheet contains a notice that Mr. Ward's specimens of copies may be seen at the University Galleries, Oxford ; St. George's Museum, Walkley, Sheffield ; The Art Museum, Manchester ; Harvard University, Cambridge, Mass., U.S.A.; and the Fine Art Society's Galleries, New Bond ·Street, London. The extract is also given in a *List of the Drawings . . . by Turner . . . shown in connection with Mr. Norton's Lectures on Turner and his Work at the Parker Memorial Hall, Boston*: University Press, Cambridge, 1874, p. 5, whence it was reprinted in *Arrows of the Chace*, 1880, i. 154 *n.*]

[2] [The references to the *Times* allude to an article on the "Copies of Turner Drawings" which were then exhibited for sale in the rooms of the Fine Art Society. With this letter should be compared *Ariadne Florentina*, §§ 227 *n.*, 243, where Ruskin again refers to the value of these copies of Turner.]

"You observe in the course of your article that 'surely such attempts could not gratify any one who had a true insight for Mr. Turner's works?' But the reason that the drawings now at 148, New Bond Street, are not for sale, is that they *do* gratify *me*, and are among my extremely valued possessions; and if among the art critics on your staff there be, indeed, any one whose 'insight for Mr. Turner's work' you suppose to be greater than mine, I shall have much pleasure in receiving any instructions with which he may favour me, at the National Gallery, on the points either in which Mr. Ward's work may be improved, or on those in which Turner is so superior to Titian and Correggio, that while the public maintain, in Italy, a nation of copyists of these second-rate masters, they are not justified in hoping any success whatever in representing the work of the Londoner, whom, while he was alive, I was always called mad for praising.

"I am, Sir, your obedient servant,
"JOHN RUSKIN.

"PETERBOROUGH, *April* 23."

(3) An open letter to Mr. Ward on his copy of Turner's "Fluelen":—

"LONDON, 20*th March*, 1880.—The copy of Turner's drawing of Fluelen, which has been just completed by Mr. Ward, and shown to me to-day, is beyond my best hopes in every desirable quality of execution; and is certainly as good as it is possible for care and skill to make it. I am so entirely satisfied with it that, for my own personal *pleasure*—irrespective of pride—I should feel scarcely any loss in taking it home with me instead of the original; and for all uses of artistic example or instruction, it is absolutely as good as the original.—JOHN RUSKIN."[1]

(4) A letter to Mr. Ward on his copy of Turner's "Bridge of Meulan"—

"HERNE HILL,
"LONDON, S.E., *May* 17*th*, 1882.

"MY DEAR WARD,—In enclosing you cheque for the very moderate charge on *Bridge of Meulan*, let me very fully congratulate you on the extreme skill you have now acquired in rendering Turner's best and most finished watercolour work. Your large copy of my *Fluelen* achieved what I had thought impossible in the facsimile of his clearest and purest washes of broad colour: and the drawing of *More Park*, on which I saw you yesterday engaged, was—so far as you have carried it—perfection itself in the seizure of the most subtle results of Turner's elaborate and almost microscopic execution, in that and its contemporary drawings.

"I am therefore happy in putting it in your power to produce a facsimile

[1] [The copy in question is from a drawing formerly in the possession of Ruskin (see the Turner Notes, 1878, No. 70, p. 453, above), and was executed for the late Mr. T. S. Kennedy, of Meanwoods, Leeds, who had bought the drawing. The letter has been lithographed and circulated on a fly-sheet; it was also reprinted in *Arrows of the Chace*, 1880, vol. i. p. 154 *n*.]

XIII. 2 o

of Turner's mighty drawing of the *Coblentz;* and I sincerely trust that your laboriously acquired skill, and unflinching fidelity, may be at last acknowledged, and justly rewarded.

"Ever faithfully yours,
"J. RUSKIN."[1]

2. ON MISS ISABELLA JAY'S COPIES

(1) A lithographed circular, dated January 4, 1868:—

"Miss Isabella Jay's copies of Turner's pictures are the most accurate and beautiful I have yet seen, in many respects attaining fully to the expression of the master's most subtle qualities; and I think that such copies are much more valuable and instructive possessions than the original drawings of second-rate artists."

(2) Another lithographed letter, dated 21st November 1870:—

"MY DEAR MISS JAY,—I have been looking at your recent copies of Turner with real pleasure. They are executed on entirely right principles, and are far more precious than the most costly engravings could be, in interpreting, and not unfrequently in very closely approaching, the subtlest qualities of effect in the originals. I hope you will persevere in this work: many women are now supporting themselves by frivolous and useless art: I trust you may have the happiness of obtaining livelihood in a more honourable way by aiding in true educational efforts, and placing within the reach of the general public some means of gaining better knowledge of the noblest art.

"Believe me, sincerely yours,
"JOHN RUSKIN."

[1] [This letter was printed (with the date wrongly given as 1883) on p. 4 of a Prospectus issued by "Neill & Son, Art Publishers and Printsellers, Haddington, N.B.," and also in the privately-issued (1893) *Letters from John Ruskin to William Ward*, vol. ii. pp. 82–83. The original drawing of the "Bridge of Meulan" is No. 140 in the National Gallery; that of "More Park" is No. 168 (see above, p. 97). The "Coblentz" is No. 62 in Ruskin's *Notes on his Drawings by Turner* (see above, p. 454).]

TURNERS, FALSE AND TRUE

[1871, 1884]

1. "'TURNERS,' FALSE AND TRUE[1]

" To the Editor of the ' Times'

"Sir,—I have refused until now to express any opinion respecting the picture No. 40[2] in the Exhibition of the Old Masters, feeling extreme reluctance to say anything which its kind owner, to whom the Exhibition owes so much, might deem discourteous.

"But I did not suppose it was possible any doubt could long exist among artists as to the character of the work in question; and, as I find its authenticity still in some quarters maintained, I think no other course is open to me than to state that the picture is not by Turner, nor even by an imitator of Turner acquainted with the essential qualities of the master.

"I am unable to assert this on internal evidence only. I never saw the picture before, nor do I know anything of the channels through which it came into the possession of its present proprietor.

"No. 235 is, on the contrary, one of the most consummate and majestic works that ever came from the artist's hand, and it is one of the very few now remaining which have not been injured by subsequent treatment.—

"I am, Sir, your obedient servant,

"JOHN RUSKIN.

"DENMARK HILL, *Jan. 23.*"

2. "THE EXETER TROUVAILLE"

" To the Editor of the ' Pall Mall Gazette'

"84, WOODSTOCK ROAD, OXFORD, *October 26.*

"Sir,—Would you kindly put an end to a report—of which I did not trouble myself to stop the vociferation till it got, unluckily, into your columns

[1] [This letter appeared under the heading "The Exhibition of Old Masters" in the *Times* of January 24, 1871. It was thence reprinted in *Arrows of the Chace,* 1880, vol. i. p. 156, with the heading as given above. The letter was also reprinted in George Redford's *Art Sales,* 1888, vol. i. p. 178, where further particulars of the spurious picture may be found.]

[2] ["Italy," a reputed Turner, lent by the late Mr. Wynn Ellis. No. 235 was "A Landscape," with cattle, in the possession of Lord Leconfield.]

—that I have attested the Exeter trouvaille? I have never seen any of the drawings, but wrote in reply to an enthusiastic account of them by the finder that I thought it highly probable he was right in his exultation, but could not certify what I had not seen; declining also, as I am constantly now obliged to do, to let the drawings be sent for verification. You will perhaps also allow me on this occasion to advise the general public through your columns that I hold it no part of the duties either attached to my Oxford chair, or compatible with my enjoyment of private life, to do picture-dealers' work for nothing, still less for a 'consideration.' The part of your paragraph respecting the Yorkshire drawing is perfectly true; but it ought to be added that the work was of small importance, and one for which the dealer was not likely to carry his contest far.

" I am, Sir, your obedient servant,

" J. RUSKIN." [1]

[1] [Mr. W. F. Moore had announced the possession of pictures by Turner. They were exhibited at Exeter, and the advertisements of the exhibition stated that Ruskin had attested their genuineness. This statement was repeated in the *Pall Mall Gazette* (October 11, 1884), and called forth Ruskin's letter, which appeared in that paper on October 27, 1884. The letter was in course copied into *The Exeter and Plymouth Gazette* (October 29), in which paper a correspondence was in progress as to the authenticity of the pictures. A correspondent thereupon wrote to the Exeter paper (November 6), printing in parallel columns extracts from Ruskin's letter to the *Pall Mall Gazette* and extracts from a private letter (dated October 6) received by Mr. Moore from Ruskin. These extracts were as follows :—

"MY DEAR SIR,—I heartily congratulate you on your finds, having no doubt of their genuineness. . . . But I can give you no advice about selling, further than that I place any drawings I wish to part with at the Fine Art Society's Rooms, 148, New Bond Street, under the care of Mr. Huish. I have been myself the mere prey of the dealer all my life. Very truly yours,

" J. RUSKIN."

The letter to the *Pall Mall Gazette* of October 27, 1884, was reprinted in *Igdrasil*, for June 1890, vol. i. p. 211, and thence reprinted in the privately-issued *Ruskiniana*, 1890, Part i. p. 29. The reference to "the Yorkshire drawing" is to the following passage in the *Pall Mall* (October 11): "Some few months ago a Sheffield manu-facturer found in a second-hand shop and bought for an old song a drawing of the 'Lake near Lord Harewood's House, Yorkshire,' which Mr. Ruskin declared to be" etc., etc. This in turn referred to an earlier issue of the *Pall Mall* (February 29, 1884), in which the following remarks by Ruskin addressed to Mr. Jackson Smith, the manufacturer in question, were quoted :—
"Your drawing is indeed a very curious and beautiful example of Turner's earliest works. You are extremely wicked to trust it to the post with only that bit of pasteboard, and it is a mercy it is not crushed into a curl paper. In case you are ever disposed to part with it, I think you might count on my being ready to outbid the dealer."]

3. A PORTRAIT OF TURNER[1]

"The portrait shown to me to-day by Mr. Wass is, I have no doubt, a painting of Turner when young by himself, and is of extreme interest to me, though slighter in work than the one in the National Gallery; for that very reason seeming to give, in all probability, the truest image extant of the man at that time of his life.

"JOHN RUSKIN."

[1] [This signed statement is reprinted (without date) from the article referred to above (p. 473) by Cosmo Monkhouse in *Scribner's Magazine* for July 1896 (vol. 20, p. 89). It refers to a life-size oil picture of a young man, belonging to Mr. C. Wentworth Wass; it was exhibited at the Grosvenor Gallery in 1888, and at the New Gallery (Victorian Exhibition in 1891–1892). It was there described as a "Portrait of Turner by Himself, painted at the age of 22." It shows a good-looking young man, fashionably attired in black coat and white waistcoat. It does not greatly resemble the other portraits of the artist; it has been suggested that this may be the portrait which he left as a pledge of his affection to the heroine of his first romance, as told by Thornbury (p. 42 of the 1877 edition). The portrait is reproduced at p. 91 of Mr. Monkhouse's article.]

NOTES ON DRAWINGS BY RUSKIN
PLACED ON EXHIBITION

By Professor Norton at Boston and New York

[1879]

[IN 1879 it occurred to Professor Charles Eliot Norton that an exhibition of Ruskin's own drawings, such as had already interested the London public, would be equally appreciated by his numerous readers in America, "and of even greater value to large numbers of them who have not the opportunity of studying works of art in the old world, and who, for the most part, having at hand only the pirated edition of Mr. Ruskin's books with its disgraceful travesties of the noble and exquisite illustrations with which the author's edition of his own works were adorned, could have received only a most imperfect, if not altogether false impression of the quality and range of his artistic powers as therein displayed."

Ruskin acceded to the suggestion, and sent a large number of his drawings, to which were added several in Professor Norton's collection. The exhibition was first held at Boston, and afterwards in New York, in the autumn of 1879, and a catalogue was prepared by Professor Norton.[1]

[1] [*Bibliographical Note.*—The title-page of this catalogue is :—

Notes on Drawings | By | Mr. Ruskin, | Placed on Exhibition by Professor Norton | In the Gallery of | Messrs. Noyes and Blakeslee, | 127 Tremont Street, Boston. | October, 1879. | Cambridge : | University Press : John Wilson & Son. | 1879.

An octavo pamphlet of 34 pp., in mottled-grey wrappers, with the title-page repeated on the front cover, except that instead of the publisher's imprint are the words "Price, Twenty-Five Cents." On p. 2 of the wrapper is an advertisement of the authorised English editions of "Mr. Ruskin's Works"; on p. 3, an announcement of "a portfolio containing facsimiles of thirty-three of Turner's etchings for the *Liber Studiorum,* selected from those in the possession of Mr. Ruskin and Professor Norton"; and also of "a series of permanent photographs," to be issued by Mr. W. J. Stillman, "of twenty-five subjects chosen from the most interesting works of Gothic and Renaissance Architecture in Tuscany." In the pamphlet Professor Norton's "Prefatory Note," quoted from above, occupies pp. 3–6, being dated "Cambridge, October 10, 1879," and the Notes, pp. 7–34. The number of pieces

Some remarks from Professor Norton's Prefatory Note may here be cited:—

"The character of this collection is unique. These drawings are not the work of an artist by profession; there is not a picture among them. They are the studies of one who, by patience and industry, by single-minded devotion to each special task, and by concentrated attention upon it, has trained an eye of exceptional keenness and penetration, and a hand of equally exceptional delicacy and firmness of touch, to be the responsive instruments of faculties of observation and perception such as have seldom been bestowed on artist or on poet. Few of these drawings were undertaken as an end in themselves, but most of them as means by which to acquire exact knowledge of the facts of nature, or to obtain the data from which to deduce a principle in art, or to preserve a record of the work of periods in which art gave better expression to the higher interests and motives of life than at the present day. These studies may consequently afford lessons to the proficients in art not less than to the fresh beginners."

The Notes in the Catalogue, compiled by Professor Norton, were for the most part reprinted from the London Catalogue or from Ruskin's published books. He sometimes applied to a drawing which had not been shown in London a note which Ruskin had written for a different one; thus, the note on 25 R. (*b*), on p. 508 above, was applied to No. 20 on this page—a drawing done at about the same time. But there were Notes on other pieces "taken from Ruskin's memoranda upon the drawings themselves." The following are the titles of all the drawings shown in America which were not included in the London Exhibition, together with the Notes thereon as printed in the American Catalogue:—]

I. EARLY DRAWINGS. 1828–1845.

17. GRASS BLADES.

18. THISTLE.

20. VAL ANZASCA.

II. SWITZERLAND. 1846–1876.

28. FALLS OF SCHAFFHAUSEN (1850?). Colour.[1]

29. FALLS OF SCHAFFHAUSEN (1850?). Unfinished study in colour.

shown was 106; of these 25 were marked by an asterisk as indicating that they were also included in the London Exhibition.

The exhibition was afterwards transferred to New York, when the title-page of the catalogue was thus altered:—

Notes on Drawings | By | Mr. Ruskin, | Placed on Exhibition by Professor Norton, | of Harvard College, | at the | American Art Gallery, | *Madison Square*, *New York*, | No. 6 East Twenty-Third Street. | December, 1879. | Cambridge University Press: John Wilson & Son. | 1879.

The front page of the wrapper was similarly altered; a mistake was corrected under No. 73 (see p. 586 *n.*, below); and on p. 4 of the wrapper an advertisement was added of the American Art Rooms. The catalogue was reset and the pagination slightly differs, but the text of the two catalogues is otherwise identical.]

[1] [Ruskin's note on this drawing has been given in *Modern Painters*, vol. i. (Vol. III. p. 529 *n.*). The true date of the drawing must be much earlier; probably 1842.]

31. STUDY OF DETAIL FOR PROPOSED ETCHING OF FRIBOURG (1856). Pen drawing touched with colour.[1]

32. SIMILAR STUDY (1856). Pencil and pen drawing, with added colour.

33. SKETCH FOR ETCHING OF FRIBOURG (1859). Pen drawing, touched with colour.

34. WALL TOWER OF LUCERNE. Pencil study, touched with colour.

35. LAKE OF BRIENZ. Colour.

36. LUCERNE. Pencil drawing, washed with colour.

37. DAWN AT NEUCHÂTEL. Colour.

38. LAUTERBRUNNEN. Pencil study, touched with colour.

39. GENEVA (1862 or 1863). Pencil sketch.[2]

40. GENEVA (1862 or 1863). Begun detail for the little pencil study. Pencil with touch of colour.

41. AARBURG, cliffs of Jura above (1863). Sketch in pencil for Swiss towns.

42. LAUFFENBURG. *Twilight* (1863). Pencil sketch, with colour added.

43. HOUSE AT LAUFFENBURG (1863). Sketch in colour.

44, 45. SKETCHES OF BRIDGE AT LAUFFENBURG (1863). Pencil.
 Two tries at subject.[3]

46. LUCERNE (1866). Colour.

47. LAUTERBRUNNEN (1866). Colour.[4]

48. OLD VEVAY (1869). Pencil.

50. LINES OF THE ALPS OF TYROL, MUNICH (1859). Pencil and pen sketch.

51. LINES OF THE ALPS FROM KEMPTEN (1859). Pencil and pen sketch.

52. PEN SKETCH OF CRESTS OF LA CÔTE AND TACONAY. (For etching in *Modern Painters*, vol. iv., Plate 35.)[5]

[1] [This drawing was No. 352 in the Ruskin Exhibition at Manchester, 1904; and No. 32 was No. 226 in the Royal Society of Painters in Water-Colours, 1901; while No. 33 was No. 76 in that exhibition, and No. 127 at Coniston, 1900.]

[2] [Nos. 39 and 40 were No. 72 at the Royal Society of Painters in Water-Colours.]

[3] [One of these was No. 41 in the same exhibition, in the catalogue of which Ruskin's further note was added: "I got into a great mess with the rocks in this drawing, but it is a valuable one in bare detail." It was also in the London Exhibition (see above, p. 523, 44 R.). The American Catalogue gave the date wrongly as 1868.]

[4] [This drawing was No. 286 at the Royal Society of Painters in Water-Colours, and No. 91 at Manchester.]

[5] [No. 79 at the Water-Colour Society.]

53. Pencil Sketch of Leading Contours of Aiguille Bouchard. (For etching in *Modern Painters*, vol. iv., Plate 33.)

54. St. Gothard Pass, from near Fluelen. Pencil and pen.

55. Study for Etching of Turner's "Pass of Faido." Pencil and pen.

56. Etching of Turner's "Pass of Faido." (From *Modern Painters*, vol. iv., Plate 21.)

57. Etching of Pass of Faido. *Simple topography.* (From *Modern Painters*, vol. iv., Plate 20.)[1]

58. Etching from a Picture by Turner (1870?).

III. VENICE

59. Study of Capitals in St. Mark's, for *The Stones of Venice* (1845). Pencil and brush.
A single example of a multitude of studies.

60. Studies of Venetian Capitals. Pencil and brush.[2]

61. Archivolt of one of the Doors of St. Mark's. Pen and brush.
Drawing chiefly made from daguerreotype, with added study of details. Engraved for *Examples*, but the plate was stolen or lost.[3]

62. Southern Portico of St. Mark's.
Chiaroscuro drawing in sepia for the etching for the mezzotint in *Examples of the Architecture of Venice*.[4]

63. Door-Heads from Ca' Contarini Fasan Porta di Ferro and in Campo S. Margarita. (From *Examples of the Architecture of Venice*, Plate 11.)

64. Photograph of Door-Head in Campo S. Margarita.

65. Door-Heads: 1. In Ramo Dirimpetto Mocenigo. (From *Examples of the Architecture of Venice*, Plate 12.)

66. Door-Heads: 2. In Campiello della Chiesa San Luca. (From *Examples of the Architecture of Venice*, Plate 13.)

-57, see Vol. VI. pp. xxv.-xxvi. No. 55 was No. 86 at the Water-Colour Society, and No. 146 at Manchester; No. 57 was No. 104 at Coniston, No. 320 at the Water-Colour Society, No. 150 at Manchester.]
[2] [These were the sketches for *Examples of the Architecture of Venice*, Plate 3, Vol. XI. p. 322.]
[3] [Afterwards found; engraved in this edition as Plate 16 in *Examples*, Vol. XI. p. 350; No. 239 at the Water-Colour Society.]
[4] [Plate 6, Vol. XI. p. 330; No. 134 at the Water-Colour Society, where No. 63 was No. 135.]

67. STILTED ARCHIVOLTS. FROM A RUIN IN THE RIO DI CA' FOSCARI. (From *Examples of the Architecture of Venice*, Plate 9.)

68. SKETCH ON GRAND CANAL (1876). Left off, tired.[1]

69. PART OF SKETCH OF NORTH-WEST PORCH OF ST. MARK'S. Made in 1877. Copied at Brantwood in 1879.[2]

70. VENETIAN RENAISSANCE CAPITAL (1879). Look from the other side of the room. Chiaroscuro sketch.

71. FREE-HAND EARLY BYZANTINE CARVING (1879). Chiaroscuro sketch.

72. NOTE OF COLOUR AND CHIAROSCURO. From Tintoret's picture of the Annunciation in the Scuola di San Rocco, Venice (1852).

IV. MISCELLANEOUS STUDIES IN ITALY, FRANCE, AND ENGLAND

(Nos. 73 to 105)

73.[3] INTERIOR OF A PALACE, VICENZA (1849). Pencil.

74. STREET IN VERONA (1872). Pencil.

75. STUDY FOR ETCHING, from photograph of the Duomo at Florence (1874). Pencil.

76. LUNG' ÁRNO, FLORENCE (1874). Pencil.

77. FROM SAN MINIATO (1845). Colour.[4]

78. ST. ETIENNE LE VIEUX (?), CAEN (1848).

79. PART OF THE CATHEDRAL OF ST. LO, NORMANDY (1848).

A portion of this drawing is engraved in *The Seven Lamps of Architecture*, Plate 2.

80. PART OF THE CHURCH OF ST. WOLFRAM, ABBEVILLE (1868). Rapid study in pencil and colour-wash.[5]

81. OLD HALL IN WORCESTERSHIRE, or thereabouts; Herefordshire, perhaps (1854 ?). Pencil touched with colour.

[1] [No. 68 may be identical with one of the three drawings—17–19 R.—in the London Exhibition (see above, p. 500). It is now in the collection of Mr. Wedderburn, and was No. 46 at the Water-Colour Society; No. 385 at Manchester. It is marked "Left off, beaten and tired, 1876. Signed, J. Ruskin, 1879."]

[2] [This sketch is engraved as Plate D in Vol. X.]

[3] ["Verona," in the Boston edition.]

[4] [No. 246 at Manchester.]

[5] [No. 307 at Manchester.]

82. PART OF TURNER'S RICHMOND, YORKSHIRE (1858 or 1859). Study for etching (never executed) for *Modern Painters.*

83. OKEHAMPTON.
Study for etching after Turner's drawing. A try for truer rendering of the England drawings. Failure.[1]

84. PHOTOGRAPH FROM PENCIL DRAWING (No. 34 in the London Exhibition[2]) from Turner's water-colour drawing of Arona.

85. PHOTOGRAPH FROM DRAWING OF GNEISS WITH ITS WEEDS, ABOVE THE STREAM OF GLENFINLAS. (The drawing was No. 45 in the London Exhibition.[3])

86. STUDY IN COLOUR OF BLOCK OF GNEISS, ON THE ALPS (1854?).[4]

87. A STONE OF MY GARDEN-WALL (1873).

88. EVENING AT NORWOOD (1865).

89. SUNRISE FROM DENMARK HILL (1868).

90. STUDY OF SUNRISE.
March 19, 1868. Ended in soft rain from high clouds, hardly enough to put up umbrella, for all the afternoon. Rain in evening. Wind here south-west, the black scud floating fast to the left.

91. DRAWING IN COLOUR OF BONE ENGRAVED BY A PRE-HISTORIC MAN. British Museum.

92. NOTES OF WORK IN BRITISH MUSEUM (1872).

93. STUDY OF BIRD ANATOMY—IBIS, CRANE, GANNET—FOR NOTES TO *Love's Meinie* (1874). British Museum.

94. MORE STUDIES FOR NOTES TO *Love's Meinie* (1874).[5]

95–99. LESSONS FOR OXFORD SCHOOL:—
STUDY OF STONE (1874).
IVY (1873).
LEAVES AND BERRIES (1873). Keep your red red, and your brown brown, and your green green, for your life.
WITHERED RUSH-BLOSSOM, MAGNIFIED. Study in lamp-black.
WILD VIOLET (1879). Outline with brush. For *Proserpina.*[6]

[1] [No 192 at Coniston; No. 415 at the Water-Colour Society. The date is 1874.]
[2] [See above, p. 521.]
[3] [See above, p. 524.]
[4] [Perhaps the same as 46 in the London Exhibition; see above, p. 524.]
[5] [No. 186 at Coniston; No. 143 at the Water-Colour Society.]
[6] [Plate ix.; the preceding study was No. 44 at the Water-Colour Society.]

100. HIBISCUS (1867). Study in colour.

101. BUDDING SYCAMORE (1875). Sketched at Greta Bridge.

102. COTONEASTER (1879).[1]

103. STUDY OF MAGNIFIED PHEASANT'S FEATHER (1879).[2]

104. OAK-BUDS (1878).

105. DRY OAK LEAVES (1879).

106. DRY OAK LEAVES (1879).

[1] [Engraved in *Proserpina*, Plate xiii.]
[2] [This and No. 105 are now in the Ruskin Museum at Sheffield.]

VII

LIGHT AND WATER-COLOURS

[IN the spring of 1886, Mr. (now Sir) J. C. Robinson wrote to the *Times* protesting against the exposure to "the strong light of day" of any modern water-colour drawings in public collections. "If," he wrote, "the specimens are openly and continuously exhibited to the public in the day-time, in a very few years, by the very fact of such exposure alone, they will be practically ruined and worn out. The strong light of day, indeed, causes such works to fade and wane away daily and hourly even." He proposed, therefore, that "all national collections of drawings be exhibited to the public in the evenings [by artificial light] and at no other time" (*Times*, March 11). This letter excited lively controversy, in which Ruskin joined with some acrimony. He was, as we have seen (pp. 83 *seq.*), in favour of what may be called a system of modified exhibition. He contributed a letter to the *Times* on the subject, on April 14. This letter is printed below. Among those who took a prominent part in the controversy against Sir J. C. Robinson was Sir J. D. Linton, then P.R.I. With the idea of refuting Sir J. C. Robinson's statement by means of ocular demonstration, an Exhibition of Water-Colour Drawings by Deceased Masters of the British School was held at the Royal Institute in July 1886. In the catalogue of this exhibition, the correspondence which had appeared in the *Times* was reprinted, and to it Ruskin contributed a further article on the subject. This also is reprinted below.]

1. LETTER IN THE *TIMES*, APRIL 14, 1886

"SIR,—You are much to be thanked for your judicial close on the late controversy in your columns on the permanence of water-colour, but I wish it were the pride of the leading journal of Europe not to admit controversy into its pages at all, and to print on subjects admitting doubt only the statements which narrow inquiry.

"The public may justly sympathize with Sir James Linton in the love of his art which beguiles him into the conviction of its immortality, and pardon Mr. Robinson the care for the future which provokes him into exaggeration of immediate loss.

"But, on the other hand, the patronage of water-colours must not be flattered by the idea that they enrich in flavour by keeping, like old wine; nor, on the other, is the entirely sound and authoritative protest of the

589

trustees of the National Gallery enforced in any wise by Mr. Robinson's fallacious alarm-cry respecting the contents of the gallery at Kensington.

"The Kensington Water-Colour Gallery is still one of the most delightful and instructive rooms in London; and the most delicate and precious drawing it contains, Turner's 'Hornby Castle from Tatham Church,' has sustained, during the last ten or twelve years, no greater harm than I might attribute my own instinct of, more to the failure of my old eyes than of Turner's colour.[1]

"I may be permitted also to advise Mr. Robinson, in passing, that neither Mr. Fawkes nor I sent, at the Academy's request, our chosen drawings to London[2] that we might learn from Mr. Robinson which were the best, or which we had taken the most care of.

"The drawing which was exclusively so fortunate to obtain Mr. Robinson's approbation (Llanthony) was, indeed, none of ours; and it certainly could not be faded, as there never had been any colour in it. I praised it highly for its great effect, in the first volume of *Modern Painters*[3]— bought it some thirty years ago, and parted with it afterwards because it possessed none of Turner's distinctive qualities, but was merely an effect of Copley Fielding's better executed.

"But the general point on which the natural feeling of the public needs confirmation against troublesome gossip is the essential quality and value of a water-colour painting as a piece of polite art.

"Pure old water-colour painting, on pure old paper, made of honest old rags.

"There is no china painting, no glass painting, no tempera, no fresco, no oil, wax, varnish, or twenty-chimney-power-extract-of-everything painting which can compare with the quiet and tender virtue of water-colour in its proper use and place. There is nothing that obeys the artist's hand so exquisitely; nothing that records the subtlest pleasures of sight so perfectly. All the splendours of the prism and the jewel are vulgar and few compared to the subdued blending of infinite opalescence in finely inlaid water-colour; and the repose of light obtainable by its transparent tints and absolutely right forms, to be rendered by practised use of its opaque ones, are beyond rivalship, even by the most skilful methods in other media.

[1] [No. 88 in the South Kensington Water-Colour Collection, Sheepshanks' gift. Some of the Turners in that Museum are protected by hangings, which the visitor can push aside. At the National Gallery, the desks in which drawings are exhibited for three months at a time are fitted with blinds which can be drawn when the Gallery is not open to the public. Many of the drawings on the walls which are exposed to direct sunlight are protected by blinds which are drawn down when necessary, the visitor being able to raise them during his inspection. Ruskin's practice at Denmark Hill was similar: see above, p. lii. At Brantwood also his Turners on the walls were protected, and several were kept in cabinets.]

[2] [The reference is to the collection of Water-Colours by Turner which was included in the "Old Masters" Exhibition of 1886–1887. Ruskin took a strong interest in the collection, as appears from a letter to Mrs. Fawkes, reprinted in a later volume of this edition. The drawings contributed by him to the exhibition were "Heysham,"

"Properly taken care of—as a well-educated man takes care of his books and furniture—a water-colour drawing is safe for centuries; out of direct sunlight, it will show no failing on your room wall till you need it no more; and even though, in the ordinary sense of property, it may seem less valuable to your heir, is it for your heir that you buy your horses or lay out your garden? We may wisely spend our money for true pleasures that will last our time, or last even a very little part of it; and the highest price of a drawing which contains in it the continuous delight of years cannot be thought extravagant as compared to that we are willing to give for a melody that expires in an hour.

"I am, Sir, your obedient servant,

"JOHN RUSKIN.

"BRANTWOOD, *April* 12, 1886."

2. APPENDIX TO THE "CATALOGUE OF THE EXHIBITION OF WATER-COLOUR DRAWINGS BY DECEASED MASTERS OF THE BRITISH SCHOOL" (ROYAL INSTITUTE, JULY 1886)

The mingled spite and impertinence of Mr. Robinson's letter in the *Times* of the 12th instant release me from any further notice of his endeavours to destroy the most beautiful art of England:[1] but to his request that Mr. Ruskin should exhibit "the four drawings which that gentleman contributed to the Manchester Exhibition in 1857," Mr. Ruskin replies that he never contributed one;[2] neither to that, nor to any other exhibition, was ever drawing of Turner's sent by me, until I allowed my whole collection to be seen at Bond Street in 1878, when, if ever, Mr. Robinson's observations on the fading of Turners should have been communicated to the public. He had the right, then, to say what he chose—for I showed the drawings of my own free will, and he had the perfect materials for observation, for I showed drawings of every time and in every state. But he stained his ignorance with the worst discourtesy in debating what he supposed to be the defects in the noblest drawings ever made by Turner in the full strength of his life,—permitted by Mr. Fawkes, at the request of the Royal Academy, to be for the first time moved from the house in which, and for whose walls, they were made.

[1] [The letter dated June 11 appeared in the *Times* of June 14. The writer began with recommending Sir James Linton to make his answer "fair and straight-forward." He admitted that "rare specimens" could be produced and exhibited of water-colours in perfect condition. But, he added, "let me advise Sir James Linton to obtain from Mr. Ruskin, or whoever may now possess them, and exhibit at the same time, the four drawings by Turner, which that gentleman contributed to the Manchester Exhibition in 1857, and which, according to him, were utterly ruined and "reduced to mere wrecks of what they were" by exposure to the light during that "fatal year" only (see *Arrows of the Chace*, 1880, Section 4).]

[2] [Sir J. C. Robinson was misled by the fact that four drawings which were in the Manchester Exhibition, and which Ruskin had spoken of as faded, were subsequently acquired by him: see above, p. 343.]

The four drawings referred to in the Manchester Exhibition were exhibited by I know not whom, and there wrecked, as I wrote in the letter now reprinted in *Arrows of the Chace*,[1] by exposure at once to damp and sunlight. But the wrecks were still so lovely that I afterwards gave Messrs. Colnaghi 130 guineas for the vignette of Troy, the same firm £760

harne.[2] The drawing which suffered most fatally was the Virginia Water, from which the rose colour in the sky literally disappeared; but the wonder was, under the treatment the drawings received at Manchester, that anything but soot stains on blank paper survived it all.

I wrote at that time, energetically, to prevent further bleaching of Turner drawings; and, under Sir Charles Eastlake's authority, placed the National Gallery Collection of Turner drawings in the cabinets, where they have remained safe to this day. I presented to Cambridge and Oxford the cabinets for the Turner drawings I gave them, and would have done the same for the Raphael drawings at Oxford the moment I entered on my first professorship; but the lovers of Raphael insisted on the continual exposure of the collection, and, to the best of my knowledge, I received no help by advice for its protection from Mr. Robinson, who drew up its catalogue.

To whom, here bidding final requiem, I take Sir James Linton's leave to use the occasion of this present display of old English drawings for a few general words on the value and permanence of water-colour as a means of national instruction.

First, in portraiture. All our popular taste has been depraved, and all our best feelings vulgarized, by the use of photography instead of miniatures, or water-colour sketch. I find also numbers of students losing their lives in vain efforts to paint in oil and get into the Academy, when they might be earning an honourable and happy livelihood by water-colour portraiture, if the public were taught to recognize its value.

Again, in the representation of natural phenomena, a water-colour sketch is,—I do not say the readiest,—it is the *only* way of rightly noting effects of light colour, aërial relation, and cloud form rapidly passing, and it is also the only method of giving truthful detail in landscape. Modern illustration by wood block, representing all effects of light as explosions, and all foliage as black and white, have half destroyed the ordinary observer's power of *seeing* nature, how much more of enjoying it!

Again, in the illustration of natural history; it has long been recognized by men of science that water-colour laid by hand was necessary for all scientific publications of the highest class. But it has never been enough felt by them that the living beauty, whether of flowers or animals, could only be represented by accomplished artists, and that the science of the future should have, not only Bewick, but John Lewis in its service, and train its rustic William Hunts to the painting of the kingfisher and butterfly.

Lastly, for cheerful and graceful room decoration in domestic life, there is nothing comparable to water-colour drawings. The useless and expensive

[1] [In vol. i. pp. 146–152; now reprinted in this volume: see above, p. 343.]
[2] [Nos. 49, 26, and 39 in Ruskin's Turner Collection: see above, pp. 446, 430, 441.]

decorations of the upholsterer are merely an expression of pride; and as for fresco and arabesque—no one ever heard of anybody's honestly enjoying them,—besides that they are an insult to the guest who can never hope to live in so fine a house. Oil-pictures are very grand, but cumbrous, and often gloomy; while there is no parlour so small but it may be dignified—and no corner so dull but it may be lighted, by a pretty water-colour.

Of the five examples in the present exhibition, the good-natured reader may not be displeased to have the precedents. The little Prout, No. 163, was the first drawing we ever possessed at Herne Hill—copied by my cousin Mary, as related in *Præterita*, for delight of my father on his birthday.[1] It has been an exhaustless pleasure to us ever since—always in the rooms most lived in—never protected from their quiet light—and I know no change in it since I was ten years old.

The Lewis exhibited by Mr. Severn was bought by my father about 1840, and has been the pride of Herne Hill ever since. It was never protected from the light until very recently, and I recognize no enfeebling of any single hue of touch.[2]

The Turner, No. 90, "Scene in Savoy," was Mr. Dillon's, exposed on his walls to ordinary daylight, and since, frankly shown on mine. It is a very early drawing, certainly not much later than 1812 or 1814, and I cannot conceive of it as ever more beautiful than now.[3]

The Devonport and Salisbury were hung in the excellent light of Mr. Windus's drawing-room at Tottenham, and came from Tottenham to Denmark Hill, where before 1840, though, like all the rest of our Turner drawings, protected by covers when no one was looking at them, they were always uncovered at breakfast time, and often, when we had visitors, during the day.[4]

These two drawings contain passages of colour as delicate and beautiful as can be seen by the master's hand. The sky of the Devonport I consider the loveliest in all my collection, and that of the Salisbury is unrivalled among those expressive of sunshine through rain. There is not a hue that I know of, lost, in either work: there is not one that could be deepened with advantage, and I see no reason why, with ordinary care, the drawings should not be as bright, when they are centuries old, as they are to-day, after their first half-century of proper use and protection.

JOHN RUSKIN.

BRANTWOOD, *June* 19, 1886.

[1] [The Prout, No. 163, was "An Old English Cottage"; it was No. 95 in the Exhibition of Prout and Hunt (see Vol. XIV.). The reference in *Præterita* is in ch. iv. of vol. i.]

[2] [The Lewis, No. 119, was "The Dancers."]

[3] ["The Scene in Savoy" is No. 68 in Ruskin's *Notes on his Drawings by Turner:* see note on p. 458, above.]

[4] [The "Devonport" and "Salisbury" are Nos. 36 and 38 in the catalogue of Ruskin's Turners: see above, pp. 438, 440.]

INDEX

INDEX I

LIST OF PICTURES, DRAWINGS, SKETCHES, AND STUDIES BY TURNER AT ANY TIME IN THE COLLECTION OF ¡RUSKIN, WITH THE PAGES IN THIS VOLUME WHERE THEY ARE REFERRED TO

The principal sources from which this List is compiled are: (1) The Catalogue (here pp. 556–557) of his collection drawn up by Ruskin about the year 1860 for Thornbury's *Life of Turner;* referred to as "Thornbury." (2) The list of drawings (here pp. 559–560) presented by Ruskin to the University of Oxford in 1861; here referred to as "Oxford." (3) Catalogues of the Ruskin Drawing School (see p. 559 *n.*). (4) His catalogue of drawings (here pp. 557–558) presented to Cambridge in the same year; here referred to as "Cambridge." (5) The auction catalogue of drawings (here pp. 569–572) sold by him at Christie's in 1869. (6) The catalogue of his collection as exhibited at the Fine Art Society's Rooms in 1878 (here pp. 389–536); here referred to as "R. T.," with the additional pieces exhibited in 1900 (see p. 402). (7) The auction catalogue of drawings (here pp. 573–574) intended for sale at Christie's in 1882. (8) Ruskin's MSS. (9) The catalogue of Turner's Works in Sir Walter Armstrong's *Turner* (Agnew, 1902) supplies a few items, not included in the other sources; such items are referred to as "Armstrong." It may be added that many items included here are not in the Armstrong list. Where, in the catalogues above enumerated, a drawing is merely named, a reference to the list only is given; where a note is added, a reference to the page is supplied.

The object of the present List is not to give a catalogue of Turner, so much as to facilitate reference to Ruskin's allusions. Particulars of the drawings (sizes, medium, etc.) are, therefore, not as a rule given; but where the drawing was engraved in the artist's lifetime, the fact is stated in brackets after the title; and occasionally, where identification would otherwise be difficult, other particulars are given.

ABBEY, RUINED. (Early unfinished drawing.) R. T., 5 (p. 415). Oxford Educational Series, 102

ABERGLASLYN, PONT. R. T., 3 (p. 414)

"AIGUILLETTE." See CLUSES, VALLEY OF

ALPINE STREAM. Sold by Ruskin at Christie's (1869), 36 (p. 570)

ALPINE STREAM. R. T., 118 (p. 471)

ALPINE TORRENT AND PASS. Sold by Ruskin at Christie's (1869), 37 (p. 571)

ALPINE VALLEY. Sold by Ruskin at Christie's (1869), 12 (p. 570). A so entitled is included

Bunney

INDEX II

THE following List of all the Drawings by Turner, exhibited in the National
Gallery, is designed to serve the double purpose of (1) an Index to this
volume, and (2) a Ruskin Guide to the collection. Ruskin's catalogues, col-
lected in this volume, do not conform, as already explained (above, p. xl.),
to the existing arrangement in the Gallery. This Index will enable the
visitor to the Gallery to refer, in examining any drawing there, to the place
where Ruskin discusses it.

A few words of explanation on the existing arrangement on the base-
ment of the National Gallery (west wing) of the Drawings and Sketches by
Turner may be useful to the reader. The collection is (1) in part permanently
exhibited, and (2) in part periodically exhibited.

The drawings permanently exhibited fall into three classes :—

(a) Original drawings and sketches for Liber Studiorum : Nos. 461 to
522 and 863 to 884. These are at present (1904) hung in the First Room.

(b) A representative collection of sketches and drawings, being part of
those selected by Ruskin in 1857 for their "exemplary and illustrative"
character. These are at present hung in Rooms I. and II.: Nos. 523–624.
(The other part of this series, Nos. 401–460, are in the cabinets; see below.)

(c) A miscellaneous collection of sketches and drawings, of all periods,
framed and exhibited during recent years. For many years the groups (a)
—except Nos. 863–884—and (b) were all that were accessible to the public.
In 1885, however, a third room was made available, and several more
sketches were framed and exhibited. In 1890 a fourth room was thrown
open, and many further sketches were shown. These are at present hung in
Rooms III. and IV.: Nos. 625–863 and 885.

The remainder of the collection accessible to the public is periodically
exhibited. It consists of 460 frames (Nos. 1–460). Four hundred of these
were arranged by Ruskin in cabinets, so as to be safe from permanent
exposure to light, though accessible to students, as explained at p. x.
of this volume. Of these drawings, 60 are exhibited to the public at a

time in the desks in Room I. They are changed every three months (on January 1st, April 1st, July 1st, October 1st). The remainder are kept locked up in cabinets in an inner room, where students may obtain access to them on obtaining special permission. It should be added that a certain number of the drawings (*e.g.*, Nos. 301–350), being too large or too small to fit into the desks in Room I., are not included among those periodically exhibited to the public.

The following synopsis will further explain the arrangement of the collection :—

Nos. 1–460. "Cabinet" drawings, periodically exhibited in the desks.

461–522. Liber Studiorum drawings and sketches permanently exhibited on the walls.

523–624. Drawings selected by Ruskin and permanently exhibited on the walls.

625–862 and 885. Drawings subsequently selected and permanently exhibited on the walls.

863–884. Liber Studiorum drawings (Vaughan Bequest), permanently exhibited on the walls.

In all 1156 drawings and sketches are exhibited at the National Gallery, permanently or periodically, in 882 frames.[1]

In addition to these drawings, several are exhibited in other Museums and Galleries. A collection of 21 pieces is on "permanent loan" at the South Kensington Museum. A collection of 251 (selected by Mr. Ruskin) are similarly placed in the Ruskin Drawing School in the University Galleries at Oxford (see above, pp. 560–569). Six other collections, each consisting of 50–70 drawings, are circulated among various provincial Galleries and Museums.[2] The total number of drawings comprised in the Turner Drawings which are thus exhibited in one way or another is about 1550. The remainder of the collection is retained in eleven tin boxes at the National Gallery (see above, Introduction, pp. xli.–xlv.).

[1] The difference between 885 and 882 is accounted for by the fact that three of the numbered drawings have been removed on loan to the South Kensington Museum. Of the 1156 drawings, 574 are permanently exhibited, and 582 are in cabinets. Of the former class 352 are in colour, 85 in pencil, 29 in pen and ink, 18 in Indian ink, 84 are Liber Studiorum drawings, and there are three engravings. Of the 582 drawings in the 460 cabinet frames, 396 are in colour, 58 in pen and ink, 60 in pencil, 55 in pencil touched with white, and 13 in pencil touched with colour.

[2] In ch. iv. of *The Laws of Fésole* (1877) Ruskin says: "Of Turner's lead outlines, examples enough exist in the National Gallery to supply all the schools in England, when they are properly distributed. My kind friend Mr. Burton is now so fast bringing all things under his control into good working order at the National Gallery, that I have good hope, by the help of his influence with the Trustees, such distribution may be soon effected." Most of the provincial selections were made after this date.

INDEX

 Note.—The following Index is (1) to groups of drawings, with references to Ruskin's allusions in this volume to such groups; (2) to the several drawings. The titles correspond generally with those on the mounts or frames; they were written by Mr. Wornum and successive Keepers; the identifications were in most cases Ruskin's.

1–25. SKETCHES IN SAVOY AND PIEDMONT (1803), pp. 320, 374.

[*Of these sketches, Ruskin selects, as the most noteworthy, Nos. 3, 5, 9, 10, 11, 12, 14, 17, 18, 19, 22, 23, 24, 25. To the same group belong Nos. 538–547. The latter are permanently exhibited.*]

 1. Grenoble.
 2. Entrance to the Little Chartreuse.
 3. Chain of Alps of the Chartreuse.
 4. Rumilly, near Annecy.

 Ruskin discovered this place in 1858 :—
 "I had a great piece of good fortune to-day," he wrote to his father from Annecy (Sept. 4). "As I was looking over the map, before starting for Bonneville, my eye fell on the name of one of Turner's towns which I had in vain hunted everywhere for (Rumilly), at about 12 miles from here, on the French side. I ordered a couple of horses directly, and away I went at half-past ten, through the loveliest country imaginable; found my town, or village rather, all right—Turner's tower, mill wheel, and bridge, all touched (the mill wheel very rotten, luckily left because mill itself ruined)—sketched tower, which was all I wanted, and back here to dinner at five."

 5. Grenoble, with Mont Blanc.
 6. Post-house, Voreppe.
 7. Voreppe.
 8. Voreppe.
 9. Entrance to the Grande Chartreuse, by Voreppe.
 10. Entrance to the Chartreuse, with Water-mill.
 11. Bridges: Grande Chartreuse.
 12. Entrance to the Chartreuse.
 13. The Little Bridge, Chartreuse.
 14. Cascade of the Chartreuse.
 15. The Little Church of St. Humber.
 16. Near the Grande Chartreuse.
 17. Gate of the Chartreuse (looking forward).
 18. Gate of the Chartreuse (looking back).
 19. Gate of the Chartreuse (looking back, farther off).
 20. Near the Grande Chartreuse.
 21. St. Lauriot, Savoy.
 22. Descent to Aosta.

XIII. 2 q

23. NEAR AOSTA.
24. THE BRIDGE OF MARTIGNY.
25. BRIDGE OF VILLENEUVE, VAL D'AOSTA.

26–40. STUDIES ON GREY FOR "RIVERS OF FRANCE" (1833–1835).

[Another series of similar studies is contained in Nos. 101–125. They are sketches made on the spot. Some of the finished drawings prepared for the engravers are in the collection: see note on Nos. 126–160. For a general reference to Turner's work on grey paper, see "Cestus of Aglaia," § 27.]

26. FOUR STUDIES AT MARLY AND ROUEN.
27. TWO STUDIES IN FRANCE, AND
 TWO STUDIES FOR A PICTURE.
28. FOUR STUDIES IN FRANCE.
29. FOUR STUDIES IN FRANCE.
30. TWO STUDIES AT BOULOGNE, AND
 TWO STUDIES AT AMBLETEUSE.
31. FOUR STUDIES AT CALAIS.
32. FOUR STUDIES IN FRANCE.
33. FOUR ENGLISH MARINE STUDIES.
34. ROUEN, IN FRANCE: TWO MARINE STUDIES.
35. ON THE RHINE, ST. GERMAIN, DIEPPE, ON THE SEINE.
36. ORLEANS, TOURS (colour on grey).
37. LIBER STUDIORUM SUBJECTS: TWO LAKE OF THUN, MONT ST. GOTHARD, VILLE DE THUN (pencil).

> See Nos. 474, 475, 477, for Turner's drawings in brown of these subjects.

38. ON THE SEINE? (colour on grey).
39. LUXEMBOURG? AND HUY ON THE MEUSE (colour on grey).
40. HONFLEUR, HONFLEUR? (colour on grey).

41–50. CONTINENTAL SKETCHES (Later Period).

[These sketches belong to a group of fifty selected by Ruskin to illustrate Turner's colour studies of mountains. In the same group he placed Nos. 71–100, 279–290, and 583 and 589. For Ruskin's note on the whole group, see p. 371.]

41. LAUSANNE, LOOKING OVER THE LAKE OF GENEVA, p. 226.
42. FORT DE L'ECLUSE, FROM THE OLD WALLS OF GENEVA, pp. 224, 372.
43. LAKE OF LUCERNE, FROM KUSSNACHT, p. 202.
44. LAUSANNE, p. 224.
45. THE RIGI, FROM LUCERNE, pp. 204, 372.
46. VEVAY, p. 226.
47. THE ALLÉE BLANCHE, LOOKING TO THE COL DE LA SEIGNE, p. 225.
48. CASTLE NEAR MERAN, p. 220.
49. FRIBOURG, SWITZERLAND, p. 221.
50. FRIBOURG, SWITZERLAND, p. 224.

101–125. STUDIES FOR "RIVERS OF FRANCE" (1833–1835), p. 385.

[*These studies, again, should be compared with the drawings of the Seine done for the engravers, Nos. 126–160. For a further note on the drawings of this style and period, see under No. 52 in the Ruskin Turners, p. 449.*]

For a note on this study, see, in a later volume, the catalogue of *The Ruskin Cabinet, Whitelands College*, No. 53.

For this sketch also, see *The Ruskin Cabinet, Whitelands College*, No. 52.

126-160. THE SEINE (1834-1835), pp. 97, 236, 387, and compare *Modern Painters*, vol. i. (Vol. III. pp. 237-238).

[*This group consists of drawings made for the illustrated book* Turner's Annual Tour, *of which the two later volumes, published in 1834 and 1835, had as sub-title "Wanderings by the Seine." The work was projected by Charles Heath, a publisher, in conjunction with Turner. "It was part of the bargain between Turner and Heath that the original drawings which were made for the engravers should remain the property of the artist. Mr. Armytage, the engraver of three of the series, informs me that when full of apologies for being behind-hand, he called upon Turner to submit to him proofs of his completed plates, the great man was much more anxious about the safe return of his drawings than their successful translation" (Marcus B. Huish: "The Seine and the Loire," 1890, p. viii.). Turner's Annual Tour for 1833 was "Wanderings by the Loire." The total number of published drawings was 62. Of these, 35 are now at Trafalgar Square. Of the Loire drawings, several were presented by Ruskin to Oxford, see p. 559. Some of Turner's slighter sketches and memoranda made on the Loire are in the National Collection, see, e.g., Nos. 116-124.*]

126. HARFLEUR.
127. QUILLEBŒUF. See *Modern Painters*, vol. i. (Vol. III. p. 566).
128. BETWEEN QUILLEBŒUF AND VILLEQUIER.
129. CAUDEBEC, p. 97, and see *Modern Painters*, vol. i. (Vol. III. p. 464).
130. LA CHAISE DE GARGANTUA.[1] See *Modern Painters*, vol. i. (Vol. III. p. 549).
131. ROUEN, LOOKING UP RIVER.
132. ROUEN, LOOKING DOWN RIVER.
133. ROUEN CATHEDRAL. See *Modern Painters*, vol. i. (Vol. III. p. 607).
134. LILLEBONNE.
135. LILLEBONNE.
136. PONT DE L'ARCHE.
137. CHÂTEAU GAILLARD, FROM THE EAST.

> "It is said that when Mr. Ruskin, in going through the Turner drawings which were left to the nation, came across this one, he exclaimed, 'Here's a gem that's worth a thousand pounds.'"—M. B. Huish: *The Seine and Loire*, 1890, No. 23.

138. BETWEEN MANTES AND VERNON.

> As already stated (p. 451) Ruskin asked Mr. William Ward to give him particulars of Turner's method in the drawings in body-colour on grey. Mr. Ward selected this drawing for analysis, as follows :—
> "Wash of gamboge and yellow ochre (body-colour) over left side of drawing.
> "Wash of cobalt beginning at right corner and carried over previous wash across to left corner.
> "Light yellow clouds put in with same colour as first wash but with more Chinese white.
> "White clouds on right drawn with touches of blue (after

[1] Near Duclair is a curiously formed rock, in the shape of a seat, which gives its name to this view. Turner lights up the seat with a flash of lightning.

hillside has been completed a wash of cobalt is laid on partly
covering the clouds and stopping a little short of the hillside,
clouds are then slightly reinforced with body-cólour.)

"A purple ground laid on from bank on left and carried partly
over hill on right varying the colour.

"Outline of hill completed with touches of brown and green,
then wash of red carried partly over dark colour, then yellow wash
brought down to roofs of houses.

"Washes of yellow-green sepia and yellow ochre over sky for
tree masses.

"Yellow bank is next put in.

"Pump and figures on left laid in with wash of sepia and
Chinese white, then drawn with Indian red and burnt sienna and
touched up with sepia.

"Vehicles laid in with purple.

"Tree trunk on left laid in with grey-green, dabbing with
finger for texture, stopping short at head of figure and continuing
under the arm.

"Other trunks and branches put in with warm greenish brown
and black, afterwards touched up with Indian red, grey-green, black,
and sharp touches of yellow ochre.

"The foliage is then finished by a crumbling dash of dark green
over the yellow in left corner, then completing the form and colour
by point drawing with warm browns, orange, and black.

"The distance is now laid in with a blot of blue, drying in the
required shape, and banks of river completed with touches of purple,
green, etc.

"The ground of the hill being of the right tone, the light
mass of houses are drawn in with body-colour, then the roofs,
windows, etc., outlined with a pen in red (the red used is burnt
sienna, Indian red, and a little vermilion for brightest), afterwards
bringing out the prominent lights with Chinese white. The vehicles
and figures are outlined with the same red pen, and high lights on
figures and table-cloth put in with same brush of white.

"The brown and purple shadows across the road are now put
in, then the orange lights on road, hillside figures, and vehicles.

"The black figure comes in after the yellow bank, but before
the shadows which go over him, and stop short at the white ladies.

"Upon examination with a lens there is always much more point
drawing and more colours than appear to the naked eye."

181. Rosy Castle on River, p. 386.
182. Heidelberg, p. 386.
183. Red Sunset on a Hill Fortress, p. 386.
184. Dinant. Meuse, p. 386.
185. Dinant, p. 386.
186. Luxembourg ? p. 386.
187. Luxembourg ? p. 386.
188. Luxembourg ? p. 386.
189. Luxembourg ? p. 386.
190. Luxembourg ? p. 386.
191. Luxembourg ? p. 386.
192. Meuse, p. 386.
193. Coast of Genoa, p. 386.
194. Coast of Genoa, p. 386.
195. Italian Lake ? p. 386.
196. Marseilles, p. 386.
197. Riviera ? p. 386.
198. Sorrento Coast ? p. 386.
199. Vico ? Coast of Sorrento, p. 386.
200. The Vermilion Palace, p. 386.

201–225. VIGNETTES FOR ROGERS' "ITALY" (1830), pp. 97, 236, 375, 445.

201. Naples.
202. Italian Composition (Perugia ?)

> Vignette at p. 168 of Rogers' *Italy*. See *Modern Painters*, vol. i. (Vol. III. p. 307).

203. Aosta. See *Modern Painters*, vol. i. (Vol. III. p. 434).

> Of this drawing there is a copy "by William Ward and Ruskin" in the Manchester Art Museum, Ancoats Hall ; it was shown in the Ruskin Exhibition, Manchester, 1904 (No. 178). In a letter to the Committee of the Museum Ruskin wrote (1881) :—
> "In the Aosta I deepened the entire shadow in the left ; drew in the mountain tops sharper ; gave the two towers above the gate their form, and painted in all the roofs of church at the side of the gate. I am surprised in looking at the engraving to-day to see how much you gain in the drawing."

204. The Battle of Marengo.

> Illustrating "The Descent" from the Great St. Bernard in Rogers' *Italy*. See *Modern Painters*, vol. i. (Vol. III. pp. 429, 444).

205. St. Maurice, p. 97.

> Ruskin placed a copy of this vignette, by Mr. William Ward, in his drawing-school at Oxford. See *Catalogue of Rudimentary Series*, p. 17 ; *Lectures on Landscape*, § 73 ; see also *Modern Painters*, vol. i. (Vol. III. p. 417), and vol. v. pt. vii. ch. iii. § 10.

206. Pæstum. See *Modern Painters*, vol. i. (Vol. III. p. 414), and *Eagle's Nest*, § 7.

> The lightning which is a feature in the plate is not shown in the drawing.

207. Hannibal Crossing the Alps.

> Illustrating the section "The Alps," in Rogers' *Italy*. No. 209 is a sketch which Turner began, but abandoned, for the same subject. His Academy picture, No. 490 in the National Gallery, had been exhibited many years earlier, in 1812.

208. Isola Bella, Lago Maggiore.

> Vignette to the last section of Rogers' *Italy*, "A Farewell"; see *Poetry of Architecture*, § 110 (Vol. I. p. 86), and *Modern Painters*, vol. i. (Vol. III. p. 443). See also, in a later volume, a note in the catalogue of *The Ruskin Cabinet, Whitelands College*.

209. Hannibal Crossing the Alps, p. 83.
210. The Lake of Geneva. See *Modern Painters*, vol. i. (Vol. III. p. 385).
211. Hospice of St. Bernard, p. 514.

> This drawing was largely modified in the engraving. Much was added, especially in the sky; and some things, including the dog, were left out. For Ruskin's note on the cloud effects in the published vignette, see *Modern Painters*, vol. i. (Vol. III. p. 417).

212. Martigny: The "Silver Swan." See *Lectures on Landscape*, § 53.

> Illustrating the section "Marguerite de Tours," in Rogers' *Italy* :—
>
> > "And should I once again, as once I may,
> > Visit Martigny, I will not forget
> > Thy hospitable roof, Marguerite de Tours,
> > Thy sign the Silver Swan. Heaven prosper.thee."
>
> The figures behind the carriage, rendered with some spirit in the drawing, are omitted in the plate. For a reference to this vignette in connection with the poetry of inns, see *Fors Clavigera*, Letter 93.

213. The Lake of Lucerne (Tell's Chapel), p. 452; and see *Modern Painters*, vol. i. (Vol. III. p. 458).
214. Florence.
215. The Lake of Como. See *Modern Painters*, vol. i. (Vol. III. p. 383).

> In the drawing an added pencil outline of the Villa d'Este may be noticed, as a further instruction to the engraver.

216. Rome. See *The Ruskin Cabinet, Whitelands College*, No. 46.
217. Verona: Moonlight.
218. St. Peter's, Rome. See *The Ruskin Cabinet, Whitelands College*, No. 47.

> The sun and sky which appear in the plates of this and the following vignette do not exist in the drawings.

219. The Campagna.

220. THE GARDEN, p. 376 ; and see *Modern Painters*, vol. i. (Vol. III. p. 306).

Frontispiece to Rogers' *Poems*.

221. GALILEO'S VILLA, ARCETRI. See *Modern Painters*, vol. i. (Vol. III. p. 389).

Illustrating Rogers' lines, and also Milton's :—

" Sacred be
His villa (justly was it called the Gem !)
Sacred the lawn, where many a cypress threw
Its length of shadow, while he watched the stars."—*Rogers*.

Milton visited Galileo, old and blind, a prisoner to the Inquisition in 1638 :—

" The broad circumference
Hung on his shoulders like the moon, whose orb
Through optic glass, the Tuscan artist viewed
At evening from the top of Fesole."—*Paradise Lost*, i. 286.

• 222. BANDITTI.

Illustrating "An Adventure" in Rogers' *Italy*. This drawing was greatly altered in the plate. The second group of figures on the left was omitted ; the waterfall was raised, and woods and hills were shown above the stone bridge.

223. PADUA : MOONLIGHT. THE CANAL FOR VENICE. See *Modern Painters*, vol. i. (Vol. III. p. 390).

224. TIVOLI. THE TEMPLE OF THE SIBYL.

A comparison of this drawing with the plate shows that the temple has been very much pinched up in the latter.

225. AMALFI.

This is an instance in which the cloud effects, which are a great feature in the plate, were entirely added by the engravers, doubtless under Turner's superintendence. For Ruskin's note on the clouds, see *Modern Painters*, vol. i. (Vol. III. p. 386).

226–250. VIGNETTES FOR ROGERS' "POEMS" (1834), p. 380.

[*To this group of the best vignettes belong also Nos. 220 and 397. Nos. 391, 392, 393, 394, 395, 396, 398, 399, 400, and 577 are also vignettes for the "Poems," but are of inferior merit : see p. 381.*]

226. TWILIGHT, p. 380 ; and see *Modern Painters*, vol. i. (p. 355).

Vignette to Rogers' *Poems* (" The Pleasures of Memory ") :—

"Twilight's soft dews steal o'er the village green,
With magic tints to harmonize the scene.
Stilled is the hum that thro' the hamlet broke,
When round the ruins of their ancient oak
The peasants flocked to hear the minstrel play,
And games and carols closed the busy day."

227. THE NATIVE VILLAGE.

Vignette to "The Pleasures of Memory" :—

"The adventurous boy, that asks his little share,
And hies from home with many a gossip's prayer,
Turns on the neighbouring hill, once more to see
The dear abode of peace and privacy ;
And as he turns, the thatch among the trees,
The smoke's blue wreaths ascending with the breeze,
The village common spotted white with sheep,
The churchyard yews round which his fathers sleep ;
All rouse reflection's sadly pleasing train,
And oft he looks and weeps, and looks again."

228. ST. ANNE'S HILL (FRONT VIEW).

Illustration to the passage in Rogers' *Human Life* where the poet re-
calls days spent in the company of Fox during the statesman's
retirement at St. Anne's Hill. Notice the chair and the books
illustrating the lines :—

"How oft from grove to grove, from seat to seat,
With thee conversing in thy loved retreat,
I saw the sun go down ! Ah, then 'twas thine
Ne'er to forget some volume half divine,
Shakespeare's or Dryden's—thro' the chequered shade."

229. ST. ANNE'S HILL (IN THE GARDEN).

Vignette to Rogers' lines "Written in Westminster Abbey, Oct. 10,
1806, after the funeral of the Right Hon. Charles James Fox."
The principal tree in this vignette is given as Fig. 3 in Plate 27 of
Modern Painters (Vol. VI. p. 100) as an instance of "The Aspen
under Idealization."

230. TORNARO, p. 376 ; and see *Modern Painters*, vol. i. (Vol. III. p. 364).

Vignette for Rogers' *Human Life.*

231. GIPSIES.

Vignette to "The Pleasures of Memory" :—

"Down by yon hazel copse, at evening, blazed
The Gipsy's fagot—there we stood and gazed ;
Gazed on her sun-burnt face with silent awe,
Her tattered mantle, and her hood of straw ;
Her moving lips, her cauldron brimming o'er."

232. THE OLD OAK IN LIFE.

Vignette to Rogers' poem "To an Old Oak," in which is contrasted the
life of the oak on the village-green with its end in the ship-builder's
yard :—

"Then culture came, and days serene ;
And village sports, and garlands gay.
Full many a pathway crossed the green ;
And maids and shepherd youths were seen
To celebrate the May."

233. THE OLD OAK IN DEATH.

Here in the dockyard is " the long corse that shivers there Of him who
came to die " :—

> "Father of many a forest deep,
> Whence many a navy thunder-fraught !
> Erst in thy acorn-dells asleep,
> Soon destined o'er the world to sweep,
> Opening new spheres of thought ! "

234. GREENWICH HOSPITAL, p. 380.

Vignette to "The Pleasures of Memory" :—

> "Go, with old Thames, view Chelsea's glorious pile,
> And ask the shattered hero, whence his smile?
> Go, view the splendid domes of Greenwich—Go,
> And own what raptures from Reflection flow."

235. THE WATER-GATE OF THE TOWER.

Vignette to *Human Life :—*

> "On thro' that gate misnamed, thro' which before
> Went Sidney, Russell, Raleigh, Cranmer, More."

236. "THE BOY OF EGREMOND."

Initial vignette to Rogers' poem so named :—

> "In tartan clad and forest-green,
> With hound in leash and hawk in hood,
> The Boy of Egremond was seen."

It is said that the figures in many of these vignettes—*e.g.*, Nos.
226, 235 (boat also), 236, 248, 249—were inserted by Stothard.
See *Reminiscences of F. Goodall, R.A.*, 1902, pp. 59, 60.

237. BOLTON ABBEY, p. 380.

Terminal vignette to "The Boy of Egremond," whose death at the
Strid was the cause of the foundation of Bolton Abbey : for the
legend, see Vol. VI. p. 305.

238. ST. HERBERT'S ISLE, DERWENTWATER (IDEAL).

Vignette to "The Pleasures of Memory" :—

> "When evening tinged the lake's ethereal blue,
> And her deep shades irregularly threw ;
> Their shifting sail dropt gently from the cove,
> Down by St. Herbert's consecrated grove;
> Whence erst the chanted hymn, the tapered rite
> Amused the fisher's solitary night;
> And still the mitred window, richly wreathed,
> A sacred calm thro' the brown foliage breathed."

239. LODORE.

Vignette to "The Pleasures of Memory" :—

> "Gazed on the tumbling tide of dread Lodore;
> And thro' the rifted cliff, that scaled the sky,
> Derwent's clear mirror charmed her dazzled eye."

240. LOCH LOMOND. See *Modern Painters*, vol. i (Vol. III. p. 550).

Vignette to Rogers' lines " Written in the Highlands of Scotland " :—

"Blue was the loch, the clouds were gone,
Ben-Lomond in his glory shone,
When, Luss, I left thee ; when the breeze
Bore me from thy silver sands."

241. JACQUELINE'S COTTAGE, p. 381 ; and see *Modern Painters*, vol. i. (Vol. III. p. 435 *n.*).

Vignette to Rogers' poem " Jacqueline " :—

"The day was in the golden west;
And curtained close by leaf and flower,
The doves had cooed themselves to rest
In Jacqueline's deserted bower . . .
Round which the Alps of Piedmont rose."

242. THE ALPS AT DAYBREAK (IDEAL), p. 381; and see *Modern Painters*, vol. i. (Vol. III. pp. 366, 433).
243. THE FALLS AT VALLOMBRÉ, p. 380.

Vignette to Rogers' " Jacqueline ' :—

"Not now, to while an hour away,
Gone to the falls in Vallombré,
Where 'tis night at noon of day ;
Nor wandering up and down the wood,
To all but her a solitude,
Where once a wild deer, wild no more,
Her chaplet on her antlers wore,
And at her bidding stood."

244. ST. JULIENNE'S WELL, p. 381.

Vignette to the third part of Rogers' poem " Jacqueline " :—

" That morn ('twas in St. Julienne's cell,
As at St. Julienne's sacred well
That dream of love began)—
That morn, ere many a star was set,
Their hands had at the altar met
Before the holy man."

245. THE CAPTIVE, p. 381.

Vignette to Rogers' poem "Captivity" :—

"Caged in old woods, whose reverend echoes wake,
When the heron screams along the distant lake,
Her little breast oft flutters to be free,
Oft sighs to turn the unrelenting key. . . .
And terraced walls their black reflection throw
On the green mantled moat that sleeps below."

246. COLUMBUS AT LA RABIDA. See *Elements of Drawing*, § 87.

Vignette at the beginning of Rogers' poem "The Voyage of Columbus" :
Columbus asking pittance at the gate of the convent.

247. DEPARTURE OF COLUMBUS, p. 380.

Vignette to Canto I. of the same poem.

248. DAWN ON THE LAST DAY OF THE VOYAGE.

Illustration to Canto VIII. of the same poem.

249. LANDING IN AMERICA. See *Modern Painters,* vol. i. (Vol. III. p. 390).

Illustration to Canto IX. :—

"Slowly bareheaded, thro' the surf we bore
The sacred cross and, kneeling, kissed the shore."

250. CORTEZ AND PIZARRO.

Illustration to the Epilogue to "The Voyage of Columbus" : Cortez and
Pizarro in the convent church of La Rabida.

251–269, 271–275. SKETCHES IN PENCIL, SOMETIMES TOUCHED
WITH COLOUR, AT ROME (Middle Period), p. 377.

[*In this group Ruskin, in his proposed rearrangement, placed also Nos.* 251, 326,
327, 328, 331, 332, 590, 591, 592, 597, *and* 600.]

251. ROME.
252. TIVOLI : THE TEMPLE OF VESTA (NEAR), p. 379.

One of a group of five sketches of Tivoli ; the others are Nos. 302, 303,
339, 340.

253. GENERAL VIEW OF ROME (pencil on grey).
254. TIVOLI : THE CASCADES.
255. THE TIBER AND CASTLE OF ST. ANGELO (colour).
256. ROME : THE COLONNADE OF ST. PETER'S (pencil).
257. ROME : FOUNTAIN IN FRONT OF VILLA MEDICI (pencil).
258. THE PORTICO OF ST. PETER'S (colour).
259. ROME : ST. PETER'S AND THE VATICAN (pencil).
260. THE ALBAN MOUNT (colour).
261. ROME : THE COLOSSEUM (pencil).
262. ROME : THE CASTLE OF ST. ANGELO (pencil).
263. ROME : STONE PINES ON MONTE MARIO (pencil).
264. ROME : GENERAL VIEW (pencil).
265. ROME : INTERIOR OF THE COLOSSEUM (colour), p. 378.
266. STUDY IN ROME (pencil).
267. ROME : ST. PETER'S FROM THE WEST (pencil).
268. ROME : THE TIBER AND THE APENNINES (pencil).
269. ROME : ST. PETER'S AND THE VATICAN (pencil).
270. ROME (pencil).
271. ROME : THE COLOSSEUM, p. 378.
272. ROME : THE COLOSSEUM AND BASILICA OF CONSTANTINE (colour).
273. ROME : ST. PETER'S FROM THE SOUTH.
274. ROME : THE PALATINE (pencil).
275. ROME : THE COLOSSEUM, WITH FLOCK OF GOATS (pencil).

276–290. CONTINENTAL SKETCHES (Late).

[*See also Nos. 41–50.*]

276. TREPORT, p. 191.
277. EU CATHEDRAL, p. 192.

For another sketch of Eu, see No. 665.

278. COBLENTZ, p. 193.
279. EHRENBREITSTEIN, p. 193.
280. COBLENTZ: BRIDGE ON THE MOSELLE, p. 194; and see *Elements of Drawing*, §§ 196, 205.
281. ON THE RHINE, p. 195.
282. HEIDELBERG, p. 197.
283. HEIDELBERG, p. 197.
284. HEIDELBERG, p. 197.
285. SCHAFFHAUSEN, p. 198.
286. CONSTANCE, p. 199.
287. ZURICH, p. 199.
288. LUCERNE, p. 200.
289. ZURICH, p. 200.
290. MOUNT PILATUS, FROM KUSSNACHT, p. 201.

291–295. SKETCHES IN VENICE (Late).

[*For a note on the group of sketches to which these belong, see under Nos. 351–372.*]

291. VENICE: SOUTH SIDE OF ST. MARK'S.
292. VENICE: DUCAL PALACE. THE CAMPANILE.
293. VENICE: BOATS ON THE GIUDECCA.
294. VENICE: S. GIORGIO FROM THE DOGANA.
295. VENICE: STEPS OF THE SALUTE WITH THE DOGANA.

296–305. MISCELLANEOUS SKETCHES.

296. STUDIES OF SKY (Latest Period).
297. SCOTLAND? (Latest Period).
298. THE TIBER (pencil).
299. ROME: THE CAPITOL (pencil).
300. BRIDGES IN THE CAMPAGNA (pencil).
301. NAPLES: VILLAS AT POSILIPPO (pencil).
302. TIVOLI: THE TEMPLE OF VESTA (pencil), p. 379.
303. TIVOLI: GENERAL VIEW FROM THE VALLEY (pencil), p. 379.
304. CAPRI, FROM NAPLES, p. 379.
305. NAPLES FROM QUEEN JOANNA'S VILLA (pencil).

335. VESUVIUS (colour), p. 379 *n.*; and see *The Ruskin Cabinet, Whitelands College,* No. 35.

336. MONTE ST. ANGELO AND CAPRI: MORNING (colour).

337. MONTE ST. ANGELO AND CAPRI: EVENING (colour).

> A copy of this drawing "by William Ward and Ruskin" is in the Manchester Art Museum, Ancoats Hall, and was shown at the Ruskin Exhibition at Manchester, 1904 (No. 176). Ruskin, when advising the Committee of the Art Museum to obtain a copy of this drawing, wrote (January 29, 1881):—
>
>> "It has a lovely sky and some perfect trees, Vesuvius, and a palace or two, and is of supremest time and power;—only a sketch, mind;—but worth more than pictures."
>
> At the request of the Committee, Ruskin afterwards intimated what his work on the copy had been:—
>
>> "My work on the Naples was rather general. Mr. Ward had left it somewhat paler, and I went carefully over all the darks, bringing out the rose colour on the mountains as a definite light, and putting more decision into the castle forms.
>>
>> "It is now a very close copy of the original tones, and these are, it seems to me, singularly pure and tender. The forms of the sky and trees, followed by Mr. Ward with great care, are entirely exemplary for fast sketching."

338. CAMPAGNA: SNOWY APENNINES IN DISTANCE (colour).

339. TIVOLI: THE TOWN WITH ITS CASCADES AND THE CAMPAGNA (colour).

> "People who look at this," said Ruskin of this drawing, "must learn" (*Letters to William Ward,* ii. 69).

340. TIVOLI: GENERAL VIEW FROM THE VALLEY (colour), p. 379.

341–350. MISCELLANEOUS DRAWINGS.

341. CUMBERLAND (pencil).
342. CUMBERLAND: COCKERMOUTH CASTLE (pencil).
343. CUMBERLAND (pencil).
344. CUMBERLAND (pencil).
345. CUMBERLAND: COCKERMOUTH CASTLE (pencil).
346. TWO SKETCHES IN SCOTLAND.
347. SCOTLAND.
348. SCOTLAND.
349. SCOTLAND.
350. SAVOY (chalk and pencil on brown).

351–372. SKETCHES, CHIEFLY IN VENICE (Late), p. 383.

351. VENICE: LA SALUTE AND CAMPANILE.
352. VENICE: THE GRAND CANAL.
353. VENICE: THE RIALTO.
354. VENICE: CASA GRIMANI AND RIALTO.
355. VENICE: MOUTH OF GRAND CANAL (SUNSET).
356. VENICE: THE GRAND CANAL (ABOVE THE RIALTO).

XIII. 2 R

357. VENICE: CROSS-CANAL, NEAR ARSENAL.
358. VENICE: ON THE CROSS-CANAL, BETWEEN BRIDGE OF SIGHS AND RIALTO.
359. THE SAME SUBJECT, NEARER.
360. VENICE: CHURCH OF SAN STEFANO.
361. STEAMER AT SEA.
362. SEASIDE FORT, WITH TOWERS.
363. TOURS.
364. MERAN.
365. METZ.
366. CASTLE AT BOTZEN.
367. MARETSCH CASTLE AND TOWER OF BOTZEN.
368. RUNKELSTEIN CASTLE, NEAR BOTZEN.
369. FORTRESS. TYROL?
370. FORTRESS. TYROL?
371. VENICE: THE ARSENAL, p. 97; and see *Stones of Venice*, vol. iii. (Vol. XI. p. 363).
372. FISHING-BOATS AND FISH AT SUNSET. See *Elements of Drawing*, § 71 n.

373–375. STUDIES OF BIRDS AND FISH, p. 370.

[*To this group belongs also No. 415. The group in Ruskin's proposed arrangement follows the early drawings of Scotland: see Nos. 306–314.*]

373. STUDY OF FISH (TROUT, ETC.).
374. STUDY OF FISH (PERCH).
375. TEAL.

376–380. PORTS AND RIVERS OF ENGLAND (1824–1828), p. 382.

376. THE MEDWAY.
377. RAMSGATE, p. 53.
378. THE MOUTH OF THE HUMBER, pp. 59, 382.
379. PORTSMOUTH, pp. 48, 63.
380. SHEERNESS, pp. 48, 58, 382.

381–390. VARIOUS SKETCHES (Late Period).

[*For some general remarks on Turner's later sketches, see pp. 383, 555.*]

381. ON THE RHINE?
382. ON THE RHINE?
383. SAUMUR.
384. NAMUR.
385. TOWN IN FRANCE: BRIDGE AND BARRACKS?
386. CHÂTEAU D'ARC?
387. NORTH TRANSEPT, ROUEN.
388. AVIGNON.
389. NAMUR.
390. ON THE RHINE?

435. Four Subjects, p. 292.
 (*a*). Theatre at Dijon.
 (*b*). Avenue of Poplars.
 (*c*). Room at Petworth Castle.
 (*d*). Round Tower in Twilight.
436. Fortress : Evening, p. 294.
437. Lausanne, in Rosy Sunset, p. 294.

438-460. MISCELLANEOUS DRAWINGS, ILLUSTRATIVE OF POINTS DESERVING ESPECIAL NOTICE.

438. Four Leaves from a Sketch-Book (pencil), p. 300.
439. Six Leaves from a Sketch-Book filled on the Lake of Geneva (pencil), p. 302.
 (*a*). Junction of the Rhone and Arve.
 (*b*). Studies of Boats.
 (*c*). Lausanne from the North. See also *Modern Painters*, vol. v.
 pt. viii. ch. iv. § 8, and Fig. 98.
 (*d*). Lausanne from the East.
 (*e*). Geneva from the West.
 (*f*). Geneva from the West at a greater distance.
440. Studies of Poultry, p. 275.

 For other studies of a similar kind, see No. 609.

441. Buckingham Gate (near Hungerford Bridge), p. 309.
442. Four Subjects.
 (*a*). Interior of French Cottage : Dressing for Tea, p. 312.
 (*b*). Promenade at Nantes, p. 312.
 (*c*). Twilight, p. 311.
 (*d*). Sunset, p. 311.
443. Four French Subjects, p. 312.
 (*a*). Havre ?
 (*b*). Saumur.
 (*c*). Caudebec.
 (*d*). Harfleur.
444. Four Sketches in colour on the Loire and Meuse, p. 312.
445. Marine Studies with Fish.
 (*a*). Marine Study of a Buoy, Gurnet, and Dog-Fish.
 (*b*). Seaside Study with Mackerel in the Foreground.
446. Drachenfels, p. 313.
447. Grenoble, p. 313.
448. Carnarvon Castle (pencil), p. 314.
449. Wells Cathedral (pencil), p. 314.
450. Four Sketches at and near York, p. 315.
451. Companions to the foregoing.
452. On the Rhine, p. 315.
453. Bellinzona, pp. 207, 315.
454. Fribourg (Switzerland), p. 315.
455. Fribourg (Switzerland), p. 315.

456. Landscape Sketch, with Abbey Buildings in Middle Distance (colour).
457. Dryslwyn Castle, Vale of Towy, S. Wales.
458. A Castle (pencil).
459. Study of Shipping (pencil and brown).
460. Sketch in Glasgow (pencil).

461–522, 863–884. DRAWINGS FOR "LIBER STUDIORUM,"[1] pp. 82, 96.

461. Jason. See *Modern Painters*, vol. i. (Vol. III. p. 240), and vol. ii. (Vol. IV. p. 259).
462. Solitude.

Sometimes called "The Reading Magdalen."

463. Bridge with Goats.
464. Bridge in Middle Distance. See *Modern Painters*, vol. iii. (Vol. V. p. 399).

Otherwise known as "The Sun between Trees."

465. Cephalus and Procris. See *Modern Painters*, vol. ii. (Vol. IV. pp. 245, 309), and *Lectures on Landscape*, §§ 95, 96.
466. Pastoral.

Not engraved. A Claude-like subject, much resembling (says Mr. Rawlinson in his catalogue of *Liber Studiorum*) Apuleia in search of Apuleius.

467. Pastoral with Castle.

Sometimes wrongly called Okehampton.

468. Woman and Tambourine. See *Modern Painters*, vol. iii. (Vol. V. p. 399).
469. The Tenth Plague of Egypt. See *Modern Painters*, vol. i. (Vol. III. p. 240).
470. Hindoo Ablutions.
471. Hindoo Devotions.

[1] [For the plates in *Liber Studiorum*, Turner made in the first instance, drawings in sepia, or some warm tint in water-colour, the same size as the intended plate; the drawing comparatively slight, and strengthened with pen lines, foreshadowing the etched lines. These lines were first etched upon the copper plate, this part of the work, with a few exceptions, being done by Turner himself. The plate was then mezzotinted, in some instances by Turner himself; and in all other cases the progress of the engraving was supervised by him with the utmost care. The drawings here exhibited are those made by Turner in sepia. The original plan of the book was to include one hundred and one subjects. Seventy-one plates were issued between the years 1807 and 1819, and the publication was then dropped. Of the original drawings, fifty-one came into the possession of the nation by Turner's bequest (Nos. 461–511). Twenty-two more were added in 1901 by the bequest of Mr. Henry Vaughan (Nos. 863–884). The original drawings are, with some exceptions, inferior in interest to fine impressions from the plates. Ruskin did not include them in his catalogues of examples arranged for the instruction of students: see above, pp. 96, 338.]

472. CHRIST AND THE WOMAN OF SAMARIA.
473. LAUFENBURG ON THE RHINE. See *Modern Painters*, vol. v. pt. viii. ch. ii. § 12.
474. THE LAKE OF THUN, SWITZERLAND, p. 418.
475. CASTLE OF THUN, SWITZERLAND.
476. THE LITTLE DEVIL'S BRIDGE, ALTDORF.
477. MOUNT ST. GOTHARD.
478. BONNEVILLE, SAVOY.
479. THE ALPS FROM GRENOBLE TO CHAMBERY. See *Modern Painters*, vol. i. (Vol. III. p. 237).
480. NORHAM CASTLE, ON THE TWEED, p. 121.
481. HOLY ISLAND CATHEDRAL.
482. MORPETH.
483. RIVAULX ABBEY, YORKSHIRE.
484. CRYPT, KIRKSTALL ABBEY. See *Modern Painters*, vol. v. pt. ix. ch. ix. § 17; and compare the note on the oil-picture, No. 487, p. 121 of this volume.
485. DUNSTANBOROUGH CASTLE.
486. COAST OF YORKSHIRE.
487. WINCHELSEA, p. 437.
488. EAST GATE, WINCHELSEA, pp. 121, 437; and see *Modern Painters*, vol. v. pt. ix. ch. xi. § 29.
489. HIND HEAD HILL.
490. MARTELLO TOWER, BEXHILL.
491. ST. CATHERINE'S HILL, NEAR GUILDFORD.
492. PEMBURY MILL, KENT.
493. GREENWICH HOSPITAL.

Or "London from Greenwich." Compare the oil-picture, No. 483.

494. CHEPSTOW CASTLE, RIVER WYE.
495. THE WYE AND SEVERN.
496. FLINT CASTLE: SMUGGLERS, pp. 41, 633.
497. DUNBLANE ABBEY. See *Lectures on Landscape*, §§ 38–43.
498. PEAT BOG, SCOTLAND.
499. VIEW NEAR BLAIR ATHOLE. See *Modern Painters*, vol. i. (Vol. III. p. 586), and *Lectures on Landscape*, § 36.
500. THE CLYDE.
501. INVERARY CASTLE. See *Modern Painters*, vol. v. pt. vi. ch. viii. § 6.
502. SHIPS IN A BREEZE.

Otherwise known as "The Egremont Sea-piece," from the picture painted for the Earl of Egremont.

503. THE GUARDSHIP AT THE NORE.

Taken, says Mr. Rawlinson in his catalogue of *Liber Studiorum*, from a picture by W. Vandevelde. A comparison of the drawing with the plate shows in the latter that the distant men-of-war on the left and the boats in the offing were afterthoughts.

504. BRIDGE AND COWS.
505. WATERMILL. See *Modern Painters*, vol. i. (Vol. III. p. 236), and *Lectures on Landscape*, § 96.

506. Stack Yard.

507. Farm-yard with Pigs. See *Modern Painters*, vol. i. (Vol. III. p. 236).

508. Hedging and Ditching, p. 434; and see *Modern Painters*, vol. v. pt. ix. ch. xi. § 28.

509. Marine Dabbler, p. 41; and see *Modern Painters*, vol. iv. (Vol. VI. p. 26).

510. Young Anglers. See *Modern Painters*, vol. v. pt. vi. ch. viii. § 10.

511. Juvenile Tricks. See *Modern Painters*, vol. iv. (Vol. VI. p. 26).

512. Sketch for a Liber Studiorum Subject.

513. „ „ „ „ „

514. „ „ „ „ „

515. „ „ „ „ „

516. Ploughing at Eton.

Original drawing, afterwards much altered in engraving: see No. 878.

517. Sketch for a Liber Studiorum Subject.

518. „ „ „ „ „

519. The Felucca.

Original drawing: unpublished.

520. Bridge with Goats.

Etching tinted in sepia for engraving: see No. 463.

521. Basle.

Etching tinted in sepia for engraving.

522. Flint Castle.

Etching tinted in sepia for engraving: see No. 496.

523-537. EXAMPLES OF TURNER'S PERIOD OF DEVELOPMENT (1775–1800). See Nos. 401–409.

523. Three Early Sketches at Clifton, p. 364.

523 (a). View on the River Avon, p. 251.
 (b). "North-West View of Malmesbury Abbey" (1791), p. 252.
 (c). "View from Cook's Folly," p. 252.

524 (a). Tower of St. Mary Redcliffe, Bristol, p. 253.
 (b). Transept and Tower of York Cathedral, p. 253.
 (c). Tower of Boston, Lincolnshire, pp. 245, 253.

525 (a). Sketch of the Town of Leeds, p. 254.
 (b). Sketch of Bolton Abbey (about 1800), p. 254.

526. Six Sketches of Manufactory Subjects, p. 255.
 (a). Large Fire-engin (*sic*) in Coalbrook Dale.
 (b). Copper Work at Swansea.
 (c). Fire-engin, Coalbrook Dale.
 (d). Iron Foundry, Maidly Wood, at the top of the hill.
 (e). Largest Fire-engine of Coalbrook Deal.
 (f). Mr. Morris's Fire-engin, near Glasmount.

527. Study of Rocks near Tivoli, pp. 255, 365.

528. Study of Spars of Merchant Brig, p. 256.

[*These nineteen drawings, in ten frames, belong to the same group as Nos. 1–25: for other notice on the whole group, see under those numbers.*]

552. CONTAMINES, SAVOY, p. 267.
553. "SOURCE OF THE ARVERON," p. 267.
554. FLANK OF THE VALLEY OF CHAMOUNI, p. 268.
555. BATTLE OF FORT ROCK (finished drawing), pp. 82, 246, 268, 278.
556. IVY BRIDGE (finished drawing), pp. 269, 277, 366.

557–568. A SERIES OF SUBORDINATE STUDIES.

[*To this same group of subordinate studies as first arranged by Ruskin belong also Nos. 411, 412, 413, 414, and 415, now placed in the cabinets.*]

557. TWO STUDIES OF A FIGURE, FOR PICTURE OF THE DELUGE, p. 269.
558. FOLKESTONE, pp. 269, 365.
559. STUDY OF A CUTTER, pp. 245, 270, 337.
560. STUDY OF A PILOT BOAT, p. 270.
561. TWO MARINE STUDIES, p. 271.
561A (IN THE OIL COLLECTION). A MOUNTAIN STREAM, p. 310.
562. TWO MARINE STUDIES, p. 271.
563. STUDY OF AN ARM CHAIR (in oils), p. 271.
564. VARIOUS STUDIES OF VEGETATION, p. 272.
565. STUDIES OF PIGS AND DONKEYS, p. 272.
566. SKETCHES IN ROUEN, WITH ENGRAVING OF "ROUEN FROM ST. CATHE-RINE'S HILL," p. 273.
567. STUDIES OF SKELETONS, p. 273.
568. STUDY OF DEAD DUCKS, p. 274.

569–576. EXAMPLES OF TURNER'S SECOND STYLE (1820–1835).

[*Formerly arranged in sequence with Nos. 418–426.*]

569. OUTLINE SKETCHES OF PARK SCENERY (PETWORTH PARK AND COCKER-MOUTH CASTLE), p. 279.
570. OUTLINE SKETCHES OF COCKERMOUTH CASTLE, p. 279.
571. STUDY OF EVENING AND NIGHT SKIES, p. 280.
 (a). STUDY OF A SKY, WITH A CATHEDRAL TOWER, AND EVENING MIST ON THE MEADOWS.
 (b). MOONLIGHT, ON CALM SEA.
572. STUDY OF STORM CLOUDS, p. 280.
573. THREE STUDIES AT SEA.
 (a). RUNNING WAVE IN A CROSS-TIDE: EVENING, pp. 247, 280.
 (b). TWILIGHT ON THE SEA, p. 280.
 (c). SUNSHINE ON THE SEA IN STORMY EVENING, p. 280.
574. THREE MARINE STUDIES, p. 281.
 (a). BREAKING WAVE ON BEACH.
 (b). SUNSET ON THE SEA.
 (c). COASTING VESSELS.
575. FOUR SKETCHES ON THE SEINE, p. 282.
576. SKETCHES OF ROOMS AT PETWORTH, p. 287.

625–862. MISCELLANEOUS DRAWINGS.

[*The catalogues written by Ruskin stopped with No. 624. The following additional drawings were framed and exhibited subsequently. They illustrate all the different styles and periods of Turner's work, as defined in preceding notes. Among them are a few which had been included in Ruskin's first selection of One Hundred Drawings (see pp. 208, 209). The name given to some of the subjects is conjectural. Most of the sketches are in water-colour.*]

632. SEA AND ROCKS (colour on grey).
633. DUNSTANBOROUGH (neutral tint).

> Turner exhibited a picture of Dunstanborough in 1798 ; see p. 406.

634. CRYPT, CANTERBURY CATHEDRAL (early).
635. ON THE THAMES.
636. STUDY OF SHIPPING (early).

> See notes on Nos. 528, 533, 614.

637. LOCH LONG (EVENING).
638. LLANTHONY ABBEY.

> For note on another early drawing by Turner of this subject, see *Pre-Raphaelitism*, § 49 (Vol. XII. p. 382).

639–686. CONTINENTAL SKETCHES (Later Period).

[*These, with Nos.* 691–695, 764, 765, 767–769, 772–777, 779, 780, 783–786, 791, 800, 824–830, 832–848, *belong to the series of sketches made by Turner on his later Continental tours : see notes on Nos.* 41–50.]

639. SION, RHONE VALLEY.
640. VENICE. THE DOGANA AND THE SALUTE.
641. RIVER AND BRIDGE.
642. CASTLE OF CHILLON, LAKE OF GENEVA.
643. THE GREAT ST. BERNARD.
644. VENICE. LA SALUTE.
645. ALPINE CASTLE.
646. FORT BARD, VAL D'AOSTA ?
647. VENICE. GRAND CANAL.
648. CASTLE IN THE VAL D'AOSTA.
649. VENICE. GRAND CANAL.
650. EHRENBREITSTEIN.
651. LUCERNE.
652. VALLEY OF THE RHONE, NEAR SION.
653. ITALIAN RIVIERA ?
654. LAKE SCENE.
655. SUNSET ON A LAKE.
656. COBLENTZ.
657. A MOUNTAIN LAKE.
658. LUCERNE (EVENING).
659. VENICE. THE DOGANA AND THE SALUTE.
660. LAUSANNE.
661. ?
662. ? (green and blues).
663. A MOUNTAIN TOWN.
664. LAKE OF MORAT, SWITZERLAND.

> So described ; but 664, 677, and 683 are more like Tancarville.

665. EU, WITH LOUIS PHILIPPE'S CHÂTEAU.
666. HEIDELBERG.

A large number of the sketches enumerated in the following pages resemble Nos. 101–125, etc., or Nos. 26–40 : see notes on those two groups. Another similar series, which includes some very lovely sketches, appears to record a tour on the Moselle : see, *e.g.*, Nos. 711, 728, 729.

706. FOUR SKETCHES AT PETWORTH (colour on grey).

 Compare Nos. 425, 435.

707. STUDY IN FRANCE (colour on grey).
708. STUDY OF SEA.
709. HONFLEUR (colour on grey).
710. A RUINED ABBEY (early).
711. COCHEM ON THE MOSELLE (colour on grey).
712. HAVRE (colour on grey).
713. LILLEBONNE (colour on grey).
714. BARGES (early).
715. RIVER SCENE (late).
716. SKETCH IN FRANCE (colour on grey).
717. SKETCH IN FRANCE (colour on grey).
718. SHAKESPERE CLIFF—FOLKESTONE.
719. STUDY OF SKY.
720. SKETCH IN FRANCE (colour on grey).
721. A FRENCH DILIGENCE (colour on grey).
722. SEA AND BOATS.
723. ON A FRENCH RIVER.
724. BLACK BOAT (study for a vignette).
725. SKETCH IN FRANCE (colour on grey).
726. FISHING-BOAT.
727. FOUNTAINS ABBEY (pencil, half-coloured).
728. ALKEN, ON THE MOSELLE (colour on grey).
729. COCHEM, ON THE MOSELLE (colour on grey).
730. SEA-PIECE.
731. BOWES CASTLE—NEAR BERNARD'S CASTLE, YORKSHIRE (early).
732. TREIS, ON THE MOSELLE (colour on grey).
733 (a). MARLY, ON THE SEINE (pen on grey).
 (b). ROUEN (pen on grey).
734. A RIVER VALLEY (sketch in body colour).
735. A WINDING RIVER.
736. ROCK OF VENTIMIGLIA, NEAR MENTONE (colour on grey).
737. A SKETCH IN FRANCE (colour on grey).
738. ENGLISH LANDSCAPE.
739. DUNSTANBOROUGH (early).
740. TRARBACH, ON THE MOSELLE (colour on grey).
741. ROOM AT PETWORTH.
742. VALE OF PICKERING, YORKSHIRE (with huntsmen).
743. MORTERATSCH GLACIER, ENGADINE.
744. TUNNY FISHING, MEDITERRANEAN.
745. SCHLOSS ELTZ, ON THE MOSELLE (colour on grey).
746. AN ENGLISH RIVER VALLEY.
747. SKETCH IN FRANCE (colour on grey).
748. SKETCH IN FRANCE (colour on grey).
749. CORNFIELD AND RAINBOW.
750. ENGLISH LANDSCAPE.
751. A WINDING RIVER.
752. SKETCH IN FRANCE (colour on grey).

801. ENGLISH LANDSCAPE.
802. KILGARREN CASTLE (early).

> Kilgarren Castle on the Twyvey was a favourite subject of Turner's. Five oil-pictures by him of it are in existence; the earliest was exhibited in 1799 : and see p. 417.

803. A CHURCH TOWER (early).
804. COTTAGE AND WINDMILL (early).
805. TOM TOWER, OXFORD (early).
806. WOODCROFT CASTLE, NORTHAMPTONSHIRE.
807. MOEL SIABOD, FROM THE ROAD NEAR CAPEL CARIG, N. WALES.
808. A RUINED ABBEY (pencil).
809. ROWSLEY, ON THE DERWENT.
810. LANDSCAPE (early).
811. OLD BUILDINGS (early).
812. PARK SCENERY.
813. ROMAN CAMPAGNA.
814. ROME : PONTE MOLLE.

> These two sketches, and No. 792, appear to belong to the same series at Nos. 329, 330. See notes thereon.

815. FOUR MISCELLANEOUS SKETCHES.
 (a). TREE AND TOWER (early).
 (b). WALSINGHAM CHAPEL, NORFOLK (early).
 (c). CHURCH WALL (early).
 (d). LICHFIELD CATHEDRAL, WEST FRONT.
816. FOUR SKETCHES (different periods).
 (a). OLD WESTMINSTER BRIDGE.
 (b). IN A WOOD.
 (c). OLD CHURCH.
 (d). A MOUNTAIN STREAM.
817. TEN EARLY DRAWINGS (tinted).
 (a). SALTWOOD CASTLE, KENT.
 (b). CHICHESTER CATHEDRAL.
 (c). NETLEY ABBEY.
 (d). CHURCH.
 (e). ROCHESTER.
 (f). SKETCH IN GLASGOW.
 (g). KIRKSTALL ABBEY.
 (h). LANCASTER.
 (i). MOUNTAIN BRIDGE.
 (j). STANTON HARCOURT, NEAR OXFORD.
818. SIX SKETCHES (different periods).
 (a). LANCASTER.
 (b). SEA STUDY.
 (c). COUNTRY LANE.
 (d). RABY CASTLE.
 (e). FOLKESTONE.
 (f). RIVER SCENE.

819. CAPRI.

Compare Nos. 336 and 337.

820. THE DENT DU MIDI, END OF LAKE OF GENEVA.
821. STUDY OF WAVES.
822. CASTLE.
823. LANDSCAPE.
824. LAUSANNE?
825. ALPINE GORGE.
826. GENEVA.
827. LAUSANNE.
828. ALPINE SCENE.
829. SEA-PIECE.
830. BELLINZONA.
831. RIVER SCENE (early).
832. FRIBOURG, SWITZERLAND.
833. RIVER AND MOUNTAINS.
834. LAKE OF LUCERNE, FROM BRUNNEN.
835. ?
836. LAUSANNE.
837. VENICE.
838. 'CASTLE AND LAKE.
839. SWISS LAKE.
840. ON THE LOIRE?
841. ALPINE FORTRESS.
842. VENICE: GRAND CANAL AND THE SALUTE.
843. VENICE: GRAND CANAL AND CAMPANILE.
844. FORTRESS, TYROL?
845. SWISS SCENE.
846. FRIBOURG, SWITZERLAND.
847. VENICE: MOONLIGHT.
848. MONT PILATUS.
849. BRIDGE OVER RIVER LUGWY, CAPEL CARIG.
850. HEAD OF LAKE OF LUCERNE (BAY OF URI).
851. BRIDGE ON THE MOSELLE?
852. NUNEHAM COURT, NEAR OXFORD (early).

See note on Nos. 401–409.

853. RIVER SCENE (early).
854. BONNEVILLE, SAVOY, WITH MONT BLANC.

One of the same series as Nos. 319–325. See notes thereon.

855. GATEWAY TO PRIORY, BRIDLINGTON, YORKSHIRE.

Lent to the South Kensington Museum.

856. VIEW FROM RICHMOND HILL.

Lent to South Kensington Museum.

857. Raglan Castle (early).
858. River Scene (early).
859. ?
860. Study for "The Golden Bough."

> The picture, No. 371 in the National Gallery Collection, has been removed to Dublin.

861. Kilchern Castle, Loch Awe, Scotland (early).
862. Mountain Valley (Geese in Foreground).

863–884. DRAWINGS FOR "LIBER STUDIORUM," BEQUEATHED BY MR. HENRY VAUGHAN.

[See notes on Nos. 461–522.]

863. Frontispiece to Liber Studiorum. See *Modern Painters*, vol. v. pt. ix. ch. xi. § 30.

> A drawing in ink and bistre over a completed etching, evidently (says Mr. Rawlinson) the guide for the engraver of the mezzotint work of the frame and border.

864. Rizpah.

> The picture in the National Gallery Collection, No. 464 (now removed to Liverpool), differs considerably from the drawing. For the subject, see *Pre-Raphaelitism*, § 35 (Vol. XII. p. 370).

865. Raglan. See *Modern Painters*, vol. v. pt. ix. ch. xi. § 29.

> "I do not know," says Mr. Rawlinson, "how the name of Raglan attached itself to the plate. Turner has given it no title. Neither the castle nor the surroundings are like Raglan. It has, however, marked resemblance to Berry Pomeroy Castle, near Totnes, and we know that Turner was painting in South Devon about a year before. The moat is now filled up, but the miller hard by remembers when there was just such a moat as is drawn here."

866. The Grande Chartreuse. See *Modern Painters*, vol. iv. (Vol. VI. p. 316), and vol. v. pt. ix. ch. xi. § 28; and compare *Lectures on Landscape*, § 98.

867. Macon.

> "Not engraved. This drawing and Nos. 870, 871, 876, 877, and 466 were never engraved or etched. As they are in sepia, and of the same size as the *Liber* drawings, they are supposed to be Turner's preparations for the completion of the work."—*Rawlinson*, p. 170.

868. Crowhurst.

> Unpublished drawing.

869. THE DELUGE.
870. FALLS OF THE RHINE: SCHAFFHAUSEN.

A magnificent drawing; not engraved.

871. SEA-PIECE: VESSELS IN A BREEZE.

Not engraved.

872. THE TEMPLE OF JUPITER, ÆGINA.

Engraved, but not published.

873. BANKS OF THE THAMES, KINGSTON.

Taken with scarcely any alteration from the oil-picture, painted about 1809, No. 491 in the National Gallery. Engraved, but not published.

874. MOONLIGHT AT SEA: THE NEEDLES, ISLE OF WIGHT.

Engraved, but not published.

875. THE FIFTH PLAGUE OF EGYPT.
876. DERWENTWATER.

Not engraved.

877. LUCERNE.

Not engraved.

878. PLOUGHING AT ETON.

An etching, coloured in sepia as the guide for the engraver. Compare No. 516.

879. THE SOURCE OF THE ARVERON. See *Modern Painters*, vol. iv. (Vol. VI. p. 373), and vol. v. pt. vi. ch. ix. § 6; for early sketches of this subject, see in this collection Nos. 553, 610.
880. WINDSOR FROM SLOUGH: SHEEP-WASHING.

This subject was engraved but not published. A portion of the etching from this drawing was selected by Ruskin as a lesson in tree-drawing; see *Elements of Drawing*, §§ 106, 107.

881. TWICKENHAM.
882. GLAUCUS AND SCYLLA.

Glaucus as a Triton beckoning from the waves to Scylla, who is removing from him on the shore. Engraved, but not published.

883. TEMPLE OF ISIS. SCENE IN PETWORTH PARK.

A cluster of leaves from the foreground in this drawing is illustrated in *Modern Painters*, vol. v. figs. 94, 95, 96, as an example of careful symmetry in composition.

XIII. 2 T

884. From Spenser's "Faery Queen."

> "The *Faery Queen,* they say, has been searched in vain to find the source of this subject. There is certainly no passage in that poem which describes a knight sitting on the ground and leaning his head in miserable thought upon his shield, while before him lie the abandoned shield and arms of another knight who has carefully piled them up like a monument before he has said his farewell to life. But I have always thought that Turner had in his mind, when he drew this place, the scenery around the Cave of Despair described in the first book of the *Faery Queen.*"—Stopford Brooke : *Notes on the Liber Studiorum,* p. 116.]

885. Quarter-deck of the " Victory."

> A drawing bequeathed by Mr. Harry Vaughan. For Turner's studies of the *Victory,* see Ruskin's note on p. 170 of this volume.

In one of the Turner water-colour rooms at the National Gallery, there is now placed a bust of Ruskin by Conrad Dressler. This bust, made at Brantwood in 1884, was presented to the National Gallery in 1901 by Mr. T. Thornton.

END OF VOLUME XIII

WS - #0058 - 181223 - C0 - 229/152/41 [43] - CB - 9780484213011 - Gloss Lamination